The Louis I. Kahn Collection
Pennsylvania Historical and
Museum Commission and
University of Pennsylvania

**Lenders
to the
Exhibition**

Kimbell Art Museum

The Yale University Art Gallery

The Menil Collection

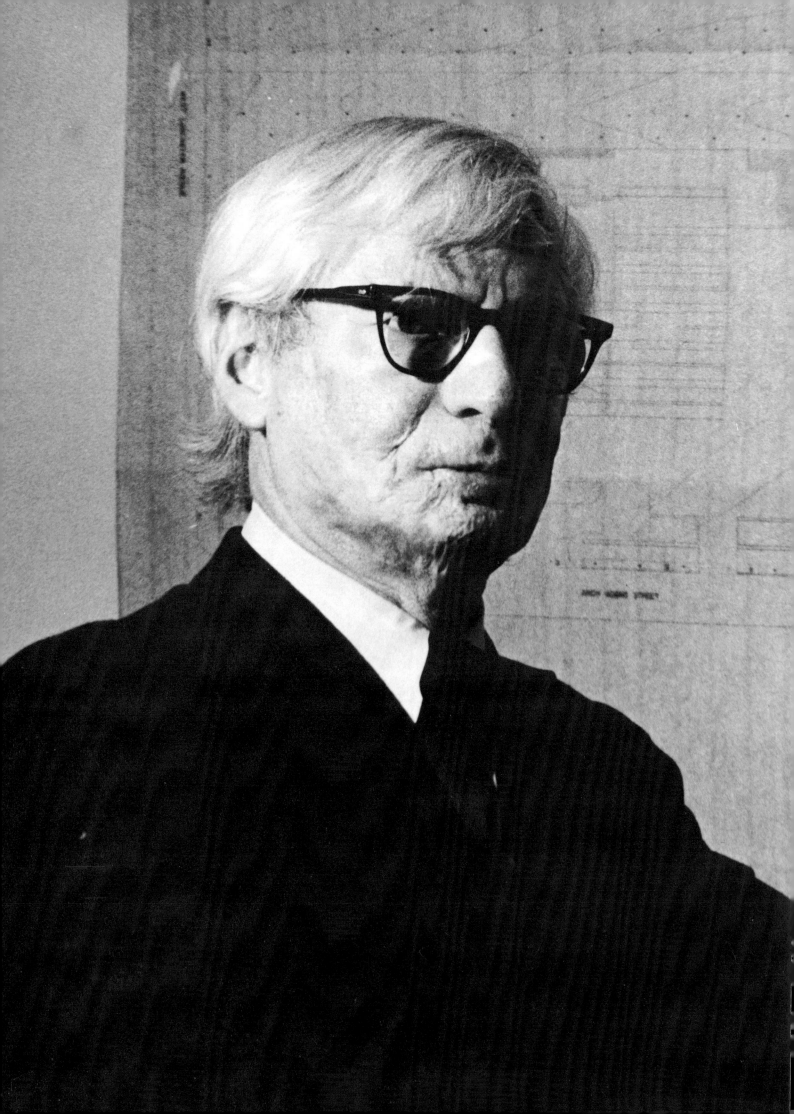

# The Art
# Museums of
# Louis I. Kahn

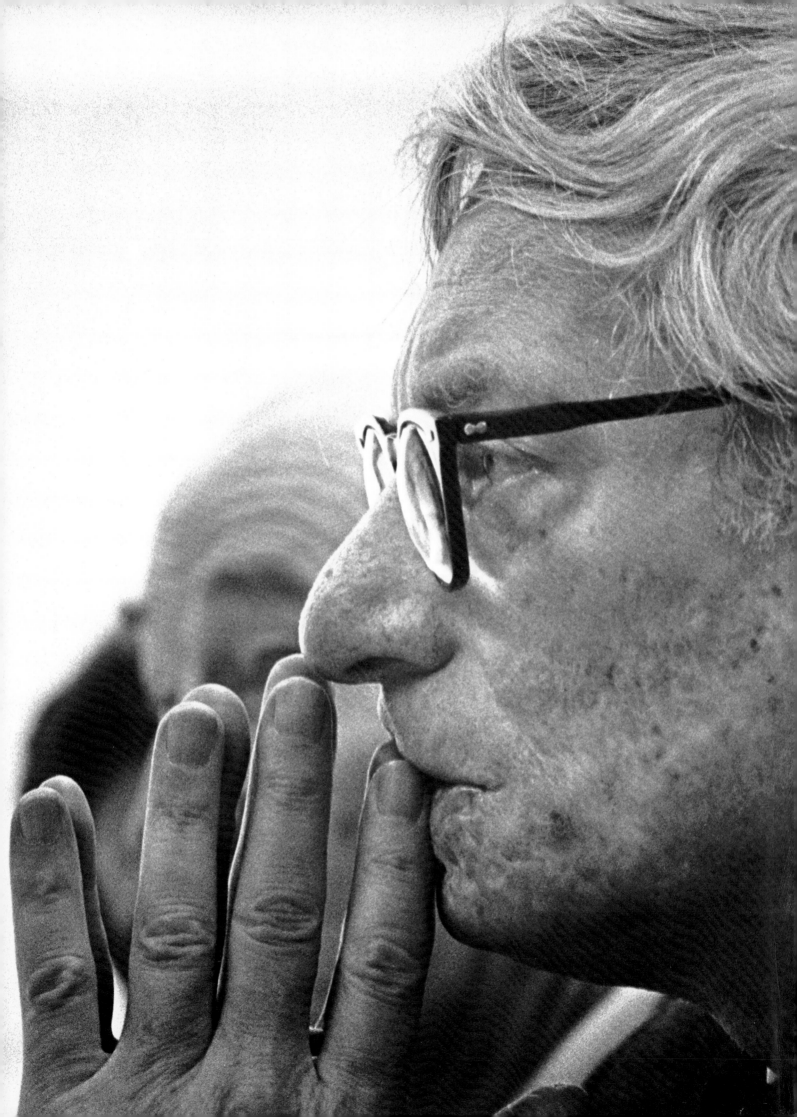

# The Art Museums of Louis I. Kahn

Patricia Cummings Loud

*Foreword by*
Michael P. Mezzatesta

Published by the
Duke University Press
in association with the
Duke University
Museum of Art

Durham and London

1989

iv

This catalogue is published on the occasion of an exhibition seen at the following museums:

| | |
|---|---|
| **Duke University Museum of Art** | November 10–December 31, 1989 |
| **Yale University Art Gallery** | January 27–March 11, 1990 |
| **Kimbell Art Museum** | April 7–June 17, 1990 |
| **San Francisco Museum of Modern Art** | July 19–September 16, 1990 |

Copyright © 1989 Duke University Press
Printed in the United States of America

Library of Congress Catalogue Card Number 89-51072
ISBN 0-8223-0998-X (paper)
ISBN 0-8223-0989-O (cloth)
Design and Production Art by Tom Dawson/Bill Maize, DUO Design Group, Fort Worth, TX

**Frontispiece**
Louis I. Kahn.

**Cover**
Schematic site plan for the
de Menil Museum, Houston,
by Louis I. Kahn. October
1973. Catalogue 114.

The publication of this catalogue has been made possible by a generous grant from the
**Mary Duke Biddle Foundation**

Additional support has been provided by:

Frank E. Hanscom III and the Mobil Foundation, Inc., matching gift program
The Friends of the Art Museum
Reigh Ashton in memory of her husband Samuel Ashton
The Josephine T. Beswick Fund

Contents

Louis I. Kahn at a presentation of plans for the Kimbell Art Museum to the Kimbell Art Foundation.

**Foreword**
Over the past four decades hardly an art museum has been built that has not been affected in some way by one of Louis I. Kahn's three museums — the Yale University Art Gallery (1951–1953); the Kimbell Art Museum (1966–1972); and the Yale Center for British Art (1972–1977). Kahn's influence, international in scope, has redefined in fundamental ways the client's and architect's approach to museum planning. His feeling for natural light, space, and materials, his sensitivity to the art object, and, most importantly, his belief in the importance of man's relationship to art itself, has helped to establish a standard of architectural excellence against which new museums are frequently measured. Kahn's museums are humane structures within which the visitor encounters art in an environment that enhances both the object and the viewer's intellectual and spiritual life.

That this should be the case is not surprising when one considers the man that Louis Kahn was. To those people who studied with him, worked with him, or knew him, he was more than a teacher, colleague, or friend. He was a modern-day mystic whose delphic proclamations — "man is not nature but is made by nature" or "all matter is spent light" — suggested a new, metaphysical, approach to architecture. In many ways Louis Kahn was a seer who, like the double-headed Janus, simultaneously looked back to the Beaux-Arts past even as he saw beyond modernism. Yet at the same time he was very much a man of the moment. Kahn said that he could concentrate on only one project at a time. This was the case because he involved himself totally in every detail of his buildings — from the color of concrete to the quality of light on that concrete; from the spacing of joints to the flow of space from area to area. Herein lies the essence of Kahn as an architect: his dedication to detail, craftsmanship, and quality materials was part of a quest — a quest that sought, as he said, "to discover what a building wants to be."

People who never knew Louis Kahn, and I am one, can obtain a sense of the man's special character through his buildings. For six years as Curator of European Art I lived in what is undoubtedly Kahn's masterwork — the Kimbell Art Museum. Ten years before arriving there, I used to listen to Richard F. Brown, the founding director of the Kimbell and my summer neighbor, talk about building a museum in Fort Worth. The memory of his excited description of the pouring of the majestic cycloid vaults and his equal delight with the design for a water fountain (see fig. 3.71) has never left me. His joy in working with Kahn was exhilarating. For me the daily experience of the Kimbell's space and light, indeed almost every detail of the building's fabric, was equally exciting and constantly deepened my admiration for the remarkable man who created it.

How was it that this building came to be? How did it evolve? What were the forces that shaped it? This exhibition and book, the first comprehensive analysis of Kahn's art museums, are intended to help provide some answers to these questions. Guest curator, Patricia Cummings Loud, has prepared a detailed history of Kahn's three museums as well as the unrealized Menil Museum, a project he was engaged in at his death in 1974. Each chapter traces the creative process from early working drawings through sketches, plans, sections, elevations, presentation drawings and models to the completed building. Through her close reading of documents and drawings, we are able to follow the evolution of Kahn's ideas, which were constantly changing as each structure began to assume its own identity. Patricia Loud's special contribution is to make us witnesses to the process of creation, a process that comes alive in her narrative and in the beautiful and expressive drawings in the exhibition.

Indeed, Kahn, a master draftsman trained in the Beaux-Arts tradition, produced sketches that carry the many layered reminders of thoughts changed and changed again or the bold, assured line of an idea right from the start. This fact is clear in the drawings seen in this show: ten for the Yale University Art Gallery; thirty-eight for the Kimbell Art Museum; forty-five for the Yale Center for British Art; and fifteen for the Menil Museum, many seen for the first time. Kahn's sensitive graphic style provides an insight into the inspiration of the moment even as it records the gradual formalization of specific concepts. Patricia Loud's thoughtful analysis illuminates that evolutionary process seen in the drawings, drawings that are records of the continual dynamic between client and architect and the philosophical and aesthetic criteria that motivated Kahn.

Louis Kahn's gift was the ability to unite rational analysis with an intuitive sense of a building's emerging personality. That he succeeded so well is evident not only in these three distinguished structures but also in the homage paid to them in museums built since 1953. However, no less than these outstanding museums themselves, Louis I. Kahn's passion for the traditions and art of architecture and his continuous quest to realize his personal vision, are his enduring legacy.

The presentation of *The Art Museums of Louis I. Kahn* is triply significant for Duke. Some twenty-four years ago a group of dedicated individuals, under the leadership of Duke University President Douglas Knight, set into motion events that led to the founding of the Duke University Museum of Art. This year marks the museum's twentieth anniversary. A second milestone is the fact that this show, which will be seen at the Yale University Art Gallery, the Kimbell Art Museum, and the San Francisco Museum of Modern Art, is the first major traveling exhibition to be circulated by DUMA, and so heralds a new phase in its growth as an institution. Finally, as plans have been announced by President H. Keith H. Brodie to build a new art museum with the generous assistance of the Nasher Family Foundation, no exhibition could mark more appropriately DUMA's first twenty years or provide the essential lessons necessary for the construction of a museum that will be an heir to the excellence of Louis Kahn's art.

We are indebted to many people for the successful completion of this project but none more so than Patricia Cummings Loud, our guest curator. For the past two years she has worked assiduously organizing the exhibition and writing the catalogue even as she carried out the responsibilities of a full-time job at the Kimbell Art Museum. Her dedication to this exhibition has been equaled only by her good humor in the face of the critical museum publication deadline. Working with her has been a wonderful experience. We are extremely grateful for the excellent job that she has done and for her contribution to the scholarship on Louis I. Kahn. These essays provide an important dimension to our understanding of Kahn as an architect.

One hundred of the one hundred and eight drawings and two of the six models in the exhibition are from the Louis I. Kahn Collection at the University of Pennsylvania. From the moment that this exhibition was first proposed in 1987, its most enthusiastic supporter has been Julia Moore Converse, Curator of the Kahn Collection. Her assistance in every phase of the organization of this show has been instrumental in making it a reality. She and her dedicated staff labored long and hard overseeing, among other things, details of photography, matting, framing, and crate construction. Her kindness, generosity, and sound advice are deeply appreciated. We are most grateful to her for helping to bring *The Art Museums of Louis I. Kahn* to the public.

Thanks must also be extended to the other lenders to the exhibition — the Yale University Library; the Kimbell Art Museum; and the Menil Collection. We would like to acknowledge Mary Gardner Neill and Edmund P. Pillsbury, Directors of the Yale University Art Gallery and the Kimbell Art Museum, respectively. Their support in helping to present the exhibition at two of Kahn's museums makes this tour all the more meaningful. We are also pleased that the exhibition will be seen at the San Francisco Museum of Modern Art. The enthusiasm of John R. Lane, Director, made it possible to bring the show to San Francisco at a moment when plans for a new museum are underway. Paul Winkler, Acting Director of The Menil Collection, was helpful in several ways, and we thank him for his support.

Special recognition also is due Tom Dawson, the designer of the catalogue. Working with him has been both a pleasure and a privilege. The results of his efforts speak for themselves. Finally, we would like to mention the contribution of Michael Bodycomb, the Fine Arts Photographer of the Kimbell Art Museum. His color photographs of the three museums are often works of art in their own right.

The publication of this catalogue has been made possible by a number of generous contributions that are acknowledged in the front matter. We would like to express our gratitude to all of these benefactors for their support, especially the Mary Duke Biddle Foundation. The Foundation's assistance with new initiatives has been essential in advancing DUMA's programs for the future. To the Foundation, and to all of the people who brought this exhibition into being, we extend our thanks.

Michael P. Mezzatesta
*Director*

This book is a catalogue for the exhibition of Louis I. Kahn's drawings and models for his art museums and a documentary guide to their development. The exhibition was initiated by Michael Mezzatesta, Director of the Duke University Museum of Art, who has been unfailingly and generously supportive of its realization and catalogue. Nor could this exhibition have been realized, quite apart from its conception, without the unstinting cooperation of the Louis I. Kahn Collection of the University of Pennsylvania and the Pennsylvania Historical and Museum Commission, whose works make up the preponderance of those on view. They have been supplemented with drawings and models from the collections of the Yale University Art Museum, the Kimbell Art Museum, and The Menil Collection. Taken together, they expand our appreciation of Louis I. Kahn's gifts.

Unlike Wright, Kahn did not have the equivalent of a Taliesan West to carry on his work and nourish his fame. Those who admire his work and architectural philosophy nonetheless constitute a fellowship no less binding and substantial for being informal. Many who knew or worked with him have been generous with their time, their insight, and their knowledge. Mrs. Esther I. Kahn is a special partisan. I must also thank Marshall D. Meyers, Anne G. Tyng, Jules D. Prown, Simone Swan, Vincent Scully, Christian Devillers and other former students and colleagues whom I have been privileged to meet and who have taught me much. I am happy to have this opportunity of expressing my gratitude to Julia Moore Converse, Curator of the Kahn Collection, for her dedicated professional assistance, her encouragement and friendship through years of research. Her changing staff of serious graduate students has helped me considerably. The materials they care for are a treasury whose value to those who wish to use them is well understood. In addition to matters of conservation and framing, Ms. Converse further arranged and oversaw photography of the personal and office drawings in the Collection. Will Brown of Philadelphia recorded these Kahn Archives with notable accuracy. It is my hope that the present exhibition and book will bring reward to all who have contributed to their creation.

The facilities of the Loeb Architectural Library and the Fogg Art Museum Library of Harvard University and the Yale University Archives have also been my resources. At the Yale Art Gallery, Tony Hershel and William Cuffe materially assisted with the exhibition and with photography. At the Yale Center for British Art, Constance Clement has found just the right photographs. Paul Winkler and Susan Davidson of The Menil Collection have been of great help. A number of the other museums mentioned in this book have provided photographs, many painstakingly researched from their archives. We are grateful.

At the Kimbell Art Museum, I must single out the library staff, and Sally Monroe, curatorial secretary, for special thanks. As in the past, it has been a pleasure to work with Tom Dawson, whose talents are a vital resource to all who publish in the arts. Michael Bodycomb's photographs, I feel, are sensitive recognitions of the qualities of Kahn's museums and should be especially noted.

At Duke University Press, Joanne Ferguson, Bob Mirandon, and others have responded to the unwonted challenge of brief deadlines and broad expectations with tact and understanding.

Neil Levine and John Coolidge of Harvard University have been supportive for many years. This book takes its origin in dissertation research under the former's direction. Wishing their trust to be vindicated, I hope they know just how much I have gained from their wisdom and investment of time and care. Similarly I here acknowledge my debt to Edmund P. Pillsbury, Director of the Kimbell Art Museum, who has long encouraged my studies on the work of Kahn and who has assisted this project particularly with the gift of time. Finally, to my husband, John F. Loud, my deepest thanks.

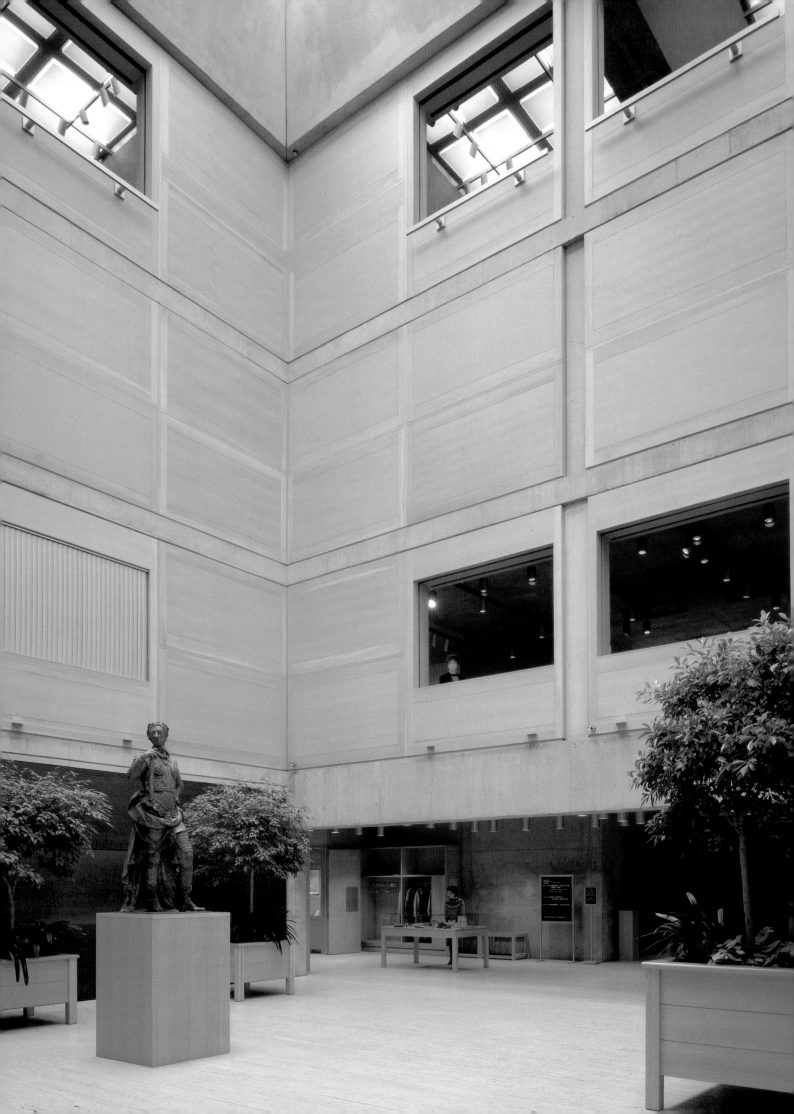

# Louis I. Kahn and Museums

Louis Isadore Kahn's art museums are especially significant in his oeuvre, for they include his first major commission, the last building completed during his lifetime, and an important unfinished project completed three years after his death in 1974. As a group, they represent a comprehensive overview of his work. The building type itself, of developing importance during the eighteenth and nineteenth centuries, has become one of the most prestigious of the late twentieth century. For these reasons the museum is of special significance to Kahn, among whose principal works the execution of three of the same type is unusual.[1] Indeed, his art museums also represent some of the most generally admired works by this eminent American architect. Since Frank Lloyd Wright, no architect in this country enriched the architectural traditions of his time to such an extent. The museums also illustrate Kahn's own personal development, not in the sense of a succession of styles, or modes of the day, but as a deeply considered concept of what the museum should be, how it should be developed, and how it should function. They reveal his evolution both as an architect and as an architectural thinker.

Kahn's biography might be summarized as the quintessential American dream: the poor immigrant against all odds and by dint of hard work and his own talent attains, in the land of opportunity, the pinnacle of fame and success (not, in this case, fortune as well). Born on the island of Osel, off the coast of Estonia, on February 20, 1901, Kahn was the son of Leopold Kahn, a Jewish artisan in stained glass, a literate man gifted in languages, and his Latvian wife, Bertha Mendelsohn Kahn, who was educated in Riga in the Germanic tradition. As a child of three, Louis Kahn suffered a dreadful accident that was to mark him literally for the remainder of his life. Attracted by the color of coals burning green rather than red or blue, he reached into the fire and pulled some out into his apron. The coals flared up and seriously burned his face and hands, leaving permanent, disfiguring scars. His mother thought he had been touched by destiny after this and singled him out for support. Her special care and a talent in drawing that surfaced early sustained and distinguished Louis in his youth. His drawings, in one story he later told, caught the attention of the captain of the ship bringing his mother, two younger siblings, and himself to join the father in America. The family was rewarded with gifts of oranges when his mother presented the captain with the five-year-old's drawing of a steamship.[2]

The family settled in Philadelphia, close by an older half-brother of Leopold's. Their life was hard, their poverty harsh. Kahn's father injured his back while employed as a laborer only two years after they arrived and thereafter could no longer work. The family was thrown onto the resources of the mother who took in sewing and needlework. But despite their bleak circumstances, there was a compensating warmth and support. The family remained close to and respected by the immigrant community, and Leopold Kahn helped recent arrivals with his skills in language and letter writing.

Diffident and shy, all too conscious of his scarred face, Kahn did not begin school until he was seven, when his ability in draftsmanship set him apart. Asked to create illustrations for his teachers on the blackboard, he gained self-confidence. He was singled out for special schooling in art. Private philanthropy saw to it that he received lessons in painting after winning city-wide art competitions, and once again it was a

Yale Center for British Art, New Haven. Entrance court.

patron who came forward to advance his interest in music. As a child, he had by arrangement listened in on a neighbor's piano lessons and practiced on her instrument. Kahn was given a grand piano when he was ten by someone who recognized his talent. (He enjoyed telling of having to sleep on the piano because of the lack of space in his home.) Later in life Kahn often belittled his academic skills, saying that only his artistic abilities had made him a respectable student.

Philadelphia endeared itself to him and he remained a loyal son, grateful for the bounty that he had received. The city had provided him with "availabilities" to develop his talents. He was later to use this word in characterizing the essential life-giving quality possessed by a city or an institution, a quality deserving of highest praise. In 1971–74, when he made designs for the celebration of the Philadelphia Bicentennial, they included "The Forum of the Availabilities."

Kahn attended a public high school that offered encouragement in the arts. It was during his last year in Central High School, when he took a mandatory course on the history of architecture, that he discovered architecture and determined to become an architect. In the class he made five drawings of different styles — Egyptian, Greek, Roman, Renaissance, and Gothic — not only for himself but also for half his classmates. That year he won a full four-year scholarship to the Pennsylvania Academy of Fine Arts. Rather than accepting it, however, he insisted on following the new career choice of architect despite his parents' hopes that he continue in a field in which the way seemed prepared. At the University of Pennsylvania Kahn entered the Beaux-Arts program for architecture students devised by Paul Philippe Cret. During his years at the University, as he had in high school, he continued to help support the family by playing accompaniment for silent films in Philadelphia theaters. He also found occasional employment making presentation drawings for local architectural offices. These jobs helped eke out a living for his family and himself while he was in school. But in his final undergraduate year he was able to obtain a teaching assistantship in the drawing and painting courses that architecture students were required to take all four years.

While this appointment constituted important recognition of his talent before graduation, Kahn's ability to draw and sketch was invaluable as he received his Beaux-Arts training, for pictorial renderings were of fundamental importance in the study and practice of architecture within the Beaux-Arts system. These courses were crucial for the development of his own graphic technique and, more importantly, in the evolution of his working method. For this reason we must pause in order to review the role of drawing in the education of the Beaux-Arts architect. Studies were directed on the basis of these, and students progressed through various phases, learning how to make particular types of drawings. It was from drawings that judgments were made for awards of prizes and distinctions. Student years, for Kahn as for the others, were years of paper architecture.

Beaux-Arts drawings of the sort that Kahn learned to produce were admired for their own value and preserved, as in the library of the École des Beaux-Arts, Paris, or collected by architects. One of the most distinguished of the collections, also including artifacts, manuscripts, and books, had been formed by Sir John Soane (1753–1833) in England; he in turn drew on collections made by other architects. Under Cret, the University of Pennsylvania continued the venerable tradition of emphasizing drawings and of keeping the best for its own collection. (The Architectural Archives at the University is an American version of the French tradition.)

What Kahn was mastering during his years of study at the University of Pennsylvania is worthy of attention, forming as it did his fundamental knowledge of architectural drawing. A student who successfully completed the Beaux-Arts method of study was trained to do several types of drawings. First in sequence was the *esquisse*, the sketch, specifically, a preliminary drawing that would show the scheme, known as the *parti*, chosen to satisfy a program's requirements and to organize the design. The sketch was to be done quickly, without reference to books or outside advice. (At the University, as in Paris, it was prepared in a few hours alone *en loge*, "in a cubicle.") Except for the basic framework, thorough definition was not expected, as only further

study would elaborate details. But the approach, the scheme for the whole building, was fixed by the *esquisse*. A student's discipline was to work out all problems he encountered in the project without changing the basic *parti*. In these drawings general effect counted. They were also the initial creative moment for the young architect.

Kahn valued this type of drawing throughout his career. Characterizing Beaux-Arts training many years later, he spoke first of the *esquisse*, which he said conveyed the nature of a building, its essential character, its identity.[3] Students would prepare their ideas for making these sketches through the study of existing designs in handbooks or of buildings they could experience themselves, but Kahn thought what counted most was intuition, calling that "our most accurate sense" and saying that the design depended on intuitive understanding. In his own teaching, in his own words, he taught "appropriateness" rather than how to "do things." Thus he did not follow the Beaux-Arts method entirely. The idea-sketch for him was related to the evocation he described with the word "beginning." To him this meant attempting to create the design without drawing on past examples of the same type of building (unlike the Beaux-Arts method). Kahn instead sought to draw on his own recognition of basic motivations inspiring the building. It was an attitude that bespoke his modernist beliefs, and the same can be said of his lack of interest in the five orders of architecture.

The Beaux-Arts student's experience of developing the *esquisse* without changing the basic compositional concept was considered, at least in theory, the equivalent of dealing with limitations found in actual practice (special conditions, cost limitations, peculiarities of site or client). The sketch was supposed to determine scale and proportions through the study of details. A good proportion between walls and openings, voids and solids, advanced or recessed masses should be discovered in this way. (Often a figure would be included beside the building to show scale.) These drawings consisted of plans, sections, and elevations, the three combined thought to convey more in their thoroughness than any perspective sketch. Perspectives, in fact, were not allowed for a plan project unless it was an archaeological one. Details were made for walls, doors, windows, ornamental courses, cornices, columns, entablatures, vaults, the joining of stone, ceilings, stairs — all considered to be the elements making up the whole. To learn to depict these details and to recognize good proportions, students were instructed to look at examples of executed buildings or of well-drawn documents, but not, however, the work of students, even prize-winning plates. Traditional architecture, "the accumulated legacies of the centuries,"[4] established the standards to be used.

The Beaux-Arts system at Pennsylvania required that a design express a character appropriate to the type and use of the building. This was an idea that Kahn made part of his personal philosophy of architecture and that he associated with the *esquisse*, although he did not follow prescribed methods later in his career. Particular attributes, either traditional ornamentation for type or the use of certain materials or details that create special effects, were the means to convey that character, and it was necessary that the student learn how to render a drawing with these elements. This goal was advanced by the study of certain books, including Guadet's *Eléments et Théorie de l'Architecture*, D'Espouy, *Fragments d'Architecture Antique* and *Fragments d'Architecture: Moyen Age et Renaissance*, Gromort, *The Elements of Classic Architecture*, Letarouilly, *Edifices de Rome Moderne*, César Daly, *Motifs Historiques*[5] as well as the study of actual buildings to increase general knowledge. The goal of this training was also to have the student analyze and evaluate different aspects of a program in order to be able to select the most effective solution for whatever problems might be presented.

Some drawings were to indicate structure. *Pouché* relied on using dark and light values, the dark showing the structural components, supporting walls and columns. The character of the work itself was to be revealed thus, just as it was also conveyed by compositional arrangements and patterns of circulation. Kahn as a mature architect found he could use *poché* for his own purposes. Some of his planning ideas, he said, came from such drawings. By studying these "pocketed" plans, as he called

them, expressive of structure, he conceived hollow walls, whereby the wall becomes a container or service space.[6] The Bath House of the Jewish Community Center in Trenton, 1956–57, is recognized as the first most clearly ordered design utilizing this concept. Its hollow piers house various services. Kahn went further, saying that his idea of separating service spaces and spaces served came from his Beaux-Arts training.

There were other special types of Beaux-Arts drawings. *Mosaic* was used to make an effective presentation of the plan and scheme, of *parti*, by emphasizing rooms and circulation patterns through light and dark, using conventionalized (not realistic) representations of, for example, floor or ceiling patterns or furniture. After drafting a plan, values were usually then brushed or penciled in quickly to convey the sought-after effect. *Entourage* was another type intended to present the total compositional setting — the relationship of the project with the site, or with other buildings, or with special features that might be included — through pictorial values. *Entourage* had to be carried along with the study of the building. Here, it was recommended that the student make rapid studies on tracing paper with charcoal and chalk, the technique Kahn was to employ so frequently in his mature work. Again, plan, section, and elevation were all to be kept in mind in order to project the work in its three dimensions. The draftsman's own logic and clarity was to order application: separation of light and shadow, neat edges, washes to give distance, atmosphere. Kahn made the "lessons in shades and shadows" part of his own architecture as well.[7] Through them he first grew aware of the inseparability of light and building or, rather, of the possibility, as he said, of constructing light. This interweaving of light, structure, and building became a major distinguishing feature of his museums.

For a Beaux-Arts presentation (to client, jury, or teacher), a sheet of paper could be effectively arranged with "fragments" of various drawings. John Harbeson, Cret's student who became a teacher-architect and was Kahn's first professor at the University of Pennsylvania, recommended studying the drawings and plates, especially title pages and frontispieces, of Piranesi and of Percier and Fontaine,[8] but he endorsed centering a principal drawing on the paper with details at a larger scale around it, plan and section in panels, as the simplest approach. "Indication" was to convey three-dimensionality and floor areas. It could be achieved by drawing as if making an *esquisse*, by studies, or by drawing a presentation. The point was to get an "effect" that would reveal the large principles of design. Rendering to convey the work's three-dimensionality meant modeling, usually with washes or watercolor but sometimes with pen and ink, pencil, oil, or a mixed process. Color was allowable here but not in analytical work. Paul Cret's drawings were cited by Harbeson as outstanding examples.

These techniques and types of drawings were mastered by Louis Kahn in his student years, 1920–24. With maturity his drawings became ever more personal and individual in style, without (unless of course drafted) the precise lines that the Beaux-Arts reference inevitably calls to mind. But that background was meaningful to him. And it is of interest that Harbeson's instructions for drawings presented compelling or telling compositions, gave "snap and life" to two-dimensional representations, and conveyed effects of character, mass, and silhouette. Ideas and techniques learned from Cret and Harbeson were adopted by Kahn and underlie not only actual drawings and buildings but also his very thoughts about architecture, even when, in his acceptance of modernist principles, he reacted against Beaux-Arts traditions. He might not wish to use historical solutions for building types or to be dependent upon what already had been done. But when he conjured his projects, he sought to create a design that could be called true to type. For him a building had to answer the inspirations calling it into existence. It was destined to represent the nature of the type as well as the specifics of a program.

The drawings for Kahn's art museums can be seen as versions of traditional Beaux-Arts drawings: *esquisse*, studies, and presentation. The first two are spontaneous, lack specific detail (numbers of windows, for example) and instead convey mass, silhouette, and the larger relationships. Kahn was especially skillful with these

drawings, even using them for presentations to clients in many instances. Design principles are in the ascendant, weight sometimes being given to this or that aspect, such as massing, structure, or circulation. Details remain relatively unimportant until development is advanced. It is at this stage that sizes and relationships of rooms are studied on the plan, that proportions and scale concern the architect.

Even in Kahn's more formal presentations, when major decisions had been made, he preferred to indicate primary masses and proportions rather than details as he concentrated on the character of his buildings (Harbeson's "indication"). He was, moreover, uninterested in representing surface textures suggestive of materials, preferring a general effect. Models made for his projects were similarly abstract and simplified, nonspecific or noncommittal about materials that might be used in the final version. When photographs were made of these for study of the three-dimensional design, he wanted them made in diffuse, shadowless light that reduced the surface material of the model itself. That way, shapes and massing are more prominent.

Kahn worked over plans, sections, and elevations for all phases of the museum designs, as if following the mental discipline of his earlier training. We can recognize this in the drawings and sketches that follow the growing realization of a building. However, the Beaux-Arts method of drawing was transformed through his own experience of modern architecture and modern art. While his background remained the foundation of his approach to creating a work of art, his personal style reflects certain modern values: abstraction and the unfinished sketch. In contemporary art he responded to sculpture, and although he planned a few murals for some of his buildings, these were decorative abstractions. Most modern painting did not interest him very much, although the sketches made on his trip in 1928–29 seem to participate in the pictorial style of the 1920s. Architecture meant all to Kahn, and what he drew from the other arts was more a matter of attitude and spirit. That he was a gifted and talented designer and draftsman endows his architectural studies and drawings with special panache and vitality, counting for far more than their documentary evidence.

As Kahn's approach to drawing was first formed in the Beaux-Arts tradition, his initial study of museums was also conditioned by the development of the modern museum as a type. It is worthwhile to review this heritage and the role that it played in his own life. Interestingly enough, the development of the museum coincides with that of the École des Beaux-Arts itself in the eighteenth and nineteenth centuries. The first museums after antiquity were literally palaces in the sense that secular and religious rulers were the most notable collectors in the Renaissance, far surpassing what artists and merchants were capable of collecting, and in the sense that special rooms or galleries for display were set aside in these palaces. By the nineteenth century some of these palaces could be considered almost complete museums. Interest in antiquities spurred many collections, for those objects were considered the most prized and worthy of study. By the mid-eighteenth century an increasing impetus toward public display of sculptures was therefore under way, and artists and visitors were welcomed to most private galleries.

One of the early and influential settings created as a museum, in fact often emulated, was the Vatican Museum in Rome, the Pio-Clementino (c. 1773–80) by Michelangelo Simonetti (1724–81). The Belvedere Court had been arranged for classical sculpture by Bramante as early as the beginning of the sixteenth century, but with the remarkable growth of the Vatican collection, thanks to archaeological finds and increasing scholarly attention, the museum building was urgently needed. Its antiquities were considered the finest in Europe and the scholarship devoted to them the most prestigious. Simonetti (and later Pietro (1726–81) and his son Giuseppe Camporese (1763–1822), who succeeded him as architects) followed antique structural forms and constructive systems and used simplified classical detailing to create a setting appropriate for the statuary.[9] The rooms were inspired by Roman baths and other ruins; especially notable were the Sala Rotonda, a miniature Pantheon with an oculus in which representations of the principal deities were shown (fig. 1.1), and the Sala a Croce Greca (fig. 1.2). The museum became a famous monument, itself an expression

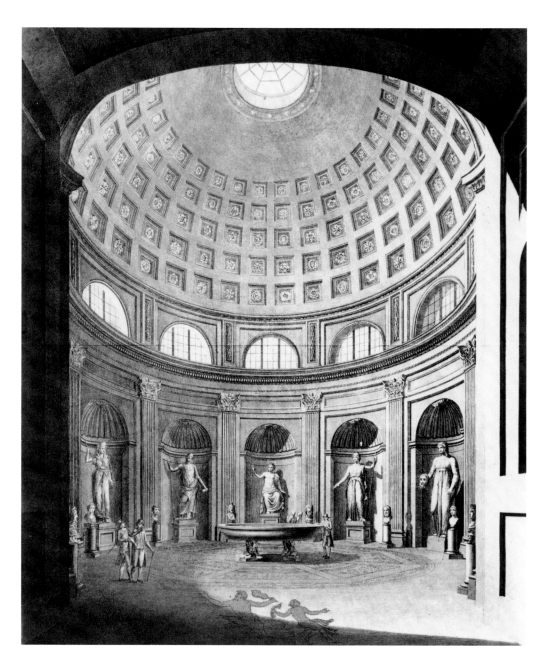

**1.1**
*Museo Pio-Clementino,
Rome. Sala Rotonda. Perspective view.* Michelangelo
Simonetti, Pietro and
Giuseppe Camporese.
Vatican Museum.

of Neoclassical ideals. It was visited by artists, architects, and all those interested in the arts who came to Rome in the latter part of the eighteenth century (and thereafter) and introduced to them prototypical Neoclassic museum spaces that the French Beaux-Arts system was to propagate throughout Europe and, later, the United States.

The pattern for architectural education shaped by the French Academy emphasized reason, construction, and classical examples. (The actual École des Beaux-Arts was the nineteenth century transformation and continuation of the Académie Royale d'Architecture.) These principles were expounded through lectures and tested by monthly and annual design competitions. Winners of the annual contest, the Grand Prix, received three years at the French Academy in Rome at the expense of the government. In the 1780s the requirement was established that these architectural pensionnaires in Rome make detailed studies of classical buildings. The drawings were sent to Paris to be exhibited and kept in the Academy Library, where they informed students in Paris of classical works. More importantly, these drawings and competition projects were published as engravings that circulated throughout Europe and served as models for foreign architects as well.[10] Thus the distribution of this Neoclassical vocabulary, reflecting the age of the Enlightenment, was in the end international.

As for museum projects for the Grand Prix, we can see a progressive development from the mid-eighteenth century, first as an attachment to a royal residence or palace (1753), then as a Salon des Arts (several of these), and finally, in 1778–79, as a full-fledged museum that would be opened to the public. That sequence reveals

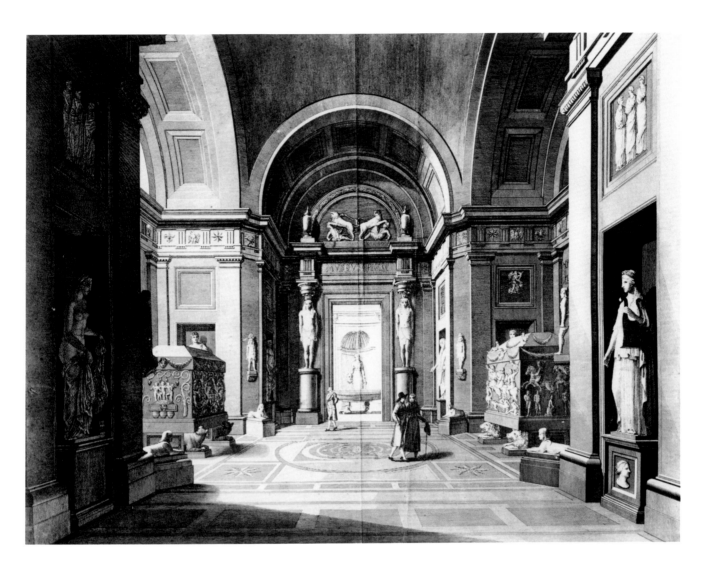

**1.2**
*Museo Pio-Clementino,*
*Rome. Sala a Croce Greca.*
*Perspective view of stairway.*
Michelangelo Simonetti,
Pietro and Giuseppe
Camporese. Vatican Museum.

both magnification and a fundamental shift in importance. Museums were no longer only for royal patrons and aristocrats to enjoy and display their possessions but were to be appreciated by a growing middle class.

Early museum designs for the competitions, however, were ambitious, paper architecture, very complex and abstract, inspired by Neoclassical ideals as well as examples of Roman architecture. An acclaimed teacher who helped set the programs for the contests, Etiènne-Louis Boullée (1728–99), passed on his own theoretical ideas concerning expressive architecture to the students, and several of the prize-winning museums clearly demonstrate his influence. His own drawings for museums convey the idealism of these buildings devoted to the arts in the broadest sense, almost as the Greeks had conceived them, as shrines. The inspirational museum with statues of heroes that he designed, which has been compared to Alexander Pope's Temple of Fame (La Temple de la Renommée),[11] is a grandiose, symmetrical, and awe-inspiring project (fig. 1.3), symbolic of the highest accomplishments of mankind. It was echoed repeatedly in the works of Beaux-Arts students. Austere classical forms were soon associated with museums.

Less visionary and more practical concerns occupied those charged with opening the Louvre as a public museum in 1793, after the French Revolution. The value placed on the arts and cultural centers during the Enlightenment as a means of bettering society was only strengthened by the transfer of decision-making from the aristocracy to appointed or elected committees intended to form democratic institutions. The truly public museum emerged. A growing, increasingly literate middle class reflected the process of industrialization and urbanization taking place in Europe, and its expectations of the surrounding world grew in proportion to its rise to wealth and power. The museum was to be an educational treasure house, not a collection of objects valued just for their prestige and their decorative qualities.

The Louvre and its Grande Galerie (fig. 1.4), the addition that had been made to the palace specifically for the collection of the king, was now to serve the public. In a

**1.3**
*Project for a museum.*
Etienne-Louis Boullée. 1783.
Paris, Bibliothèque Nationale.

dramatic painting offering a prophetic solution for improving the lighting of the gallery in the 1790s, the painter Hubert Robert proposed adding skylights to the Grande Galerie (fig. 1.5). Such remodeling in the Louvre did not actually take place until the twentieth century, but Robert's suggestion was an inspiration for the architecture of galleries in the nineteenth century and even later. (Boullée had designed the well-known project for the expansion of the Royal Library into a huge barrel vault with skylight in 1788, and this visionary design may well have influenced Robert, as it seems to have inspired Kahn while he was designing the Kimbell Art Museum.) The Louvre became a national treasure unsurpassed in size and quality, admired and envied by other countries, as its holdings were enlarged through the conquests of Napoleon and by purchase in the early years of the new century.

It was carefully guided through this growth. New rooms were opened to the public when more space was required to show the spoils of conquest and other new acquisitions. Vast collections were organized by division according to nationality and by alphabet within those categories, a change from the aristocratic arrangements aimed primarily at creating an aesthetically pleasing wall. Another innovation to assist the public was the provision of an explanatory text for each work and inexpensive catalogues and guides. The educational fervor that was a part of the spirit of the time led to more specialized museums as well. Two others in Paris were spawned in the wake of the Revolution: the Musée National des Techniques and the Musée des Monuments Francais. Both were placed in former religious quarters, the first in the Priory of Saint-Martin-des-Champs, the second in the convent of the Petits-Augustins.

While the Louvre has remained an important example of a royal palace that was made a public museum, the two last-named museums established other types that were to have great meaning in the course of the nineteenth century. As its name implies, the Museum of Technology reflected growing scientific and industrial concerns and was a type that proliferated rapidly throughout the century. The Museum of French Monuments was dedicated to the national heritage. Alexandre Lenoir arranged the nationalized property of the church and religious establishments in the convent and its adjoining garden explicitly to preserve the relics of medieval art, but seeing these tombs and effigies in such a setting served to awaken a romantic response in many visitors, one that we see echoed by the period rooms in the twentieth century. Although its own existence as an institution was brief,[12] the response to national identity fostered by this museum characterized a state of mind conducive to the development of museums throughout nineteenth-century Europe.

The first constructed public museums in Germany were commissioned by autocratic, if enlightened, royalty. Leo von Klenze (1784–1864) was chosen by the crown

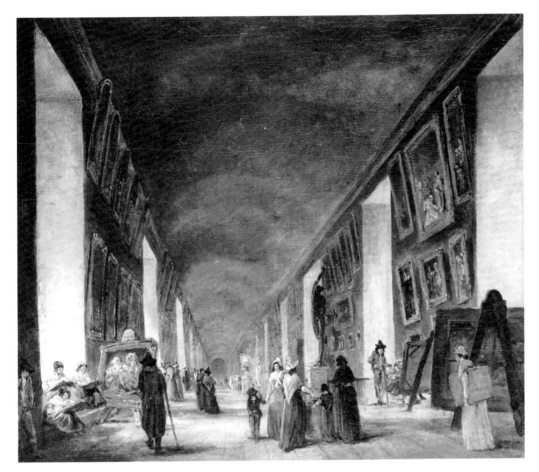

**1.4**
*The Louvre, Grande Galerie.*
Painting by Hubert Robert.
Paris, Musée du Louvre.

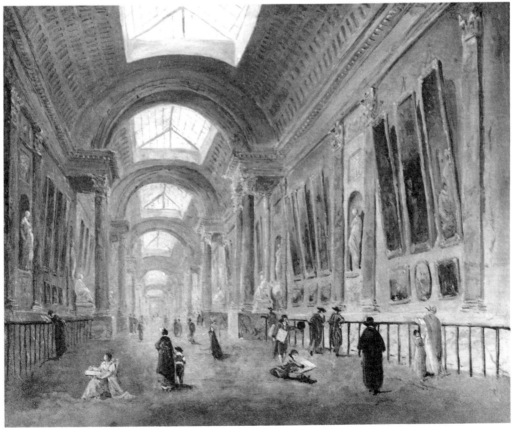

**1.5**
*The Louvre, Grande Galerie,
Project with skylights.* Paint-
ing by Hubert Robert. Paris,
Musée du Louvre.

prince of Bavaria, later King Ludwig I, to be his architect to expand and develop the capital city of Munich. Klenze's patron saw himself as a modern Medici and dreamed of Munich becoming the first city in art among the German-speaking principalities. His architect had studied in Berlin, where the Neoclassical influence of Friedrich Gilly (1771–1800) was strong, and he had worked for Charles Percier (1764–1853) and Pierre Leonard Fontaine (1762–1853) in Paris, where he became acquainted with the theories of Jean-Nicolas-Louis Durand (1760–1834). It was Durand who popularized the ideals of Boullée and the Beaux-Arts and made them more accessible and practicable in his books based on his course of study at the École Polytechnique.[13] Klenze had already been architect for the court of Napoleon's brother in Kassel, but his work for the future King Ludwig I included his earliest monumental project.

The Glyptothek (fig. 1.6), which Klenze designed for the prince in 1816, the year he was called to serve, was a prototypical structure for a pedagogical exposition on the history of sculpture. The collection emphasized the Greek, Roman, and Renaissance periods, and the acquisition of the Aegina marbles was Ludwig's initial motivation in planning the museum. (Its name, Glyptothek, was an invention by the court librarian.) The building itself was to serve a didactic purpose by reinforcing the periods through structural forms and decorative motifs, thus participating in the artistic program. Klenze made drawings for the façade with three possibilities: Greek, Roman, and Italian Rennaisance, each reflecting high points of the collection within.[14] A final version synthesized the styles. Eight Ionic columns create a portico with a pediment, while windowless walls with aedicula-framed niches recall a Renaissance palazzo. The Glyptothek's plan (fig. 1.7) has the same clear geometry of earlier Neoclassical museums but simplified, as in Durand's pattern-book designs. It forms a square, four wings enclosing a single courtyard. The interior contains halls illustrating different types of vaulting with accompanying murals intended to interpret the periods. Two corner rotundas are lighted from the top, like the Sala Rotonda in the Pio-Clementino, while windows on the courtyard side bring light into other galleries.

It is the Altes Museum in Berlin, however, that most fully embodies the ideal of the museum as a "temple of art," one that to succeeding generations became the definitive statement for an art museum, especially national museums (fig. 1.8). It was a royal commission from the King of Prussia, and the program was didactic. Berlin in the early

**1.6**
*Munich, Glyptothek. Exterior.*
*Leo von Klenze. 1815–30.*

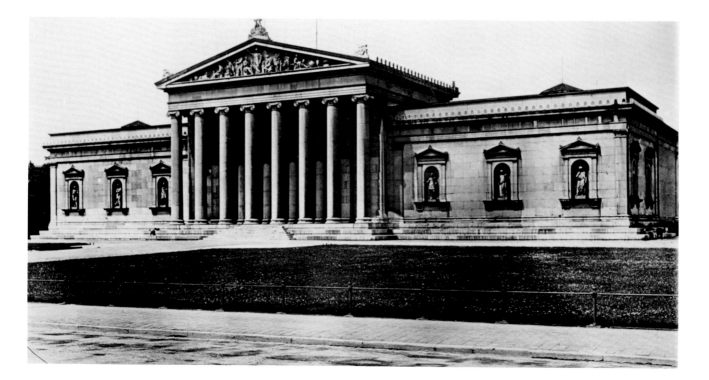

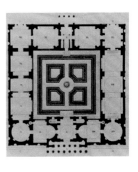

**1.7**
*Munich, Glyptothek. Plan.*
Leo von Klenze. 1815–30.

years of the century, recovering from the humiliation of Prussia's defeat by Napoleon, looked inward to discover its own identity. A renewal of the Prussian state was the goal of intellectuals, a goal thought to be attainable through new cultural and political institutions and educational reforms led by Wilhelm von Humboldt. Republican Greece was the model and the Neoclassical style was considered the appropriate state style. The architect for the Altes Museum, Karl Friedrich Schinkel (1781–1841), a philosophical idealist and painter as well as an architect, thought that architecture was a means of molding society and that the role of the architect was to serve meaningfully in this capacity. He belonged to the intelligentsia seeking liberal changes at this time in Prussia.

Designed in late 1822 by Schinkel and built 1825–30, the Altes Museum took its place in a grand scheme with a plaza before it, the landscaped Lustgarten and the Schloss opposite on the south, the Domkirche on the east, and the river on the west (fig. 1.9). It was a world in which everything had its proper place and relationship. Both architect and client, King Friedrich Wilhelm III, wanted a memorable architectural spectacle that would convey the aesthetic and educational importance of central Berlin. Inside, the arrangements of art were planned to be art historical for the purpose of initiating the bourgeois audience to what had been, up to then, aristocratic collections. The most respected art historians in Germany — first Aloys Hirt, then Gustav Friedrich Waagen and Friherr von Rumohr — were involved, along with Schinkel, in a committee headed by Humboldt to plan how works were to illustrate the whole history of art. Looking ahead to the survey's completion, they planned for future acquisitions as well as current holdings. Sculpture was placed on the lower floor, paintings on the upper. (The ground floor served as a podium and contained storage, offices, and rental space.)[15]

**1.8**
*Altes Museum, Berlin.* Friedrich Schinkel. 1822–30.

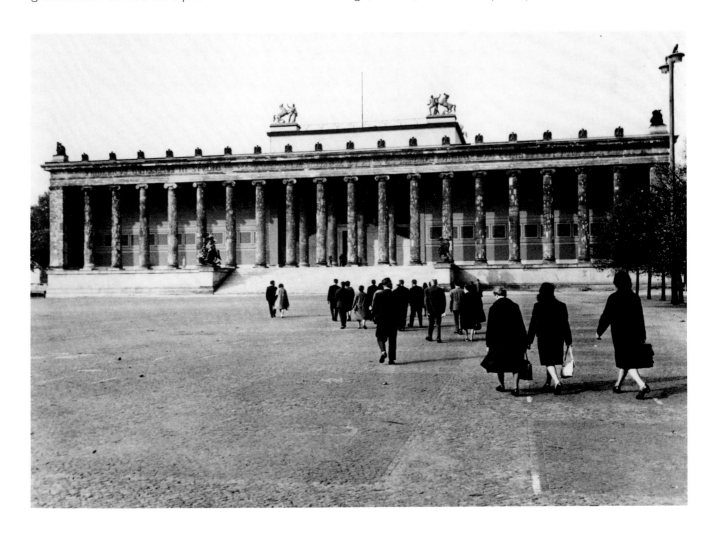

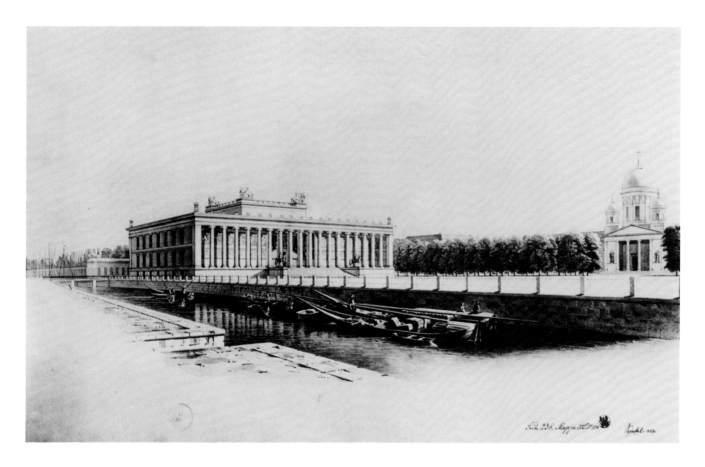

**1.9**
*Altes Museum, Berlin. Exterior perspective.* Friedrich
Schinkel. 1822–30. Berlin,
Altes Museum.

**1.10**
*Altes Museum, Berlin. Plan.*
Friedrich Schinkel. 1822–30.

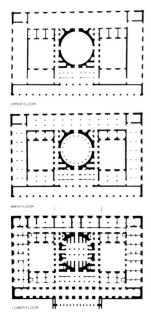

UPPER FLOOR

MAIN FLOOR

LOWER FLOOR

Its plan is that of a contained, rectangular building of connecting galleries with a central unifying rotunda between two courtyards (fig. 1.10). The two-story rotunda offers visitors a climax of spatial and cultural experiences culminating in statues placed high over their heads, an arrangement recalling Boullée's museum as well as the Pantheon and the Pio-Clementino rooms. Such a top-lighted central space realized Durand's rotunda in his book's ideal museum plan, and we will find echoes of it in Kahn's conception of the Yale Center for British Art. The monumental Ionic colonnade across the front recalls Boullée; it embodied numerous Neoclassical projects by Beaux-Arts architects. Inside, on the upper floor, an innovative use of screen walls at right angles to the windows increased usable wall space with acceptable lighting. The monumentality and formality of the Altes Museum, physically and psychically, was intentionally conceived by Schinkel, who wanted the building to be more than a mere container. Its symbolism established a formula for important art museums with which Louis Kahn would become well acquainted.

A smaller, more intimate art gallery, however, is also among the notable early examples and important to Kahn's conception of the museum: Sir John Soane's Dulwich Picture Gallery of 1811–14 (fig. 1.11). Modest in size, scope, and expense compared to national museums in existing palaces or the slightly later Altes Museum, its influence grew more slowly but nevertheless surely as the century went on. It was created for a donation of 370 paintings and one hundred others already in the possession of Dulwich College, outside London.[16] Soane's gallery has become a prototype for later museums, particularly smaller, private ones, while its individual rooms with top-lighting have been a model for larger museums. Indeed, its lighting system has been very influential, especially in the United States.

Soane may have drawn from Durand's published museum and gallery designs, which he knew.[17] The Dulwich plan (fig. 1.12) is simple, composed of the main picture gallery rooms interconnected on a long axis; a loggia (originally unexecuted) is to be found to one side, and on the other, smaller rooms for alms houses. (The latter were required in the program but later converted into offices, storage, or exhibition rooms.) Two outer rooms project as corner pavilions. Another program requirement was the donor's mausoleum. This Soane advanced from the building block in the center of the composition. Each element of the plan reads clearly and separately, as is true of the building as a whole. Architectural detailing is simplified, possibly more than Soane might have wished because of limited funds for construction.[18] However, by the time

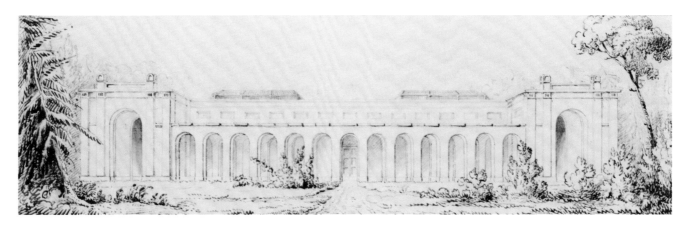

**1.11**
*Dulwich Picture Gallery, London.* Sir John Soane. Drawing by C. J. Richardson. 1811–14. London, Victoria and Albert Museum.

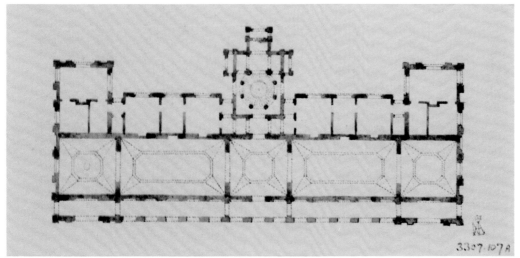

**1.12**
*Dulwich Picture Gallery, London.* Sir John Soane. Drawing by C. J. Richardson. 1811–14. London, Victoria and Albert Museum.

of this work Soane's Neoclassicism had become personal and idiosyncratic, a style often described as primitivist, which seems appropriate to the conception for the gallery.

Natural light enters the interior of the gallery from architectural lanterns overhead (fig. 1.13). Light coming from above into well-proportioned rooms, alternating square or double-squared galleries, establishes a special quiet and meditative atmosphere. That Soane was responsive to such a potential can be judged by the examples of his other works, such as the picture gallery for William Beckford at Fonthill, Wiltshire,[19] the Bank of England interiors, and his own Lincoln's Inn Fields house-museum. The concept eventually reached a wider audience with the proliferation of museums of various sizes and types. Kahn would certainly have known this museum. Lighting in both the Kimbell and the upper floor of the Yale Center for British Art has a similar effect.

Another, much larger, painting gallery must be included among influential prototypes for the Beaux-Arts. The Munich Pinakothek (fig. 1.14), later renamed the Alte Pinakothek, also by Leon von Klenze for his royal patron, was planned to complement the sculpture gallery, the Glyptothek. It was designed in 1823–24, several years after the latter and only slightly after the Altes Museum, and built between 1826–36. Ludwig, inspired by the Renaissance, requested a building similar to the Pitti Palace in Florence, and Klenze went to northern Italy to see palaces and galleries during his work on the design. Freely adapted Renaissance palazzi were the model, as witness the two types of wall systems with aedicular-framed windows that appear on the exterior. Such an iconographic correspondence of style with contents was, as in the Glyptothek, part of the artistic program. Interior ornamentation drew inspiration from Raphael's grotesques. (In homage, the cornerstone was laid on Raphael's birthday.)

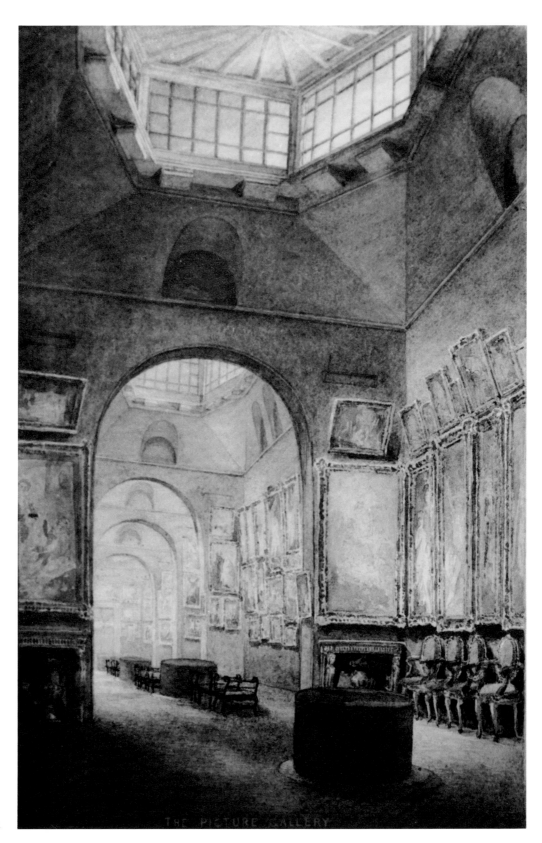

**1.13**
*Dulwich Picture Gallery, London.* Interior perspective. Sir
John Soane. 1811–14. London, Sir John Soane Museum.

Renaissance sources were adapted to a practical gallery plan by Klenze: an
elongated rectangle with short wings extended on the ends (fig. 1.15). During the plan-
ning, the architect kept in mind the pictures to be displayed. Through the center on the
long axis are large galleries with clerestory lighting; on the north side there are small
exhibition rooms; and on the south a loggia serves as a passageway permitting
choices as to which galleries are entered. Because of its arrangements and the clarity
of route for visitors, it is a scheme that has frequently been utilized by later museum
designers. This was a palace made for art rather than one converted into use as an art
museum. The prince wanted to present the history of art through the consolidated col-

**1.14**
*Pinakothek (Alte Pinakothek),
Munich.* Leo von Klenze.
1823–36.

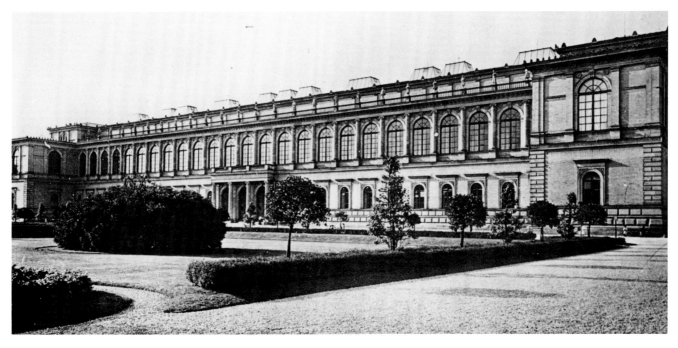

**1.14**
*Pinakothek (Alte Pinakothek),
Munich.* Leo von Klenze.
1823–36.

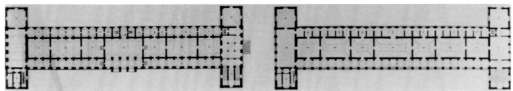

**1.15**
*Pinakothek (Alte Pinakothek),
Munich. Plan.* Leo von
Klenze. 1823–36.

lections — some 1,300 paintings in the 1820s — formed by generations of the dukes of Wittelsbach. Klenze explained his program:

> It [the museum] must make the right impression on visitors and put them in a suitable frame of mind; for it is intended for the whole nation, not just for artists who will be favorably disposed by their nature. The paintings must be set out chronologically in schools, but one must be able to reach each room directly, so as not to be distracted by the previous sight of other works. Large and small paintings do not mix: the large ones will overpower the small ones, while the small ones will spoil the effect of the large ones. They must be displayed separately in different halls, particularly since the large historical paintings must have roof-lighting only, while window-lighting is better for the small paintings.[20]

These are among the museum buildings in Europe, along with others such as the British Museum, the National Gallery, and the South Kensington Museum (the Victoria and Albert after 1899) in London, that an American Beaux-Arts student would want to see. The goal of the Beaux-Arts student in Paris in the eighteenth and nineteenth centuries was to win the Grand Prix and experience Rome and its antique and Renaissance architecture. Few American students in the late nineteenth and early twentieth centuries might actually study in the École, but even those not so fortunate wanted the opportunity to study the buildings of Europe, a preference that could hardly have abated as the Beaux-Arts system took root in architectural schools in the United States. Europe contained the very sources that a student should know. And so it was for Louis Kahn in Philadelphia in the 1920s.

After Kahn completed his training at the University of Pennsylvania in 1924, he worked for John Molitor, the City Architect, as chief designer for the Philadelphia Ses-

quicentennial Exposition and then as a draftsman for the architect William H. Lee. Having saved enough for the trip, he left in February 1928 for Europe, at last to see the monuments for himself, and spent a little over a year traveling and sketching in every country except Spain and Russia. (He did visit his grandmother on the island of Osel, Estonia, and relatives in Riga, Latvia.) It was the year abroad that American Beaux-Arts architects since late in the nineteenth century had considered necessary for advancement in their careers. How important modern architecture in Europe was to Kahn during this year is difficult to judge, but he seems not to have devoted attention to its examples. He would have been aware of modern European architects. As early as 1927, Paul Cret spoke of Le Corbusier with admiration in a talk at the T-Square Club in Philadelphia.[21] (This is an organization founded by architects using the Beaux-Arts atelier system in which Kahn was an active member, serving as its president in the 1940s.) But there are no International Style buildings among Kahn's travel sketches of these early years, only traditional architectural subjects, mostly from England and Italy.[22]

When Kahn returned to Philadelphia in the fall of 1929, he began a career in his own city. His travel drawings, many similar in their modernity to art deco style American paintings of the period, were shown at the Pennsylvania Academy of Fine Arts. He married, and he joined the Office of Paul Cret, the professor he admired. Although the bright future that might have been predicted from all this was tarnished by the Depression and even the job with Cret did not last long because of the economic stresses of the time, Kahn was always to make the most of what life presented. In Cret's office he worked on designs for the 1933 Chicago World's Fair and for the Folger Shakespeare Library in Washington, D.C. (1933), later even including these in a chronology of his works that he assisted in preparing.[23] The library, executed in Cret's characteristic stripped classicism considered appropriate to official Washington architecture, included a paneled, vaulted exhibition hall that the patron asked be reminiscent of England of the sixteenth and seventeenth centuries, a version of the period rooms Cret had introduced into his recently completed (1927) Detroit Institute of Arts (fig. 1.16).

While Kahn was not actually involved with the Detroit museum, he would surely have been aware of it. Cret had begun work on the design in 1922, while Kahn was still his student at the University of Pennsylvania, and, according to his biographer, it was the building that meant the most to Cret of all those in his career.[24] It was an important commission and probably one of the most advanced realizations for its time of a museum with a complete program. In planning it, Cret worked closely with museum director Wilhelm R. Valentiner, who had been trained in museums in Germany and was brought to the United States to introduce the new method of display, period rooms, first in the Metropolitan Museum of Art, New York, and then in Detroit, with a museum built to accommodate the concept.[25]

The plan of the Detroit Institute of Arts (fig. 1.17) shows Cret's reliance upon Beaux-Arts axial organization with cross-axes offering clear patterns for the circulation of visitors within the galleries. Rationality guided the distribution of galleries and auditorium, with the lecture room, study, and service areas all located on a ground floor that serves as a podium for the upper story (fig. 1.18). Cret also used the courtyards traditional to museums. On the central axis he placed an enclosed garden court beyond the large main hall opposite the entrance. A second, larger court was in the right wing of the major cross-axis, while equivalent space in the left wing was devoted to temporary exhibition galleries.

Valentiner's classification system for the art in the museum was cultural (American, European, Asian) rather than by media (painting, sculpture, decorative arts), as this was more effective with period rooms. While construction went on, the director arranged to purchase objects for special installations in the rooms and courtyards.[26] Some years later Valentiner wrote that the Detroit period rooms were "galleries representing periods of art" rather than "rooms from old houses," such as the rooms in the American wing of the Metropolitan Museum of Art.[27] But they were in fact a mixture of the two, sculptural and architectural fragments being incorporated into the fabric of the

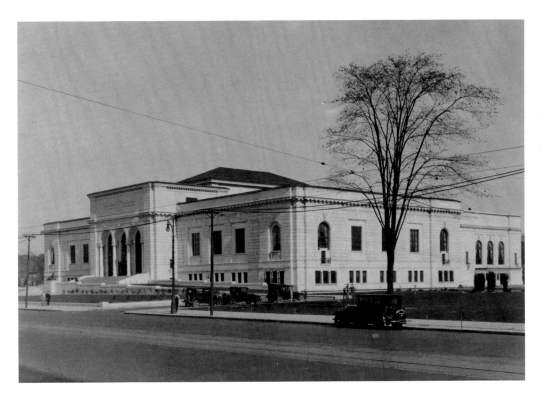

**1.16**
*Detroit Institute of Arts.* Photographed c. 1928–30. Paul P. Cret. 1822–27.

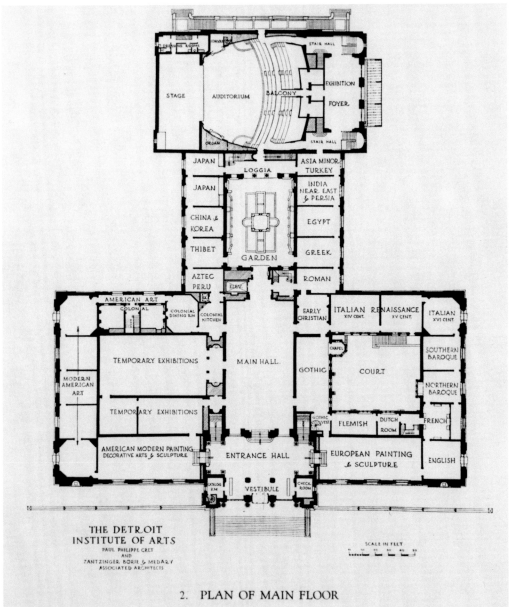

**1.17**
*Detroit Institute of Arts. Plan, upper floor.* Paul P. Cret. 1922–27.

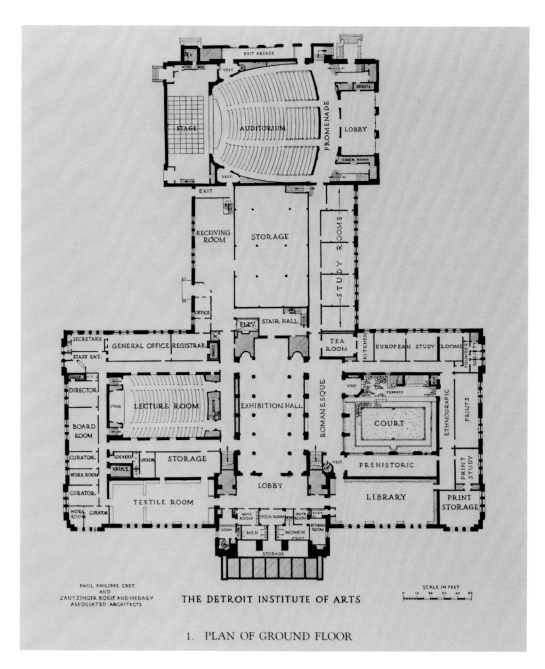

THE DETROIT INSTITUTE OF ARTS

PAUL PHILIPPE CRET
AND
ZANTZINGER BORIE AND MEDARY
ASSOCIATED ARCHITECTS

SCALE IN FEET

1.  PLAN OF GROUND FLOOR

building, along with the installation of several colonial American rooms. A description contemporary with the opening of the museum referred to "original documents" from old houses or palaces and "suitable period adaptations" (see the Gothic room, fig. 1.18), but the writer went on to praise Cret's skill as an interpreter who could design in an historic style without duplicating details and motifs from existing buildings.[28] This ability was the goal of a Beaux-Arts education, but few architects were so talented.

Because of Cret's importance to Kahn's formative years, a talk he gave on museum architecture deserves summary here. It took place at the T-Square Club in 1934, several years after he had finished the Detroit museum, the Barnes Collection (1923–25), and the Rodin Museum (with landscape architect Jacques Greber, 1926–30), the latter two in Philadelphia.[29] It is likely that the former student was in his master's audience on that very occasion. The salient points of Cret's presentation probably indicate the direction of Kahn's own thoughts on the subject of this building type. Cret identified the museum essentially as an exhibition space, "a single room used for the display of works of art." The primary consideration was a reasonable balance between

expense and the amount and quality of space provided, but after that the main concern was lighting: assure the maximum light over the greatest extent of surfaces, he said. It was his opinion that uniform intensity of light would produce only an average effect, neither really good nor completely inadequate. The skylight supplemented by a diffusing sash, developed at the end of the eighteenth century and still used, yielded the most even distribution, but Cret thought the quality of light left something to be desired. Overhead lighting was suited to large rather than small rooms, which without windows might appear gloomy and prison-like. He recommended a combination of systems in order to show under the best of conditions different types of objects that needed different kinds of lighting. In the Great Hall at Detroit (fig. 1.20) he had used clerestory lighting, for instance, while employing sidelighting in the smaller Gothic Room (fig. 1.19). As we study Kahn's museums we will see that he too came to consider light the essential element in art museums and that he also preferred having a combination of light sources.

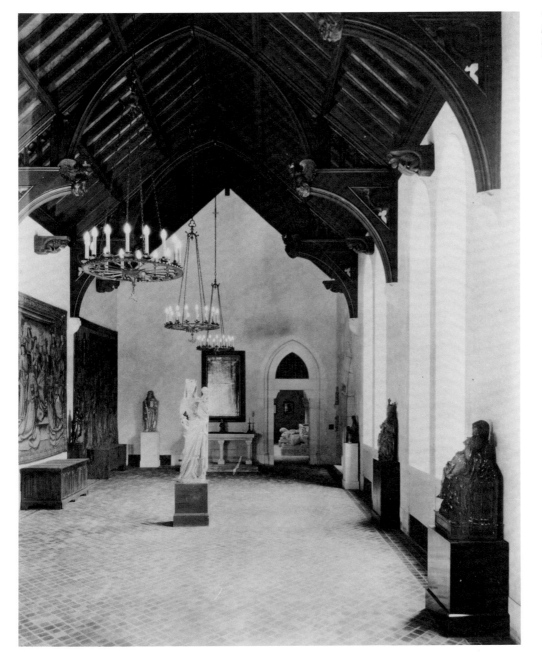

**1.19**
*Detroit Institute of Arts. Gothic Room.* Photograph c. 1927–30. Paul P. Cret.

Architectural character, that central Beaux-Arts attribute, counted for a great deal to Cret: an enclosed space could be metamorphosed from mere shelter to architecture through detailing. There should be neither too much ornamentation nor too little. Although some curators sought a neutral background for art, he thought monotony, boredom, and even museum fatigue would be the result if the settings were too simple in treatment. Variety was the key. An art museum, he said, was to create an attitude of mind and a special atmosphere (words that recall those of Klenze). Harmony between object and setting was the architect's goal. (Again, the Pio-Clementino and early German museums come to mind, as do the period rooms of Cret's time.) He recommended employing basic forms of historic architecture: not only the art of the past but that of the present would appear exemplary in such an environment. To support his opinion, Cret cited the sculpture gallery of the Louvre, located on the floor below the Grande Galerie, surrounded by strong, basic stone vaults that revealed their texture and joinery. There, thought Cret, all monumental three-dimensional works, no matter the period, were exhibited satisfactorily.

Although Kahn was to reject architectural decoration as such, much of what Cret had said in 1934 can be related to his own museums of the 1950s to 1970s. Kahn believed in Cret's essential forms perhaps even more forcefully than Cret himself did. For Kahn, these forms, rather than the classical orders, were what made the architectural tradition. Detailing is crucial to his buildings, but that detailing is closer to Cret's "texture and joinery of the strong stone vaults of the Louvre" than to the latter's period style moldings or cornices. In Kahn's works materials are handled not just straightforwardly but with a sense of the worth of their own properties and qualities. Kahn's concept of the adornment of a building dealt with structure and construction, with the joint as the beginning of ornament, as he often said. Thus we will find separation, even declaration, of parts of the building; we will find concrete handled so that it is marked by the means of its forming. It was Kahn's own way, or part of his way, of creating the "special atmosphere" (or character) that he too continued to believe the art museum — all buildings, in fact — should possess.

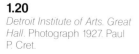

**1.20**
*Detroit Institute of Arts. Great Hall.* Photograph 1927. Paul P. Cret.

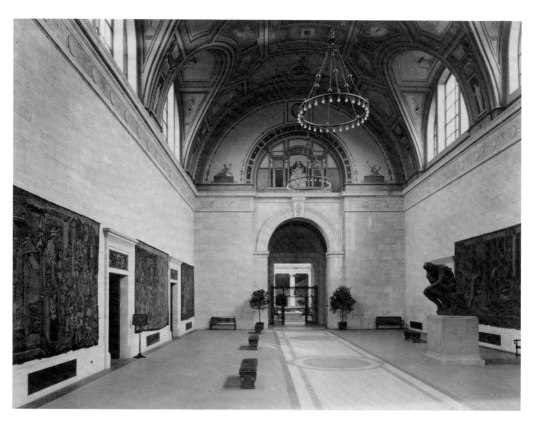

Cret was aware that museum curators were becoming more desirous of having rooms that offered the possibility of rearrangement for changing conditions and exhibitions. Here was an early inroad of the aesthetic of the International Style into the museum world. Cret called it mobility and said this value could be provided by movable walls. But not walls that were paper-thin, insubstantial — these gave an appearance of impermanence that subverted a museum's mission to provide the proper, substantial setting that enduring works of art deserved. Kahn accepted the premises of the International Style, and although he redirected a number of them as he developed his own ideas, the principle of flexibility was one he retained. He was to find his own means of achieving a strong, enduring setting in his museums, but he was never willing to reject the modernist concept of mobility.

Kahn's modernism was essentially self-taught and probably the more meaningfully felt because of it. The lean years of the Depression prolonged his education, in a sense expanding his horizons as he continued his paper architecture. After leaving Cret because of a lack of work, he was a designer in the office of Zantzinger, Borie and Medary and then founded and directed the Architectural Research Group for unemployed architects and engineers. This group studied Philadelphia housing and projected city plans, housing projects, and slum clearance (1932–33). Research must have included European examples of modern architecture, especially from the Netherlands and Germany, since the social concern for housing associated with it had been spearheaded there. For a few years Kahn was employed by the City Planning Commission under the Works Project Administration. He and his wife continued to live in her parents' house as Kahn began practice with Alfred Kastner in 1935 and then with the Philadelphia Housing Authority in 1937. In 1941 he was invited by George Howe to become associated with him; Oscar Stonorov joined them the following year. Their commissions were primarily for housing.

While neither of the other two men overtly influenced his architecture, Kahn's work with Howe and Stonorov demonstrated his commitment to the planning and aesthetics of modern design. Association with them can be assumed to have completed his induction into the American experience of modernist architecture, since both were well known representatives of this style. Howe, educated at Harvard and trained at the École in Paris, had been a successful Philadelphia architect of conventional houses who made a mid-life transition into modernism, producing the acclaimed high-rise landmark, the Philadelphia Savings Fund Society building, in 1932 with William Lescaze. Stonorov had studied and worked with Le Corbusier and was an editor of one of the first monographs on the great architect's work. (Kahn was to say many times that he considered Le Corbusier, like Paul Cret, one of his teachers.)

Before turning to Kahn's own museums, the first designed according to a program for which George Howe was largely responsible, a look at the museums of Philadelphia and a few other influential examples will be helpful. Those in Philadelphia Kahn knew most intimately. They were a part of his own life and the repositories of art for the city that had been an early artistic center for the United States. The Pennsylvania Academy of Fine Arts was the first in order of acquaintance, Kahn having won a scholarship for lessons in the Academy while still in high school. This institution has a remarkable history, for it had been erected as one of the earliest independent art museum buildings in the world (fig. 1.21), in 1805–6, to a design by John Dorsey.[29] Architecturally that building had no special distinction, related as it was to its contemporary, late federal-style domestic architecture: small, simple, and cubic with a Neoclassical central entrance framed by Ionic columns and surmounted by a carved pediment with motifs symbolic of the arts. The interior boasted a main room that was circular and top-lighted, possibly inspired by the Pio-Clementino rotunda, in which plaster casts of antique sculpture were exhibited. Regular art classes were begun in the Academy as early as 1813.

The Academy's early existence and, more importantly, its continued survival were a matter of civic and national pride. Continuing support for its cultural and educational activities was demonstrated by the business and professional community of Phila-

**1.21**
*Pennsylvania Academy of Fine Arts (First Building), Philadelphia.* 1805–6. John Dorsey. Engraving and etching by Benjamin Tanner after J. J. Barralet, 1809. Pennsylvania Academy of the Fine Arts, The John S. Phillips Collection.

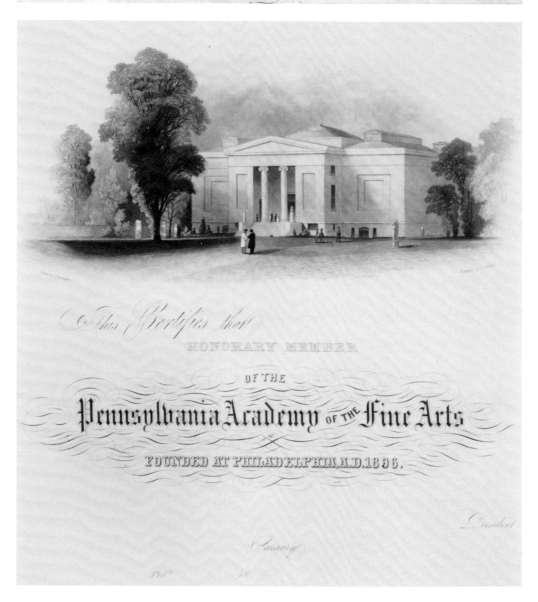

**1.22**
*Pennsylvania Academy of Fine Arts (Second Building), Philadelphia.* 1846–47. Richard A. Gilpin. *Detail from Membership Certificate.* Mezzotint and stipple by John Sartain after J. Hamilton. Pennsylvania Academy of the Fine Arts, Bequest of Dr. Paul J. Sartain through Harriet Sartain.

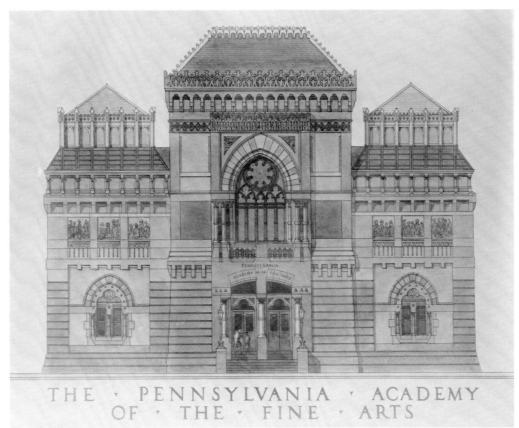

**1.23**
*Pennsylvania Academy of
Fine Arts (Third Building),
Philadelphia.* Frank Furness
and George W. Hewitt. 1872–
76. Ink and watercolor over
graphite. Joseph Patterson
Sims. Pennsylvania Academy
of Fine Arts.

**1.24**
*Pennsylvania Academy of
Fine Arts (Third Building),
Philadelphia. Section looking
west through hall-side gal-
lery.* Frank Furness and
George W. Hewitt. 1872–76.
Ink, brown wash on linen.
Pennsylvania Academy of
Fine Arts.

delphia to an unusual degree for the time. For they supported its growth with additions to the original building. The later, enlarged version (fig. 1.22), its image printed on the nineteenth century membership certificate, appears a proper temple of art, if more modest when compared to its German kin, with windowless walls, skylights, and an Ionic-columned entrance.

But the Academy Louis Kahn knew, and for which he developed a special affection, was a building of 1872–76 (fig. 1.23) by a Philadelphia hero-architect, Frank Furness (1839–1912), the dominant architectural personality in the city during the late nineteenth century.[30] Furness conceived of a palace of art and modernized it by employing an eclectic and personalized Victorian style combining French composition and Ruskinian Gothic ornament and detailing. (He had studied with Richard Morris Hunt in this country's first atelier patterned after those of the École des Beaux-Arts, where Hunt had been a student.) The plan masterfully solved the complexities of the program for the academy-museum: art school on the lower floor, skylights in galleries for works of art on the upper one, and a magnificent open, dual stairwell connecting the two (fig. 1.24).

Kahn truly cared for this building, which he knew through many years and where his drawings and paintings were shown several times during his life. It must have been an important source of his belief in the value of natural light from above for both lighting and exhibition and the ambience he thought right for a museum. He was a strong supporter of the building's restoration and photographic documentation, recommending to a director of the Academy a particular photographer for his "thoughtful and poetic work" with "no harsh contrasts, no dramatization."[31] (The photographer had documented some of his own buildings.) Richard J. Boyle, who became Academy director in 1973, has described the experience of walking through it with Kahn, a member of its board of trustees. Kahn drew Boyle's attention to how the spaces were created and to the daylight that filled them. He spoke of the building's structure and order and of how practically it served as both museum and school.[32]

The Museum of the University of Pennsylvania, or University Museum (fig. 1.25), was probably the next Philadelphia museum Kahn came to know well. Designed for archaeological collections, and thus closer to the British Museum tradition than a typical art museum, it was first named the Free Philadelphia Museum of Science and Art, by its very name a product of its time, and was intended to become the great general

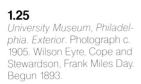

**1.25**
*University Museum, Philadelphia. Exterior.* Photograph c. 1905. Wilson Eyre, Cope and Stewardson, Frank Miles Day. Begun 1893.

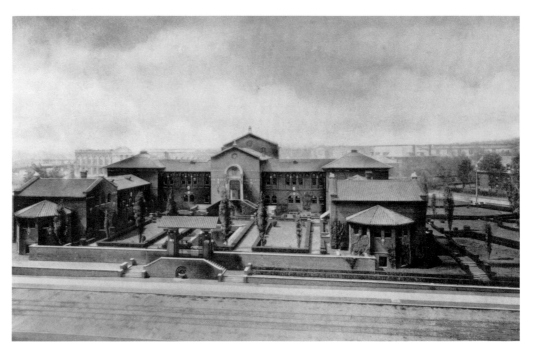

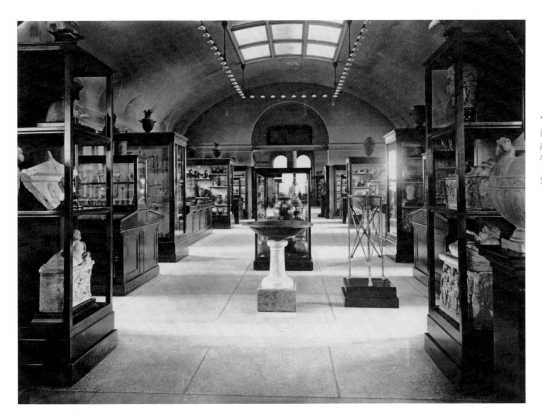

**1.26**
*University Museum, Philadelphia. Exhibition of Mediterranean section, August 1905.* Wilson Eyre, Cope and Stewardson, Frank Miles Day.

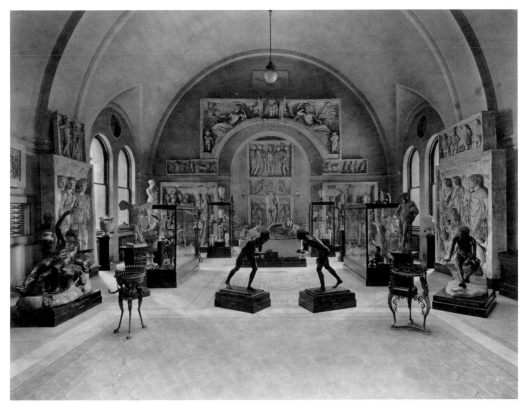

**1.27**
*University Museum, Philadelphia. Exhibition of William Pepper Hall, c. 1905.* Wilson Eyre, Cope and Stewardson, Frank Miles Day.

museum of Philadelphia.[33] Its design was the responsibility of a confederation of local architects: Wilson Eyre (1858–1944), the firm of Cope and Stewardson, and Frank Miles Day (1861–1918). (However, the name of Eyre is most closely associated with this museum.)[34] These architects worked in the styles of their period, Queen Anne, the Shingle Style, and Collegiate Gothic, and the resulting Italianate building reflects a blend of sources characteristic of the Arts and Crafts influence on local architecture.

   Its plan echoes the axial organization of complex spaces associated with the formal, rational, compositional construction developed by the French Beaux-Arts tradition. On the front, the entrance is behind a forecourt with wings extending to either side and ending in apsidal projections. Early drawings show there were to be many exten-

sions and cross-axes,[35] in a logical Beaux-Arts plan organizing huge museums, such as this one and its near contemporary, the Hunt plan for the Metropolitan Museum of Art in New York. Traditional galleries made up the interior. The appointments and room arrangements demonstrated ideas about scholarship and the presentation of art: a complete display of the collections in cases (fig. 1.26). Vaulted galleries with classical statuary and bronzes recall rooms in the Pio-Clementino museum, if more crowded and with casts as well as original works of art (fig. 1.27).

Kahn may have been introduced to the University Museum by his high school teacher as part of the required course on the history of architecture that originally set him on his career path. William F. Gray was a great admirer of the museum. In an essay on *Philadelphia Architecture*, written in 1915, not long before Kahn took his course, Gray said of it:

> While the Lombard motif is evident, the scheme is strong and direct, pictur-
> esque, and with many elements of great interest and charm. The beautiful
> texture of the walls, the small but well-placed sculpture, and the interesting
> colored marble inlaid ornament combine in producing what critics have gen-
> erally regarded as one of the most beautiful works in the country.[36]

Kahn would have become better acquainted with the museum during his student years at the University, to say nothing of the later years of his professorships when meetings and social events frequently brought him to the University Museum. It too would be part of his conception of the nature of an art museum.

In 1928, the year Kahn went abroad, the Philadelphia Museum of Art was com-
pleted (fig. 1.28). It had been under construction during Kahn's years at the University (since 1919, in fact) and was the major architectural project under way in the city. The design was by Horace Trumbauer (1869–1938), C. L. Borie (1870–1943) and C. C. Zantzinger (1872–1945), all architects associated with Cret on the Detroit Institute of Arts. (It should be remembered that Kahn was a designer for the firm of Zantzinger, Borie and Medary from late 1930 until early 1932.) As one would expect, the museum possessed the organized composition of a Beaux-Arts prototype, including classical facades and a regular progression through axially oriented spaces (fig. 1.29). A cen-
tral, temple-like pavilion contained the main hall and grand stairwell with an auditorium on the ground floor and a temporary exhibition gallery on the second. Wings to either side had secondary appendages extending outward and ending in pavilions, thus creating a large U-shape and forming a court of honor before the entrance. (Kinship with the organization of the University Museum is clear.) The wings were organized into triple files of galleries or a central corridor with rooms ranged to either side.

**1.28**
*Philadelphia Museum of Art.*
*Exterior, photograph 1933.*
Horace Trumbauer, C. L.
Borie and C. C. Zantzinger.
1919–28.

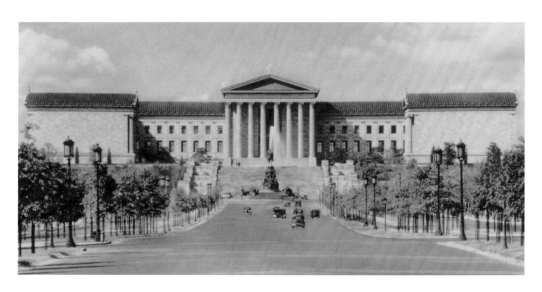

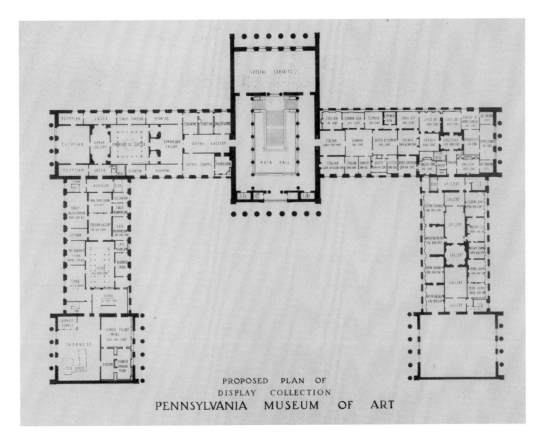

PROPOSED PLAN OF
DISPLAY COLLECTION
PENNSYLVANIA MUSEUM OF ART

**1.29**
*Philadelphia Museum of Art.
Plan.* Horace Trumbauer, C. L.
Borie and C. C. Zantzinger.
1919–28.

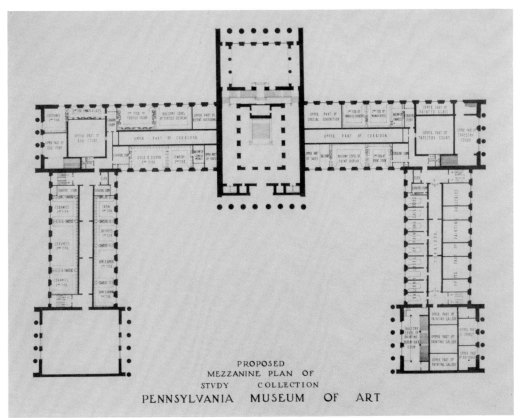

PROPOSED
MEZZANINE PLAN OF
STVDY COLLECTION
PENNSYLVANIA MUSEUM OF ART

What was new and interesting about the Philadelphia Museum was not the scheme of its architecture but the desire of its director to have it reflect the transformations he recognized as taking place in the ideals and functions of art museums. Fiske Kimball (1888–1955) was aware of shifts in emphasis and innovations in museum programs. He responded with enthusiasm to the expansion of collections from exclusively painting and sculpture (sometimes even in separate museums as in Munich and London) to include decorative arts (or arts and crafts, as he termed them) and a broadening interest in historic periods.[37] Kimball saw as a related and parallel devel-

opment the increased attention given to the study of different cultures and historical periods. Although he became director six years after construction began and could affect the plans but little, he worked as much as he could to organize the galleries and other spaces.

Kimball planned that the museum provide "a series of antique architectural elements, forming part of the main circuit and extending over the whole history of art, which is unique among museums anywhere." Period rooms would be part of the circuit, although Kimball felt that simulated period detailing should be avoided, thinking it to be confusing for visitors, and was of the opinion that the museum's own architecture should be consistent. According to Kimball, it would be best to intermingle authentic period rooms and galleries in a systematic relationship that would convey style in an atmospheric ensemble, yet at the same time have the freedom to arrange galleries with other related types of objects. He divided the holdings, placing on the first floor and mezzanine the study collections for specialists and students (comprehensiveness primary and artistic quality secondary), while the upper floor held the highest-quality works in the whole collection exhibited for the general public.[38] The works of art and their arrangements were of utmost importance to Kimball, the architecture of considerably less significance, needing most of all to be conveniently planned.

Other innovations Kimball wished to incorporate were temporary exhibitions and educational activities. The Metropolitan Museum of Art in New York had initiated exhibitions of loaned works as early as 1873, with 112 objects from thirty-two collections,[39] and in 1883 Wilhelm von Bode organized an old master exhibition in Berlin with works drawn from private collections. The idea appealed to museum curators, for such showings enriched the experience of the museum for its visitors. But it meant interpretation was needed to make these exhibitions more meaningful, to put them into context. Similarly, interpreting the permanent collection was part of the educational mission of a museum. Specialized space should be provided for both. The twentieth-century museum was increasingly involved with lectures, tours, and classes for the general public, not to speak of schools of all types and levels and various other organizations — all separate from any museum school or academy.

Kimball wanted to provide adequate space and facilities for such growing programs.[40] His influence was exercised on the organization of the interior, on exhibition installations with original period rooms and composite period juxtapositions of works of art, and finally through educational programs. In the sixteen galleries and period rooms installed by the time the museum opened, the display was as extensive as possible, intended to suggest the evolution of art in both East and West.[41] Kimball had completely considered the modern museum, dealing logically with arrangements and lighting, access and circulation, offices, the service section, and the mechanical plant.[42] After Fiske Kimball, planning a program for an art museum would never again be a routine request for exhibition spaces with a little something set aside for storage, a few offices, and heating facilities. Museums had changed, as Louis Kahn was well aware when he made his designs.

It was not only in the planning of art museums as institutions that change occurred in the 1930s.[43] As buildings, they were hardly immune to the currents of modernism, the International Style as it came to be called in the United States after the 1932 exhibition arranged by Henry-Russell Hitchcock and Philip Johnson for the Museum of Modern Art.[44] Architecture as volume rather than mass, the principle of regularity rather than symmetry in design, and the absence of arbitrarily applied decoration were pointed out as signifying modern buildings by Hitchcock and Johnson. The Kunstverein, Hamburg, 1930 (fig. 1.30), by Karl Schneider, an art gallery illustrated in their book, with its thin, smooth surfaces and strip windows — albeit a remodeled nineteenth-century townhouse with a symmetrical entry and plan — served as their example of this architecture in a building devoted to the arts.

It was in the Netherlands in the 1930s that museums incorporating some fresh approaches to the existing iconography first appeared.[45] Among these is one that Louis Kahn found especially memorable when he visited it during the *CIAM* Confer-

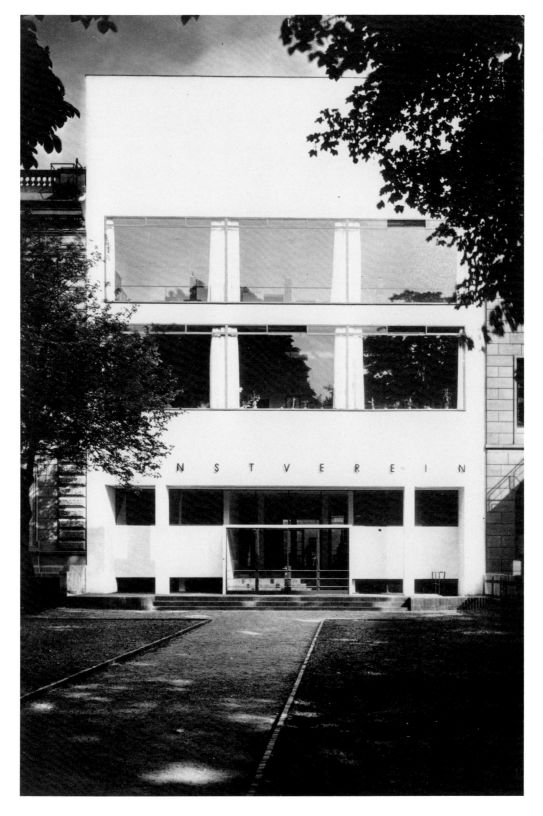

**1.30**
*Kunstverein, Hamburg.*
*Façade.* Karl Schneider.
1930. Photograph courtesy,
The Museum of Modern Art,
New York.

ence (Congrèes Internationaux d'Architecture Moderne) in Otterlo in 1959: the Kröller-Müller Museum of 1937–38 (fig. 1.31). This museum by Henry van de Velde (1863–1957), one of the pioneers of the modern movement, was originally erected as a temporary building to meet immediate needs, for the private collection had been given to the state in 1935 under stipulation that a museum be built for it within five years. Construction was prompted in part to meet that condition, in part as a project for unemployed workers from Arnhem.[46] For years a house-museum building had been projected by the Kröller-Müllers, and one actually begun under van de Velde earlier had had to be abandoned after a financial crisis in 1922.[47]

Van de Velde, over seventy when he received the Kröller-Müller commission for the second time, based the 1937 plan on the earlier version, though the scheme was

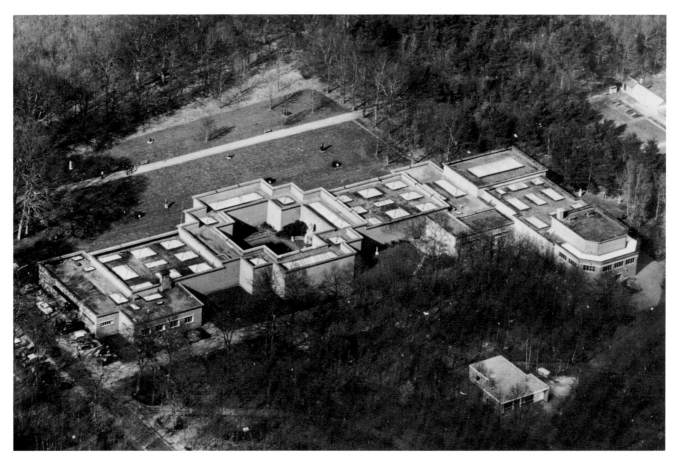

**1.31**
*Kröller-Müller National
Museum, Otterlo. Aerial
view.* Henry Van der Velde.
1937–38.

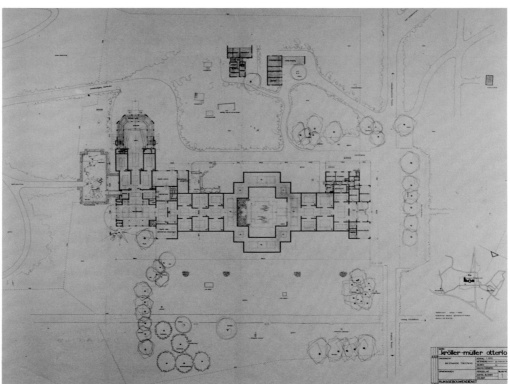

**1.32**
*Kröller-Müller National
Museum, Otterlo. Plan.* Henry
Van der Velde. 1937–38.

reduced in scope. In the center of the long, one-story building is a cruciform courtyard with a gallery for the Van Gogh paintings, considered the heart of the collection, ranged around it (fig. 1.32). To the east and west of the court, triple ranges of galleries are aligned symmetrically, the center ones in enfilade and all with skylights. It is a straightforward and practical plan, made irregular in shape by the galleries projecting around the court and by the addition of a sculpture gallery and auditorium on the east.[48] While the museum includes a courtyard, it is without traditional cross-axes and reflects a functional approach to planning.

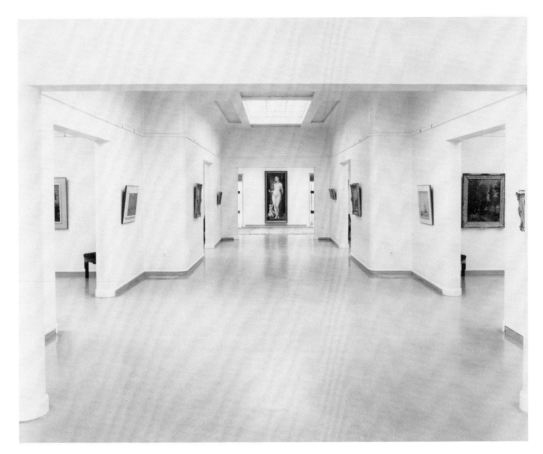

**1.33**
*Kröller-Müller National Museum, Otterlo. Interior view of gallery.* Henry Van der Velde. 1937–38.

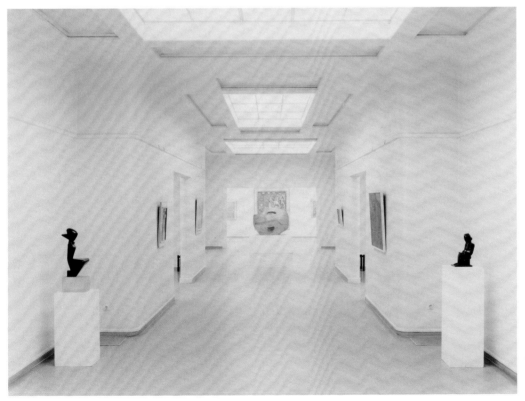

**1.34**
*Kröller-Müller National Museum, Otterlo. Interior view of gallery.* Henry Van der Velde. 1937–38.

The main west entrance (now relocated) had a glass wall, and glass also formed one side of the courtyard, but there were no windows in the exhibition areas (fig. 1.33). Because of this exclusion of exterior views, the visitor, once inside the galleries, had little sense of the site's park setting. Kahn's design for the Kimbell Art Museum was to be close to it in spirit: on the west a glass-walled entrance and galleries without windows, their light originating from above and from glazed, enclosed courtyards. The park site therefore is excluded from one's experience within the museum, where one concentrates on the works of art and the interior spaces. Detailing in the Kröller-Müller

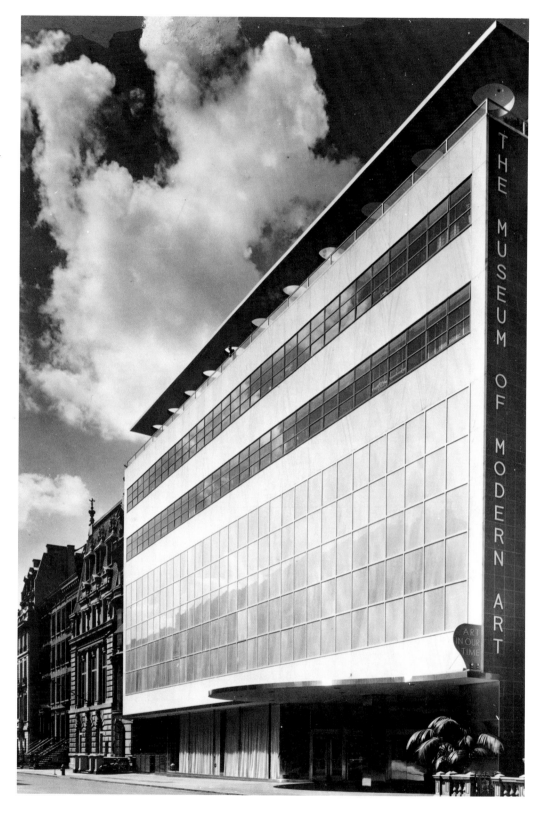

**1.35**
*Museum of Modern Art, New York. Façade.* Philip L. Goodwin and Edward Durell Stone. 1939. Photograph courtesy, The Museum of Modern Art, New York.

is extremely simple and unadorned, with only functional, plain moldings, the whole revealed by the strong light from the skylights (fig. 1.34). Its collection, which is devoted to the art of the nineteenth and twentieth centuries, was to be seen chronologically, the earliest works placed in the rooms just beyond the entrance and works created since Van Gogh in those beyond the court. (Additions have altered the early concept.) The simplicity, intimate scale, and natural light, qualities recalling those of the Dulwich Picture Gallery, all serve to create an atmosphere enhancing the paintings. One can understand the response Kahn had to this museum and the influence it exerted on him.

In the United States the building for the Museum of Modern Art, New York (fig. 1.35), became the most influential example of an International Style museum.

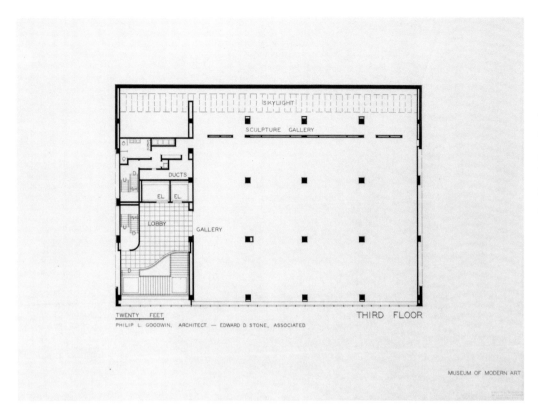

**1.36**
*Museum of Modern Art, New
York. Plan, third floor galleries.
Proposal.* Philip L. Goodwin
and Edward Durell Stone.
1938. Ink on Ozalid, 20¼ x
27¾ in. Collection, The
Museum of Modern Art, New
York. Anonymous Gift.

Designed by Philip L. Goodwin (1885–1958) and Edward Durell Stone (1902–78), this museum had a strong impact for decades to come, enhanced as it was by its role in American artistic life. In its mission to encourage and to develop the study of modern art, including the application of art to "manufacture and practical life," the institution has commanded international attention.[49] The new building was expected to represent the highest standards. Talbot Hamlin pointed out that it would be "judged rigorously" by the public as exemplifying contemporary art and that critics would compare it to "the high criterion set by its own contents."[50] Alfred H. Barr, the director who charted a complex program for all the arts, including practical, commercial, and popular, believed that the building should make a statement for modern architecture.[51] (He had, in fact, wanted Mies van der Rohe to be architect.)

The Museum of Modern Art of 1939 became a new prototype for art museums. Its emphasis on changing, temporary exhibitions and its experience in arranging these in its former quarters established certain priorities and precedents. In the first location, an office building, there had been open loft space divided by partitions into galleries. The second location was a large brownstone townhouse that had been renovated by removing some interior walls to create galleries; it had, however, retained a certain intimacy of house-like rooms. Both features — loft space, usually thought commercial, and a relatively low ceiling height, more domestic than traditional museum dimensions — were retained in the new building. Also consistent with the New York environment and a tight urban site was the continuation of an upward circulation pattern: five stories and a penthouse, unlike traditional museums of two or possibly three floors.

The most innovative feature of the museum design was the use of a plan associated with high-rise commercial buildings, but the aesthetic behind this choice was the free, flowing space of the International Style. In any event, the plan was an ideal one for their purposes since the interior walls, which are non-load bearing, are completely flexible and can be manipulated in various ways for changing exhibitions. Barr asked for natural light in the galleries.[52] Skylights, made possible with a setback of the floor above, were used in the third floor sculpture gallery, and windows overlooked the garden behind the building (fig. 1.36). But most of the galleries were to be lighted by a translucent window wall, double sheets of glass with spun glass between, that stretched across the upper part of the façade. Because of the interior partitions, however, exhibitions relied on artificial light after all.

This new museum met with critical acclaim as the personification of modern architecture in its functionalism and simplicity. Lewis Mumford wrote of "picture galleries actually designed to fit the pictures . . . unity of interior and exterior . . . [and] the

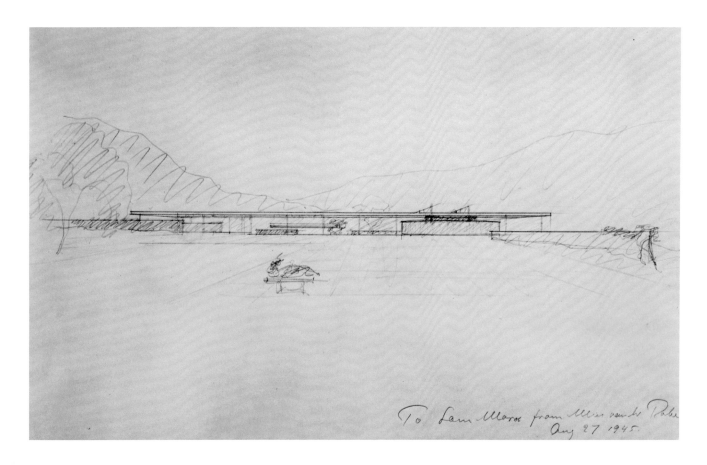

*To Sam Maron from Mies van de Rohe*
*Aug 27 1945.*

**1.37**
*Project: Museum for a Small City. Exterior perspective.*
Mies van der Rohe. 1942.
Whereabouts unknown.
Photograph courtesy, The
Museum of Modern Art,
New York.

combination of appropriate materials, light, color and living forms [the plantings, that demonstrate] the rich decorative resources of modern architecture."[53] Talbot Hamlin found the building "vivid and dignified," seeing what he recognized as the modernized Beaux-Arts organization of the façade "as much a piece of pure façade pictorial architecture as old fashioned buildings with a colossal order which runs through several stories."[54] Lee Simonson, who had suggested a skyscraper museum as early as 1927, wrote the president of the Museum that he thought it would "set a standard for all museums for years to come."[55]

And indeed it did. Goodwin, of the same generation as Mies, Le Corbusier, and Wright, is not of the stature of these major architects, but his achievement nonetheless was significant. The ideas of modern architecture were realized in a building type that had been one of the most resistant to change, except in a superficial application of styles, as Kimball had found in his efforts to introduce new programs. The Museum of Modern Art could initiate remarkably active and diversified programs with its flexibility. Furthermore, this particular museum could be described as a flagship for museum professionals who saw it as embodying the most advanced concepts of contemporary art and museum practice. Goodwin was commissioned architect of an addition to the Yale University Art Gallery a few years later largely as a result of his New York museum, and he bequeathed, in a sense, his International Style formula for a museum to Louis Kahn who received the commission after him.

An unrealized project, the "Museum for a Small City" of 1942 by Mies van der Rohe (fig. 1.37),[56] sums up a changed conception of a museum's function and role in society and of its architectural identity at the time Kahn was to begin his designs for museums. Although the Mies museum includes a courtyard, it is not a traditional court that has been described as an "enclosed landscape."[57] Typological references to temple, palace, or villa no longer exist, either in the perspective or the plan (fig. 1.38). The grid of columns establishes a visual order while the space remains fluid. The building was to be made of modern materials, steel and glass. But more significantly, the building represents a shift in the concept of a museum that had evolved in the nineteenth and early twentieth centuries to become an institution providing diverse functions for public, specialists, and students. "Museum for a Small City" is closer than any in the past to being a neighborhood museum, a place in a park for visitors to come casually, to attend lectures and programs, rather than a place to approach on a pilgrimage. Art in this place was not to be put on a pedestal high over the viewers' heads.

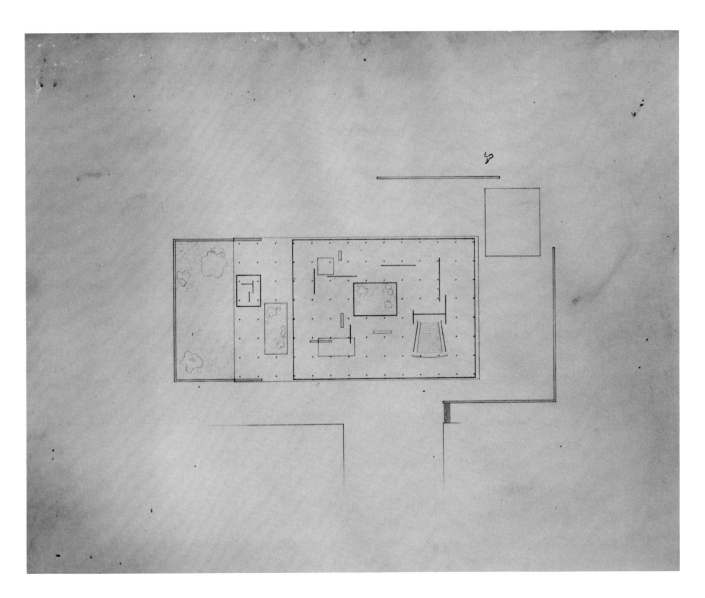

**1.38**
*Project: Museum for a Small
City. Plan.* Mies van der Rohe.
1942. Pencil on illustration
board, 30 x 40 in. Collection,
Mies van der Rohe Archive,
The Museum of Modern Art,
New York. Gift of the Architect.

Its glass exterior forms an almost literal "museum without walls." And its asymmetrically placed screens or panels, not reaching as high as the roof and therefore not dividing the space, form limited backgrounds for works of art (fig. 1.39). Many times, indeed, the works themselves — paintings are shown mural-sized, like Picasso's *Guernica* — stand alone and seem part of the architecture. They were to assist in marking the space and creating the atmosphere. People were to mingle with them. This is a building for a more visually sophisticated and knowledgeable audience than that for which the Altes Museum was planned at a time when experiencing works of art in a museum setting was new to the public. The unspecified audience for Mies's museum was assumed to be accustomed to images and expectant of dramatic presentation. A continuing historical trend of increasing awareness and interest in all types of art is reflected in such an attitude. It was the kind of audience the Museum of Modern Art was doing much to develop through exhibitions and publications. Mies himself used photographs of works by Picasso and Maillol and employed a collage technique to create an impression, almost a vignette, rather than a literal rendering of the interior. Works of art are not strange in this world but familiar and approachable, part of everyday life. Books, photographs, and reproductions have expanded the horizons of the clientele of such a museum.

The museums we have examined make up the received typology of museums for Louis Kahn. His response to the Mies museum might have been qualified. While he

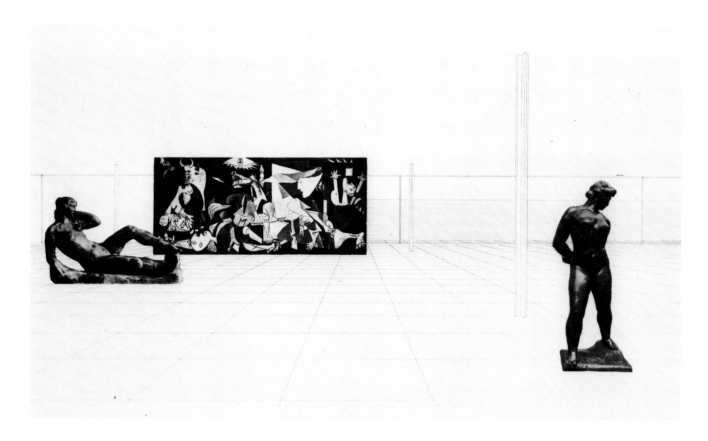

would welcome the attitude toward the public it was to serve, would have admired the open spatial plan and undoubted perfectionism in detailing characteristic of a Mies building, the thinness and weightlessness of the project would have had less appeal. He would not have been satisfied by what Cret would have termed its insubstantiality. "Monumentality" was in fact the title of his 1944 essay appealing for the incorporation of new attitudes, materials, and methods of construction while acknowledging historical sources. The best architectural monuments have in common a striving for structural perfection, he said, that is largely responsible for their impressiveness, clarity of form, and logical scale.

> the images we have before us of monumental structures of the past cannot live again with the same intensity and meaning. Their faithful duplication is unreconcilable. But we dare not discard the lessons these buildings teach for they have the common characteristic of greatness upon which the buildings of our future must, in one sense or another, rely.[58]

Among Kahn's examples were the continuation of the Roman vault, dome, and arch, which would reappear, he asserted, with "added powers made possible by our technology and engineering skill." Kahn imagined future institutional projects ("buildings of high purpose") that would benefit from engineering, would use new materials, and would show the "gigantic sculptural forms of the skeleton frame." Writing during wartime years, he sensed that techniques of modern standardization, prefabrication, and specialization, used in conjunction, would lead to works that would be of the modern age, affording traditional Vitruvian "delight and service."

Kahn's words now seem prophetic of his own accomplishments. Aware of tradition and sensitive to the modern currents in architecture, Kahn, in his approach to the design of museums, was to fuse the old with the new.

**Notes**

1. Among the works listed in the Baldwin Memorial Archive of the American Institute of Architects, the three executed museums are unique. However, Kahn's housing and his church or synagogue designs are also notable for their numbers. See Heinz Ronner and Sharad Jhaveri, *Louis I. Kahn: Complete Works, 1935–1974*, 2nd revised and enlarged ed. (Basel and Boston: Birkhaüser, 1987): 11–17.

2. Kahn, "A Verbal Autobiography." From a conversation with Jaime Mehta, October 22, 1973. Richard Saul Wurman, *What Will Be Has Always Been: The Words of Louis I. Kahn* (New York: Access Press and Rizzoli International, 1986): 225.

3. Kahn, "Kahn on Beaux-Arts Training." In "The Span of Kahn," by William Jordy, *Architectural Review* (June 1974): 332.

4. Guadet quoted by John F. Harbeson, *The Study of Architectural Design*, rev. ed. (New York: Pencil Points Press, 1927): 35.

5. Harbeson recommended these and other books. *The Study of Architectural Design*, 29.

6. Kahn, "Kahn on Beaux-Arts Training," 332. For examples of *poché*, see Harbeson, *The Study of Architectural Design*.

7. Ibid.

8. Harbeson, *The Study of Architectural Design*, 37.

9. See Carlo Pietrangeli, *I Musei Vaticani, cinque secoli di storia* (Rome: Edizioni Quasar, 1985): 29–104. Robert Adam's rotunda after the Pantheon, a private Neoclassical gallery for Newby Hall, was begun earlier (1767–80) but was not as well known. Even earlier (around 1618) was Rubens's semicircular gallery, also inspired by the Pantheon and built onto his Antwerp house for his collection of antiques. See Jeffrey M. Muller, "Rubens's Museum of Antique Sculpture: An Introduction," *Art Bulletin* 59 (1977): 571–82.

10. See Helen Rosenau, "The Engravings of the Grand Prix of the French Academy of Architecture," *Architectural History* 3 (1960).

11. Rosenau credits J. Baltrusaitis with the Pope comparison and mentions an Ovidian tradition. *Boullée and Visionary Architecture* (London: Academy Editions, 1976): 15 and 24, n. 1.

12. This museum, opened in 1793, was as popular as the Louvre (twelve editions of its catalogue were sold). It was closed in 1816, when religious objects were returned to churches or placed in the Louvre or the Cimitière Père La Chaise.

13. Durand, *Précis des leçons d'architecture donnée à l'école polytechnique* (Paris, 1802–5).

14. Illustrated in Nikolaus Pevsner, *A History of Building Types* (London: Thames and Hudson, 1976): 125. These were submitted to the architectural competition the prince held for the museum commission. Klenze was selected independently, however, and was allowed to draw from the designs by other competitors if he wished.

15. A. F. von Wolzogen, *Aus Schinkel's Nachlass: Reisetagebucher, Briefe und Aphorismen*, vol. 3 (Berlin 1862–64). H. G. Pundt, *Schinkel's Berlin, A Study in Environmental Planning* (Cambridge, Mass.: Harvard University Press, 1972): 147. The commercial space on the ground floor foreshadows Kahn's shops on the ground floor of the Yale Center for British Art in a rudimentary way.

16. See "Dulwich College and the Bourgeois Bequest," in *Soane and After, The Architecture of Dulwich Picture Gallery*, an exhibition organized by Giles Waterfield (London: Dulwich Picture Gallery, 1987): 5–8.

17. Henry-Russell Hitchcock comments on Soane's approach to the Dulwich commission, finding it closest to Durand's rationalism. *Architecture: Nineteenth and Twentieth Centuries*, rev. ed. (Baltimore: Penguin Books, 1967): 60. Soane was well aware of French architecture. John Summerson divides his work into five periods, characterizing his second, or student, period (1776–80) as influenced by French Neoclassicism. "Soane: The Man and the Style," in *John Soane* (London and New York: Academy Editions and St. Martin's Press, 1983): 9–10. (A revised and condensed edition of Summerson, *Sir John Soane* [London, 1952].)

18. See Waterfield, *Soane and After*, 20. He cites "ideal" drawings for the Gallery. Soane contributed his services for this commission and offered to assist with building costs.

19. Soane's gallery for Fonthill House, Wiltshire, 1787, utilized top-lighting out of necessity, since the addition was essentially a conversion of an existing passageway. He found that the available wall space for paintings and the quality of the light, a subject of great interest to him, proved advantageous. See G.-Tilman Mellingham, "Soane's Dulwich Picture Gallery Revisited," in *John Soane*, 91. Mellingham states the Fonthill House gallery was the first top-lit gallery in a country house, 82 and fig. 14.

20. Klenze, *Sammlung architecktonischer Entwurfe* (Munich: Gotta, 1830), as quoted in Wolf-Dieter Dube, *The Munich Gallery, Alte Pinakothek* (London: Thames and Hudson, 1970): 8.

21. Cret, "The Architect as Collaborator of the Engineer," in Theophilus B. White, *Paul Philippe Cret* (Philadelphia: Art Alliance Press, 1973): 61–65.

22. See *The Travel Sketches of Louis I. Kahn* (Philadelphia: Pennsylvania Academy of the Fine Arts, 1978).

23. See Heinz Ronner, Alessandro Vasella and Sharad Jhaveri, *Louis I. Kahn: Complete Works, 1935–1974* (Basel and Stuttgart: Birkhaüser, 1977).

24. White, *Paul Philippe Cret*, 33.

25. See Margaret Sterne, *The Passionate Eye: The Life of William R. Valentiner* (Detroit: Wayne State University Press, 1980). Sterne's book includes correspondence and passages from Valentiner's "Reminiscences" and describes his training in Berlin under Wilhelm von Bode, 70–85, and work in the Metropolitan Museum of Art, 86–110.

26. Clyde H. Burroughs, "The New Detroit Museum of Arts," *Museum Work* 8 (September–October 1925): 74. See Harvey Hamburgh, "Some Heraldic Shields in Kresge Court," *Bulletin of the Detroit Institute of Arts* 59 (Spring 1981): 38–47. Valentiner made purchases of decorative sculpture in Italy to incorporate into the walls of the courtyard. In 1926 Cret wrote Valentiner, sending plans for installations in the brickwork and returning photographs of the Bargello courtyard, 46, n. 8.

27. Valentiner, "The Museum of Tomorrow," in *New Architecture and City Planning*, Paul Zucker, ed. (New York: Philosophical Library, 1944): 670. See also Richard F. Bach, "The Detroit Institute of Arts," *Architectural Forum* (February 1929): 193–202. Bach refers to the interiors in Detroit as "the German method of a period room or period style display" (195). "The important consideration is, to be sure, that the architect of today has designed a new setting in an older vein and so has provided an appropriate harmonizing background or interior for a concerted display of objects disposed as nearly possible in their life relationships" (198).

28. Bach, "The Detroit Institute of Arts," 195.

29. George B. Tatum, *Penn's Great Town: 250 Years of Philadelphia Architecture* (Philadelphia: University of Pennsylvania Press, 1961): 56–57, plate 37. *Philadelphia Architecture in the Nineteenth Century*, Theophilus Ballou White, ed. (Philadelphia: Philadelphia Art Alliance and University of Pennsylvania Press, 1953): 23, plates 7, 8.

30. See James O'Gorman, *The Architecture of Frank Furness* (Philadelphia: Philadelphia Museum of Art, 1973): 34–39. A copy of this book was in Kahn's personal library.

31. John Ebstel was the photographer Kahn recommended. Letter, Louis I. Kahn to Thomas N. Armstrong III, November 1971. Louis I. Kahn Collection, Pennsylvania Historical and Museum Commission, Box LIK 10, Master Files, Architectural Archives, University of Pennsylvania, Philadelphia.

32. Boyle, "Foreword," in *The Travel Sketches of Louis I. Kahn*, 7.

33. Cecil Claude Brewer, "American Museum Buildings," *Journal of the Royal Institute of British Architects* 20, 3rd series (April 12, 1913): 370. Brewer noted that in 1911, the University Museum was only one-sixteenth complete.

34. Stewardson died in 1896 and Cope in 1902. Frank Miles Day is listed as being involved with the museum from 1895–99. Work on the Museum continued until 1926, but only a portion of the original plan was ever constructed. Ralph Adams Cram (1863–1942) ascribed to Day "good taste," to Eyre "personality," and to Cope and Stewardson "poetry." Tatum, *Penn's Great Town*, 122.

35. Tatum, *Penn's Great Town*, 121, fig. 129.

36. Gray, "Philadelphia's Architecture," *Publications*, City History Society 1 (1915). Quoted in *Philadelphia Architecture in the Nineteenth Century* 33. For Kahn's comments on the course, see Patricia McLaughlin, "How'm I Doing, Corbusier?" *Pennsylvania Gazette* 71 (December 1972): 19, and Kahn, "A Verbal Autobiography," in Wurman, *What Will He Be Has Always Been*, 224.

37. Fiske Kimball, "The Modern Museum of Art," *Architectural Record* 66 (December 1929): 559. Kimball noted the growth in numbers of art museums since 1900 and the expansions of existing museums, as in Boston, Chicago, and Washington, D.C.. In "architectural practice, the art museum is coming to occupy the place held by the public library a few years ago," he said.

38. Kimball, "The Modern Museum," 565.

39. Kenneth Hudson, *Museums of Influence* (Cambridge: Cambridge University Press, 1987): 59.

40. Kimball, "Planning the Art Museum," *Architectural Record* 66 (December 1929): 581–90.

41. Preface by Anne d'Harnencourt, in *Introduction to the Philadelphia Museum of Art* (Philadelphia: Philadelphia Museum of Art, 1985): 2.

42. Kimball, "Planning the Art Museum," 582–90.

43. One of the innovative planners was Clarence Stein. Kimball commented on his skyscraper museum. See Stein, "The Art Museum of Tomorrow," *Architectural Record* 67 (January 1930): 5–12; "Glass Walls for New Art Museum," *Art News* 31 (October 29, 1932): 3; "Making Museums Function," *Architectural Forum* 56 (June 1932): 609–17; "Architecture et amenagement des musée," *Mouseion* 7 (1933): 7–26; "Eclairage naturel et eclairage artificiel," *Museographie* (Paris: International Museums Office, 1934); "Form and Function of the Modern Museum," *Museum News* 16 (January 1939): 5–12; "Study Storage: Theory and Practice," *Museum News* 22 (December 15, 1944): 9–12. Stein was consultant for the service and storage arrangements in the 1938–39 Museum of Modern Art, New York.

44. Henry-Russell Hitchcock and Philip Johnson, *The International Style: Architecture Since 1922* (1932, New York: Museum of Modern Art; W. W. Norton Company, 1966).

45. The Dutch museums include the Boymans Museum, Rotterdam, for which extensive studies were carried out on skylights. See A. N. Zadoks, "L'Inauguration du nouveau musée Boymans," *Beaux-Arts* (July 19, 1935): 1. J. Decoen, "The New Museum at Rotterdam," *Burlington Magazine* 67 (September 1935): 131–33. "Les Nouveau Boymans," *Renaissance* 18 (October 1935): 112–15. Daniel Catton Rich, "Perfection at Rotterdam," *American Magazine of Art* 28 (October 1935): 580–90. "Das neue Boymansmuseum in Rotterdam, A. van der Steur, architect," *Monatshefte für Baukunst und Stadtebau* 19 (December 1935): 417–23. D. Hannema (the director) and A. van der Steur, "La Technique de L'Eclairage dans les musée et le systeme adopte au musée Boymans," *Mouseion* 33–34 (1936): 161–83. H. P. Berlage's (1856–1934) Municipal Museum (Gemeentemuseum), The Hague, completed posthumously, opened also in 1935. See Zadoks, "Le Musée de La Haye," *Beaux-Arts* (August 2, 1935): 1. L. Artz, "Das neue Gemeindemuseum im Haag. H. P. Berlages letztes werk," *Montshefte für Baukunst und Statebau* 19 (July 1935): 257–61. H. E. van Gelder, "Le nouveau musée municipal de La Haye," *Mouseion* 33–34 (no. 1–2, 1936): 145–60. See also H. Paul Rovinelli, "Berlage Revisited," *Progressive Architecture* 67 (June 1986): 29–30.

46. *Kröller-Müller Museum* (Haarlem: Joh. Enschede en Zoneon Grafische Inrichting B. V., 1978): 19. An article written after World War II discusses plans for a larger museum by Van de Velde exhibited when the museum opened in the summer of 1938. See Adeline R. Tintner, "Henry Van de Velde and the Kröller-Müller Museum," *Magazine of Art* 39 (October 1946): 244–47. It was only in 1965 that the decision was made to improve the temporary building. Extensive restoration was undertaken in 1970–72.

47. Peter Behrens, Mies van der Rohe, and Hedrick Petrus Berlage, as well as Van de Velde, all made house-museum designs for the Kröller-Müllers. See *Kröller-Müller Museum*, 10–17. Hitchcock considered the Mies project the most important work in the early years of his career, one premonitory of later developments. *Architecture: Nineteenth and Twentieth Centuries*, 363–66.

48. Soon after 1936, Van de Velde designed the sculpture gallery with glass walls on two sides. It was not completed until after World War II, in 1953, when the auditorium and additional exhibition space was added. (The architect was ninety.)

49. A. Conger Goodyear gives the background on the founding of the Museum of Modern Art. *The Museum of Modern Art: The First Ten Years* (New York: Museum of Modern Art, 1943): 15–16. Hudson calls it one of the art giants of the century with worldwide influence and treats it in his chapter on "Temples of art." *Museums of Influence*, 60–64.

50. Hamlin, "Modern Display for Works of Art," *Pencil Points* 20 (September 1939): 615–20.

51. Barr's breadth of interest has been attributed to his training in medieval art under Charles Rufus Morey at Princeton University; he taught the first college course on modern art at Wellesley College before coming to the Museum. See Sam Hunter, "Introduction," *The Museum of Modern Art: The History and the Collection* (New York: Museum of Modern Art, 1984): 8–41. Also see "Appendix A, 'The Director's 1929 Plan,'" Goodyear, *The First Ten Years*, 137–39. Barr expressed his hopes about the architecture of the new building in a letter to Goodyear. Letter, July 6, 1936, in Rona Roob, "1936: The Museum Selects an Architect, Excerpts from the Barr Papers of the Museum of Modern Art," *Archives of American Art Journal* (1983): 25.

52. Goodyear, *The First Ten Years*, 128.

53. Mumford, *The New Yorker* (June 3, 1939), quoted by Goodyear, *The First Ten Years*, 129–30.

54. Hamlin, "Modern Display for Works of Art," 615. Dominic Ricciotti, crediting Richard C. Wilson for the interpretation, remarks on the tripartite facade composition, likening it to an Italian palazzo with the window area marking the "piano nobile." "The 1939 Building of the Museum of Modern Art: The Goodwin-Stone Collaboration," *American Art Journal* 17 (Summer 1985): 76, n. 58.

55. Goodyear, *The First Ten Years*, 131.

56. The project was commissioned by and first published in *Architectural Forum* (May 1943): The fact that it was ideal, unspecific, and without a detailed program or collection should be noted. Helen Searing comments on the fact that only its contents give clue to its identity. *New American Art Museums* (Berkeley: University of California Press, 1982): 51.

57. Arthur Drexler, *Ludwig Mies van der Rohe* (New York: George Braziller, 1960): 24–25.

58. Kahn, "Monumentality," In *New Architecture and City Planning*, Paul Zucker, ed. (New York: Philosophical Library, 1944): 577–88.

# The Yale University Art Gallery

Yale University Art Gallery,
New Haven. Stairwell.

## Commission Background

Louis Kahn's relationship with Yale University included his first major commission, the Yale University Art Gallery, and ended with one of his last, the Yale Center for British Art, which was completed posthumously. Kahn first came to Yale as a visiting critic in architecture in 1947, the year the visiting critic program was first seriously utilized for architectural education there. Under Dean Everett V. Meeks, founder of the Department of Architecture at Yale, which espoused the Beaux-Arts model, distinguished, actively practicing architects who normally did not engage in teaching were introduced into the academic setting in New Haven.[1] Kahn had been invited to come in the spring of 1948, but he arrived a semester early when the first of the critics appointed, Oscar Niemeyer, was unable to secure a visa for entry into the United States.[2] Kahn's effectiveness as a teacher was such that he was asked to continue as a senior critic for Yale, and eventually he succeeded Edward Durell Stone as chief critic in 1950. He continued to teach architecture as a visiting critic at Yale until 1957 while maintaining his own office and practice in Philadelphia.

In 1948, following the retirement of Dean Meeks, who was an architect, fine-arts studies at Yale were reorganized. Charles H. Sawyer was appointed director of the arts division and dean of fine arts; Harold Hauf, professor of architectural engineering, was put in the newly created position of chairman of the architecture department. The point of this reorganization was to bring together the departments of art, architecture, and art history, as well as the art library, uniting them all under a single administration and strengthening the disciplines within the university. Hauf, however, left the architecture chairmanship after a year, and Kahn proposed his friend and former partner George Howe to fill the position. An offer came to Howe as he was nearing the end of his tenure as the first resident fellow in architecture and the first modernist architect at the American Academy in Rome.[3]

Howe's assumption of the chairmanship in February 1950 began a new era of architectural education at Yale. Howe, educated at Harvard University and trained in the Beaux-Arts system in Paris, became a modernist after a conventionally successful career. After the Pennsylvania Savings Fund Society Building in Philadelphia (1926–32), executed in association with William E. Lescaze, he built modern houses such as Fortune Rock on Mount Desert Island, Maine, in the 1930s, and low-cost housing with Louis Kahn and Oscar Stonorov in the 1940s. Yale was keenly aware that Walter Gropius had established an esteemed program teaching the new architecture at Harvard; many considered it almost a continuation of the Bauhaus. Yale therefore selected Howe, the most prominent American architect working in the modern style, to lead its own program and to establish it as another important architectural school with its own character.

The end of the 1940s and beginning of the 1950s thus signaled change in the teaching of the arts at Yale.[4] Josef Albers (1888–1976), who like Gropius and Marcel Breuer (1902–81) at Harvard was formerly of the Bauhaus, arrived as a visiting critic in art at Yale in 1949 and became chairman of the art department the following year. He brought new techniques and ideas to the teaching of art. Howe, for his part, continued

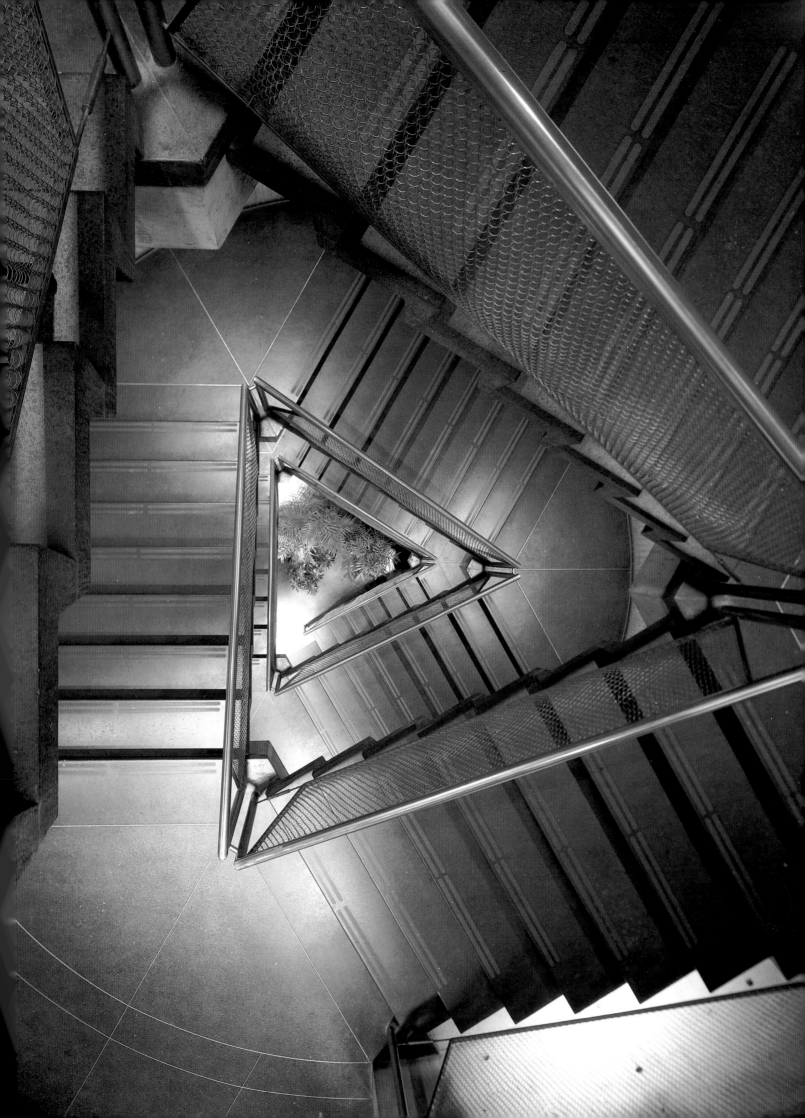

**2.1**
*Project: Yale University Art Gallery. Model.* Philip L. Goodwin. 1941.

the architectural pluralism already established under Beaux-Arts-educated Dean Meeks by inviting various practicing architects to Yale as visiting critics. Pedagogically he placed emphasis on modernism and on architectural education as a humanistic discipline. One of the most articulate and stimulating visitors was Philip Johnson, who had studied at the Harvard Graduate School of Design for an architectural degree after leaving the staff of the Museum of Modern Art. Johnson had recently completed his Miesian-style Glass House in New Canaan, Connecticut (1949). Kahn was at Yale before either Howe or Johnson, but he had built little and was known there more as a teacher than as a practicing architect. Both Howe and Johnson recognized Kahn's potential and were instrumental in encouraging him.[5] In fact, before leaving Rome for Yale, Howe had recommended Kahn for a fellowship at the American Academy. There Kahn spent several months and toured Greece and Egypt in late 1950 and early 1951. The opportunity to review ancient and classical monuments after experience and practice in modern architecture was important for him; it was a time that was to be telling on his future work, including his museums.

A proposed addition to the Yale University Art Gallery by Egerton Swartwout (Yale, 1891) reflected the growth and new vitality of the fine arts at the University. Expansion had been considered before World War II, and a plan by Philip Goodwin was approved by the Yale Corporation and announced in the late fall of 1941.[6] Goodwin's modern building (fig. 2.1) was designed to provide temporary exhibition space and additional room for the growing permanent collection on the ground floor; offices, library, and the photograph and slide collection on a mezzanine; and galleries for paintings, collections of textiles, prints, and drawings, and the collections of Asian art on a top-lighted second floor. Conservation and restoration, photography, storage, and shipping were all consigned to the basement. Wings attached to the building were for library stacks and sculpture studios.

Goodwin's new gallery was also to provide faculty offices, classrooms, and seminar rooms, but Yale's announcement of the addition stressed the division of the collections, noting that there would be "great works on permanent display." The bulk of the objects assigned to study collections were to be "open to students and the interested public," and only a small portion of the collection was to be relegated to basement storage. Placement of the addition was no problem as it was to occupy the space originally included as part of the grand scheme for Swartwout's gallery, which was only two-fifths constructed. For the new construction, one or more of the four parts of the build-

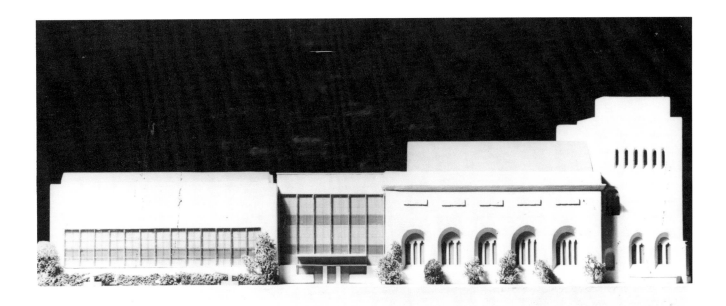

2.2
*Project: Yale University
Art Gallery. Model.* Philip
L. Goodwin. 1941.

ing (exhibition and study collections, administration and temporary exhibits, wings for the library, and sculpture studios) could be constructed independently; but the announcement also stated that "construction will wait on circumstance." Goodwin's design (fig. 2.2), however, was fated never to be realized, coinciding as it did with the war years.

The addition was proposed anew in 1950, when programs in the arts generally were revitalized at Yale. Goodwin now planned to accommodate additional programs, including the newly formed graduate division in city planning. His new proposal called for a three-story building instead of a two-and-a-half-story one, and its cost was estimated at $2 million.[7] In 1950 A. Whitney Griswold was appointed the new president of Yale University. Griswold, who would be a strong leader in the university community and would oversee a remarkable building program,[8] felt the need to emphasize the sciences, which he believed had been neglected at Yale. Aware that he entered office with an academic deficit of $448,486, he approached construction programs with caution. The first building at Yale commissioned under his administration was a utilitarian laboratory addition. He questioned the need and expense for the new gallery and consulted with members of the Advisory Committee of the Associates in Fine Arts at Yale University.

In November 1950 Charles Sawyer, director of the arts division, and James T. Soby, who were members of the fine arts advisory committee, responded to Griswold's questions as to the educational priority and the justification of an expenditure of $1.5 million, the amount evidently specified by Griswold, for a new addition to the gallery.[9] Sawyer and Soby wrote that the University would enrich its collections with gifts already promised and other new gifts if adequate exhibition space were available, adding that special exhibitions had important contributions to make to the educational experience. They also proposed that a "laboratory or center of visual materials" for teaching in the humanities as well as the arts would have an even greater appeal for contributors and supporters. They thought the sum Griswold had settled on should be adequate for an effective and useful building, given careful restudy and redesign of Goodwin's existing plans. At least six months would be necessary for the architect and a building committee to study and develop revisions after the project was approved by the University. Because of his architectural knowledge and experience, they recommended that George Howe should be included on the committee.

Goodwin withdrew from the project and suggested giving the commission to Philip Johnson, whose work up to this point in his career included only houses.[10] But Howe and Johnson himself thought Kahn should design the new gallery addition. In early January 1951 Sawyer, who was to act as client for Yale on this project, wrote Kahn, then at the American Academy in Rome, that Philip Goodwin had withdrawn from the gallery commission because of an emergency eye operation and that while the withdrawal was a "blow," it was also an opportunity to reconsider the program, focusing on

**2.3**

*Carver Court Housing Development, Coatesville, Pennsylvania. Perspective view.* Louis I. Kahn. 1943. Louis I. Kahn Collection, University of Pennsylvania and Pennsylvania Historical and Museum Commission.

the educational utilization of the building requested by the new president.[11] Howe, Sawyer, and Eero Saarinen (1911–61; Yale, 1933), who was working with Douglas Orr (1892–1966; Yale, 1919) on the laboratory addition that was the first of the buildings commissioned by Griswold, met and agreed to propose to the University that Kahn in association with the New Haven office of Douglas Orr be awarded the commission. Kahn was to have "primary responsibility for the design," and Orr's office was to work on the program, prepare the working drawings, and supervise construction.[12] Sawyer said that he and Howe would represent Kahn in discussions and decisions, postponing anything final until Kahn's return from Rome in mid-March 1951.

This commission represented a milestone in Kahn's career. The depression years of the 1930s had been particularly difficult for him professionally. It was with housing projects that he had occupied himself, and many of these were projected studies. He was registered with the American Institute of Architects in 1935. Up to the time of the Yale commission, the largest significant works he had produced were specialized: the public housing with Howe and Oskar Stonorov, notably Carver Court housing in Coatesville, Pennsylvania (1941–43) (fig. 2.3); Willow Run housing in Detroit, Michigan (1943), with Stonorov; housing for Philadelphia City Planning (1946–1948) as part of an association of consultant Philadelphia architects (Stonorov and Kahn, Wheelwright and Stevenson, with realtor Harry Johnson); and the Mill Creek Project for the Philadelphia Housing Authority (1950–54) with Kenneth Day, Douglas G. Baraik, and Louis McAllister. Kahn established his own office in 1947 with a commission from the Philadelphia Psychiatric Hospital for the Pincus Occupational Therapy Building (fig. 2.4). (Kahn and Stonorov had designed unrealized additions for the hospital in 1944–46.)

Kahn also had designed numerous houses during these years, although not many were built. The Morton Weiss house in Norristown, Pennsylvania (1948–49) (fig. 2.5), demonstrates how he applied the ideas on practical planning he had evolved in his work in public housing, such as grouping the utilities and work areas, to a private house design. Although this functional type of arrangement was generally characteristic of modernist architecture, it would later be seen by some as a premonition of his more mature "served" and "serving" spaces.[13]

In appearance, the Weiss house demonstrates Kahn's acceptance of the aesthetic of modernism with its unornamented planar walls, large expanses of glass, and flat roof (fig. 2.6). A rough fieldstone masonry giving textural contrast was employed (fig. 2.7), as in some of Le Corbusier's villas of the 1930s and Marcel Breuer's houses of the 1940s. Yet an unusual feature here was the treatment of the south window-wall: the double-hung panels forming the windows had plywood in one sash and glass in

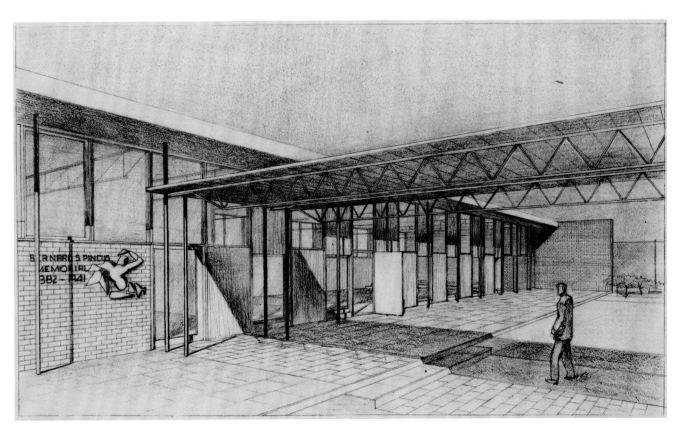

**2.4**
*Philadelphia Psychiatric Hospital, Pincus Building, Philadelphia. Perspective.* Louis I. Kahn. Louis I. Kahn Collection, University of Pennsylvania and Pennsylvania Historical and Museum Commission.

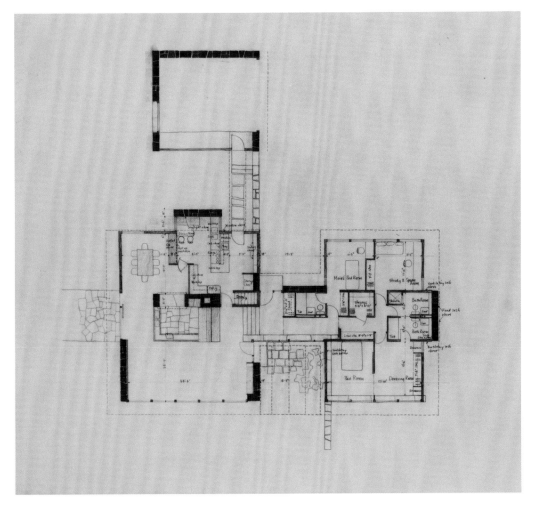

**2.5**
*Weiss House, East Norriton Township, Montgomery County, Pennsylvania. First plan.* Louis I. Kahn. Louis I. Kahn Collection, University of Pennsylvania and Pennsylvania Historical and Museum Commission.

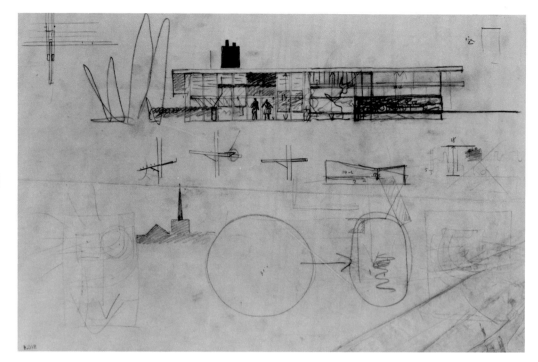

**2.6**
*Weiss House, East Norriton Township, Montgomery County, Pennsylvania. South elevation, section.* Louis I. Kahn. Louis I. Kahn Collection, University of Pennsylvania and Pennsylvania Historical and Museum Commission.

**2.7**
*Weiss House, East Norriton Township, Montgomery County, Pennsylvania. North and south elevations.* Louis I. Kahn (drawn by A. G. T.). June 23, 1948, rev. August 9, 1948. Louis I. Kahn Collection, University of Pennsylvania and Pennsylvania Historical and Museum Commission.

**2.8**
*Weiss House, East Norriton Township, Montgomery County, Pennsylvania. Elevation diagrams of window wall variations.*

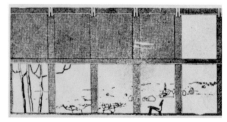

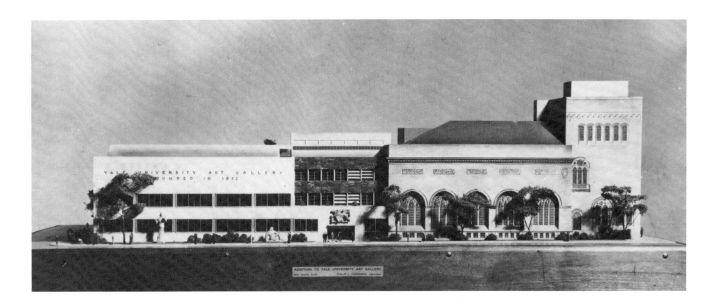

**2.9**
*Project: Yale University
Art Gallery. Model.* Philip
L. Goodwin. 1950.

the other. It is possible to control the amount of light and the degree of privacy in the house through manipulation of the sashes (fig. 2.8). The Weiss house was awarded a medal for design by the Philadelphia chapter of the American Institute of Architects and another by the Home Builders' Association in recognition of Kahn's ingenious approach to architectural problems. Having won his peers' admiration, at the age of fifty he was at last accorded substantial recognition in the Yale commission.

## The Program for the Yale Art Gallery Addition

The program for the Yale Art Gallery essentially was established in Kahn's absence. Late in January 1951, George Howe wrote to Kahn of the program discussions which he considered "the beginning of the real design process." The basic scheme, as Howe articulated it, was

> to build a new modern gallery and work building on the site of the present store buildings on Chapel Street, between York Street and the parking lot, leaving the latter open as a garden, with a view between the old and new gallery buildings to Weir Hall [then the architecture building] with its terrace in front and Harkness Tower beyond. The old and new galleries would be connected by a bridge at the third floor, to be used as an exposition gallery, and by a service tunnel.[14]

In a decided change from Goodwin's concept of a slightly recessed but solid connector for the galleries, Howe thought that an open space between the two would contribute more to the effect of the whole ensemble. Howe's program of January 18, 1951, which summarized the initial work of the building committee, called for a loft building with bays of 23 feet by 25 feet (four bays wide and five long) on three floors.[15] Height was taken from Goodwin's last design, which equaled the height of the old gallery. In all, a space of approximately 650,000 square feet was requested at a cost of $1.5 million, inclusive of alterations to the existing gallery and Wier Hall.

The most prominent source for the spatial concept of the new gallery is Goodwin and Stone's Museum of Modern Art in New York, where the flexibility of the open spaces for exhibition had been validated in numerous arrangements for various shows and the museum's own collection. Goodwin's 1941 Yale design, approved by the corporation, was already modernist. The 1950 façade echoed that of the Museum of Modern Art (fig. 2.9) with a thin-surfaced wall with strip windows, which, like the entrance, were asymmetrical in placement. This museum stood in marked contrast to the Beaux-Arts gallery next door. Its plans too were modernist, demonstrated in plans and photographs of the model. These provided, of course, for academic classrooms, studios, library, exhibition galleries, and study galleries, but otherwise recall strikingly the Museum of Modern Art. Providing for these various functions would have called for interior partitions, but in the areas devoted to the showing of art Goodwin used the open spaces that had proven so effective in New York.

Howe was also committed to the integration of modernism into Yale's architectural and intellectual environment. As the most distinguished professional architect on the faculty and chairman of the department, Howe's judgment carried weight, especially with Sawyer, who trusted him to advance the cause of modern architecture at Yale. He seems to have prevailed during discussions of the program.[16] Howe, feeling it necessary to move forward from what he called the "abandoned palace" concept of art galleries of the past, cited as reasons for change the complexity of the architectural program and the restriction of funds. Moreover, Goodwin's design, previously approved, had created a precedent for breaking Yale's tradition of architectural historicism established by the James Gamble Rogers college buildings of the 1920s and 1930s.

While Howe was providing practical justifications for a modern design, modernism had become the new standard for museum architecture. By 1950 Laurence Vail Coleman, director of the American Association of Museums, could write that it had taken years of creative work by a younger generation "to pull museums away from what has 'always' been done. But the change has been made."[17] Coleman thought two notable examples were Philip Goodwin's design for the Yale University Art Gallery and the 1939 prizewinning design by Eliel (1873–1950) and Eero Saarinen with J. Robert F. Swanson for a Smithsonian Gallery of Art in Washington, D.C. (fig. 2.10).[18] George Howe, along with Walter Gropius, had been a member of the jury of architects making the Smithsonian award. The jury characterized the design as simple and direct, functional and well studied, possessing clarity of composition and a "fine use of materials."[19]

**2.10**
*Project: Smithsonian Gallery of Art, Washington, D.C. Model.* Eliel and Eero Saarinen with J. Robert Swanson. 1939.

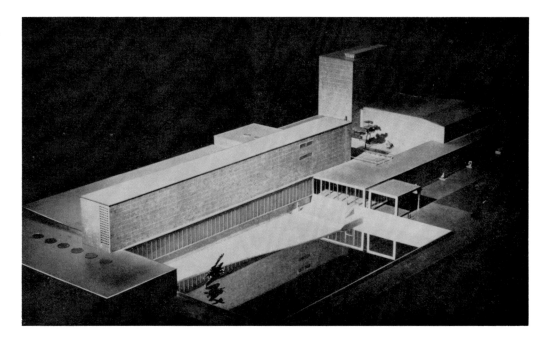

The Smithsonian project shows the influence of modern European architectural design in its flat roof, strip windows, and characteristic regularity, horizontality, and planarity emphasizing volume rather than mass. Different parts of the building reflecting the functional plan, such as the stage house of the auditorium, are expressed on the exterior. One is reminded of Gropius's complex for the Bauhaus, Dessau (1925–26) (fig. 2.11), where the plan is directly expressed. The Smithsonian gallery contrasted different parts: the exhibition area with offices and administration above, a lower-roofed library wing, a tapering auditorium with a stage tower. Eero Saarinen had returned from Finland to join his father's firm in 1936. He had practiced there for several years after studying architecture at Yale and had become acquainted with modern European

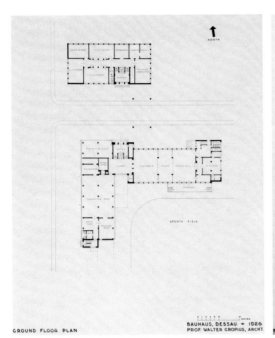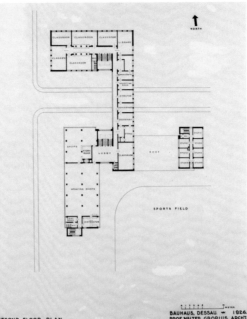

**2.11**
*Bauhaus, Dessau. Plan. Ground Floor and Second Floor.* Walter Gropius. 1925–26. Photograph courtesy, The Museum of Modern Art, New York.

developments. He was instrumental in introducing the new architectural style to the Saarinen firm.

The National Gallery of Art (fig. 2.12), which was completed in 1941, suffered in the eyes of some critics when compared to the Smithsonian gallery model.[20] Designed by John Russell Pope (1874–1937) in the official Washington Neoclassical style and inspired in its plan by the early public museums in Germany and England, it was completed after Pope's death by Otto R. Eggers (1882–1964) and Daniel Paul Higgins (1886–1953). According to architect-critic Lorimer Rich, despite the high quality of execution, its impressive size and acceptable formula of design reflect the past rather than presaging the future. Its plan (fig. 2.13) was clearly derived from the Beaux-Arts museum plans of the late nineteenth and early twentieth centuries in the United States. It was not expressed on the exterior so that it could be read. The dean of the Harvard Graduate School of Design, Joseph Hudnut (1884–1968), an expert on Georgian colonial architecture who believed in the new architecture and was instrumental in bringing Gropius to Harvard, saw it as "the last of the Romans" in his 1941 critique.[21]

Howe's Yale Art Gallery program concentrated on an efficient creation of maximum, relatively inexpensively constructed space. Exterior architectural design was to

**2.12**
*National Gallery of Art, Washington, D.C. View of principal façade.* John Russell Pope, Otto R. Eggers and Daniel Paul Higgins. 1937–41.

**2.13**
*National Gallery of Art, Washington, D.C. Plan diagram.*
John Russell Pope, Otto R. Eggers and Daniel Paul Higgins. 1937–41.

be achieved by the arrangement of parts and by the relationship of the gallery to its site and surrounding buildings. Thus Howe conceived of an open space between the old and new galleries with a bridge linking them on the upper floor. The interior plan was to be spatially flexible like that of the Museum of Modern Art (fig. 1.36), completely different from the period rooms of the museums of the 1920s in Detroit and Philadelphia. The open space inside the gallery expressed a major principle of modernism and was extremely practical for this particular project because it would make possible efficient use by the architecture and design departments. The same interiors, however, were expected to convert effectively into art exhibition space at some future date when the whole building would be devoted to showing art.[22]

By the first of February, after conferences with gallery director John Marshall Phillips and with the art and art history departments, a more detailed program was written. It assigned what had become by then eight (rather than Howe's nine) bays of each floor to specific exhibition, study, and storage areas, workshops, offices, and service

and utility functions.[23] Recognizing new developments in the conservation of objects, this program also recommended air-conditioning for the building. One and one-half bays of each floor were thus assigned to the stairway, elevator, and ducts. Additional half bays would be required on the first floor for the entrance and sales desk and in the basement for equipment.

Discussion continued among the members of the building committee — Sawyer, Howe, Phillips, Associate Director Lamont Moore, and Professor Sumner McKnight Crosby — and revisions (no longer extant) were made by architect Dillingham Palmer of the Orr office, who was assigned to work with the committee.[24] According to Sawyer's letter acknowledging Kahn's acceptance and reporting on progress, these preliminary plans, which must have been schematic, were "based on studies made by George Howe."[25] Sawyer described Howe's proposal as a "four-story loft building" attached to the existing gallery by means of the basement and a sixty- to seventy-foot third-floor bridge. This separation of the two buildings would solve "problems" (as Sawyer put it) of integrating the modern design with the old gallery, as well as with its existing floor levels. The loss of built space between the galleries was regrettable, Sawyer thought; it might be needed in the future.

Howe's scheme and Palmer's drawings of schematic plans were sent to Kahn's Philadelphia office in anticipation of his return.[26] It seems that the various departments were in agreement over the allocations of space and had accepted Howe's plan to have an open court between the two galleries. Palmer noted the problem of accommodating circulation of public, students, and staff within the building. Sawyer, wishing to avoid the stairwell "bottleneck" of the old gallery, had suggested a ramp, as in some Le Corbusier buildings, but Palmer thought this probably too space-consuming and expensive. After presentation of plans to the complete art and architecture faculties and to President Griswold, discussions continued through March. Kahn joined in after his return from Rome, and some revisions were made in the program's allocation of space as a result of these meetings.

The change to additional built form rather than the open space Howe had placed between the galleries first appears in a scheme of February 14, 1951, which indicates two floors for a "connecting wing." This decision was made before Kahn's return and must reflect the realization that built space in this area would contribute much more to the usefulness of the building. The next scheme, dated March 28, which includes the period of Kahn's early activity in the planning, shows the "bridge" to be a more solid link through the floors. The three versions — Howe's original program and the amended schemes of February 14 and March 28, 1951 — show a decreasing number of total square feet but an increasing size of the connecting section between the old and new galleries.[27] In the March 28 scheme, the "bridge" became a unit in itself, with three floors assigned to the museum and one to architecture. Additional space was allotted the museum, while design's share shrank from 10,400 to 5,750 square feet. In all, the building was reduced by 5,400 square feet during these revisions, reductions motivated in large part by the need to reduce the project's cost.

After the building committee weighed and considered the schemes further, Palmer wrote a program on April 2, 1951, calling the project "Design Laboratories and Exhibition Space,"[28] an appellation that goes back to Sawyer and Soby's suggestion for a building that would have wider appeal to potential donors than simply an addition to the gallery. New space now was set tentatively at 46,000 square feet (as in Howe's first scheme) to be built for $1.5 million, including fees, equipment, landscaping, and alterations to Weir Hall (also as Howe projected but without mention of remodeling the old gallery). The history of art department and the library would be assigned to Weir Hall. Three major considerations in Palmer's new program were (1) first priority to educational functions as requested by President Griswold, (2) maximum flexibility for the space because of the future change in use to a gallery, and (3) the creation of as much usable space as possible under budgetary restrictions. The second consideration was particularly important; the building was intended to be a gallery flexible enough in plan to serve other academic uses for an unspecified length of time. Orr sent sketches to Kahn on April 4, 1951, suggesting tentative concepts.[29]

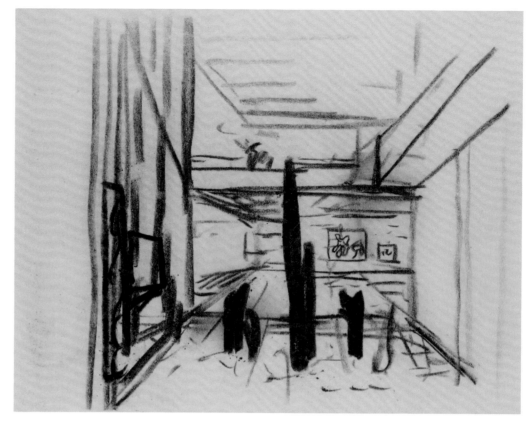

**2.14**
*Yale University Art Gallery. Interior perspective.* **Catalogue 1.** Louis I. Kahn. Louis I. Kahn Collection, University of Pennsylvania and Pennsylvania Historical and Museum Commission.

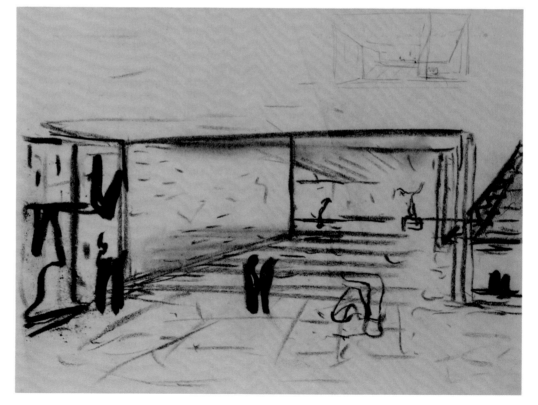

**2.15**
*Yale University Art Gallery. Interior perspective.* **Catalogue 2.** Louis I. Kahn. Louis I. Kahn Collection, University of Pennsylvania and Pennsylvania Historical and Museum Commission.

### Design Development

Although much preliminary work had been done before Kahn began his work on the project, he was the designer, and clearly he was recognized as such. According to Palmer's notes, Kahn's sketches on April 9 and 10, 1951, were used along with diagrams in a meeting with the building committee to explain his concept of multiple levels (possibly including the bold charcoal sketches shown in figs. 2.14 and 2.15).[30] An undated, colored perspective sketch of the north side of the new building (fig. 2.16) includes a narrow bridge linking the gallery with Weir Hall; the larger bridge of the con-

**2.16**
*Yale University Art Gallery. Exterior perspective, north side, looking west.* **Catalogue 3.** Louis I. Kahn. 1951. Yale University Art Gallery.

**2.17**
*Yale University Art Gallery. Exterior perspective looking north.* Louis I. Kahn. Louis I. Kahn Collection, University of Pennsylvania and Pennsylvania Historical and Museum Commission.

necting unit is suggested by the open walk-through between the galleries. It may partly reflect what was described as the scheme of April 9. The sketch shows a handsomely proportioned window wall on the north side of the large bridge, a feature that remained constant during the design process and came eventually to be used on the entire north wall, with refinement in the detailing and spacing of mullions. In this sketch the building's north side proper appears as a closed wall with vertical articulation suggesting a frame. The sculpture terrace is sunken; there is a high wall between it and Weir courtyard. Another early sketch indicates a plain, masonry south front set close to Chapel Street (fig. 2.17, with the bridge connector seen in fig. 2.16 on the right). This closed south face also remained constant; the distinctive horizontal drip moldings that demarcate the floor levels were added later.

The committee studied Palmer's tentative program in order to establish if there were any special requirements that would be wanted by the academic departments that should be added. Despite the fact that the building already was larger than the one originally budgeted, Palmer's notes show that facilities for museum receptions were an early addition. Nor was this the only significant change proposed, for the committee rejected the bridge between the gallery and Weir Hall.

Howe, who had been unable to attend the meeting on April 10, met with the architects to review Kahn's sketches on April 11.[31] He saw that the addition of a bay increased the cubic area of the building to 720,000 feet and asked that a reduction be made to bring it closer to the 650,000 cubic feet of his January program. Howe also suggested omitting the bridge to Weir Hall, as indeed had been recommended by the building committee the previous day, and that the connection with Weir be only through the basement. A more finished perspective presentation of the north side (fig. 2.18), possibly of April 10 or shortly after, reflects this change and shows several transitional levels to the terrace, or rather terraces, for these were to assume a greater importance for both building and site. The drawing also illustrates Kahn's early concept of narrow, low vaults in series for the ceiling of the gallery.

After the meeting with Howe, Palmer recalculated the areas of the current schematic plan and compared them to those of Howe's January scheme. He pointed out that Howe had not included a "core or vertical circulation" space.[32] In addition, greater cubic size in the new design resulted from "staggered levels" and a "taller gallery on the 'bridge.'" At this time Sawyer and Howe summarized a presentation of an "interim progress report of the Art Building Committee" for the Corporation Committee on Architectural Plan.[33]

In early May Sawyer asked the architects for design proposals "to accompany the program already approved" before the following June 8, for presentation to the corporation committee.[34] Preliminary plans dated April 25 and a section and elevation of May 8 were submitted for cost estimates on May 10, 1951.[35] A description of the "concrete loft building" with columns and flat floor slab construction indicates the basic simplicity of the structure. Specifications were in place for "exposed concrete" columns and ceilings in the architectural areas. Galleries were described as having hung acoustical plaster ceilings, the vaulted series seen in the perspective of the court with terraces (fig. 2.18) and in an early section (fig. 2.19). These were not structural vaults, for Kahn conceived of the space created between them and the structural slab above as housing for ducts and conduits, as indicated in the section. The exterior was to be faced with the same stone as the old gallery (twelve-inch squares of Aquias freestone). At the Chapel Street entrance, as seen in Kahn's lively schematic perspective with the south facade of the old gallery (fig. 2.20), and on the west and north elevations, glass walls with columns and spandrels faced with black slate were specified. (Black slate was the material Kahn had used on the Radbill Building of the Pennsylvania Psychiatric Hospital.) Slate also was designated for the interior gallery floors.

After the June meeting of the corporation committee and preliminary design approval, the architectural contract was signed on June 22, 1951. A separate agreement between Orr and Kahn divided responsibilities and payment.[36] As described above, this design, which now exists only through the written record and a few

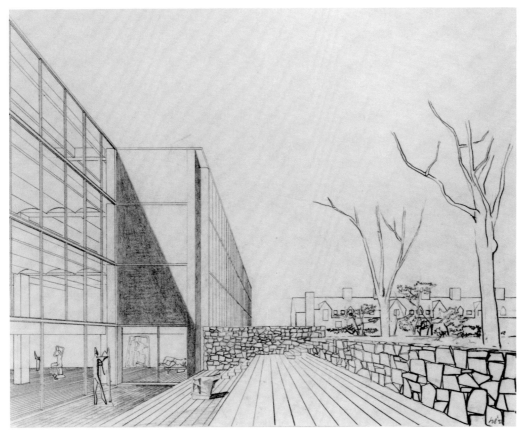

**2.18**
*Yale University Art Gallery. Exterior perspective, north side, looking west.* **Catalogue 4.** Louis I. Kahn. 1951. Yale University Art Gallery.

**2.19**
*Yale University Art Gallery. Cross-section. Early version.* Louis I. Kahn (office drawing). Louis I. Kahn Collection. University of Pennsylvania and Pennsylvania Historical and Museum Commission.

**2.20**
*Yale University Art Gallery. Exterior perspective, facing entrance on south front, looking west.* **Catalogue 5.** Louis I. Kahn. Louis I. Kahn Collection. University of Pennsylvania and Pennsylvania Historical and Museum Commission.

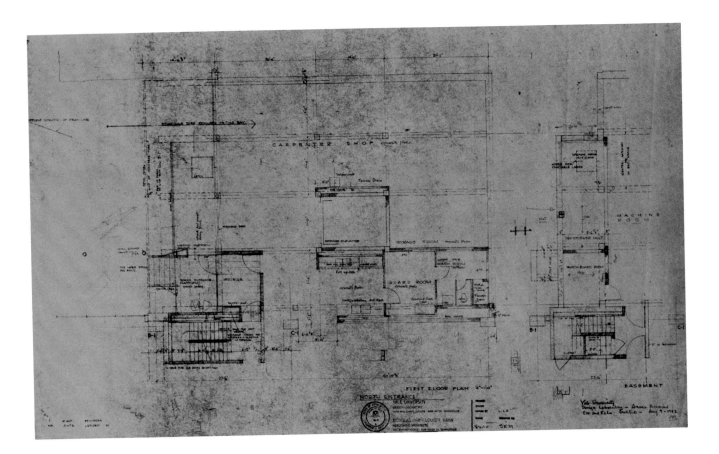

**2.21**
*Yale University Art Gallery.
Plan. First floor, north
entrance.* Louis I. Kahn
(drawn by L. I. K.). Louis I.
Kahn Collection. University of
Pennsylvania and Pennsylva-
nia Historical and Museum
Commission.

sketches in the Kahn Collection and the Yale University Art Gallery, was not yet devel-
oped into detailed plans. Architectural design continued. Kahn found it advantageous
to group utilities and stairway, in the accepted modernist method familiar to him, in
order to create the program's unencumbered and flexible loft space, thus differentiat-
ing "serving" from "served" spaces, although he did not yet call them that. A drafted
plan detail of August 9, 1952, by Kahn himself is the later development of the spe-
cialized service space and entrance (fig. 2.21). An undated note to him from Palmer
accompanied studies of the core space that located stairs and landings to "save as
much north light as possible."[37] Kahn was concerned not only with the functions but
also still searched for a commanding architectural feature for the building. In describ-
ing its design process, he later said, in 1953, "we can only think of form after the
requirements of the building have been fulfilled."[38] A space-frame concept was the
special identifying order he evolved for the gallery.

There is no documentation of the development of plans between May and August
1951, but it is probably during this period that Kahn developed an important and inno-
vative idea: the tetrahedral slab based on the space-frame. The slab was to unite floor
and ceiling through the use of a three-dimensional tetrahedron pattern, with the top flat
plane forming the floor, and the hollowed out lower plane forming a ceiling beneath it.
A multiplanar truss system has the potential for great strength and a wide span, appro-
priate for the open space desired by everyone in this case. The triangular openings
provide spaces for placement of ducts, conduits, and even the light fixtures them-
selves within the reinforced concrete structure. It is a powerful and sculptural effect. To
Kahn it gave visual and functional unity to the building.

Architect Anne Griswold Tyng collaborated closely with him on this project. Their
association began in 1945 when the office was Stonorov and Kahn, just a year after
Tyng completed the program under Gropius at the Harvard Graduate School of
Design. She then joined his independent office, along with two other architects in 1947,
and continued to work with him throughout his career.[39] Tyng asserts that her preoc-
cupation with geometry as an ordering principle in architecture, which began in 1949
under the influence of Buckminster Fuller's lectures at the University of Pennsylvania,
was the stimulus for Kahn's triangulated space-frame system in the Yale Art Gallery.[40]
Kahn, of course, had known Fuller since the 1930s. The structural potentials in Fuller's
work attracted much attention from architects at this time. Kahn was in touch with him
while Fuller was lecturing as a visiting critic at Yale in 1952, although this was after the

decision on the slab. According to Fuller, they commuted together "to George Howe's architectural school at Yale . . . discussing mathematics" around the time the gallery was under construction.[41]

Undoubtedly there was some influence or inspiration from Fuller himself as well as from Tyng. Kahn later said that Fuller's work was structurally more sophisticated, and that he sought a simpler adaptation for a flat ceiling.[42] Tyng's geometry was also more complex. She used tetrahedral geometry in a project for an elementary school exhibited in the Philadelphia American Institute of Architects annual exhibition in the fall of 1951 (see the model of a unit, fig. 2.22), and in the design of a house for her parents in Cambridge, Maryland (fig. 2.23). That house — a three-dimensional application of the

**2.22**
*Project. Elementary School. Bucks County, Pennsylvania. Model of structure for a classroom unit.* Anne G. Tyng. 1951.

**2.23**
*Tyng house. Cambridge, Maryland, exterior view.* Anne G. Tyng. 1953.

**2.24**
*Yale University Art Gallery.
Reevaluation of structural
system, section.* **Catalogue
6.** Louis I. Kahn. 1954. Louis I.
Kahn Collection, University of
Pennsylvania and Pennsylvania Historical and Museum
Commission.

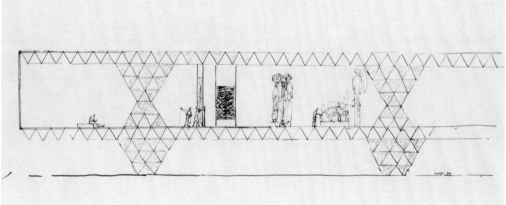

**2.25**
*Yale University Art Gallery.
Reevaluation of structural
system, section.* **Catalogue 7.**
Louis I. Kahn. 1954. Louis I.
Kahn Collection, University of
Pennsylvania and Pennsylvania Historical and Museum
Commission.

same geometry with all possible elements participating, from the sloping roof to eaves and dormer windows and even the exterior trellis — was completed in 1953, the same year the gallery was finished.

In the tetrahedral slab, however, Kahn created something recognizably new and different. When viewed as a ceiling the visual order is dominant because of the heightened dramatic play of light and shadow across the sculptural surface of reinforced concrete. Although Kahn was not immediately concerned with all the tetrahedral slab's implications when he first decided to use it, later, in 1954, with a greater awareness of the structural potentials of the system, he devoted some theoretical conjecture to the design of the supporting columns in the Yale Art Gallery. The result can be seen in two fascinating and experimental drawings (figs. 2.24 and 2.25) in which columns are transformed into triangulated structures related to the ceiling itself, transmitting loads in six directions. The art objects and the structural elements dominate, making the figures appear tiny, mere accessories, in their spatial environment. Kahn's conjectural drawings were related to the theoretical preoccupations that were also a part of the Kahn and Tyng joint project for the cantilevered City Towers of 1952–57 (fig. 2.26), a tetrahedral design that was an artistic speculation itself.[43]

While the structural system of the Yale University Art Gallery has been debated (see below), the aesthetic impact of the design was immediately evident, and its use apparently caused no real questions until March 1952. Practicality was a potent force when the triangular openings were dedicated to lighting and ductwork (fig. 2.27). To this also should be added the visual expression of the loft — an open and sweeping space (except in the core area with its functional elements) — as was fitting for the

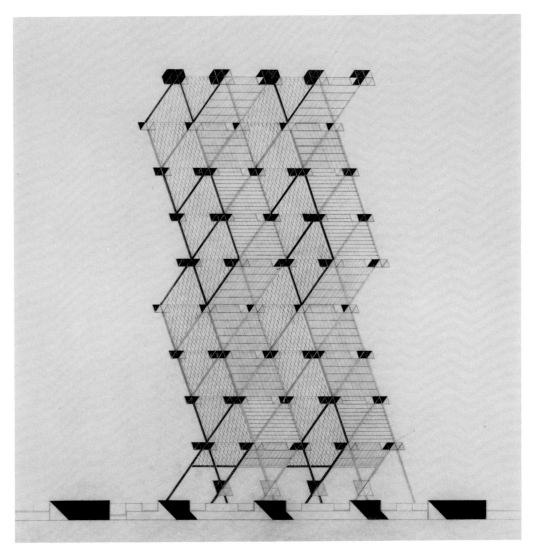

**2.26**
*Project. City Tower, Philadel-phia, Pennsylvania. Elevation.*
Louis I. Kahn. Louis I. Kahn
Collection, University of Penn-sylvania and Pennsylvania
Historical and Museum
Commission.

**2.27**
*Yale University Art Gallery.
Ceiling plan details.* Louis I.
Kahn (office drawing). April
18, 1952. Louis I. Kahn
Collection, University of Penn-sylvania and Pennsylvania
Historical and Museum
Commission.

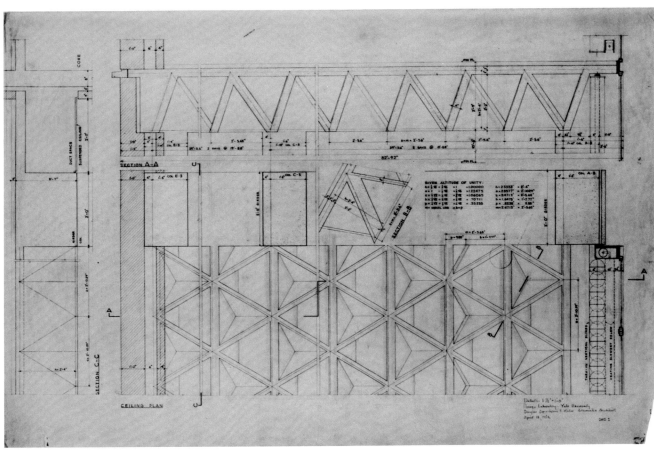

established program. Further, it was possible to shift movable partitions with relative freedom because the ceiling pattern would allow them to be braced in more than one or two directions.

Final preliminary plans were drawn for the "Yale Design Laboratory/Art Building," as Palmer called it at the time, in August 1951, when Palmer sent Kahn some possible alternate schemes for the first floor and basement core.[44] Planning for utility spaces continued through the fall. By August 23, however, the University had authorized construction of a mock-up of a typical bay on the basis of the plans of August 1.[45] A model was built, probably partly on the basis of informal advice from Major William H. Gravell, an elderly Philadelphia engineer Kahn respected and who encouraged him on the design. (After Gravell's death, Kahn spoke with former colleagues of Gravell who established the firm of Keast and Hood.)[46] Henry A. Pfisterer, professor of architectural engineering at Yale and structural consultant for the project, later described the model as presenting a "multiplanar truss system (space-frame) of equilateral triangles with the entire top surface filled in to provide the floor and with alternate inclined triangles in each of the three dimensions also made solid."[47]

In a letter to Kahn asking him to meet on the project in December 1951, Palmer summed up developments: "No decisions of much moment either in design or program since final preliminary drawings were approved last August . . . Chief things that need solving or deciding that are holding up progress are: the sash, the stairs, the annex (receiving, tunnel, location of air-conditioning equipment), the elevator (size)."[48] He noted that the mock-up was ready for experimentation on lighting, both natural and artificial, and on ceiling treatment, implying that the system was not fully worked out. Kahn must have devoted himself to dealing with these problems at this time, as the next stage for the building could not have been undertaken otherwise.

## Construction

Before the end of 1951 Yale University applied to Washington for the steel allocation necessary to build the Design Laboratory and followed up on the application in February 1952.[49] The Office of Defense Mobilization had assumed central control of metals such as steel and copper because of wartime conditions created by the Korean conflict. By March, Yale had been informed that a third-quarter authorization for the building would be made.[50] But the amount of steel employed in a slab structure based on tetrahedrons now opened basic questions concerning the design. Notes of a March meeting attended by Kahn, Orr, Howe, Pfisterer, and Charles Solomon, who represented the George B. H. Macomber Construction Company (present, no doubt, as a construction adviser), report that it was decided to go back to the original beam and slab because the new system would use more steel (which "Washington has asked us to reduce"), require more formwork, be more expensive to build and have to be tested. Another consideration was the additional time it would require for development.[51]

Nevertheless, at another meeting three days later it was decided to continue exploring the availability of appropriate contractors, and to ask three companies to bid on a fixed-fee basis.[52] A construction company having structural steel in its inventory would be able to begin work without waiting for the Yale consignment to be delivered later in the year. The fact that the plans were not yet finalized did not prevent the investigation of this option,[53] and so the floor slab came up for reconsideration at the meeting. Clearly, interest in using the tetrahedron shapes was still high. Henry Pfisterer was critical of the structure in his April structural evaluation, calling it "fireproofed metal rather than reinforced concrete," and estimating that it would use two to three times more steel than conventional construction.[54] Yet he and Kahn worked out modifications to make the structure expressive of reinforced concrete while retaining the tetrahedron form: The slab would be poured after the ribs were cast. This would make the structure neither monolithic nor a true space-frame. It actually would consist of beams braced with ribs forming triangular openings. On the other hand, the New Haven build-

ing code, which required the use of a beam system, would be satisfied. It was Pfisterer who pointed out that the modifications would make the construction acceptable to the city engineers.

The acoustics consultant, Robert B. Newman, in his analysis of the slab advised that the ceiling would provide "some diffusion and break-up of sound," but he recommended that at least 50 percent of the exposed slab surface receive some such treatment as a mat insulation or perforated acoustic tile.[55] Acoustic material was actually used to make the forms during construction because of Newman's advice. It was left in place after casting and became integral with the slab system.

**2.28**
*Metal formwork for casting tetrahedrons, Yale University Art Gallery.*

At this point Kahn was asked by Sawyer to help persuade University officials to accept the committee's judgment on the ceiling construction's intrinsic value.[56] He listed three reasons persuasive to him: (1) "the lighter construction giving a greater sense of space . . . needed in the Gallery . . . because of the low ceiling heights," (2) the "better acoustical properties inherent in the nature of the construction," and (3) "better distribution of the general illumination without any diminishment of the opportunities for specific illumination." Sawyer thought the engineers were now satisfied that it was a "workable" system. As for additional cost, this was a matter for debate because a hung ceiling would also add more expense. He regretted the two months spent "on these structural problems" which, to his mind, might better have been devoted to "careful and reasonable interior planning." Clarification and resolution on the matter, he thought, would be a matter of a next week or ten days.

On the contrary, the slab system continued to be an intermittent preoccupation throughout most of 1952. Pfisterer, in answer to his official petition for a permit to construct a test panel, was notified by the New Haven building inspector that the concept was technically in violation of the code regulations.[57] Permission was granted nonetheless for "authenticated tests, as would be required by the Board of Examiners." Pfisterer arranged for the tests, with inspection services, to be made in July 1952 for what he described as a "sample panel of special type cast-in-place concrete joist floor system."[58]

Meanwhile, the George B. H. Macomber Company was selected as the contractor. The company was recommended by Kahn and Orr to Sawyer and Yale University on the basis of five considerations: (1) the combined estimate and fee proposal, which was the lowest submitted; (2) their inventory of reinforcing steel which was sufficient for the entire project; (3) the company's demonstrated interest and the architects' previous experience with their efficiency and technical competence on the other (i.e., Orr had worked with them); (4) their ability to monitor and control costs; and, (5) the advantage to the University of a fixed fee.[59] The construction contract was authorized on May 26, 1952, while the formal contract was still in preparation for signatures.[60]

The Macomber Company, conversant with reinforced concrete, was intrigued by the experimental nature of this project. The president, C. Clark Macomber, later wrote that "an experience such as working out the Yale University Art Gallery and Design Center is a privilege given to few builders."[61] The company's cooperation with the architects with justice almost could be termed a partnership, as, for example, when they devised the metal forms for the tetrahedral floor system (fig. 2.28). Macomber considered this construction a process of "making theoretical ideas work." If he thought the use of narrow two-inch boards for forming columns, beams, and stairwells old-fashioned and impractical ("they recall methods of the past"), he still found the experience of working with Kahn's architectural concepts clearly stimulating and rewarding. Kahn changed his mind about forms after this; his instructions for concrete in later buildings did not call for formwork with small boards. Macomber's opinions had significance for him as well.

With the selection of an experienced and competent contractor, construction on the gallery was to begin with excavation scheduled for June 10, 1952. (It actually began two weeks later.) While awaiting results of tests on the structural slab, foundation work on the "annex" and the section of the site next to the Weir Hall courtyard would be undertaken.[62] A series of meetings was called to gather all necessary data from the

**2.29**
*Yale University Art Gallery. View of stairwell.* 1953. Photograph by Lionel Freedman.

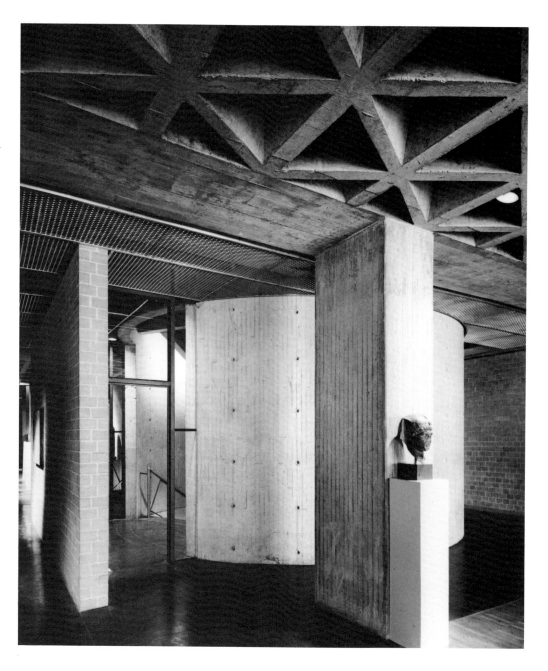

architects and consultants and to discuss and select exterior and interior materials, including partitions and exhibition panels.[63] At the mock-up a conference between the architects, Sawyer, and lighting consultants Richard Kelly and Stanley McCandless. (McCandless was a lighting specialist who taught at Yale and was associated with the Century Lighting Company.)[64] Included were representatives of Meyer, Strong, and Jones, mechanical engineers, for the conference was intended to reach decisions that were necessary for the working drawings to proceed. Ducts and conduits would be placed as the slabs were cast.[65] It was decided to run lighting trolley ducts down every other row of the voids of the tetrahedrons to achieve optimum flexibility in lighting.

Kelly played an important role in much of Kahn's subsequent work. His background included experience in lighting design even before he took an architectural degree at Yale in the 1940s, when he studied under McCandless. On the Yale commission he worked with Edison Price, who designed many of the fixtures. Although both Price's parents had been designers of theater lighting with their own firm, this was only Price's second professional job on his own.[66] Kelly and Price as a team were destined to work with Kahn as his lighting consultant and fixture designer on at least six more buildings, including the Kimbell Art Museum and the Yale Center for British Art, after this initial project together.

Architects, consultants, and the Macomber Company worked through the summer on various preparations while foundation work was under way and the required drawings were prepared and checked.[67] Some of the decisions reached at this time

represented continuing endeavors to keep costs for the building at a minimum.[68] Designs for the main stairwell, office partitions, and mechanicals were included on the list of "items needed" during the summer.[69] Most matters were routinely handled in meetings held to discuss and establish priorities and make decisions, but Kahn was quite inventive as a problem-solver during this time.

Early on, he proposed substituting less expensive maple-wood floors for slate (floors made for gymnasiums, according to Anne G. Tyng) everywhere except in the core area, a suggestion that met with the satisfaction of all.[70] He also conceived the circular stairwell with triangular flights of stairs at this time. Rather than the ramp that had interested Sawyer, Kahn used a silo of concrete (fig. 2.29), an abstract shape enclosing easy flights of stairs. His idea was to create an unusual form that would be attractive, even intriguing, to its users. The handrail and guard for the stairs (fig. 2.30) are made from stainless steel pipe with a steel wire mesh manufactured for conveyer belts. This novel solution was presented to the building committee in a model in November.[71]

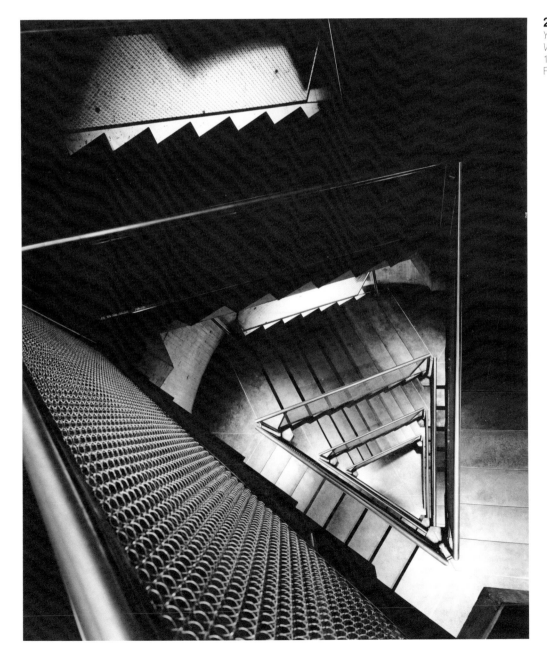

**2.30**
*Yale University Art Gallery.*
*View looking down stairwell.*
1953. Photograph by Lionel
Freedman.

**2.31**
*Yale University Art Gallery. Reflected ceiling plan.* Louis I. Kahn (office drawing). Louis I. Kahn Collection, University of Pennsylvania and Pennsylvania Historical and Museum Commission.

Already evident, however, was Kahn's well-known penchant for reserving judgment and making changes, noted in subsequent projects. An example was his difficulty in deciding upon the brick for the building. In a meeting on July 29, 1952, brick was selected for both the exterior and interior, and stone was chosen for exterior details and for interior floors and stairs.[72] (The stone on the exterior of the old gallery, originally specified for use, was not available, and a similar color of brick was wanted.) But one week later, on August 5, Kahn "discovered a new brick" that he had seen at a church under construction in Holyoke. Palmer requested that Macomber obtain a sample from the supplier ("as large as our other samples"), that the new brick be laid at the gallery site for inspection by Sawyer and Howe, and that the order for the previously selected brick be held up.[73] After careful consideration, the brick chosen earlier was used.

Kahn later described this process of working out each component of the design as part of finding "what the building wanted to be." Form existed in his mind but as if in an independent, partially obscured existence. To be able to sense form, he needed freedom to shift and change his mind on improvements, all for the greater end of bringing the building closer to what it "wanted to be." Just as in the case of Kahn's later commissions, this characteristic approach slowed work on the Yale Art Gallery and was often frustrating to those trying to carry out construction. But it was important to Kahn, and, as it turned out, to the eventual products of his efforts, that he take time, worlds of time, to let a concept develop and mature.

By August, after tests on the slab, the first cast tetrahedrons could be seen and approved, although it was noted that "some bugs need to be worked out."[74] Macomber was verbally authorized to proceed with the forms to make the slabs (see reflected ceiling plan, fig. 2.31). The ribs of the tetrahedrons were poured first, using the metal forms on plywood decks. After the forms were removed, air-conditioning ducts and electrical conduits were placed, and then the top slab was poured with the acoustical material adjusted as needed and positioned to act as the underside.[75] The latter became part of the ceiling. Reinforcing steel of the ribs was tied to the upper slab, and the complete structure thus integrated.

Sawyer, summarizing the summer's work on the gallery in September for reports to the trustees of the Associates in Fine Arts of Yale University (whose members contributed funds for construction of the Yale University Art Gallery) and to the corporation architectural planning committee (the president's advisory committee overseeing architecture at Yale), expressed concern that changes in specifications and higher than anticipated estimates for lighting, heating, and plumbing work meant that a com-

plete new estimate should be undertaken. He believed that steps to reduce the "requirements to something closer to the original budget" were necessary.[76] After the meetings Sawyer repeated requests for cuts for the sake of the budget, although he refrained from suggesting likely areas for such cuts.[77]

Still, progress was real, even if it had taken longer than desired by the University representatives. In late August the Macomber Company revised its schedule, changing the time of completion on the structure from November 24, 1952, to March 1953.[78] Ensuing changes consisted of making minor modifications, finalizing placement details, and selecting types of fixtures. Occasionally one of the workers would suggest some practical improvement in the design, which would then be included. For instance, the electrical subcontractor proposed relocating the power supply for wall plugs to the ceiling trolley ducts rather than using a separate supply from the floor. It was recognized that this also would make possible a more flexible arrangement of partitions.[79]

In October Kahn and Sawyer reviewed the entrance.[80] Kahn made a perspective sketch of the Chapel Street entry, incorporating the gallery's name as a functional balustrade (fig. 2.32). Meetings were scheduled to look at lighting for the service core, the drafting rooms, and the stairs, and to deal with ongoing budgetary problems.[81] It was decided to use terrazzo rather than stone for the core floors and for stairs, a savings of nearly $14,000; quartered oak rather than maple for wooden floors would offer a similar reduction in cost. Other possible savings were briefly considered though not necessarily accepted, such as blacktop rather than Belgian paving block for the drive and service court. Kahn decided to substitute an expanded metal mesh for the ceiling of the core section (see fig. 2.29). It was cheaper and also would be more useful because of the concentration of ducts in the area.

On November 7, 1952, an official cornerstone ceremony took place. By the end of that month Orr reported that the methods adopted for placing forms and pouring the tetrahedrons were producing "very satisfactorily finished concrete." The process, however, was slower and more costly than foreseen, and he suggested using contingency funds to continue experimentation and improve the method.[82] At this time the designs of the mechanical and electrical engineers and those of the structural engineer were "virtually complete." After discussion with Kahn, Orr recommended to Sawyer that payment be made to these consultants.[83]

There was early interest in the project among architectural circles, especially because the tetrahedral floor system/modified space-frame was seen as a structural innovation. Burton H. Holmes, technical editor of *Progressive Architecture*, spoke with Pfisterer in Orr's office after the pouring of the test model. He wrote Orr asking permis-

**2.32**
*Yale University Art Gallery. Exterior perspective, front entrance.* **Catalogue 8.** Louis I. Kahn. 1952. Yale University Art Gallery.

sion to witness tests and to publish an article on the system on an exclusive basis. Orr responded that another publication had already approached Kahn, although Holmes would be welcome at tests scheduled for August 28.[84] Earliest publication was in *Architectural Forum* in fall 1952; this was followed by a description in *Progressive Architecture* in January 1954.[85] Those in New Haven most closely involved with the building were disappointed by the initial draft of the *Forum* piece, and Kahn hoped in vain that publication might be postponed.[86] The two-page article appeared in the November issue as planned; but Kahn, Orr, and Pfisterer had influenced the writer to some degree, and they felt the text presented the structural system a little more favorably than it had in the first version.[87]

As published in the *Architectural Forum*, details on forming the slab were omitted, the design's heaviness and strength were stressed, and modifications made to the space-frame concept were explained. However, the belief of both designer and developers in the design and in the advantages it would offer in lighting, acoustics, and the circulation of heated and cooled air was articulated. The floor design was related to the theories of Buckminster Fuller, a matter of interest at this time; indeed an article on Fuller's "Oc-tet" truss, "a true space-frame," shared part of the second page in *Forum's* section on recent building engineering.[88] In his annotations on a draft of the article, Kahn acknowledged that "Fuller's recent explorations in structure" convinced him of the efficiency of the tetrahedron as a basic structural frame, but he said nothing further concerning Fuller's influence.

By December work on the building had progressed to such an extent that Sawyer proposed monthly rather than weekly meetings.[89] But appeals from the contractor for "more information" came frequently, as they had from the beginning. Despite increasing success in casting the tetrahedrons, and at less expense than forecast, George Macomber expressed concern in his year-end cost report for a "poor financial outlook." He cited lack of complete information and a "piecemeal operation" because of this, naming the circular stairs, front entrance, penthouse, and service core walls as special problems.[90] In a January meeting, however, Clark Macomber expressed confidence that the building would be complete "five months after the start of interior masonry" and "the receipt of complete hardware and door information." Orr thought everything necessary would be finalized by January 25, 1953.[91]

Despite this optimistic prediction, the February meeting still involved several decisions on materials, including the final selection of black terrazzo for flooring for the core area, and approvals for cost changes.[92] Shortly afterward, Sawyer "unearthed from various sources" still other unresolved items: details for the circular stair for which working drawings were lacking and exact specifications for interior finishes and hardware.[93] He acknowledged his own responsibility for the latter. By the next month Kahn had a new drawing for the entrance vestibule that was quickly approved except for checking the size of slate for the flooring.[94] Decisions also were made in March concerning the "break through to the old building" at basement, first floor, mezzanine (as the second floor was called here), third floor. Lighting for the core area was once more debated, and the decision was postponed.

Concerns over costs and schedule mounted. In the April meeting the following was announced: that the cost overrun was already $7,000 more than the amount approved; there was no contingency fund left; numerous change orders were generally approved and implied additional costs; and completion would now be as late as September 1 unless all decisions were made immediately.[95] By the end of the month Sawyer requested a return to weekly meetings "in the hope of finishing the building on time" and announced that all changes involving expenditures now had to be passed under his scrutiny and that of David Hummel of the Yale Buildings and Grounds Office.[96] Progress continued, however, despite all these difficulties. Exhibition partitions (with legs) for the works of art were finally decided upon, and oak with a light finish "to match wood floors" was selected for use in seminar rooms and offices. A new budget of $1,436,170 was approved, covering all change orders through number 100. Nevertheless, notes recording the meeting suggest that the ever-present sense of

pressure on all involved in the project was becoming even more intense.

In truth, the building was in its final stages with drawn-out and finely wrought decisions still being made, as was always to be the case with Kahn. His sense of responsibility for the design was on-going, and he felt it necessary to consider every detail. By June the landscape plan was prepared and approved and subcontractors for painting and woodwork were chosen.[97] While in New Haven for Yale reunion events, the feature editor of *Progressive Architecture* saw the building and initiated arrangements with Sawyer to publish it in his magazine.[98] In August Kelly came again to New Haven to consult with Kahn and Sawyer. As a result, different, Price-designed fixtures (rather than some already ordered) were selected for a number of locations throughout the building, and a metal exit light was specially designed.[99] The lighting fixtures for works of art had shielded housing and an angled lens that could be adjusted directionally; for general lighting a downlight with silver reflecting bowl was fabricated. Both types are recessed in the tetrahedrons, and interchangeability of the units offers maximum flexibility for arrangements within the interior.

At the same time George Macomber went over still-unresolved questions and presented his final schedule. Students and faculty were able to use classrooms and workshops when the fall term began in late September. In early October Macomber compiled a "punch list" for the review of the building by owner, architects, and contractor. Orr presented Sawyer with the bill for architectural services for the Yale University Art Gallery and Design Center, the official signal that it was finished.[100]

## Evaluation of Completed Building

The building was dedicated and opened to the public on Friday, November 6, 1953, in a ceremony attended by museum representatives from other cities and educators from other institutions in the fields of art, architecture, and city planning. Their opinions and reactions were given unusual coverage by *Progressive Architecture* in the issue on the gallery the following May.[101] The professionals in architectural criticism and education did not find it flawless, and their remarks expressed somewhat conventional respect for a new modern design. (Modernism was established as the prevailing style, but it had been slower in making inroads into academic architecture steeped in Collegiate Gothic.) But visitors consistently found the building interesting.[102] Time was to pass before it was analyzed more seriously.

The new gallery and design center was appealing to these specialists for a number of reasons. It appeared simple, unadorned, and modern, reflecting the evolved aesthetic of buildings in the modern style. Its skin does not reveal a frame but expresses its volume, and its plan is open and unencumbered by vertical supports (see plans, figs. 2.33, 2.34, 2.35 and 2.36) — both features stemming from the same modernist tradition — as in the Museum of Modern Art and the Mies museum project published in 1943. The interior columns define a module of twenty by forty feet, with the central core set off by twenty-foot spacing and a forty-foot span for the galleries to either side, in a basic rectangular shape. Outermost columns are along the perimeter of the east and west walls. On the east another forty-foot span forms the neck joining the addition to the old gallery. Engaged columns are expressed but not stressed. Almost unlimited possibilities for arrangements of partitions exist within the open spaces on either side of the service core. (Those for academic areas on some floors seemed relatively fixed, however, to many observers when the building opened.) The dramatic concrete circular stairwell, its round silo contrasting with the angularity of the building as a whole, is on the south end of the central service core. In its outer dimensions and proportions, even its coloration and tonality, the new gallery blends with the old, but there is a clear and unmistakable distinction of a modern vocabulary.

The building presents a brick wall to the street — cool, aloof, and protective of the contents within (see south elevation, fig. 2.37). The discreet stone moldings express the floor levels on the interior, but little else is revealed. An exception on this south side is the recessed entrance at a right angle to the street, adjoining the connection to the

**2.33**
*Yale University Art Gallery. Plan, first floor.* Louis I. Kahn (drawn by E. P. C.). Louis I. Kahn Collection, University of Pennsylvania and Pennsylvania Historical and Museum Commission.

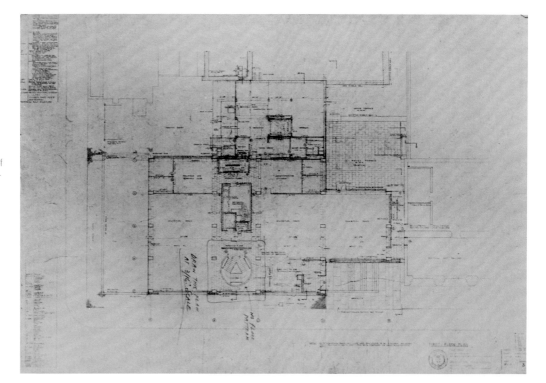

**2.34**
*Yale University Art Gallery. Plan, second floor.* Louis I. Kahn (drawn by E. P. C.). Louis I. Kahn Collection, University of Pennsylvania and Pennsylvania Historical and Museum Commission.

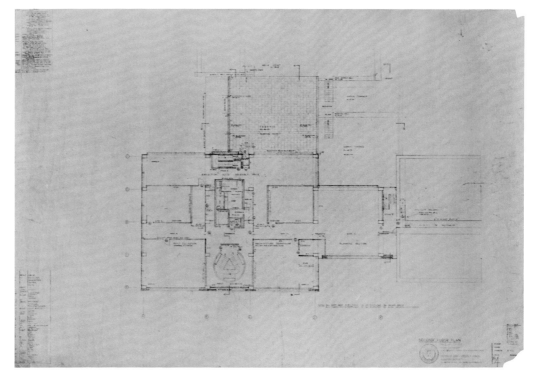

old gallery. Here, a glass wall of the entry allows a glimpse of the interior, which can be seen through all floors. A sliver of window also separates the masonry joining the old and new galleries with a subtle emphasis on the joint itself. (The window lights an interior transition area needed because of varying floor levels.) This use of an open space, or void, between parts or even materials, essentially an elaboration of the joint, was to become a characteristic of Kahn's later architecture.

In contrast to the closed south face turned to Chapel Street is the north wall of the gallery (see north elevation, fig. 2.38): windows disclose the interior of the building, revealing its slab structure and opening onto the two terraces. The lower terrace is a sculpture court with two levels. The upper terrace roofs the museum workshop and gives onto what was then the second-floor lounge. Beyond the courts is the Weir Hall courtyard. In the European classical tradition, there is a formal façade and a garden facade to Kahn's gallery. The west side, at a greater distance from York Street than the

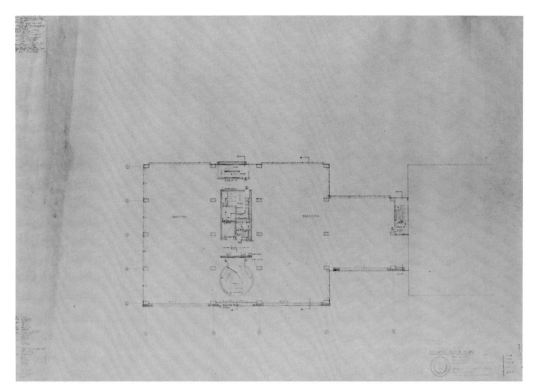

**2.35**
*Yale University Art Gallery.
Plan, third floor.* Louis I. Kahn
(drawn by E. P. C.). Louis I.
Kahn Collection, University of
Pennsylvania and Pennsylvania Historical and Museum
Commission.

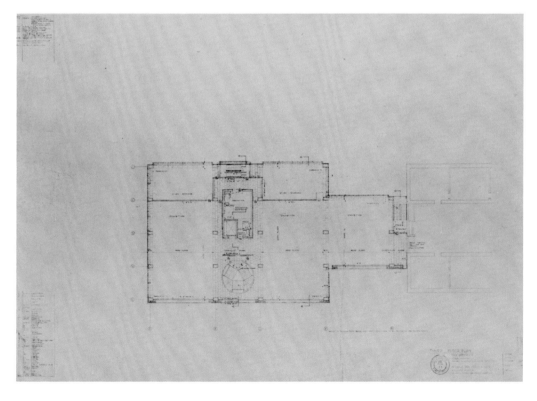

**2.36**
*Yale University Art Gallery.
Plan, fourth floor.* Louis I.
Kahn (drawn by E. P. C.).
Louis I. Kahn Collection, University of Pennsylvania and
Pennsylvania Historical and
Museum Commission.

front is from Chapel Street and sheltered behind still another court (see site plan, fig. 2.39), is glazed to bring natural light into galleries and offices.

When the building opened in 1953, most of the basement, second, and fourth floors were devoted to academic use: classrooms, studios, and offices. Part of the basement and ground floor were assigned as nonpublic museum spaces for the museum workshop, shipping and receiving, storage, and offices. It was essential that these functional areas be included, looking toward the time when the gallery would occupy the whole building. Partitions then in place on the floors devoted to architecture and design were expected to serve only temporarily, although no one ventured to say how long this period was to be. Program discussions, however, had made it clear that the ability to transform the interior beyond providing for arranging temporary exhibitions was an important criterion. Loft space was especially useful, while the permanent placement of the service core with the circular stairwell offered a stable center.

**2.37**
*Yale University Art Gallery.*
*North elevation.* Louis I. Kahn
(drawn by E. P. C.). July 3,
1952. Louis I. Kahn Collection,
University of Pennsylvania
and Pennsylvania Historical
and Museum Commission.

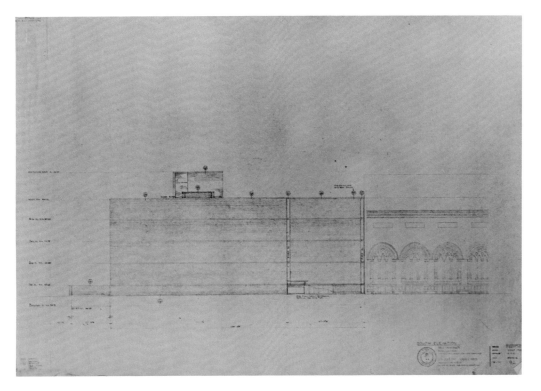

**2.38**
*Yale University Art Gallery.*
*North elevation.* Louis I. Kahn
(drawn by E. P. C.). November
18, 1953. Louis I. Kahn
Collection, University of Penn-
sylvania and Pennsylvania
Historical and Museum
Commission.

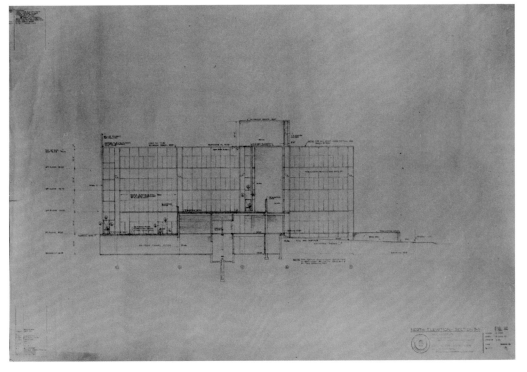

The feature most often remarked upon, however, was the tetrahedral ceiling (fig.
2.40). Technologically, the space-frame was an exciting, avant-garde concept which
was seen to hold vast potentialities for architecture in the years after World War II. Even
modified, the system of the Yale Art Gallery offered one of the first serious architectural
realizations of the space-frame. Other architects and critics were appreciative of the
attempt to use new technology in an important new building, and the visual and aes-
thetic delights conferred upon the interiors by Kahn's three-dimensional ceiling were
especially appreciated. The ceiling offers variety within unity and makes for an unusual
environment. Powerful in a formal sense, it provides a setting for works of art that
enhances their display.

Louis Kahn had reason to feel gratified by the building as realized and by the gen-
eral response to it. Speaking of what he considered its significant features in an inter-
view for the student newspaper's special supplement on the gallery, he conveyed
something of this gratification. Gesturing at the ceiling, he said, "It's beautiful and it

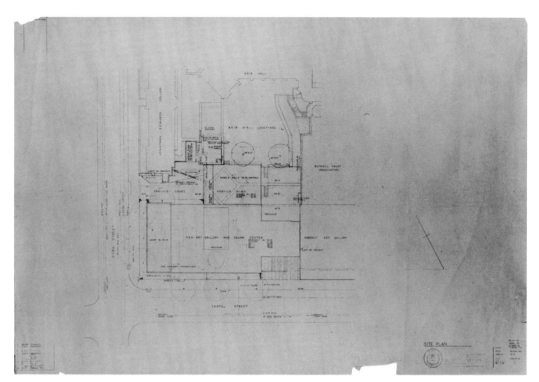

**2.39**
*Yale University Art Gallery. Site plan.* Louis I. Kahn (drawn by E. P. C.). Louis I. Kahn collection, University of Pennsylvania and Museum Collection.

**2.40**
*Louis I. Kahn under the Yale University Art Gallery ceiling.* 1953. Photograph by Lionel Freedman.

serves as an electric plug (trolley ducts permit attachment of electrical features any-where on the service) and as a lung. It breathes. Air is forced in through these vent pipes and through the corrugations in the ceiling."[103] In operation, air is forced into the voids through louvers on the top of the ducts, then downward. Thus the slab itself assists in the distribution and circulation of air. This very practical use of the tetrahe-drons to house the utilities for air-conditioning and lighting speaks of Kahn's increasing attention to these new and essential elements in design. (It should be observed that in 1951, air-conditioning an entire building of this size was out of the ordinary and a rel-atively new engineering feat. Only after several months of discussion was it agreed to use the system throughout. Until 1958, when the whole was fully air-conditioned, it was implemented only in the galleries.)

Kahn's characterization of the ceiling as "breathing" because it assisted in cir-culation (air forced upward from the ducts and downward from contact with the ceil-ing) was a biological analogy of a type that had special meaning for him. He continued to use such analogies, for he thought of architecture in such an anthropomorphic way.[104] This building particularly, incorporating the service elements into the architec-tural design itself as functioning parts of a total body, is the first dramatic declaration of his thoughts. From this achievement Kahn was to formulate the concept of servant and served spaces (announced in the Trenton Bath House) that became so basic in his designs.

The free spatial design he achieved in the gallery pleased Kahn. In his 1953 inter-view he said, "A good building is one the client cannot destroy by wrong use of space. Almost all the partitions are movable, so whenever the space is needed for something else, they can fit the space to suit their need without ruining anything." Asked for a flex-ible building, he provided open space. But he was guided by his sense that the spatial role of the building was not the only important measure. Overall design and careful detailing of selected materials also conferred meaning. The ceiling was important to the character of this open space and furnished a structure guiding the placement of temporary partitions.

Kahn sought a special human quality in particular elements of the building: "These stairs, now. They are designed so people will want to use them." It was not so much a matter of pleasing the users as it was the desire to interest them in the stair-way's shape, scale, and spatial experience. This expression of humanity was important to the architect; it was in keeping with his anthropomorphic sense of the building, but, perhaps more important, it was a result of his intuitive feeling for human reactions. It was not an infallible faculty but it did not often fail him. Kahn sensed architectural forms as expressing affective, emotive qualities as well as functioning in a practical sense.

All the materials excepting wood floors and exhibition panels were left natural or unfinished. This was in accord with Kahn's ideas of honesty, even morality, in architec-ture — an idea that relates him to the constructivist French tradition as well as to mod-ern architecture. "I believe in frank architecture. A building is a struggle, not a miracle, and the architect should acknowledge this," he said in the student interview. The idea was one he often repeated. In his approach, the selection of materials and the crafts-manship needed to work them to his specification were important. Just as he placed great care in forming the concept for a building, the means through which it was real-ized also had to be logical. He worked to affect the workman's approach to his craft, for it had to be consistent with his own. Once large decisions were made, whatever happened during the process became, as he later said, a record of how the building was made. The philosophy inherent in his statements in the Yale student newspaper foreshadowed his later architecture and explanations.

If Yale University could take pride in the modern new Gallery and Design Center, it could also find satisfaction in the expense involved, despite the misgivings during construction. Because of concern about staying within the budget and close attention given to costs during the design and building processes (decisions were made after comparing prices for alternative possibilities, though a standard of quality was upheld), the new addition to the Yale Art Gallery — as large in outward dimensions as

the old gallery but with twice as much floor space—came close to the restricted budget that had been allotted (see Appendix A). Final costs were recapitulated in December.[105] Exclusive of fees, furnishings, light fixtures, and plantings, the Gallery and Design Center cost $1,480,000; work in the old gallery cost a further $30,000. In cubic feet, the new construction had cost $1.65 per foot, including exterior stone walls, the bluestone terrace, Belgian block paving, etc., as well as the exhibition panels (considered by some to come under the category of furniture). The expense amounted to $21.65 per square foot. (The original projection of remodeling the old gallery and Weir Hall was not realized at the original sum, however.)

Because of Kahn's reputation for being difficult to pin down, late for deadlines and bringing in projects over budget, it is significant that he was not, in fact, so profligate. Given the facts, it seems he transgressed in practically none of these areas. He did seem to need the constant reminders about deadlines and expense that a conscientious client would keep before him, but he was willing and able to search for improvements in the design and for better and cheaper methods and materials when they served his cause. Yet it cannot be denied that he needed time to work out all aspects of the "struggle" ("a building is a struggle, not a miracle," he told the student interviewer) before he was satisfied it had become what it "wanted to be."

**2.41**
*Yale University Art Gallery. Partial floor plan.* **Catalogue 9.** Louis I. Kahn. Louis I. Kahn Collection, University of Pennsylvania and Pennsylvania Historical and Museum Commission.

**2.42**
*Yale University Art Gallery. Garden plan, elevation, section, detail.* **Catalogue 10.** Louis I. Kahn. Louis I. Kahn Collection, University of Pennsylvania and Pennsylvania Historical and Museum Commission.

Kahn's work on the gallery did not stop with its dedication. He and Orr offered to furnish and equip the student-faculty lounge on the second floor (see fig. 2.41). In gratitude, Sawyer invited them to serve on the program committee for the facility.[106] Kahn designed the tables, and in April 1954 he had the supports fabricated in a Philadelphia metal shop and sent to New Haven for assembly with wooden tops.[107] Sawyer also consulted Kahn about the relocation of the entrance gate on York Street, problems with the air-conditioning system and about the "demand for a door on the second floor" to the terrace similar to that on the first floor to the sculpture court.[108] He wrote Kahn again after the city inspector and the University's insurers insisted on handrails at the entrance, and Kahn made designs.[109] Sawyer took steps to see to their manufacture. Plans for the sculpture court terrace that director Lamont Moore wanted to complete were also requested of the architect.[110] Kahn responded readily with a scheme (fig. 2.42). He was an artist wishing to develop a work that kept his interest. No aspect of the building was too insignificant for his attention.

Published descriptions and evaluations of the Yale University Art Gallery and Design Center emphasized first the structural innovation with its visual impact and then its potential versatility. Its role as a gallery was all but ignored. Varied use, however, is descriptive of the early years: that was the gallery's actual role. Vincent Scully's essay in the dedication issue of the *Yale Daily News* was entitled "Somber and Archaic

**2.43**
*Yale University Art Gallery. View of north window walls at night, 1953.* Louis I. Kahn. Photograph by Lionel Freedman.

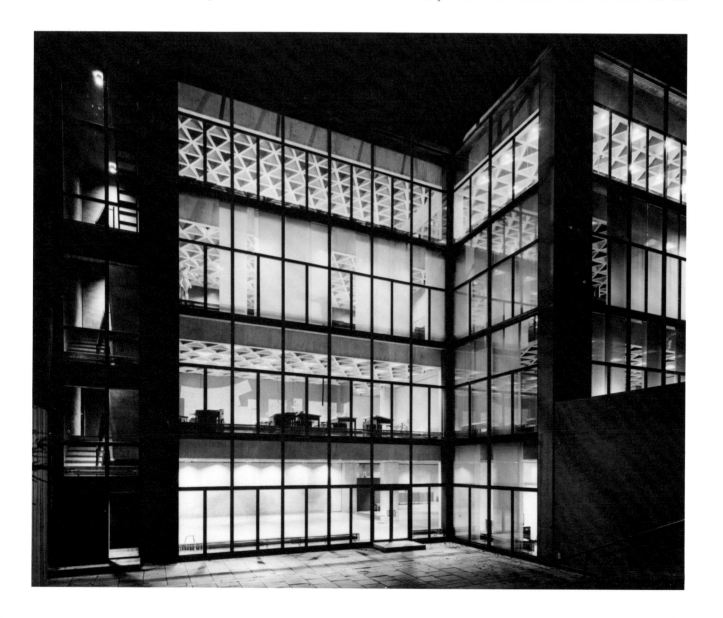

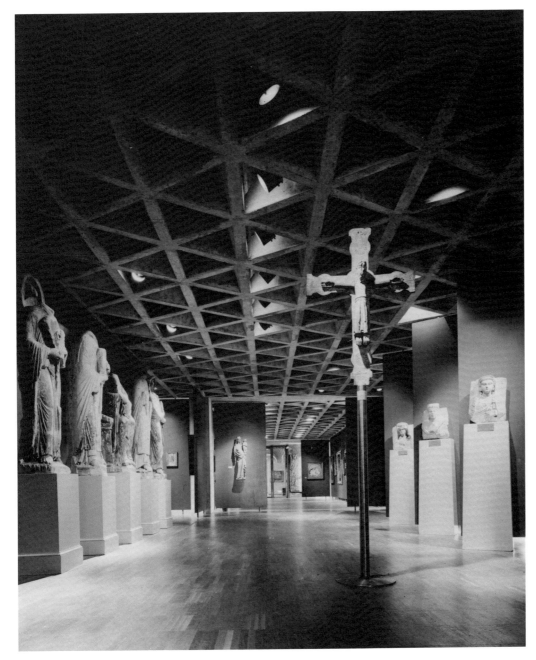

**2.44**
*Yale University Art Gallery.
View of Gallery, 1953.* Photograph by Lionel Freedman.

Tension" and was one of the earliest examinations of the gallery by an architectural critic, it but did not mention its museum role.[111] In it he made the first, but hardly the last, reference to Kahn's work as archaic. Scully's response to the building recognized its strength, forcefulness, simplicity, and originality as opening a new period of architectural design, one he thought of as a beginning, tough and searching, and thus "archaic." He described the building as a "new kind of reinforced concrete slab construction," with a "cellular structure of hollow tetrahedrons" forming both ceiling and floor as a homogeneous unit. Although somewhat critical of the façade, the west side and the intersection with the older building, all of which he considered unintegrated, Scully saw the courtyard façade facing Weir Hall as "almost as noble" as the interior with its visually heavy canopy (fig. 2.43). He compared the gallery to Le Corbusier's Unite d'Habitation in Marseilles, not just for its rough concrete but for its "expressive tension between geometric will, structural imagination and rough structural techniques." (Kahn himself, in that same issue's interview, had drawn comparison between his own building's as-cast concrete and Le Corbusier's concrete which had splinters of formwork still present in its surfaces.) Scully found the new building "as strict and ordered as the Medici-Riccardi Palace."

In the full coverage by *Progressive Architecture* Sanderson included a photograph showing a gallery with an arrangements of panels and lights he described as illustrating "a dim, cathedral-like aura" (fig. 2.44). This was contrasted with a "day-

**2.45**
*Yale University Art Gallery.
View of architecture studio,
1953.* Photograph by Lionel
Freedman.

lighted gallery for student critiques" (fig. 2.45) to reveal the building's range of uses and its different aspects.[112] Director Lamont Moore (appointed in October 1953 after the death of John M. Phillips) spoke of the building's suitability "for expanding either gallery or school functions,"[113] as called for in the program. This aspect was singled out, after the structure of the ceiling, as the most significant characteristic. Sanderson placed the new art gallery within the context of the history of the arts at Yale University by including illustrations of earlier art buildings — the earliest college art museum in the United States, the Trumbull Gallery (fig. 2.46), designed by the painter John Trumbull; Street Hall by Peter B. Wight (fig. 2.47); Swartwout's 1929 Art Gallery (fig. 2.48); and Philip Goodwin's projected design.[114] (These were featured in an exhibition in the new gallery on the occasion of its opening.) All, even including the Trumbull Gallery of 1831, had served the multiple lecture, studio, and exhibition purposes associated with an academic institution.

Kahn's gallery was thus seen as a continuation of the tradition of a versatile fine-arts building. But its exhibition space was significant even in the beginning. It should be acknowledged that the decision to build it was greatly influenced by the promised gift of the collection of the Société Anonyme, which Katherine Dreier would have placed elsewhere had there not been space to exhibit it (fig. 2.49). Within a decade of its completion there were also sizable gifts to Yale from Stephen C. Clark, Louis and Hannah Rabinowitz, Philip L. Goodwin, and Mr. and Mrs. Fred Olsen. Without the new gallery these gifts would not have been bestowed.

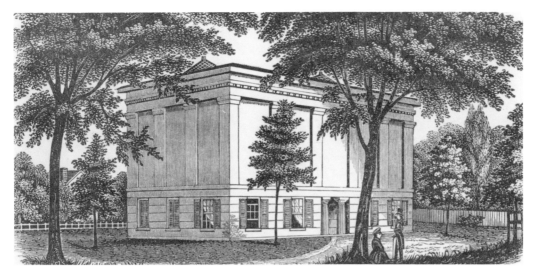

**2.46**
*Trumbull Gallery, Yale University*. John Trumbull. 1832. Yale University Archives.

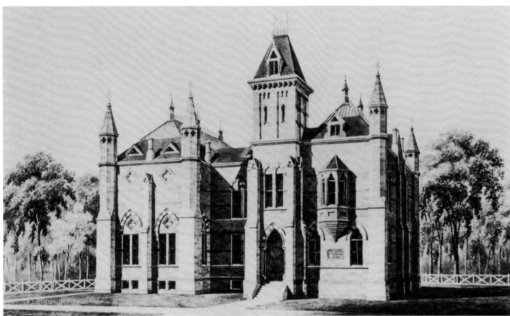

**2.47**
*Street Hall, Yale University*. Peter B. Wight. 1864. Yale University Archives.

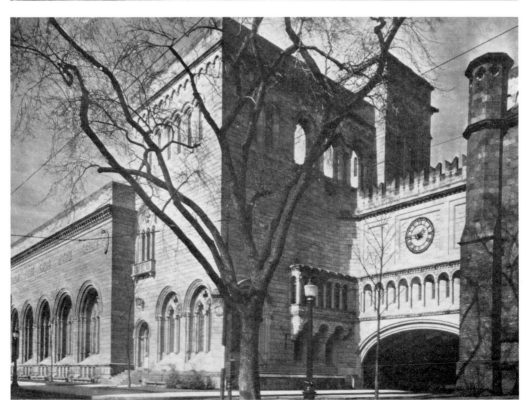

**2.48**
*Yale University Art Gallery*. Edgerton Swartwout. 1928.

**2.49**
*Yale University Art Gallery.*
*Interior view of gallery, 1953.*
Photograph by Lionel
Freedman.

By all accounts the building fulfilled its temporary purpose for multiple use. In particular, its palpable presence stimulated architecture students all through the 1950s and until Paul Rudolph's Art and Architecture Building was dedicated in 1963, after which Kahn's building was no longer used by them. As one student of those years wrote: "Certainly Vincent Scully championing Wright, Mies, Corbusier, and then Louis Kahn and [Scully's] dramatic lecture on the Parthenon was a catalyst for Yale undergraduates leaning toward architecture. Working in Louis Kahn's building, his presence was always felt — inspirational — but somewhat remote."[115] Another wrote: "Our building of Kahn's affected me very much with its loving attention to detail and warmth and animation of the drafting room, even empty on Sunday morning."[116]

Not until Vincent Scully's 1956 essay on the Yale University Art Gallery and Design Center for *Museum (UNESCO)* was concentrated attention given to considering its museum function as such.[117] Once more, however, emphasis was put first on the flexibility demanded by a program calling for wide spans. Scully saw the exterior as "a kind of mask" for the interior, an observation that implicitly acknowledged the closed façade on Chapel Street. He praised the vitality of the interior, created by the power of the ceiling design. The three-dimensional tetrahedrons, their dominance even more pronounced because of the spotlights placed within the spaces, he thought a dramatic change for a museum interior. Compared to the neutrality and white walls of characteristic International Style museums (without naming the Museum of Modern Art) or the nineteenth-century "richly urbane setting" (we might add, the period rooms of the early twentieth century), the Yale Art Gallery offered a positive setting, "rough and primitive" he described it, that Scully found both modern and timeless. Devices for readily changeable installations, including lighting, had already offered individualized settings for various exhibitions — Palmyrene, Gandharan, and Japanese art — with a minimum of effort and expense.

Within a few years, even before Rudolph's Art and Architecture Building was occupied, there were changes in the exhibition areas on the first and second floors. Unsettling administrative and pedagogical shifts had occurred in the years since George Howe had retired as chairman of the architecture department.[118] Paul Rudolph's advent as chairman in February 1958 opened yet another period of architectural education at Yale. Meanwhile, the summer before he arrived, Andrew Carduff

**2.50**
*Yale University Art Gallery.
Interior view of gallery,
third floor.*

**2.51**
*Yale University Art Gallery.
Interior view of gallery.*

Ritchie was appointed director of the Yale University Art Gallery. A recognized scholar, Ritchie had been director of the Albright Art Gallery, Buffalo, before becoming director of painting and sculpture at the Museum of Modern Art, New York, a post he had held for nearly ten years. Wishing an environment closer to the Museum of Modern Art's for the display of art and concerned about the increasing numbers of works of art he had to display, Ritchie set about "remodeling" the Yale gallery to create a more neutral effect, more like that in the Museum of Modern Art. In this endeavor he turned to the new architecture chairman, Rudolph, for advice.

As a result, Kahn's completely flexible space was molded into a series of gallery-like rooms with solid white, black-trimmed panels that disguised the cinder blocks, the concrete columns, and parts of the concrete girders. The silo staircase was

enclosed by panels.[119] Kahn, still teaching graduate students at Yale, was not consulted and was taken aback by the remodeling.[120] The change to a gallery had been foreseen, but it is unfortunate that it happened without Kahn's participation. After remodeling, the geometric ceiling held its own insistent presence but with less expanse. There was indeed additional wall space, but at the sacrifice of the former flexibility. Ritchie was able to hang more pictures and exhibit more sculpture than ever before, however, and the setting for the works was considered by many to be as effective (fig. 2.51). In answer to some who objected to the alterations, members of the Yale faculty stressed the fact that the basic structure was not changed and that the alterations could be seen as temporary.[121] The gallery continued to be admired. Twenty-five years after its completion, on the occasion of an award by the American Institute of Architects, the current director of the gallery, Alan Shestack, praised its adaptability "to all kinds of fine art exhibitions. Although the building itself is distinguished," he said, "and has distinctive architectural elements such as its famous ceiling, it allows the works of art to dominate the space."[122] Recently remodeling has undertaken restoration of the building to bring it closer to Kahn's original ideas. The staircase has again been revealed, restoring it to the special, appealing condition Kahn conceived for it.

## Implications for Kahn's Career

None of the subsequent changes overtly affected the course of Kahn's career. The Yale Art Gallery opened a remarkable new creative period in his artistic life and eventually brought him recognition on an international level. The Yale architectural magazine *Perspecta*, underwritten at its beginning by George Howe and supported in the early years by Philip Johnson and various Yale alumni, published Kahn's ideas and projects as well as the gallery and his other executed works throughout the 1950s, thus making them available to a wider audience.[123] As early as 1955 Kahn was cited by the English critic Reyner Banham as an inspiration for the new architectural movement of Brutalism.[124] Visiting appointments for practicing architects at Yale were continued by Rudolph, and the program brought in distinguished international practitioners, including James Stirling, Colin Saint John Wilson, Frei Otto, and Alison and Peter Smithson, as well as architects working in the United States, such as Mies van der Rohe, Ulrich Franzen, John Johansen, Edward L. Barnes, Romaldo Giurgola, Robert Venturi, and others. The presence of Kahn's building was remarked by these architects, helping to establish his reputation abroad.[125]

The gallery also had an effect upon the Yale University scene. About the time it was completed, President Griswold initiated his great building program, commissioning outstanding American architects for Yale University buildings. By Griswold's own account, his interest in new architecture at Yale began in 1953.[126] One can speculate that he was inspired in part by the gallery and by the general interest and response to it, even though he seemed somewhat distant in the beginning and, during his lifetime, did not commission another building from Kahn.

For Kahn, the building was a breakthrough — artistically, professionally, and personally — a monumental accomplishment that was recognized and appreciated, caused interest to be focused upon his subsequent thought and work, and brought him an important degree of self-realization and confidence. It was the first time he created a major structure of reinforced concrete, the material that became so characteristic of his architecture. Work on this building brought home to him the importance of engineering for concrete in creative building. During its execution he also selected materials and combined these in ways that he found pleasing, thereafter reusing them often. It was at Yale, for example, that he first juxtaposed concrete and oak; his other museums employed them even more extensively. Thus the commission brought about Kahn's discovery of structure, materials, and, perhaps most important, the power of the forms he was capable of creating. The Yale Art Gallery served to catalyze many of his basic ideas and beliefs about architecture, both in words and in work. Significant in its own right as a museum expanding the modernist concept, it presaged accomplishments to follow.

**Notes**

1. "Arbiter of the Arts. A Beaux-Arts Dean Has Reigned Over Yale's Architecture, Painting, Sculpture and Drama for the Past Quarter of a Century," *Architectural Forum* 86 (June 1947): 74–76, 152, 154. Robert A. M. Stern relates the rumor that the system of visiting critics was instigated to replace a number of faculty members who resigned in a single year in "Yale 1950–65," *Oppositions* 4 (October 1974): 58, n. 3. However, Edward D. Stone, who came to Yale to teach in 1947, claims to have introduced the six-week visiting critic appointment in New Haven. See Stone, *The Evolution of an Architect* (New York: Horizon Press, 1962): 37. At any rate, the variety of viewpoints nurtured by Meek's policy was compatible with and probably conducive to the pluralistic approach of Yale's architecture program as it was to develop.

2. Esther I. Kahn in conversation with the author explained that Niemeyer's professed communism made him inadmissible by the U.S. State Department. See also "Esther I. Kahn," interview with Alessandra Latour, May 5, 1982, in Latour, *Louis I. Kahn, l'uomo, il maestro* (Rome: Edizioni Kappa, 1986): 25. Other resident visiting critics in 1947–48 were Paul Schweikher, Carl Koch, and Gardner Dailey. See *Architectural Forum* 87 (December 1947): 114.

3. This fellowship was from 1947 to 1949. See Robert A. M. Stern, *George Howe, Toward a Modern Architecture* (New Haven, Conn.: Yale University Press, 1975): 173, n. 34; 210, n. 50.

4. See Stern, *George Howe*, 211–18; and "Yale 1950–1965," 35–43. Also William S. Huff, "Kahn and Yale," in Latour, *Louis I. Kahn* 331–65.

5. Stern asserts that Johnson's backing of Kahn for the commission of the gallery was influential for Howe. See "Yale 1950–1965," 41.

6. *Bulletin of the Associates in Fine Arts at Yale University* 10 (December 1941): 1–3; *Museum News* 19 (January 15, 1942): 2.

7. *Museum News* 28 (May 1, 1950): 1.

8. See Vincent Scully, "Architecture and Man at Yale," *Saturday Review of Literature*, May 23, 1964: 26–29; Walter McQuade, "The Building Years of a Yale Man," *Architectural Forum* 118 (June 1963): 88–93; Jonathan Barnett, "The New Collegiate Architecture at Yale," *Architectural Record* 131 (April 1962): 125–38.

9. Letter, November 27, 1950, Charles H. Sawyer and James T. Soby to President A. Whitney Griswold. Louis I. Kahn Collection, Correspondence with Yale University, File Box LIK 107. The Kahn Collection is owned by the Pennsylvania Historical and Museum Commission, administered by the Trustees of the University of Pennsylvania, and is on deposit in the Architectural Archives, University of Pennsylvania, Philadelphia.

10. Stern, *George Howe*, 224.

11. Letter, January 8, 1951, Sawyer to Kahn. Kahn Collection, Correspondence with Yale University, File Box LIK 107. In conversation with the author, Sawyer described his role for the building of the Yale Art Gallery addition as like that of Richard F. Brown when the Kimbell Art Museum was created.

12. Douglas Orr, a respected architect with offices in New Haven until his death in 1966, produced a "prodigious output of buildings and devoted much time to professional and public service," according to his obituary. See *Architectural Forum* 125 (September 1966): 88. He was president of the American Institute of Architects in 1947–48 and initiated the Honors Awards of the AIA; he was a member of the National Academy of Design and an honorary corresponding member of the Royal Society of British Architects. *Architectural Record* 140 (September 1966): 36. In early 1951 he was working with Eero Saarinen, who later became President Griswold's most trusted architectural adviser, on a physics laboratory for Yale. See Griswold, quoted in Barnett, "New Collegiate Architecture," 126. Orr's office was later responsible for Yale's Helen Hadley Hall and the Gibbs Research Laboratories (with Paul Schweikher). He was on the committee awarding Kahn the commission for Erdman Hall, Bryn Mawr College, in 1960, and selected its site. See Katherine E. McBride, "The Architect and the Building," *Bryn Mawr Alumnae Bulletin* 63 (Summer 1962): 2–5.

13. Alison and Peter Smithson used a diagram of the Weiss house plan to illustrate "embryo 'servant' and 'served' areas." See "Louis Kahn," *Architects' Yearbook* 9 (1960): 106.

14. Letter, January 22, 1951, Howe to Kahn. Kahn Collection, Correspondence with Yale University, File Box LIK 107.

15. Art Gallery Annex, January 18, 1951. Kahn Collection, Correspondence with Yale University, File Box LIK 107. See Appendix A in this volume.

16. For example, memo, February 6, 1951, Sawyer; and memo to Sawyer, February 6, 1951, unsigned. Kahn Collection, Correspondence with Yale University, File Box LIK 107. Sawyer questioned the proposed Recommendations and Assumptions of February 1, 1951. A Justification of Suggested Plan appears certainly to be by Howe. Sawyer's letter to Kahn on February 14, 1951, supports the solutions offered, although he still objected to the loss of building space for the "vista" created between the two galleries.

17. Laurence Vail Coleman, *Museum Buildings, Vol. 1, A Planning Study* (Washington, D.C.: American Association of Museums, 1950): 68.

18. Coleman, *Museum Buildings* 60. Both museums are illustrated in his book.

19. "In this Issue," *Pencil Points* 22 (August 1941): 496. The jury consisted of Frederick A. Delano, chairman; John A. Holabird; Henry R. Shepley; Gropius; and Howe. See also Joseph Hudnut, "Smithsonian Competition Results," *Magazine of Art* 32 (1939): 456–59, 488–89.

20. See Lorimer Rich, "A Study in Contrasts," *Pencil Points* 22 (August 1941): 497–516.

21. Joseph Hudnut, "The Last of the Romans," *Magazine of Art* 34 (April 1941): 169–73.

22. The gallery was to have the complete building at some future date. See below, program of April 12, 1951, and letter, August 27, 1951, Sawyer to Palmer. Kahn Collection, Correspondence with Yale University, File Box LIK 107. Sawyer was concerned that the "loft building" not be reduced in order to preserve flexibility; he emphasized the importance of circulation within it.

23. Recommendations and Assumptions for Art Gallery Space Assignments in New Addition to Building Complex for Division of the Arts, Yale University, February 1, 1951. Kahn Collection, Correspondence with Yale University, File Box LIK 107.

24. Memo, Building Committee, February 6, 1951. Kahn Collection, Correspondence with Yale University, File Box LIK 107.

25. Letter, February 14, 1951, Sawyer to Kahn. Kahn Collection, Correspondence with Yale University, File Box LIK 107.

26. Letter, February 15, 1951, Dillingham Palmer to Kahn. Kahn Collection, Correspondence with Douglas Orr, 1951–52, File Box LIK 107. Palmer explained the plans as a "mere beginning," but "the allocations of space to the departments (gallery, history of art, library, architecture and design)" were agreed upon, as was the open plan for Weir Hall courtyard, obtained by locating the building near the corner of York and Chapel Streets. The problem of providing adequate circulation was not yet solved.

27. Recapitulation of Areas, March 28, 1951. Kahn Collection, Correspondence with Yale University, File Box LIK 107. See Appendix A.

28. Design Laboratories and Exhibition Space for Yale University, April 2, 1951. Kahn Collection, Yale Art Gallery, 1951, File Box LIK 84.

29. Letter, April 4, 1951, Orr to Kahn. Kahn Collection. Correspondence with Douglas Orr, 1951–52, File Box LIK 107. What these sketches were is no longer known.

30. Notes, confirmation of the Yale Gallery Building Committee, April 10, 1951, Palmer. Kahn Collection, Yale Art Gallery, 1951, File Box LIK 84.

31. Notes, meeting of architects with Mr. Howe, April 11, 1951, Palmer. Kahn Collection, Yale Art Gallery, 1951, File Box LIK 84.

32. Letter, April 11, 1951, Palmer to Sawyer. Palmer presented a diagram "to cut back the cubage and to restore balance between work areas and exhibition areas." Letter, Palmer to Sawyer, April 12, 1951. Kahn Collection, Yale Art Gallery, 1951, File Box LIK 84.

33. Letter, enclosing minutes of meeting, Corporation Committee on Architectural Plan, April 14, 1951, Sawyer to Kahn. Kahn Collection, Correspondence with Yale University, File Box LIK 107.

34. Letter, May 3, 1951, Sawyer to Orr with copies to Saarinen and Kahn. Kahn Collection, Correspondence with Yale University, File Box LIK 107. Orr worked with both architects on different projects. The program for the physics laboratory was approved by the Corporation Committee April 13, 1951.

35. Letter, May 10, 1951, Palmer to W. J. Megin, Inc. Kahn Collection, Correspondence with Douglas Orr, 1951–52, File Box LIK 107. Estimates for mechanical work were requested from Meyer, Strong and Jones, Palmer added.

36. Contract for design laboratory and agreement between Orr and Kahn, June 22, 1951. Kahn Collection, Yale Art Gallery, File Box LIK 84. Orr wrote the agreement between the architects and sent it to Kahn with an explanation of the interoffice agreement. Letter, June 12, 1951, Orr to Kahn. Kahn Collection, Yale Art Gallery, File Box LIK 84. After hourly summaries for March through early September 1951 (Kahn, 585 hours; Kahn's office, 702 hours; Orr, 107 hours; Orr's office, 806.5 hours), Orr proposed monthly statements and reconciliations of costs and accounts. Letter, September 7, 1951, Orr to Kahn. Kahn Collection, Yale Art Gallery, 1951, File Box LIK 84.

37. Note, undated, Palmer to Kahn. Kahn Collection, Yale Art Gallery, 1951, File Box LIK 84. The stairs are located in the south part of the building's service core.

38. Henry F. S. Cooper, "The Architect Speaks," Yale Daily News, special supplement, The New Art Gallery and Design Center, Dedication Issue, November 6, 1953.

39. She reports she worked less often with him after 1959 and as a consultant after 1964. "Anne Griswold Tyng," interview with Alessandra Latour, May 2, 1982, in Latour, Louis I. Kahn, 55.

40. Anne Griswold Tyng, "Architecture Is My Touchstone," Radcliffe Quarterly 70 (September 1984): 6. Also "Anne Griswold Tyng," in Latour, Louis I. Kahn 55. In conversation with the author, Anne Tyng has said that she assisted Kahn with working out the concept, but the design was his. Tyng was interested by Fuller's theories expounded in lectures at the University of Pennsylvania in 1949 and began her own projects in Kahn's office, attempting to adapt them architecturally. Anne Griswold Tyng, "Louis I. Kahn's 'Order' in the Creative Process," in Latour, Louis I. Kahn, 285. Kahn recognized her special affinity for geometry in architecture in a 1965 letter of recommendation to the Graham Foundation: "Anne Tyng knows the aesthetic implications of geometry inherent in biological structures bringing us in touch with the edge between the measurable and the unmeasurable. . . I know of no one living who has a deeper grasp of her subject and its architectural implications." Letter, March 2, 1965, Kahn to John D. Entenza. Kahn Collection, Master Files, Box LIK 10.

41. Buckminster Fuller, "Telegram to Esther Kahn, Philadelphia, March 20, 1974," in Latour, Louis I. Kahn 179. Scully credits a lecture series by Fuller at Yale in 1952 as Kahn's inspiration. See Vincent Scully, Louis I. Kahn (New York: Braziller, 1962): 21. The lecture seems to have come later than the decision to use the slab structure. See Huff, "Kahn and Yale," in Latour, Louis I. Kahn, 339.

42. John W. Cook and Heinrich Klotz, Conversations with Architects (New York: Frederick A. Praeger, 1973): 212.

43. On the City Tower, see Louis Kahn, "Toward a Plan for Midtown Philadelphia," *Perspecta* 2 (1953): 10–27. Louis Kahn, "Order of Movement and Renewal of the City," *Perspecta* 4 (1957): 61–64. *A City Tower: The Concept of Natural Growth*, Universal Atlas Cement Company, United States Steel Corporation Publication, 1957; Walter McQuade, "Wind Bracing Comes Out from Behind the Curtain," *Fortune* 71 (May 1965): 145; Anne Griswold Tyng, "Geometric Extensions of Conscience," *Zodiac* 19 (1969): 130–62; "Louis I. Kahn: Silence and Light," *Architecture and Urbanism* 3 (January 1973): 145–49; Kenneth Frampton, "Louis Kahn and the French Connection," *Oppositions* 22 (Fall 1980): 34–36; Heinz Ronner and Sharad Jhaveri, *Louis I. Kahn: Complete Works, 1935–74*, 2nd ed., expanded and revised (Boston and Zurich: Birkhäuser, 1987): 30–33.

44. Letters, August 17, 1951, Palmer to Kahn, and August 20, 1951, Palmer to Kahn. Kahn Collection, Correspondence with Douglas Orr, 1951–52, File Box LIK 107. The latter concerns kitchens and pantries for official University receptions as requested that month.

45. Letter, August 27, 1951, Orr to Kahn, enclosing a copy of the August 23 authorization. Kahn Collection, Correspondence with Douglas Orr, 1951–52. Letter, August 27, 1951, Sawyer to Palmer. Kahn Collection, Correspondence with Yale University, File Box LIK 107.

46. A scale model for the project by Panoramic Studios, Philadelphia, was supplied on September 25, 1951, according to their invoice. Kahn Collection, Yale Art Gallery, File Box LIK 107. (The model probably was destroyed in a studio fire, according to Sue Ann Kahn.) Henry Pfisterer described the "design concept developed in model form." See Pfisterer, Design Laboratory, Yale University, Description of Structural System. Kahn Collection, Correspondence with Yale University, File Box LIK 107. Prints, "the latest on receiving and mechanical spaces," were sent after consultation with Sawyer. Letter, November 6, 1951, Earl P. Carlin to Kahn. Kahn Collection, Correspondence with Douglas Orr, 1951–52, File Box LIK 107. Carlin, a recent Yale architecture graduate, worked briefly in Kahn's Philadelphia office but moved to Orr's office in New Haven to assist on the project. On Carlin's later work in partnership with Peter Millard, centered in New Haven, see Robert A. M. Stern, "The Office of Earl P. Carlin," *Perspecta 9–10* (1965): 183–98.

47. Nick Gianopolis related these facts in an interview, crediting the final version to work between Kahn and Pfisterer (referred to as Fiester). Richard Saul Wurman, *What Will Be Has Always Been: The Words of Louis I. Kahn* (New York: Access Press and Rizzoli, 1986): 274.

48. Letter, December 13, 1951, Palmer to Kahn. Kahn Collection, Correspondence with Douglas Orr, 1951–52, File Box LIK 107.

49. Letter, December 13, 1951, Palmer to Kahn. Kahn Collection, Correspondence with Douglas Orr, 1951–52, File Box LIK 107. Palmer stated that application had been made "to Washington for the go-ahead and if approval materializes," drawings would be needed. Letters, February 18, 1952, Sawyer to Juan T. Trippe and to J. Trevor Thomas, and letter, February 19, 1951, Juan T. Trippe to Charles E. Wilson. Kahn Collection, Correspondence with Yale University, File Box LIK 107. Kahn Collection, Correspondence with Yale University, File Box LIK 107. Sawyer emphasized the importance of the new building, pointing out that it would assist a member of the design faculty who was working for the Atomic Energy Commission.

50. Letter, March 4, 1952, Thomas to Sawyer. Kahn Collection, Correspondence with Yale University, File Box LIK 107.

51. Reference was made to "yesterday's word from Washington." Memo, Yale Art Gallery, March 11, 1952. Kahn Collection, Correspondence with Yale University, File Box LIK 107.

52. Memo, Yale Art Gallery Meeting, March 14, 1952. Kahn Collection, Correspondence with Yale University, File Box LIK 107. The memo (Description and List of Materials, Design Lab, Yale University, March 20, 1952) that accompanied the letters sent to contractors refers to "ceilings" as "special metal acoustic panels in the exhibition, exposed concrete, painted, other." The importance of "the character of the concrete work" was stressed. The quality of formwork ("narrow vertical boarding rather than plyform") was to be "carefully studied and executed to achieve 'Architectural' concrete." Letter to contractors for bids, March 21, 1952, Orr and Kahn to Dwight Building Company, George B. H. Macomber Company, W. J. Megin, Inc. Kahn Collection, Correspondence with Douglas Orr, 1951–52, File Box LIK 107.

53. "The difference in time of nearly completed plans and wholly finished would be quite negligible." Letter, March 31, 1952, Orr to W. W. Randolph of Yale Service Bureau. Kahn Collection, Correspondence with Douglas Orr, 1951–52, File Box LIK 107.

54. Memo on floor system, April 8, 1952, Henry Pfisterer. Kahn Collection, Correspondence with Yale University, File Box LIK 107.

55. Report, April 17, 1952, Newman of Bolt, Beranek, and Newman. Kahn Collection, Correspondence with Douglas Orr, 1951–52, File Box LIK 107.

56. Memo, April 17, 1952, Sawyer to Kahn. Kahn Collection, Correspondence with Yale University, File Box LIK 107. In April 1952 Kahn was incapacitated by illness. See telegram, April 22, 1952, Sawyer to Kahn. Kahn Collection, Correspondence with Yale University, File Box LIK 107.

57. Letter, May 21, 1952, Pfisterer to Henry G. Falsey, and letter, June 18, 1952, Falsey to Pfisterer. Kahn Collection, Correspondence with Douglas Orr, File Box LIK 107.

58. Letters, July 1, 1952, and July 16, 1952, Pfisterer to Thompson and Lichtner Co., Inc., attention: Mr. Miles Claire. Kahn Collection, Correspondence with Douglas Orr, 1951-52, File Box LIK 107.

59. Letter, May 8, 1952, Orr and Kahn to Sawyer. Kahn Collection. Correspondence with Yale University, File Box LIK 107. Anne G. Tyng remembers the inventory of steel and the real interest of the Macombers in the experimental construction as being of great importance in the selection of the contractor.

60. Letter, May 26, 1952, Orr and Kahn to George B. H. Macomber Company. Kahn Collection, Correspondence with Douglas Orr, 1951–52, File Box LIK 107.

61. Macomber, in "P/A Views," *Progressive Architecture* 5 (May 1954): 22–24. The Macomber Company later was to become the contractor for the Yale Center for British Art with a negotiated contract let on October 1, 1972. See chapter four.

62. Memo of meeting, May 21, 1952, George Macomber, Collins, and Pfisterer. Letter, June 2, 1952, Palmer to Kahn. The Macomber schedule was enclosed. Macomber stated that the work began two weeks late and was delayed another two weeks by "delay on information." Letter, July 21, 1952, George Macomber to Palmer. Kahn Collection, Correspondence with Douglas Orr, 1951–52, File Box LIK 107.

63. Conference, June 18, 1952, Sawyer, Howe, Moore, Orr, Kahn. Kahn Collection, Correspondence with Douglas Orr, 1951–52, File Box LIK 107. Memo on exhibition panels, July 30, 1953, Carlin to George Macomber. Kahn Collection, Correspondence with Douglas Orr, 1953. File Box LIK 107. Drawings sent with revisions by Kahn and a Mr. Roaen included the suggestion that a cork pad, such as in "Polecat" lamps, be used instead of neoprene pads. The University increased the number of panels ordered to 125.

64. McCandless could not be made the official consultant because of his commercial affiliation, although he served as an adviser. First reference to Kelly as lighting consultant for the art gallery appears in notes of meeting at mock-up, January 23, 1952, Sawyer, Moore, Kelley [sic], Hummel, Howe, Kahn, Pfisterer, and Palmer. Kahn Collection, Correspondence with Yale University. See also memo on schedule, March 17, 1952. Kahn Collection, Correspondence with Douglas Orr, 1951–52, File Box 107. Kelly sent a lighting plan for the mock-up with a letter dated March 28, 1952, Kelly to Kahn. Kahn Collection, Correspondence with Yale University. File Box LIK 107. On Richard Kelly, see "Lighting Starts with Daylight," *Progressive Architecture* 54 (September 1973): 82–85.

65. Letter, June 25, 1952, Sawyer to Orr. Kahn Collection, Correspondence with Douglas Orr, 1951–52, File Box LIK 107.

66. See Stanley Abercrombie, "Edison Price: His Name Is No Accident," *Architectural Plus* 1 (August 1973): 34.

67. Schedule of Required Drawings, July 17, 1952, Palmer and Solomon of Macomber Company. Kahn Collection, Correspondence with Douglas Orr, 1951–52, File Box LIK 107.

68. See, for example, letter, July 21, 1952, Palmer to Kahn. Kahn Collection, Correspondence with Douglas Orr, 1951–52, File Box LIK 107.

69. Letter, July 2, 1952, Palmer to Sawyer. Kahn Collection, Correspondence with Douglas Orr, 1951–52, File Box LIK 107.

70. In conversation Anne Tyng remarked on Kahn's unusual inventiveness in working out solutions for problems, citing the use of flooring made for gymnasiums in this building. First reference to wood flooring was in specifications sent to the Macomber Company. Letter, April 25, 1952, Palmer to Solomon. It was for "'ironbound' flat grain maple 33/22 inches." On the stone for interior floors, there were several changes: travertine on July 2, 1952, Georgia marble on July 30, 1952, and terrazzo, as suggested by Howe, on October 10, 1952. Letters, July 2, 1952, July 30, 1952, and October 10, 1952, Palmer to George Macomber. All in Kahn Collection, Correspondence with Douglas Orr, 1951–52, File Box LIK 107.

71. Notes of meeting, November 24, 1952. Kahn Collection, Correspondence with Yale University, File Box LIK 107.

72. Letter, July 30, 1952, Palmer to Macomber Company. Kahn Collection, Correspondence with Douglas Orr, 1951–52, File Box LIK 107. The stone selected for interior floors at this time was too expensive and was subsequently changed.

73. Letters, August 5, 1952, Palmer to Macomber, and August 6, 1952, Carlin to Kahn. Kahn Collection, Correspondence with Douglas Orr, 1951–52, File Box LIK 107. "It was decided to continue with exterior and interior brick as originally selected." Meeting, August 8, 1952, Sawyer, Howe, Hummel, Orr, Kahn, et al. "Brick finally chosen and will not save us any money. Costs about $80.00 per thousand as against $110.00 per thousand in budget. But one third smaller, so cost is really $107.00 against $110.00, plus increased cost of laying smaller brick." Letter, August 21, 1952, Palmer to David M. Hummel, Yale University Service Bureau. All in Kahn Collection, Correspondence with Yale University, File Box LIK 107.

74. Notes of meeting, August 8, 1952, Sawyer, Howe, Hummel, Orr, Kahn, et al. Kahn Collection, Correspondence with Douglas Orr, 1951–52, File Box LIK 107.

75. Memo, August 5, 1952, Palmer to Macomber Company. Kahn Collection, Correspondence with Douglas Orr, 1951–52, File Box LIK 107. Palmer referred to Pfisterer's specifications for varying amounts. This was change order no. 21.

76. Letter, August 28, 1952, Sawyer to Orr and Kahn. Kahn Collection, Correspondence with Yale University, File Box LIK 107.

77. Letter, September 19, 1952, Sawyer to Orr and Kahn. Kahn Collection, Correspondence with Yale University, File Box LIK 107. Sawyer asked for a complete set of revised plans and specifications for the October 10 meeting of the architectural planning committee; any changes thereafter would be made only after approval by the building committee and the university treasurer. The *New York Times* reported the new gallery was made possible by gifts from the trustees of the Associates of Fine Arts and others contributing to a nucleus of the James Alexander Campbell Fund, established in 1942 by Hugh M. Campbell (Yale, 1936). See "Yale to Dedicate New Art Gallery," *New York Times*, November 1, 1953.

78. Letter, August 21, 1952, Palmer to Kahn. Kahn Collection, Correspondence with Douglas Orr, 1951–52, File Box LIK 107.

79. Letter, August 27, 1952, Palmer to Hummel. Kahn Collection, Correspondence with Douglas Orr, 1951–52, File Box LIK 107.

80. Letter, October 2, 1952, Palmer to George Macomber. Kahn Collection, Correspondence with Douglas Orr, 1951–52, File Box LIK 107.

81. Memo, meeting, October 14, 1952, Sawyer, Howe, Moore, Hummel, Solomon, Kahn, et al.; letter, October 23, 1952, Palmer to Sawyer; and notes of meetings, October 21, 1952, and November 11, 1952. Kahn Collection, Correspondence with Yale University, File Box LIK 107.

82. Memo, November 24, Orr to Sawyer. Kahn Collection, Correspondence with Douglas Orr, 1951–52, File Box LIK 107. Pfisterer reported that "lifting of the inclined outer form, resulting in leakage and poor soffit edges, was a serious problem during the early construction stage." Form anchorage to the deck was improved, the concrete mix was altered to increase slump, and compacting procedures were changed to provide minimum internal vibration to counter this problem. Design Laboratory, Yale University, Description of Structural System. Kahn Collection, Correspondence with Yale University. File Box LIK 107.

83. Letter, November 25, 1952, Orr to Sawyer. Kahn Collection, Correspondence with Douglas Orr, 1951–52, File Box LIK 107.

84. Letters, August 5, 1952, Holmes to Orr, and August 12, 1952, Orr to Holmes. Kahn Collection, Correspondence with Douglas Orr, 1951–52, File Box LIK 107.

85. "Building Engineering: 1. Tetrahedral Floor System: Yale's New Design Laboratory Conceals Lighting and Ductwork with a 31–Inch-Deep Floor Structure," *Architectural Forum* 97 (November 1952): 148–49. "Design/Techniques: Structural Methods, Three-dimensional Floor System," *Progressive Architecture* 53 (January 1954): 82.

86. Typescript draft of article "Tetrahedral Floor System," stamped Received Office of Louis I. Kahn, November 5, 1952, Vernon Read to Kahn, and annotated by Kahn. Handwritten draft of letter, undated, Kahn to Pfisterer. Kahn Collection, Yale Art Gallery, File Box LIK 107. Kahn thought the version "boring" as it stood.

87. Letters, November 10, 1952, Sawyer to Kahn, and November 14, 1952, Sawyer to Walter Snarski. Kahn Collection, Correspondence with Yale University, File Box LIK 107. In his letter to Snarski, Sawyer states the article was revised in consultation with Kahn, Orr, and Pfisterer and was "reasonably satisfactory," although he would have preferred publication only after the building was completed.

88. "Building Engineering: 2. Thru-Way Floor Truss," *Architectural Forum* 97 (November 1952): 149–50.

89. Notes, meeting, December 17, 1952, Sawyer, Phillips, Breckenridge, George Macomber, Clark Macomber, Kahn, Carlin, Palmer. Kahn Collection, Correspondence with Yale University, File Box LIK 107.

90. Memo, January 22, 1953, Palmer to Kahn, enclosing letter, January 16, 1953, Macomber to office of Orr. Kahn Collection, Correspondence with Douglas Orr, 1953, File Box LIK 107.

91. Notes of meeting, January 20, 1953, Orr, Palmer, G. Macomber, and C. Macomber. Kahn Collection, Correspondence with Yale University, File Box LIK 107.

92. Notes of meeting, February 10, 1953, Sawyer, Howe, Moore, Sanford, Hummel, Breckenridge, G. Macomber, C. Macomber, Kahn, and Orr. Kahn Collection, Correspondence with Yale University, File Box LIK 107.

93. Letter, February 19, 1953, Sawyer to Orr. Kahn Collection, Correspondence with Yale University, File Box LIK 107.

94. Notes of meeting, March 20, 1953, Sawyer, Moore, Howe, Hummel, and Kahn. Kahn Collection, Correspondence with Yale University, File Box LIK 107.

95. Notes of meeting, April 10, 1953, Sawyer, Hummel, Howe, Moore, Macomber, and Kahn. Kahn Collection, Correspondence with Yale University, File Box LIK 107.

96. Notes of meeting, April 27, 1953, Sawyer, Moore, Macomber, Kahn. Kahn Collection, Correspondence with Yale University, File Box LIK 107.

97. Notes of meeting at dean's office, June 18, 1953, Palmer to Hummel. Inquiries were directed to Macomber on cost estimates for landscaping with provision that Yale University would furnish some of the plantings. Letter, June 17, 1953, Carlin to G. Macomber. Macomber responded with an estimate. Letter, June 29, 1953, G. Macomber to office of Orr, attention: Palmer, copy to Kahn. All, Kahn Collection, Correspondence with Douglas Orr, 1953, File Box LIK 107.

98. Letter, August 21, 1953, Sawyer to George Sanderson. Sanderson had written Sawyer June 9 and June 26, 1953, about coverage of the building by his periodical. On Sanderson's advice official photographs were not released until later. Sanderson arranged for photographer Lionel Freedman to record the gallery in November 1953 in the company of Sawyer and Kahn. Some of these photographs were published the following May in *Progressive Architecture*. Letter, November 12, 1953, Sanderson to Kahn. All, Kahn Collection, Correspondence with Yale University, File Box LIK 107.

99. Letter, August 12, 1953, Dorothy M. Hooker, secretary to Sawyer, to Kahn. A meeting with Kelly was set for August 17, 1953. Notes of meeting, August 18, 1953, Sawyer, Hummel, G. Macomber, and Kahn. Kahn Collection, Correspondence with Yale University, File Box LIK 107. Fixtures are described in Sanderson, "Extension: University Gallery," 95; and in Boris Pushkavev, "Order and Form, Yale Art Gallery and Design Center Designed by Louis I. Kahn," *Perspecta 3* (1955): 55.

100. Letter, October 7, 1953, G. Macomber to Office of Orr. Letter, October 22, 1953, Sawyer to Orr. Kahn Collection, Correspondence with Douglas Orr, 1953, File Box LIK 107. Sawyer acknowledged Orr's memo and bill of October 14, reporting it approved and forwarded to the comptroller's office.

101. See "A New Building for the Arts," *Yale Alumni Magazine* 18 (December 1953): 8–13. Sanderson took the opportunity to invite specialists in architecture present at the dedication ceremonies and formal opening to contribute their opinions on the Yale Art Gallery for publication in "P/A Views," supplementing the coverage on the gallery. Those contributing were Robert W. McLaughlin, Director of the School of Architecture, Princeton University; Leopold Arnaud, Dean of the School of Architecture, Columbia University; G. Holmes Perkins, Dean of the School of Fine Arts, University of Pennsylvania; architectural historian Frederick Gutheim with part of an article from *The New York Herald-Tribune*; Jose Luis Sert, Dean of the Graduate School of Design, Harvard University; and C. Clark Macomber, President of George B. H. Macomber Company. "P/A Views": 15–16, 22, 24.

102. Sanderson, "Extension: University Art Gallery," 293.

103. Cooper, "The Architect Speaks," 2.

104. Jules Prown commented on Kahn's use of such analogies in speaking of systems in a building in biological terms. See "Jules D. Prown" in Latour, *Louis I. Kahn* 137.

105. Letter, December 23, 1953, Palmer to Sawyer. Kahn Collection, Correspondence with Douglas Orr, 1953, File Box LIK 107. See also letters, February 5, 1954, Alma Farrow, secretary to Kahn, to Douglas Orr, and February 9, 1954, Julia V. Sveda, secretary to Orr, to Farrow. Kahn Collection, Yale Art Gallery, File Box LIK 107. Final calculations brought the total to $1,482,118.61, including "items of disagreement" and the building fee, according to Sveda.

106. Letter, October 22, 1953, Sawyer to Orr. Kahn Collection, Correspondence with Douglas Orr, 1953, File Box LIK 107. The program committee for planning consisted of Howe, Paul Schweikher, and Sawyer as well.

107. Letter, April 1, 1954, Kahn to Sawyer. Kahn Collection, Correspondence with Yale University, File Box LIK 107.

108. Letter, June 30, 1954, Sawyer to Kahn. Kahn Collection, Correspondence with Yale University, Box File LIK 107.

109. Letters, August 6, 1954, Sawyer to Kahn, and August 23, 1954, Kahn to Sawyer. Kahn Collection, Correspondence with Yale University, File Box LIK 107.

110. Letter, September 3, 1954, Sawyer to Kahn. Kahn Collection, Correspondence with Yale University, File Box LIK 107.

111. Yale announced the new Art Gallery and Design Center with emphasis on its spacious and functional interior. "A New Building for the Arts," 8–13. Scully's essay was "Somber and Archaic; Expressive Tension," *Yale Daily News*, special supplement, The New Gallery and Design Center, dedication issue, November 6, 1953, 10.

112. Sanderson, "Extension: University Art Gallery," 97.

113. "Yale to Dedicate New Art Gallery," The *New York Times*, November 1, 1953.

114. Sanderson, "Extension: University Art Gallery," 89–90. Sanderson requested the material on the art buildings at Yale. Letter, October 21, 1953, Sanderson to Sawyer. Kahn Collection, Correspondence with Yale University, File Box LIK 107.

115. Letter, February 19, 1974, John K. Copelin to Robert Stern, in Stern, "Yale 1950–1965," 47.

116. Etel Thea Kramer, "Notes on the Yale School of Architecture" (typescript, 1974) in Stern, "Yale 1950–1965," 49–50. See also Stern quoting Jaquelin Robertson, "Yale, 1950–1968," 45. See also Huff, "Kahn and Yale" in Latour, *Louis I. Kahn* 331–65. The latter is a revised, expanded version of an article with the same title in *Journal of Architectural Education* 35 (Spring 1982): 22–31.

117. Scully, "La musée des beaux-arts de l'Universite Yale, New Haven/Art Gallery and Design Center, Yale University," *Museum (UNESCO)* 9 (1956): 101–13.

118. See Stern, "Yale 1950–1965"; and Huff, "Kahn and Yale," in Latour, *Louis I. Kahn* 331–65.

119. The round stairwell had been considered very important. An analogy between Johnson's Glass House in New Canaan, and the Yale Art Gallery has received comment. Both possess planar, orthogonal exteriors without expression of frame and contain a cylindrical silo form, Johnson's for bath and fireplace, Kahn's for the main stairs. Huff, "Kahn and Yale," in Latour, *Louis I. Kahn* 339. Kenneth Frampton, *Modern Architecture: A Critical History* (New York: Oxford University Press, 1980): 242.

120. Huff, "Kahn and Yale," 343. Stern, in "Yale 1950–1965," writes of a "clash" between Kahn and Rudolph, which he speculates would have arisen out of pedagogical differences in any case as Rudolph sought to establish his dominance on the Yale architectural scene as the new chairman (46–47).

121. Huff, "Kahn and Yale," 347. The second floor was used by the architecture department until they moved back to Weir Hall in 1958, when the upper floor only was for a drafting studio (until 1963). Ritchie first redesigned the second floor for use for exhibition, the print room, and the Asian art department; he then changed the first and third floors, as well as the third floor of the old gallery, to gain more hanging space and to complete climate control and air-conditioning. After 1963 the fourth-floor studios and the basement area that had been used by the design department, became available and the gallery was enlarged again. See A. C. Ritchie, "Director's Report for the Years 1957–62," *Yale University Art Gallery Bulletin* 29 (April 1963): 5–6.

122. Alan Shestack, quoted in "Kahn's Gallery at Yale Wins 25-Year Award," *American Institute of Architects Journal* 68 (May 1979): 11.

123. Kahn's writings and projects appeared in *Perspecta* 2 (1953): 10–27 and 45–47; *Perspecta* 3 (1955): 59, 60–61; *Perspecta* 4 (1957): 2–3 and 58–65; *Perspecta* 7 (1961): 9–28; *Perspecta 9–10* (1965): 303–35.

124. Reyner Banham first wrote of Kahn in "The New Brutalism," *Architectural Review* 118, no. 708 (December 1955): 355–61.

125. Kahn was invited to address the international conference of modern architects in Otterlo, The Netherlands, in 1959. See Jurgen Joedicke and Oscar Newman, eds., *New Frontiers in Architecture, CIAM in Otterlo*, (New York: Universe Books, 1961); Kahn's talk, 205–16. The Smithsons published "Louis Kahn" in 1960 (see n. 13).

126. Barnett, "New Collegiate Architecture": 126.

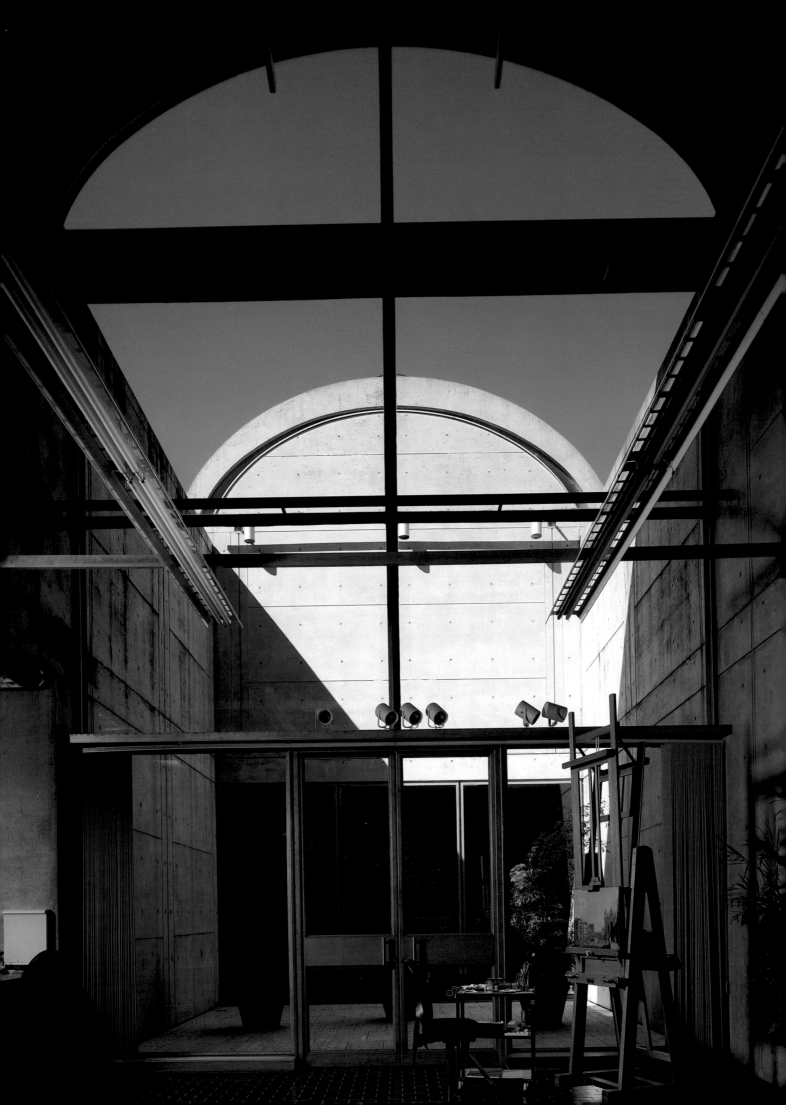

# The Kimbell Art Museum   CHAPTER 3

## Commission Background

Kahn's commission for the Kimbell Art Museum came fifteen years after he designed the Yale Art Gallery addition, and it was for a new and very different kind of art museum. At Yale the arts had had a long tradition, beginning with the art gallery built for the collection of John Trumbull in 1831 — the first college or university art gallery in the United States. Through the years the holdings had grown, and expansion of the gallery in 1951 was in part to create exhibition space for anticipated and committed gifts and legacies that would enrich the Yale collections. The Kimbell Art Museum, on the other hand, was not only new as an institution but undefined as a collection. The collection had been started by Texas multimillionaire Kay Kimbell and his wife Velma, and it was expected to grow more rapidly than that of most art museums. In the beginning this lack of specification about the collection meant some ambiguity, but Kahn accepted this as an opportunity to create an ideal setting for works of art.

Kay Kimbell and his wife, together with his sister and her husband, the Coleman Carters, formed the Kimbell Art Foundation in 1936, only five years after he bought his first painting. By 1948 the Foundation was exhibiting paintings on the second floor of the Fort Worth Public Library, the only place in the city where art was publicly exhibited, and was considering building or leasing a building for a museum. The Kimbells' collection already was playing a significant public role in the city. The Fort Worth Art Association, which controlled the exhibition space in the library, showed the collection primarily to schoolchildren as part of an educational program, but there were other visitors as well.[1] A Foundation committee investigating museum possibilities came upon several possible sites but reported that funds were insufficient to build a museum of the quality desired. The committee learned that city bonds were to be issued for a new municipal museum that might offer a place to show the paintings, and that two other Fort Worth private collectors were also considering establishing a museum. In the meantime the library was used to display the Kimbell paintings.[2]

A museum was considered in annual Foundation meetings from time to time, but the library remained the primary venue for exhibitions. The space was not large enough to show the complete collection, however, and so works were rotated. In 1953 the foundation mounted a special exhibition of eighteenth-century English art, an area particularly favored by the Kimbells.[3] The catalogue was prepared in New York by Bertram Newhouse of the Newhouse Galleries. Newhouse became a member of the board of trustees of the Foundation and curator of the collection in 1960. By this time the municipal museum was in operation, and regular exhibition of the Kimbell pictures there was contemplated even as works were shown in local churches, country clubs, and other public places. Construction or lease of a building again was considered and rejected. The Kimbells planned to will their house to the Foundation for use as a museum, although it was conceded that a location in the vicinity of the Art Center (the municipal museum, later the Modern Art Museum of Fort Worth) and the Amon Carter Museum of Western Art (later the Amon Carter Museum), which had opened in January 1960, would be preferable.[4]

Kimbell Art Museum, Fort Worth. Conservator's studio and courtyard.

**3.1**
*Topographic map of site of
Kimbell Art Museum.* Louis I.
Kahn Collection, University of
Pennsylvania and Pennsylvania Historical and Museum
Commission.

Kay Kimbell died in April 1964, and under the terms of his will funds were made available for the Foundation to construct a museum. Within months his wife made a gift of her share of the estate in order to assist the realization of this goal. Until the museum was finished, paintings and art objects would continue to be housed in the Kimbell home. Mrs. Kimbell would admit the public "at reasonable times," and expenses for the collection's care and preservation would be covered by the Foundation.[5] The board of directors took seriously their charge to form a museum and sought advice from, among others, the chief curator of the National Gallery in Washington and a vice president of the Morgan Guaranty Trust in New York, who recommended visits to the Metropolitan Museum of Art, the Huntington Hartford Museum, the Guggenheim Museum, and the National Gallery.[6] This suggestion was followed, and visits by board members were duly made to Boston and New York museums. The board resolved that Mrs. Kimbell and her niece, Mrs. Kay Carter Fortson, should visit museums in London, Paris, and Rome, asking for recommendations on the scope and character of activities; architectural features such as type, size, and plans; the qualifications of a curator (they even were to obtain names and addresses of English candidates); and possible acquisitions.[7]

By September 1964 the Foundation president had already taken an option on the purchase of a site when the executors of the Foundation committee expressed preference for yet another site—nine acres in Will Rogers Memorial Park (see fig. 3.1). The Foundation's attorney undertook negotiations with municipal representatives on this city-owned site.[8] The land could not be sold without a vote by all citizens, but exclusive use could be granted to the Foundation to maintain and operate a museum open to the public for the period of its corporate existence. The only cost to the Foundation would be for removing an existing road through the site and constructing an access road to the Will Rogers Auditorium and Coliseum.[9] Because of the importance of the view of the city from the Amon Carter Museum, which shared the park uphill from the Kimbell site, a height restriction of forty feet was placed on future construction.

The board appointed Richard Fargo Brown, at the time director of the Los Angeles County Museum, as director of the Kimbell Art Museum with responsibility to oversee the formation of architectural and operating programs. He had been recommended by other museum directors as one of the outstanding professionals in America with experience in museum construction, acquisitions, and administration.[10] A preliminary agreement leading to a ten-year contract between Brown and the Foun-

dation charged the director with submitting (1) a proposal on basic policies, objectives, and philosophy, including plans for the acquisitions of art objects, (2) a budget for the next year or some other agreed-upon period, (3) a memorandum on requirements and information essential to an architect in the preparation of plans, and (4) a recommendation for an architect. It was anticipated that the building and its equipment, furnishings, and gardens would cost approximately $7.5 million. Between 1965 and 1972 an equal amount would be made available for acquisitions.[11]

In Brown's first meeting with the board after he accepted the position (diplomatically held in El Paso, Texas, between Los Angeles, where he was still director, and Fort Worth, on October 18 and 19, 1965), he presented his concept of purpose: "to acquire and exhibit works of art which are of the highest obtainable quality and definitive of their age and area."[12] He also had ready a list of nine European works plus a whole collection of Asian art to propose for acquisition. Board members agreed to prepare their own budget showing the probable availability of funds over the next three years as the estate was transferred into income-producing assets. Brown named five possible architects for the new museum in order of his preference: Marcel Breuer, Mies van der Rohe, Louis Kahn, Max Abramovitz and Pier Luigi Nervi. He planned to send the board members brochures and descriptive material on these architects.

It was a curious diversity of architectural personalities; all were active and considered significant at the time, and all, excepting Kahn and Nervi, practiced within the parameters of what was commonly called the International Style. Brown had wanted Mies as architect for the Los Angeles museum but had been overruled by the board. (One wonders if he proposed some of these architects with the thought of future compromise with the board on selection.) At this time Breuer was completing the stark new Whitney Museum in New York begun in 1963. The Whitney departs from strict interpretation of the International Style in its sculptural façade (later characterized as "neobrutalist") but exemplifies modernism in its severe, serious, hard-edged assertiveness and interior loft spaces. Breuer became architect for an addition to the Cleveland Museum of Art the following year. Mies, a recognized form giver among modern architects, had designed the innovative Museum for a Small City project in 1942 and Cullinan Hall for the Museum of Fine Arts in Houston in 1954–58. In 1962 he received the commission for the new National Gallery in Berlin (completed in 1968). Abramovitz was a principal in the Harrison and Abramovitz firm, which was best known for institutional office and public buildings such as Lincoln Center in New York (1959–66), then nearing completion. Their Philharmonic (Avery Fisher) Hall was completed in 1962, and the Metropolitan Opera was under construction (1962–66). The firm had built a small International Style gallery, the Rose Art Center (1962), at Brandeis University in Waltham, Massachusetts. Nervi, the great Italian architect-engineer, had designed no art museums. He was the preeminent designer of dramatic buildings in reinforced concrete such as the Palazetto dello Sport and Palazzo dello Sport built for the 1960 Olympics in Rome. He also had collaborated with Breuer and French architect Bernard Zehrfuss on the UNESCO Secretariat and Conference Hall in Paris (1953–58), and in the early 1960s he was involved with the New York Bus Terminal, Place Victoria Tower in Montreal, Australia Square Tower in Sydney, and several projects in Italy.

A month later, Brown had a draft of the policy statement ready for study by the board. He had acquired one painting and a sculpture and had two paintings under consideration. The board had budgeted $1 million for acquisitions in 1965 at the El Paso meeting and added another $2 million for 1966.[13] Another $1 million was projected to be budgeted annually thereafter. Four paintings were approved for acquisition and, with Brown outlining the procedure he would follow in supplying information on future possible acquisitions, others were approved for further investigation. On the new museum, Brown reported that Lou Danciger, a West Coast architect he knew personally, had recommended Louis Kahn highly. Several suggested itineraries were presented for members of the building committee who might wish to inspect projects and buildings by Kahn and other suggested architects.

Brown officially assumed the directorship in February 1966. At the April 1 meeting six objects were presented for consideration, and the purchase of an Asian sculpture was authorized. Brown was so energetic in enlarging the collection and organizing the museum that it was suggested that monthly meetings would be necessary to act upon his recommendations. He was just as active in looking for an architect and made a presentation at that meeting on Gordon Bunshaft, chief designer for Skidmore, Owings, and Merrill. In a meeting on April 27, 1966, the Policy Statement written by Brown was approved by the Foundation committee. (This was amended June 1, 1966.) Brown met with architects over the next few months and felt a personal response to Kahn as a creative artist. He also would have seen Kahn's growing reputation high-lighted by the spring 1966 exhibition at the Museum of Modern Art. In a special meet-ing on June 9, 1966, Brown recommended Louis I. Kahn as architect for the Kimbell Art Museum and presented his Pre-Architectural Program (dated June 1, 1966).[14] He was authorized to employ Kahn together with a resident firm, following the practice in Fort Worth of having a local architect work with nonresident architects. Preston M. Geren and Associates was the board's preference for the local associate. The program was sent to Kahn, Mies, Bunshaft, Edward L. Barnes, and several others not specified. Brown, however, was convinced by this time that Kahn would create the work of art he and the board members desired[15] and hoped he would accept the commission.

Kahn's reputation as a major architect had risen steadily since the Yale commis-sion, and he was internationally recognized. Although relatively few of his projects had been built, the publication of those realized and of his unbuilt designs immediately after the completion of the Yale gallery was influential. The Bath House for the Jewish Community Center in Trenton built in 1955–56 was an achievement far more significant than its small size and modest budget might indicate — in publishing it Kahn articu-lated his served and serving spaces philosophy.[16] Another important project, in this case unbuilt, was for an American consulate in Luanda, Angola (1961). There he was concerned with the control of intense natural light, and he devised schemes inspired by regional architectural practices that he adapted in later works, including the Salk Institute and his art museums.[17] By the end of the 1950s the Alfred Newton Richards Medical Research Laboratories Building (completed in 1961) was under construction for the University of Pennsylvania. Although scientists later working in the Richards Building had functional criticisms, the creative vigor and sculptural form of the design, with its poetic utility towers as serving spaces, were undeniable. This building led to a special exhibition at the Museum of Modern Art in 1960[18] and to the important com-mission for the Salk Institute for Biological Studies in La Jolla, California (1959–62).

In the early 1960s Kahn began work on the master plan and individual buildings for Dacca, the capital of West Pakistan (now Bangladesh), and on several projects in Pakistan and India, including the Indian Institute of Management in Ahmedabad, which involved him from 1962 until his death in 1974. In 1966, in recognition of his work, the Museum of Modern Art, New York, mounted the museum's only one-man architec-tural retrospective of the decade.[19] During these years Kahn built no art museums, but there were related projects having galleries or exhibition spaces, such as the Fine Arts Center for Fort Wayne, Indiana (1961–73) (of this only the Theater for Performing Arts was built, 1965–73), and the Philadelphia College of Art (1964–67).[20] The Yale Uni-versity Art Gallery, however, remained important to him. He singled it out from among his other buildings, as a learning experience in his closing address for the tenth inter-national conference of modern architects (CIAM) in Otterlo, The Netherlands, in 1959.[21]

Always creative, Kahn was an independent thinker whose work on any particular building led to "the thoughtful making of spaces," as he defined architecture. He could now articulate his ideas more effectively than he had in 1951. He could comprehend the nature or identity of the idea — the form in a Platonic sense — and design a build-ing expressive of it while at the same time accommodating needs and requirements of use.[22] He was now sure of his own understanding of form and less dependent on requirements defined by others. This new conceptual grasp of form and use had come

about in part because of the changes in the Yale galleries. The loft space, which he had thought could not be "destroyed by wrong use of space" by the client simply by virtue of his having provided almost complete flexibility for arrangements, was now fixed into rooms denying the building's inherent nature. Kahn would not make that mistake again.

### The Program for the Museum

Brown's program was carefully considered. In California during the planning and construction of the Los Angeles County Museum by William L. Pereira and Associates in 1961–65, he had gained insight into museum architecture by working closely with his staff and the architects.[23] There he had not had as much input as he had wished; for example, his advice on the sizes of galleries and work areas was not followed. His strong opinions about museums arose partly from that experience and partly as the result of a professional life in museums that had begun as a graduate student in Harvard University's Fogg Art Museum and continued as research curator in the Frick Collection, New York. Now, as he framed the Kimbell program, Brown specified space for each functioning unit of the building, but also — and this was important to Kahn — he articulated the philosophy behind the creation of this new museum. While preserving and exhibiting objects of art, it was to enhance them through "harmonious simplicity and human proportion" of spaces. The experience of viewing objects was to be tempered by their environment. And so Brown asked for "warmth, mellowness and even elegance."[24]

Functional organization was to be clear and logical; the galleries were foremost, but every aspect of museum operations was to be thought out and provided for with equal care and attention. Brown wanted a clear separation of organizational divisions, with a direct approach to each appropriate to its use. Proportions, materials, and craftsmanship should all unite to convey honesty in the relationship of visible form and the means of construction. Such a design, he felt, would be strong in the best sense. Clarity of plan would provide ease of viewing and help prevent museum fatigue. All components necessary for a museum to function as a vital institution should be provided. The building was to be complete and self-contained in the sense that there was to be no planned allowance for phased stages of future construction.

The Kimbell Museum was to be larger than Kahn's earlier Yale Art Gallery: 132,400 square feet were requested in Brown's program, as compared to 46,000 square feet in Howe's original Yale program. (Howe's program, it should be remembered, at first assigned only 30 percent of square footage to the gallery.) The Kimbell program also differed in specifically detailing usage as opposed to general floor (or even bay) assignments at Yale. Public exhibition space was to be 40,000 square feet with an additional 7,200 square feet for showing temporary exhibitions, or a total of 47,200 square feet devoted to viewing works of art. The budget for building the Kimbell Art Museum was set at $6,471,500, including special equipment, furnishings, landscaping, and designers' fees.[25] After space assignments, in the section on "features of particular importance to museums," Brown spoke first and foremost of natural light, which he wanted to play the major role in illumination. This was obviously one reason why he found Kahn so interesting as an architect.[26]

Any museum must call on artificial light at times. The museum may be open at night or late on winter afternoons, or the day might be cloudy or rainy. Brown conceded that artificial light had to be adequate throughout the whole building. For works of art, however, he liked natural light best: it was the most familiar light for visitors; it was the light in which they could more easily relate their visual experience of works of the past to life in the present; it was, in short, comfortable. He also considered it preferable for the specialist judging the quality and reading the surface of artworks. Although he suggested an inward orientation because of the lack of an appealing outward vista (unlike the Carter Museum, whose site profits from the view of the downtown skyline), he dismissed skylights and clerestory windows because neither offered varied points

of view or a sufficient reference to the outside world. (Skylights and clerestories, more-over, had functional complications such as creating glare and leaking inside.) Brown thought the visitor should have an opportunity to relate to nature, at least momentarily, from time to time.

Quantity of natural light was less important to Brown than the sense of participation in the natural world that it gives. He set no limits, though, on the amount of light in the galleries. Although this seems surprising given today's attitudes, at that time the museum profession was only beginning to be concerned with the exact measurement of candlepower in exhibition areas. It had long been realized that light presented a danger to certain works of art — works on paper or fabric should not be touched by direct sunlight — but in the 1960s detailed scientific studies were only just beginning to appear with some frequency.[27] Brown was aware of the problems of light, and he specifically addressed the intensity of Texas sunlight as a major factor to be taken into consideration during design because of its physical properties and psychological effects. Yet he wanted changes in the weather, the seasons, and the position of the sun to be realized within the building and become part of the observer's experience of the art. He believed that unchanging and unwavering light would make the objects and the museum seem "canned," or packaged. Kahn, who had designed the Yale Art Gallery so that artificial light was actually necessary in exhibitions, even though natural light was part of the scheme, now agreed completely with Brown's point of view, for he held as a philosophical tenet that natural light must be introduced into a room before the room could exist as architectural space.

Artificial lighting should be incandescent, Brown thought, that quality being most compatible with natural light. He did not think general illumination such as downlighting would be necessary, because walls and cases would be illuminated adequately; and fixtures might interfere with viewing works of art. Fixtures should be minimized. But he asked that the system for installing objects be designed by the architect so that it became part of the architecture. Maximum surveillance of artworks would be made possible through an open plan, and that in itself could be considered a security measure. A comprehensive system of internal communication, including the signs for the building and special exhibition labels, was also to be designed by the architect to be consistent with the overall design. Climate control was to ensure the preservation of objects through correct, constant temperature, humidity, and clean atmosphere. Such were Brown's suggestions. He expected the architect to deal with them creatively.[28]

### The Evolution of the Design

On October 5, 1966, the architectural contract was signed. Kahn came to Fort Worth for this occasion and to meet Preston Geren, the associate architect selected by the Foundation. Under the terms of the contract, Kahn was responsible for the design of the Kimbell Art Museum, and the Geren firm was to act as a local associate by arranging legal compliance with state and local regulations, preparing working drawings, engaging mechanical and electrical engineers, advising on consultants, making cost estimates, advising on bids, and, finally, supervising construction. The contract required that schematic and preliminary designs for the museum should be made within six months, working drawings within the next six months, and the construction contract let by March 1, 1968. The building was to be completed by September 1, 1969, and installed by March 1, 1970.[29]

On schedule, in March 1967 Kahn and his office produced a small-scale model reflecting his early thoughts about the Kimbell Art Museum (fig. 3.2). It showed a large, square, vaulted building, sprawling and low, with skylights, courtyards, light wells, and a shaded arcade surrounding the whole. It almost filled the entire site. Given Kahn's approach to architectural design as he explained it in the late 1950s and early 1960s, this model must be viewed as basic to his concept of the museum; it underlay all future development. Size, of course, did not concern him as he began to design. What mattered was relationships between parts.

**3.2**
*Kimbell Art Museum. General site model.* **Catalogue 11.** Kimbell Art Museum.

Some elements communicate with Kahn's other works of the same time; the porches and arcade recall those he employed to counteract the light and heat of Ahmedabad and Dacca. But vaulted space is not often found in Kahn's work and seems specifically inspired by this museum commission. It evokes Renaissance and Neoclassical galleries, which probably were the early inspiration, but vernacular Mediterranean buildings are reflected as well, and some of Le Corbusier's housing projects of the 1920s and 1930s (for example, Monol and the agricultural village in Sarthe) and houses of the 1950s and 1960s (Jaoul, Sarabhai), with their vaults in series.

From the beginning Kahn envisioned vaulted galleries with a north-south orientation bringing natural light into the building through skylights of narrow slits at the apex of the vaults. This remained a stable feature in the design. We see it in the sketch sheet of March 1967 with several small trapezoidal site plans and various types of reflectors under low vaults (fig. 3.3). We see it in the schematic plans that include an elevation and section with a figure before a large sculpture (fig. 3.4), also of March 1967. The skylights, not unlike those in Beaux-Arts museums of the late nineteenth and early twientieth centuries, are related to them as concepts and stem from earlier museum designs such as Hubert Robert's suggestions for lighting the Grande Galerie of the Louvre.

**3.3**
*Kimbell Art Museum. Various schematic site plans, partial sections.* **Catalogue 12.** Louis I. Kahn. March 1967. Louis I. Kahn Collection, University of Pennsylvania and Pennsylvania Historical and Museum Commission.

**3.4**
*Kimbell Art Museum. Schematic plans, elevations.*
**Catalogue 13.** Louis I. Kahn.
March 1967. Louis I. Kahn
Collection, University of Pennsylvania and Pennsylvania
Historical and Museum
Commission.

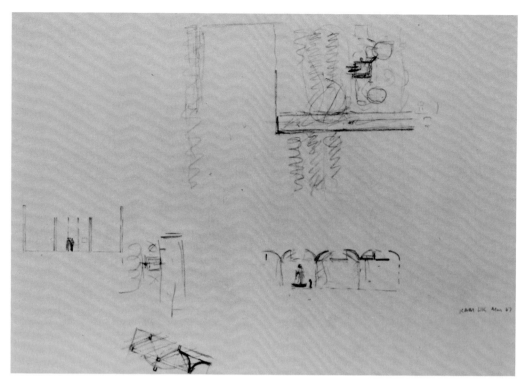

**3.5**
*Kimbell Art Museum. Schematic sections.* **Catalogue 14.** Louis I. Kahn. Louis I. Kahn Collection, University of Pennsylvania and Pennsylvania Historical and Museum Commission.

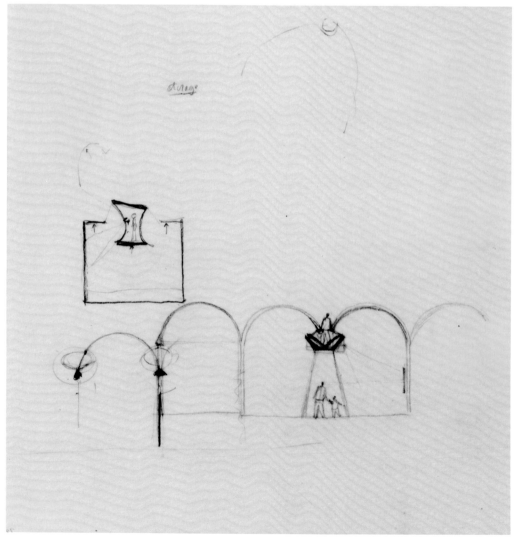

This is a return to traditional museum lighting, a drastic about-face from the dependable electric light seen in contemporary museums at this time. Electricity had long proven its convenience. Lights were available day or night; they were reliable; and

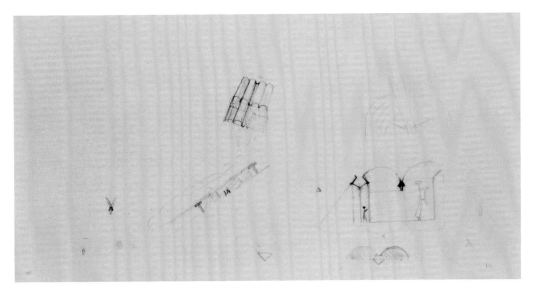

**3.6**
*Kimbell Art Museum. Schematic elevation, section, axonometric view.* **Catalogue 15.** Louis I. Kahn. Louis I. Kahn Collection, University of Pennsylvania and Pennsylvania Historical and Museum Commission.

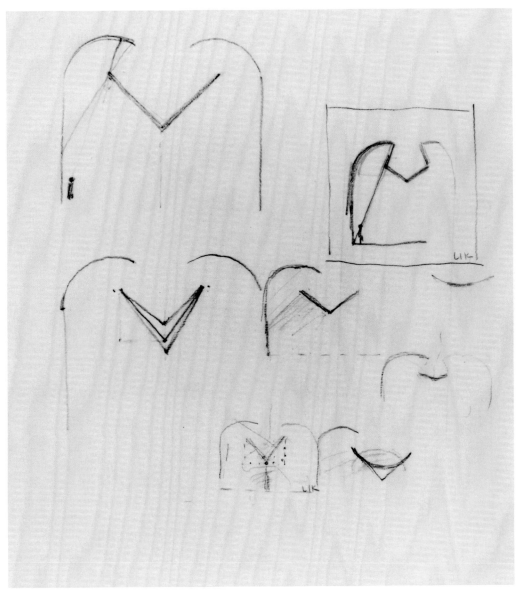

**3.7**
*Kimbell Art Museum. Schematic vault sections, reflectors.* **Catalogue 16.** Louis I. Kahn. March 1967. Louis I. Kahn Collection, University of Pennsylvania and Pennsylvania Historical and Museum Commission.

above all they were predictable in terms of quantity and quality. And they could be manipulated for special effects to set off an exhibition or a specific work, a technique first perfected in the retail world. Offering the curator or museum exhibition designer a wide range of options, the electric light was standard in contemporary museum design, and the Museum of Modern Art's example was generally admired, its displays emulated.

Kahn experimented with types of vaults, some even angular like the folded plate of the Rochester Church. One section suggested a practical use for a reflector: security surveillance; in another the reflector served also as a lighting device (fig. 3.5). But adjacent long units in series were consistently employed (fig. 3.6). Quite early, in a departure from traditional practice, the interior reflectors or light shields whose purpose was to deflect direct light were conceived as part of the skylight (fig. 3.7). They grew in importance, evolving into a three-dimensional shape that would elicit a sense of a lowered ceiling and more intimate space while at the same time reflecting light onto the walls, as Kahn indicated in a remarkably free and spontaneous charcoal drawing of a gallery interior perspective dated March 1967 (fig. 3.8). Sculptural reflectors and angular vaults in the early models became Kahn's servant and served spaces in this version of the first design presented to Brown. The reflectors were to contain ducts and conduits (fig. 3.9), recalling the service role of the Yale Art Gallery ceiling.

**3.8**
*Kimbell Art Museum. Perspective of gallery interior.* **Catalogue 17.** Louis I. Kahn. March 1967. Louis I. Kahn Collection, University of Pennsylvania and Pennsylvania Historical and Museum Commission.

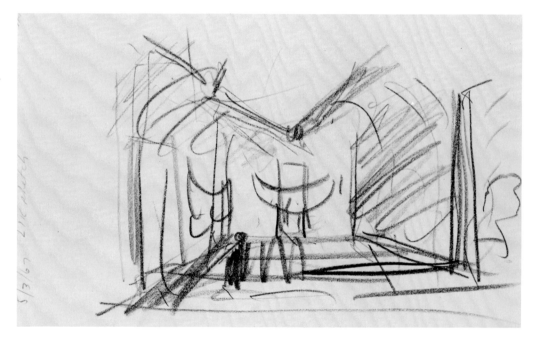

**3.9**
*Kimbell Art Museum. Vault and reflector studies.* **Catalogue 18.** Louis I. Kahn. Louis I. Kahn Collection, University of Pennsylvania and Pennsylvania Historical and Museum Commission.

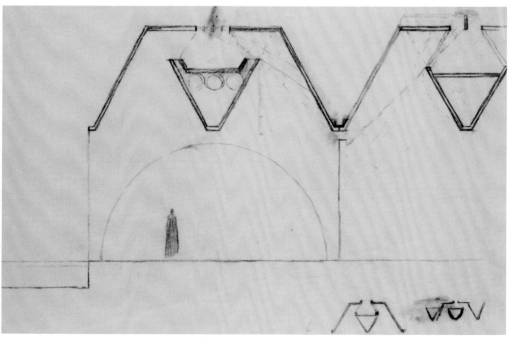

This early scheme was received with enthusiasm by Brown, the board members of the Foundation, and the associate architect in Fort Worth, but all saw it as very pre-liminary.[30] Lighting of the galleries particularly intrigued members of the board, and to see the effect they asked for construction of a mock-up of a part of one of the galleries. Geren wrote Kahn to ask for advice on this request and for more detailed plans in order to construct such a mock-up.[31] A second, more detailed, model was brought by Kahn to Fort Worth in early June 1967 (fig. 3.10).[32] The trees planted in the center of the irreg-ularly shaped site (originally on either side of the obliterated street) are integrated into large interior courtyards planned as sculpture gardens. Terraces regularize the gentle slope of the land, conveyed on the model by layers of chipboard marking the grada-tions. Two asymmetrical pools complete the front terrace, with flights of stairs north and south. On the north the steps lead down to a lawn with trees, while on the northeast corner of the building a ramp leads up from ground level to the porch. Twelve interior courtyards and light wells, including the two large ones, pierce the roof of this version and suggest the importance of light to the design. Kahn made a plan sketch, partially axonometric (fig. 3.11), emphasizing these light sources. It also shows a portion of the arcade.

In the plan it can be seen that the square shape of the whole is due to the arcade (fig. 3.12). Essentially there are two long, rectangular parts, three vaulted units on the west and six on the east, surrounded by the arcade and porches. The two sections are connected by three short vaults placed a little to the north of center, an element that is included in the main west-east axis. The lower-floor plan indicates little development other than parking and an automobile drive-through (fig. 3.13).

Brown's considered response to the scheme was expressed in a letter that July in which he stated, "We want the direct, simple sparse shell of structural validity and integrity which is inherently there already. But somehow we also must achieve the warmth and charm I spoke of in the program."[33] The four-hundred-foot square size made him apprehensive—it might seem ostentatious and would surely require expen-sive maintenance. He pointed out that the art this museum would contain would be small in scale. "The average size picture on the walls of the Kimbell Art Museum will be about two and one-half feet in one direction and three or four feet in the other. Some of them (for example, fourteenth- or fifteenth-century Italian panels) are all of twelve inches in the largest dimension." The best pictures in the Kimbell private collection

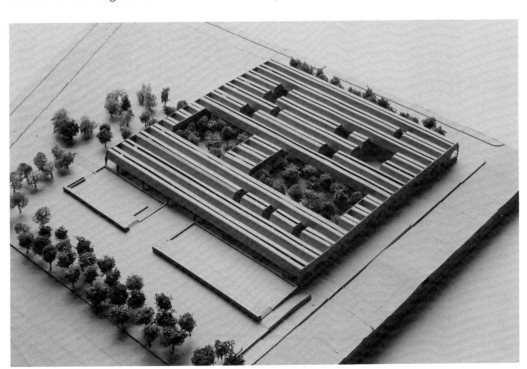

**3.10**
*Kimbell Art Museum. Site model.* **Catalogue 19.**
Kimbell Art Museum.

**3.11**
*Kimbell Art Museum.
Schematic plan, elevation,
axonometric view.* **Catalogue
20.** Louis I. Kahn. Louis I.
Kahn Collection, University of
Pennsylvania and Pennsylvania Historical and Museum
Commission.

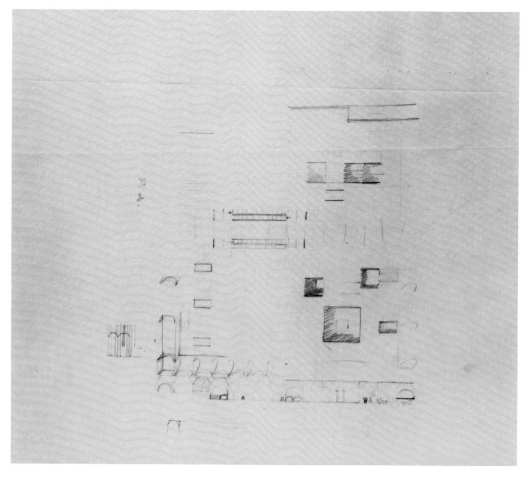

**3.12**
*Kimbell Art Museum. Plan,
gallery floor, first version.*
Louis I. Kahn (office drawing).
Louis I. Kahn Collection, University of Pennsylvania and
Pennsylvania Historical and
Museum Commission.

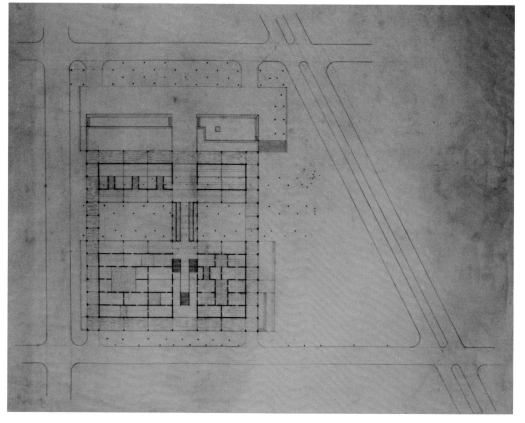

were described as "genteel" and "polite" representations. Spaces for these paintings should not overwhelm them or the average-sized visitor (a "lady from Abilene") to the museum.

Among Brown's specific recommendations for revisions were his suggestions that the lower level west of the parking space be used for operational components, that

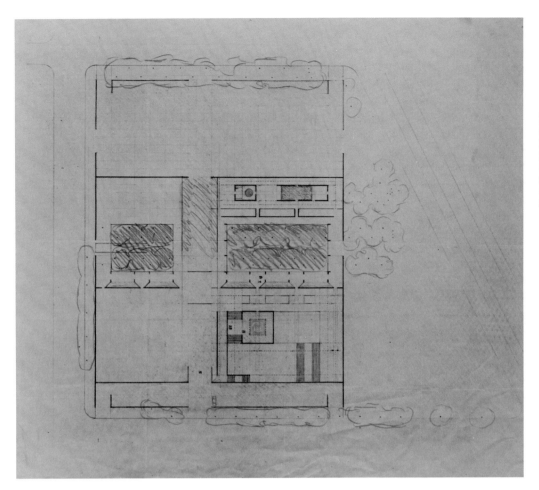

**3.13**
*Kimbell Art Museum. Plan, lower floor, first version.* Louis I. Kahn (office drawing). Louis I. Kahn Collection, University of Pennsylvania and Pennsylvania Historical and Museum Commission.

enclosed courtyards be reduced in size, and that the "central circulation artery, the 'galleria,' " be narrower. He thought the strip skylight and the circulation core of the plan a "brilliant solution," provided the axial unit was the right size and shape and appropriate in relationship to the vaults.

Before Kahn left for Pakistan (shortly after receiving Brown's letter), he made sketches and instructed his office about revising the design. One of these (July 1967) with gallery elevation and section and a schematic plan shows the return of the vault from the thirty-foot angular shape to a lower, gentler curve, closer to earlier sketches (fig. 3.14). An architect in his office described Kahn's revision to Brown as having walls of "cast concrete structural elements providing for solid wall infills of appropriate materials or doors or windows to other spaces or gardens."[34]

At the end of the summer Marshall Meyers returned to Kahn's office from his independent practice especially to assist in the development of the second design. A complete presentation, with exterior perspectives, elevations, and sketch plans, was ready in the third week of September.[35] The handsome charcoal perspective dated September 22, 1967, sketchy but firm (fig. 3.15; several other views were executed the same day), shows that the design continued to be long, low, and spreading. Porches behind pools stretch across the front. Maillol's sculpture *L'Aire*, which Brown acquired in 1967, figures as a centerpiece on the path between the pools, as seen in another presentation sketch of the front terrace with porticos to the left (fig. 3.16). In graphite and negro lead on the yellow tracing paper he favored, Kahn made an elegantly spare elevation of the east-west expanse, trees and sculptures suggested, with columned channels regularly spacing the vaulted units (fig. 3.17).

The design plan was very close to the first version: a rectangle for the auditorium and temporary exhibition galleries in the west near the main entrance, a narrow neck, and a larger eastern rectangle for the galleries (fig. 3.18). Kahn's later schematic plan for the gallery level, executed in charcoal, is worked over in his typical manner of rubbing out and overlaying as he considered sizes and locations of light wells and circulation patterns (fig. 3.19). The new plan no longer includes connecting north and south arcades and east portico; thus the garden courtyards with trees, formerly internal, open directly onto surrounding lawns.

**3.14**
*Kimbell Art Museum.
Schematic elevations and
sections.* **Catalogue 21.** Louis
I. Kahn. July 1967. Louis I.
Kahn Collection, University of
Pennsylvania and Pennsylva-
nia Historical and Museum
Commission.

**3.15**
*Kimbell Art Museum.
Perspective view from south-
west.* **Catalogue 22.** Louis I.
Kahn. September 22, 1967.
Louis I. Kahn Collection, Uni-
versity of Pennsylvania and
Pennsylvania Historical and
Museum Commission.

**3.16**
*Kimbell Art Museum. Perspective view of front, pools and sculpture from north.* Louis I. Kahn. Photograph, Kimbell Art Museum Archives.

Viewed from southwest and the northwest, Kahn's perspective sketches of the west front emphasize the regularity and repetition of the vaults, softened by trees and elements of the landscaping (figs. 3.15 and 3.20). The west pavilion consists of two longitudinal vaults plus a third as a porch, while the east consists of seven. The vaulted shape, now more spreading and Mediterranean, has a thin reflector, projected to be made of glass, beneath the skylight. These vaults are spaced alternately with flat channels, which in this second design have become Kahn's service spaces for ducts and conduits. He explained this in a section sketch that was part of the presentation (fig. 3.21).

Around this time, in November 1967, Kahn described the evolving Kimbell Museum in a talk delivered at the New England Conservatory of Music in Boston. Referring to the "museum in Texas" he was designing, he said:

> Here I felt that the light in the rooms structured in concrete will have the luminosity of silver. I know that rooms for the paintings and objects that fade should only most modestly be given natural light. The scheme of enclosure of the museum is a succession of cycloid vaults each of a single span 150 feet long and 20 feet wide, each forming the rooms with a narrow slit to the sky, with a mirrored glass shaped to spread natural light on the sides of the vault. This light will give a touch of silver to the room without touching the objects directly, yet give the comforting feeling of knowing the time of day. Added to the skylight from the slit over the exhibit rooms, I cut across the vaults, at a right angle, a counterpoint of courts, open to the sky, of calculated dimensions and character, marking them Green Court, Yellow Court, Blue Court, named for the kind of light that I anticipate their proportions, their foliation, or their sky reflections on surfaces, or on water, will give.[36]

**3.17**
*Kimbell Art Museum. Schematic site elevation.* **Catalogue 23.** Louis I. Kahn. September 27, 1967. Louis I. Kahn Collection, University of Pennsylvania and Pennsylvania Historical and Museum Commission.

**3.18**
*Kimbell Art Museum. Plan, gallery floor, second version.* Louis I. Kahn (office drawing). Louis I. Kahn Collection, University of Pennsylvania and Pennsylvania Historical and Museum Commission.

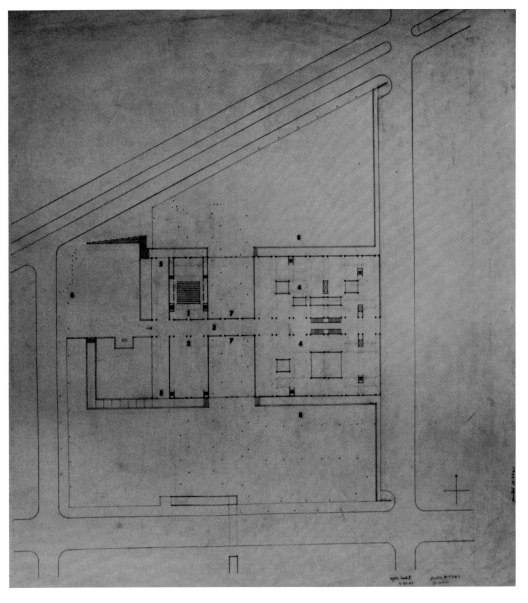

**3.19**
*Kimbell Art Museum. Schematic plan, gallery floor.* **Catalogue 24.** Louis I. Kahn. Louis I. Kahn Collection, University of Pennsylvania and Pennsylvania Historical and Museum Commission.

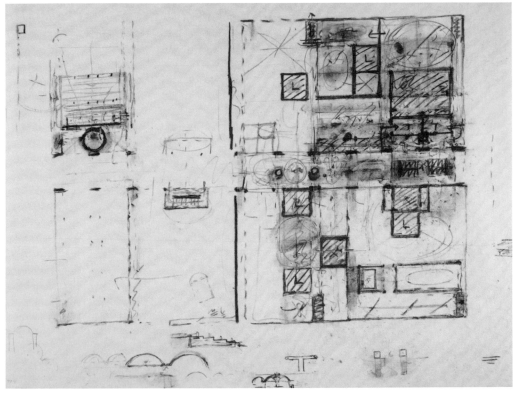

While many features were changed by the time the building was completed, his vision-ary description is remarkably acute in conveying effects in the rooms and courtyards as now realized.

Meyers researched ways of drawing the curve Kahn instinctively chose for the vault. This curve is seen in Kahn's sketch of elevations with various vaults, shown with figures among gardens with trees and several small studies of the Maillol probably made in preparation for a presentation drawing (fig. 3.22). It was Meyers who pro-posed using a cycloid curve, which is determined by tracing a single point on the cir-cumference of a circle rolled along a straight line of specified length. Meyers's drawing of December 7, 1967 (fig. 3.23), illustrates the scheme: concrete structure with stone infill, a glazed slit window between the stone and concrete vault, the roof leaded.[37]

Structural engineer August Komendant was consulted about the roof.[38] Komen-dant had worked with Kahn on the Richards Laboratories at the University of Penn-sylvania, the Salk Institute, and the Olivetti factory in Harrisburg, Pennsylvania, as well as several other projects. A shell construction (a speciality of Komendant) would cre-ate a lightweight roof of great strength spanning a large area and requiring relatively few support columns. Now that a vault was established, Edison Price, the lighting fix-ture fabricator who was to work with lighting consultant Richard Kelly on the Kimbell as he had on the Yale Art Gallery, was sent a sketch and asked for comments and advice on the shape for a reflector. Shortly thereafter, Kahn and Meyers went to Fort Worth for consultation.[39]

**3.20**
*Kimbell Art Museum. Per-spective view from northwest.* Louis I. Kahn. September 22, 1967. Louis I. Kahn Collection, University of Pennsylvania and Pennsylvania Historical and Museum Commission.

**3.21**
*Kimbell Art Museum. Sche-matic section of galleries.* Louis I. Kahn. September 22, 1967. Louis I. Kahn Collection, University of Pennsylvania and Pennsylvania Historical and Museum Commission.

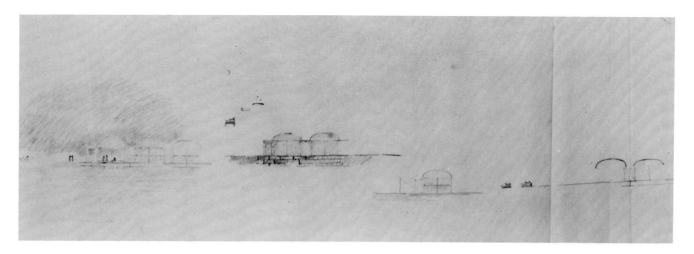

**3.22**
*Kimbell Art Museum. Schematic elevations, studies of vaults.* **Catalogue 25.** Louis I. Kahn. Louis I. Kahn Collection, University of Pennsylvania and Pennsylvania Historical and Museum Commission.

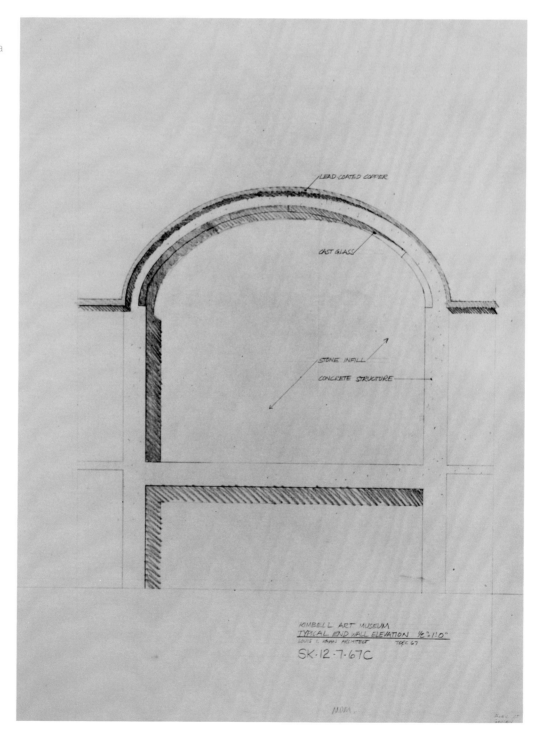

**3.23**
*Kimbell Art Museum. Elevation, typical end wall.* Louis I. Kahn (drawn by M. M.). December 7, 1967. Louis I. Kahn Collection, University of Pennsylvania and Pennsylvania Historical and Museum Commission.

A major change in the new plan was in the lower level, which became the service level, as it were, for the galleries upstairs. In slightly later versions of this plan, with area assignments recorded, there are four garden courts on the upper level among the permanent collection area (fig. 3.24) and five light wells that bring natural light to the lower floor, which has a grid of columns placed parallel to the flat channels (fig. 3.25). This service level contains offices, the library and research area, a double-height conservator's studio with light well providing north light, the museum workshops, shipping, receiving, storage areas, and a drive-in truck dock. On the east at this level is an open porch serving as an automobile drive-through for a central public entrance with a double stairwell for visitors to use to reach the gallery floor. The connecting unit between the pavilions is open on the lower level, with stairs to either side also giving access to the upper floor. The lower floor on the west pavilion has a lounge for receptions on the south.

Response to this design was very positive. Brown arranged for Kahn to present a model (fig. 3.26) and description of the building to the board at the end of November.[40] Afterward, Brown wrote to confirm the board's formal acceptance of the schematic design. "Everyone, unanimously and wholeheartedly, is extremely pleased with the philosophy, concept, style, function and general layout of the proposed building."[41] Whatever inevitable adjustments might be made — some already had been discussed in Fort Worth — Brown considered the schematic phase over. While Kahn was in Texas, arrangements were made by a foundation publicist for Peter Plagens and Howard Smagula to publish the design at the time of a general press release in February 1968. Writers from several publications were already interested in illustrations of the design.[42]

In a second letter listing his concerns, however, Brown wrote of aspects he wished to see reconsidered.[43] The board asked for expanded parking, possibly on the west side of the site, and Brown thought this a good idea because he wanted the east entrance to be "strictly a back door." The east parking area could be for staff. Kahn had agreed to remove the last bay on the east on the upper level and the portico below it, for it would not be possible to shift the whole building forward on the site because of the trees (see site plan, fig. 3.27, which still shows the seventh bay). Landscape architect George Patton, after consulting with Kahn in November and December, traveled to Fort Worth to view the site in January.[44]

Brown thought more space was needed for the museum bookstore and suggested widening the axial corridor for it at the connector, although he liked the existing narrowness, considering it a bridge between the two parts of the building. The auditorium stage would be used most frequently for lectures and films. For a museum, little stage storage would be necessary. The reception, dining, and catering area would need special stairs and elevators not yet provided on the plan. He thought that the service-level floor should be continuous, without the interruptions of unexcavated ground ("flower pots") beneath garden courts.[45] Brown made himself Kahn's apprentice through his complete involvement with the developing plans.

In January 1968 estimates were made on the schematics approved by the trustees, after involved preparations by the architects' offices and their individual estimators. Among the documents used was Komendant's typical structural section of the shell roof (including reinforcing, prestressing, and outline specifications, fig. 3.28).[46] Brown's estimate for the total linear feet needed for exhibition included his suggestion to use wood paneling for English eighteenth-century, traditional Baroque, and later Renaissance paintings as well as fine linen fabric, rough-textured fabric, and special period cloth coverings.[47] Patton's landscaping estimates, based on the Pre-Architectural Program and on observations made in Fort Worth, were not ready until February 1968.[48] Information on the "glass reflector and lighting fixture," which Meyers called a "beam splitter," was included with outline specifications.[49]

Adjustments were made to lower costs (bronze was changed to stainless steel, and stone floors became 20 percent stone and 80 percent wood, for example). Summaries in February by Meyers showed Geren's estimate to be $5,527,120, or, with site

**3.24**
*Kimbell Art Museum. Plan, gallery floor, second version.* Louis I. Kahn (office drawing). Louis I. Kahn Collection, University of Pennsylvania and Pennsylvania Historical and Museum Commission.

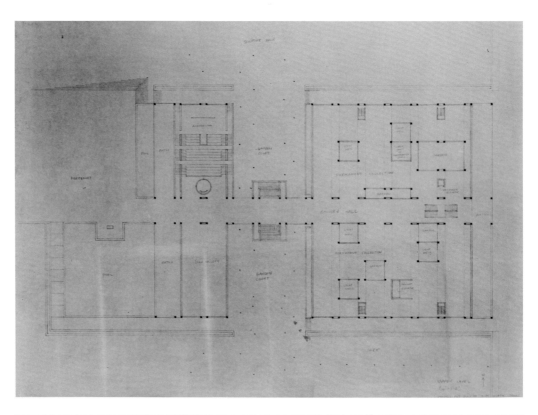

**3.25**
*Kimbell Art Museum. Plan, lower floor, second version.* Louis I. Kahn (office drawing). Louis I. Kahn Collection, University of Pennsylvania and Pennsylvania Historical and Museum Commission.

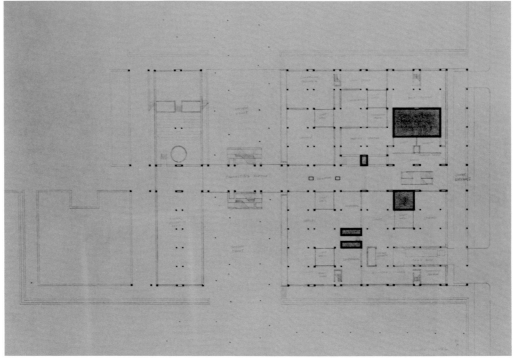

work and landscaping included, $6,225,120. Kahn's estimator arrived at a figure of $5,118,450 for the building and $6,162,961 as a grand total. Further revisions resulted in another summary with totals of $6,160,120 (Geren) and $5,108,596 (Kahn) for the board of directors to consider. They retained the budget of $6,500,000 for all expenses, and Brown and his staff then decided to scale down the service level to reduce cost. Brown also wanted site work simplified. Lighting fixtures and interior partitions could be fewer because not all the galleries would be in use when the museum

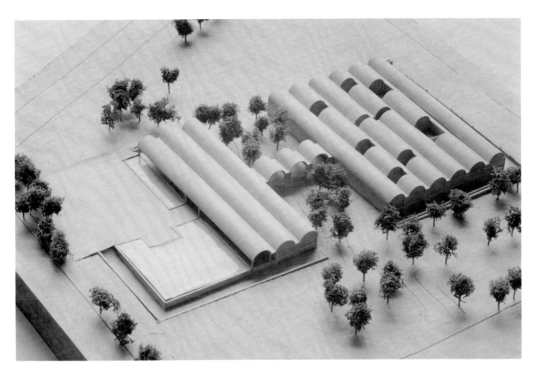

**3.26**
*Kimbell Art Museum. Model, second version.* **Catalogue 26.** Louis I. Kahn. Kimbell Art Museum.

**3.27**
*Kimbell Art Museum. Schematic site plan, building plan.* **Catalogue 27.** Louis I. Kahn (office drawing). Louis I. Kahn Collection, University of Pennsylvania and Pennsylvania Historical and Museum Commission.

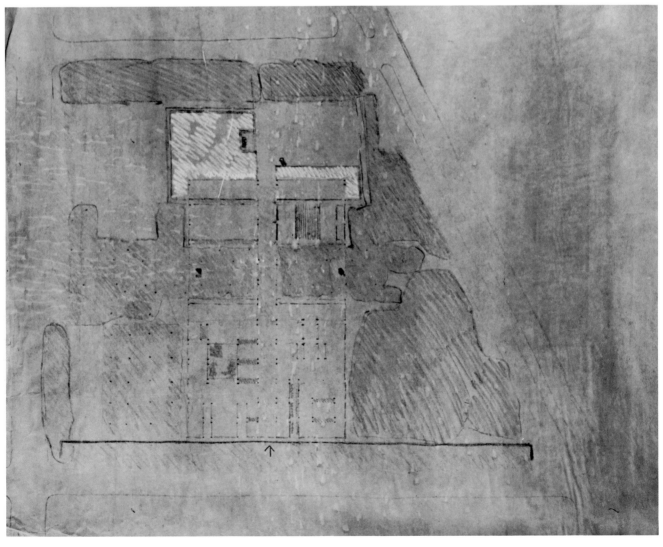

**3.28**
*Kimbell Art Museum. Section of vault.* Louis I. Kahn. August Komendant drawing. January 12, 1968. Louis I. Kahn Collection, University of Pennsylvania and Pennsylvania Historical and Museum Commission.

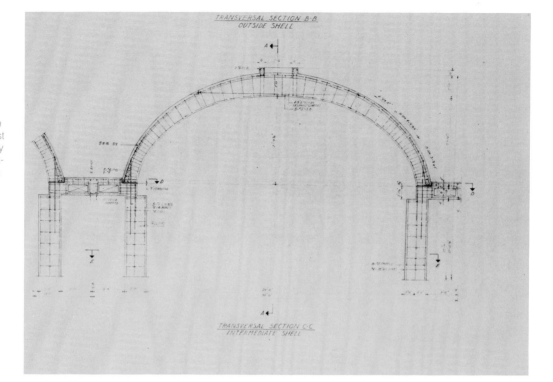

**3.29**
*Kimbell Art Museum. Schematic plan, service level.* **Catalogue 28.** Louis I. Kahn. June 3, 1968. Louis I. Kahn Collection, University of Pennsylvania and Pennsylvania Historical and Museum Commission.

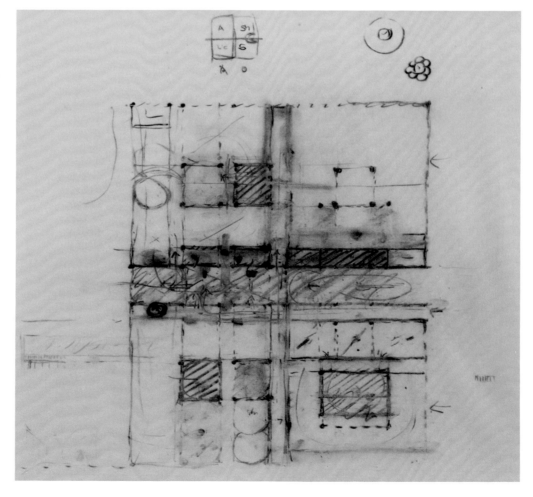

opened. Brown's suggestion was to remove one bay (making five instead of six on the east) and to reduce the width of the building by ten feet.[50]

These revisions were only the beginning. Over the next few months attempts to bring down costs went on, but the design remained essentially the same. Kahn prepared a sketch (fig. 3.29) that tried to meet Brown's concerns for efficiency in the organization of the service area. His office made another at Brown's suggestion with only

three light wells on the lower level (one for the conservator on the south, one for administration, and one for curatorial research).[51] Kahn also experimented in plan and section with schemes for the auditorium (figs. 3.30 and 3.31). After all was said and done, the most significant modification was the reduction in dimensions;[52] basic design changed relatively little. On August 15, 1968, a comparison of sizes was prepared by Brown to accompany a suggestion for yet further reduction.[53]

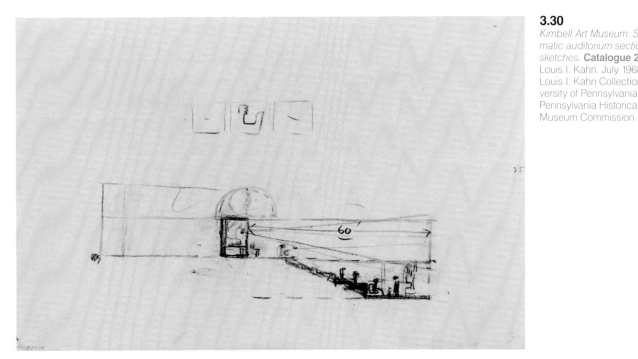

**3.30**
*Kimbell Art Museum. Schematic auditorium section, sketches.* **Catalogue 29.** Louis I. Kahn. July 1968. Louis I. Kahn Collection, University of Pennsylvania and Pennsylvania Historical and Museum Commission.

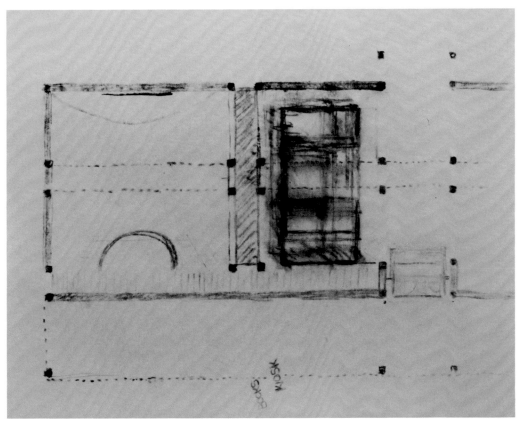

**3.31**
*Kimbell Art Museum. Schematic plan for auditorium and bookstore, entrance, portico.* **Catalogue 30.** Louis I. Kahn. Louis I. Kahn Collection, University of Pennsylvania and Pennsylvania Historical and Museum Commission.

Brown met with Kahn in Philadelphia on August 19 and 20, 1968, "to work out final layout in the service areas," an encounter which, as matters turned out, was pivotal for the building's design.[54] Still seeking improved relationships, Kahn sketched a plan for the service level on August 20 (fig. 3.32). Expansion of the axial center had been attempted in June and July, and plans were drawn with a larger connector (gallery level, fig. 3.33, and service level, fig. 3.34). One of Kahn's sketches for the temporary exhibition gallery, lounge, and bookstore shows that he considered a major expansion of the three connector vaults (fig. 3.35), and a general site plan echoes this (fig. 3.36). The vaults appear to lack intervening channels where they are enlarged between the two pavilions. Perhaps their extensions covered courts. Apparently the scheme was not developed further, and no plans exist. But Kahn's complete freedom to boldly reconsider rather than make mere adjustments bespeaks his vitality and creativity when stimulated to work on the design.

A charcoal drawing of August 24, 1968, schematic and freshly recorded, suggests a changing layout (fig. 3.37). With site plan, building plan, and elevations, it points to an emerging new idea that was to lead to the third design scheme. Kahn conceived a new relationship for the parts of the building, and he took a completely new tack. By September 26 new plans, elevations, sections, and various renderings of a new design were sent to Brown (see figs. 3.38, 3.39, and 3.40).[55] According to Meyers, this change came about because Brown realized that there would be times between temporary exhibitions when the galleries at the front entrance would be empty, making a disappointing introduction for visitors arriving at the museum.[56] But this perception encouraged Kahn's ever-present interest in reworking. It was part of his struggle to find what the building "wanted to be." Brown assisted him by raising questions that stirred him with new points of view. A sketch plan for the auditorium, the temporary exhibition gallery, a courtyard, and a reception area and kitchen for caterers indicates by a simple arrow pointing toward the entrance that, even if no loan installation were in place, the visitor would not be faced by a large, negative space (fig. 3.41).

The most obvious changes in the third design are seen in the building's shape and its relationship to the oddly configured trapezoidal site. Now the building consists of a central unit with two north and south wings projecting to either side and forming a forecourt. It is the Beaux-Arts scheme of the University Museum and the Philadelphia Museum. The architect was constantly aware of the importance of landscape; one site plan even has color to heighten its qualities (fig. 3.42). The complete museum with its recessed forecourt is located on the site's east end, behind the rows of trees, and the perimeter of the site there is enriched with plantings. The same is true of the far western

**3.32**
*Kimbell Art Museum. Schematic plan, service level, studies.* **Catalogue 31.** Louis I. Kahn. August 20, 1968. Louis I. Kahn Collection, University of Pennsylvania and Pennsylvania Historical and Museum Commission.

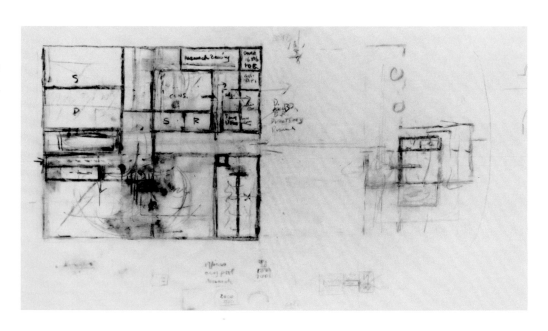

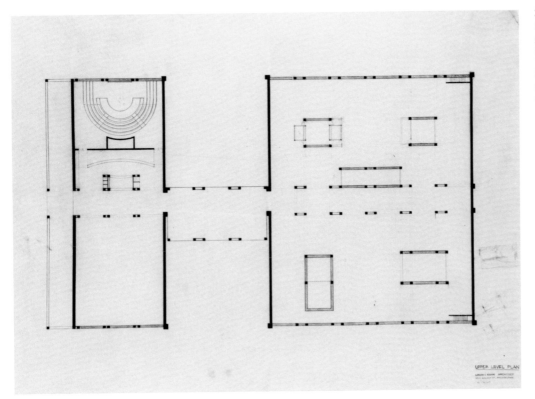

**3.33**
*Kimbell Art Museum. Plan,
gallery floor.* Louis I. Kahn
(office drawing). June 26,
1968. Louis I. Kahn Collec-
tion, University of Pennsylvania
and Pennsylvania Historical
and Museum Commission.

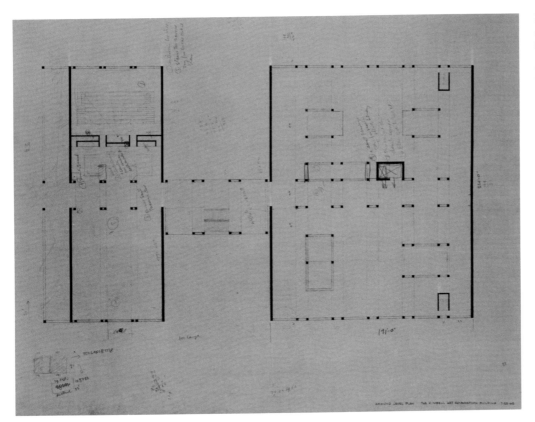

**3.34**
*Kimbell Art Museum. Plan,
gallery floor with notations.*
Louis I. Kahn (office drawing).
July 23, 1968. Louis I. Kahn
Collection, University of Penn-
sylvania and Pennsylvania
Historical and Museum
Commission.

**3.35**
*Kimbell Art Museum. Sche-matic plan for lounge, bookstore, and loan gallery, connector.* **Catalogue 32.** Louis I. Kahn. August 20, 1968. Louis I. Kahn Collec-tion, University of Pennsylvania and Pennsylvania Historical and Museum Commission.

**3.36**
*Kimbell Art Museum. Sche-matic site plan, intermediate version.* Louis I. Kahn. Louis I. Kahn Collection, University of Pennsylvania and Pennsylva-nia Historical and Museum Commission.

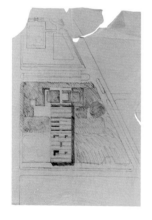

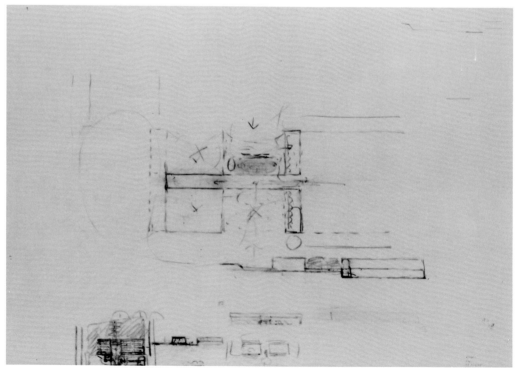

**3.37**
*Kimbell Art Museum. Sche-matic site and building plans, elevations studies, section.* **Catalogue 33.** Louis I. Kahn. August 24, 1968. Louis I. Kahn Collection, University of Pennsylvania and Pennsylva-nia Historical and Museum Commission.

edge, as shown in the small sketch. Although Patton did not send his landscape plan to Kahn and Brown until February 1970, the concept seems to have been discussed with Kahn and established very early. Patton's continuing involvement with revisions emphasizes the importance of the park setting for the Kimbell Art Museum, which is unique among Kahn's three constructed museums. In his statement on the landscape plan Patton wrote:

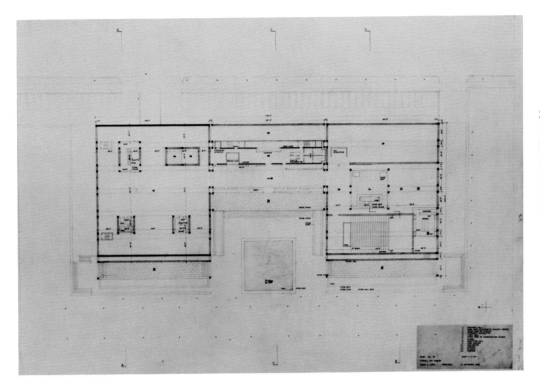

**3.38**
*Kimbell Art Museum. Plan,*
*gallery floor, third version.*
Louis I. Kahn (office drawing).
September 25, 1968. Louis I.
Kahn Collection, University of
Pennsylvania and Pennsylva-
nia Historical and Museum
Commission.

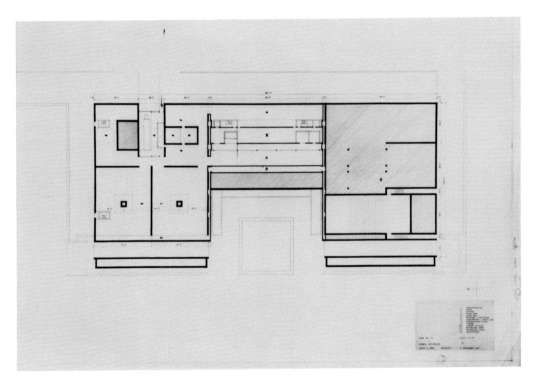

**3.39**
*Kimbell Art Museum. Plan,*
*service floor, third version.*
Louis I. Kahn (office drawing).
September 25, 1968. Louis I.
Kahn Collection, University of
Pennsylvania and Pennsylva-
nia Historical and Museum
Commission.

The landscape architects believe their design proposal for the Kimbell
Museum will extend the civilized environment of the museum beyond its
walls to the limits of the site and in a manner that the structure and the land-
scape will fuse intrinsically. Three major concerns influenced the develop-
ment of this design.

The first, to enrich the amenities of city boundaries and ways of approaching
the museum;

the second, to convey an offering of a particular landscape element—water
—in the spirit of aesthetic generosity exemplified by the museum's founders;

the third, to provide diverse experiences of the site at different seasons of the
year, and absorb large numbers of visitors without apparent crowding.[57]

**3.40**
*Kimbell Art Museum. Site plan.* Louis I. Kahn (office drawing). September 25, 1968. Louis I. Kahn Collection, University of Pennsylvania and Pennsylvania Historical and Museum Commission.

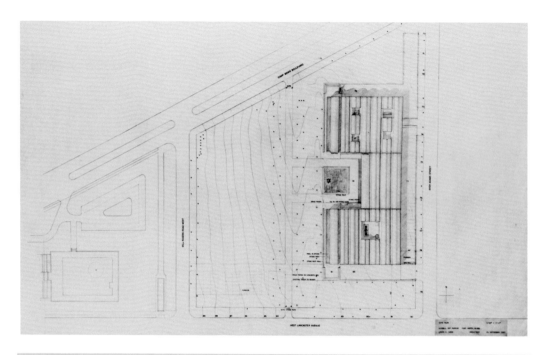

**3.41**
*Kimbell Art Museum. Schematic auditorium plan, sketches.* **Catalogue 34.** Louis I. Kahn. September 1968. Louis I. Kahn Collection, University of Pennsylvania and Pennsylvania Historical and Museum Commission.

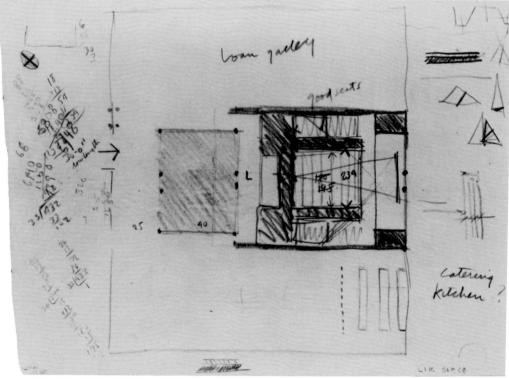

The link between the landscape, on the one hand, and the building and its approaches, on the other, had been close from the beginning, though one might think it diminished by the new placement behind rows of trees. Patton's concept was of "green rooms" — five outdoor spaces in the landscape related to the museum. Even the broad expanse of lawn to the west that he called the "park" was one of these:

An open lawn which can be traversed at any point is an invitation to all ages providing freedom of movement, an expanse of sky and a domain which gives scale and dignity, without a trace of austerity, to the distant view of the museum.

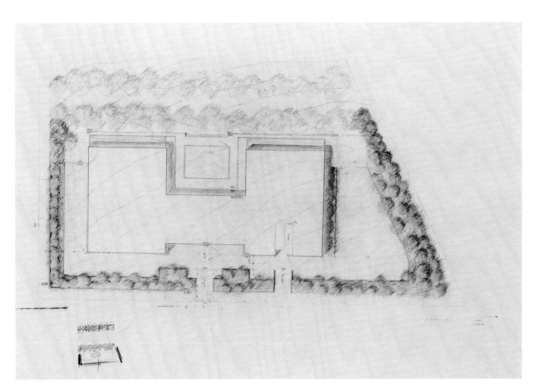

**3.42**
*Kimbell Art Museum. Sche-
matic and drafted site plans.*
**Catalogue 35.** Louis I. Kahn.
October 29, 1968. Louis I.
Kahn Collection, University of
Pennsylvania and Pennsylva-
nia Historical and Museum
Commission.

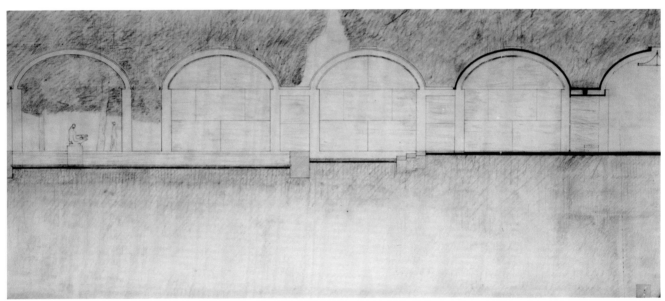

**3.43**
*Kimbell Art Museum. Sche-
matic and drafted site
section.* Louis I. Kahn (office
drawing). Louis I. Kahn
Collection, University of
Pennsylvania and Pennsylva-
nia Historical and Museum
Commission.

The above described green spaces and waterways generously extend the invitation to humanism offered by the museum to those who may not yet have crossed its threshold and give refreshment of spirit to others who are familiar with its treasures. Modest, varied, open to improvisation and free of artifice, these grounds may also become the fulcrum of other cultural and institu-tional buildings expected to rise nearby.[58]

By November 15, 1968, phase two of the hard-line architectural drawings began. The design was for a large building, the vaults described variously by Meyers as 150 feet long and 20 feet across in October and as 116 feet long and 24 feet across in November.[59] At the main entrance, reflecting pools are located before the side porti-cos, and a larger pool with the Maillol sculpture is in the forecourt (see the section, fig. 3.43). The entrance is in the center of the circulation axis that now runs north-south instead of west-east as before (fig. 3.44). The north wing contains galleries and four courtyards, one of which is completely enclosed on this level because it is for the con-servator's studio on the lower floor. These galleries have an open plan, with only the exterior walls and the walls of the courts fixed. The south wing has a large courtyard spanning two vaults, the auditorium (also the width of two vaults), a reception or dining

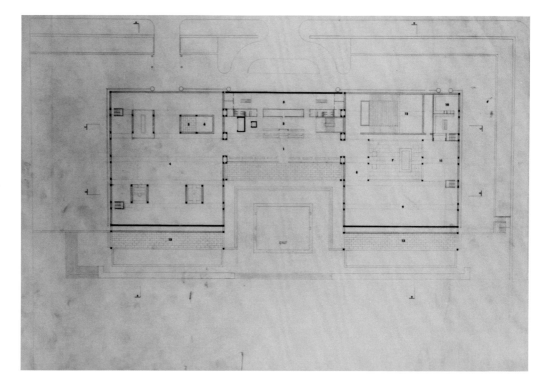

**3.44**
*Kimbell Art Museum. Plan, gallery floor.* Louis I. Kahn (office drawing). November 14, 1968. Louis I. Kahn Collection, University of Pennsylvania and Pennsylvania Historical and Museum Commission.

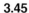

**3.45**
*Kimbell Art Museum. Plan, service floor.* Louis I. Kahn (office drawing). November 14, 1968. Louis I. Kahn Collection, University of Pennsylvania and Pennsylvania Historical and Museum Commission.

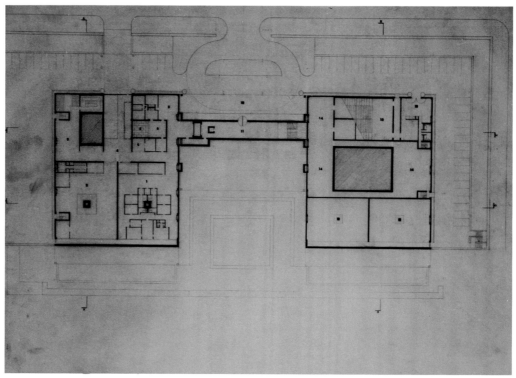

area with adjacent kitchen, and galleries for temporary exhibitions. Besides the entrance lobby and its portico, the center of the building has the bookstore, main stairwell and elevators, public toilets, and the staff library with short balconies on either end. There is simplicity, logic, and spaciousness in the plan.

On the lower floor, the service level for the museum, the center (with the library floor above forming a portico) has a public entrance adjacent to a drive-through, the "back door" Brown had requested, and a lobby with stairs and elevator (fig. 3.45). Otherwise, with the exception of the stage and lower part of the auditorium, the floor is devoted to operational, curatorial, and administrative purposes. In the south is a special caterer's or service entrance with kitchen facilities and various machine rooms. The north wing has a drive-in truck entrance along with a shipping and receiving area, offices, shops, conservator's studio, and storage. Natural light would come through the conservator's court and under the long, narrow light well along the west wall. The plan

**3.46**
*Kimbell Art Museum. Model, third version.* **Catalogue 36.** September 1968. Kimbell Art Museum.

has two large unexcavated areas in the lower level, beneath the large south courtyard and the northeast court of the north wing. A basswood model, the largest and the last made for the Kimbell Art Museum before construction, represents this scheme (fig. 3.46).

Brown still had reservations about the scale of the new project. He called it "huge" when writing a note to Kahn from Saarinen's Dulles Airport, comparing its scale to that of the new plans and signing himself "Richard the Chickenhearted."[60] But he urged work forward even as he questioned and commented on plans. He approved changes made in October and November to place the building slightly farther to the west on the site, to rearrange and reduce some interior spaces, to create the east public entrance noted above, and what he considered satisfactory parking arrangements. Due to the urgency communicated by the board of directors to begin construction soon, however, he complained of a lack of progress on the working drawings that he wanted to present to the board at the November meeting.[61] In response to his demands, outline specifications, room finish schedule, and drawings sufficient for an estimate were sent to Geren's office at the end of 1968.[62]

## Construction

While some aspects of the design were still being reconsidered during the late fall of 1968, the Geren firm was preparing working drawings, consulting the mechanical and electrical engineers (Cowan, Love, and Jackson), and sending Kahn samples of stone.[63] Komendant's clarification of the structural system was important to the associate architect and to the contractor, A. T. Seymour III of the Thomas Byrne Construction Company, who was chiefly responsible for making the estimate. Both he and Geren were doubtful about the shell roof, and Komendant was brought to Fort Worth for discussions in early February. In the first months of 1969 information was gathered and decisions were made in preparation for the estimate and eventual construction,[64] and in early March an initial figure was presented by Seymour: $7,989,000, with certain exclusions and qualifications, over a two year construction period from July 1, 1969, to July 1, 1971.[65]

Since the estimate was well above the limit, Brown requested a further review after changes and deletions.[66] Kahn advised Brown to accept Seymour's figure and to work with the builder to bring the cost down. Seymour proposed a fixed fee contract (as at Yale with the Macomber Company) with maximum cost guaranteed, which would allow work on the foundations to begin while working drawings were prepared.[67] The Byrne Company was retained as contractor after a late March board meeting. Geren wrote Kahn of the decision to employ Thos. S. Byrne, Inc., under a negotiated contract,

**3.47**
*Kimbell Art Museum. Plan, gallery floor.* Louis I. Kahn (office drawing). March 19, 1969. Louis I. Kahn Collection, University of Pennsylvania and Pennsylvania Historical and Museum Commission.

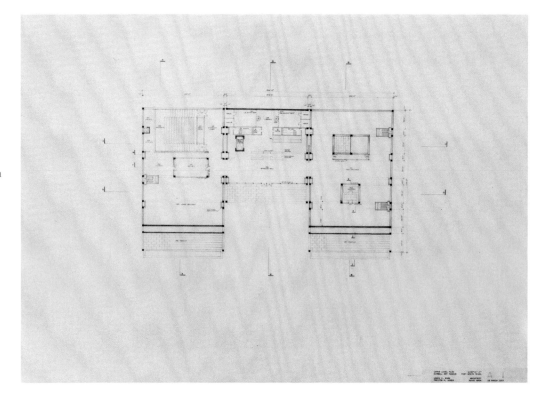

**3.48**
*Kimbell Art Museum. Plan, service floor.* Louis I. Kahn (office drawing). March 19, 1969. Louis I. Kahn Collection, University of Pennsylvania and Pennsylvania Historical and Museum Commission.

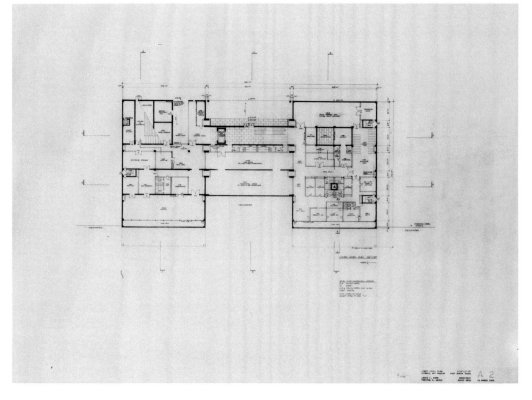

explaining that the record of competent and responsible work by the firm was persuasive. They had built the Amon Carter Museum, and Geren considered their workmanship on it "beyond criticism."[68] Geren asked that sketches for revised layouts be completed as soon as possible so that working drawings could advance. In a May 1 meeting, final contractual agreements and procedures were agreed upon. "Appropriate" drawings were to be furnished to the contractor by June 1 with the assumption that design development would continue.[69]

Revisions begun March 19, 1969, were thus the result of changes after the estimates, and they reflect a smaller building, 318 feet by 174 feet compared to an earlier 418 feet by 270 feet (figs. 3.47, 3.48, and 3.49). Kahn continued working on plans (see sketch plan for the service level, fig. 3.50). One of Geren's architects suggested excavating what had been planned merely as crawl space beneath the museum, and this

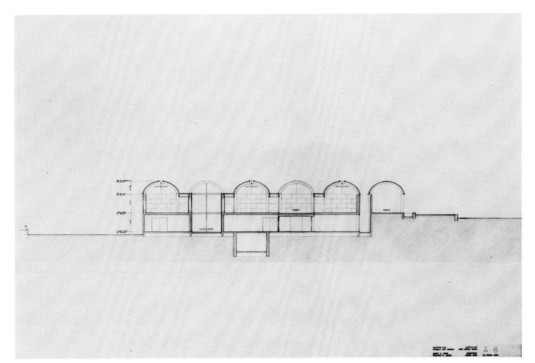

**3.49**
*Kimbell Art Museum. Section.*
Louis I. Kahn (office drawing).
March 19, 1969. Louis I. Kahn
Collection, University of Penn-
sylvania and Pennsylvania
Historical and Museum
Commission.

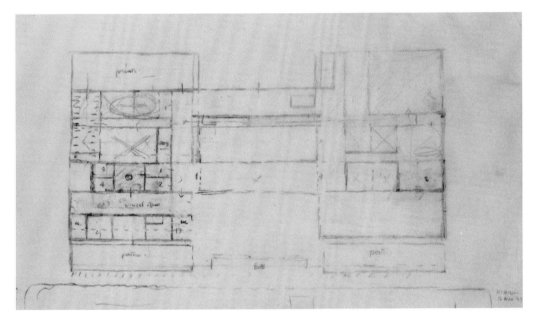

**3.50**
*Kimbell Art Museum. Sche-
matic plan, service level.*
**Catalogue 37.** Louis I. Kahn.
March 16, 1969. Louis I. Kahn
Collection, University of Penn-
sylvania and Pennsylvania
Historical and Museum
Commission.

led to the creation of an additional level, a basement, to allow complete access for ser-
vice and increase storage.[70] The basement evolution was not Kahn's own doing, but it
was one to which he responded. (He had responded similarly to the electrical sub-
contractor at Yale whose suggestion concerning power for outlets also improved the
gallery's flexibility.) Brown was concerned about varying floor levels at the truck entry
and dock. Kahn's east elevation (fig. 3.51) had included the truck entrance in that long,
elegant expanse. Brown now suggested shifting the entry to the north side of the build-
ing in order to circumvent this problem entirely.[71] Consequently, the entrance for cater-
ers was eliminated, and the two wings were reversed eventually.

The auditorium also evolved. Kahn's sketched plan of March 16, 1969, extends it
across two vaults in the southeast of the building (fig. 3.52). But by May 20 a new vari-
ant was presented to Brown with the auditorium under a single vault and a channel; its
seating capacity reduced to two hundred.[72] Meyers suggested that film and slide pro-
jection could be beamed from the mezzanine of the adjacent library. (The "expansion
joint" separating the three sections of the structure had not yet evolved.) At the same
time the large garden court was made thirty-six feet square: Meyers thought this a
good proportion for dining as well. The space immediately east of the courtyard,
today's restaurant, was contemplated as useful for receptions or occasional formal
dinners.

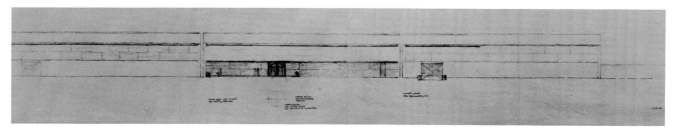

**3.51**
*Kimbell Art Museum.*
*Schematic east elevation.*
**Catalogue 38.** Louis I. Kahn.
Louis I. Kahn Collection, University of Pennsylvania and
Pennsylvania Historical and
Museum Commission.

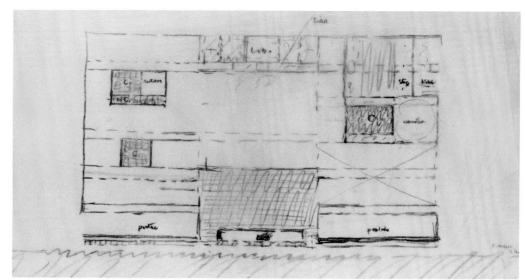

**3.52**
*Kimbell Art Museum. Schematic plan, gallery floor.*
**Catalogue 39.** Louis I. Kahn.
March 16, 1969. Louis I. Kahn
Collection, University of Pennsylvania and Pennsylvania
Historical and Museum
Commission.

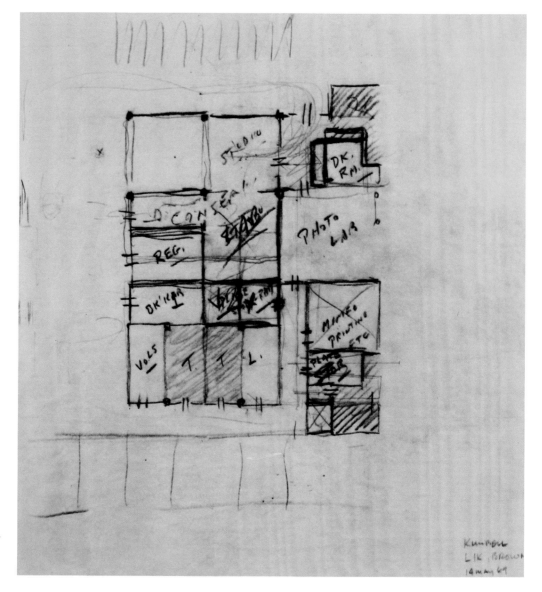

**3.53**
*Kimbell Art Museum. Schematic partial plan, service level, south wing.* Louis I.
Kahn and Richard F. Brown.
May 14, 1969. Louis I. Kahn
Collection, University of Pennsylvania and Pennsylvania
Historical and Museum
Commission.

As part of the same revision, the building was enlarged on the east to create space on the lower level for public toilets beside the lobby (rather than on the upper floor), while the main stairs were put on its west side. Brown and Kahn worked together over the layout of offices, photography, and conservation areas, and produced a joint sketch plan approximating final arrangements on May 14, 1969 (fig. 3.53).

The agreement reached between the foundation and the construction company scheduled preliminary excavations in July.[73] The sheer rapidity of changes provoked Geren to complain of "considerable pressure on my firm for preparation of working drawings." The contract, he recalled in his letter, had specified time for schematic drawings; one stretch was set aside for preliminary working drawings and still another for final drawings and specifications.[74] He pleaded for prompt review by Kahn's office and also for frequent telephone consultation. Despite these concerns, an official ground-breaking ceremony took place on July 30, 1969. Kahn was unable to attend but sent Mrs. Kimbell a charming sketch of the museum in its setting of trees, lawns, and courts, explaining the garden environment in his letter (fig. 3.54).

Plans for the building were essentially established when construction began but nevertheless remained general. Brown warned Kahn that Geren had reported to the board that there had been additional changes by Kahn after an agreed cutoff time.[75] No doubt this was true. Geren and Kahn had different approaches to design and building. Kahn thought that the two should evolve together, while Geren thought of them as discrete stages or phases in a building's realization. It did not seem unusual to Kahn to proceed before all decisions were made and all problems solved. These divergent manners of working were to become increasingly troublesome as construction progressed. Brown became convinced that with Kahn's flexibility better and eventually more economical solutions had been and would again be found. At the same time he wanted drawings produced in a timely manner.[76]

Foundation plans were ready in June, but later than desired by the builder. Komendant's complete structural design was arranged separately by the Geren firm. They asked for consultation services for floor slab through roof and requested that he check shop drawings and make site visits for supervision.[77] Before agreeing, Komendant proposed that he alone should decide the work and coordination schedule and the methods of construction. He also wished to coordinate the architects with the general contractor.[78] Komendant was instrumental in reducing the number of columns on the lower level by designing a lightweight slab construction for the gallery floor. Structural drawings were sent to the architects in August with instructions that changes were to be received by Komendant, by a specified date, after which he would complete them, showing reinforcing.[79] He also arranged for the concrete tests.[80] In early September he brought his drawings to Fort Worth accompanied by Fred Langford, a concrete formwork consultant to Kahn.[81] Komendant's international reputation as a specialist in shell construction and his prompt productiveness with drawings instilled confidence in the associate architect and the builder, a fact that helps account for the important role he played, quite aside from his expertise.

Just as the same travertine used at the Salk Institute was chosen for the Kimbell, the Salk concrete served as a standard in Kahn's office for superior architectural concrete. The Kimbell travertine was specified by Kahn to come from exactly the same quarry used for the Salk stone. He was assured by the importer that his samples derived from that source. The first sample had a honed finish rather than the rough-sawn finish of Salk travertine.[82] Actual pieces of travertine that Kahn brought back from the site in California were used for matching color.[83] Various concrete examples proposed for the Kimbell building were sent to Philadelphia. After seeing them, Kahn recommended adding pozzolan (volcanic ash), which had been used to enhance the color's warmth at Salk. Meyers even reported that a Los Angeles supplier had a "Salk mix" that I. M. Pei used for buildings at the University of Southern California. Kahn, of course, preferred local materials whenever possible, especially for concrete.[84]

Seymour expressed concern over the added cost for pozzolan, but apparently welcomed advice from Fred Langford, who had collaborated with Kahn on formwork

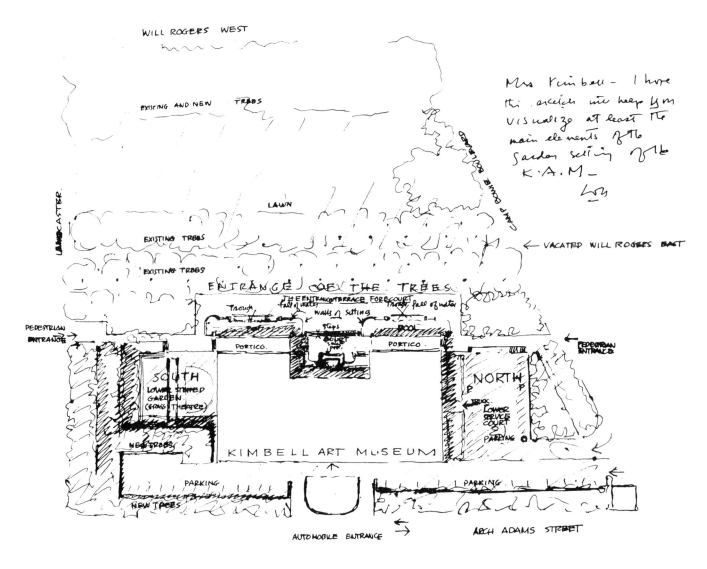

**3.54**
*Kimbell Art Museum. Sketch of site plan and letter.* **Catalogue 40.** Louis I. Kahn. June 25, 1969. Kimbell Art Museum.

for concrete both at the Salk Institute and on buildings in Dacca. Hence Langford was asked for a proposal on special details.[85] Though he worked on the Kimbell project from July 1969 through May 1970, he did not receive the recognition of an appointment as special consultant, despite Kahn's conviction of the importance of his contribution.[86] Instead, he worked in Philadelphia as Kahn's adviser and did not return to Fort Worth after December 1969, although his drawings were sent and used. Kahn was intimately concerned with materials and demanded their precise use. Concrete and travertine were to be handled exactly as his specifications stated. His sketched versions of ways of joining travertine panels on the vault end walls suggest how intently he considered this detailing (fig. 3.55).

Design changes continued as working drawings were developed. In one case, the architects working on these found it difficult to fit in all the equipment and plumbing for the public toilets in the narrow rooms to either side of the east entry. They suggested relocating these rooms to the opposite side of the lobby, where space could be taken from the mechanical room without difficulty.[87] In another case Kahn and Geren discussed partitions for the offices. Geren proposed suspended ceilings to facilitate the flexible arrangements that Kahn wanted. Though he agreed to any change in partitions, Kahn felt (as he had earlier at Yale) that hung ceilings would be unacceptable.[88] They did not conform to his principles of correct and honest architectural expression. Another late change, however, was carried out when Brown requested an enlarged freight elevator with front and rear doors. Revisions to accommodate this and its loading platform, dated August 20, 1969, reduced the size of the pantry.[89] Drawings for the lower level were revised again on August 26, 1969.

Dear Mrs Kimbell:                                    Wednesday June 25 '69

I plan to come to see you soon to show and explain the garden ideas I have surrounding the Kimbell Art Museum. I hope you will find my work beautiful and meaningful.

The entrance of the trees is the entrance by foot which links Camp Bowie Boulevard and West Lancaster Ave. Two open porticos flank the entrance court of Terrace. In front of each portico is a reflecting pool which drops its water in a continuous sheet about 70 feet long in a basin two feet below, the sound would be gentle. The stepped entrance court passes between the porticos and their pools with a fountain, around which one sits, on axis designed to be the source of the portico pools. The west lawn gives the building perspective.

The south garden is at a level 10 feet below the garden entrance approached by gradual stepped lawns shaped to be a place to sit to watch the performance of a play music or dance the building with its arched silhouette acting as the back drop of a stage. When not so in use it will seem only as a garden where sculpture acquired from time to time would be.

The North garden though mostly utilitarian is designed with ample trees to shield and balance the south and North sides of the building

The car entrance and parking is also at the lower level running parallel to Arch Adams street. This end too is lined with trees designed to overhang the cars as shelter. For this we must choose the right tree whose habits are respectful to the car tops.

When I see you I expect to bring a model which showed say more than my little words

By now you know that I cannot be present at the ground breaking ceremony. Unfortunately I have emergency duties in India at the same time. In my absence I wish everything well.

I am confident that the work will progress well from now on. I believe everyone believes in the building and its good purposes

I expect to return from India by the 12th of July. I will need a few weeks to firm up the material I hope to present to you for discussion.

                    Sincerely yours
                    Lou I Kahn

After initial work on excavation, pier foundations, and preparations for walls under the lower floor, work on the site slowed until Komendant had revised the structural drawings, and new mechanical and electrical drawings were in hand. Construction was complicated by the death of the elder Geren in September. His son, Preston M. Geren, Jr., took over the office but was not as familiar with the project. At this point Seymour foresaw that work might come to a halt for lack of information.[90] Experimental and sample pours of concrete were continued while construction below ground level went on. Kahn viewed concrete samples with travertine pieces and made his selections. Pumping problems developed with the concrete chosen, and attempts were made to duplicate the color with other materials.[91] Kahn viewed samples again in December and in February, and at last chose one using local cement and sand.[92]

Kahn took an interest in sketching special features of the museum. He was preoccupied, for example, by the courtyards, so important to the general scheme and to introducing natural light into the interior. Water, already described by Patton in his landscape plan as a symbol of generosity on the part of the Kimbells, came up again in Kahn's letter to Mrs. Kimbell as an integral part of his ideas for the museum. Reflecting pools and a fountain in the forecourt offered a place to sit and rest. Water played a role in the courts, as did trellises. His sketches for these were idea drawings (figs. 3.56 and 3.57). The kitchen had been a subject of thought for the owner, consultants, and assistants since January, but much of the time was spent deciding upon and arranging equipment, ductwork, and venting. Its design was not final until May 1970.[93] Kahn's sketch integrates the kitchen into the vaulted interior, conferring on it a simple dignity normally unexpected for such a space (fig. 3.58).

Yet another functional part of the museum special to Kahn was the library. While it did not have the same significance in the Kimbell program as the libraries in his later Yale Center for British Art, as a book lover he strove for both special character and practical arrangement. (He was at work simultaneously on the library for Phillips Exeter Academy in New Hampshire, and he received the commission for the Yale Center for British Art in late summer 1969.) Kahn first imagined the library on two floors. With the reduction of the building's size, the library was scaled down. In an effort to preserve the sense of vaulted space, he planned two balconies or mezzanines with staircases at the ends in a sketch almost like an ideogram (fig. 3.59).[94]

In December 1969 he changed this to a single mezzanine floor in a drawing prepared to offer Brown alternatives (fig. 3.60).[95] The plan already included motorized, compact shelving and the central stairwell wrapped around a small book elevator or dumbwaiter. Although the microfilm room was to disappear, and the number of compact ranges on the south was to be reduced, the arrangement in this plan is close to that of the existing library. On the mezzanine Kahn proposed alternative suggestions for studies at the two ends; neither was used, as it turned out. Komendant surmised

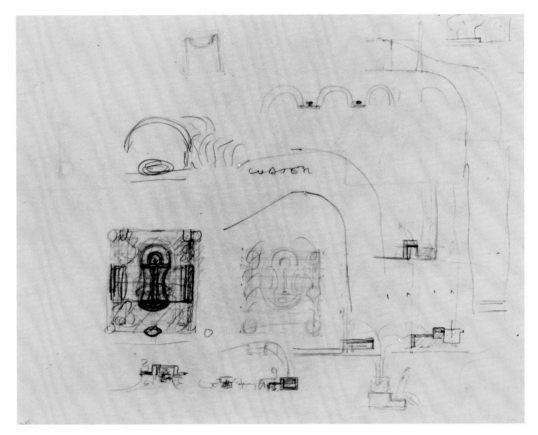

**3.56**
*Kimbell Art Museum. Schematic plans, sections and studies for court with fountain.* **Catalogue 42.** Louis I. Kahn. December 1969. Louis I. Kahn Collection, University of Pennsylvania and Pennsylvania Historical and Museum Commission.

**3.57**
*Kimbell Art Museum. Schematic courtyard with trellis elevation.* **Catalogue 43.** Louis I. Kahn. Louis I. Kahn Collection, University of Pennsylvania and Pennsylvania Historical and Museum Commission.

that potential structural conflicts existed with the mezzanine floor, and Kahn developed different plans for the library afterward (fig. 3.61). Later, these doubts about structure were resolved.[96]

Of major importance was the design for the reflector. Kahn began consulting with Richard Kelly on this in November 1968, when Kelly suggested using plastic instead of glass.[96] By the following January Kelly had prepared a schematic study of vault and reflector curves calculated to produce maximum reflectance (fig. 3.62). Meyers drew a section based on this two months later, on March 4, 1969 (fig. 3.63).[98] (Their work had constituted information under consideration for the February and March 1969 estimates.) Kelly advised on ultraviolet filtration for the skylights, on lighting fixtures combined with the reflector and on those under the soffits of the channels as well as elsewhere in the building, and finally on the nightlighting of gardens.[99] He suggested using foliage to control light in the courtyards and introduced the track lighting that successfully integrated with the reflector and was later used elsewhere as well.[100]

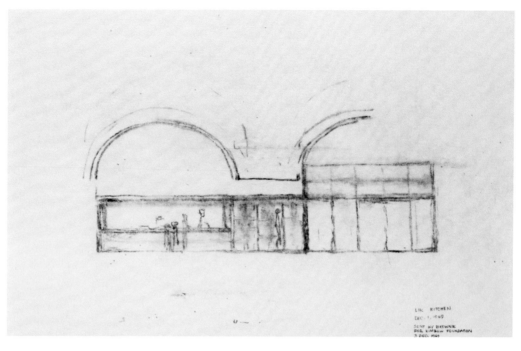

**3.58**
*Kimbell Art Museum. Schematic kitchen elevation.* **Catalogue 44.** Louis I. Kahn. December 1, 1969. Louis I. Kahn Collection, University of Pennsylvania and Pennsylvania Historical and Museum Commission.

**3.59**
*Kimbell Art Museum. Schematic plan, library with mezzanines at ends.* **Catalogue 45.** Louis I. Kahn. Louis I. Kahn Collection, University of Pennsylvania and Pennsylvania Historical and Museum Commission.

Showing his concern for all details, Kahn sketched what he wanted for track fittings and wiring at end panels of the vaults (fig. 3.64).

Although Kahn brought a great many plans, studies, and sketches to Fort Worth in late December 1969, serious problems in coordination were increasing.[101] The younger Geren who had replaced his father was taken aback by billings from various consultants and by expenses for his own firm. He examined the contract and agreement as he took control of the Geren firm, and he asked Kahn to submit some billings to Brown, noting that consultants were to be approved in advance and in writing by the owner. For his part, he charged the Kimbell Art Foundation for revision of working drawings after schematic and preliminary plans had been approved and for his reimbursable expenses. He formally requested that Kahn make monthly expense reports to him, as he in turn would to Kahn.[102] (The latter procedure was included in the agreement but had been all but ignored.) In consequence, Kahn recommended to Brown that Patton and Kelly be made consultants and made suggestions for others. Both received appointments.[103] They had, of course, worked for some time on the Kimbell project, Patton since the fall of 1967. According to Kahn, Kelly had been involved since "the inception of the idea of the shell, skylight and lighting fixture integration as far back as the preliminary design."[104]

The combination of new plans and recent invoices set off signals for a reevaluation of expenses. Brown had specified in his May 5, 1969, memorandum that "constant, cumulative, detailed running accounts" be kept, but the building committee of the board in January 1970 requested a complete review.[105] Brown compared the problem

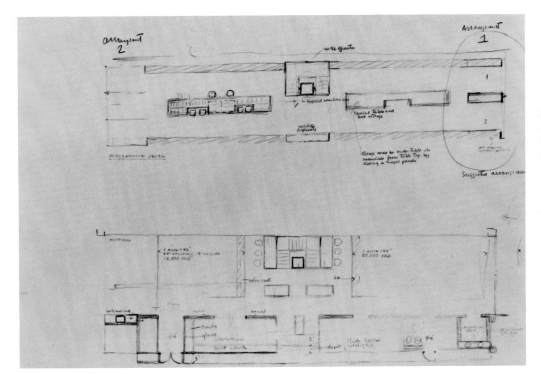

**3.60**
*Kimbell Art Museum. Schematic plan, library and mezzanine.* **Catalogue 46.**
Louis I. Kahn. December 31, 1969. Louis I. Kahn Collection, University of Pennsylvania and Pennsylvania Historical and Museum Commission.

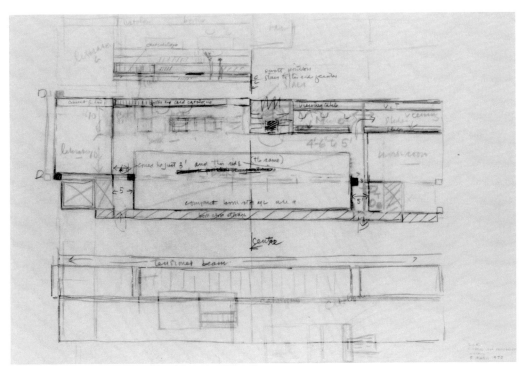

**3.61**
*Kimbell Art Museum. Schematic plan for variant of library, interior elevation and perspective.* **Catalogue 47.**
Louis I. Kahn. March 15, 1970. Louis I. Kahn Collection, University of Pennsylvania and Pennsylvania Historical and Museum Commission.

to the earlier one of having general plans for the building that cost 50 percent more than the funds available. Meanwhile, the budget had been reduced by ongoing expenses, and the building was under construction. He considered it necessary to project costs in detail in order not to be faced with "last ditch, costly butchery" that he feared might harm the design. He asked that Kahn have consultants furnish such information as part of their services, because the board would refuse any projects without costs included in the proposal.

This was followed by many calls to scrutinize expenses. Geren asked for a reevaluation when he examined the new site and landscape plans received in December, and Seymour reported a cost overrun of $20,000.[106] In April Seymour wrote that the cost of work on the building alone had increased by $1,363,000 owing to additions or expansion in such matters as stainless steel, roofing and skylights, mechanical and electrical work, and metal soffits, and that three months more would be needed because of delayed plans.[107] Meetings by representatives of the architects, the Kimbell Art Foundation, consultants, and contractor resulted in a new budget that added

**3.62**
*Kimbell Art Museum. Study for lighting: reflector curve, light intensity.* Richard Kelly (and Isaac Goodbar). January 4, 1969. Louis I. Kahn Collection, University of Pennsylvania and Pennsylvania Historical and Museum Commission.

**3.63**
*Kimbell Art Museum. Study for lighting and reflector.* Louis I. Kahn (drawn by M. M.). March 4, 1969. Louis I. Kahn Collection, University of Pennsylvania and Pennsylvania Historical and Museum Commission.

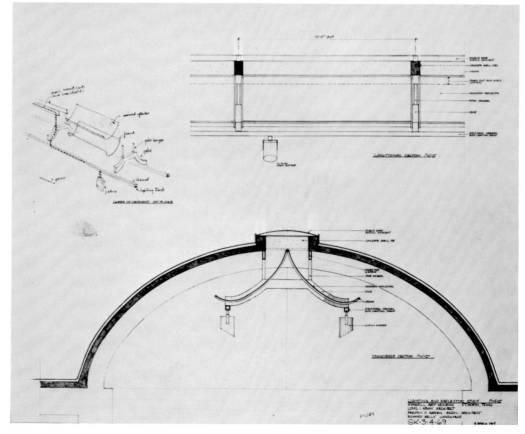

$140,600, bringing the total to $6,196,100. (Security installations, equipment and furnishings, design and consultant fees, and sales tax were not included.) A new completion date was set: September 1971. To make this possible, Seymour said that he would have to have all plans affecting upper-floor slabs by May 5 and complete drawings and specifications by June 1, 1970. Expenses were reduced through omissions, changes in materials, and alterations in mechanical and electrical systems. Backup

**3.64**
*Kimbell Art Museum. Sche-matic section with detail of power source for light track.*
**Catalogue 48.** Louis I. Kahn. Louis I. Kahn Collection, University of Pennsylvania and Pennsylvania Historical and Museum Commission.

walls for travertine in interiors were to be concrete block rather than cast-in-place concrete.[108] Kahn thought this more appropriate.

Construction went on, despite changes and delays, and the first pour of architectural concrete for upper-level walls was recorded by Seymour in early March 1970.[109] Frank Sherwood, Geren's project coordinator, requested advance notice of the installation of reinforcing steel and tendons for the upper-level slab so that arrangements could be made to have Komendant present for all operations, including the later poststressing at a time determined by the development of the concrete following the pour.[110]

Komendant witnessed construction, gave some instructions, and made a number of comments after his visit. He found the work in general and the formwork good but advised that more water should require less vibration.[111] Plate vibrators were preferable and should be used in the centers of wall sections. Specific details were given on handling ties: tie-cone holes were to be plugged with lead to within one-quarter inch of the wall surface. The contractor's helpful suggestions on handling the tie-cones were recognized. Clearly, in Kahn's mind, the surfaces were a major factor in the aesthetic of the building, and he sought to involve everyone who could contribute to high quality.

Refinement of details went on. A sketch by Kahn of the window elevation of the west entrance demonstrates the subtle proportions of stainless steel mullions and the doors themselves in the window wall (fig. 3.65). To Kahn, every detail contributed to the total building and demanded study (see door details, fig. 3.66). One change was the shape of the lunette, the strip of window separating the vaulted roof and the travertine diaphragm wall; on his drawing Kahn referred to it as a "lightband." A section through the vault of October 28, 1969, which includes the points on the path of the circle determining the cycloid curve, shows this window of equal width throughout (fig. 3.67). Kahn pondered whether to make it two inches or four, as it would admit light but, in either case, not glare. The strip windows between columns on the east and west walls serve a similar function. These windows demarcate parts of the building and further demonstrate the structure by emphasizing the difference between what is a structural member (concrete) and what is not (travertine). The windows also are an elaboration of the motif of the joint and recall the slit between the old and new galleries at the Yale Art Gallery.

**3.65**
*Kimbell Art Museum. Schematic and drafted elevations of center west front.* **Catalogue 49.** Louis I. Kahn. Louis I. Kahn Collection, University of Pennsylvania and Pennsylvania Historical and Museum Commission.

Komendant's engineering of the shell roof includes edge diaphragms at the ends of the vaults; these are thickened at the crown. After mulling over the effect on the lunette, Kahn decided to "honor the engineering" by shaping the slits to reflect the cycloid curve on the lower side and the curve of the diaphragm on the upper.[112] Thus the opening varies from six to nine inches. Kahn's sketch of a section shows the gracefully shaped window along with the materials to be used (fig. 3.68).

On June 8, 1970, plans were delivered to the contractor by Sherwood with expectation that the turnkey estimate for construction would be made in early July.[113] These plans had been developed from conferences in Sherwood's office between the owner, representatives of Kahn's and Geren's offices, and the contractor, according to Sherwood's letter. In a separate memorandum to Seymour on the same date, Sherwood described patterns in the concrete to be made by formwork and cone-ties for retaining walls and for the walls of the conservator's court. Exterior site walls were not to have either the V-joint detail or the lead-filled plugs of the walls of the building (fig. 3.69).[114] Despite this progress, tension had been building between Geren and Kahn. Indeed, Geren wrote Kahn on June 8 that the plans would not be submitted to him for review and that the only changes to be made before Seymour gave his final estimate would be for inconsistencies or to add the library stairway if Kahn had it completed in time.[115]

**3.66**
*Kimbell Art Museum. Sketches for door elevation.* **Catalogue 50.** Louis I. Kahn. May 1970. Louis I. Kahn Collection, University of Pennsylvania and Pennsylvania Historical and Museum Commission.

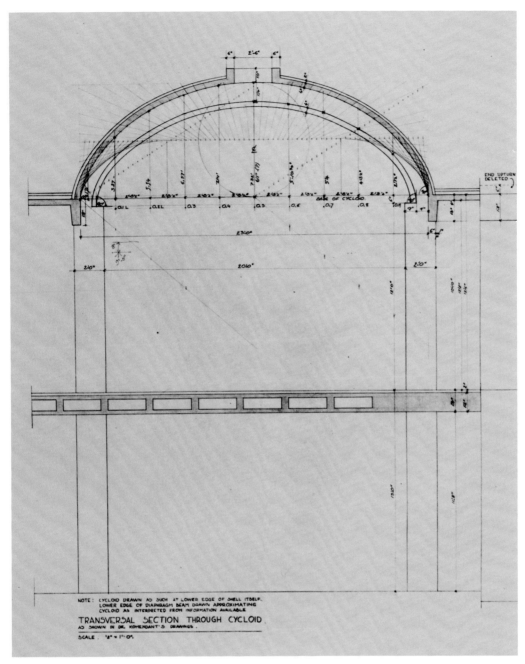

**3.67**
*Kimbell Art Museum. Section through vault with cycloid curve.* Louis I. Kahn (office drawing). Louis I. Kahn Collection, University of Pennsylvania and Pennsylvania Historical and Museum Commission.

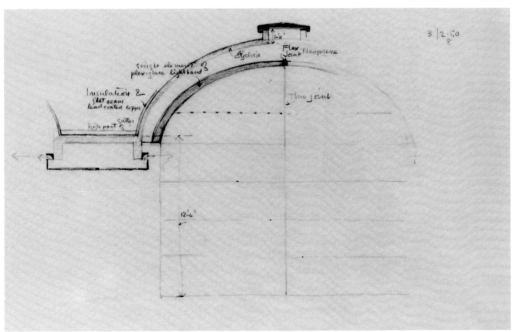

**3.68**
*Kimbell Art Museum. Vault section with materials specified.* **Catalogue 51.** Louis I. Kahn. Louis I. Kahn Collection, University of Pennsylvania and Pennsylvania Historical and Museum Commission.

**3.69**
*Kimbell Art Museum. Detail of concrete wall.*

Kahn came to Fort Worth later in June, when he and Komendant were to work out the details in the forming system and Komendant was to witness construction, but he was unable to change Geren's mind. He wrote Geren that he considered it necessary to check drawings and samples of materials, even when they seemed to conform to all specifications, in order to fulfill his obligation to the owner for the complete design.[116] Sherwood could come to Philadelphia for personal consultations to avoid the delay of mails, or, if that were not possible, he or a representative could come to Geren's office in Fort Worth. But Geren refused to allow Kahn to see the drawings, saying that revisions were too costly in time and money. Furthermore, he informed Kahn he intended to terminate the architects' agreement between Kahn and the Geren firm for the Kimbell Art Museum as of August 1.[117]

Construction continued despite the confusion caused by the estrangement of the architects. Brown finally brought about a resolution by asking the two to prepare a mutually agreed-upon amendment to the contract, which he pointed out could not be broken legally except by the owner. The ammendment was to set down the separate duties and services to be performed by each architect until the building was completed.[118] A Clarification to the Contract was duly executed September 24, 1970, under which a working arrangement was spelled out. Kahn was to approve all working drawings and materials; he was to be sent all shop drawings; he was still to provide plans

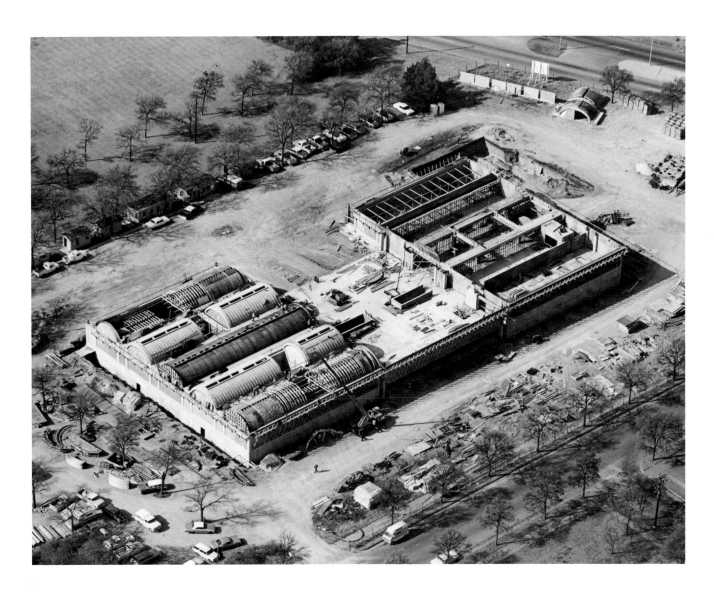

**3.70**
*Kimbell Art Museum.
Construction site, January
18, 1971.*

and specifications for kitchen equipment, fixtures, and shelving, library stairs, library book lift, auditorium seating, gallery partitions, and any additional work the owner might require. Any changes, however, had to be approved by Brown.

Over the summer the upper-floor slab was well advanced, poststressing was initiated under the guidance of Komendant, and construction of columns and flat channels was begun. The latter served as decks, or platforms, for the builders during the forming and casting of the vaults. Seymour described the work with its posttensioning as "a highly sophisticated structural design." After a ruptured tendon in the north wall caused complications and necessitated additional outside consultation and machinery, Seymour requested more supervisory visits by Komendant.[119]

Site plans and specifications were still lacking in October, and Seymour informed Brown that all decisions would have to be made so that the guaranteed maximum cost contract could be met.[120] He now anticipated the completion date to be November 1971, but that was subject to change if information continued to be incomplete. By the time of Kahn's November site visit a mock-up of the cycloid vault was ready for his inspection.[121] Vault construction on the building itself began shortly thereafter. By late January 1971 photographs documenting the site show the south wing lacking only two vaults, both of which are in progress (fig. 3.70).

Casting the vaults took a surprisingly short time for such a complicated engineering project: by October 1971 all sixteen were finished and even roofed with lead.[122] The Byrne company developed reusable forms made of three layers of marine plywood (plastic-coated) that could be shifted with relative ease around the site on dollies. On the exterior, slip forms were raised about one foot at a time during the pouring process. Ribs were placed on the exterior as part of the form, but they were left in place to serve as anchorage for the placement of insulation and for the plywood decking (which reused the forms) beneath the lead sheathing. Komendant's shell design made possible the skylight in the thirteen interior vaults. On either side of the opening,

a raised curb acts as a Vierendeel truss; concrete struts placed across the skylight every ten feet balance any bending moments of the shell. Posttensioning so strengthened the vaults that they actually carried the flat channels once the reinforcing steel tied vaults and channels together.

The museum roof is the result of a creative use of engineering and technology applied to Kahn's architectural design. In Kahn's words: "Komendant actually made the design of our sense of the vault. We are the instigator of it, we wanted the cycloid right away, and we gave him the cycloid, with the problems of all the parts."[123] These words convey the intuitive nature of an architectural idea for which Komendant was creative enough to engineer a system. The shell roof of alternating vaults and channels, complex and sophisticated as it is, appears disarmingly simple and permits the overhead natural light that Kahn visualized for the interior. Its vaulted shape, however, is not structural in the historical sense of the term "vault."

With vaults under construction, the building began to take form before the eyes of those who had imagined it. The contractor, though, looking to his schedule, still asked for complete site-work drawings. These were in preparation.[124] Travertine shop drawings and placement began. Kahn wanted the travertine to have straight ("plumb") edges. "Concrete could vary if that is what happened to it, but space between travertine and concrete would never be more than one-quarter inch."[125] With those instructions from Kahn came many others: he wanted a "horizontal pattern with running bond" for the cork on office walls. His concern for these details is entirely consistent with his aesthetic approach to every aspect of the building. No detail escaped his attention. Others might make suggestions or suggest designs, but Kahn's own inventive analysis was necessary.

Kahn and Kelly arrived in Fort Worth in June 1971 to see the long-anticipated installation of prototypes for the reflector. From the beginning Kahn had spoken of the effect of light inside the building as part of its essential nature. Kelly had worked out the design of the curve by January 1969 (fig. 3.61), but it underwent several revisions. His suggestion to use perforated aluminum had also come in 1969 during discussions on cost estimates, for it offered qualities Kahn wanted at far less expense than acrylic. The aluminum was in manufacture for lighting fixtures, and Kelly thought it a logical material to use because it offered transparency while at the same time controlling light. He utilized the services of a mathematician in calculating reflectance.[126] His combination of the reflector and supporting yoke with the light track was conceived early, and in January 1970 the peak of the reflector was lifted into the domed skylight itself, reaching for more light. A drawing was reviewed by Kahn in May 1970, and revisions were made to widen the reflector and achieve a more sweeping curve.[127]

Manufacture of the prototypes was begun in fall 1970 by testing two types of perforated aluminum.[128] The type recommended by Kelly had the most open quality but was not as wide as desired for the reflector. Kelly thought a solid piece of aluminum approximately fifteen inches wide could be added in the center where the reflector rose steeply into the skylight; it would not be obvious and would make little difference to the reflected light. Because of the importance of this decision, Meyers had asked that two reflectors of varying perforations, each ten feet long, be made before the final order was given to the fabricator. Finding that neither sample worked to the satisfaction of both Kahn and Brown came as a major disappointment to all.[129] The more transparent reflector allowed direct sunlight to enter the gallery and strike south-facing walls, an unexpected occurrence and one Brown would not allow because of the damage the light might do. The more opaque reflector turned out not to reflect light to Kahn's satisfaction.

Kahn first thought that he must completely change his idea for the reflector, but Sherwood pointed out that it would be possible to make the section directly beneath the skylight opening opaque and leave the remainder with open perforations. In addition, it was realized that a completely transparent reflector could be retained in certain places where it would be safe to allow occasional sunlight: lobby, bookstore, dining area, library, and auditorium. (The last named has an open reflector, but with motorized

shutters whose openings were designed by Kelly so that light can be shut out.) As a result, the concept was not only preserved in part; there is also an added, welcome variation in the qualities and intensities of light within the museum, reinforcing Kahn's original idea of modulating light in the interior by the introduction of courtyards. There are even locations within the building from which sky and clouds can be seen overhead.

Also important to his concept was the placement of partitions within the gallery rooms. The upper floor is open, as we have seen, and the first arrangement proposed by interior consultant Lawrence Channing evidently treated the space freely. Channing wrote to remind Kahn that the first layout had "little walls standing around this way and that way," which Kahn had found "unresponsive to the building," but that he had heeded Kahn's advice that the soffits of the channels were equipped with hardware "intended to hold panels for pictures and guide their placement."[130] A new scheme devised by Channing had "arms" to attach to the edges of the soffits, either at a right angle or parallel, for panels made with an aluminum frame. Placement thus assures a respect for the spatial quality of the vaulted rooms, maintaining their integrity while providing considerable flexibility in possible arrangements. Kahn's "society of rooms" would be preserved.

The auditorium Kahn designed for the museum presented special problems. The consultant for acoustics, Dr. C. P. Boner, had reported in 1970:

> The multiple cycloid form will produce "lines of acoustical confusion," with the line being on the order of twelve feet below the apex. Where this line occurs well above the ears of the listener, the effect is not major. Where it occurs more or less within the plane of the ears, there are weird effects. In museum environments, where speech alacrity is not too vital, these weird effects sometimes lend an interesting atmosphere. In the auditorium, the cycloid shape would presumably deny us the option of designing a distributed type sound system. This would mean, perhaps, that space would have to be found for a small horn cluster up front somewhere. . . . We would suspect that reverberation control may have to be via carpeting, tapestries on walls, rather than via ceiling-type absorption. Perhaps some type of wall absorption (such as carpeted wall panels) could be thought of.[131]

After a meeting in Philadelphia, Boner proposed more specifically that the auditorium should have wall-to-wall carpeting, fully upholstered seats, walls broken up with tapestries (preferably with many openings and set out from the wall), and that the front of the projection room and all rear wall surfaces should be "soft."[132] Kahn followed all the suggestions except tapestries in the design of the auditorium. Theater seats chosen with the approval of Channing were upholstered. At least two installation methods for different numbers of chairs were considered.[133] For the soft end wall, Kahn took the opportunity to enrich the room with a fabric woven especially for the walls and projection booth under his supervision of color and weave; samples were submitted to Dr. Boner for his comments as well.[134] The horizontal panels of a deep orange-red and strips of yellow echo the patterns of the travertine stone and the aggregate floors of the west porticos with their light-colored dividing strips.

A construction schedule for the work remaining on the museum made by the Byrne Company in late June 1971 indicated areas still without plans or under revision but showed considerable progress. Seymour noted deflections in certain concrete spanning members earlier that month, expressing concern primarily for coordination and alignment with other installations.[135] Kahn continued his visits, selecting materials, revising details (such as the base for the Maillol sculpture in the large north courtyard), and choosing paint colors. In the September meeting Seymour asked for the drinking fountain design, reminding Kahn that he had been requesting this for fifteen months.[136] In the same meeting a new, more open, gauge of perforated aluminum was selected for the reflectors.

In October 1971 Seymour's construction schedule projected occupancy of the lower floor the following February and March and of the upper floor by early April.[137] Delays were occasioned by the lack of approvals on travertine, stainless steel, reflectors (arrivals had been damaged), and other items. Samples of stainless steel sandblasted (by pecan hulls) to achieve a milled appearance were sent to Kahn for examination, on Brown's instruction.[138] Kahn's design for the drinking fountains, with copies of his sketch of sweeping curves, were sent from Philadelphia on December 22, 1971. This was the last transmittal from his office for the Kimbell Art Museum (fig. 3.71).[139]

Seymour's next schedule, in January 1972, showed basic work nearing completion.[140] In February the final approval for the light reflector was given, and unbleached wool carpeting was selected.[141] During the next few months fabric was installed on the auditorium walls, Kahn's suggestion to use Italian terra-cotta pots (like those in the American Academy in Rome) for interior plantings was followed up, Sherwood devised the wire trellises using marine hardware for the courtyards, and final waterproofing was attained on the interior.[142] In May and June representatives of the architects began their inspections, producing "punch lists" of details to be attended.[143]

The American Association of Art Museum Directors' annual meeting was entertained with a dinner by the Kimbell Art Foundation in the partially furnished and partially installed new Kimbell Art Museum in June 1972 (only three days after the staff moved into the new building) to preview the building and collection. The final inspection of the building, a largely ceremonial last review of concept and execution, was by Kahn and Brown on August 1, 1972. The building opened to the public in a succession of celebrations in the first week of October 1972.

### Evaluation of Completed Building

The Kimbell Art Museum, the last of his buildings completed during Kahn's lifetime, opened amid great public fanfare at a moment when his importance as an architect on the international scene was at its height. He had been awarded the American Institute of Architects' Gold Medal in 1971, and in early 1972 the Royal Society of British Architects informed Kahn that it intended to present its gold medal to him in June.[144] Special attention was therefore focused upon the Kimbell, including the collection

now being opened to public view. When the museum opened during the week of October 4, 1972, several days were devoted to receptions, festivities, and speeches. It was on one of these occasions that a Los Angeles visitor observed that Brown had achieved the great museum building that had eluded him in the Los Angeles County Museum.[145]

For the Kimbell's trustees, Kahn's concept of a villa in a garden, as he had explained it in his letter to Mrs. Kimbell, fit their idea of a traditional and classical art museum, even perhaps surpassing their expectations in its beauty and serenity. Kahn had appropriated sources from familiar historic American museums. The tripartite Beaux-Arts organization, for example, could be found on the west front with its advanced side wings and recessed center forecourt—the "court of honor"—recalling the museums in Philadelphia that Kahn visited as a youth and saw as a young architect. But he had transformed this concept of a museum building and its setting. One does not approach the Kimbell head-on and find a monumental entrance. Axial paths echoing the axis inside the building itself lead the visitor in toward the forecourt from the streets. Clearly expressed is the vault on four columns, the unit multiplied to form the entire upper floor, all of which can be read by the visitor in the porticos. Thus the museum's constructive means and its logical organization are visually comprehensible. The main west entrance is in the center of the museum's axis, and the gallery floor layout can be perceived directly or inferred. The interior seen upon entering confirms intuition and further reinforces the tradition of museums through our familiarity with the vaulted gallery illuminated from above. Location within the building is easily sensed even by the first-time visitor.

The Kimbell's exterior provides more than one inference. The entrance from the parking lot is sheltered in a shadowy void forming a recessed porch, equivalent in size and proportion to the porticos on the west but without the elegance of the vault. Windows are hardly apparent; indeed, the usual indications that communicate scale are nearly nonexistent (fig. 3.72). As a consequence, the building savors a certain tradition when seen from the east, north, or south: the tradition of warehouses or storage structures with low vaults, like those of ancient Egypt (the Ramesseum) or Rome (the Porticus Aemilia) or even of Auguste Perret (the docks warehouse in Casablanca, 1915). One could add—though his are not warehouses—Le Corbusier's Monol housing of 1919 and certain of his private houses in the 1950s and 1960s.[146] Many a contemporary observer, alternatively, has conjured up other contemporary images: large, modern industrial units such as aircraft hangers, even silos, quonset huts, or European railroad terminals.

At the same time we have classical Mediterranean allusions. The gravel paths approaching the museum from south and north (and paralleling the processional approaches to the Amon Carter Museum just up the hill) become sacred ways leading one beside dark pools of gray granite with waterfalls (fig. 3.73). At the forecourt they converge in a grove of uniform small trees spaced in rows and selected to canopy any visitor walking over the gravel toward the entrance portico (fig. 3.74).[147] Repeating that motif on the south is another small "sacred grove," this time of crape myrtle trees, which may be seen east of the path's entrance from West Lancaster Street. Each grove forms an outdoor room, as designated by George Patton. The grove sheltered by the building's wings, with its canopy of yaupon hollies, especially contributes to a quickening sense of place; this site is Parnassian, dedicated to the muses. Renaissance villas also consciously emulated such classical settings.[148]

At the Kimbell Museum, all is preparation for entering the building. The journey is made physical not only in distance but through the senses. One walks over grass, steps on crunching gravel, hears as well as sees water. Then the usually brilliant Texas light that Kahn thought silvery is relieved by the shadow of a portico or by the small trees in the court. Gravel gives way to firm aggregate under the entrance portico and, once inside, to travertine and wood. Like a classical villa, the gallery level is uplifted by the lower level and one looks outward onto the green space and trees: a park preserve, a museum sanctuary.

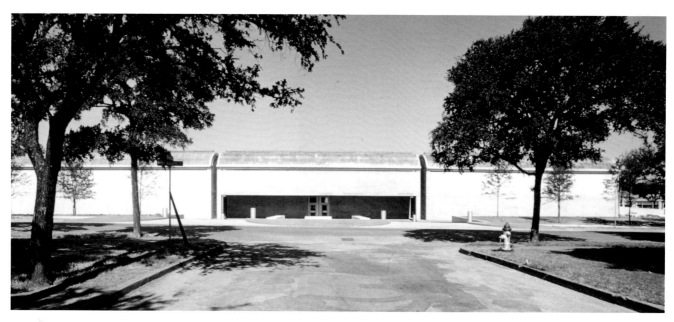

**3.72**
*Kimbell Art Museum.
View looking west.*

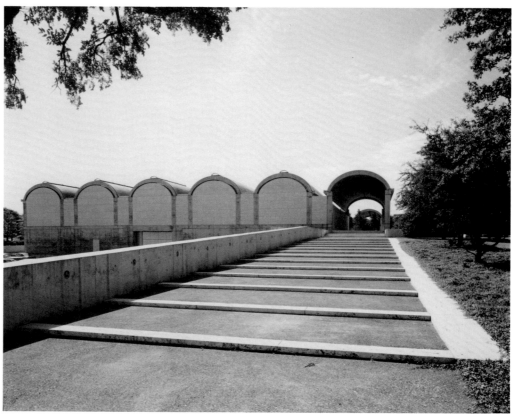

**3.73**
*Kimbell Art Museum.
View looking south.*

The Yale Art Gallery gave us Kahn's double-faced building with a street facade and a garden facade. So too does the Kimbell Art Museum. The difference is striking, however. At the Kimbell the street facade is austere. Only a few yards distant is the public parking area. This is the entrance thought of by both architect and patron as the "back door." At Yale the front of the building is the public face of the institution: closed, proper, and protective except for the glazed, angled entry wall with its slice of view to the inside. It is on the garden facade, sheltered and enclosed by surrounding college buildings, that a wide window wall reveals and lights the interior and opens onto terraces with sculpture and places for visitors to sit. In Fort Worth the garden facade is

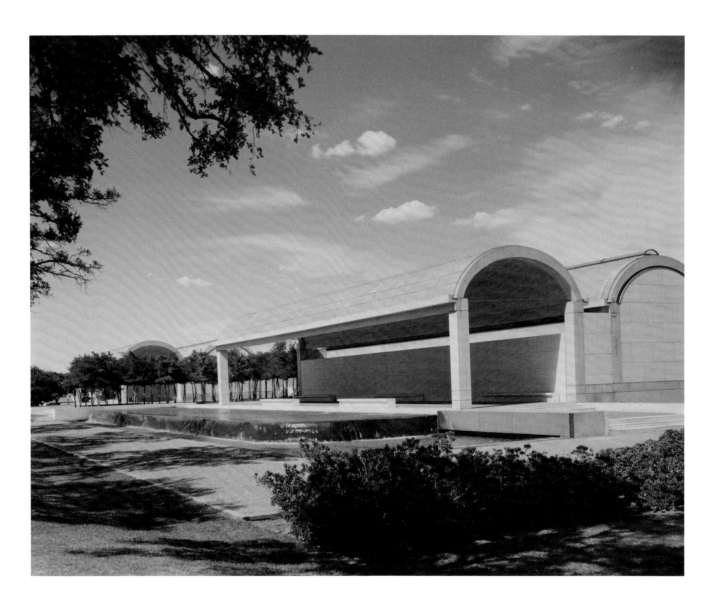

the true front of the building; opened by the porticos and forecourt, it extends a welcome to visitors who must make the transition by approaching over paths or across the broad lawn.

The Kimbell's handsome proportions, simplicity and elegance in details, clarity of plan, and repetition of the low, spreading vaults are the hallmarks of Kahn's design, his classical museum. An average visitor, however, perceives the museum's interior space and its special lighting as most definitive and idiosyncratic (fig. 3.75). In contrast to the Yale Art Gallery's continuous open space, concentrated natural light at the window walls, and tight service core, the Kimbell galleries' skylights disperse light throughout. Kahn often stated that light was central in his architecture. With the Kimbell he achieved an unsurpassed quality of light that bathes whole rooms and reveals works of art in their richness. Onto the underside of the vaults and down the side walls and partitions flows a silvery light channeled by pierced aluminum reflectors. Still more light is allowed through in the areas where there are completely transparent reflectors. (We are reminded of the "beam splitters" in Marshall Meyers's early description, when these were to be made of mirrored glass.) In galleries where solid aluminum is immediately below the skylights this effect is reduced, but reflectance is just as silvery.

As foreseen by the architect in his 1967 address in Boston, courtyards introduce a different type of light into the galleries, varying the intensity and sometimes introducing subtly differing colorations. Window slits on exterior walls and lunettes under the

**3.74**
*Kimbell Art Museum. View of west front seen from south.*

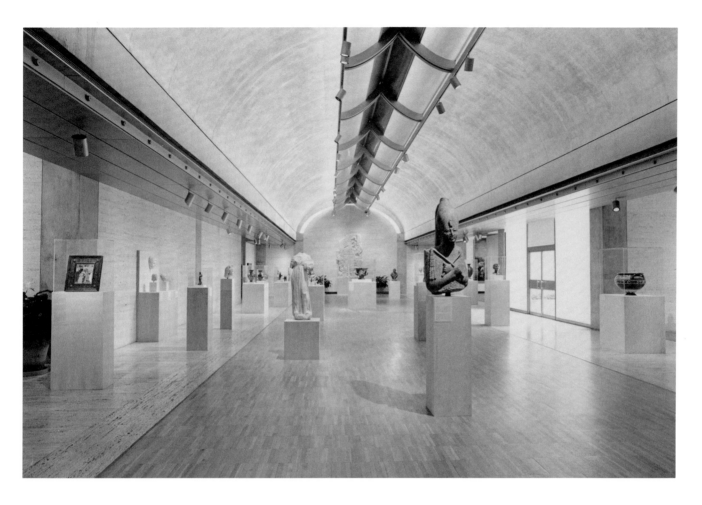

**3.75**
*Kimbell Art Museum. View
of south gallery.*

vaults create further variations of light within the building. Control of the strong, often glaring, Texas sunlight transforms it and makes it almost a part of the architecture, so essential is it to the character of the museum. Kahn called material "spent light" and defined structure as "the maker of light, because structure releases the spaces between and that is light giving."[149] Statements like these are invested with weight and substance in the context of the Kimbell Art Museum.

As we have seen, the galleries possess an open plan but convey the sense of individual, lofty rooms separated by low channels, which in their turn are spaces more compressed and slightly darker. The distinction in materials on the floor reinforces the pattern: under the large spaces, white oak; under the channels, travertine. The open space possesses a definite shape. As at Yale, where the ceiling is used for horizontal distribution of services, here the channels — cast U-shaped concrete elements with aluminum soffits — perform the role of service spaces for ducts and conduits and serve to distribute air. They also have been used effectively for art installations. Temporary panels placed at the outer edges have created a long, narrow space, open at the ends, for showing drawings related to paintings exhibited in the bigger area. The arrangement has worked well and offers the additional advantage of exhibiting light-sensitive works in reduced light. The architect may not have foreseen just this possibility, but it is consistent with his idea of the museum's space and his expectation that it would adapt to more varied use than originally planned. (Kahn once suggested that enclosures beneath the low spaces could be used to store paintings that related to others in the galleries, a suggestion probably stemming from the study gallery he designed for the Yale Center for British Art.)[150] Elsewhere on the gallery floor other service components are found beneath the channels: the main stairwell and fire stairs, the passenger elevator, entrance to the library, storage areas, an auditorium aisle, and even entrances to the building.

In the nonpublic areas — library, offices, and workshops — Kahn also controlled natural light through means derived from observations of indigenous architecture, going back to his 1961 design for the consulate in Luanda, Angola.[151] Using walls outside windows to cut glare and soften light, he placed the glass end-walls of the library three feet away from the travertine diaphragm walls that terminate the adjoining vaulted units north and south. The west light wells for offices and shops act in much the same way. Before entering interior spaces, light is bounced off travertine or, as the case may be, architectural concrete. The quality of the concrete itself, with its V-shaped demarcations of formwork panels catching the light, provides a pleasure the architect foresaw for those who work there.

Each wing has its own courtyard. In fact, the plan represents a variation on the traditional museum double-court layout. The large square court in the north wing is immediately seen from the front entrance and is a part of the axial spine; the southern courtyard is smaller, a twenty-foot square, and lies a little to the west of the center axis. The larger has the Maillol sculpture, the other a travertine fountain with a small standing figure by Bourdelle. Both have plantings of vines (Kelly's idea) to reduce the intensity of sunlight.

The service floor follows divisions set forth in Brown's program and is separated from the public space — the major served and service spatial distinction. Building services, workshops, and security headquarters are in the north, while reception, administrative, curatorial, and conservation facilities are in the south. A contemporary museum building must provide for technical resources and nontraditional needs beyond those conceived for the earliest museums. The floor beneath the galleries came to be used for such purposes, as in Cret's Detroit Institute of Arts. Kahn considered each building a fresh problem as he sought the source of its "beginning," but he did not necessarily reject precedents simply because they already existed. It was a matter of discovering a solution autonomously rather than proceeding from precedent. He trusted his intuitive feel for relationships.

Kahn relied on Brown's knowledge for the functional organizational arrangements of the plan but on himself for a sense of proportionality within and among the rooms. With the exception of the staff library discreetly placed in the vault behind the storage wall of the bookstore, and therefore all but invisible to visitors, the upper floor is dedicated to public functions. It consists primarily of galleries, but besides the bookstore there are the auditorium, a dining area and kitchen, and the main entrance lobby, as well as the courts, all thoughtfully arranged and interrelated. The lobby and bookstore are in the central location; the auditorium and dining room are in the north wing to one side of the large courtyard. The north galleries, as designed, are for temporary exhibitions; the south galleries are devoted to the permanent collection. (Occasionally the size of an exhibition will require a change in arrangements.)

Brown asked that everything needed by an active and up-to-date museum be included in the Kimbell, but nonpublic areas were the ones in which he was most willing to make sacrifices for the sake of economy. It was Kahn who held to humanistic values for such spaces.[152] Several serious critiques of the museum's architecture have taken these areas to task for lacking the qualities of the public portions.[153] Yet workers in these so-called less-privileged spaces feel that they share space in the same inspirational building. The materials and quality of detailing are the same on both floors; on both there is natural light, though to a lesser extent on the lower floor. For those who work within it, the building contributes to the profound sense of place and identity.

Just as the student newspaper interview after the completion of the Yale University Art Gallery was revelatory of Kahn's ideas, his thoughts about the Kimbell Art Museum formed the central core of several interviews given as it neared completion and shortly afterward. Two interviews were especially interesting — one with William Marlin, then an editor of *Architectural Forum*, in Philadelphia on June 24, 1972, and one with Marshall Meyers, who had been so close to the project, in Philadelphia on August 11, 1972. Two other interviews close to this time were more far-reaching, but the Kimbell figured importantly here as well: with Patricia McLaughlin for the December 1972 issue

of the University of Pennsylvania magazine *Pennsylvania Gazette*; and with William Jordy, who was preparing an assessment of both the museum and the Exeter Library (also dedicated in October 1972) for publication (in 1974) in the British *Architectural Review*.[154]

Kahn's own words, his inimitable phraseology, especially distinguish and characterize the first three of these interviews, which might be synopsized as defining the building and defending natural light and natural materials. To Marlin, Kahn explained that "the whole plan of Kimbell is based on the room-like quality; and the natural light as being the only acceptable light." These were the form, the inseparable parts of the design. He valued the changeability of natural light — its ability to convey mood, weather, and seasons and even to create associations with the artist. "A painting that you don't see as well one day as you do another has a quality which the painting itself wants you to realize. It doesn't want you to have a one-shot image of it. Even it was painted in moods." Rather than windows that would permit too much glare, he preferred light from above, which is the most "brilliant," modified by the "natural light fixture" — the reflector to filter sunlight.

The cycloid vault structure that could function like a beam spanning one hundred feet from column to column and the low space between vaults "gave the small room and the large room at play. . . . The vault defies division, [and] the room has this character of completion." That same vault formed the exterior porches "like a presentation, like a piece of sculpture outside." The portico was not merely an addition, he said, but the same as the interior "without any obligation of paintings on its walls." It was a place of rest, an architectural introduction not called for in the program, an "offering." It was typical of Kahn that he thought of architecture generally not as "the solution of a problem but [as] a presentation of its spirit . . . an offering to architecture itself. . . . So the porch is part of that. . . . This is Kimbell," he summed up. "Kimbell stands as natural light, and the making of rooms which are really indivisible, you see, so that the room remains a room."[155]

Meyers entitled his interview with Kahn "The Wonder of the Natural Thing." Kahn's attention was directed to preferred materials: "natural materials have a way of blending together." Kahn accepted these as opposed to manufactured ones that were consciously "artistic" or "whims of the manufacturer." He preferred unpolished stainless steel because of its "unity, the sense of blending," without highlights and with "repose." Travertine for walking areas in the museum was excellent because "it is naturally not a slippery material," far better than marble, slippery and glaringly white. Kahn, it seems, established a hierarchy of natural materials according to how they relate to each other. "Travertine and concrete belong beautifully together because concrete must be taken for whatever irregularities in the pouring" are revealed. Kahn did want those irregularities avoided, but he accepted what happened accidentally (in his terms, "naturally") in the process of construction. Time, he believed, would unify all materials eventually, but the architect could achieve unity by carefully choosing certain materials — wood, travertine, concrete — "which are so subtle that each material never ruins the other. . . . And that's why the choice."

Light, too, should be natural. Variety is achieved through the introduction of natural light into a building. He thought natural light to be like man's nature: unpredictable, intuitive, but answering to "all the laws of the universe." For this reason, he believed, one instinctively requires natural light. He ascribed the creation of the reflector to the strength of his belief in the "wonder" of natural light. "It resulted in the invention of a shape" for the reflector, a shape attained with the assistance of others ("scientific-minded" and "art-minded"). This reflector offered the necessary protection for works of art while making possible the inclusion of natural light in the interior.[156]

Kahn focused on the Kimbell briefly and pointedly in talking with McLaughlin. He again emphasized natural light ("all the light here is natural") and explained why he thought such light was best in a museum: "It is the light the *painter* used to paint his painting. And artificial light is a static light — where natural light is a light of mood." It permits seeing the painting under differing conditions, in different lights. So stated, we

have Kahn's idea of form, or what he called in this interview the "nature" of a place. "And research would never have given it to me, because all I could find was ways of doing it completely contrary to the ways I think a museum might be. So it must be derived out of your own sense of its nature, of its service, of the *nature* of a school, of the *rooms* of a school, or the rooms of a museum."[157]

William Jordy's article, based in part on his interview, included Kahn's own words on the Beaux-Arts tradition, but it was also the most profound consideration of the Kimbell Art Museum in the early years. Situating the museum within the context of recent architectural history and Kahn's own oeuvre, Jordy also cited the low vaults of Le Corbusier's Jaoul and Sarabhai houses as forerunners of such designs in the 1960s and identified the long, vaulted gallery with a light slot at the top as the generative concept — "the room as the beginning of architecture." The important difference between Le Corbusier's and Kahn's vaults, he pointed out, is that the former's are essentially tunnel-like with side walls and lighting from the ends, ultimately derived from Mediterranean vernacular sources. Kahn's, more structurally advanced, are supported by only the four columns and lighted from the top, thus creating a different kind of space.

Jordy criticized the service and administrative areas, saying that their placement in the lower floor, the stylobate of the museum, makes them suffer in comparison to the galleries. There is, however, a convention for this arrangement in museums: skylights for galleries, sidelighting for sculpture, dark storage below. There is also modern museum methodology to consider. Jordy found the library and auditorium awkwardly forced into the gallery spacing, being made to conform to the scheme of the vaulted space. Following Kahn's logic, he believed they should have received exceptional treatment as exceptional spaces. But he concluded and summarized his analysis by stating that the levels of meaning so significant in Kahn's work basically reinforce one another in the Kimbell: functional use, structural syntax, and ceremonial extrapolation.[158]

Richard Brown, author of the program and acting client for the Foundation, was given to strong, unequivocal opinions. If he liked something, it could not be improved. Thus he found the Kimbell to be "what every museum man has been looking for ever since museums came into existence: a floor uninterrupted by piers, columns, or windows, and perfect lighting, giving total freedom and flexibility to use the space and install art exactly the way you want."[159] Even during the construction period he was convinced the building would function as he wished, despite his initial rejection of skylights and clerestories. He sent an essay on museum architecture to Kahn in the spring of 1971 with the comment "the right answer is getting the roof on here in Fort Worth."[160] He asked for clarity, simplicity, elegance, and natural light in a versatile, workable building, and he believed Kahn had achieved every one of these, to judge by interviews and accounts. Five years later he said: "This place was deliberately designed as a building, as a space, to exhibit works of art, all done so people would feel as if they are in somebody's great big house."[161] Later experience arranging the growing Kimbell collection and temporary exhibitions convinced him even more that "Louis Kahn provided us with the kind of space that is the most flexible and the most amenable. . . Every time we tailor the specific kind of installation to the material involved in a more imaginative and flexible way than any museum in the country."[162]

Brown had hoped for just this sense of "great big house," or palazzo, as he referred to the museum in one letter to Kahn.[163] That was not everyone's taste for a museum. Hilton Kramer, a critic representing the *New York Times* during the official opening, seeing the "handsome rugs, fresh flowers on the tables and plenty of leather chairs and couches everywhere," spoke snidely of the Kimbell being "a private club rather than a public institution."[164] Kramer wrote further that the effect was of "warmth, comfort, luxury, no expense spared," a phrase repeated under the newspaper illustration of a gallery. As one might expect, the budgetary struggles of design and construction were neither recognized nor appreciated by those who had not lived through them, though Brown made no secret of the fact that the square-foot cost was lower than for most public buildings.[165]

Brown had required in the contract that the architect explain all aspects of the design of the museum. According to Meyers, Brown made himself Kahn's pupil, learning how to interpret the subtle distinctions of a plan. Meyers emphasized how Brown wanted the museum visitor to be "in touch with the ever-changing world outside the museum," but he said Brown also had the ability to convey needed information, information of the type that normally did not interest Louis Kahn.[166] Brown himself described bringing the museum into being as "one of the greatest experiences of my life, because I learned so much of how a great architect works, thinks, draws, designs."[167] Throughout design and construction he responded to Kahn as the artist-architect.

Immediate critical reactions to the new museum were almost invariably favorable, if again somewhat conventional and respectful.[168] Unlike the early reports about Kahn's Yale University Art Gallery, which showed interest in technical innovations by a little-known architect, this was a case of recognizing the work of a master. Kahn only recently had been cited by the American Association of Architects as "architect, educator, 'form-giver,'" and his influence on the present generation was compared to that of Le Corbusier, Mies, and Gropius in an earlier period. Another point of contrast to the Yale gallery was the immediate focus on the building as a museum.

A few early reviews expressed reservations or negative reactions. Emily Genauer, for example, wrote that the Kimbell Art Museum was "a setting directly and sympathetically scaled to the physical dimensions and absorptive capacities of human beings," but confessed to a wish for grandeur in a museum rather than what she saw as the exceptional hospitality of the Kimbell.[169] The strongest negative views followed technical lines. Donald Hoffmann, a critic for the *Kansas City Star*, who was by training an art historian and particularly interested in the Chicago school, was unmoved by the natural light, believing that "the warm light in the building comes from a profusion of lamps in tracks along the outer edges of the aluminum shielding." His purist, structuralist aesthetic was particularly offended at Kahn's posttensioned vaults. There is "something wrong with a vault that isn't a vault," he wrote; "Kahn has taken an ancient form — or a form at secondhand from Corbusier — and has debased it through the marvels of contemporary structural engineering." The engineering itself was not examined, and the implication would seem to be that these marvels are not for use in buildings. "Nor can I believe that Kahn's very regular clustering of identical structural units shows any high level of aesthetic organization. There is no hierarchy of spaces, no compelling sense of integration."[170]

In a similar vein, a 1987 analysis also focused on the building's structure and its expression. Peter McCleary thought the vaults a structural hybrid, "neither pure vault nor pure shell," basing his evaluation on the use of both stiff edge-beams and cables within the concrete. The skylight at the apex removes material at the point of maximum compressive stress. "The structural behavior of the roof [is] beyond the intellectual and visual comprehension of most architects and engineers," said McCleary, rejecting published explanations. But he also reported Kahn's own priorities, conveyed to him in conversation between the two during construction. Kahn told him that "the quality of light and place in the then partially completed museum was sufficiently beautiful that, for the moment, he was willing to sacrifice the truth of the structural principle."[170] Most visitors are convinced by the beauty of these architectural spaces in light and accept their structural means unquestioningly as logical.

An interesting parallel can be drawn between the Yale Art Gallery and the Kimbell Art Museum in connection with this criticism concerning structure. Kahn's space-frame for the Yale gallery floor was modified so that it became a floor of braced beams that preserved the appearance of a space-frame because of the tetrahedral openings. Unlike some critics, Kahn never expressed much regret over the loss of opportunity to use the space-frame, and in fact found that the slab as constructed served the purposes for which he designed it. The Kimbell's vaults with skylights are not traditional but are made possible by Komendant's shell design; structurally they are closer to a bridge between columns. Nevertheless, they are visually convincing when read as

vaults with skylights. Some concrete walls also contain structural beams that are not visible to the spectator. (Frank Sherwood has pointed out that there are distinctions in formwork patterns suggesting these, but one must be intimate with the structure to comprehend them.) Kahn's attitude toward this aspect of architecture was humanistic: he embraced the structuralist belief in honesty of structural expression, but realized that at times human interpretation of expression rules structure.

Museum professionals look at the Kimbell (and any museum) from the point of view of specialists, a view in which structural considerations have far less significance. Thomas Messer, then director of the Solomon R. Guggenheim Museum, Frank Lloyd Wright's innovative design (which Emily Genauer considered the finest contemporary museum design), thought the close collaboration between Brown and Kahn admirable because it meant that the functional parts of the museum and their working relationship were planned with advice by an expert:

> I think it is exciting to see the Renaissance loggia mode applied to it. . . . The whole issue of a museum's function is greatly exaggerated in the public's mind. Only the people who work there really know if it works or not, and I understand it is extremely functional. A museum is not all that complicated a mechanism. The important thing that an architect can contribute is a noble, monumental, or intimate space—whatever is required of him—where works of art come alive. And I certainly feel that this has been done.[172]

Messer was accurate in reporting the Kimbell staff satisfied. After all, the business manager, photographer, building engineer, librarian, and curatorial associates all had opportunities to contribute their views and needs. Brown, of course, acted as primary consultant and deserves recognition for working out practical relationships and logical connections of the components of the museum with Kahn. As the museum approaches the end of its second decade, these components remain admirably flexible and effective. Many museums, including larger and more recent ones, have not been so fortunate and have already turned to expansion and reorganization. In the Kimbell, interior spaces, and even the porticos, have gracefully responded to changing programs.

Physically the museum has changed little since it opened its doors to the public in 1972. What change there has been only points up the building's strength. Wood-paneled partitions are no longer used; they and the various fabrics first covering panels have been replaced by natural Belgian linen like that chosen by Kahn for walls in the Yale Center for British Art. The color and texture are more in keeping with the travertine, concrete, and white oak and provide a more neutral background for works of art. Rugs and furniture have changed, chosen with the assistance of the interior consultant with whom Kahn worked on the Exeter Library and whom he originally had recommended to Brown (and later recommended to Jules Prown at Yale).[173] They too are more closely related in color and tonality to Kahn's natural materials. But these seem superficial in comparison to what Kahn created. Spaces remain as he designed them. In their simplicity they offer an even greater versatility than was at first apparent, one more meaningful to the museum's staff as they have experienced the building both over time and through the revelations of how effectively it accommodates, even enhances, a wide scope of visiting exhibitions representing a variety of forms and cultures. It can seem an ideal background for astonishingly different types of works of art.

As with all growing and vital institutions, the Kimbell Art Museum's programs have expanded in many areas. The collection itself has become increasingly distinguished due to an acquisition policy that continues an emphasis on quality over quantity and an art market that has yielded beautiful and exciting works. The Kimbells' legacy has made this possible. And the community has responded to the building, the collection, and the outreach extended by the professional staff. Educational programs attract many visitors and include some innovative and experimental attempts to enlarge aesthetic possibilities for handicapped children. Concerts and films complement the tem-

porary exhibitions, which themselves bring an ever-widening range of artistic expression to the museum's visitors. The responsiveness of Kahn's spacious, beautifully lighted rooms to new usage and to varied works of art and types of installations has been their supreme virtue.

1. Minutes of meeting, Board of Directors, Kimbell Art Foundation, November 26, 1948. Kimbell Art **Notes** Foundation Archives.

2. Committee report to the Board of Directors, Kimbell Art Foundation, attached to minutes of meeting, March 30, 1949. Kimbell Art Foundation Archives. It was reported that the secretary of the Fort Worth Art Association, who acted as docent, guide and caretaker — conducting tours, classes, and study groups ("forums") — estimated that between 45,000 and 50,000 visitors, excluding the schoolchildren, viewed the Foundation paintings in the course of a year.

3. Minutes of meeting, Board of Directors, Kimbell Art Foundation, June 16, 1953. Kimbell Art Foundation Archives. The exhibition was considered a success, with 7,000 attending during the three-week period. It was noted that construction of the municipal museum was under way.

4. Committee report to Board of Directors, Kimbell Art Foundation, appended to minutes of meeting, January 14, 1960. Kimbell Art Foundation Archives.

5. Minutes of meeting, Board of Directors, Kimbell Art Foundation, May 7, 1964. Announcement that the Kimbell Art Foundation was "distributor and beneficiary under the will of Kay Kimbell" had been made several weeks earlier. Minutes of meeting, April 21, 1964. Kimbell Art Foundation Archives.

6. Minutes of meeting, Executors of Estate of Kay Kimbell, deceased, July 28, 1964. Kimbell Art Foundation Archives.

7. Minutes of special meeting, Board of Directors, Kimbell Art Foundation, July 28, 1964. Kimbell Art Foundation Archives.

8. Minutes of joint meeting of Executors of the Estate of Kay Kimbell and the Board of Directors, Kimbell Art Foundation, September 4, 1964. Kimbell Art Foundation Archives. The site first considered adjoined Lancaster Street, which passes through Amon Carter Park, but was across the river from the park.

9. Minutes of joint meeting of Executors of the Estate of Kay Kimbell and the Board of Directors, Kimbell Art Foundation, September 15, 1964. Kimbell Art Foundation Archives.

10. Minutes of meeting, September 28, 1965, Board of Directors, Kimbell Art Foundation, with attached agreement between A. L. Scott, President, Board of Directors, and Richard F. Brown, September 22, 1965. Kimbell Art Foundation Archives. Brown was made an advisory member of the board.

11. Agreement between A. L. Scott and Richard F. Brown, September 22, 1965. Kimbell Art Foundation Archives.

12. Notes of meetings, Board of Directors, Kimbell Art Foundation, October 18 and 19, 1965. Kimbell Art Foundation Archives.

13. Minutes of meeting, Board of Directors, Kimbell Art Foundation, November 20, 1965. Kimbell Art Foundation Archives.

14. Minutes of meeting, Acquisitions Committee, Kimbell Art Foundation. Kimbell Art Foundation Archives. The Policy Statement, as amended June 1, 1966, is to be found in Kimbell Art Museum, *In Pursuit of Quality: The Kimbell Art Museum* (Fort Worth: Kimbell Art Museum, 1987): app. 1, 317–18. Minutes of special meeting, Board of Directors, Kimbell Art Foundation, June 9, 1966. Kimbell Art Foundation Archives. Brown's Pre-Architectural Program, dated June 1, 1966, is to be found in *In Pursuit of Quality*, app. 2, 319–27. It is summarized in Appendix B in this volume.

15. Brown made this clear in subsequent interviews. "Kahn's Museum: Interview with Richard F. Brown," *Art in America* 50 (September–October 1972): 44–48; Richard Shepard, "After a Six-Year Honeymoon, the Kimbell Art Museum," *Art News* 71 (October 1972): 22–31. See also Brown's account of his meeting and first impressions of Kahn, in "Statement: Louis I. Kahn (1974)," in *In Pursuit of Quality*, app. 3, 328–30. Brown told Peter Plagens in 1967 that he thought Kahn the outstanding architect of the second half of the twentieth century. See Plagens, "Louis Kahn's New Museum in Fort Worth," *Art Forum* 6 (February 1968): 20.

16. For early publication see "Louis Kahn, Order in Architecture," *Perspecta* 4 (1957): 58–59; Walter McQuade, "Architect Louis Kahn and His Strong-boned Structures," *Architectural Forum* 121 (October 1957): 134–43.

17. Early publication was again in the Yale architectural journal; see "Kahn," *Perspecta* 7 (1961): 9–28. Kahn referred to the consideration of light based on observations made during his Angola project in a number of published talks in the next few years.

18. The design was reported "on the boards" by McQuade, who included an early perspective and plan, in "Architect Louis Kahn," 143. On the exhibition, see Wilder Green, "Louis I. Kahn, Architect: Alfred Newton Richards Medical Research Building, University of Pennsylania, Philadelphia, 1958–1960," *Museum of Modern Art Bulletin* 28 (1961): 1–24. The exhibition was held in July 1961. The catalogue text by Wilder Green was reprinted in *Arts and Architecture* 78 (July 1961): 14–17, 28.

19. On the buildings, see Heinz Ronner and Sharad Jhaveri, *Louis I. Kahn: Complete Works, 1935–1974*, 2nd ed., revised and expanded (Boston: Birkhauser, 1987): 130–45 (Salk), 234–65 (Dacca), 266–71 (Islamabad, Pakistan), 208–33 (Ahmedabad). On the exhibition, see "Exhibition at the Museum of Modern Art, April, 1966, Devoted to the Work of Louis Kahn," *Art in America* 54 (March–April 1966): 124–25; "Three for Kahn," *Architectural Forum* 124 (May 1966): 91; "Kahn Enshrined," *Architectural Forum* 124 (June 1966): 30.

20. Ronner and Jhaveri, *Complete Works*, 198–207, 276–81.

21. Louis Kahn, closing remarks at the Otterlo congress, ed. Jurgen Joedicke and Oscar Newman, in *New Frontiers in Architecture, CIAM at Otterlo* (London: Alec Tiranti; Stuttgart: Karl Kramer Verlag, 1961): 205–16.

22. Kahn summed up his philosophical and artistic approach in "Structure and Form," *Voice of America Forum Architecture Series* (Washington, D.C.: Government Printing Office 1961): no. 6, 1–9. Vincent Scully included this, retitled "Form and Design," in *Louis I. Kahn* (New York: George Braziller, 1962): 114–21.

23. See the account of the Los Angeles County Museum in *Art in America* 50 (Fall 1962): 126; 53 (April 1965): 109. Also Alfred Frankfurter, "Los Angeles County Museum," *Art News* 64 (March 1965): 30–34; *Arts and Architecture* 82 (May 1965): 17.

24. Brown, "Pre-Architectural Program," in *In Pursuit of Quality* 319.

25. Brown, "Pre-Architectural Program," in *In Pursuit of Quality* 321–26.

26. Ibid. Kahn discussed light in speaking of the Luanda American consulate design in "Kahn," *Perspecta* 7: 9–12; and in "A Statement," *Art and Architecture* 81 (May 1964): 18–19, 33. Probably even more important were the buildings illustrating his control of light: the Salk Institute and the First Unitarian Church in Rochester, New York, for example.

27. The matter has had increasing importance in the planning of art museums. In the mid-1960s several international institutional organizations were consolidated to form the International Council of Museums Committee for Conservation and the International Council of Monuments and Sites. From the early 1960s onward, there have been international congresses and resulting publications detailing special studies related to optimum conditions for the conservation of objects. (Not much study seems to have been devoted to the effects of light levels on the viewing experience.) Technical studies became more frequent in the late 1960s and 1970s. See Garry Thompson, ed., *1967 London Conference on Museum Climatology* (London: International Institute for Conservation of Historic and Artistic Works, 1967; revised 1968); special issue on presentation and conservation of modern art, *Studio International* 189 (May–June 1975); Garry Thompson, *The Museum Environment* (London: Butterworths, 1978); Nathan Stolow, *Conservation and Exhibitions* (London: Butterworths, 1989).

28. For example, Brown presented the three main divisions in his program as if occupying different floor levels for the sake of organization, but he stated that "actual architectural design may produce a better solution." See "Pre-Architectural Program," in *In Pursuit of Quality*, 321. In his letter to Kahn enclosing the program, Brown wrote that he expected facilities and spaces to be "envisioned better by whatever architect is selected than by ourselves." Letter, June 13, 1966, Brown to Kahn. Kahn Collection, Correspondence with Dr. Richard F. Brown I, 3.66–12.70, File Box LIK 37. The Kahn Collection is owned by the Pennsylvania Historical and Museum Commission and is on deposit in the Architectural Archives, University of Pennsylvania, Philadelphia.

29. Architectural Contract, October 5, 1966, Kimbell Art Museum files. The contract was not the standard American Institute of Architects contract but was written by Brown, Foundation President A. L. Scott, and Benjamin Bird, the attorney for the Kimbell Art Foundation. Specific stages of design and construction were identified with specific times for completion, and specific responsibilities were outlined, but there were more unusual requirements, such as that the architect explain all processes to the Foundation representative (Brown), and that all sketches, drawings, or copies thereof would be owned by the client. Furthermore, models were required for presentation and were to become the property of the Foundation. The time schedule was summarized in the separate Projected Architectural Costs and Time Schedule Based on Suggested Architectural Contract, August 29, 1966. Kimbell Art Museum files. A separate agreement between the architects was required by the contract with the Kimbell Art Foundation, and Kahn proposed one based on his earlier work with Orr. A copy of the executed document was sent to Brown on November 15, 1966. Kahn Collection, All Transmittals, 11.66–, File Box LIK 37.

30. Letter, March 30, 1967, Geren to Kahn. Kahn Collection, Preston M. Geren Correspondence I, 11.11.66–7.21.69 (1.24.70), File Box LIK 37. Geren wrote that he had checked building codes since Kahn was in Fort Worth with the first model.

31. Letter, May 15, 1967, Geren to Kahn. Kahn Collection, Preston M. Geren Correspondence I, 11.11.66–7.21.69 (1.24.70), File Box LIK 37.

32. Memorandum, June 2, 1967, based on telephone call from Brown to Kahn. A meeting was arranged for June 5, 1967. Letter, June 30, 1967, Brown to Kahn. Kahn Collection, Correspondence with Dr. Richard F. Brown I, 3.66–12.70, File Box LIK 37. Photographs of models left in Fort Worth were sent, as were original drawings that had also been photographed.

33. Letter, July 12, 1967, Brown to Kahn. Kahn Collection, Correspondence with Dr. Richard F. Brown I, 3.66–12.70, File Box LIK 37.

34. Letter, July 13, 1967, David Polk to Brown. Kahn Collection, Correspondence with Dr. Richard F. Brown I, 3.66–12.70, File Box LIK 37.

35. Letter, September 27, 1967, Meyers to Brown. Kahn Collection, Correspondence with Dr. Richard F. Brown I, 3.66–12.70, File Box LIK 37. Nineteen slides were sent for a presentation meeting with the board of directors.

36. Kahn, *L'Architecture d'Aujourd'hui* 40 (February–March 1969): 15–16.

37. Meyers later wrote a Kimbell curatorial assistant that he had a book which included diagrams of curves for barrel-vaulted shells: semicircle, ellipse, cycloid, and a sector of a circle. Fred Angerer, *Surface Structures in Building* (New York: Reinhold, 1961): 43. He showed this to Kahn probably in October or November 1967. The cycloid was a shape that would have a low height yet span 100 or 200 feet, and it was chosen for functional and aesthetic reasons. Letters, August 8 and 18, 1972, Meyers to Nell Johnson. Kimbell Art Museum files, Kimbell Museum, Cycloid, Box 2. For explanation and a model, Meyers recommended H. Martyn Cundy and A. P. Rollett, *Mathematical Models*, 2nd ed. (Oxford: Clarendon Press, 1961).

38. Meyers referred to discussions "a few weeks ago" in a letter to Komendant requesting a descriptive drawing and outline specifications which were to assist Geren in making an estimate. Letter, December 8, 1967, Meyers to Komendant. Kahn Collection, Kimbell Art Museum, Dr. Komendant, File Box LIK 37. Komendant used the structure of the Kimbell Art Museum to explain curvilinear cylindrical shells in his *Contemporary Concrete Structures* (New York: McGraw-Hill, 1972): 504–08. Komendant's book on his work with Kahn contains his more detailed account of the Kimbell project. See *18 Years with Architect Louis I. Kahn* (Englewood, N.J.: Aloray Publishers, 1975).

39. Letter, November 21, 1967, Meyers to Price. Kahn Collection, Miscellaneous Drafting Room File, File Box LIK 95. Kelly was responsible for determining the curve of the reflector later. He started consultations with Kahn on the Kimbell Art Museum the following year.

40. Letter, October 21, 1967, Meyers to Brown; letter, October 24, 1967, Brown to Meyers. Kahn Collection, Correspondence with Dr. Richard F. Brown I, 3.66–12.70, File Box LIK 37. Meyers sent Geren copies of the drawings from which the slides had been made: two plans and a section, two studies of the vault, and four of Kahn's sketches. Letter, October 24, 1967, Meyers to Geren. Kahn Collection, Preston M. Geren Correspondence I, 11.11.66–7.21.69 (1.24.70), File Box LIK 37.

41. Letter, December 4, 1967, Brown to Kahn. Kahn Collection, Correspondence with Dr. Richard F. Brown I, 3.66–12.70, File Box LIK 37.

42. Plagens, "Louis Kahn's New Museum," 18–13. Letter, December 4, 1967, James J. Meeker to Kahn. Kahn Collection, Correspondence with Dr. Richard F. Brown I, 3.66–12.70, File Box LIK 37. Meeker asked for drawings by December 15 for Plagens and Smagula and for an architectural rendering for the general press release in February. He also had spoken with Mrs. Bernier concerning a story on the Kimbell for *L'Oeil*. Meyers wrote Brown that C. Ray Smith of *Progressive Architecture* had contacted him, as had a young architect teaching at Yale who was preparing an article on Kahn for *Architectural Design*. He asked that a long, one-half-inch to one-foot section be sent for photography or photostating. Letter, December 11, 1967, Meyers to Brown. Kahn Collection, Correspondence with Dr. Richard F. Brown I, 3.66–12.70, File Box LIK 37.

43. Letter, December 11, 1967, Brown to Kahn. Kahn Collection, Correspondence with Dr. Richard F. Brown I, 3.66–12.70, File Box LIK 37.

44. Invoice dated December 29, 1967, for 5 hours for Patton and 54.5 hours for assistant. An enclosed note from Patton informed Kahn he thought he should visit the site before doing more. Kahn Collection, Kimbell Correspondence and LIK Fee Billings, File Box LIK 95. Letter, January 28, 1968, Patton to Kahn. Kahn Collection, Kimbell Art Museum, Patton, George, Landscape Architects, File Box LIK 37.

45. Letter, December 11, 1967, Brown to Kahn. Kahn Collection, Correspondence with Dr. Richard F. Brown I, 3.66–12.70, File Box LIK 37.

46. Letter, December 8, 1967, Meyers to Komendant. Letter, January 12, 1968, Komendant to Kahn. Kahn Collection, Kimbell Art Museum, Dr. Komendant, File Box LIK 37.

47. Letter, December 20, 1967, Brown to Kahn. Kahn Collection, Correspondence with Dr. Richard F. Brown I, 3.66–12.70, File Box LIK 37.

48. Letter, February 15, 1968, Patton to Meyers. Kahn Collection, Kimbell Art Museum, Patton, George, Landscape Architects, File Box LIK 37.

49. Letters, December 11 and 21, 1967, Meyers to Geren. Kahn Collection, Preston M. Geren Correspondence I, 11.11.66–7.21.69 (1.24.70), File Box LIK 37. Along with the second letter Meyers sent Geren the Tentative Schedule of Finishes, adding that the reflector estimate should add $1.20 for each square foot for gallery space on the upper level.

50. Letters, February 21, 1968, Meyers to Brown; and April 5, 1968, Brown to Kahn. Kahn Collection, Correspondence with Dr. Richard F. Brown I, 3.66–12.70, File Box LIK 37. Letter, April 5, 1968, Brown to Geren. Kahn Collection, Preston M. Geren Correspondence I, 11.11.66–7.21.69 (1.24.70), File Box LIK 37.

51. Letter, May 21, 1968, Richard Garfield to Brown. Brown had asked for plans with new proportions in late April so that he could make suggestions. Letter, April 25, 1968, Brown to Meyers. Kahn Collection, Correspondence with Dr. Richard F. Brown I, 3.66–12.70, File Box LIK 37.

52. The vaults became twenty-two feet across, and the service areas eleven feet wide. Letter, May 15, 1968, Meyers to Brown. Kahn Collection, Correspondence with Dr. Richard F. Brown I, 3.66–12.70, File Box LIK 37.

53. Kimbell Art Museum, Comparative Space Breakdown, August 15, 1968. Kahn Collection, Correspondence with Dr. Richard F. Brown I, 3.66–12.70, File Box LIK 37. See Appendix B.

54. The appointment was set a month in advance. Letter, July 19, 1968, Brown to Kahn. Brown reported that the board was pressing to get the project under way and that he would bring an independent Texas contractor with him. In early August the president of the board wrote Kahn to urge progress, sending a notice about projected construction of the regional airport, which he feared would affect the availability of skilled construction workers and supplies. Letter, August 7, 1968, A. L. Scott to Kahn. Kahn Collection, Correspondence with Dr. Richard F. Brown I, 3.66–12.70, File Box LIK 37.

55. Kahn Collection, Kimbell Art Museum, All Transmittals, File Box LIK 37.

56. Meyers has said this in several conversations with the author.

57. Summary of Landscape Plan, February 10, 1970, Patton to Kahn and to Brown. Kahn Collection, Kimbell Art Museum, Patton, George, Landscape Architects, File Box LIK 37.

58. Ibid.

59. Letter, November 27, 1968, Meyers to Komendant. Kahn Collection, Kimbell Art Museum, Dr. Komendant, File Box LIK 37.

60. Letter, November 5, 1968, Brown to Kahn. Kahn Collection, Correspondence with Dr. Richard F. Brown I, 3.66–12.70, File Box LIK 37.

61. Letter, December 20, 1968, Brown to Kahn. Kahn Collection, Correspondence with Dr. Richard F. Brown I, 3.66–12.70, File Box LIK 37.

62. Meyers reported these were sent December 30 and 31, 1968. Representatives of the Geren firm and of Cowan, Love and Jackson had met with them in Philadelphia. Meyers asked for Brown to make a new estimate for exhibition panels and to give information on kitchen equipment and electrical circuitry. Letter, January 7, 1969, Meyers to Brown. Kahn Collection, Correspondence with Dr. Richard F. Brown I, 3.66–12.70, File Box LIK 37.

63. Letters, October 23, 1968, Meyers to T. H. Harden of Geren Associates, November 13, 1968; Hardin to Meyers, November 15, 1968; Geren to Meyers, December 6, 1968; Kenneth McCalla of Texas Quarries, Inc., to Meyers, December 23, 1968; Hardin to Meyers. Kahn Collection, Correspondence with Preston M. Geren I, 11.11.66–7.21.69 (1.14.70), File Box LIK 37.

64. Meyers reported that he and Komendant were coming in late January or the first week of February; letter, January 7, 1969, Meyers to Brown. Brown sent the information needed; letter, January 22, 1969, Brown to Meyers. Requirements for the photographic studio, darkroom and shop area were sent by the Kimbell business manager; letter, February 21, 1969, Bo King to Meyers. Brown furnished additional information for the library; memorandum, Considerations for Library, April 9, 1969, Brown to Kahn. All in Kahn Collection, Correspondence with Dr. Richard F. Brown I, 3.66–12.70, File Box LIK 37. Letters, February 19, 1969, Meyers to Harden; March 4, 1969, Meyers to Harden. Kahn Collection, Correspondence with Preston M. Geren I, 11.11.66–7.21.69 (1.24.70), File Box LIK 37.

65. Letter, March 9, 1969, Seymour to Meyers. Kahn Collection, Thos. S. Byrne Inc., 2.27.69–11.70, File Box LIK 37.

66. Letters, March 24, 1969, Seymour to Brown; March 25, 1969, Brown to Seymour. Kahn Collection, Thos. S. Byrne Inc., File Box LIK 37.

67. Meyers related Kahn's advice by telephone. Memorandum, March 24, 1969, Meyers to Kahn. Kahn Collection, Correspondence with Dr. Richard F. Brown I, 3.66–12.70, File Box LIK 37.

68. Geren reported that Seymour had started marking up sepias of plans to indicate materials, finishes, and the structural requirements upon which the proposal was based. Letter, March 31, 1969, Geren to Kahn. Kahn Collection, Preston M. Geren Correspondence I, 11.11.66–7.21.69 (1.24.70), File Box LIK 37.

69. Memorandum, May 5, 1969, Brown to Kahn, Geren, and Byrne. Kahn Collection, Kimbell Correspondence and LIK Fee Billings, File Box LIK 95.

70. Letter, March 31, 1969, Harden to Meyers. Kahn Collection, Preston M. Geren Correspondence I, 11.11.66–7.21.69 (1.24.70), File Box LIK 37.

71. Letter, April 18, 1969, King to Meyers. Kahn Collection, Correspondence with Dr. Richard F. Brown I, 3.66–12.70, File Box LIK 37.

72. Letter, May 20, 1969, Meyers to Harden. Kahn Collection, Preston M. Geren Correspondence I, 11.11.66–7.21.69 (1.24.70), File Box LIK 37.

73. Letter, May 5, 1969, Brown to Kahn. Kahn Collection, Correspondence with Dr. Richard F. Brown I, 3.66–12.70, File Box LIK 37. Letter, May 9, 1969, Seymour to Brown. Kahn Collection, Thos. S. Byrne Inc., 2.27.69–11.70, File Box LIK 37.

74. Letter, June 4, 1969, Geren to Brown. Kahn Collection, Preston M. Geren Correspondence I, 11.11.66–7.21.69 (1.24.70), File Box LIK 37.

75. Telegram, June 4, 1969, Brown to Kahn. Kahn Collection, Correspondence with Dr. Richard F. Brown I, 3.66–12.70, File Box LIK 37.

76. Throughout June he suggested revisions to the truck dock and alternate schemes for office divisions, but on July 25 he telegraphed Kahn to ask for a report on the drawing status. Letters, June 11, 1969, King to Wisdom; July 25, 1969, King to Meyers; telegram, July 25, 1969, Brown to Meyers. Kahn Collection, Correspondence with Dr. Richard F. Brown I, 3.66–12.70, File Box LIK 37.

77. Letter, July 19, 1969, Geren to Komendant. Kahn Collection, Kimbell Art Museum, Dr. Komendant, File Box LIK 37.

78. Letter, July 24, 1969, Komendant to Geren. Geren wired acceptance of Komendant's conditions; telegram, July 26, 1969, Geren to Komendant. Kahn Collection, Kimbell Art Museum, Dr. Komendant, File Box LIK 37.

79. Komendant's drawings were sent to the architects for the addition of stairs, openings, embedded objects, floor elevations, etc.; transmittals, August 15, 1969; and August 22, 1969, Komendant to Kahn and to Geren. Kahn had suggestions; letter, August 29, 1969, Meyers to Komendant. Geren's architects offered comments on the lower floor; letters, August 25 and August 29, 1969, Harden to Komendant. All in Kahn Collection, Kimbell Art Museum, Dr. Komendant, File Box LIK 37.

80. Letter, August 18, 1969, Seymour to Komendant. Kahn Collection, Thos. S. Byrne, Inc., 2.27.69–11.70, File Box LIK 37. Letter, August 26, 1969, Komendant to Don Bumgarner of Texas Industries, Preston M. Geren Correspondence II, 8.69–7.31.70, File Box LIK 37.

81. Kahn reported to Harden that arrangements had been made with Seymour to have Fred Langford come to discuss "the formwork which leads to valid imprints on the concrete." Telegram, August 28, 1969, Kahn to Harden. Kahn Collection, Preston M. Geren Correspondence II, 8.69–7.31.70, File Box LIK 37.

82. Letters, April 4, 1969, Meyers to Iberti of Walker and Zanger, Ltd.; and April 7, 1969, Iberti to Meyers. Kahn Collection, Walker and Zanger Correspondence, File Box LIK 37. The travertine in California had found its way to a stoneyard after serving as ballast on an Italian ship.

83. Actual samples of travertine brought back by Kahn from the Salk Institute were used for matching. Iberti proposed calling the color "light Roman travertine-Salk." Letters, May 27, 1969, Meyers to Iberti; and May 27, 1969, Iberti to Meyers. Kahn Collection, Walker and Zanger Correspondence, File Box LIK 37.

84. Letter, July 11, 1969, Meyers to Harden. Meyers also wrote to inform Harden about the plywood and plastic coating used at Salk. Letter, August 5, 1969, Meyers to Harden. When he sent exact information on the Salk mix, it was in hopes that it might suggest possibilities in local sources, he said. Letter, August 21, 1969, Meyers to Harden. All in Kahn Collection, Preston M. Geren Correspondence I, 11.11.66–7.21.69 (1.24.70), File Box LIK 37.

85. Letter, September 3, 1969, Seymour to Kahn, attention: Meyers. Kahn Collection, Thos. S. Byrne, Inc., 2.27–11.70, File Box LIK 37.

86. Drawings were sent to Langford for his advice as early as July. Transmittal of sixteen drawings, July 11, 1969, to Langford. Kahn Collection, All Transmittals, File Box LIK 37. Kahn wrote Geren that "every building should have a logical system in keeping with materials, aesthetic and operational conditions. I understand there is no disagreement in the use of three-eights inch surfacing plywood. The sample proves Virgil's [Earp, the job supervisor for the Byrne company] good interests and skill. This, however, is only one aspect of the operation. Such concerns as columns, corners, pilasters, cold joints, etc., which Fred makes suggestions about, are the problem areas not yet demonstrated. . . I hope Mr. Seymour sees these advantages technically which would be from the architectural point of view more expressive of an order." Letter, February 1, 1970, Kahn to Geren. Kahn Collection, Kimbell, Fred Langford, Formwork, File Box LIK 37. Geren did not agree on the importance of formwork but wrote Seymour to ask the difference in cost between Langford's design and the "continuous method Byrne, Inc. had in mind." Letter, February 2, 1970, Geren to Seymour. Kahn Collection, Preston M. Geren Correspondence II, 8.69–7.31.70, File Box LIK 37. Seymour said Landford's system would cost $70,200 more, based on details of January 30, 1970. Letter, February 11, 1970, Seymour to Geren. Kahn Collection, Thos. S. Byrne, Inc., 2.27.69–11.70, File Box LIK 37. Langford later wrote that no response was ever made to his proposal. Letter, May 20, 1970, Langford to King. Kahn Collection, Kimbell, Fred Langford, Formwork, File Box LIK 37. His drawings were used, however.

87. Letter, July 11, 1969, Harden to Meyers. Kahn Collection, Preston M. Geren Correspondence I, 11.11.66–7.21.69 (1.24.70), File Box LIK 37.

88. Kahn's comments were written on Geren's letter. Letter, July 21, 1969, Geren to Kahn. Kahn Collection, Preston M. Geren Correspondence I, 11.11.66–7.21.69 (1.24.70), File Box LIK 37.

89. Letter, August 20, 1969, Meyers to Hardin. Hardin questioned the change, saying it came too late, but accommodation was made. Letter, August 22, 1969, Hardin to Meyers. Kahn Collection, Preston M. Geren Correspondence II, 8.69–7.31.70, File Box LIK 37.

90. Letter, September 18, 1969, Seymour to Brown. Kahn Collection, Thos. S. Byrne, Inc., 2.27.69–11.70, File Box LIK 37.

91. Seven samples, including one with pozzolan, had been sent to both Kahn and Komendant on August 1, 1969. Walls were poured with two of these chosen by Kahn. Meyers recorded Kahn's choice of number one, natural with limestone sand, on October 31, 1969. Kahn Collection, Preston M. Geren Correspondence II, 8.69–7.31.70, File Box LIK 37. Travertine, honed and rough-sawn, had been sent by Iberti. Letter, September 26, 1969, Iberti to Meyers. Iberti recorded the selection of AR Diamond Sawn Light Roman Travertine of current production. Letter, October 28, 1969, Iberti to Seymour. Kahn Collection, Walker and Zanger Correspondence, File Box LIK 37. The record was also made by Seymour. Kahn Collection, Thos. S. Byrne, Inc., 2.27.69–11.70, File Box LIK 37.

92. Seymour listed several experiments and suggested December 19 as a good time for Kahn to review the new sample. Memorandums, October 23, 1969; December 5, 1969; and December 9, 1969, Seymour to Kahn, Geren, Komendant, Cowan, Love and Jackson, and Kimbell Art Foundation. The final selection made by Kahn, consisting of Bridgeport cement and Aledo sand, was recored by Seymour and used in a pour in March. See letter, March 5, 1970, Seymour to Geren. Kahn Collection, Thos. S. Byrne, Inc., 2.27.69–11.70, File Box LIK 37.

93. Notes on meeting, Philadelphia, January 29, 1969, Hedrick, Garfield, and Wisdom. Kahn Collection, Correspondence with Dr. Richard F. Brown I, 3.66–12.70, File Box LIK 37. A copy of the kitchen layout plans was sent in May 1970, but it had been completed earlier and left in Fort Worth. Transmittal, May 13, 1970, to Frank Sherwood. Kahn Collection, All Transmittals, 11.66–, File Box LIK 37.

94. Boullée's project for the expansion of the Bibliothèque Nationale (c. 1780) was part of Kahn's inspiration to use vaults with skylights for the Kimbell Art Museum. He spoke of this during the speech in Boston in which he first described the museum. See Patricia Cummings Loud, "History of the Kimbell Art Museum," in *In Pursuit of Quality* 35. It may well have had influence specifically on the library design that expressed the vault and utilized two mezzanines at the ends. Boullée's mezzanines in the huge vault run along the sides.

95. The librarian, Ilse Rothrock, took credit for this, saying she had pointed out the inconvenience for users on the upper level at one end discovering the necessity to descend and climb stairs at the opposite end of the room. Conversation with author.

96. Letter, March 17, 1970, Geren to Komendant. Kahn Collection, Preston M. Geren Correspondence II, 8.69–7.31.70, File Box LIK 37. Meyers wrote that other schemes were developed after Komendant did not approve the structural nature of the scheme. However, Komendant said in late March that the earlier plan was possible. Letter, March 27, 1970, Meyers to Brown. Kahn Collection, Dr. Richard F. Brown Correspondence I, 3.66–12.70, File Box LIK 37. See also letters, July 16, 1970, Neil Thompson (of Kahn's office) to Komendant; October 30, 1970, Thompson to Komendant; November 6, 1970, Thompson to Komendant. A memorandum by Meyers explained that the design went through several changes, including the mechanical air system, that Komendant did not note. The slab and wall beam had to be redesigned. Memorandum, August 26, 1970, Meyers to Kahn. All in Kahn Collection, Kimbell Art Museum, Dr. Komendant, File Box LIK 37.

97. Meyers acknowledged the suggestion. Letter, November 27, 1968, Meyers to Kelly. Kahn Collection, Kimbell Art Museum, Lighting Information, File Box LIK 37.

98. Meyers enclosed a summary of discussions on costs. Letter, March 10, 1969, Meyers to Kelly. Kahn Collection, Kimbell Art Museum, Lighting Information, File Box LIK 37.

99. Letter, November 19, 1969, King to Kelly. Meyers identified the areas he wanted information on from Kelly. Letter, November 27, 1968, Meyers to Kelly. He also asked about ultraviolet filtration. Letter, June 17, 1970, Meyers to Kelly. Kahn Collection, Kimbell Art Museum, Lighting Information, File Box LIK 37.

100. Edison Price sent information on the track light at the request of Kelly. Transmittal, January 15, 1970, Price to Kahn. Kahn Collection, Transmittals, 11.66–, File Box LIK 37. Note, January 28, 1970, Price to Kahn. Kahn Collection, Kimbell Art Museum, Lighting Information, File Box LIK 37.

101. Transmittals, December 22, 1969, drawings taken to Fort Worth by Louis I. Kahn. Kahn Collection, Kimbell Art Museum, All Transmittals, File Box LIK 37.

102. Letter, November 12, 1969, Geren to Kahn; billing, November 20, 1969, Geren to Kimbell Art Foundation, attention: Brown. Kahn Collection, Preston M. Geren Correspondence II, 8.69–7.31.70, File Box LIK 37.

103. Letters, November 26, 1969, Kahn to Brown; and November 28, 1969, Brown to Kahn. Kahn Collection, Correspondence with Dr. Richard F. Brown I, 3.66–12.70, File Box LIK 37.

104. Letter, December 16, 1969, Kahn to Brown. Meyers wrote that Kelly had started consulting on the Kimbell Art Museum in a conference on another project in the fall of 1968 and had continued with the first formal meeting on the project on October 10, 1968. Letter, December 16, 1969. Kahn Collection, Correspondence with Dr. Richard F. Brown I, 3.66–12.70, File Box LIK 37.

105. Memorandum, May 5, 1969, Brown to Kahn, Geren, and Byrne. Kahn Collection, Kimbell Correspondence and LIK Fee Billings, File Box 95. Letter, January 13, 1970, Brown to Kahn. Kahn Collection, Correspondence with Dr. Richard F. Brown I, 3.66–12.70, File Box LIK 37.

106. Letters, February 2, 1970, Geren to Seymour; and March 19, 1970, Seymour to Geren. Kahn Collection, Kimbell Museum, Thos. S. Byrne, Inc., 2.27.69–11.70, File Box LIK 37.

107. Based on plans Seymour received March 27 and April 6 and 9, 1970. Letter, April 10, 1970, Seymour to Geren; see also Preliminary Construction Schedule, April 13, 1970. Kahn Collection, Kimbell Museum, Thos. S. Byrne, Inc., 2.27.69–11.70, File Box LIK 37.

108. Memorandum, April 22, 1970, Seymour to Kimbell Art Foundation. Kahn Collection, Kimbell Museum, Thos. S. Byrne, Inc., 2.27.69–11.70. Frank Sherwood summarized decisions made in this meeting, which was attended by Brown, King, E. B. Brown, Kahn, Wisdom, Neil Thompson, Geren, Sherwood, Dewayne Manning, Virgil Earp, Seymour, Hardin, Komendant, C. L. Jackson, and Graham.

109. Memorandum, March 5, 1970, Seymour to Geren. Kahn Collection, Kimbell Museum, Thos. S. Byrne, Inc., 2.27.69–11.70.

110. Memorandum, April 24, 1970, Sherwood to Seymour. Kahn Collection, Preston M. Geren Correspondence II, 8.69–7.31.70, File Box LIK 37.

111. Memorandum, May 11, 1970, Meyers to Sherwood. Kahn Collection, Preston M. Geren Correspondence II, 8.69–7.31.70, File Box LIK 37.

112. Kahn, quoted from an interview with William Jordy. See Jordy, "The Span of Kahn. Kimbell Art Museum, Fort Worth, Texas, and Library, Phillips Exeter Academy, Exeter, New Hampshire," *Architectural Review* 155, no. 928 (June 1974): 332.

113. Twenty site development plans, thirty-six architectural plans, fifteen structural drawings, thirteen mechanical and thirteen electrical plans, and six landscape plans. Memorandum, June 8, 1970, Sherwood to Thos. S. Byrne, Inc., attention: Seymour. Kahn Collection, Preston M. Geren Correspondence II, 8.69–7.31.70, File Box LIK 37.

114. Memorandum, June 8, 1970, Sherwood to Seymour. Kahn Collection, Preston M. Geren Correspondence II, 8.69–7.31.70, File Box LIK 37.

115. Letter, June 8, 1970, Geren to Kahn. Kahn Collection, Preston M. Geren Correspondence II, 8.69–7.31.70, File Box LIK 37. Geren noted that he had received complete cabinetwork details that had not been reviewed by the owner. Brown came to see these in Geren's office and omitted most of them — a waste of "your time and yours and my money to develop such plans to completion."

116. Letters, July 15 and 30, 1970, Kahn to Geren; and July 20, 1970, Geren to Kahn. Kahn Collection, Preston M. Geren Correspondence II, 8.69–7.31.70, File Box LIK 37. Geren considered that Kahn had "failed to perform services specified" by not providing preliminary working drawings and specifications.

117. Letter, August 3, 1970, Geren to Kahn. Kahn Collection, Preston M. Geren Correspondence II, 8.69–7.31.70, File Box LIK 37.

118. Letter, August 10, 1970, Brown to Kahn and Geren. Kahn Collection, Correspondence with Dr. Richard F. Brown I, 3.66–12.70, File Box LIK 37.

119. Letter, September 22, 1970, Seymour to Sherwood. Kahn Collection, Kimbell Museum, Thos. S. Byrne, Inc., 2.27–69–11.70, File Box LIK 37.

120. Letters, October 2 and 9, 1970, Seymour to Brown. Kahn Collection, Kimbell Museum, Thos. S. Byrne, Inc., 2.27.69–11.70, File Box LIK 37. Byrne reported that lack of decisions, changes, etc., led him to feel he was virtually losing control of costs and completion date. His second letter listed decisions on designs and materials he wished made on Kahn's visit the following Wednesday, October 14, 1970.

121. Letter, November 13, 1970, Seymour to King. Kahn Collection, Kimbell Museum, Thos. S. Byrne, Inc., 2.27.69–11.70, File Box LIK 37. On this visit travertine was again approved for the local subcontractor and shop drawings for its placement were authorized, a Haydite wall sample was approved except for its thick joint, oak flooring was decided upon as opposed to maple wood, and a shop drawing for lighting fixtures was approved. Lead was to be placed on the mock-up in preparation for the December 1 visit.

122. See A. T. Seymour, "Contractor Challenged by Kimbell Museum Design," *Fort Worth Star Tele-gram*, Kimbell Art Museum section, October 1, 1972: 18–25; reprinted in *Via 7: The Building of Architecture* (University of Pennsylvania and MIT Press, 1984): 77–85; and in Alessandra Latour, *Louis I. Kahn, l'uomo, il maestro* (Rome: Edizioni Kappa, 1986): 321–29; "Post-tensioned Shells Form Museum Roof," *Engineering News Record* 187 (October 28, 1971): 24–25; and "Break-away Forms Cast Arching Roofs," *Construction Management and Economics* (April 1972): 90–92. Komendant explains the structure in detail and with illustrations in *Contemporary Concrete Structures*, 504–08. See also his account in *18 Years with Architect Louis I. Kahn*, 115–31.

123. Transcription of Kahn interview with William Marlin, June 24, 1972, Philadelphia, Kimbell Art Museum files.

124. Letter, January 18, 1971, Seymour to Brown. Kahn Collection, Kimbell Museum, Thos. S. Byrne, Inc., 1.71–, File Box LIK 37. Memorandum, January 29, 1971, Meyers to Sherwood. Kahn Collection, Preston M. Geren Correspondence III, 8.1.70–4.71, File Box LIK 37. Enclosed were two sketches of a "haha" suggested by Neil Thompson, Kahn's on-site representative for most of 1970, on the west side of the south court. Meyers noted site development was undergoing revision. In February Seymour again appealed to Brown to see that Geren's office issue revised plans. He understood they were being held in expectation of further revision but planned to excavate the north end of the site the following week and would use the December plans if he must. It was actually mid-1971 before work on the site proceeded.

125. Letter, March 12, 1971, Meyers to Sherwood. Kahn Collection, Preston M. Geren Correspondence III, 8.1.70–4.71, File Box LIK 37.

126. Letter, October 30, 1970, Kelly to Meyers. Kahn Collection, Kimbell Art Museum, Lighting Information, File Box LIK 37. Kelly explained that the bill he enclosed for Isaac Goodbar, who had worked with and without a computer, was an old one.

127. Letter, May 8, 1970, Thompson to Kelly. Kahn Collection, Kimbell Art Museum, Lighting Information, File Box LIK 37.

128. Two types of perforations were available: 8 percent and 19.6 percent open. The first was five feet wide, the second only four feet. Kelly thought at this time that either would be successful for transparency and reflectivity, although he recommended the more open because he thought it would require less upkeep. See letter, October 6, 1970, Meyers to Sherwood. Kahn Collection, Kimbell Museum, Thos. S. Byrne, Inc., 2.27.69–11.70, File Box LIK 37.

129. Meyers describes the development of the reflector in "Masters of Light: Louis Kahn," *American Institute of Architects Journal* 68 (September 1979): 60–62.

130. Letter, October 5, 1971, Channing to Kahn. Kahn Collection, Kimbell Museum, Lawrence Channing, Interior Consultant, File Box LIK 37. Channing also designed furniture and gallery pedestals. According to this letter, Kahn suggested revisions. Channing said that he had removed all steel from the furniture in response to Kahn's criticisms, but he was sorry Kahn did not like it better. Channing explained that Brown wanted panels to be covered with various fabrics and woods in order to convey provenance and historical settings.

131. Letter, April 24, 1970, Boner to Geren. Kahn Collection, Kimbell Museum, C. P. Boner and Associates, File Box LIK 37.

132. Letter, June 10, 1970, Boner to Geren and Kahn. Kahn Collection, Meeting notes, Dr. Boner and Kahn, 6.4.70, File Box LIK 37.

133. Memorandum, January 6, 1971, Meyers to Sherwood. Kahn Collection, Preston M. Geren Correspondence III, 8.1.70–4.71, File Box LIK 37. The chairs (JG Westminster) were to have aisles of three feet at the stage, increasing to four feet six inches at the foyer. Prints of the auditorium plan were sent to the furniture company for installation suggestions for either 193 seats with tapered aisles or 180 using straight aisles. Letter, April 15, 1971, Meyers to JG Furniture Company. The company recommended the second arrangement. Letter, April 19, 1971, Meyers to King. Samples were reviewed on site by Kahn and Brown in June. Letter, November 16, 1971, Meyers to Sherwood. Final layout and installation instructions came from JG Furniture in January 1972. Letter, January 25, 1972, Meyers to Sherwood. All in Kahn Collection, Master Files, File Box LIK 10.

134. Yvonne Bobrowicz's proposal was sent to Brown by Meyers. Letter, March 21, 1972, Meyers to Brown. Kahn Collection, Master Files, File Box LIK 37. Boner approved the acoustical properties, although at the time Kahn was not yet satisfied with color. Letter, April 16, 1972, Meyers to Brown with copy of Boner's letter. Within a few days Kahn approved both color and design. Letter, April 19, 1972, Meyers to Brown. Kahn Collection, Correspondence with Dr. Richard F. Brown II, 1.71–, File Box LIK 37. Sherwood sent field dimensions and a rubbing of the actual curve of the top of the wall. Letter, April 19, 1972, Meyers to Sherwood. Kahn Collection, Preston M. Geren Correspondence IV, 5.1.71–, File Box LIK 37.

135. Memorandum, June 11, 1971, Seymour to Geren, attention: Sherwood. Kahn Collection, Kimbell Museum, Thos. S. Byrne, Inc., 1.71–, File Box LIK 37. Komendant did not express concern for the deflections and concurred with Seymour's decision to proceed with the library mezzanine with the camber calculated as instructed. Letter, June 25, 1971, Sherwood to Seymour. Kahn Collection, Preston M. Geren Correspondence IV, 5.1.71–, File Box LIK 37.

136. Memorandum with notes on meeting, September 29, 1971, Seymour to Sherwood (notes by Karl Bourie, Byrne job engineer). Sherwood also reported on the September 28, 1971, day-long meeting. Kahn Collection, Kimbell Museum, Thos. S. Byrne, Inc., 1.71–, File Box LIK 37.

137. Memorandum with construction schedule attached, October 14, 1971, Seymour to Brown. Kahn Collection, Kimbell Museum, Thos. S. Byrne, Inc., 1.71–, File Box LIK 37. Seymour listed architectural plans and owner decisions still outstanding.

138. Letter, October 15, 1971, Sherwood to Meyers. Kahn Collection, Preston M. Geren Correspondence IV, 5.1.71–, File Box LIK 37. Brown actively involved himself with construction by, for example, examining travertine that he required to be reset according to directions from Kahn's office.

139. Kahn Collection, Transmittals, Kimbell Museum, 12.23.71–, File Box LIK 37. On December 13 and 17 shop drawings for travertine and for kitchen and darkroom cabinets were sent to Geren; on December 20 color samples and dry-wall partitions had been sent to Brown.

140. Memorandum with construction schedule, January 14, 1972, Seymour to Brown. Kahn Collection, Kimbell Museum, Thos. S. Byrne, Inc., 1.71–, File Box LIK 37. Included was a schedule from McHarg Marble and Tile Company showing shipments of travertine due in the Houston port (dock strikes had delayed some of these) as late as February 10, 1972. All were for specified locations in the building.

141. Letters, February 16, 1972, Sherwood to Byrne. Kahn Collection, Preston M. Geren Correspondence IV, 5.1.71–, File Box LIK 37.

142. Letter with drawings of wall and cloth, April 28, 1972, Meyers to Channing; letters, November 17, 1971, Brown to Meyers; and July 10, 1972, Meyers to Brown. Kahn Collection, Correspondence with Dr. Richard F. Brown II, 1.71–, File Box LIK 37. Letter, April 27, 1972, Meyers to Sherwood. Kahn Collection, Preston M. Geren Correspondence IV, 5.1.71–, File Box LIK 37. Memorandums, April 21 and 27, 1972, Seymour to Geren, attention: Sherwood. Kahn Collection, Kimbell Museum, Thos. S. Byrne, Inc., 1.71–, File Box LIK 37. Letter, May 10, 1972, Sherwood to Seymour. Kahn Collection, Preston M. Geren Correspondence IV, 5.1.71–, File Box LIK 37.

143. Lists, May 9, 1972, Sherwood to Byrne; June 6, 1972, Meyers and Sherwood to Byrne. Kahn Collection, Preston M. Geren Correspondence IV, 5.1.71–, File Box LIK 37.

144. "Louis I. Kahn to receive American Institute of Architects Gold Medal," Architectural Record 149 (February 1971): 36; "World-renowned 'Sculptural' Architect to Receive AIA Gold Medal in June," American Institute of Architects Journal 55 (March 1971): 10; "Gold Medals '71: Louis I. Kahn," Architectural Forum 134 (March 1971): 72; Philip Mein, "Kahn," Architects' Journal 155, no. 6 (9 February 1972): 276–79; John Winter, "Louis Kahn," Royal Institute of British Architects 79 (February 1972): 10; "Institute's '71 Gold Medalist to Receive Similar Honor from British Architects," American Institute of Architects Journal 57 (March 1972): 11.

145. "Kahn's Museum: An Interview with Richard F. Brown": 44–48; Richard F. Shepard, "After a Six-year Honeymoon, the Kimbell Art Museum," 22–31; "The mind of Louis Kahn," Architectural Forum 137 (July–August 1972): 42–89; "Louis Kahn: Kimbell Art Museum," Oeil 214 (October 1972): 32–37; Barbara Rose, "New Texas Boom," Vogue 160 (15 October 1972): 118–121, 130; "Fort Worth's Kimbell: Art Housing Art," Progressive Architecture 111 (November 1972): 25, 29; "Kimbell Art Museum," Architectural Record 152 (November 1972): 43; Robert Hughes, "Building with Spent Light," Time 101, (January 15, 1973): 60–65; "Kahn's Kimbell: A Building in Praise of Nature and Light," Interiors 132 (March 1973): 84–91; "The Museum Explosion," Newsweek 82 (September 17, 1973): 88–89.

146. Simon Boussiron's 1910 Goods Station at Bercy, outside Paris, used vaulted shells of concrete to span a large, relatively open interior. See Nikolaus Pevsner, *Sources of Modern Architecture and Design* (London: Thames and Hudson, 1968): 161. Perret used more sophisticated versions in Casablanca and in the Ateliers de Decors in Paris (1923). See Bernard Champigneulle, *Perret* (Paris: Arts and Metiers Graphiques, 1959); plates 16 and 17. For a more detailed consideration of possible and likely sources for the Kimbell, ancient and modern, including Le Corbusier, see Loud, "History of the Kimbell Art Museum," 31–39.

147. Neil Levine has pointed out an analogy with the entrance to the Bibliothèque Sainte-Genevieve in Paris, where one proceeds to the reading room through the vestibule with trees painted on the walls — the groves of academia — echoes of gardens Henri Labrouste wished actually could have been accommodated on the site of the library. Conversation with the author.

148. Parnassus inspired Ferdinando de Medici in the scheme for the gardens of his villa, later the French Academy, in Rome. See Glenn M. Andres, *The Villa Medici in Rome* (New York: Garland, 1976): 291–95.

149. Kahn, "I Love Beginnings," *Architecture and Urbanism* 2, special edition (1976): 279, 285. The text was originally an address to the Aspen Design Conference in 1973.

150. "Conversation with William Jordy," in Richard S. Wurman, *What Will Be Has Always Been: The Words of Louis I. Kahn* (New York: Access Press and Rizzoli, 1986): 238.

151. See n. 17.

152. Brown related that "I had drawn the lower service level in a way I thought would be just nifty, with everything working together beautifully. I took it to Philadelphia and we sat down at the drafting board and Lou looked at it, and said, 'I can see where that would really work marvelously for you, but I would never want to go down in there.' A couple of months later I understood why. As a very sensitive architect who understood the psychological effects of these spatial and structural things, and their integration, he wouldn't and he was right." ("Kahn's Museum: An Interview with Richard F. Brown," 48).

153. See Jordy, "The Span of Kahn," 330; Lawrence W. Speck, "Evaluation: The Kimbell Museum," *American Institute of Architects Journal* 71 (August 1982): 40; Dana Cuff, "Light, Rooms and Ritual," *Design Book Review* 11 (Winter 1989): 46.

154. Marlin's interview is unpublished as a whole. A transcribed typescript is in the Kimbell Art Museum files. The interview was in preparation for the July–August issue, essentially a monograph devoted to Kahn, and quotations were used in that periodical. See "The Mind of Louis Kahn," *Architectural Forum* 137 (July–August 1972): 42–90 (the Kimbell Art Museum, 56–61). Meyers's interview is published in Latour, *Louis I. Kahn*, 399–403. McLaughlin's interview is "How'm I Doing, Corbusier?" *Pennsylvania Gazette* 71, no. 3 (December 1972): 18–26. Jordy's interview was used in the text of his article on the museum and several paragraphs quoted independently; see "Kahn on Beaux-Arts Training," *Architectural Review* 150 (June 1974): 329–35.

155. Marlin transcription, Kimbell Art Museum files; see n. 154.

156. Typescript of interview sent by Meyers to Brown, August 1972, Kimbell Art Museum files; Latour, *Louis I. Kahn*, 399–403.

156. McLaughlin, "How'm I Doing?" 23.

157. Jordy, "The Span of Kahn," 318–42. Jordy's critique remains most essential in the literature on the building. See Patricia Loud, "The Critical Fortune," *Design Book Review* 11 (Winter 1987): 52–55.

159. "Kahn's Museum: Interview with Richard F. Brown," 44.

160. Photocopy of Carter Brown, "Architecture versus the Museum," *AIA Government Affairs Review*, received in Kahn's office April 1, 1971. Kahn Collection, Correspondence with Dr. Richard F. Brown II, 1.71–, File Box LIK 37. (Original in Kimbell Art Museum files.)

161. Katie Sherrod, "Kimbell: Five Years of Greatness," *Fort Worth Star Telegram*, October 15, 1977, 2a.

162. Ann Delbridge, "Richard F. Brown's Last Interview," *Worth* (March 1980): 3.

163. "Kahn's Museum: Interview with Richard Brown," 47.

164. Hilton Kramer, "Kimbell Opening: A Diary," *New York Times*, October 15, 1972.

165. "Kahn's Museum: Interview with Richard F. Brown," 46.

166. "Interview 2: Thoughts about Kahn. Marshall Meyers," *Architecture and Urbanism*, special edition (November 1983): 223–27.

167. "Kahn's Museum: Interview with Richard F. Brown," 47. See also Brown's account of meeting Kahn in his office and studio, "Statement: Louis I. Kahn," in *In Pursuit of Quality*, 328–30.

168. Jon McConal, "Critics Unanimous in Praising Kimbell," *Fort Worth Star Telegram*, October 2, 1972. George McCue was art and urban design critic of the *St. Louis Post Dispatch*. Hilton Kramer represented the *New York Times*. McConal also quoted Charles Cowles, publisher of *Art Forum*, and Rosamond Bernier, publisher of *L'Oeil*. Carmen Goldthwaite, "Critics Use All the Words for Kimbell," *Fort Worth Press*, October 3, 1972, 3. Barbara Rose represented *Vogue*, and Henry Seldis both the *Los Angeles Times* and *Washington Post*. In addition there were quotations from Susan Drysdale of the *Christian Science Monitor*, Brian O'Doherty of *Art in America*, John Coplans of *Art Forum*, McCue, and Cowans. These newspaper accounts are in volume 1 of the Kimbell Art Museum Scrapbook.

169. Emily Genauer, "More on the Museum Boom," *Houston Post*, October 22, 1972. An edited version of the same essay is "Architecture Entree on Museum," *Newsday* (October 20, 1972).

Kimbell Art Museum, Fort Worth. Entrance lobby and bookstore, seen from the head of the stairs.

170. Donald L. Hoffmann, "Light, Space and Structure in the Kimbell Art Museum," *Kansas City Star*, October 8, 1972. Hoffmann authored several articles and a book on John Welborn Root, *Meaning of Architecture: Buildings and Writings by John Welborn Root* (New York: Horizon Press, 1967). His articles include "Frank Lloyd Wright and Viollet-le-Duc," *Journal of the Society of Architectural Historians* 28 (October 1969): 173–82.

171. Peter McCleary, "The Kimbell Art Museum: Between Building and Architecture," *Design Book Review* 11 (Winter 1987): 48–51.

172. Messer, quoted by Susan Drysdale, "Fort Worth Museum," *Christian Science Monitor* and *Houston Post*, November 9, 1972.

173. Letter, November 26, 1969, Kahn to Geren. Kahn Collection, Preston M. Geren Correspondence II, 8.69–7.31.70, File Box LIK 37.

# The Yale Center for British Art    CHAPTER 4

## Commission Background

The Yale Center for British Art was Louis Kahn's second commission from Yale University for a mixed-use university arts building. As in the case of the Yale University Art Gallery addition, the educational function of the building was a major factor in the program. But, unlike the Gallery program, which required flexibility so that the interior could be changed according to changing requirements, the Center's program was very specific in identifying a broad array of needs: provision for exhibition and open storage space for paintings, sculpture, drawings, and prints; a rare book collection; a research library; a photograph archive; an auditorium; classrooms and seminar rooms; workshops and offices; and conservation facilities. The complexity of the program was striking for an institution still in the process of formally organizing itself.

The Paul Mellon Center for British Art and British Studies, as it was known in the beginning and through the time of Kahn's involvement,[1] was made possible in 1966 by the gift to Yale University of Paul Mellon's (Yale, 1929) large and important collection of British art. In 1931 Mellon had begun collecting illustrated books with sporting plates; he proceeded to paintings in 1936, especially of horses, and subsequently expanded his collection to rare books. After 1959 he began collecting British art more seriously, acquiring within two and a half years four hundred paintings by artists such as Hogarth, Wright of Derby, Turner, Constable, and Stubbs. His interests were not so much in traditional, formal portraits, such as his father had collected, but in genre, sport, scenes of play, landscapes and marines, conversation pieces, and informal portraits. His gift to Yale of this specialized collection, homogeneous and difficult to blend with others, also included funds to acquire a site and to construct and endow a building.

The Center was planned with great care by an interdisciplinary committee appointed by Yale President Kingman Brewster, Jr., and chaired by Professor Louis Martz. Its report, submitted after a year's consideration in the winter of 1967–68, divided the institution into three parts: (1) art gallery and rare books with curatorial and museum staff, including conservator and photographer, (2) research library, and (3) academic program with instruction in British art history, an undergraduate major in British Studies, and support for graduate cross-disciplinary work with utilization of visual materials in historical, literary, and other studies.[2] Professor Jules David Prown was appointed Director of the Center in July 1968 with the charge, in part, to act as the architectural client for Yale, the owner, for the construction of the Mellon Center.[3]

In February 1969, after some time spent exploring the concept of the center and several months concerned with architectural ideas, Prown wrote Kahn to arrange a meeting.[4] He had already spoken with President Brewster, Paul Mellon, and Edward L. Barnes, who was Brewster's chief architectural adviser and officially Consulting Architect to the University, informing them of his first preference for Kahn as architect for the Center, and he now so informed Kahn.[5] By this time Yale University had purchased the site, the block on Chapel Street between High and York Streets, halfway through the block toward Crown Street and directly across Chapel Street from the Art Gallery.

Yale Center for British Art, New Haven. Library court, looking toward stairwell.

The city of New Haven took interest in the location, for it was considered to be inner-city commercial property in the process of deterioration. Mayor Richard C. Lee had announced the Mellon gift with President Brewster, saying the projected Center would bring a "new dimension of elegance" to the city.[6] Almost immediately, however, the city's growing concern over the loss of taxable property and student antagonism to university expansion created a difficult situation. As a compromise, some students and faculty members proposed the inclusion of commercial shops on the ground floor to preserve tax revenues for the city and an urban character for the site. While the University was not enthusiastic about this suggestion, it was realized that accommodation was necessary.

Before making contact with Kahn, Prown had written his "Preliminary Thoughts on Architecture" for President Brewster, specifying the humanistic building he thought needed, to relate the "real world" of the present to the experience of the Center for its visitors.[7] The world Prown had in mind was both Yale and New Haven, the environment as a whole in which the program and holdings of the Mellon Center were to exist. He recommended that the building not be monumental but on a scale related to the many small works of art and the somewhat fewer large objects. He wanted daylight for the exhibition galleries, offices, and conservation areas and artificial light where prints, drawings, and rare books would be exhibited and used. A comfortable, clearly organized interior, "as in a plan that revolves around a courtyard or courtyards," would add interest and help alleviate fatigue. Materials appropriate to the character of the collections should be used. Finally, it might be necessary to find novel solutions for institutional arrangements and the organization of contents because of desired flexibility in scholarly use.

As for the architect, Prown naturally hoped for someone compatible with himself and responsive to the programmatic requirements of the Center.[8] But he then proceeded to supply an inventory of character desiderata so specific that we are reminded of Louis Kahn at every turn. In Prown's words, he thought it desirable that the architect have a penchant for human scale; a humane sense of materials and textures; a concern for the relationship of inner and outer space, use of natural light, incorporation of views of the outside world, landscape gardening; a sense of the requirements of an urban setting; a sense of the requirements of an academic setting; possibly previous museum experience which would show a responsiveness to art objects and a sense of balance concerning the relationship between the architecture to the objects displayed. It would be necessary for the architect to have a qualified and sizable backup staff that would affect which work might be given to subordinates and also would assure the quality of associates as consultants. It would seem Prown's list was drawn up with a particular architect in mind.

In April 1969 Prown, Mellon, and Stoddard Stevens accompanied Kahn on a visit to the Salk Institute in La Jolla, a visit Prown considered "fruitful and successful in every way."[9] He was impressed by the rapport he saw between the client and architect as well as by the architecture of the Institute itself. Barely two months later came Prown's public announcement of his recommendation that Kahn design the Mellon Center for British Art and British Studies. Noting that Kahn was a great teacher, Prown added that he was "responsive to people just as he is responsive to art objects."[10] Although the loss to the city of taxable property, both housing and commercial space, was not yet completely resolved (and would not be until 1972), Prown was confident that the building would be a "beautiful and livable and vital urban space." Kahn's appointment was formally confirmed by the Yale Corporation and officially announced to the public in October 1969.[11]

To initiate work on the architectural program at the end of summer of 1969, Kahn and Prown went to Washington, D.C., and Upperville, Virginia, to see the Mellon collection that the new building was to house.[12] This visit was important to Kahn's sense of what the building should be. He liked the setting of the house for the collection and responded positively to Mellon's intimate library. Kahn's form for the Center doubtless took its origin in these two sources. A remark by Mellon, he later said, had significance

for him, namely that one needed to get close to a painting in order to see it on a dull morning because one was in a house and not a museum.[13] Kahn and Prown also visited the Phillips Gallery in Washington. The Phillips Collection, exhibited in a renovated and enlarged house just off Dupont Circle, possesses an intimacy of scale and atmosphere much admired among museum professionals for the relationship created between the art and the visitor. Prown hoped that the Center, despite its considerably larger and more elaborate program and scale, might capture something of that quality. Next, after conferring with Edward W. Y. Dunn, Jr., the Director of Buildings and Grounds Planning, Prown proposed a schedule for the Center which would be most satisfactory to Yale, one that called for completion by January 1974.[14]

While not immediately responding to the schedule, Kahn did send a draft of an Agreement between Owner and Architect to Dunn, telling him he had spoken with several engineering firms appropriate for the work in question (Henry Pfisterer for structural and two others for mechanical-electrical work). Dunn responded favorably, recommending in addition the employment of a security consultant whose fees could either be billed directly to the University or to the architect, and also suggesting two other possible consultants for mechanical and electrical engineering with whom Yale had worked in the past. In early December Kahn answered both Prown and Dunn, agreeing to the schedule and sending the agreement.[15] The latter, signed by Yale's representatives, was received in Kahn's office on February 19, 1970. In his letter to Dunn, Kahn noted that press announcements he had seen set the cost of the building at $6 million.[16]

## The First Program

In January 1970 the Building Design Program, Preliminary, The Paul Mellon Center for British Art and British Art Studies, by the Yale Office of Buildings and Ground Planning was released to the architect.[17] Included as appendices were portions of both the 1967 committees' reports and Prown's Preliminary Thoughts on Architecture and the *Yale University Guidebook for New or Remodeled Building Construction*. Under the heading Site in the program, reference was made to an art library to be built when funds became available where the Calvary Baptist Church then stood, at Chapel and York Streets. (A few months later Kahn was asked for schematic drawings for such a library.)[18] Commercial space within the project was wanted, likewise a physical connection to the art gallery. Zoning requirements for an off-street service and loading area and for parking were noted.

Space needs were initially those of the 1967 report, and it was observed that these might not be adequate. (Indeed, revisions to the program began almost immediately.)[19] "Area Requirements" called for a 147,000 square-foot building with 53,000 square feet devoted to exhibition.[20] It was noted that although the Mellon collection was still increasing in size, major growth was not anticipated. Lighting was to be natural for the paintings with auxiliary artificial light provided for dark days and evenings; works on paper would have side and/or filtered light. The library and reading room for students, curatorial staff, and administrative staff were to include conference rooms, service areas, offices, stacks, and carrels. All but the stacks should be on one floor, for efficiency's sake. The gallery workshop and registrar's work area were to be located near the service entrance, together with a center for building maintenance coordination and control.

It had been decided to have seminar rooms and curatorial offices near the galleries and reserve view room for the study collection. New museums of the 1920s, as Fiske Kimball had planned in the Philadelphia Museum, had situated their own study collections separately. Unlike the Kimbell Art Museum's program, which called for a separation of areas for the operations of the museum, this one sought to integrate academic spaces into public galleries. Only those spaces seen to be strictly operational — gallery workshop, registrar's workroom, and the building maintenance center — were set apart.

## Design Development for the First Program

Kahn began work on conceptual plans for the Center promptly. In December he came to New Haven to discuss the project with Prown, with students, and with Dunn and David Hummel, the representatives of Buildings and Grounds Planning.[12] (Hummel had worked with him on the Yale Art Gallery seventeen years earlier). Within weeks he presented schematic plans to serve as a basis for development. An early, dated section of February 4, 1970, (fig. 4.1) shows the initial concept: a ground floor devoted to auditorium and shops, the public part of the Center itself beginning on the second floor. This plan was organized around two courts, and a bridge (included in the section) would connect the future art library. In February some more specific directions are indicated by informal notes of a meeting between Kahn, his assistant Carles E. Vallhonrat, Prown, and his assistant director Henry Berg: the second floor as the study level with library, an undivided painting gallery, and the combination of one open court and a closed one.[22] Detailed requirements on the library were then sent by Berg,[23] and a second floor plan of February 22, 1970 (fig. 4.2) has a research library extending the length of the south side, the rare books and drawings area on the north, and a reading room with adjacent offices running between them.

In this early stage there were two entrances to the building, from both the east and the north, with gates that pivoted to open and close (see ground floor plan, fig. 4.3, further developed in fig. 4.4). Prown and Berg worked closely with Kahn, holding frequent meetings, according to Vallhonrat's notes, in which they gave their responses to plans and transmitted new requirements, such as memoranda on conservation department needs.[24] The final preliminary design was presented March 15, 1970 (model, fig. 4.5). The Chapel Street facade conveyed the two-part nature of the building, exhibition, and study. Each was centered on its own courtyard, or, more precisely for the west half, on the library reading room that became an open court above the second floor mezzanine. This model, its exterior revealing the gallery vaults and including four towers for services on the east and west corners, possesses sculptural form despite the planar Chapel Street facade, with its in-fill panels and windows.

Plans were expected to evolve. Prown wanted to present them in late April to Mellon, Brewster, and various Yale scholars for their reactions.[25] By April, Kahn's vision had

**4.1**
*Yale Center for British Art. Schematic section.* **Catalogue 53.** Louis I. Kahn. February 4, 1970. Louis I. Kahn Collection, University of Pennsylvania and Pennsylvania Historical and Museum Commission.

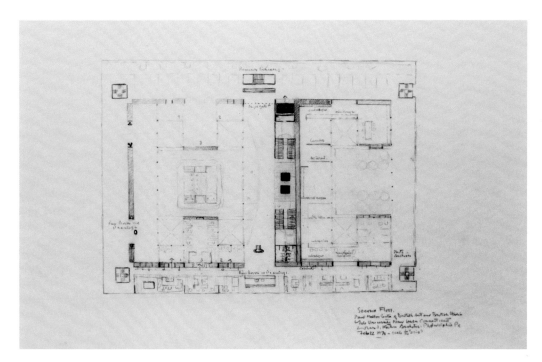

**4.2**
*Yale Center for British Art. Schematic plan, second floor.* **Catalogue 54.** Louis I. Kahn. February 22, 1970. Louis I. Kahn Collection, University of Pennsylvania and Pennsylvania Historical and Museum Commission.

**4.3**
*Yale Center for British Art. Schematic plan, first floor.* **Catalogue 55.** Louis I. Kahn. March 1970. Louis I. Kahn Collection, University of Pennsylvania and Pennsylvania Historical and Museum Commission.

**4.4**
*Yale Center for British Art. Schematic plan, first floor.* **Catalogue 56.** Louis I. Kahn. April 9, 1970. Louis I. Kahn Collection, University of Pennsylvania and Pennsylvania Historical and Museum Commission.

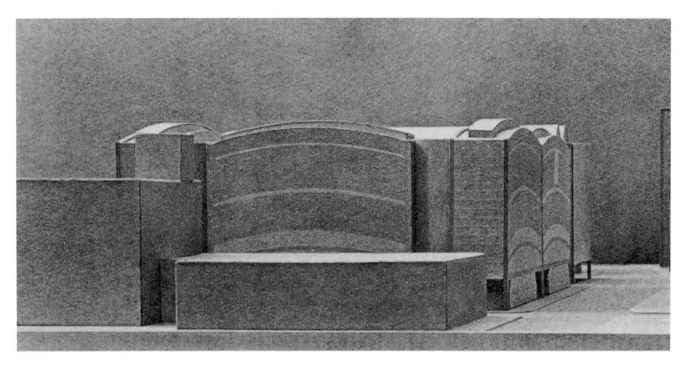

**4.5**
*Yale Center for British Art. Model, first version.* **Catalogue 57.** Louis I. Kahn. Photograph dated June 6, 1970. Louis I. Kahn Collection, University of Pennsylvania and Pennsylvania Historical and Museum Commission.

**4.6**
*Yale Center for British Art. Schematic plans, sections.* **Catalogue 58.** Louis I. Kahn. April 1970. Louis I. Kahn Collection, University of Pennsylvania and Pennsylvania Historical and Museum Commission.

**4.7**
*Yale Center for British Art. Schematic plan.* **Catalogue 59.** Louis I. Kahn. May 10, 1970. Louis I. Kahn Collection, University of Pennsylvania and Pennsylvania Historical and Museum Commission.

**4.8**
*Yale Center for British Art. Schematic plan, partial first floor, section.* **Catalogue 60.** Louis I. Kahn. Louis I. Kahn Collection, University of Pennsylvania and Pennsylvania Historical and Museum Commission.

**4.9**
*Yale Center for British Art. Schematic plans, section of stairwell.* **Catalogue 61.** Louis I. Kahn. Louis I. Kahn Collection, University of Pennsylvania and Pennsylvania Historical and Museum Commission.

taken form to the point of including the entrance courtyard and stairway. The latter was the true entrance to the museum since the ground floor, other than the auditorium, was assigned to commercial shops or nonpublic spaces (see fig. 4.6). Kahn eventually conceived a glass-enclosed stair with fountain in the court (figs. 4.7, 4.8, and 4.9), an elegant variation on the traditional Beaux-Arts grand staircase that related parts of the building. Piranesi's fantastic stairways seem to be echoed in Kahn's drawing for the stair (fig. 4.10). A persistent feature in this stage were the four utility towers clad in stainless steel at the outer corners. Natural light was another constant, as has been pointed out by Prown.[26] Bringing natural light into a building was for Kahn not only a visual but a philosophical concern, and the program for the Center called for as much natural light as possible. His own proclivity for seeing works of art in natural light already had been demonstrated in his design for the Kimbell Art Museum with its skylights and courtyards. The electric lights there he considered simply auxiliary lighting.

According to Prown, that part of the program that dealt with the library focused and identified a major theme for the architect as a place "where art objects would be 'read' and studied as well as enjoyed."[27] The library became the special, unusual ingredient in the program for a museum. Kahn lavished attention on the library, for example visualizing "ingels" [*sic*] to study in comfortably (see plan, fig. 4.11). Inglenooks, seating around a fireplace, are traditionally English and had been developed as a practical medieval arrangement to trap warmth. Later architects, notably Richard Norman Shaw (1831–1912) and William Eden Nesfield (1835–88), revived them for Victorian country houses as quaint and picturesque cosy nooks.[28] Their inclusion in the library would confer a desirable association with domestic English architecture.

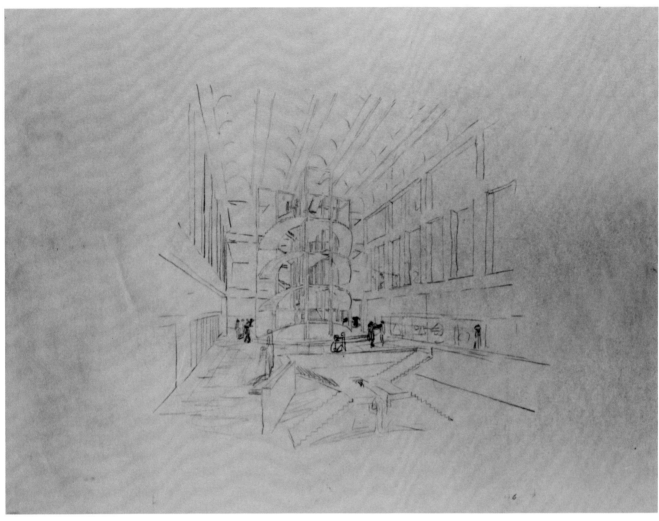

**4.10**
*Yale Center for British Art. Interior perspective, entrance court with stairway.* **Catalogue 62.** Louis I. Kahn. Louis I. Kahn Collection, University of Pennsylvania and Pennsylvania Historical and Museum Commission.

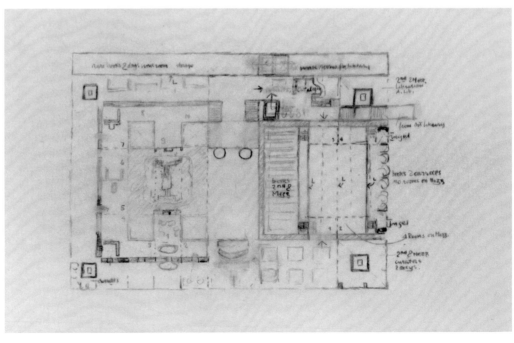

**4.11**
*Yale Center for British Art. Schematic plan, second floor and mezzanine.* **Catalogue 63.** Louis I. Kahn (office drawing). April 9, 1970. Louis I. Kahn Collection, University of Pennsylvania and Pennsylvania Historical and Museum Commission.

One critic has suggested that this project, following as it did hard upon both the Kimbell Art Museum in Texas and the Phillips Exeter Academy Library in New Hampshire (which does have fireplaces), managed to combine the main features of those programs.[29] It should be pointed out, however, that the two kinds of institution, art museum and library, now converging in the program for the Mellon Center, had always been dear to Kahn's heart as architectural projects. Art and books had special significance for him. His ability to draw was recognized at an early age as his chief talent,

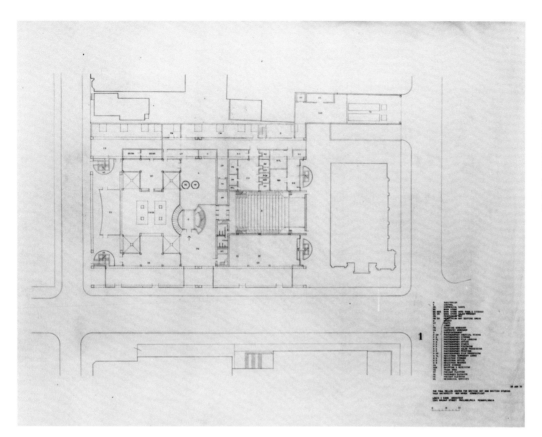

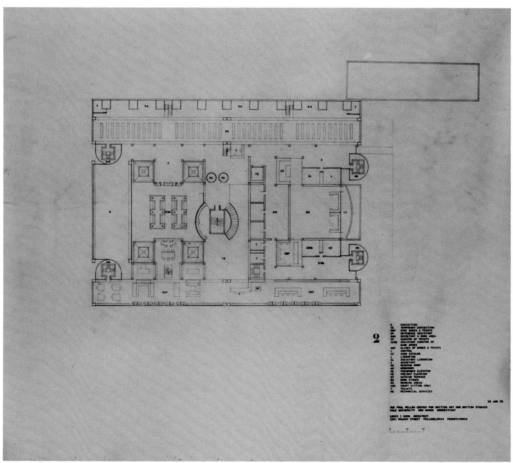

and until discovering architecture he had thought he might be an artist. Old books (not necessarily rare), especially ones on architecture, were some of the few material possessions he cared about, and he collected them throughout his career.

Preliminary specifications were prepared in Kahn's office according to the program and the schematic design, and final selection of consultants was undertaken.[30]

**4.14**
*Yale Center for British Art. Plan, second floor mezzanine.* Louis I. Kahn (office drawing). June 10, 1970. Louis I. Kahn Collection, University of Pennsylvania and Pennsylvania Historical and Museum Commission.

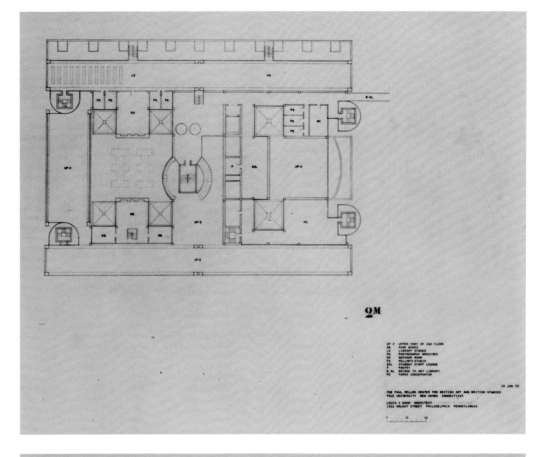

**4.15**
*Yale Center for British Art. Plan, third floor.* Louis I. Kahn (office drawing). June 10, 1970. Louis I. Kahn Collection, University of Pennsylvania and Pennsylvania Historical and Museum Commission.

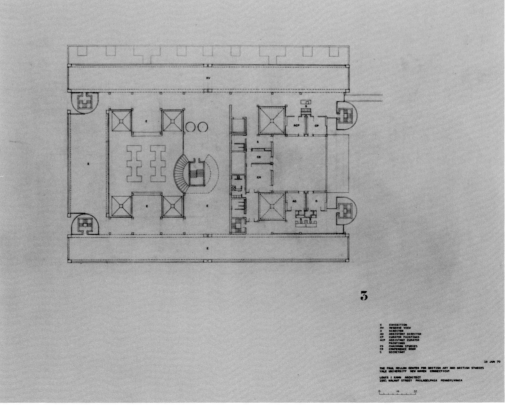

Kahn telephoned Henry Pfisterer, his colleague on the Yale University Art Gallery, and the latter's firm, now Pfisterer, Tor and Associates, became the structural consultant for the Center.[31] Abba Tor actually provided most of the services for the Mellon Center with the assistance of William Kaminski in the New Haven office and Divyakant S. Parikh in New York.[32]

By June 1970 preliminary designs had progressed to the point that Kahn sent Mellon seven plans, three elevations, two sections, and six sepias of perspective stud-

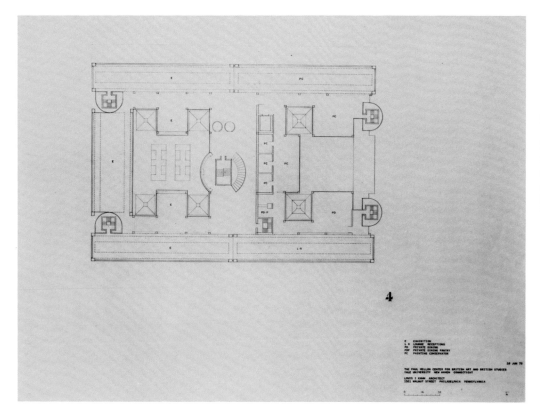

**4.16**
*Yale Center for British Art.
Plan, fourth floor.* Louis I.
Kahn (office drawing). June
10, 1970. Louis I. Kahn
Collection, University of Penn-
sylvania and Pennsylvania
Historical and Museum
Commission.

ies (for examples, see figs. 4.12, 4.13, and 4.14, 4.15, 4.16, 4.17, and 4.18).[33] Mr. Genetti
in Philadelphia, who had worked on early estimates for the Kimbell Art Museum for
Kahn, was asked to evaluate various schemes in preparation for a comprehensive
estimate.[34] At this point the galleries on the top floor had two longitudinal, overarching
roofs with skylights arranged to admit north light (figs. 4.19 and 4.20). This light was a
major characteristic of the rooms, although admittedly the arches themselves would
have created the dominant visual effect. Their curves were expressed in the exterior
granite panels, as in the Chapel Street elevation of June 10, a combination elevation
and partial section (fig. 4.21), and in another elevation of early September 1970 (fig.
4.22). It was the building's vierendeel truss structure that made such wide spans pos-
sible: its middle floors were to be constructed like bridges, extending over spaces
below intended for shops and a basement parking garage, and supporting spaces
above for the top floor galleries.

The ground floor (fig. 4.14), as before, had commercial shops, the courtyard with
stairwell, and the Center's bookstore, auditorium, and nonpublic areas. The second
floor (fig. 4.15) was devoted primarily to the library. Rare books, drawings, and prints ran
all along the north side; the center was taken by a reading room and offices for cura-
tors and librarians, while book stacks stretched the length of the south side. West of
the reading room was an outdoor terrace. A second-floor mezzanine (fig. 4.18), through
which passed the upper part of the reading room, was intended for additional stacks.
There too were part of the rare book collection, a photography archive, a lounge for stu-
dents and staff with pantry, seminar rooms, studies for fellows, and, finally, the paper
conservation department. This mezzanine was to be linked to the future art library by
a bridge (also shown on earlier plans in April). On the third floor, the large reserve view
room took the entire length of the south side (fig. 4.16). Main offices for the Center,
including its academic programs, were on the third floor. The top floor (fig. 4.17) had
long, skylit exhibition rooms together with, on opposite sides of an open court above
the reading room, the painting conservation laboratory and a lounge for receptions
with a private dining room and pantry. On all floors, in fact, exhibition galleries were
arranged around the entrance court, Kahn being concerned that the lower ones share
in natural light. Everything in the original program plus refinements added to it by
Prown and Berg was included in these plans.

Kahn produced a number of schematic studies later in June and July, but basic
plans did not alter appreciably. On August 17 there were new plans, elevations, and
sections in response to a request from Berg for a set of measured drawings and a tab-
ulation of the space use that could be employed in a forthcoming conference with

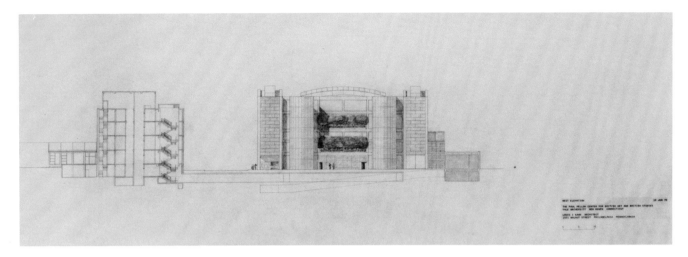

**4.17**
*Yale Center for British Art.
West elevation, drafted and
rendered.* **Catalogue 64.**
Louis I. Kahn. June 10, 1970.
Louis I. Kahn Collection, University of Pennsylvania and
Pennsylvania Historical and
Museum Commission.

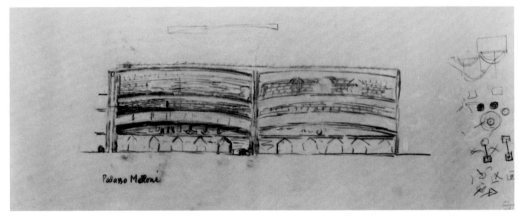

**4.18**
*Yale Center for British Art.
Schematic north elevation.*
**Catalogue 65.** Louis I. Kahn.
June 1970. Louis I. Kahn Collection, University of
Pennsylvania and Pennsylvania Historical and Museum
Commission.

**4.19**
*Yale Center for British Art.
Schematic section, fourth
floor gallery.* **Catalogue 66.**
Louis I. Kahn. June 1970.
Louis I. Kahn Collection, University of Pennsylvania and
Pennsylvania Historical and
Museum Commission.

President Brewster and the Buildings and Grounds Committee.[35] Comparison of the planned areas with those of the program shows proportional shifts. The building was some 8,000 square feet larger than originally called for; the amount of space devoted to the Center's study needs had greatly expanded, while space for exhibitions had diminished.[36]

In preparation for the estimate, plans, sketches, elevations, and sections were all sent to the consultants, who now included Richard Kelly for lighting, collaborating on Kahn's third museum.[37] But a series of meetings between Kahn and Prown in September produced additional changes. For example, in the first of these, Prown said that two entrances in the lobby of the Center were not wanted; that some flexibility in the lecture hall (perhaps even the possibility of dividing it) would be an improvement; that the slide collection should be related to the research library rather than near the rare books; that less space could be assigned the paper conservator.[38] He also asked for perspectives and for a model to present various committees — Buildings and Grounds, Academic, and Student — with the expectation that there would be revisions before a press release later in October. In a schematic elevation of September 22, 1970, Kahn now asserted the frame of the building on the Chapel Street facade (fig. 4.23).

Two preliminary estimates were prepared by independent companies using the schematic drawings that were marked up with a general finish schedule and structural

**4.20**
*Yale Center for British Art.*
*Perspective sketch of fourth*
*floor gallery.* **Catalogue 67.**
Louis I. Kahn. Louis I. Kahn
Collection, University of Penn-
sylvania and Pennsylvania
Historical and Museum
Commission.

**4.21**
*Yale Center for British Art.*
*Schematic section, elevation*
*of fourth floor.* **Catalogue 68.**
Louis I. Kahn. Louis I. Kahn
Collection, University of Penn-
sylvania and Pennsylvania
Historical and Museum
Commission.

and mechanical/electrical information furnished by the consultants.[39] The one that
was followed placed costs for the building at $14,800,000 for a gross area of 272,000
square feet (an average unit cost of $54.41 per square foot), established on the basis
of a construction schedule beginning in June 1971 and continuing until June 1973.
Further plan development and exploration of costs led to an estimate prepared by
Kahn's office of $15,200,000 for the Center, including a tunnel but with several factors
still unresolved: the truck-dock wing, basement parking, and a bridge to the Art Gal-

**4.22**

*Yale Center for British Art. Schematic north elevation, section.* **Catalogue 69.** Louis I. Kahn. September 1970. Louis I. Kahn Collection, University of Pennsylvania and Pennsylvania Historical and Museum Commission.

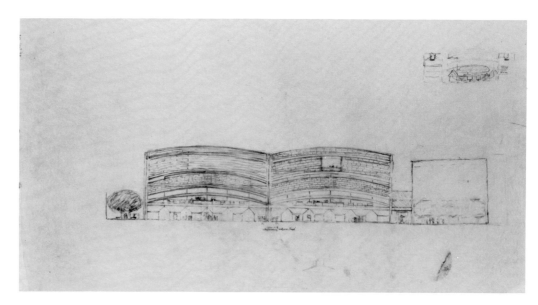

**4.23**

*Yale Center for British Art. Schematic north elevation.* **Catalogue 70.** Louis I. Kahn. September 22, 1970. Louis I. Kahn Collection, University of Pennsylvania and Pennsylvania Historical and Museum Commission.

lery.[40] Kahn's speculative designs for that bridge, incidentally, suggest his intense awareness of the existing one over High Street between Street Hall and the Old Art Gallery (see fig. 2.48) and convey too his interest in relating the new bridge to it. He seems to have been thinking of different structural possibilities. A traditional bridge with an arch motif appears in this interesting drawing (fig. 4.24), but he wanted to use modern materials and considered steel panels. We are left today with an intriguing, unrealized conjecture. In the end, however, all estimates were considerably more than the $6 million Mellon stipulated for construction.[41]

In December Kahn completed revisions and sent Prown copies of seven plans (including two basement levels), four sections and four elevations and several original drawings, such as that for the double-height library (figs. 4.25, 4.26, 4.27, 4.28, 4.29, 4.30, and 4.31), as well as a large model (fig. 4.32).[42] These document the design of the office estimate, which incorporated recommendations for commercial shops made by a Yale consultant.[43] The graceful, glass-enclosed stairway and the entrance court are present; the commercial shops occupied more space than before, having both mezzanines and basements (fig. 4.26).

On the second floor there is a simplified office and workroom arrangement, making the reading room more open (fig. 4.27). The second-floor mezzanine is only slightly altered: the paper conservator being assigned a smaller area opposite the earlier

**4.24**
*Yale Center for British Art. Schematic plan and elevations of bridge.* **Catalogue 71.** Louis I. Kahn. November 7, 1970. Louis I. Kahn Collection, University of Pennsylvania and Pennsylvania Historical and Museum Commission.

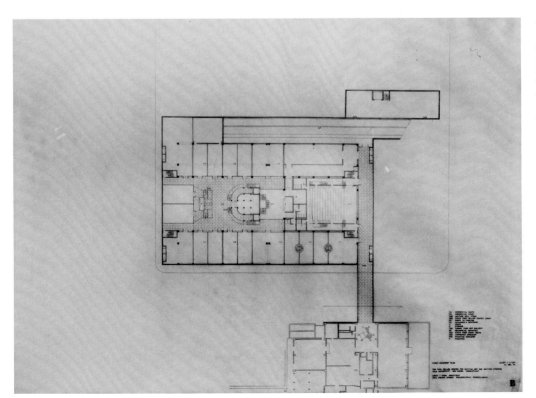

**4.25**
*Yale Center for British Art. Plan, basement.* Louis I. Kahn (office drawing). December 21, 1970. Louis I. Kahn Collection, University of Pennsylvania and Pennsylvania Historical and Museum Commission.

**4.26**
*Yale Center for British Art. Plan, first floor.* Louis I. Kahn (office drawing). December 21, 1970. Louis I. Kahn Collection, University of Pennsylvania and Pennsylvania Historical and Museum Commission.

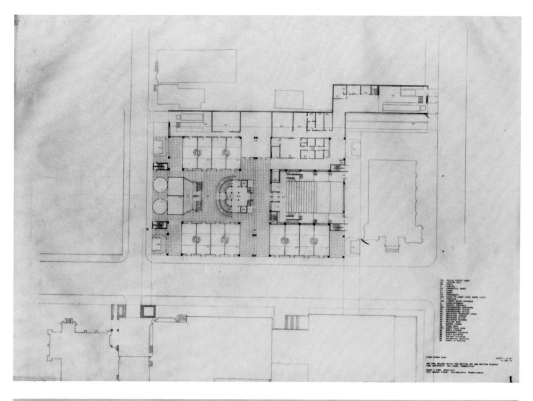

**4.27**
*Yale Center for British Art. Plan, second floor.* Louis I. Kahn (office drawing). December 21, 1970, revised 15 March 1971. Louis I. Kahn Collection, University of Pennsylvania and Pennsylvania Historical and Museum Commission.

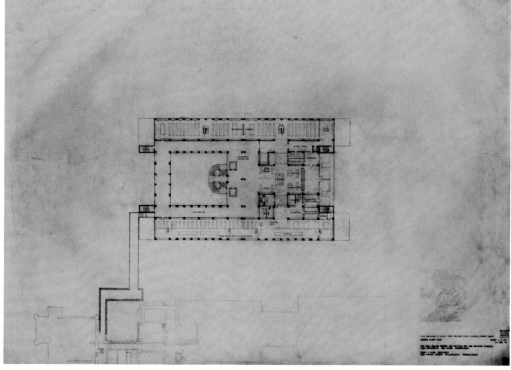

location and the arrangement of seminar rooms and studies for fellows made more uniform. On the third floor the scheme is also as it was, with glass pyramids as skylights for the library below (fig. 4.28). In a charming perspective sketch Kahn depicted the gallery on this floor with panel partitions creating a series of house-like "rooms," surprisingly intimate for so large a space (fig. 4.33). The top floor has garden terraces (see fig. 4.30) outside the vaulted galleries with skylights. No longer are there overarching roofs. With difficulty, Prown had persuaded Kahn these might overwhelm the art objects under them. The new vaults are a more conventional barrel type, relatively narrow and in series, somewhat reminiscent of those of the Kimbell Museum, but higher (fig. 4.34). In reworking the design Kahn lowered them (fig. 4.35). On the upper floors especially, the plans at this stage show a more assertive pattern of the columnar structural grid, though the sizes of the columns actually diminish as they rise on the successive floors. Their effect is to divide and articulate interior space. Through the center,

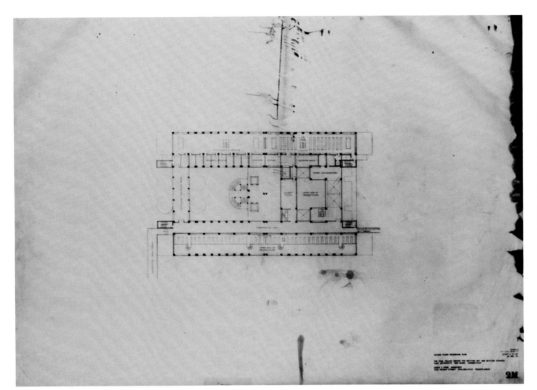

**4.28**
*Yale Center for British Art. Plan, second floor mezzanine.* Louis I. Kahn (office drawing). December 21, 1970, revised March 8, 1971. Louis I. Kahn Collection, University of Pennsylvania and Pennsylvania Historical and Museum Commission.

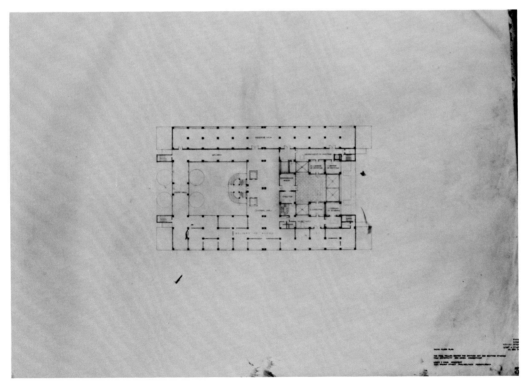

**4.29**
*Yale Center for British Art. Plan, third floor.* Louis I. Kahn (office drawing). December 21, 1970, revised March 8, 1971. Louis I. Kahn Collection, University of Pennsylvania and Pennsylvania Historical and Museum Commission.

north to south, they are doubled, evidence of a physical expansion joint also expressing the dual nature of the program and the joined nature of the building (see model, fig. 4.32).

Plans and sections were again sent to the consultants,[44] but alternative schemes for the first floor and mezzanine and sections were prepared within a week.[45] Square footage was plotted for both designs and compared to the program. They still were larger than requested, with less exhibition and more library space.[46]

Completion of design development is recorded in drawings and documents of March 15, 1971 (see sections, figs. 4.36 and 4.37; plans, figs. 4.38 and 4.39; and light monitors for the fourth-floor galleries, fig. 4.40).[47] Kahn prepared large, colored presentation drawings of the main, north and east, facades for the project, drawings that recall formal Beaux-Arts presentations (figs. 4.41 and 4.42). The Center was large, now 103,663 square feet instead of 88,000, and reflected the requests of Prown who was

**4.30**
*Yale Center for British Art. Plan, fourth floor.* Louis I. Kahn (office drawing). December 21, 1970. Louis I. Kahn Collection, University of Pennsylvania and Pennsylvania Historical and Museum Commission.

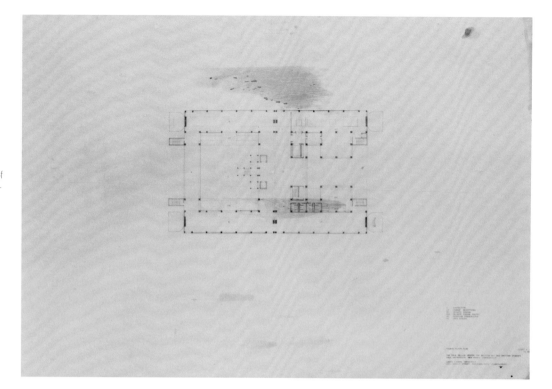

**4.31**
*Yale Center for British Art. Perspective sketch of library interior.* **Catalogue 72.** Louis I. Kahn. Louis I. Kahn Collection, University of Pennsylvania and Pennsylvania Historical and Museum Commission.

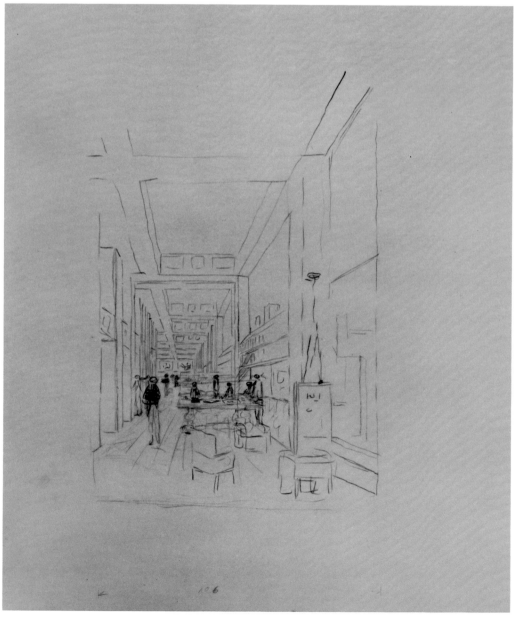

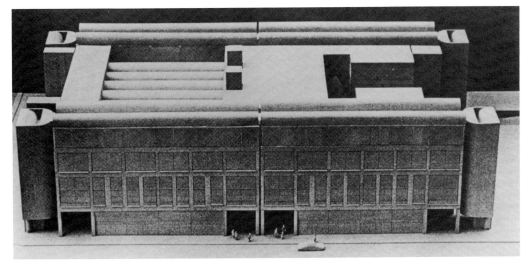

**4.32**
*Yale Center for British Art. Model, second version.* Louis I. Kahn Collection, University of Pennsylvania and Pennsylvania Historical and Museum Commission.

**4.33**
*Yale Center for British Art. Perspective sketch of third floor gallery interior.* **Catalogue 74.** Louis I. Kahn. October 1970. Louis I. Kahn Collection, University of Pennsylvania and Pennsylvania Historical and Museum Commission.

**4.34**
*Yale Center for British Art. Schematic section, fourth floor galleries.* **Catalogue 75.** Louis I. Kahn. September 1970. Louis I. Kahn Collection, University of Pennsylvania and Pennsylvania Historical and Museum Commission.

**4.35**
*Yale Center for British Art. Schematic sections, studies of lighting.* **Catalogue 76.** Louis I. Kahn. December 1970. Louis I. Kahn Collection, University of Pennsylvania and Pennsylvania Historical and Museum Commission.

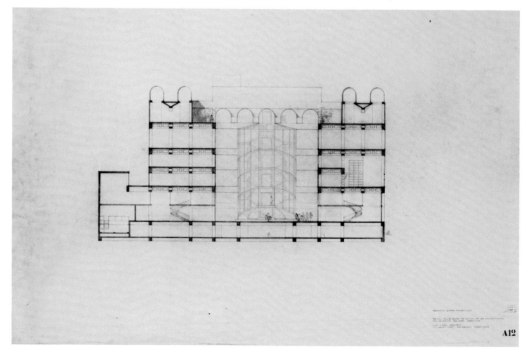

**4.36**
*Yale Center for British Art. Transverse section through entrance court.* Louis I. Kahn (office drawing). March 3, 1971, revised March 15, 1971. Louis I. Kahn Collection, University of Pennsylvania and Pennsylvania Historical and Museum Commission.

striving toward an ideal in both optimum space and convenience.[48] At the suggestion of Prown and Berg, Kahn sent Mellon a set of these architectural drawings and specifications, anticipated to be used as the guide for the working drawings as well as the basis for estimates. "The building," he wrote the donor, "has developed to a maturity that I believe in, and I hope it can be realized."[49] Kahn, Prown, and Berg were convinced of the value of the design and clearly hoped that its appeal would move Mellon to increase the budget figure.

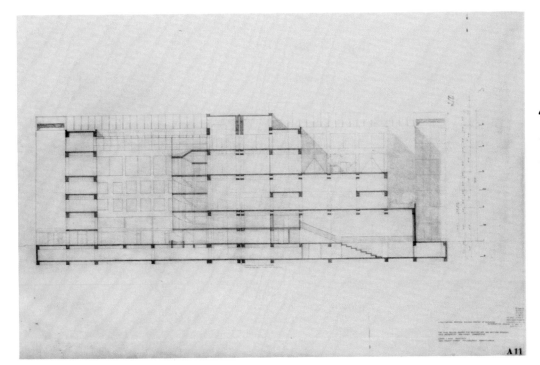

**4.37**
*Yale Center for British Art.*
*Longitudinal section.* Louis I.
Kahn (office drawing). Janu-
ary 5, 1971, revised March 15,
1971. Louis I. Kahn Collection,
University of Pennsylvania
and Pennsylvania Historical
and Museum Commission.

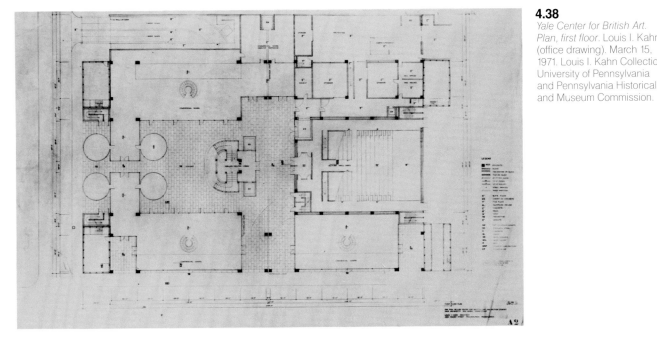

**4.38**
*Yale Center for British Art.*
*Plan, first floor.* Louis I. Kahn
(office drawing). March 15,
1971. Louis I. Kahn Collection,
University of Pennsylvania
and Pennsylvania Historical
and Museum Commission.

## The Second Program

But it was reluctantly realized that the program for the Center would have to be
scaled down. Mellon had other commitments (to the National Gallery of Art) and prices
were rapidly rising. Construction costs had increased drastically, 42 percent since the
time of Mellon's gift.[50] At the end of April, David Wisdom took a telephone call in Kahn's
office from Henry Berg who reported that net areas in the program were to be cut.[51]
Berg gave the figures that were to be incorporated in a Revised Building Program, Pre-
liminary, The Paul Mellon Center for British Art and British Art Studies, which was
issued by the Yale office of Buildings and Grounds Planning on May 6, 1971. The new
program included an appendix, Net Areas in Square Feet, 4/29/71, that superseded
the earlier area tabulations taken from the 1967 Gallery and Academic Committees
report.[52]

Most architects who had developed a schematic phase as fully as had Louis
Kahn ("to a maturity I believe in"), with enthusiastic cooperation from the client, would
have found rejection disheartening if not tragic. In conversation, Prown has expressed
regret that it was not possible to build the first project — a marvelous museum, he

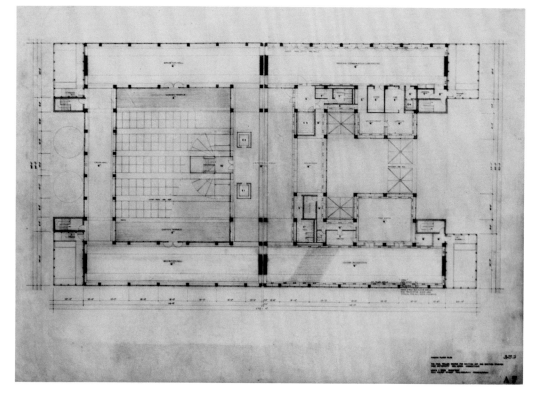

**4.39**
*Yale Center for British Art.
Plan, fourth floor*. Louis I.
Kahn (office drawing). March
15, 1971. Louis I. Kahn Collec-
tion, University of Pennsylvania
and Pennsylvania Historical
and Museum Commission.

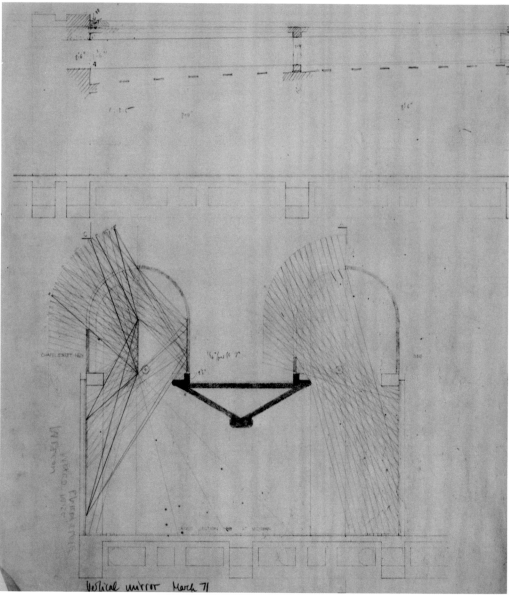

**4.40**
*Yale Center for British Art.
Lighting study, vertical mir-
ror, light monitors, fourth
floor galleries*. Louis I. Kahn
(office drawing). March 1971.
Louis I. Kahn Collection,
University of Pennsylvania
and Pennsylvania Historical
and Museum Commission.

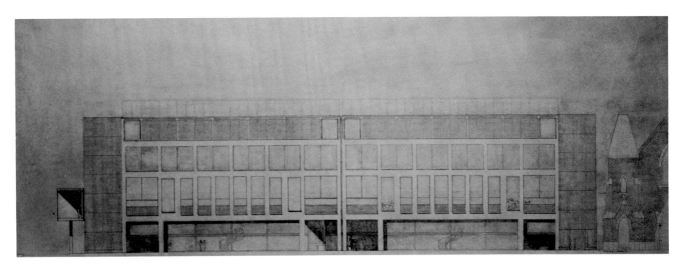

**4.41**
*Yale Center for British Art.
Elevation on Chapel Street.*
**Catalogue 77.** January 14,
1971. Louis I. Kahn. Louis I.
Kahn Collection, University
of Pennsylvania and Penn-
sylvania Historical and
Museum Commission.

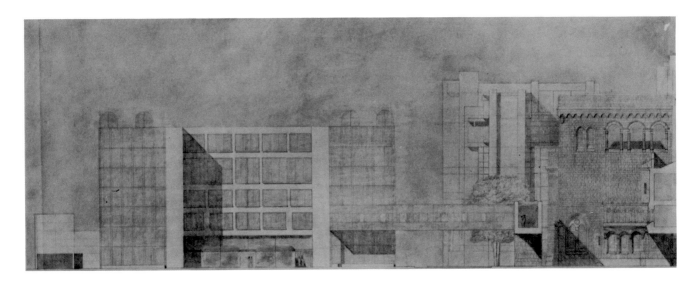

**4.42**
*Yale Center for British Art.
Elevation on High Street.*
**Catalogue 78.** Louis I.
Kahn. Louis I. Kahn
Collection, University of
Pennsylvania and Pennsyl-
vania Historical and
Museum Commission.

thought, and close to what he had envisioned in the beginning. Kahn himself said only that he was sorry expense caused abandonment of the four mechanical towers because he felt their shape carried expressive meaning. His great strength was his inventive power of design. He never complained of having to undertake redesign. Even without outside intervention Kahn was perfectly capable by himself of initiating new designs in the middle of a project in his incessant quest for improvements. Furthermore, this issue of a second program brought in its train a recognition of work accomplished that was probably unique in his career. Program change was not unusual after budgetary evaluations, but Kahn did not normally receive payment for a completed phase that reached a dead end. This time he did, and he saw the new program as a new beginning, a different building.

Cuts in the program were justified in various ways. The research library was eliminated because the new, unified Art Library had been approved by the University and would be planned for the site of the former Calvary Baptist Church.[53] (Kahn had been

asked to undertake preliminaries for that art library, several sketches for which exist in the Kahn Archives. He might have eventually received the commission, had events been different.) The need for both space and future staff were reduced, thus benefiting the operating budget as well. Under the revised program only a collection of around 10,000 reference volumes for the curatorial staff would be kept in the Center, even fewer than the library in the Kimbell Art Museum was to have. Space for displaying the permanent collection, which had been most generously estimated, was now almost half its former size. The lecture hall was to seat only two hundred.

After this program was formulated, there were further revisions. The following month Prown wrote Kahn that in discussions with Kenneth Froeberg, Vice-President of the George B. H. Macomber Construction Company, he and Dunn were informed that the quality building wanted for the Center could not be built for "less than $80 per square foot in July 1972 dollars."[54] Prown calculated that this would require a reduction of planned net square footage to 55,000, eliminating an additional 8,500 net square feet. Because of the need for efficient use of space, he asked Kahn to consider (1) transferring more programmed activities to the basement and (2) reducing the space devoted to rare books and to photo archives. The first of these implied that the auditorium, either entirely or in part, could be below ground and that nonpublic Center functions also could be located there.

After consultations, the Yale Buildings and Grounds office prepared another sheet on Basic Requirements for the Mellon Center Project, removing the painting conservation studio (2,700 square feet) and leaving the Center with 60,870 programmed net square feet.[55] Prown reasoned that the condition of the Mellon paintings was quite good and that extensive work on them would not be needed for years. The facilities of the Yale Art Gallery could be used for routine examination and minor attention.[56] The July 1971 program amendment also placed the budget limitation on record: $6,560,000 for construction and $700,000 for furniture and equipment,[57] figures at first sight not very different from those for the Kimbell Art Museum. (The inclusion of site work for the latter throws the comparison off slightly.) Also altered were instructions on parking facilities—a minimum of one hundred spaces outside the building with a budget of $160,000 for construction — and on special site requirements. The parking lot was required to exit on High Street and the off-street loading dock for the Center and commercial facilities would need on-site turnaround space. Budget for the latter facilities, 16,000 square feet, was to be $480,000. Total cost for building and site development therefore would be $7,200,000, or $7,900,000 in all, including furniture and equipment, according to the figures given by Dunn's office.

### Design Development for the Second Program

Although figures such as these were not the type that interested Kahn during design, in May he and his office prepared sketches for another Mellon Center, even before the complete revised program arrived in Philadelphia.[58] On May 20, 1971, he presented a design to President Brewster, the Associate Provost for Academic Planning, Prown, and Berg. He reduced size, as expected; and placed the entrance to the Center on the east, on High Street (as in fig. 4.43). After his presentation it was decided during the ensuing discussion that the Center should be oriented toward both High and Chapel Streets in order to extend a broad welcome to students and to citizens of New Haven.[59] With operating expenses in mind, the Yale representatives decided that commercial shops should occupy the maximum possible space, perhaps even including the "courtyards or plazas," to produce adequate rental revenue. Despite their pervasive, documented concern with net areas, "the arrangement should be of equal importance." Other suggestions from this meeting dealt with possible improvements in the relationships between design components: north light for the rare books reading room and for the prints and drawings department, their collections unified; public display areas distributed on the second as well as the third and fourth floors; storage space, even possibly the reserve view section, on the perimeter of the building with

**4.43**
*Yale Center for British Art.
Schematic plan, first floor.*
**Catalogue 79.** Louis I.
Kahn. Louis I. Kahn
Collection, University of
Pennsylvania and Pennsyl-
vania Historical and
Museum Commission.

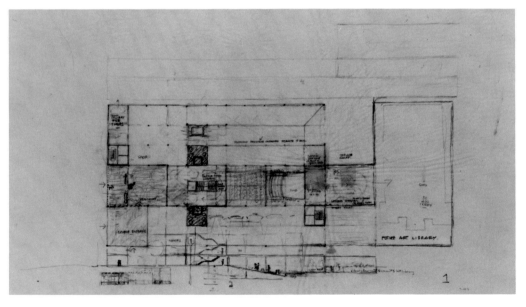

**4.44**
*Yale Center for British Art.
Schematic plan, first floor,
and section.* **Catalogue 80.**
Louis I. Kahn. July 19, 1971.
Louis I. Kahn Collection,
University of Pennsylvania
and Pennsylvania Historical
and Museum Commission.

exhibition concentrated around the court; design correlation for the similar second and third floors but different for the entrance level and fourth floor.

Kahn promptly incorporated suggestions.[60] He was always open to ideas from others in his search to improve a design, but he made the final judgment. Especially interesting is the shift of the entrance to the corner of High and Chapel Streets, his solution to the need to accommodate both the University and the city (fig. 4.44). He chose this over having two separate entrances (see schematic plans of July 3, 1971, figs. 4.45 and 4.46). Although a number of concepts which had developed during design of the first project were included in the second, especially the organization of the plan around two courts expressive of the dual nature of the program, this is a new building with a basic change in structural system and with the two courts even more pro-

**4.45**
*Yale Center for British Art. Schematic plan, drafted and freehand, version 1.* **Catalogue 81.** Louis I. Kahn. July 3, 1971. Louis I. Kahn Collection, University of Pennsylvania and Pennsylvania Historical and Museum Commission.

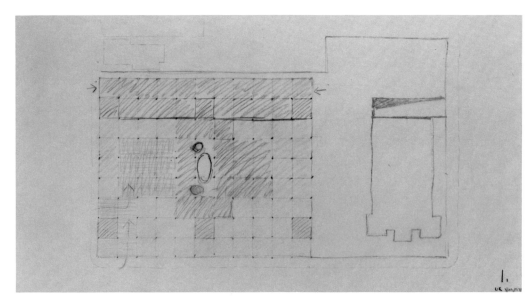

**4.46**
*Yale Center for British Art. Schematic plan, version 2.* **Catalogue 82.** Louis I. Kahn. July 3, 1971. Louis I. Kahn Collection, University of Pennsylvania and Pennsylvania Historical and Museum Commission.

nounced. Without the necessity of having a wide span for the parking garage in the basement and with a top floor of galleries now a series of room-like spaces rather than long vaults, the vierendeel trusses were dropped. Instead, a simple column and horizontal slab structure of reinforced concrete was adopted.

On the ground floor, because of the omission of every other column (with exceptions at the outer corners made later), the span between the columns was greater, double that of the floors above (fig. 4.48). This spacing distinguishes the commercial shops from the upper floors of the Center (see schematic section and elevation, fig. 4.47). The scheme represents an about-face from the smaller shops, depicted almost like individual houses in early elevations of the first project (see figs. 4.13 and 4.22); it is closer to the schematic elevation of September 1970 (fig. 4.23).

From the beginning the inclined floor of the auditorium descended below ground level (see sections, figs. 4.1 and 4.37), and in fact conflicted at one point with the parking garage. Now Kahn planned that this descent be continued to an even greater extent. The west end of the site up to the Yale theater (and anticipated location of the art library) would be excavated to the level of the auditorium stage, creating a sunken courtyard or plaza with related commercial facilities on its north and south sides. It was

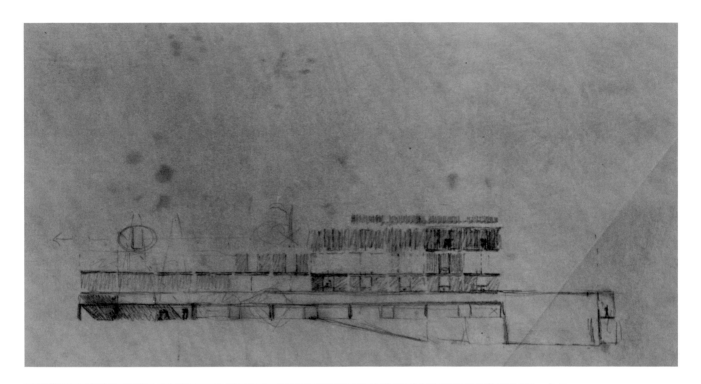

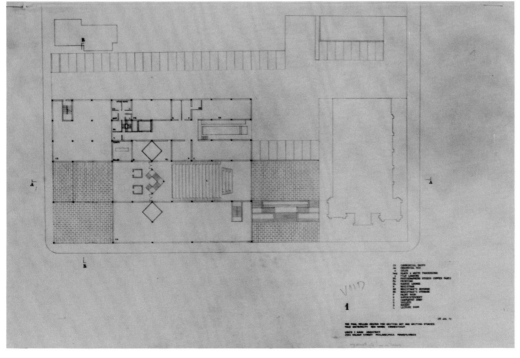

**4.47**
*Yale Center for British Art.
Schematic longitudinal section.* **Catalogue 83.** Louis I.
Kahn. July 25, 1971. Louis I.
Kahn Collection, University of
Pennsylvania and Pennsylvania Historical and Museum
Commission.

**4.48**
*Yale Center for British Art.
Plan, first floor.* Louis I. Kahn
(office drawing). July 28,
1971. Louis I. Kahn Collection,
University of Pennsylvania and
Pennsylvania Historical and
Museum Commission.

thought by the adviser for the commercial program that this area might be successful
as a restaurant or café, or for "Le Drugstore," in imitation of a popular retailing development in France at the time.[61]

As the tunnel vaults were replaced by individualized spaces for the galleries on
the top floor, the lighting system also changed (fig. 4.49). Separate skylights strongly
recall the lantern-lighting of Soane's Dulwich Picture Gallery; they are at any rate quite
different from the split vaults of the Kimbell Art Museum. These skylights are indicated
sketchily as circles on an early schematic plan (fig. 4.50) that conveys the bay system,
but the development is clearly into lantern-lit rooms. Openings above the columns and
between the lanterns contain ducts and conduits (fig. 4.51), in an arrangement anal-

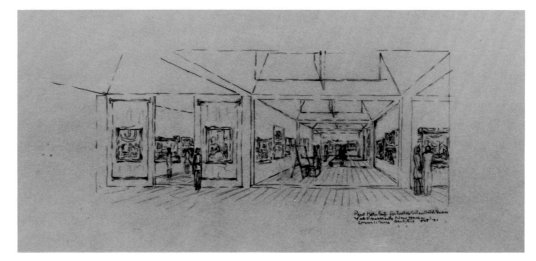

**4.49**
*Yale Center for British Art. Perspective sketch of fourth floor galleries.* **Catalogue 84.** Louis I. Kahn. October 1971. Louis I. Kahn Collection, University of Pennsylvania and Pennsylvania Historical and Museum Commission.

**4.50**
*Yale Center for British Art. Schematic floor plan.* **Catalogue 85.** Louis I. Kahn. Louis I. Kahn Collection, University of Pennsylvania and Pennsylvania Historical and Museum Commission.

**4.51**
*Yale Center for British Art. Schematic section, fourth floor galleries.* **Catalogue 86.** Louis I. Kahn. Louis I. Kahn Collection, University of Pennsylvania and Pennsylvania Historical and Museum Commission.

ogous to the flat channels between the Kimbell vaults and even to the early idea of using in a similar way spaces between narrow vaulted channels of the ceiling in the Yale University Art Gallery. Kahn's logic in seeking and finding service space is consistent.

Progress on the new design was rapid. In circumstances akin to Kahn's change of plan for the Kimbell Art Museum in August 1968, the development seemed to flow, primed by previous efforts. Major differences in design were no impediment. By late July, Kahn could present his office's tabulation of areas in the new scheme.[62] Drafted plans of August 16, 1971, show a ground floor with a large opening at the northeast corner of the building, almost one third of its length and breadth, as the entrance to the Center (fig. 4.52). Along Chapel and High Streets commercial spaces are undivided by partitions and completely separated from the Center except for fire stair exits at the northwest and southeast. The auditorium is in the center of the west half of the building. Proper entrance to the Mellon Center is from the first interior courtyard. The main stairway, now enclosed in a square turned obliquely and modified for entrance at a corner, rises beyond the elevators (passenger and freight) to either side. On the south, away from the streets but adjacent to the parking lot, are the Center's nonpublic facilities with a drive-in service entry on the west beside a turn-around area. The basement plan (fig. 4.53) includes two sizable commercial areas to either side of the sunken plaza and storage under the Chapel Street shops. Otherwise the basement serves the Center, providing storage and mechanical space, its shops (print, carpentry), and photo studio. A tunnel connects with the Art Gallery across Chapel Street.

The second floor, the real first floor of the Center (fig. 4.54), shows specialized areas for research and reading and for rare books, prints, and drawings on three sides around the second court, large and rectangular (figs. 4.55 and 4.56). Kahn first designated this court a reading room and later the library or exhibition court. The main stairwell passes through its eastern third, leaving free space equivalent to the forty-foot square entrance court on the east. That court is open from ground through roof and

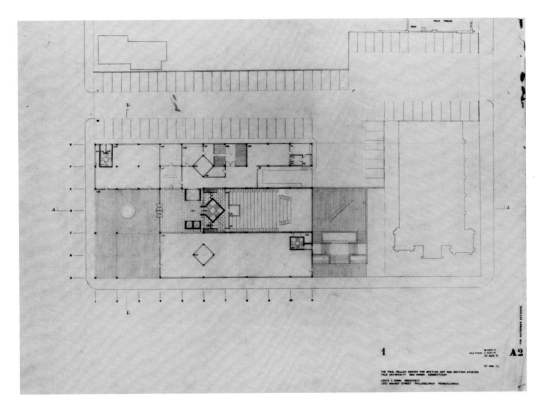

**4.52**
*Yale Center for British Art. Plan, first floor.* Louis I. Kahn (office drawing). August 16, 1971, revised September 18, 1971. Louis I. Kahn Collection, University of Pennsylvania and Pennsylvania Historical and Museum Commission.

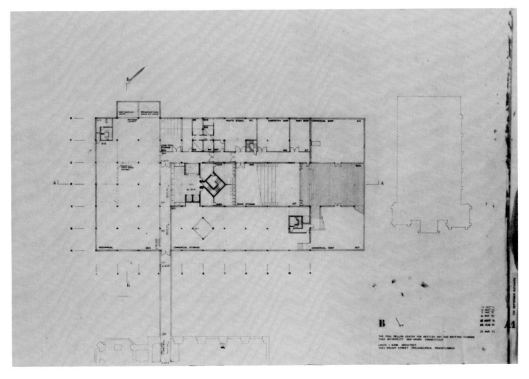

**4.53**
*Yale Center for British Art. Plan, basement.* Louis I. Kahn (office drawing). August 16, 1971, revised October 19, 1971. Louis I. Kahn Collection, University of Pennsylvania and Pennsylvania Historical and Museum Commission.

ringed by exhibition space on the upper floors, while this, the library court, rises from the second floor, surrounded by libraries for the first two of its levels and by exhibition areas on the upper floor. A student-faculty lounge and a seminar room occupy the southeast corner of the second floor. The third floor might be described in part as a mezzanine because of the two-floor reading rooms and stacks (see longitudinal section, fig. 4.57). The top floor (fig. 4.58) is the primary gallery floor with exhibition space around both courts, with a reserve view or study gallery on the south, and with offices, a storage room, and a meeting room on the west and northwest, overlooking York and Chapel Streets. It is also the floor with skylights to light the paintings in the collection. Passing from ground floor to the top and centered in the south and north ranges of bays are oblique squares, echoing but slightly smaller than the shape enclosing the main stairwell. These are to give vertical space for mechanical systems and to act as air shafts.

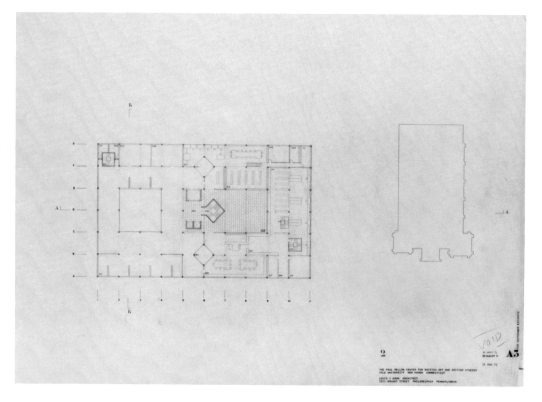

**4.54**
*Yale Center for British Art. Plan, second floor.* Louis I. Kahn (office drawing). August 16, 1971, revised September 18, 1971. Louis I. Kahn Collection, University of Pennsylvania and Pennsylvania Historical and Museum Commission.

**4.55**
*Yale Center for British Art. Interior perspective of library court looking west.* **Catalogue 87.** Louis I. Kahn. Louis I. Kahn Collection, University of Pennsylvania and Pennsylvania Historical and Museum Commission.

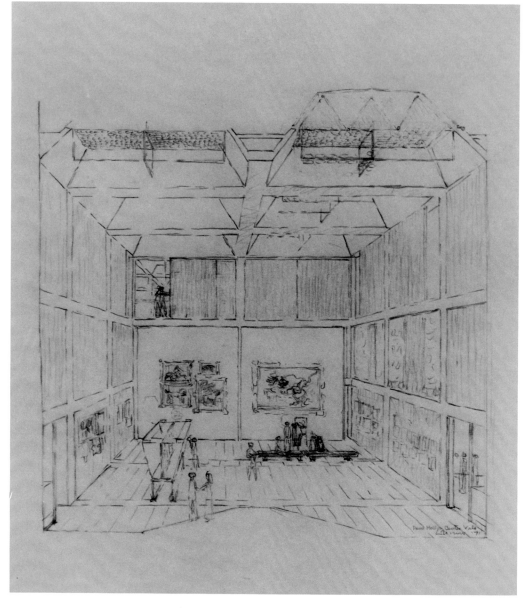

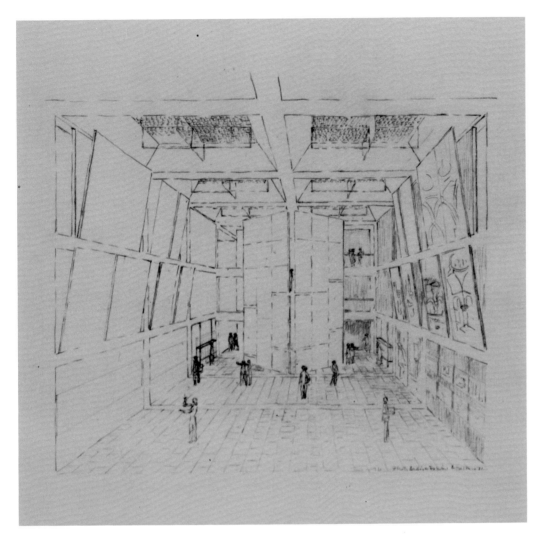

**4.56**
*Yale Center for British Art.
Interior perspective of library
court looking east.* **Catalogue 88.** Louis I. Kahn.
Louis I. Kahn Collection,
University of Pennsylvania
and Pennsylvania Historical
and Museum Commission.

**4.57**
*Yale Center for British Art.
Longitudinal section.* Louis I.
Kahn (office drawing). July
26, 1971, revised August 26,
1971. Louis I. Kahn
Collection, University of
Pennsylvania and Pennsylvania Historical and
Museum Commission.

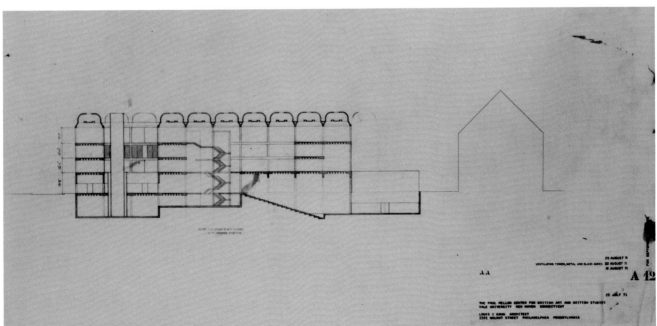

Kahn had become increasingly interested in the architectural use of metal while working on the Kimbell Art Museum. There he had used stainless steel for handrails, fixtures, trim, and window frames, aluminum for soffits and reflectors, and lead for the roof.[63] Prown, though, had quite different ideas. "The character of the collections of British art," he had written, "suggests the inappropriateness of brutal, rough-textured sheathings; of fanciful gossamer screens; or of cold, sheer impersonal glass and steel surfaces."[64] Obviously, he had doubts about the use of metal. In the first project he had

**4.58**
*Yale Center for British Art.*
*Plan, third floor.* Louis I.
Kahn (office drawing).
August 16, 1971, revised
October 22, 1971. Louis I.
Kahn Collection, University
of Pennsylvania and Penn-
sylvania Historical and
Museum Commission.

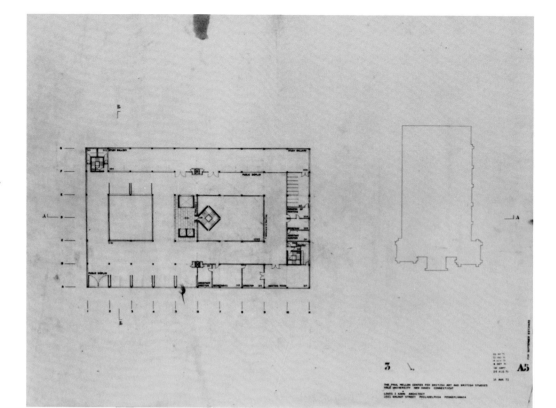

accepted encasing the mechanical towers in metal, as he understood that "everything in the building that had to do with the mechanicals" Kahn wanted to be steel.[65] Simi-larly, aluminum soffits had been employed in the Kimbell to cover the U-shaped con-crete channels with their mechanical ducts and conduits. Kahn found brushed aluminum or mill-finished stainless steel compatible with concrete, related in tonality while contrasting in surface qualities.

During the first project development he wanted structural stainless steel for the bridge over Chapel Street as well as for the mechanical towers and asked Abba Tor to look into the possibility.[66] Now, for this new design, he pursued the idea. The whole building would be clad in metal and glass, forming a smooth, planar skin. These mate-rials are related by their smooth surfaces but have different properties, contrasting as transparent and opaque, reflective and mat. To Prown he said the visual effect would be as "lead" or "pewter,"[67] the latter a word he had used to describe the lead roof of the Kimbell. He told Prown that "on a gray day it will look like a moth; on a sunny day like a butterfly";[68] and again, "it's going to look as if it had writing on it, it's going to be sgraffito."[69] While not literally illustrating his idea, several almost abstract drawings con-centrating on surface effects of the materials suggest his vision (for examples, see figs. 4.59 and 4.60), as does a more analytical later elevation in which the effects downplay the frame (fig. 4.61).

This new scheme was well received at Yale. Steps were taken for a preliminary estimate and to plan a timetable for presentations to secure approvals.[70] Even so, Prown and Berg responded to the August design (revised in September) with a five-page memorandum requesting alterations.[71] Among other items they asked that the nomenclature be changed on the plans to reflect the British floor system: Basement, Ground floor, First floor, Second floor, Third floor (the change was made but was short-lived); and that "Study Gallery" be used to designate the area previously described as "Reserve View." In a first step toward formal acceptance of the design, the Acting Pres-ident of Yale University was to show the plans and a model to Mellon in New York on November 3, 1971, with Prown and Berg, Kahn, and Wisdom present.[72] If approved by Mellon, the plans and model would be presented to the Yale Corporation on November 5 and 6, 1971, in New Haven. As donor, Mellon did not interfere with planning the Cen-ter (Prown acted as client), but his opinion and approval were sought. His role can also be described as inspirational, as it is clear that his suggestions and comments, revealed at second hand and not a matter of record, carried weight with both Kahn and Yale. We have seen that a remark he made about seeing art in a house, instead of

**4.59**
*Yale Center for British Art.*
*Schematic partial elevation.*
**Catalogue 89.** Louis I.
Kahn. Louis I. Kahn
Collection, University of
Pennsylvania and Pennsyl-
vania Historical and
Museum Commission.

**4.60**
*Yale Center for British Art.*
*Schematic partial elevation.*
**Catalogue 90.** Louis I.
Kahn. Louis I. Kahn
Collection, University of
Pennsylvania and Pennsyl-
vania Historical and
Museum Commission.

**4.61**
*Yale Center for British Art.*
*Schematic north elevation.*
**Catalogue 91.** Louis I. Kahn.
Louis I. Kahn Collection,
University of Pennsylvania
and Pennsylvania Historical
and Museum Commission.

a museum, affected Kahn's concept. During construction, when he came to the site, preparations were made in advance as if for a state visit.

A number of major decisions on architectural features as well as details were made during this period of active work on the design. Tor has explained that Kahn wanted ducts exposed, but a problem arose because the return air ducts conflicted with fenestration.[73] As structural engineer, he was asked to help find a means of channeling the flow of air, and he turned to a waffle-like airfloor slab (see figs. 4.62 and 4.67 for illustrations of the airfloor). It was modified because of multiple floor levels but allowed the free passage of return air through its interior.[74] Kahn immediately responded positively to its use, for it linked structure with functional elements, as had been the case with the Yale Art Gallery's "breathing ceiling," as Kahn had called it. The airfloor did not affect appearance, as its exterior was that of an ordinary concrete slab.

Most comments from Prown and Berg dealt with the use, arrangements, and sizes of offices, with various rooms and windows, with requests for sliding wire racks for picture storage in several rooms, and with floor and wall coverings. They also offered suggestions, such as the inclusion of sprinklers for the commercial space as protection for the Center. Prown considered that his role as client meant he was to be actively engaged with Kahn as they pursued the creation of an architecturally significant building. He has observed that he considers Kahn's best buildings to be those in which the client was closely involved with the project. Kahn responded with remarkable creativity to stimulation, and involvement by a client kept him close to a project. One memorandum, based on revised plans of October 7, included an important, detailed request about the lighting to be provided by the roof. It was to have considerable importance to the design:

> 6. Skylights
>     The following represents our basic objectives:
>
>     A. On a brilliant sunny day we would like to rely solely on natural light to illuminate the pictures; however, we do not want bright spots or hot spots on the floors and walls.
>     B. On bright but overcast days we would like to rely mostly on natural light for illumination, using little or no artificial light to supplement it.
>     C. For less bright days we would use artificial light, preferably incandescent, to bring the natural illumination up to an acceptable level.
>     D. We desire the option of eliminating all natural light from any gallery skylight.
>     E. We do not want any beam of light to fall directly on the floor or walls.
>     F. The light admitted to the skylight should come through clear glass or plastic, treated only to remove ultraviolet rays.
>     G. We want to be able to sense change in the level of brightness of the sunlight available and do not object to sensing changes in the sun's position.[75]

During the first project Kahn had sent Kelly sun diagrams, mirror studies, lighting studies, and sections with louvers with requests for comments (see fig. 4.40). (Kelly's work had not been complete in time for the April 1971 estimate.)[76] The two met on this new design in September, before the memorandum from Prown and Berg on skylights. A section with skylight of this date shows a vault with a profile similar to those of the Kimbell, a large portion of the north side being made of plexiglass (fig. 4.62). The two also then discussed an eight-foot square lantern with lighting track below and a screen with louvers blocking light on the north.[77] Kelly's research had convinced him that this light contained more ultraviolet. But the October memorandum set him on a new direction for skylights that would satisfy all desired effects.[78] Lighting became one of the most difficult and prolonged phases of design for the building. Kelly wanted to minimize northern light because of its stronger ultraviolet content (later described as "blue"

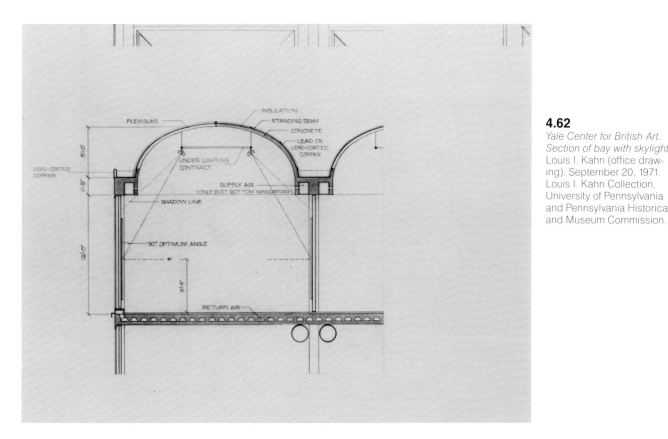

**4.62**
*Yale Center for British Art.*
*Section of bay with skylight.*
Louis I. Kahn (office draw-
ing). September 20, 1971.
Louis I. Kahn Collection,
University of Pennsylvania
and Pennsylvania Historical
and Museum Commission.

light) and modified the screening devices. They became quite complex. Fixtures were
a concern as well. Prown asked that the lighting effect be "intimate" for small exhibits
and at one point referred to the Oakland, California, museum's lighting fixtures where
tracks could be lowered individually from the high ceiling as a desirable type.[79] Kahn
had not made designs final for the skylight at the time of his death, although by then
Kelly's basic concept for a diffuser had met with his approval, the structure for the
skylight frame was decided, and the skylights themselves were about to begin
production.[80]

Revisions were made on October 14 and October 29, the latter the date of draw-
ings submitted to Mellon and to the Yale Corporation (figs. 4.63, 4.64, 4.65, 4.66, and

**4.63**
*Yale Center for British Art.*
*Plan, ground floor.* Louis I.
Kahn (office drawing). Octo-
ber 7, 1971, revised October
29, 1971. Louis I. Kahn
Collection, University of
Pennsylvania and Pennsyl-
vania Historical and
Museum Commission.

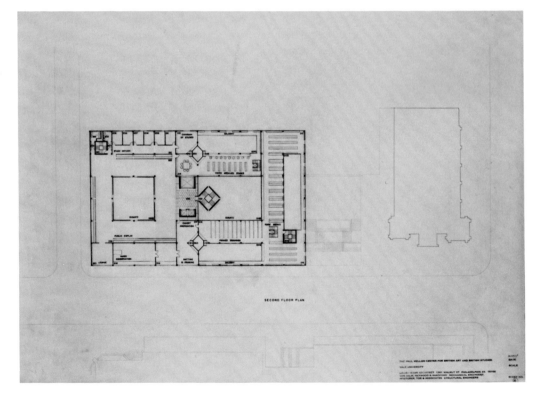

4.67).[81] One important ground floor change recorded on these drawings was the extension of commercial space parallel to High Street (fig. 4.63). This shaped the entrance opening into a square (fig. 4.68), instead of the large rectangle it had been (see fig. 4.48), and enclosed the entrance court of the Center so that it became more internal (as in Kahn's perspective sketch, fig. 4.69), its square shape carried uniformly through all floors. Whether this court should be open to the sky or closed with skylights was undecided. Kahn made two spontaneously executed interior perspectives to study the effect of each possibility, one with clouds above the vaults and the other with both vaults and clouds obscured by a frame for skylights (figs. 4.69 and 4.70). (His notation indicates walls of the former would be of metal and glass, and he shows an enclosed vestibule.) The skylit court includes windows with shutters on all floors. Both sketches appear objective sketches of the court until one observes Kahn's indications

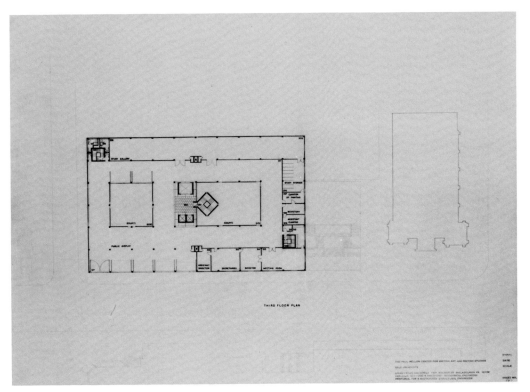

**4.66**
*Yale Center for British Art. Plan third (fourth) floor.* Louis I. Kahn (office drawing). October 29, 1971. Louis I. Kahn Collection, University of Pennsylvania and Pennsylvania Historical and Museum Commission.

of rays of light, conveyed by casual, angular lines. The skylights are more dazzling than the clouds. The decision was to use skylights without light-filtering devices elsewhere in the Center. This entrance court actually has bright daylight, completely natural.

Of lesser importance to the character of the building were practical new arrangements in the operations area. The drive-in truck dock on the plan of August 26 was eliminated, and service spaces for the Center replaced it. A required second dock was placed side by side with the existing one, a sturdy division between the two. One was for the Center and the second for the commercial shops, with a peripheral but generously proportioned passageway leading to the shops themselves. In the second floor plan of this date, the stairways for the library and rare books have been relocated (fig. 4.64). The third floor is as before, closed around the library court, its exhibition space distributed around the entrance court (fig. 4.65). The top floor is unchanged (fig. 4.66).

A section detail (fig. 4.67) illustrates the altered skylights, more angular and complex in profile, even crystalline, than those of an earlier section that resembled a series of smooth cloche hats or helmets (fig. 4.57). Kahn referred to these with their filtering

**4.67**
*Yale Center for British Art. Section, skylight detail study.* Louis I. Kahn (office drawing). October 29, 1971. Louis I. Kahn Collection, University of Pennsylvania and Pennsylvania Historical and Museum Commission.

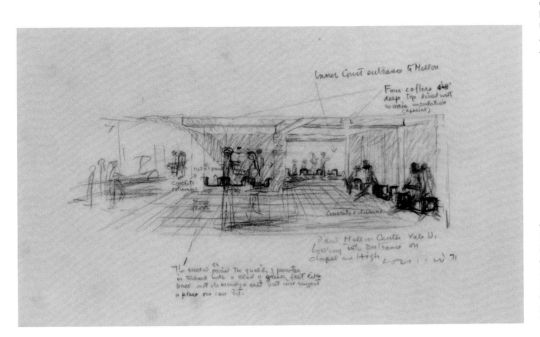

**4.68**
*Yale Center for British Art. Schematic perspective, entrance.* **Catalogue 92.** Louis I. Kahn. 1971. Louis I. Kahn Collection, University of Pennsylvania and Pennsylvania Historical and Museum Commission.

**4.69**
*Yale Center for British Art. Interior perspective sketch of entrance court without sky-lights.* **Catalogue 93.** Louis I. Kahn. Louis I. Kahn Collection, University of Pennsylvania and Pennsylvania Historical and Museum Commission.

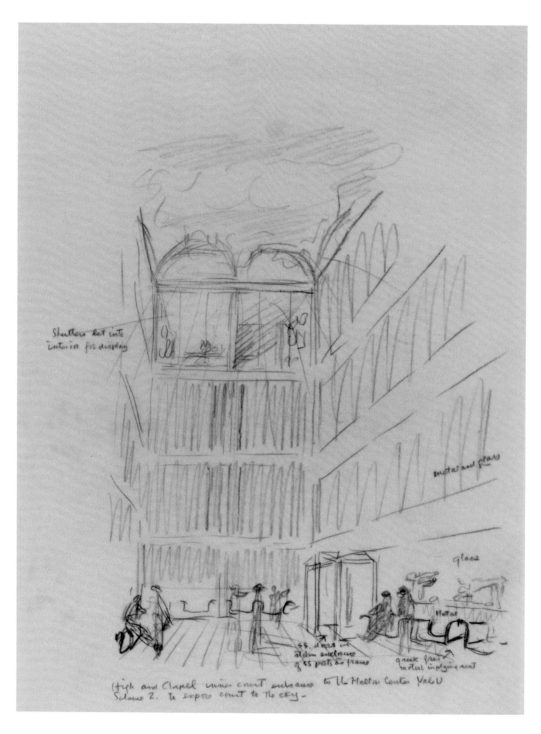

devices as a "natural light fixture," the same phrase he used for the Kimbell Art Museum's skylight and reflector. He himself considered the two related.[82] The Kimbell's fixture is utterly simple, a double-domed skylight with a sweeping winged reflector. (As we have seen, it was arrived upon, after time, by dint of trial and experimentation.) Here, a diffuser was placed under the skylights to control and direct the light, but the complexity of that diffuser was not yet satisfactory to Kahn. He conferred with Kelly and in July made a number of quick, exploratory, and probing sketches for the design, one a reversed wing shape, another a truncated pyramid (see figs. 4.71 and 4.72), before finally settling on the skylight shape.

For these revised plans, recalculated net areas were compared to the July figures and showed a considerable decrease in exhibition space, slightly smaller research

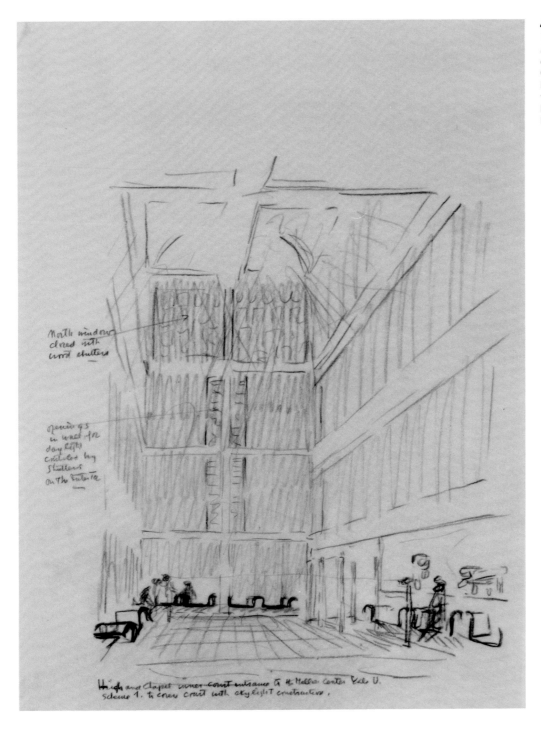

**4.70**
*Yale Center for British Art.*
*Interior perspective sketch of*
*entrance court with skylights.*
**Catalogue 94.** Louis I. Kahn.
Louis I. Kahn Collection, University of Pennsylvania and
Pennsylvania Historical and
Museum Commission.

facilities, and a smaller auditorium. On the other hand, the grouped rare book, drawings, and prints department and exhibition space (fig. 4.73) is larger, as are to a lesser extent areas for fellows' studies and staff offices, for the museum operations section (gallery workshop, registrar areas, photography studio), and for "Food, Conversation and Rest."[83]

Handsome exterior perspectives Kahn prepared for design presentation depict the building in his characteristic style for such sketches (figs. 4.74 and 4.75): discreet, spare monumentality. These are related stylistically but executed with more precision than the several charcoal perspectives of the Kimbell Art Museum of September 22, 1967 (see figs. 3.15 and 3.20). All these sketches have absolutely correct perspective, based on measured, drafted drawings that served as a framework under Kahn's trac-

**4.71**
*Yale Center for British Art. Schematic study of lighting detail.* **Catalogue 95.** Louis I. Kahn. July 7, [1971]. Louis I. Kahn Collection, University of Pennsylvania and Pennsylvania Historical and Museum Commission.

**4.72**
*Yale Center for British Art. Schematic study of skylight, partial plan.* **Catalogue 96.** Louis I. Kahn. July 7, [1971]. Louis I. Kahn Collection, University of Pennsylvania and Pennsylvania Historical and Museum Commission.

**4.73**
*Yale Center for British Art. Interior perspective of second floor exhibition space for prints, drawings, rare books.* **Catalogue 97.** Louis I. Kahn. 1971. Louis I. Kahn Collection, University of Pennsylvania and Pennsylvania Historical and Museum Commission.

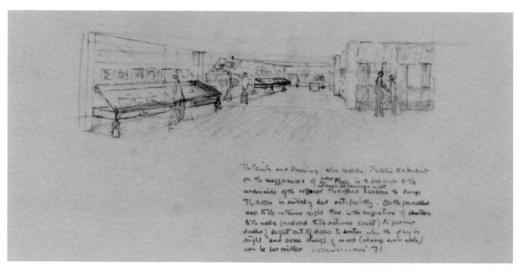

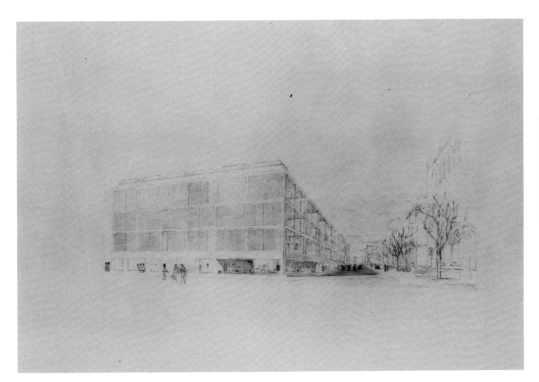

**4.74**
*Yale Center for British Art. Exterior perspective from northeast.* **Catalogue 98.** Louis I. Kahn. 1971. Louis I. Kahn Collection, University of Pennsylvania and Pennsylvania Historical and Museum Commission.

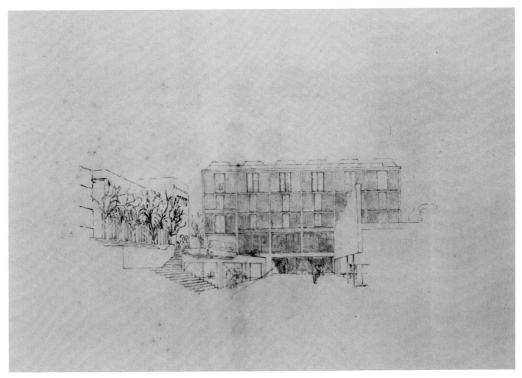

**4.75**
*Yale Center for British Art. Exterior perspective from west.* **Catalogue 99.** Louis I. Kahn. October 1971. Louis I. Kahn Collection, University of Pennsylvania and Pennsylvania Historical and Museum Commission.

ing paper. But he handled the graphite and lead casually, achieving a controlled, almost impressionistic spontaneity in line and tone that charms the viewer. Architectural essentials of shape and proportion are conveyed without specifying materials. The building's frame and the transparent/opaque skin stretched between its members are stressed but lack textural expression. Its bulk is clear.

The sunken courtyard seen from the west in his perspective is more spacious than that finally built, and the complex and interesting divided stairway (Kahn liked stairways and wanted them to be more than merely functional) was ultimately simplified. This area of the site generally recalls Kahn's organizational shaping of the sites for his other museums. At both the Yale Art Gallery and the Kimbell Art Museum he sculpted the site, following changes in the terrain but developing greater architectural definition with terraces and courts. The west courtyard of the Yale Center, on the other hand, is an independent and contrived creation, related only to the building, not to any existing topography. It makes something completely new.

In a meeting with representatives of Yale, the Macomber Construction Company, and consultants in Kahn's office on November 10, 1971, it was announced that Paul Mellon had approved the plans presented to him a week earlier and that architectural drawings were to proceed.[84] The revised roof design was discussed at length, Richard Kelly being contacted by telephone during the meeting. Concern for a buildup of heat under the skylights prompted various speculations on reflective glass, baffles, filters, or their combinations to counter this. A quarter-size model of one bay of the skylight was to be made, and a full size mock-up would follow when engineering details were made final. A schedule for drawings was set: architectural drawings to be complete by November 22, structural schematics by December 20, and complete preliminary working drawings for all phases — architectural, mechanical, and structural — by January 20, 1972. A revised estimate would then be made, readied by February 7, 1972.

Prown now drafted a statement on the preliminary design. In describing the museum he commented that in the galleries "Kahn hoped the visitor would feel that he was in a comfortable house — one with small room-like spaces and pleasant little areas in which to view an object closely, or just to sit and relax."[85] (We may recall his original response to seeing the collection in the Mellons' house.) Prown considered this "fitting" because of the nature of the art, primarily small-scale pictures of informal or intimate subjects. The system of 20 feet by 20 feet skylights on the top floor and the light they provided, which he said would be filtered to admit north light freely (as noted above, this changed before the final draft), along with other natural light less freely admitted, would contribute to the effect of individual galleries. Light control was to come through metal baffles, translucent glass, and movable interior window shutters that could be used as hanging walls, either closed or opened at right angles to the window. Variety for the visitor and flexibility for the museum staff were principles expressed architecturally and arrived at both through the materials (including the glass and stainless steel and the "warm" concrete structural frame) and the planned interwoven areas — exhibition galleries, offices, libraries, service spaces, and classrooms.

The background of the Center was recapitulated by Prown who emphasized its place in New Haven and Yale for the enjoyment of art and for use by scholars, enhanced in each case by the building itself. The size and depth of the collections and the facilities that would be offered, he felt, would make Yale the major center outside England for British art, British studies, and eighteenth-century studies. Kahn's design was an appropriate response not only to the program and collection but to the city of New Haven, to Chapel Street, to the University, and to the architect's profession. In sum, Prown believed that activities which the Center would stimulate through the museum and associated small businesses, along with the existing University Theater and the Art School, would make "a financial, commercial, urbanistic, educational, and cultural contribution" to both the University and the city.

Revisions were made to the statement because of design evolution before it was formally issued along with the press release by the Yale University News Bureau in late February 1972.[86] By then, both courts were covered by skylights, and Prown had come to see the double courtyard plan as a "return to a form of museum architecture popular at the end of the nineteenth century and through to the 1930s in this country." It is a plan that goes back actually to the Altes Museum, Berlin, 1823–30, where Schinkel placed a Pantheon dome between two courtyards. Though this plan was used later in the century, more often a museum was built around a single court. However, the 1872 Copley Square Museum of Fine Arts, Boston, by John H. Sturgis (1834–88) was planned as a double court museum (it was not all constructed), and the early Metropolitan Museum of Art, New York, was developed according to such a plan. It became in fact a Beaux-Arts formula. The 1906 masterplan for the Boston Museum of Fine Arts on the Fenway by Guy Lowell (1870–1927), among others, utilized this scheme, and a variation appeared as late as the 1941 National Gallery of Art in Washington, D.C. Prown welcomed the familiar orientation of the courtyards, which he thought reduced confusion and fatigue for visitors. In the Mellon, Prown said, the skylit courts show the importance

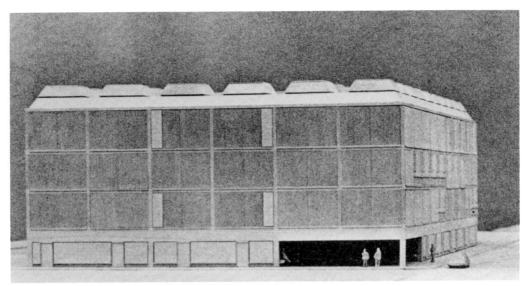

**4.76**
*Yale Center for British Art. Model, third version.* **Catalogue 73.** Louis I. Kahn Photograph dated October 29, 1971. Louis I. Kahn Collection, University of Pennsylvania and Pennsylvania Historical and Museum Commission.

of light in the architectural concept. Most dominant in the fourth-floor galleries with their skylights, light, controlled by oak shutters, would also be brought in through windows. Quoting Kahn's words, he said that "the first aim in exhibit spaces was that paintings and drawings be seen in natural light in the true color seen by the artist. The mood and color of the sky, the time of day, season of the year will be seen." Kahn also had used these words in speaking of the light in the Kimbell Art Museum.

Prown became less specific than he had been in his draft when describing the skylight design, saying only that daylight would be admitted freely, while the "harmful elements of natural light, including the direct fall of sunlight, [would be prevented] from entering and damaging works of art." The design itself was far from specific. Months later Prown was still questioning his architect about how the skylights would operate and what they would do to light.[87] However, Prown in February 1972 and in later publications described the skylights as a return to the traditional method of lighting museum galleries. Computer techniques of analysis and a greater understanding of the components of light, he explained, made possible their use without the old problems of overlighting, lack of control of light, and consequent damage to works of art.

The traditional aspects of the design appealed to Prown. He and Richard Brown both had been trained as art historians in Harvard University's Beaux-Arts Fogg Art Museum, where a courtyard and skylights in galleries created the environment for studying works of art. For them it was the best and most natural way to see paintings and sculptures. As museum professionals they began to look for escape from the enclosed free spaces and artificial lighting that museums inspired by the International Style had established and that were beginning to seem monotonous to them. The earlier experiences from the years of study asserted themselves as desirable. While for Brown light was the key ingredient and he wanted the flexibility of open space, for Prown the proper environment meant skylights and small gallery rooms.

According to the Yale News Bureau release issued with Prown's statement, "the announcement on the design and construction of the new building was made jointly by Charles H. Taylor, Jr., Provost of Yale and Mayor Bartholomew F. Guida of New Haven, emphasizing that the proposed new building would add tax revenues to the City" on February 21, 1972.[88] A model of the projected Mellon Center for British Art, close in appearance to the completed building (see fig. 4.76), was part of this presentation. The cooperation between city and University invites comparison with another joint announcement of six years earlier, when Paul Mellon's gift was disclosed in December 1966. It also demonstrated renewed cooperation achieved after a period of antagonism over an encroachment (as some saw it) by the University into the city, causing a serious loss of taxable income as well as loss of urban character. The Yale News Bureau pointed out that the estimated tax revenue would be "substantially higher" than the total tax for the commercial structures previously on the site.

The Mellon's commercial development, in addition to the cultural values it would offer, originated as a political solution to a special problem, but it was an approach about which Kahn felt strongly. One can understand this fact in the light of his interest in urban redevelopment and public housing that began as early as 1932–33 with his

Architectural Research Group and that was carried on in the 1940s and 1950s.[89] In 1967 Kahn had received a commission from the New Haven Redevelopment Agency for the Hill Renewal and Redevelopment Project, entailing a 714-acre area.[90] Clearly he saw an opportunity with the Mellon Center program to help revitalize this part of New Haven with the Chapel and High Streets shops. As he remarked in comments dictated for Life on the Street in February 1972, "this plan recognizes the importance of the continuity of shopping life on the streets."[91]

Yale University became committed to such a concept for the Center more reluctantly than Kahn, but once it did so it intended to make the space attractive for shopkeepers and practical in operation. With consultant Robert Quinlan, possibilities were examined realistically, and rentals, operating costs, and taxes were carefully estimated.[92] Among the factors taken into consideration were the potential market for the shops and whom they would serve. The architect and his office cooperated in making adjustments and changes recommended by the consultant and by the Yale Office of Buildings and Grounds.

The optimistic schedule laid out in Kahn's office on November 10, 1971, was doomed, given that details affecting the plans were still being formulated and only gradually filtered to the architect. Kahn's work method, as we have seen, required time,

**4.77**
*Yale Center for British Art. Skylight detail.* Louis I. Kahn (office drawing). July 14, 1972. Louis I. Kahn Collection, University of Pennsylvania and Pennsylvania Historical and Museum Commission.

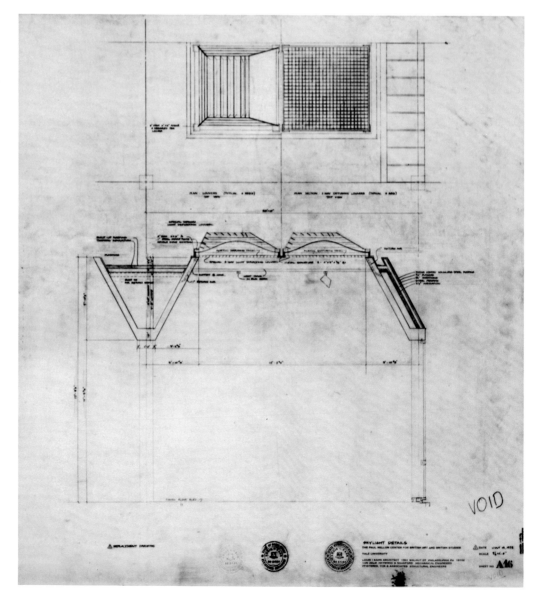

and the various demands on his attention slowed progress. Despite these problems, the project went forward relatively quickly. By late January 1972 preliminary working drawings were in process.[93] Prown and Berg continued to participate actively in assigning areas. Berg, who wanted "to keep space free but create enclosed rooms and preserve the sense of orientation and circulation supplied by the courtyards," sent a layout of partitions for the second, third, and fourth floors.[94] With each new version of the plans from Kahn there was response, usually made by Berg after discussions with Prown.[95]

The director and his assistant closely followed progress on the lighting system. Together or separately, they met with Kahn and Kelly numerous times. In a meeting on February 2, 1972, Kelly explained that the projected skylights should filter out 30 percent of incident light and that there would be provision for shades at all skylights (but shades installed only where obviously needed at first).[96] He recommended louvers for windows since he thought they would cause glare if unprotected and only sidelight art within five feet of them. Adjacent, adequately lit space would appear "gloomy" because of this glare. Berg arranged a meeting in Kahn's office with Carter Brown, director of the National Gallery, Washington, and his planning consultant David Scott.[97] They shared concerns about skylights in the projected east building by I. M. Pei (Mellon was a major donor). At that meeting Kelly presented a new skylight concept: small louvers in four sections beneath the diffuser glass (approximate to fig. 4.77, dated July 14, 1972; these hanging baffles were later eliminated). Brown expressed interest in a skylight mock-up.

By mid-May the second phase of architectural drawings was submitted for estimates.[98] The Macomber Company prepared a list of changes they thought would result in substantial savings during construction, and meetings between Froeberg and Kahn ensued to negotiate and discuss possibilities.[99] On one matter, the balconies in the two-story reading rooms, which Froeberg figured as costly and Kahn hoped to preserve, Kahn deferred to Prown and Berg. They preferred to keep them, "a major aesthetic element of these rooms," and Berg suggested their expense might be justified through simplification of materials to reduce cost, thus bringing expense closer to the cost of housing in a more usual way the 5,400 books to be kept there.[100]

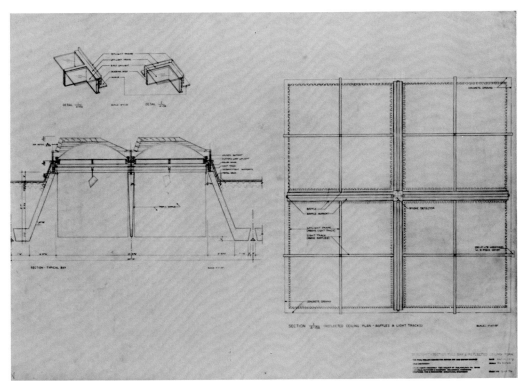

**4.78**
*Yale Center for British Art. Skylight section of bay, reflected ceiling plan.* Louis I. Kahn (office drawing). July 10, 1973. Louis I. Kahn Collection, University of Pennsylvania and Pennsylvania Historical and Museum Commission.

**4.79**
*Yale Center for British Art.*
*Longitudinal section looking*
*south.* Louis I. Kahn (office
drawing). May 12, 1972,
revised July 14, 1972. Louis I.
Kahn Collection, University of
Pennsylvania and Pennsylva-
nia Historical and Museum
Commission.

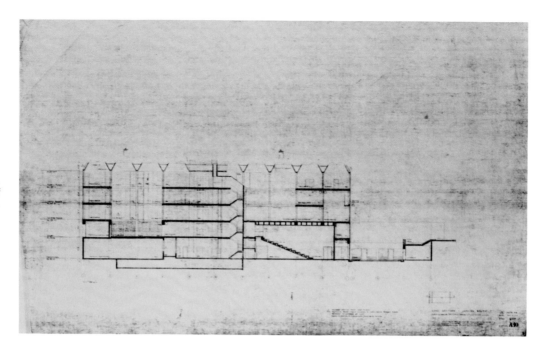

**4.80**
*Yale Center for British Art.*
*Cross sections and interior*
*elevations.* Louis I. Kahn
(office drawing). May 12,
1972, revised July 14, 1972.
Louis I. Kahn Collection, Uni-
versity of Pennsylvania and
Pennsylvania Historical and
Museum Commission.

**4.81**
*Yale Center for British Art.*
*Plan, first floor.* Louis I. Kahn
(office drawing). May 12,
1972, revised July 14, 1972.
Louis I. Kahn Collection, Uni-
versity of Pennsylvania and
Pennsylvania Historical and
Museum Commission.

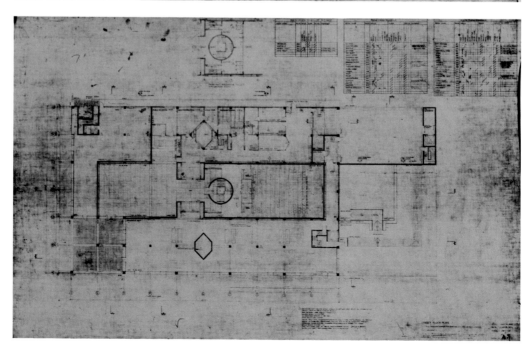

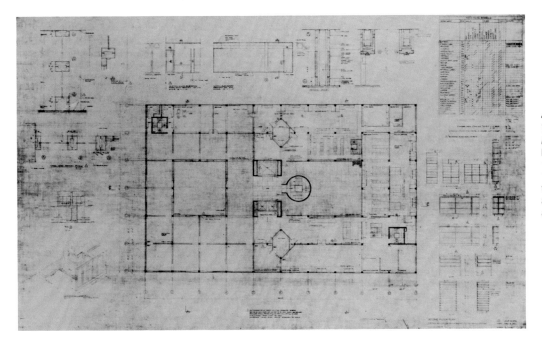

**4.82**
*Yale Center for British Art. Plan, second floor.* Louis I. Kahn (office drawing). May 12, 1972, revised July 14, 1972. Louis I. Kahn Collection, University of Pennsylvania and Pennsylvania Historical and Museum Commission.

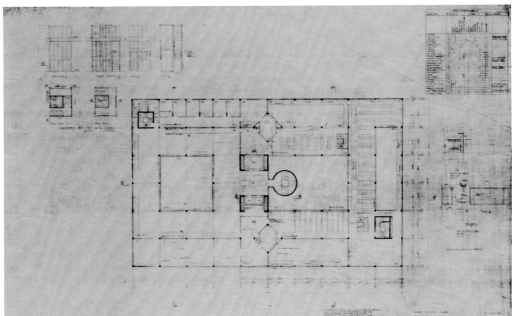

**4.83**
*Yale Center for British Art. Plan, third floor.* Louis I. Kahn (office drawing). May 12, 1972, revised July 14, 1972. Louis I. Kahn Collection, University of Pennsylvania and Pennsylvania Historical and Museum Commission.

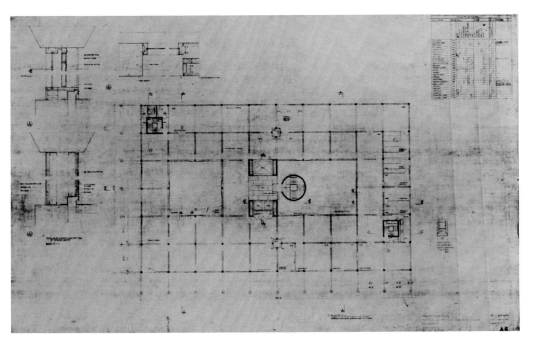

**4.84**
*Yale Center for British Art. Plan, fourth floor.* Louis I. Kahn (office drawing). May 12, 1972, revised July 14, 1972. Louis I. Kahn Collection, University of Pennsylvania and Pennsylvania Historical and Museum Commission.

Kahn prepared a list with explanatory comments for Prown of changes contemplated before construction.[101] Most were simply changes in materials, as, for example, using concrete block walls rather than cast-in-place concrete in some instances and precast rather than cast in place concrete girders in the roof. Major exceptions were (1) redesign of the west court, stair, and associated commercial space to reduce square footage and (2) the addition of some columns in the commercial spaces and the entry. Kahn himself proposed changes, the most significant being redesign of the mansard-like metal roof at its perimeter; lowering the ceiling height on the fourth floor from twelve feet to eleven feet five and three-quarter inches (in the final building it is twelve feet to the cornice and nineteen feet six inches to the dome); and using aluminum instead of stainless steel soffits in the entry. The roof redesign Froeberg had said would cost an additional $10,000; the other two changes were to "save" that amount and change the roof. Revised architectural drawings incorporating these changes were issued in July.[102]

Finally, in August, the Macomber Company proposed to Yale University a negotiated construction-management contract with a guaranteed maximum cost, after listing Cost Savings Initiated by Macomber and Approved by Architect Without Changing Scope or Design that amounted to $505,170.[103] Preparation of working drawings on the basis of the design developed as of July 14, 1972, began officially in September (figs. 4.79, 4.80, 4.81, 4.82, 4.83, and 4.84).[104]

## Construction

Because of the importance of the skylights and the need for further study, a full-scale mock-up of one twenty-foot bay was constructed on the roof of the Art and Architecture Building.[105] It was movable so that all angles of sunlight could be investigated. Kelly was sent a detailed architectural drawing (dated May 12, 1970) of the skylights and asked to provide his findings to Froeberg so they could be tried in the mock-up.[106] Kelly met with one of Kahn's assistants, made suggestions for the lighting tracks and their installation, pointed out a potential problem in the lack of a strong connection between the skylight curbing and structural steel, and reported that he was researching the use of a motor for driving the skylight shades.[107] The July 14, 1972, section of one of the skylights illustrates their complexity of design (fig. 4.76).[108]

Berg continued to supply information and to suggest changes through the following months, until June 1973 when he left the Mellon Center to become associate director of the Guggenheim Museum. Although at one point he proposed a meeting in New Haven to include Yale's technical specialists who might contribute useful information for specific areas,[109] he in fact acted as intermediary between these specialists and the Kahn office, with recommendations for different aspects of the program and collections. He passed on a letter from the director of the audiovisual department with recommendations for the lecture room;[110] requested appropriate plans be sent the assistant librarian in the Beinecke Rare Book and Manuscript Library who was to visit the Mellons' house to inspect books coming to the Center; and, again, forwarded the report on housing the books and a later revision reducing the spatial requirements.[111]

Kahn had particularly liked the Mellon library when he visited the "Brick House." Later, he suggested that Mr. Mellon's carpenter might be consulted for approvals on the cabinetwork for the rare book collection in the Center.[112] Seeking similarity in the general spirit of the collection and its ambience, he wanted to duplicate the quality of craftsmanship he had seen in Mr. Mellon's library. This was a matter fully as meaningful to Kahn, perhaps more so, as studies of shelf space for specific numbers of books or folios of certain dimensions. Details like the linear footage of shelving, necessary as they might be, were secondary to considerations of type and quality. They could be accommodated later.

An October 12, 1972, meeting (shortly after the opening of the Kimbell Art Museum) took place between architect, consultants, representatives of Yale University, and the construction company. It was a meeting that documents both the importance

Kahn placed on materials and construction procedures and the incomplete state of plans, even as preparations were being made to begin excavation the following month.[113] Foundation drawings had to be filed with the city within a few days, and Froeberg asked that they be sufficiently complete by November 2 to purchase reinforcing steel and locate the footings. Most of the meeting, however, dealt with the materials and the mock-up. Kahn's experience with architectural concrete was extensive; it had become his medium, and he was exacting in his expectations. Earlier, when the outline specifications were written for construction, he had consulted with Tor, asking that, before drawing them up, he read the Salk Institute's Phase III specifications since the concrete work there was so successful.[114] Now, in talking with the builders, Kahn was even more specific about what he sought.

He stated that he wanted concrete with large, monolithic-appearing surfaces he described as "cyclopic." This is a great change from the two-inch boards he specified for the Yale Art Gallery and even a change from the Kimbell Art Museum. Seymour has said (to the author) that he suggested larger panels for forms but that Kahn wished regular, smaller pieces with specified V-form separations. Here, in the Mellon Center, he asked for the largest possible sections. The form material was to be smooth, without grain, so that no board marks would be visible in the concrete anywhere in the building. Panel sizes were to be as large as possible so that joints could be kept to a minimum. The joints themselves were to be in a raised V-shape, one-fourth inch wide at the base and projecting no more than one-eighth inch. They should have small breaks or chips "to show the real-life nature of the material," and they were to be placed in accordance with a pattern established in relation to the columns and to the building's axis. Tie holes were to be a maximum of one-half inch in diameter and were to be left unfilled. If it was necessary for the holes to be larger, they were then to be filled with lead. Corners were to be sharp-edged and without chamfer. Kahn wanted concrete of a warm gray color. During experimentation, some samples were specially cast in an attempt to match the concrete color in the Yale Art Gallery addition.[115]

In this October meeting Kahn selected one of three samples of mill-finished stainless steel. He asked to be present during the fabrication of the next samples in order to communicate his requirements on workmanship, a further illustration of his wish to affect craftsmanship. In December he met representatives of Trio Industries and Allegheny Steel Corporation in his office, later even visiting the manufacturing plant to see the steel coil to be used.[116] Discussion about the mock-up elicited his suggestions to lower the ceiling height, eliminate the louvers, use a perforated metal baffle below the skylight (here, the Kimbell experience seems to have been in mind; he had just returned from Fort Worth), and widen the travertine border of the floor. Kahn's sense of the proportionality of all elements was at work. These mock-ups, including one set up at the Yale offices of Buildings and Grounds and the skylight study mentioned above (later moved to the building itself), were to prove valuable tools in working out design and construction details. (The airfloor was first tried there as well.) Mock-ups assembled on site afforded an opportunity to see various materials together.

In preparation for construction, application for a permit was made to the city of New Haven. The groundwork for this already existed, as plans (of April 14, 1972) had been submitted to the city the previous spring. The board of aldermen was responsible for approving zoning changes. Final approval rested with it for a mixed-use Center with commercial, academic, and public gallery components.[117] The Yale petition had been referred to a city planning committee, which passed it but asked for certain changes: additional landscaping and exterior lighting, and greater integration of the Center with its commercial spaces.[118] The committee's report suggested glass walls rather than solid ones separating the shops from the entrance to the Center as a means of relating the two. (This was eventually rejected by Yale for reasons of security.) The fall presentation to the board included a drawing of proposed site planting sent by Kahn's office.[119] The permit was issued, although initially it was only for work on the foundations. No complications were foreseen, however, and the Macomber Company immediately began the process of making bid tabulations.[120]

Requests for design changes were received even as working drawings were prepared. In one memorandum Prown and Berg requested the following: move the tunnel entrance, rearrange the photography darkrooms, relocate telephone booths, move a stairway, put in more drinking fountains (most later eliminated), remove counters from the paper conservation room, change partitions and doors.[121] A more fundamental issue arose when the New Haven Fire Marshal questioned openings into the courtyards and asked that they be limited. The disastrous June 1969 fire in the central space of Paul Rudolph's Art and Architecture Building had led to stronger fire regulations. In response to the fire marshal's comments, Berg wrote to Kahn expressing concern. He asked that the court windows not be closed and gave Prown's and his reasons: in the entrance court, windows were a must on the second floor; on the third floor there should be slits for visual orientation; and perhaps even larger openings into the court should exist on the fourth floor. In the exhibition (library) courtyard, a glass bay should define the entrances to the two libraries on the second floor; an opening at the stairway lobby would be desirable on the third, as it would without question on the fourth floor too, where Prown and Berg considered the openings onto the court essential to their concept of the building.[122] The windows were made possible when automatic fire shutters, specified by and acceptable to the marshal, were added to the design.[123]

Working drawings were of course not complete by the job meeting of January 11, 1973, and a coordination conference established a new schedule requiring plans from both the architect and mechanical-electrical engineers by January 24 in order to complete structural drawings by February 1.[124] By February 16 final drawings were completed and issued, only a few weeks behind schedule. Prown and Berg then offered suggestions on these and began consulting various Yale specialists.[125] At the next job meeting Kahn approved concrete for expressed joints, the tie system, and form materials, but disapproved the color as too green and found the steel not equal to the dark, mat finish of the approved sample. A different concrete mix with buff cement and local red sand was used for the next experimental pour of the basement wall.[126]

On March 15, 1973, Froeberg wrote Kenneth Borst, who was representing Yale's Buildings and Grounds Department now that construction had begun, to explain that the completion date for the Center would have to be extended two months because of the delays in receiving working drawings from the architect and engineers.[127] Prown reacted to this news with distress, for, based on the old schedule, he had scholarly commitments made for meetings in the Center that anticipated opening at the earlier date. With his other responsibilities to the new institution in mind, Prown therefore urged Kahn to consult with Froeberg about making up the time now lost. Although he wrote Kahn that he thought it was "a great building," he expressed reservations about the steel cladding and voiced his dismay that the skylight problem was no further advanced than it had been in September 1972. "I think that the skylight solution is ingenious, and the general dispersion of natural light seems good. However, the technical questions have not been answered, and when I stand in the mockup and look up at the complex arrangement overhead I do sometimes get the feeling, as you so often put it, that we are scratching our ear with our elbow."[128]

In May, Burghart, supervising on the site for the Macomber Company, appealed to Kahn for more complete information, advising him that without the skylight solved, the date for completion would have to be pushed forward yet again.[129] The budget was affected by delays, and the Macomber Company again prepared a list of changes previously discussed with Kahn and Yale representatives to reduce costs. These were submitted to Kahn, but revisions to drawings were not forthcoming. Burghart again wrote. They had kept the job moving, he said, by working with consultants and their representatives on individual questions, a process that had permitted time for improvement in the concrete forming system and in carpentry. However, he said that there had been insufficient work for the men since the beginning of the month. To be efficient in their operation, complete plans, including mechanical and electrical, for at least the first two floors were needed so that work could be integrated for subcontrac-

tors and managed economically.[130] Froeberg wrote as well to emphasize the possibility that the job might have to be stopped because of the lack of revised drawings.[131]

A new skylight drawing was finally ready in July (fig. 4.78), when revised drawings for the project were prepared, and on August 20, 1973, the set was issued (figs. 4.85, 4.86, 4.87; and for the skylight, 4.88). Incorporating a variety of changes, these now show the circular stairwell (so reminiscent of the silo stairwell in the Yale Art Gallery), which replaced the oblique square in the earlier version. The major change was client-inspired: a rearranged second floor is also shown accommodating a separation of the rare book and the prints and drawings libraries.[132] The new set also includes changes to the skylight and the lighting along with the enlarged auditorium projection booth (asked for by the audiovisual director) and vestibule.

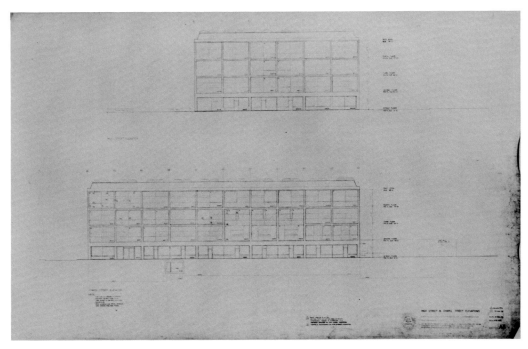

**4.85**
*Yale Center for British Art. Elevations, High and Chapel Streets.* Louis I. Kahn (office drawing). February 15, 1973, revised August 10, 1973. Louis I. Kahn Collection, University of Pennsylvania and Pennsylvania Historical and Museum Commission.

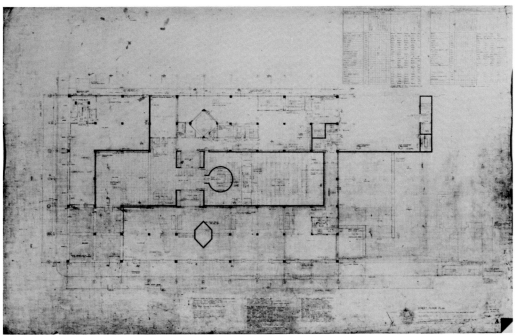

**4.86**
*Yale Center for British Art. Plan, first floor.* Louis I. Kahn (office drawing). February 15, 1973, revised August 20, 1973. Louis I. Kahn Collection, University of Pennsylvania and Pennsylvania Historical and Museum Commission.

**4.87**
*Yale Center for British Art. Plan, second floor.* Louis I. Kahn (office drawing). February 15, 1973, revised August 20, 1973. Louis I. Kahn Collection, University of Pennsylvania and Pennsylvania Historical and Museum Commission.

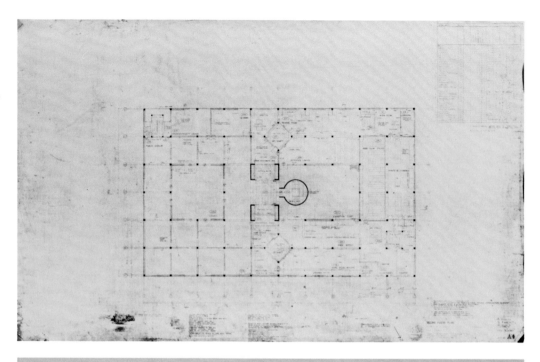

**4.88**
*Yale Center for British Art. Skylight details.* Louis I. Kahn (office drawing). August 20, 1973. Louis I. Kahn Collection, University of Pennsylvania and Pennsylvania Historical and Museum Commission.

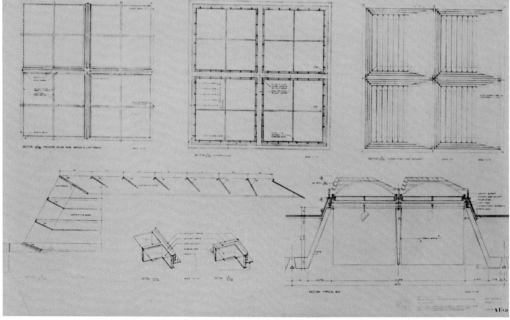

While these plans might have been expected to have eased the contractor's difficulties, work was not proceeding smoothly. At the end of the summer Kahn wrote his mechanical-electrical consultant that problems were increasing on the job site and could be traced to "the need for closer study by the Client and Architect" and for more "coordination and documentation by Mechanical-Electrical Engineers."[133] He asked that they meet with the architect on all problems concerning heating, ventilation, air conditioning, plumbing, and electrical work in order to "satisfy the architectural organization of the building," the mechanical-electrical design requirements, and the practical features of installation. Open construction and exposed ducts and lighting tracks made this essential. Kahn gave an example of what had happened when he was not involved in the design of the sprinkler system: the shop drawings for this were in conflict with other installations. In order to resolve this particular difficulty, he was now studying the layout on a larger-scale drawing that included the position of ducts and lights.

A representative of the engineers (Mr. Shadford) accordingly attended the next meeting in Kahn's office "to review changes to the sprinkler and duct distribution system to effect the aesthetic desires of Mr. Kahn."[134] While willing to go on attending meetings, Shadford considered what was involved to be, essentially, redesign. His opinion, or better the attitude it reflects, succinctly illustrates the downside of Kahn's approach to the construction process. Continuous, never-ceasing efforts to improve design exacted everyone's close and continuing involvement, as any change in one component would entail further changes in others. Closure simply never happened. His consultants would plead for guidance. They, after all, had to reply somehow to suggestions or requests from the contractor on handling change orders and modifications.[135] Documentation shows that there were frequent requests from the site having to do with cost reduction, which was part of the contractor's managerial responsibility according to contract. But the domino-like repercussions made processing them often time-consuming and difficult.

In reviewing revised drawings of August 20, 1973, Froeberg discovered the project to be substantially increased from the drawings on which the contract had been based. A new estimate, he now found, resulted in a new budget figure of $8,849,951, or $1,165,114 over the original contract.[136] He listed those areas that had changed significantly in estimated cost. Proposed revisions had already been gone over with Kahn and Yale representatives. Though cautious about financial aspects, the University kept a larger view of the project. For example, the security system, which had been reduced for budgetary reasons in May, had its August cuts restored when the consultant advised that they would seriously impair operation. Again, no change was made to the filtering system when both owner and engineer agreed it would be unwise.[137] The outcome of a series of meetings between owner, client, architect, engineers, and subcontractors punctuated by exceedingly painful decisions was that Froeberg proposed to accept the additional scope of the work with certain agreed-upon changes and an increase of $481,342 to the contract.[138]

For some time Prown had expressed concern that Kahn have a spokesman at the site during construction, and Marshall Meyers was persuaded by Kahn to become his on-site representative in the fall of 1973. The previous summer Prown had been critical of the erratic quality of the poured concrete and suggested that Yale representation on the scene might strengthen quality control.[139] In the meantime, back in Philadelphia, the Kahn office since May 1973 had been attempting unsuccessfully to find a field representative. By this time Meyers had left Kahn's office to establish one in Philadelphia with Anthony Pellecchia, another architect formerly with Kahn, but he was able to arrange his schedule to come to New Haven three days a week. He had worked fifteen years for Kahn and had been responsible for coordinating work in the office on the Kimbell Art Museum. His experience counted. Almost immediately he began making field sketches and writing reports, sending them to all those involved.[140] Changes and revisions, characteristically, went on and on.[141] With Meyers's assistance, however, at least coordination was improved. He would act quickly on Kahn's decisions, he was quite familiar with the materials and fixtures Kahn had used before, and, representing both Kahn and the University, Meyers was empowered to make some decisions on the job site.

Despite improvements in coordination, by December Froeberg was again asking Kahn for "design decisions and information" that he had requested be made final in October.[142] He listed as most critical: (a) the skylight and roof design with the diffusing glass and support frame, the baffles and shades, (b) revised drawings for the second floor and site drainage, (c) the hardware schedule, (d) approvals of shop drawings for the V-shaped roof girders and of the millwork bid, and (e) approval to proceed on work west of column 11 (the sunken west courtyard).[143]

Response from Kahn's office documents the status of these "critical areas" as 1973 drew to a close.[144] Following a suggestion from Parikh of Pfisterer, Tor and Associates, the skylights had been revised to reduce the amount of steel in them, and new drawings were at the structural consultant's for checking.[145] No one had been able to

obtain a design for the diffuser from Kelly, but the baffles had been eliminated, and the shades, while unresolved, would not hold up work since allowance was made for later inclusion. One must speculate that Kelly was reluctant to stop experimentation. The diffuser for the Kimbell, planned so carefully, had failed to perform as expected in the first versions. Revised drawings for the second floor awaited final approval from Kahn. New drainage drawings had been received from the mechanical engineer, and the Kahn office was revising the site plan to reflect changes in grade elevations. A hardware schedule had been resubmitted, though without naming three competitive brands. The owner, however, was considering taking bids without equivalent manufacturers. The second submission of shop drawings for the V-girders had come to Kahn's office and was to be released to the contractor within a matter of days. And, finally, a decision to proceed with work on the sunken courtyard and commercial spaces rested with the owner.

An ominous note was sounded by Froeberg in December, reflecting a growing but unrelated problem: materials. Attention was called to a shortage that he thought would only continue and become aggravated over the coming year, having a negative impact on both the construction schedule and costs.[146] It was symptomatic that delivery times on approved items were running late, sometimes, Froeberg found, by as much as 100 percent. Furthermore, manufacturers were growing reluctant to undertake special orders requiring particular colors or finishes. It was an inflationary period. Prown was later to say that increased costs were a major problem during construction.[147] This one area was a portent of intensifying concerns to come. Kahn's deliberate method, his artistic involvement during all stages, were well known. In part the Macomber Company had been selected precisely because of its earlier experience with him on the Yale Art Gallery.[148] In the early stages of deciding upon an architect, Prown had noted "negative reactions on the practical side" about working with Kahn from some he had consulted, including people on the knowledgeable Building Committee of the Yale Corporation. Yet everyone admired or, at the least, respected Kahn's buildings. Prown determined that hopes of having a "distinguished building" justified employing this architect, worries about budget and time notwithstanding.[149] It had not been foreseen that inflation would be so great or, of course, that Kahn's death would further complicate construction.

In mid-January 1974 Froeberg announced that the completion date for the Mellon Center had been moved forward: to May 1975.[150] That month also saw numerous Kahn approvals of various materials or processes, the beginning of skylight fabrication and his trip to the manufacturers to see the first precast V-beams.[151] While Yale representatives protested the new postponement, the record of past deadlines hardened Froeberg and made him adamant; even the current prognosis depended on resolutions and decisions being made by February 22.[152] Approval from the University to proceed with preparation of architectural and mechanical drawings and specifications "west of column 11" for the proposed restaurant was not given until early March,[153] but memoranda, notes, and letters over the several weeks of January, February, and March indicate a great deal of activity in construction. The V-beams of the roof were scheduled to be erected the last week in March.[154]

Another major problem had risen with Borst's rejection of glazing procedures and uncertainties about the construction and insulation of the roof parapet, or "mansart" as it was sometimes called.[155] The special architectural detailing of the building's smooth, planar surface was achieved by enclosing the glass with the steel panels themselves so that no external frame, even minimal framing, was involved. Borst felt that the weatherproofing was insufficient to protect the inner plywood core of the steel panel. Eventually, as it turned out, after completion of the building, revisions were required to solve problems created by the differences in outdoor and indoor temperatures.[156] This crisis, however, receded abruptly when it became necessary to decide upon a course of action for the unfinished building after the loss of its master architect.

Kahn died of a heart attack in Pennsylvania Station in New York on March 17, 1974, as he was returning to Philadelphia from a trip to India. His passing was a deep shock

for those working with him, caught unprepared and unready. Documents about the Mellon Center were awaiting him in his office: the bid tabulations for the linen wall coverings, a status report on shop drawings, and agenda notes for the next coordination meeting on March 20.[157] That agenda listed design responsibilities he was expected to solve then and there, or shortly thereafter: the diffuser and any modifications to be made on the mock-up to "bring it up to date"; the completion of design for stainless steel at the air shafts, for sinks and bubblers; special electrical features; the skylight over the circular stairs; details for the kitchenette; specifications for site lighting fixtures; and the building design west of column line 11 (the sunken courtyard and commercial areas). These were now left to be solved by his successor architects. Kahn's office was closed for several weeks following his death, but work went on at the site in New Haven.

After meetings in New Haven, the decision was made by Yale, with the agreement of the architect's widow, to assign completion of the Center, renamed at this time the Yale Center for British Art and British Studies (see note 1), to the firm of Pellecchia and Meyers, Architects. Meyers was already involved with the project, and both architects had worked closely with Kahn, Meyers most recently in charge of the Kimbell Art Museum and Pellecchia in charge of work on the Theater of Performing Arts of the Fine Arts Center, Fort Wayne (completed September 1973). Meyers reports that within two or three weeks they were able to obtain the Center drawings from the Kahn office,[158] and they not only continued construction but undertook design, where necessary, all the while attempting to interpret what Kahn would have wanted. It was everyone's disposition to be faithful to Kahn's concept for the building. Consider the contractor's wish to honor Kahn's aesthetic in a submission of stainless steel samples for doors and frames: "We believe this finish, non-reflective, is in keeping with the ideas of Mr. Kahn."[159]

According to Meyers and Pellecchia, it took three years and three hundred drawings before the building was finally completed. Their contribution, ranging from the "rather important to insignificant," in Pellecchia's words, included designing the commercial space at the sunken courtyards on the west, some millwork, doors, cases, and furniture, and the handrail for the main staircase. They also completed the skylight design, made material and fixture selections, designed acoustical hangings, selected seats and signs for the auditorium, and, finally, oversaw the completion of mechanical-electrical coordination.[160] Pellechia was right.

Prown also continued to move the project forward as he contacted Benjamin Baldwin, whom Kahn had recommended as an interior consultant, to arrange a meeting as soon as possible so that Baldwin could see the Center and review plans.[161] Baldwin's minimalist, architectural approach to furnishings, familiar to Kahn from their work together on the Exeter Library, was the approach he thought most felicitous for his own architecture. Although Kahn actually preferred to design even the furniture for his buildings himself, as suggested by his interior perspectives (such as figs. 4.55 and 4.73) and sketches of furniture details or plan details with furniture,[162] it had been found necessary to have a consultant, (This despite Prown's earlier expectation of only hiring individuals as needed for particular jobs.)[163] Prown observed that Kahn wanted "to design every last detail," but that geographically far-flung projects involving a great deal of travel took away much of his time.[164] Kahn also, some months before his death, had initiated discussion with the landscaping consultants working with Yale.[165]

## Completed Building Evaluated

When the Yale Center for British Art formally opened on April 19, 1977, it had long been anticipated by the art world,[166] and festive receptions brought distinguished visitors to New Haven to inaugurate the new institution with proper fanfare. The occasion called for official American and British governmental and academic representatives because of the specialized field of study, a national tradition. The British ambassador to the United States and a number of British museum directors were among those

present. It was an opportunity for the University to celebrate its already rich holdings in British history and literature that now made, with the Mellon collection, the Center a major asset. Mellon's gift, in fact, was partly a tribute to Yale's scholars and teachers in the field of British art and letters. He had begun his collection in 1931 under the inspiration of Professor Chauncey Brewster Tinker, late keeper of rare books at Yale. The University now prepared to embark on new programs of study with the Center serving as a catalyst, resource, and inspiration.

In connection with the opening, Prown, who resigned the directorship a year after Kahn's death, published his account of the building's development, including plans of its several phases, factual information, and his own interpretation.[167] This is a fundamental source for critics and historians. Prown's belief in the classic harmony and urban character of the design was vindicated, he felt, by the blend of traditional and innovatory plan, structure, and concept. Its traditional aspects recognized the experience and wisdom of the past, while solutions to problems were made through innovations. The Center, said Prown, combined 18,842 square feet of commercial space with 95,311 square feet devoted to the museum and study areas, a total of 114,153 square feet. Project cost was reported as $12,500,000, or $108 per square foot.[168]

The building's discreet, gray, monotone exterior of mat steel and reflective glass and its clearly read concrete frame confer a certain noble, armored mien appropriate to its purpose. If a building can be personified as possessing a powerful physicality and musculature, those are the words for the Yale Center for British Art. It takes its place with poise on Chapel Street, across from Swartwout's Old Gallery and Kahn's own Yale Art Gallery, where its height, scale, and even the module of its frame reflect the earlier buildings and help define the urban street. Yet even though conforming to its surroundings, the building has great individual presence. The balanced proportions and regularity of form assert independence as a structure even as it blends into and engages with the Yale and New Haven scene. The asymmetrically placed windows reflect divisions of interior spaces and contribute a variation to the frame that seems typically Kahnian: symmetry but not absolute symmetry. The absence of an expressed frame at the two-story libraries permits a reading of the interior on the exterior. The variation in framing pattern with the spans doubled between columns on the ground floor and, at the northeast corner, the void of the entrance breaking and contrasting with the smooth exterior skin continue the refinement within the overall structure.

Except for the sense of contained strength conveyed by the mass of the building, it is understated, even modest in its simplicity, with the materials providing the only ornament. Their careful, thoughtful handling reflects but enriches the contemporary craft of building. While steel and glass are machine-fabricated, their treatment and fit without the normal window frame displays a craftsman's skill in combining modern with traditional ideals in construction. The cast concrete, as in all Kahn's late buildings, shows the kind of surface and detailing that demonstrate admirable mastery of the medium, transforming it into an architectural material. While discolorations or flaws are not hidden or disguised, Kahn had the workmen perfect their technique to such an extent that imperfections are few. It will be recalled that to Kahn these were part of the record of how the building was made, valued for that very reason. One can surmise that this moral, open attitude reflected in part his personal adjustment to the facial scars he carried from childhood.

Inside the building the visitor experiences the same clarity and organization seen on the exterior. Without the plan being fully revealed upon entry, the entrance court immediately establishes a sense of logical orientation, and the second-floor library court continues this interior organization so that the visitor intuitively feels familiar with the plan and can find his way around the galleries through reference to the courts (fig. 4.88). The regularity and predictability of spaces is emphasized by the rhythm of columns as well. Travertine strips between these mark the twenty-foot bays of the exhibition areas — some squares, some double squares, depending on the interior, movable partitions. Organizationally, as the program had set forth, public spaces intermingle with academic, library, and office areas. The logic in the arrangement prevents

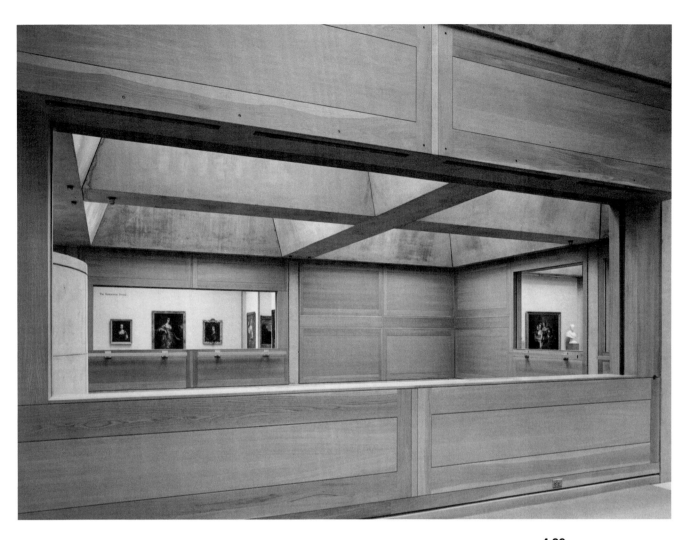

**4.89**
*Yale Center for British Art.
View of fourth-floor galleries
across courtyard.*

any sense of intrusion of one space upon another. Kahn had come to feel that the dedicated spaces required by a client should be included, but that they should meet his own standards concerning the identity of a room. Since the Yale Art Gallery, he had come to feel that spaces should provide flexibility so that they would not appear fixed but have their own identity. In the Kimbell the vaults provide the shape of a room. In the British Center the bays establish that room-like space. Kahn's idea of served and service space had enlarged to include specialized or functional rooms, but it was his desire that these would be versatile and non-limiting in possible use.

Materials on the interior — stainless steel panels on the lower floor of the entrance court but thereafter white oak, concrete, travertine, again stainless steel, aluminum, glass, plastic skylights — are that particular combination of natural or unfinished materials so characteristic of Kahn's late work. As in the Kimbell Museum, natural linen and unbleached wool carpets are part of the ensemble. (Marshall Meyers has said that a darker unbleached wool was chosen for the Mellon because of brighter light in the Center; carpeting is not used in the Kimbell galleries.) Interior detailing is subtle and restrained, achieved through the careful crafting and handling of materials rather than with applied ornamentation, just as on the exterior. But the light, the oak, travertine, and soft wool inside are warmer and more humane than the slick, cool exterior. Ambience is strong, even assertive. The naturalness of the surfaces and the intimate gallery scale make an effective setting for works of art.

The dual functions of the Yale Center appear well served by the spaces Kahn created for them: the galleries comfortably scaled to the intimate works of art displayed in clear, diffused light from the skylights, or in darker, light-protected galleries on the lower floor for works on paper; the libraries functioning as appealing reading and study spaces with conveniently arranged collections. The double-height spaces and light-filled windows, the oak tables with lamps hanging over them create warm, comfortable, yet professional, and scholarly rooms. As so often in his architecture, final arrangements seem inevitable, as if a perfection were easily arrived upon rather than sought with diligence through a complex route of try and try again with information,

suggestions, and inspiration from diverse sources. As we have seen, experimentation met with both failures and successes before acceptable solutions were found.

The architectural establishment had awaited the Center's completion with interest. Models, plans, and sketches had been published beginning as early as 1972.[169] Peter Smithson, one of the first major international architects to find inspiration in Kahn's works and to write about him, had reported on the building as it neared completion in 1976, finding in it a "marvelous competence of the exterior 'tin-skin' . . . the most encouraging thing one can see. Brutalism lives."[170] Smithson admired the use and handling of materials, even citing this as a justification for his own belief that "an aesthetic can evolve from the consideration of the material and the making in the situation of use." He praised Meyers and Pellecchia for their continuity of execution.

Evaluations of the Center's architecture soon after it opened included those by architectural historians and critics most familiar with Kahn's work, especially able to set the new building in context: Vincent Scully and William Jordy.[171] Both found the Center an unexpected development in Kahn's late work, Scully seeing in it a return after twenty years to International Style volume and structural bay, Jordy seeing Kahn's most conservative building, without the sculptural massing of served and serving spaces. The two agreed on its classic nature, although Scully found it a primitive classicism. Perhaps this was the maturity he expected to find after the archaic promise he had seen in the Yale Art Gallery. Both found Beaux-Arts overtones to the building: Scully named specifically Henri Labrouste's (1801–75) Néo-Grec Bibliothèque Ste-Geneviève (1843–50) as progenitor, and Jordy recalled the stereometry, the flush detailing of this "crafted strong box." They also saw the Center's modernism. Scully commented on the simplification of organization and building technology, while Jordy found the prototypes for the organization related to Wright's Guggenheim Museum and Philip Johnson's Proctor Museum in Utica, New York.

Where they differed, it was more a matter of emphasis and interpretation of these same features. To Vincent Scully the Yale Center for British Art was not as humanistic as its nineteenth-century predecessors. Despite seeing it as an ultimate triumph for the architect in its space of flanking bays and open court and its latent content of "peace and silence" (rather than Kahn's own familiar phrase of "silence and light"), he still found it somehow less than human, closed, and monumental in its classicism — "static, trabeated, laconic." Jordy's criticism was somewhat similar to that he had of the Kimbell. With his knowledge and understanding of Kahn's philosophical stance, he felt offices and work spaces should have had a more individualized solution that recognized their special role and function — "what they want to be," as he saw the galleries and libraries defined themselves — rather than being fitted into corners and incidental, or left-over, spaces. But he found Kahn's expression of the nature of the institution as a social creation, museum, and study center eminently satisfactory and based on the thoughts and actions of the individual.

After its opening, writers considering the Yale Center for British Art in general praised it: "the last and in its interior spaces the most beautiful of Kahn's career";[172] "a fitting summation of his work and ideas."[173] One dissenting critic, however, thought it "ends his career on a disquieting chord and points up weaknesses."[174] To Martin Filler the conception, which he characterized by quoting a phrase by Scully, a "classic tomb," was not sufficiently humane for the art it housed. He thought the courtyards too grand a gesture, and the rigor and starkness of materials conferred a "bleak atmosphere," especially in the auditorium. Although he liked the small-sized galleries, he did not believe that natural light conferred a positive architectural effect or was even the best light in which to look at paintings, for he disliked its variability. His observations did not follow from the premises of Kahn or of Prown, as expressed in the program. Beaux-Arts ideas of planning and spatial variety failed to have either symbolic or practical meaning for him. Moreover, the International Style attributes he recognized returned to the tenets of a Modern movement that Filler thought exhausted.

Several recent assessments of Kahn's museum and study center have also been positive, if sometimes qualified. A poll taken of readers of the American Institute of

Architects' official periodical included it among additions that should be made to a list of the best works of architecture in American's first two hundred years, while a survey of recent museums ("the glamour buildings of the period") in the same issue cited it and I. M. Pei's East Building of the National Gallery, two of the most architecturally significant buildings completed in the 1970s.[175] The Yale Center for British Art was cited as being designed to house a specific collection, to relate the building to the city, and to create individual "rooms" in a Beaux-Arts plan. These factors have made it influential on subsequent museums.[176]

Nearly ten years after its opening, an evaluation reported that while its staff liked the building both as a workplace and functioning museum, there were "shortcomings."[177] Some can be attributed to the experimental nature of certain features, such as the use of the stainless steel panels. Although the panels have withstood the harsh New England climate of an inner city, they cannot be cleaned without removing the mat, milled surface. And despite much concern over insulated, double-paned glass and ultraviolet control, the window mullions were not insulated and the steel panels, as we have noted, were insufficiently insulated. These factors have had an adverse effect upon climate control, apparent early in the building's occupancy.[178] Revisions to modify circulation with a variable air volume system were completed in 1981, and the monitoring stations for temperature and humidity were redesigned even earlier. Fabric window shades, which were substituted for Kahn's original wooden shutters for reasons of expense, have since been removed and oak shutters installed, in a return to an original concept. Potentially these can help with insulation as well as contribute to the aesthetic unity Kahn sought.

Kahn himself, of course, did not have the opportunity to sum up the completed museum project as in interviews with him after the Yale Art Gallery and the Kimbell Art Museum opened. He might have evolved opinions in the end about which we have no clue. But it seems unlikely; he had spoken of his design for the Mellon Center several times during the time he worked on it — for example, to Peter Blake and to William Jordy[179] — and he usually did not basically alter a major form-idea for a building. He did express more personal satisfaction with the Kimbell Art Museum. (Mrs. Kahn has said it was his favorite building, and a French architect who studied and worked with him at that time says he called it his "favorite child.")[180] How much this might be ascribed to the artist preferring his most recently finished work could be debated, but Kahn usually liked to say that his *next* was his favorite.

While he found the simplicity of the Kimbell program, its "ideal" and not yet formed collection, and the spaciousness of the park site to his liking, the very complexity of the Mellon Center program, even its specialized collection, and the urban, restricted site meant less freedom in planning and boxed in certain required features. In speaking abstractly of museums, Kahn said:

> *A museum seems like a secondary thing, unless it is a great treasury. A treasury, a guarded love for your source. Oh, what a place that would be! Not just an accumulation crowded together. You go through halls and halls and halls. The Museum of Cairo is a confined building that looks more like a storage house than it does a museum.*
>
> *A museum should spread out.*
>
> *The first thing you want in most museums is a cup of coffee. You feel so tired immediately.*
>
> *A museum needs a garden.*
>
> *You walk in a garden and you can either come in or not. This large garden tells you you may walk in to see the things or you may walk out. Completely free. You're not forced to go in. You go to see one thing or you are taken there to see it, and it's part of the visual history, the sense of the unmeasurable.*[181]

The British Center, with its university and study priorities, was a different type of museum, not a spread-out building with gardens and coffee rooms (although he had tried to accommodate these in it). There also had been the disappointment of having to abandon his idea of dramatically expressing the services on the exterior of a building, even though he resiliently reinvented his design afterward. (He had said in April 1971: "The Mellon Center is as much inspired by Carcassonne as is the Medical Towers.")[182] The idea did not rise from the building program (as the Kimbell porticos did not from the Kimbell program) but from Kahn's interest in conferring on the building its own aesthetic, expressive power, in this case the declaration of the service elements, or a purpose well-expressed. While the final design provided independently for air ducts and necessary machinery, the solution largely lacks the openness the architect hoped to achieve. It was one instance where he could not construct his premise. Yet if one regrets lost designs, it must be recognized that Kahn responded admirably to the program requirements for the Yale Center for British Art and created a beautiful building, a building that works, that functions comfortably, that embodies much of the best in his architectural philosophy. Perhaps it is a building with even more "availabilities" than he knew, which is what he always hoped would happen when he built.

**Notes**

1. The name was changed to the Yale Center for British Art and British Studies in 1974 at the request of Paul Mellon, and in 1976 "and British Studies" was omitted in the interest of clarification. Jules David Prown, *The Architecture of the Yale Center for British Art*, 2nd ed. (New Haven, Conn.: Yale University, 1977, 1982): 12. Letter, March 20, 1974, Prown to Kenneth Froeberg, Vice-President, George B. H. Macomber Co., Inc. This, written after Kahn's death, March 17, 1974, confirmed the change of name to the construction company. Kahn Collection, Correspondence with Yale Mellon Office, J. Prown and H. Berg, File Box LIK 109. The Kahn Collection is owned by the Pennsylvania Historical and Museum Commission and is on deposit in the Architectural Archives, University of Pennsylvania, Philadelphia.

2. The report of this committee was enclosed with Prown's first letter to Kahn. Letter, February 19, 1969, Prown to Kahn. Kahn Collection, Correspondence with Yale Mellon Office, J. Prown and H. Berg, File Box LIK 109. Prown summarized the findings in Release, November 23, 1971, Preliminary Design, The Paul Mellon Center for British Art and British Studies: 6–7. Kahn Collection, News Clippings, Mellon Art Gallery (Yale), File Box LIK 111.

3. J. D. Prown, "On Being a Client," *Journal of the Society of Architectural Historians* 42 (March 1983): 11–14.

4. Letter, February 19, 1969, Prown to Kahn. Kahn Collection, Correspondence with Yale Mellon Office, J. Prown and H. Berg, File Box LIK 109.

5. Prown considered Kahn "the greatest American architect of our time, uniquely equipped to respond to the opportunity afforded Yale and New Haven by Paul Mellon's gift" because of his sensitivity "both to the inner world of art and the external world of everyday existence." Statement by Prown, June 5, 1969. Kahn Collection, Correspondence with Yale, Mellon Office, J. Prown and H. Berg, File Box LIK 109. The architectural firm of Edward L. Barnes had done the survey of possible locations and selected the site to be used. According to Prown, in conversation Barnes independently recommended he talk with Kahn about the commission. "Jules D. Prown," in Alessandra Latour, *Louis I. Kahn, l'uomo, il maestro* (Rome: Edizioni Kappa, 1986): 133.

6. "The Paul Mellon Center for British Art: A Classic Accommodation between Town and Gown," *Yale Alumni Magazine* 35 (April 1972): 30–31.

7. Prown, *The Architecture*, 12–14.

8. Letter, January 21, 1969, Prown to Brewster. This section of Preliminary Thoughts has not been published. Kahn Collection, Correspondence with Yale Mellon Office, J. Prown and H. Berg, File Box LIK 109.

9. Letter, April 30, 1969, Prown to Kahn. Kahn Collection, Correspondence with Yale Mellon Office, J. Prown and H. Berg, File Box LIK 109. Prown also asked for copies of the recently published *L'Architecture d'Aujourd'hui* devoted to Kahn's work, including the second scheme for the Kimbell Art Museum. "Louis I. Kahn," *L'Architecture d'Aujourd'hui* 40 (February–March 1969).

10. Prown quoted by Robert Kilpatrick, "Louis Kahn May Design Arts Center," *New Haven Register*, June 4, 1969. Prown later spoke of the compatibility he felt with Kahn. "Jules D. Prown," in Latour, *Louis I. Kahn: l'uomo, il maestro*, 133–35.

11. Letter, July 22, 1969, Edward W. Y. Dunn, Jr., Director, Buildings and Grounds Planning, to Kahn. Dunn wrote in the absence of both the president and the provost. Kahn Collection, Correspondence with Yale University Buildings and Grounds, Box 110, Architectural Archives, University of Pennsylvania. The administrative arrangement was somewhat cumbersome, Prown found, since lines of responsibility were not always clear. He states that the client's role was the "mind or soul of the project, while Buildings and Grounds, also agents of the university/owner, oversaw the details of its embodiment." Prown, "On Being a Client," 13, n. 3. The press announcement of Kahn's appointment was in *The New Haven Journal-Courier*, October 27, 1969. A clipping was sent to Kahn along with Prown's press release. Kahn Collection, Mellon Art Gallery (Yale), File Box LIK 111.

12. Letter, September 11, 1969, Prown to Kahn. Kahn Collection, Correspondence with Yale Mellon Office, J. Prown and H. Berg, File Box LIK 109. Prown describes the visit to the Phillips Collection in *The Architecture* 16. He also recommended that Kahn see the Fitzwilliam Museum of Cambridge University for its "excellent space" and Christ Church Gallery, Oxford, for the arrangement used for showing drawings and watercolors. Telephone memorandum, September 22, 1969. Kahn Collection, Miscellaneous Correspondence, Mellon Art Gallery, File Box LIK 109.

13. Kahn, "Conversation with William Jordy," in Richard Saul Wurman, *What Will Be Has Always Been: The Words of Louis I. Kahn* (New York: Access Press and Rizzoli, 1986): 237.

14. Letter, October 29, 1969, Prown to Kahn. Kahn Collection, Yale Mellon, August 1969–December 31, 1970, File Box 112. See Apendix C. Kahn confirmed agreement in a letter, December 11, 1969, Kahn to Prown. Kahn Collection, Correspondence with Yale Mellon Office, J. Prown and H. Berg, File Box 109.

15. Letter, November 19, 1969, Kahn to Dunn. Letter, December 8, 1969, Dunn to Kahn. Letter, December 11, 1969, Kahn to Dunn, enclosing Agreement. Kahn Collection, Yale Mellon, drafting room file, August 1969–December 31, 1970, File Box 112. Letter, December 11, 1969, Kahn to Prown. Kahn Collection, Master Files, 1969–73, File Box LIK 10. Joseph Chapman, who advised on security, was consultant to Yale University.

16. Letter, February 19, 1970, Kahn to Dunn. Kahn Collection, Master Files, 1969–73, File Box LIK 10.

17. Building Design Program, Preliminary, The Paul Mellon Center for British Art and British Art Studies. Kahn Collection, Mellon I Program Void, File Box LIK 112.

18. In May 1970 Kahn received a program for the art library and was asked to submit a cost estimate for the preparation of schematic drawings. Letter, May 7, 1970, Prown to Kahn. Kahn Collection, Correspondence with Yale Mellon Office, J. Prown and H. Berg, File Box 109. Letter, May 29, 1970, Kahn to Dunn. Kahn sent an estimate previously given Prown in a telephone conversation by his assistant Carles Vallhonret, who was in charge of the project until he left Kahn's office. Kahn Collection, Master Files, 1969–73, File Box LIK 10.

19. Revision for photography studio, January 14, 1970, received office of Kahn March 26, 1970. Revision to Research Library and Reading Room, February 17, 1970, Henry Berg. Kahn Collection, Mellon I Program Void, File Box LIK 112.

20. Area Requirements. Kahn Collection, Mellon I Program Void, File Box LIK 112. See Appendix C.

21. Letter, December 11, 1969, Kahn to Dunn. Kahn Collection, Mellon Yale, drafting room file, August 1969–December 31, 1970, File Box LIK 112. Hummel had been the representative for the Buildings and Grounds Department during the construction of Kahn's Yale Art Gallery. He was Director, Division of Engineering, Construction and Utilities, Yale University, but retired before construction on the Mellon Center began.

22. Notes of meeting, February 5, 1970, J. Prown, H. Berg, Kahn, and Vallhonrat. Kahn Collection, Mellon Yale, drafting room file, August 1969–December 31, 1970, File Box LIK 112.

23. Letter, February 19, 1970, Berg to Kahn, including Tentative Revision to Program, February 17, 1970. Also letter, March 25, 1970, Berg to Kahn, regarding photographic studio. Kahn Collection, Mellon I Program Void, File Box LIK 112. Memo, Paper Conservation Department, April 27, 1970, from Peter Zegers. Kahn Collection, Correspondence with Yale Mellon Office, J. Prown and H. Berg, File Box LIK 109.

24. February 19; March 3, 10, 17, 31, April 9, 21, 28, and 29; according to Vallhonrat's notes. Kahn Collection, Mellon Yale, drafting room file, August 1969–December 31, 1970, File Box LIK 112. Also Architectural File, Paper Conservation Department, April 27, 1970, and June 30, 1970. Kahn Collection, Correspondence with Yale Mellon Office, J. Prown and H. Berg, File Box LIK 109.

25. Notes of meeting, March 17, 1970, Prown, Berg, Kahn, and Vallhonrat. Kahn Collection, Mellon Yale, drafting room file, August 1969–December 31, 1970, File Box LIK 112.

26. Prown, *The Architecture*, 31.

27. Ibid., 17.

28. For examples by Shaw, Nesfield, and others, see Mark Girouard, *The Victorian Country House* (Oxford: Clarendon Press, 1971). Prown has reported that Kahn referred to fireplaces in early conversations on the Center and has pointed out their inclusion in the Phillips Exeter Academy Library (1965–71). *The Architecture*, 17.

29. William Jordy, "Kahn at Yale, Art Center, Yale University," *Architectural Review* 162, no. 965 (July 1977): 39–40.

30. Letters, May 22, 1970, Kahn to Richard T. Baum, Jaros, Baum and Bolles Co; to Richard J. Shadford, Van Zelm, Heywood and Shadford Co.; to John E. Plantinga, Meyer, Strong and Jones Co. Kahn Collection, Master Files, 1969–73, File Box LIK 10. Shadford had written Kahn earlier concerning the provision of engineering services for the project, sending his résumé and saying he had worked with Edward L. Barnes and the office of Douglas Orr. Letter, December 8, 1969, Shadford to Kahn. A penciled note states Kahn had spoken with Barnes, and Barnes recommended the firm. Kahn Collection, Van Zelm, Heywood and Shadford, Mechanical Engineers, Mellon, File Box LIK 110.

31. Letter, July 23, 1970, Pfisterer to Kahn. Kahn Collection, Pfisterer, Tor and Associates, File Box LIK 110.

32. Tor met Kahn with an engineer friend who had worked with him in Ahmedabad and had been drawn to him. The working relationship was compatible. Tor also acted as a structural consultant on other projects in the next four years after this initial contact: the Roosevelt Memorial for Welfare Island, New York, and Tel Aviv University. See Tor's "Memoir" of Kahn in Latour, *Louis I. Kahn*, 121–28. Tor also writes of his professional relationship with Kahn in his review of Komendant's book, "Book Reviews: *18 Years with Architect Louis I. Kahn*," *Architectural Record* 162 (mid-August 1977): 107–8.

33. Transmittal, June 26, 1970, of plans of June 10, 1970, Kahn to Mellon. Kahn Collection, All Transmittals, Yale Mellon Art Gallery, File Box LIK 111.

34. Estimate of Various Schemes June 1970 toward Estimate, Genetti. Kahn Collection, Mellon, Yale Square Footage, Estimate 1, File Box LIK 111.

35. Berg included a sketch for a division of the service area of the museum. He noted that he realized that Kahn was not then in the office. Letter, August 6, 1970, Berg to Vallhonrat. Kahn Collection, Mellon Yale, drafting room file, August 1969–December 31, 1970, File Box LIK 112.

36. Schematic Design, August 17, 1970, Tabulation of Net Square Footage. Kahn Collection, Miscellaneous Correspondence, Mellon Art Gallery (Yale), File Box LIK 109. See Appendix C.

37. Transmittals, August 18, 1970, and September 8 and 9, 1970, Kahn to Van Zelm, Heywood, and Shadford; to Pfisterer, Tor and Associates; to Richard Kelly. Kahn Collection, All Transmittals, Yale Mellon Art Gallery, File Box LIK 111.

38. Notes of meeting, September 3, 1970, Prown, Berg, Kahn, and Vallhonrat. Additional meetings were set for September 9, 15, and 24, and October 6. Kahn Collection, Mellon Yale, drafting room file, August 1969–December 31, 1970, File Box LIK 112.

39. Letter, November 17, 1970, Charles L. Bell of George A. Fuller Co. to Kahn Office, attention: Vallhonrat. References were made to the estimate of October 30, 1970, and to a Cost Breakdown of November 3, 1970. Kahn Collection, Correspondence George A. Fuller Co. Mellon. Letters, October 1, 1970, J. N. Pattison of International Estimating Services to Kahn, and October 5, 1970, Pattison to David P. Wisdom. Kahn Collection, International Estimating Services, International Consultants, Inc., Correspondence Yale-Mellon, File Box LIK 112.

40. Cost of Design, December 15, 1970. Kahn Collection, Mellon Yale, drafting room file, August 1969–December 31, 1970, File Box LIK 112.

41. Mellon's gift of $23,063,973, made by means of a transfer of securities, mostly Gulf Oil Corporation and Alcoa Incorporated common stock, had been accomplished by 1970. Eli Spielman, "Mellon Center: Art Treasure or New University Headache?" Yale Daily News, October 10, 1973: 4–5.

42. Transmittal, December 21, 1970, Kahn to Prown. Kahn Collection, All Transmittals, Yale Mellon Art Gallery, File Box LIK 111.

43. See copy of letter, November 9, 1970, Robert C. Quinlan of James D. Landauer Associates, Inc., to Dunn. Quinlan met with Kahn and with representatives of Yale University to help plan the commercial shops; he continued to advise. Letter, August 24, 1971, Edgar C. Taylor, Associate Director, Buildings and Ground Planning, to Landauer Associates, Inc. Letter, December 14, 1971, Quinlan to John E. Ecklund, Treasurer, Yale University. Letter, December 22, 1971, Ecklund to Quinlan. Letter, June 16, 1972, Dunn to Louis I. Kahn, attention: David Wisdom. Kahn Collection, Correspondence University of Yale Offices: Buildings and Grounds, File Box LIK 110. Minutes of meeting, March 15, 1972, Dunn, Miller, Borst, Quinlan, Froeberg, and Meyers. Kahn Collection, Mellon Program II, File Box LIK 112.

44. Transmittals, December 28, 1970, to Pfisterer, Tor and Associates; to Kelly. Kahn Collection, All Transmittals, Yale Mellon Art Gallery, File Box LIK 111.

45. Transmittals, January 5 and 7, 1971, to George A. Fuller Co.; to Dunn; to Prown. Kahn Collection, All Transmittals, Yale Mellon Art Gallery, File Box LIK 111.

46. The Paul Mellon Center for British Art and British Studies, Yale University, New Haven, Connecticut, Design Development, December 21, 1970, Tabulation of Net Square Footage. Kahn Collection, Mellon Yale, Square Footage, File Box LIK 111. The estimate for the January 5 scheme was $9,186,450 for the Center; construction of parking, commercial spaces, tunnel, arcade, and court would have brought costs to $12,244,050 for 217,290 gross square feet at $56.50 per square foot average ($66 for Center, $57.50 for shops, as stated, but the figure would have an average of $61.75 in that case). Kahn Collection, Mellon Yale Estimate, February 1971. File Box LIK 111. See Appendix C.

47. Letter, March 17, 1971, Vallhonrat to Prown. Included were outline specifications. Letter, March 17, 1971, Vallhonrat to Dunn. Two sets of specifications and sepias of drawings for the Fuller Company estimators also were sent. Letter, March 22, 1971, Wisdom to International Consultants, Inc., attention: J. N. Pattison IV. Kahn Collection, Master Files, 1969–73, File Box LIK 10. See also letter, March 25, 1971, Bell to Wisdom. Kahn Collection, Correspondence George A. Fuller Co., Mellon. Letter, March 31, 1971, Wisdom to Pattison. Kahn Collection, International Estimating Services, International Consultants, Inc. Correspondence Yale Mellon, File Box LIK 112.

48. Net Areas in Square Feet, Design Development Drawings dated March 15, 1971. Kahn Collection, Mellon Net Areas March 15, 1971, to August 16, 1971, File Box LIK 112. See Appendix C.

49. Letter, March 31, 1971, Kahn to Mellon. Kahn Collection, Master Files, 1969–73, Box LIK 10.

50. Prown, The Architecture, 32. In his report to President Brewster, February 3, 1972, on the activities of the Paul Mellon Center from July 1, 1969, to December 31, 1971, Prown indicated that inflation in the building trades had outrun the growth of funds available for construction and estimated costs stood 42 percent above projections. A 30 percent decrease in both building and operating budgets was necessary. Kahn Collection, Mellon Correspondence, J. Prown and H. Berg II, File Box LIK 109. For his workup for the October estimate, Tor consulted a knowledgeable subcontractor associated with the nearby Wesleyan Art Center by Kevin Roche and John Dinkeloo Associates, then under construction, on costs of high quality architectural concrete. He had been surprised by the expense. Letter, September 30, 1970, Tor to Kahn. A member of Kahn's staff asked Tor to contact and explain to Pattison of International Estimating Services, who thought the cost quoted considerably higher than usual. Letter, October 5, 1970, Robert Sauers to Tor. Kahn Collection, Pfisterer, Tor and Associates, Structural Engineers, Mellon, File Box LIK 110.

51. Memorandum of telephone call recorded on pages of Net Areas in Square Feet, Design Development Drawings dated March 15, 1971, April 29, 1971, Berg to Wisdom. Kahn Collection, Mellon, Net Areas, March 15, 1971, to August 16, 1971, File Box LIK 112. Vallhonrat, in the early stages in charge of the Mellon project in the Kahn office, left in March 1971 for another position. Wisdom, who had worked with Kahn since the 1940s, was designated to take his place. Memorandum, March 17, 1971, Prown to Dunn. Kahn Collection, Correspondence Yale Mellon Office, J. Prown and H. Berg, File Box LIK 109.

52. Revised Building Program, Preliminary, The Paul Mellon Center for British Art and British Art Studies, revised May 6, 1971. Stamped received, Louis I. Kahn, Architect, May 12, 1971. Kahn Collection. Mellon Yale Program II, File Box LIK 111. See Appendix C.

53. Report on the Activities of the Paul Mellon Center for British Art and British Studies, February 3, 1972, by J. D. Prown. Kahn Collection, Mellon Correspondence, J. Prown and H. Berg II, File Box LIK 109.

54. Letter, June 16, 1971, Prown to Kahn. Kahn Collection, Correspondence Yale Mellon Office, J. Prown and H. Berg, File Box LIK 109.

55. Basic Requirements for Mellon Center Project, stamped received, Louis I. Kahn, July 12, 1971. Kahn Collection, Mellon, Minutes of Meetings 1971–73, File Box LIK 110.

56. Report on the Activities of the Paul Mellon Center for British Art and British Studies, February 3, 1972, by J. D. Prown. Kahn Collection, Mellon Correspondence, J. Prown and H. Berg II, File Box LIK 109.

57. Basic Requirements for Mellon Center Project, stamped received, Louis I. Kahn, July 12, 1971. Kahn Collection, Mellon, Minutes of Meetings 1971–73, File Box LIK 110.

58. A rough draft of the new statement of net areas arrived in Kahn's office May 1, 1971, according to a notation on a letter from Berg. Letter, May 10, 1971, Berg to Kahn, with enclosure, Revised Program, The Paul Mellon Center for British Art and British Studies. Kahn Collection, Correspondence with Yale Mellon Office, J. Prown and H. Berg, File Box LIK 109. A letter from a member of Kahn's staff to a colleague reporting on "Philadelphia action" stated that Kahn was developing "new sketches reducing the program by half" for the Mellon Center. Letter, May 28, 1971, Henry Wilcots to Don Barbaree. Kahn Collection, Master Files, File Box LIK 10.

59. Memorandum, May 21, 1971, Berg to Wisdom. Kahn Collection, Correspondence with Yale Mellon Office, J. Prown and H. Berg, File Box LIK 109.

60. Prown has said that Kahn "would agree with you, and then do it his own way." "Jules D. Prown," in Latour, *Louis I. Kahn*, 139. Documentation includes written responses from Prown and Berg and obviously reflects discussion. Kahn's decisions about a building were his own, based, as Prown said in the same interview, on his moral or ethical ideas, 135.

61. See letter, August 24, 1971, E. C. Taylor to Landauer Associates, Inc., Attention: Quinlan. Enclosed were four drawings (first floor, basement, and two parking schemes) and two sections (longitudinal and cross-section) for the new scheme. Taylor requested Quinlan's advice on the scope of parking and service areas, on service routes, and on financial viability. Kahn Collection, Correspondence with University of Yale Offices: Buildings and Grounds, File Box LIK 110.

62. New Areas in Square Feet 7/26/71. "Omitted" was the painting conservation area. Kahn Collection, Mellon, Gross Square Feet Areas, File Box LIK 111, Architectural Archives, University of Pennsylvania. The total, 73,538 square feet, was not recorded. See Appendix C.

63. Frank Sherwood, the coordinating architect for the Geren firm during construction of the Kimbell Art Museum, has explained that Kahn also proposed stainless steel plates covering exterior pockets along the edges of the vaults (after posttensioning). The idea was eventually abandoned. Conversation with author.

64. *The Architecture*, 14. Prown expressed doubt about the exterior steel cladding to Kahn as late as April 1973, saying he still had reservations about its use, although others did not share his concern. Letter, April 2, 1973, Prown to Kahn. Kahn Collection, Mellon Correspondence J. Prown and H. Berg II, File Box LIK 109. After competition, Prown still found the steel "the thing that pleases me least about the building," primarily, he thought, because of the quality of surface finish. "Jules D. Prown," in Latour, *Louis I. Kahn*, 141.

65. Ibid.

66. Letter, March 24, 1971, Tor to T. H. Wiggins, Republic Steel Research Center. Memorandum on horizontal bridge over Chapel Street, April 6, 1971, Tor to Kahn. Tor reported on Wiggins's recommendations, including how to handle the steel during construction following the criteria of the AISI Design Manual for Light Gauge Cold Formed Steel. The early cost estimate was $2 per pound ($4,000 per ton) for steel erected in place. Kahn Collection, Pfisterer, Tor and Associates, Structural Engineers, Mellon, File Box LIK 110.

67. Prown, *The Architecture*, 46.

68. Ibid., 43.

69. "Jules D. Prown," in Latour, *Louis I. Kahn*, 141. Prown believes the "writing" effect "referred to the pattern of grooves where the panels abut." *The Architecture*, 46.

70. Letter, September 9, 1971, Berg to Kahn. Berg welcomed Kahn back from an international visit to another project with the words, "I hope your trip has been as successful as your new plans for the Mellon Center," and asked him to a meeting with the Associate Provost George Langdon, Henry Broude, Kenneth Froeberg of the Macomber Co., Al Fitt (the president's advisor on community relations), Dunn, Borst, Charles Taylor (provost and acting president for the fall term), Prown, and Berg. Kahn Collection, Correspondence Yale Mellon Office, P. Prown and H. Berg, File Box LIK 109. Transmittals, August 22, 1977, elevations and sections of August 22, 1971, plans, elevations, sections, details, to Dunn, Froeberg, Tor, Shadford, Bell. Transmittals, August 26, 1971, plans, elevations, sections, details, to Froeberg, Bell. Transmittal, August 31, 1971, same to Dunn. Transmittal, September 15, 18, 20, 1971, elevations, plans, dock proposal, delivery access to basement, roof section and plan, to Yale University, Division of Engineering, Construction and Utilities. Kahn Collection, All Transmittals, Yale Mellon Art Gallery, File Box LIK 111.

71. Memorandum, September 30, 1971, Berg to Office of Louis I. Kahn. Comments continued in "Installment #3," memorandum, October 11, 1971, Berg to Office of Kahn. Kahn Collection, Correspondence Yale Mellon Office, J. Prown and H. Berg, File Box LIK 109. A copy also in Kahn Collection, Skylights, Mellon, File Box LIK 112. Revisions made in September and October are on the drawings illustrated; they reflect many of Prown's and Berg's requests.

72. Letter, October 1, 1971, Berg to Kahn. Berg recorded dates for presentations. Kahn Collection, Correspondence Yale Mellon Office: J. Prown and H. Berg. Kahn Collection, File Box LIK 109.

73. Tor, "A Memoir," in Latour, *Louis I. Kahn*, 123.

74. Letter, September 1, 1971, Tor to Wisdom. Kahn Collection, Pfisterer, Tor and Associates, Structural Engineers, Mellon, File Box LIK 110. The scheme was developed by Airfloor of California for on-grade construction. See "In the Philosophy of Louis Kahn, Engineering and Architecture Were Inseparable Parts of Total Form," *Architectural Record* 156 (mid-August 1974): 84–85.

75. Memorandum on plans of October 7 and August 26, October 11, 1971, Berg to Office of Louis I. Kahn. Kahn Collection, Correspondence Yale Mellon Office, J. Prown and H. Berg, File Box LIK 109. The desire to have the ability to close off light entirely no doubt reflects "Report on the Deteriorating Effects of Modern Light Sources," by Laurence S. Harrison, Metropolitan Museum of Art, sent to Prown by Richard Kelly. The point was made that all light, natural or artificial, causes deterioration. See Yale University Manuscripts and Archives, Kahn Collection, File Box LIK 3.

76. Transmittals, February 9, 1971. Kahn Collection, All Transmittals, Yale Mellon Art Gallery, File Box LIK 111. Letter, April 7, 1971, Wisdom to Kelly. Wisdom asked that incomplete sketches be sent since the estimate date was to be April 15. Kahn Collection, Master Files, 1969–73, File Box LIK 10.

77. Minutes of meeting, September 18, 1971, Kahn, Traub, Morss (Kahn office); Kelly. Memorandum on a telephone call with Kelly, September 21, 1971, adds information that the lantern could be reduced to a seven-foot square and be effective. Kahn Collection, Skylights, Mellon, File Box LIK 112.

78. Letter, May 31, 1972, Wisdom to Borst. Kahn Collection, Correspondence with Yale University Offices: Buildings and Grounds, File Box LIK 110.

79. Memorandum, December 20, 1972, Arthur Owen (Kahn office) to Kahn. Owen checked with Berg by telephone, December 18, 1972, in response to Prown's comment. Berg described the Oakland museum lighting system as having tracks which were individually lowered from a high ceiling. In November, Prown had said he was not convinced of the fixtures under consideration and was not assured that the skylight design would work. He wanted verification from Kelly. Meeting report, November 21, 1972. Kahn Collection, Mellon Job Meeting Reports, File Box LIK 111. According to Owen, Richard Kelly assured him by telephone, December 18, 1972, that the lighting fixture he submitted, a "combination of wall washers with narrow beam exhibit lights," would provide "a good viewing atmosphere" and that anything supplementary could be provided from baseboard outlets. Kahn Collection, Mellon, Yale Lighting, File Box LIK 112.

80. Letter, March 5, 1974, William P. Becker (Kahn office) to Froeberg. Kahn Collection, Macomber Correspondence IV, 12–20–73 to 3–25–74, File Box LIK 110.

81. Transmittals, October 14, 1971, five plans, four elevations, two sections, and nine sketches by Kahn, to Prown; to security consultant Joseph Chapman. Transmittals, October 30, 1971, plans, elevations, sections, skylight detail of October 29, 1971, to Prown; to Macomber Company; to Dunn. Transmittals of same, November 4, 1971, to Tor, to Shadford. Kahn Collection, All Transmittals, Yale Mellon Art Gallery, File Box LIK 111.

82. Kahn thought a published comparison of the two "natural light fixtures" would be interesting since they were "so distinctively different in concept." Letter, June 7, 1973, Kahn to D. B. Stewart, Editorial Staff, *L'Architecture d'Aujourd'hui*. Kahn Collection, Master Files, 1969–73, File Box LIK 10.

83. Programmed Net Areas in Square Feet, October 29, 1971. Under 7, Seminar Rooms, it was noted that there were two double use rooms, in Prints and Drawings and in Photo Archives. The reference to "5" is unclear. Kahn Collection, Mellon, Net Areas 3–15–71, 8–16–71, Gross 6–8–71, File Box LIK 112. See Appendix C.

84. Minutes of meeting, November 10, 1971, Kahn, Wisdom, Morss, Traub, Junge (Kahn Office); Borst (Yale University); Tor, Parikh (Pfisterer, Tor and Associates); Shadford (Van Zelm, Heywood and Shadford); Froeberg (Macomber Company). Kahn Collection, Mellon, Minutes of Meetings, 1971–73, File Box LIK 110. Corporation approval was not documented in Kahn's files, but Prown's report to President Brewster states that it came "at the end of 1971." Letter, February 3, 1972. Kahn Collection, Mellon Correspondence, J. Prown and H. Berg II, File Box LIK 109.

85. Draft with notations, Release, Preliminary Design, The Paul Mellon Center for British Art and British Studies, November 23, 1971. Kahn Collection, News Clippings, Mellon Art Gallery (Yale), File Box LIK 111.

86. Statement on architectural design and programs of the Paul Mellon Center, February 23, 1972. Kahn Collection, Mellon Correspondence, J. Prown and H. Berg II, File Box LIK 109. Comments on Prown's draft were sent by Kahn. Photocopy to Henry Berg, December 17, 1971. Kahn Collection, News Clippings, Mellon Art Gallery (Yale), File Box LIK 111. Berg requested statements by Kahn that could be used for publication be sent to him before the first of the year. Kahn Collection, Minutes of meeting, December 17, 1971, Berg, Wisdom, Morss. Kahn Collection, unlabeled drafting room file with "Mellon" written on front, File Box LIK 111. Three pages Kahn dictated to Wisdom were sent later. "Life on the Street," February 14, 1972. Kahn Collection, News Clippings, Mellon Art Gallery (Yale), File Box LIK 111.

87. Letter, November 20, 1972, Prown to Kahn. A later letter followed up the questions. Letter, April 2, 1973, Prown to Kahn. Kahn Collection, Mellon Correspondence, J. Prown and H. Berg II, File Box LIK 109.

88. Yale University News Bureau release #168(P), February 23, 1972. Kahn Collection, News Clippings, Mellon Art Gallery (Yale), File Box LIK 111. Before he became mayor, Guida authored the "Guida Ordinance," June 6, 1969 (later found unconstitutional), designed to prevent institutions from acquiring valuable real estate and removing it from the tax roles. See Spielman, "Mellon Center," 4.

89. The Triangle Area Redevelopment with Stonorov in 1946–48; the Temple and Poplar Street development in North Philadelphia with Kenneth Day, Louis McAllister, Douglas G. Braik, and Anne Tyng in 1950–52; Mill Creek housing, 1951–62, also with Day, McAllister, Tyng and with Christopher Tunnard for landscape (the latter housing was built in two phases, 1952–54, and 1959–62, the second phase handled by Kahn's office alone). See *The Louis I. Kahn Archive, Personal Drawings, vol. 1, Buildings and Projects, 1926–1958* (New York and London: Garland, 1987): 2–3, 154–185, 252–54, 272–93. Also Ronner and Vasella, *Louis I. Kahn, Complete Work, 1935–1974*, 2nd ed., 38, 39, 40–47.

90. *The Louis I. Kahn Archive, Personal Drawings, vol. 6, Buildings and Projects, 1967–1969*: 42–153. Ronner and Vasella, *Louis I. Kahn, Complete Work, 1935–1974*, 2nd ed., 356–61.

91. "Life on the Street," February 14, 1972, Kahn transcribed by Wisdom. Kahn Collection, News Clippings, Mellon Art Gallery (Yale), File Box LIK 111.

92. Prown notes his own reluctance for this part of the program in contrast to Kahn's immediate enthusiasm. Prown, "Louis I. Kahn, Yale Center for British Art, Yale University, New Haven, Connecticut," in *Processes in Architecture: A Documentation of Six Examples* (Cambridge, Mass: Massachusetts Institute of Technology, 1979): 31–32. See Commercial Portion, Mellon Center, December 12, 1971, by Robert Quinlan, James D. Landauer Associates. Sherman Morss, Jr., of Kahn's office, responded to the December correspondence between Quinlan and Ecland sent by Dunn (January 6, 1972) by listing revisions already undertaken to incorporate Quinlan's recommendations and enclosed plans showing these. Letter, January 13, 1972, Morss to Dunn. Kahn Collection, Correspondence with University of Yale Offices: Buildings and Grounds, File Box LIK 110. More detailed recommendations were made later. Minutes of meeting, February 28, 1972, Borst, Froeberg, Quinlan, Wisdom, Morss. Kahn Collection, unlabeled drafting room file with "Mellon" written on front, File Box LIK 111. Minutes of meeting, March 15, 1972, Dunn, Spencer Miller, Borst (Yale); Quinlan (Landauer Associates, Inc.); Froeberg (Macomber Co.); Marshall Meyers (Kahn office). Kahn Collection, Mellon, Program, File Box LIK 112.

93. Transmittal, January 24, 1972, to Shadford. Five floor plans, four elevations, three sections, one site plan. These included plans with tentative telephone locations, received from Berg by telephone, January 24, 1972. Kahn Collection, All Transmittals, Yale Mellon Art Gallery, File Box LIK 111.

94. Memorandum, January 27, 1972, Berg to Wisdom. Kahn Collection, Mellon Correspondence, J. Prown and H. Berg II, File Box LIK 109.

95. For example, minutes of meetings, April 18, 1972, and April 20, 1972, Berg, Kahn, Wisdom, Morss. Kahn Collection, unlabeled drafting room file with Mellon written on front, File Box LIK 111. Memorandum: Comments on Architectural Drawings of April 21–24, April 28, 1972, Berg to Wisdom. Memorandum: Architectural Questions and Comments from Jules Prown, May 5, 1972, Berg to Wisdom. Memorandum: Architectural Drawings Dated May 12 submitted for estimate, June 8, 1972. Kahn Collection, Mellon Correspondence, J. Prown and H. Berg II, File Box LIK 109.

96. Minutes of meeting, February 2, 1972, Berg, Kelly, Vincent Sifre-Martines (Kelly's assistant), Shadford, Spears, and Morss. Kahn Collection, unlabeled drafting room file with "Mellon" written on front, File Box LIK 111.

97. Berg wrote Brown at Prown's request. Letter, February 2, 1972, Berg to Brown. Kahn Collection, Mellon Correspondence, J. Prown and H. Berg II, Box 109. Minutes of meeting, May 11, 1972, Berg, Brown, Scott, Kelly, Sifre-Martines, Kahn, Wisdom, and Morss. Kahn Collection, unlabeled drafting room file with "Mellon" written on front, File Box LIK 111.

98. Transmittals, May 15, 1972, Phase II Architectural Drawings for estimate, to Charles L. Bell of George A. Fuller Co.; to Froeberg; to Prown; to Dunn; to Tor; to Shadford. Kahn Collection, All Transmittals, Yale Mellon Art Gallery, File Box LIK 111.

99. Minutes of meetings, May 26, 1972, and June 21, 1972, Froeberg, Frederick Wales (who was to be superintendent and project manager for the project) Kahn, Wisdom, and Morss. Kahn Collection, unlabeled drafting room file with "Mellon" written on front, File Box LIK 111.

100. Memorandum: Balconies in Reading Room, June 16, 1972, Berg to Wisdom. Kahn Collection, Mellon Correspondence, J. Prown and H. Berg II, File Box LIK 109.

101. Letter, July 14, 1972, Kahn to Prown. Kahn Collection, Mellon Correspondence, J. Prown and H. Berg II, File Box LIK 109.

102. Transmittals, July 14, 1972, Revised Phase II Architectural Drawings, to Bell; to Froeberg; to Prown; to Dunn; to Tor; to Shadford. Kahn Collection, All Transmittals, Yale Mellon Art Gallery, File Box LIK 111.

103. The Paul Mellon Center for British Art and British Studies, Cost Savings Initiated by Macomber and Approved by Architect without changing scope or design, August 14, 1972. Letter, August 14, 1972, Froeberg to Borst. Kahn Collection, George B. H. Macomber Correspondence, 1971 to 2–26–73, File Box LIK 110.

104. Letter, September 15, 1972, Wisdom to Dunn. Certain exceptions, dependent on a more definite commercial program or on "future decisions" were noted. Kahn Collection, Master Files, 1969–73, Box LIK 10. The negotiated construction contract was based on Phase II Architectural Drawings. Wisdom said beginning Phase II Construction Documents to speed construction would mean extra costs to the architect and to consultants. Letter, March 9, 1972, Wisdom to Dunn. Kahn Collection, Correspondence with University of Yale Offices: Buildings and Grounds, File Box LIK 110.

105. Borst authorized shop drawings for construction of the mock-up. Letter, May 30, 1972, Borst to Froeberg. Kahn Collection, Correspondence, University of Yale Offices: Buildings and Grounds, File Box LIK 110.

106. Letter, June 6, 1972, Wisdom to Kelly. Kahn Collection, Master Files, 1969–73, Box LIK 10.

107. Notes on meeting, Mellon Center, Yale University, Skylights, August 25, 1972, Kelly, Owen. Kahn Collection, Mellon Skylights, File Box LIK 112.

108. See "Lighting Starts with Daylight. Lighting Design: Richard Kelly," *Progressive Architecture* 54 (September 1973): 85.

109. For example, memorandum on photography and conservation, June 16, 1972, Berg to Wisdom. Kahn Collection, Mellon Correspondence, J. Prown and H. Berg II, File Box LIK 109.

110. Letters, April 13, 1972 and June 18, 1972, Charles A. Lewis to Dunn. Kahn Collection, Correspondence with University of Yale Offices: Buildings and Grounds, File Box LIK 110.

111. Memorandum, June 30, 1972, Berg to Morss. Kahn Collection, Mellon Correspondence, J. Prown and H. Berg II, File Box LIK 109. Transmittal, June 6, 1972, to Kenneth Nesheim. Kahn Collection, All Transmittals, Yale Mellon Art Gallery, File Box LIK 111. Nesheim's report on the numbers and sizes of volumes in the Mellon library was sent to Berg, who forwarded a copy to Kahn's office. Report on Mellon Library, August 11, 1972, Nesheim to Berg. Memorandum on Housing the Mellon Center Collection, August 17, 1972, Radley H. Daly to Berg. This included an analysis of the reference collection (a projected capacity of 10,000 volumes, plus expansion space accommodating 11,500 volumes) with suggestions for increasing shelf space and of the photo archive (projected capacity of 4,332 boxes as drawn) with a suggested modification in shelving to allow an additional 1,120 boxes). Kahn Collection, Mellon Correspondence, J. Prown and H. Berg II, File Box LIK 109.

112. Minutes of meeting, December 17, 1971, Berg, Kahn, Wisdom, Morss. Kahn Collection, unlabeled drafting room file with "Mellon" written on front, File Box LIK 111.

113. Minutes of meeting, Mellon Art Gallery, Job No. 7139, October 12, 1972, Kahn, Wisdom, Morss, Owen, Borst, Berg, Tor, Shadford, Froeberg, and Wales. Kahn Collection, Mellon, Minutes of meetings, 1971–73, File Box LIK 110.

114. See draft of Outline Specifications, February 24, 1972, enclosed with letter, March 30, 1972, Morss to Tor; and memorandum, April 7, 1972, Tor to Wisdom. Kahn Collection, Pfisterer, Tor and Associates, Structural Engineers, Yale Mellon, File Box LIK 110. A copy of Specifications for Formwork and Concrete Placement, Museum for Kimbell Art Foundation, Fort Worth, was also in the Mellon Center files. Kahn Collection, Mellon Yale Specifications, File Box LIK 111.

115. The experience with concrete for the Salk and Kimbell projects counted here. Pozzolan, a volcanic ash, had been used in the Salk concrete mix and was recommended, although not used, for the Kimbell. It was suggested in the October 12 meeting for the Mellon Center. Froeberg asked the New Haven Testing Laboratory to investigate its availability and its use in preparing samples. Letter, October 30, 1972, Froeberg to Stanley G. Kledaras, New Haven Testing Lab. Kahn Collection, Mellon, New Haven Testing Laboratory, Inc., File Box LIK 109. Froeberg later reported that flyash was uncommon in the area and therefore too expensive to use in New Haven. It was then that reference was made to the Yale Art Gallery concrete. Notes of meeting, December 7, 1972. Kahn Collection, Mellon Job Meeting Reports, File Box LIK 111.

116. Notes on meeting, December 1, 1972. Kahn Collection, Minutes of meetings, 1971–73, File Box LIK 110. Kahn went to the Allegheny-Ludlow plant March 16, 1973. George B. H. Macomber Co., Job No. 7139, Notes of meeting, March 8, 1973. Kahn Collection, Mellon Job Meeting Reports, File Box LIK 111. Kahn went to the Republic Steel plant in Ohio in the fall of 1973 to view the coil of steel. Marshall Meyers, "Louis I. Kahn, Yale Center for British Art, Yale University, New Haven, Connecticut," in *Processes in Architecture* 43. Samples from that coil were in New Haven by January 1974 and seen and approved by Kahn. Memorandum, January 16, 1974, Burghart to Kahn, attention: Wisdom. Kahn Collection, Macomber Correspondence IV, 12–20–73 to 3–25–74, File Box LIK 110.

117. Copies of the application and a site plan prepared by Buildings and Grounds, which had been filed, were sent to Kahn with a request for a site plan that could be used for presentation. Letter, March 7, 1972, Dunn to Kahn, attention: Wisdom. Kahn Collection, Correspondence with University of Yale Offices: Buildings and Grounds, File Box LIK 110. In a telephone call Dunn explained procedures and asked again that drawings, enhanced as Kahn considered effective for laymen, be prepared and sent. Memorandum of telephone call, March 24, 1972, Junge to Kahn. Kahn Collection, Master Files, 1969–73, LIK Box LIK 10. To complete the application, Dunn asked for copies of the October 29, 1971, drawings (officially approved by Mellon and the Yale Corporation). Memorandum, June 15, 1972, Dunn to Kahn, attention: Wisdom. Kahn Collection, Correspondence with University of Yale Offices: Buildings and Grounds, File Box LIK 110.

118. New Haven City Plan Commission/Staff Advisory Report #708/3, April 5, 1972. Kahn Collection, Correspondence with Yale University Offices: Buildings and Grounds, File Box LIK 110.

119. Wisdom was asked to prepare a revised site plan to accompany the filed plans. Letter, October 5, 1972, Dunn to Borst. Kahn Collection, Mellon Correspondence, J. Prown and H. Berg II, File Box 109. It was sent two weeks later. Letter, October 20, 1972, Morss to E. Taylor. Kahn Collection, Master Files, 1969–73, File Box LIK 10. Transmittals, October 19, 1972, to Prown; Berg; Dunn; Froeberg; Shadford; Tor. All Transmittals, Yale Mellon Art Gallery, File Box LIK 111.

120. Letter, October 23, 1972, Wales to Kahn, attention: Wisdom. Memorandums on Bid Tabulations, October 25, November 17, November 28, December 1, December 4, 1972, and January 16, February 8, 1973, Froeberg to Kahn. These continued through succeeding months. George B. H. Macomber Co., Mellon Yale Correspondence, 1971 to 2–26–72, File Box LIK 110.

121. Memorandum: Comments on Architectural Drawings Dated October 20, 1972, October 31, 1972, Berg to Wisdom. On the same day Berg wrote to ask advice about built-in and movable furniture, graphic design, and art installation. Memorandum: Furniture Design for the Paul Mellon Center, October 31, 1972, Berg to Kahn. Kahn Collection, Mellon Correspondence, J. Prown and H. Berg II, File Box LIK 109. On removing fountains, see memorandums, October 22 and 23, 1973, Meyers to Wales. Kahn Collection, Macomber Correspondence III, 8–17–73 to 12–19–73, File Box LIK 110.

122. Memorandum: Comments on Architectural Drawings Dated November 8, 1972, November 16, 1972, Berg to Wisdom. Kahn Collection, Mellon Correspondence, J. Prown and H. Berg II, File Box LIK 109.

123. Change Order #3, March 12, 1974, signed by Wisdom. Kahn Collection, Change Orders Completed, File Box LIK 110. The magnetic fire release devices in the shutters were to be installed by the manufacturer. Letter, August 10, 1973, Burghart to Kahn. Kahn Collection, George B. H. Macomber Co. Correspondence II, 3–5–73 to 8–16–73, File Box LIK 110.

124. For structural drawings, information was needed on plenums, on the fourth-floor airfloor slab, on the baffling of the airfloor, on window washing and mechanical load data, on the circular stair revisions, on the elevator lobby roof plan, and on the areaway roof details. Memorandum, January 12, 1973, Parikh and Tor to Kahn. Kahn Collection, Pfisterer, Tor and Associates, Structural Engineers, Mellon, File Box LIK 110.

125. Memorandum: Preliminary comments on final architectural drawings, February 15, 1973; and Electrical/Plumbing prints, February 8, 1973, February 19, 1973, Berg to Wisdom. Also memorandums, February 19, 20, 21, 1973, Berg to Wisdom. Plans were examined by the photo archive librarian, who commented on shelving, sink cabinet, and circulation desk. Memorandum, April 2, 1973, Jack Brown to Berg. The conservation room was also evaluated for functional use, and it was requested that a movable divider between the dry and wet treatment areas be added. Letter, April 11, 1973, Peter Zegers to Berg. These requests were forwarded to the Kahn office. Kahn Collection, Mellon Correspondence, J. Prown and H. Berg II, File Box LIK 109.

126. George B. H. Macomber Co., Job No. 7139, notes of meeting held February 22, 1973, Kahn Borst, E. Cairns (Trio Industries), Froeberg, Burghart, and Wales. Kahn Collection, Mellon Job Meeting Reports, File Box LIK 111. Also notes of meeting, February 22, 1973. Kahn Collection, Mellon Minutes of meetings, 1971–73, File Box LIK 111. The structural consultant advised against the local red sand, saying it produced too much variation in gradation. Memorandum: Concrete sand, April 10, 1973, Kaminski to Kahn, attention: Wisdom. Kahn Collection, Pfisterer, Tor and Associates, Structural Engineers, Mellon, File Box LIK 110.

127. Letter, March 15, 1973, Froeberg to Borst. Kahn Collection, George B. H. Macomber Co. Correspondence II, 3–5–73 to 8–16–73, File Box LIK 110.

128. Letter, April 2, 1973, Prown to Kahn. Prown mentioned having called about the matter on March 17, before leaving for London. Kahn Collection, Mellon Correspondence, J. Prown and H. Berg II, File Box LIK 109.

129. Burghart stated that a progress skylight drawing had been shown him without any commitment as to when it would be final. Letter, May 11, 1973, Burghart to Kahn. Kahn Collection, George B. H. Macomber Co. Correspondence II, 3–5–73 to 8–16–73, File Box LIK 11.

130. Letter, May 22, 1973, Burghart to Kahn. Kahn Collection, George B. H. Macomber Co. Correspondence II, 3–5–73 to 8–16–73, File Box LIK 110.

131. Letter, May 24, 1973, Froeberg to Kahn, attention: Wisdom. Kahn Collection, George B. H. Macomber Co. Correspondence II, 3–5–73 to 8–16–73, File Box LIK 110.

132. This was insisted upon by professional staff. Prown had considered previously that the common requirements of the rare books and the prints and drawings library made a unified area seem appropriate. The change cost about $50,000. Prown, "Yale Center for British Art, Yale University, New Haven, Connecticut," in *Processes in Architecture*, 40.

133. Letter, August 28, 1973, Kahn to Shadford. Kahn Collection, Van Zelm, Heywood, and Shadford, Mechanical Engineers, Mellon, File Box LIK 110.

134. Letter, September 4, 1973, Shadford to Burghart. Ronald Luzi was to attend the meeting. Kahn Collection, Van Zelm, Heywood, and Shadford, Mechanical Engineers, Mellon, File Box LIK 110.

135. Tor also had "difficulty with orderly processing" because structural revisions were not incorporated in new drawings. He suggested the contractor promptly inform draftsmen of structural changes as well as anticipated architectural changes. Letter, July 24, 1973, Tor to Kahn. Kahn Collection, Pfisterer, Tor and Associates, Structural Engineers, Mellon, File Box LIK 110. Letter, September 11, 1973, Shadford to Kahn. Kahn Collection, Van Zelm, Heywood and Shadford, Mechanical Engineers, Mellon, File Box LIK 110.

136. Letters, September 5, 1973, and September 21, 1973, Froeberg to Kahn. Kahn Collection, Macomber Correspondence III, 7–17–73 to 12–19–73, File Box LIK 110.

137. Letter, September 18, 1973, Prown to Borst. Letter, October 4, 1973, William A. Laird (Kahn office) to Burghart. Kahn Collection, Macomber Correspondence III, 7–17–73 to 12–19–73, File Box LIK 110.

138. Letter, October 22, 1973, Froeberg to Borst. Kahn Collection, Macomber Correspondence III, 8–17–73 to 12–19–73, File Box LIK 110.

139. Memorandum, June 13, 1973, Prown to Borst. Prown had first suggested Kahn have a New Haven representative during construction in April 1973. Letter, April 2, 1973, Prown to Kahn. Kahn Collection, Mellon Correspondence, J. Prown and H. Berg II, File Box LIK 109.

140. Meyers, "Yale Center for British Art," in *Processes in Architecture*, 37–38. Also see memorandums, October 9, 1973, Meyers to Robert Ducibella and October 12, 1973, Meyers to Burghart. Kahn Collection, Macomber Correspondence III, 7–17–73 to 12–19–73, File Box LIK 110. Memorandum, October 24, 1973, Meyers to Pfisterer, Tor and Associates, attention: Perikh [*sic*] and Shapiro. Kahn Collection, Pfisterer, Tor and Associates, Structural Engineers, Mellon, File Box LIK 110. Field Memorandums and Sketches, October 9 to October 24, 1973, October 25, 1973, Meyers to Prown. Kahn Collection, Mellon Correspondence, J. Prown and H. Berg II, File Box LIK 109. Prown later expressed gratitude for Meyers's tenacity of purpose in achieving what Kahn would want. "Jules D. Prown," in Latour, *Louis I. Kahn*, 139.

141. Prown gave a drawing to Basserman of changes in the paper conservation office, asking him to send it to Kahn's office to be incorporated into the plans. Memorandum, October 25, 1973, V. Peter Basserman (Yale Buildings and Grounds) to Laird. Kahn Collection, Correspondence, University of Yale Offices: Buildings and Grounds, File Box LIK 110. Library revisions for fenestration, cases, desk, table, and carrel arrangements and for provision of facilities for typewriter and tape recorder use in the prints and drawings room, rare book library, and reference library were sent after late November discussions between Kahn, Prown, Basserman, and Brown. Memorandum, December 3, 1973, Brown to Kahn. Memorandum, January 25, 1974, Robert E. Kuehn, Assistant Director, Mellon Center, to Kahn. Kuehn enclosed revisions for the third floor since the revised plan did not reflect changes in the paper conservator's office previously requested. Kahn Collection, Mellon Correspondence, J. Prown and H. Berg II, File Box LIK 109.

142. Letter, December 5, 1973, Froeberg to Kahn. Kahn Collection, Macomber Correspondence III, 7–17–73 to 12–19–73, File Box LIK 110.

143. The city had disapproved the proposed drainage system and required a new plan. Letter, September 28, 1973, George I. Engle, Chief Construction Engineer, Office of City Engineer, to George B. H. Macomber Co., attention: Wales. Yale University had held back from final decisions on the sunken courtyard and adjacent commercial space in hopes of having a definite tenant who would set requirements. Letter, June 16, 1972, Dunn to Kahn, attention: Wisdom. As expense mounted, it was thought that the commercial areas might not be developed there after all. Memorandum, October 17, 1973, Basserman to Kahn, attention: Laird. Kahn Collection, Correspondence with University of Yale Offices: Buildings and Grounds, File Box LIK 110.

144. Letter, December 12, 1973, Laird to Froeberg. Kahn Collection, Macomber Correspondence III, 7–17–73 to 12–19–73, File Box LIK 110.

145. They had been sent November 16, 1973. Memorandum, November 16, 1973, Brooke Drinkwater (Kahn office) to Parikh. Kahn Collection, Pfisterer, Tor and Associates, Structural Engineers, Mellon, File Box LIK 110.

146. Letter, December 14, 1973, Froeberg to Kahn. Kahn Collection, Macomber Correspondence III, 8–7–73 to 12–19–73, File Box LIK 110.

147. Prown, "Yale Center for British Art," *Processes in Architecture*, 37.

148. The system employed by the George B. H. Macomber Company has been described as the Crical Path Method (or *CPM*) of planning, scheduling, and controlling the project. See Spielman, "Mellon Center" 4.

149. Prown, "Yale Center for British Art," *Processes in Architecture*, 32.

150. He referred to his letters of October 22, December 5 and 14, 1973, memorandum of meeting December 18, 1973, and letter to Borst of December 20, 1973. See notes 137, 141, 145. The letter to Borst emphasized the necessity of beginning work by March 1 on the lower courtyard, as it was crucial for the loading docks and for egress from the lecture room. Two months would be needed to develop detailed plans, and development was necessary to complete the project and obtain an occupancy permit from the city. Letter, December 20, 1973, Froeberg to Borst. The meeting had recapitulated all matters. Kahn Collection, Macomber Correspondence IV, 12–20–73 to 3–25–74, File Box LIK 110.

151. Memorandum, January 16, 1974, Burghart to Kahn, attention: Wisdom. Memorandum, January 23, 1974, Froeberg to Kahn, with bid tabulation for roofing and skylights. Other endorsed bid tabulations the same month were for millwork, metal doors, and dumbwaiters. One for finishing hardware was sent February 1, 1973. The inspection of beams was scheduled by letter, January 25, 1974, Froeberg to Allied Building Systems, Inc., attention: Frank Lore, Vice President. Kahn Collection, Macomber Correspondence IV, 12–20–74 to 3–25–74, File Box LIK 110.

152. Letter, February 8, 1974, Basserman to George B. H. Macomber Co., attention: Froeberg. Kahn Collection, Correspondence with University of Yale Offices: Buildings and Grounds, File Box LIK 110. Letter, February 11, 1974, Froeberg to Basserman. Kahn Collection, Macomber Correspondence IV, 12–20–73 to 3–28–74, File Box LIK 110.

153. The intention was to construct the "shell" of the proposed restaurant and to undertake interior work only when a tenant became committed. Letter, March 11, 1974, Basserman to Kahn, attention: William Becker. Kahn Collection, Correspondence with University of Yale Offices: Buildings and Grounds, File Box LIK 110.

154. Letter, March 13, 1974, Burghart to Basserman. The letter also noted that the installation of the storm drainage system was to proceed. Kahn Collection, Macomber Correspondence IV, 12–20–73 to 3–28–74, File Box LIK 110.

155. Letters, March 15, 1974, Borst to Froeberg, and March 18, 1974, Borst to Burghart. Kahn Collection, Correspondence with University of Yale Offices: Buildings and Grounds, File Box LIK 110. Burghart wrote to urge that Borst, "as the man who ultimately gives us orders on behalf of Yale," attend coordination meetings, since the procedures and materials had been discussed at the March 6 meeting and would now be included as well at the March 20 meeting. Time and expense would be affected, Burghart thought, by his decisions. Letter, March 15, 1974, Burghart to Borst. Kahn Collection, Macomber Correspondence IV, 12–20–73 to 3–25–74, File Box LIK 110.

156. Susan E. Shur, "Museum Profile: Yale Center for British Art," *Technology and Conservation* 4 (Spring 1979): 21–22.

157. Memorandum, March 11, 1974, Burghart to Kahn. Burghart noted that the price quoted for the linen fabric "will only be [good] until April 1." Note with agenda, March 15, 1974, Burghart to Becker, Luzi, Meyers, Kahn. The Yale Center for British Art and British Studies, Job No. 7139, Status Report of Shop Drawings, March 8, 1974. A memorandum canceled the meeting of March 20 because "Mr. Kahn will not be available," and anticipated setting a date a week later. Memorandum, March 19, 1974, from Burghart. Kahn Collection, Macomber Correspondence IV, 12–20–73 to 3–25–74, File Box LIK 110. Kahn's body was identified, but for several days after his death March 17, 1974, there was a mistake about making contact with his family and his whereabouts was unknown to them and to his colleagues.

158 Meyers, "Yale Center for British Art," in *Processes in Architecture*, 39.

159. Memorandum, March 26, 1974, Froeberg to Kahn office, attention: Meyers. Kahn Collection, Macomber Correspondence IV, 12–20–73 to 3–25–74, File Box LIK 110.

160. Meyers and Pellecchia, "Yale Center for British Art," in *Processes in Architecture*, 39.

161. Letter, March 26, 1974, Prown to Baldwin. Kahn Collection, Mellon Correspondence, J. Prown and H. Berg II, File Box LIK 109. As noted elsewhere, Kahn had also recommended Baldwin to Richard Brown for work on the Kimbell Art Museum.

162. See *The Louis I. Kahn Archive, Personal Drawings*, vol. 6, 563–68.

163. Letter, April 4, 1973, Prown to Manfred Ibel. Earlier correspondence on furnishings include letters, October 31, 1972, and March 14, 1973, Berg to Kahn. Later, Prown wished to remove some library furniture from the architectural contract, since using modular units already in manufacture, as seen in the Kimbell library, would provide for more flexibility and growth later. Letter, March 13, 1974, Kuehn to Kahn. Kahn Collection, Mellon Correspondence: J. Prown and H. Berg II, File Box LIK 109.

164. "Jules D. Prown," in Latour, *Louis I. Kahn*, 137.

165. Letters, February 13, 1973; February 14, 1973; February 21, 1973; and March 14, 1974, Robert Zion to Kahn. Kahn Collection, Zion and Breen, Site Planners/Landscape Architects, File Box LIK 109.

166. See accounts of the opening ceremonies, of the building, of the collection, and of the history of British studies at Yale in *Newsweek* (April 18, 1977): 90–91 and *Time* (April 25, 1977): 63–64.

167. Prown, *The Architecture of the Yale Center of British Art*. (The second edition was published in 1982.) See also Prown, "The Architecture of the Yale Center for British Art," *Apollo* 105, new series (April 1977): 234–37.

168. Prown, *Architecture*, 71. Figures produced by the architects varied somewhat from this: 116,785 total square feet, consisting of 18,818 for commercial space and 97,967 for the Center, at a cost of $9,600,000, or $82.20 per square foot for construction. Transmittal, Architects Project #7407, March 4, 1977, Pellecchia and Meyers by K. Krause to Marnie Halsey, Yale Center for British Art. Yale University Manuscripts and Archives, Kahn Collection, File Box 4.

169. "The Paul Mellon Center for British Art: A Classic Accommodation between Town and Gown," *Yale Alumni Magazine* 35 (April 1972) 30–31. "Mellon Art Center at Yale," *Interiors* 131 (April 1972): 30. Deborah Waroff, "Kahn," *Building Design* (2 June 1972): 12–13. "Paul Mellon Center for British Art, Yale," *Architectural Record* 152 (July 1972): 41. "The Mind of Louis Kahn," *Architectural Forum* 137 (July–August 1972) 42–89. "Louis I. Kahn: Silence and Light," *Architecture and Urbanism* 3 (January 1973): 5–222. "In the Philosophy of Louis Kahn, Engineering and Architecture Were Inseparable Parts of Total Form": 84–85. Romaldo Giurgola and Jamini Mehta, *Louis I. Kahn, Architect* (Zurich: Verlag fur Architektur, 1975).

170. Smithson, "Louis Kahn's Centre for British Art and British Studies at Yale University," *RIBA Journal* 83 (April 1976): 149–51.

171. Scully, "Yale Center for British Art," *Architectural Record* 161 (June 1977): 95–104. William Jordy, "Kahn at Yale," 37–44.

172. Stanley Abercrombie, "Louis I. Kahn, Pellecchia and Meyers, Benjamin Baldwin, Yale Center for British Art," *Interiors* 136 (July 1977): 52–59.

173. Andrea O. Dean, " A Legacy of Light," *American Institute of Architects Journal* 67 (May 1978): 83–88.

174. Filler, "Opus Posthumous. Yale Center for British Art, Yale University, New Haven," *Progressive Architecture* 59 (May 1978): 76–81. See his editorial as interior design editor of *Progressive Architecture* in which he expressed his view that the Modern movement had been repudiated as "a style that has become unfashionable." "The Plain, the Fancy, the Real and the Unreal: Introduction: Interior Design," *Progressive Architecture* 58 (September 1977): 57–58. Hoffmann, who had objected to the "false" vaults of the Kimbell Art Museum (see chapter 3, n. 169), wrote a letter to the editor in praise of Filler's analysis. *Progressive Architecture* 59 (July 1977): 10.

175. "Architecture 1976–86," *Architecture* 75 (January 1986):27. Andrea O. Dean, "Showcase for Architecture," *Architecture* 75 (January 1986): 28–31.

176. Dean lists the addition to the Speed Museum, Louisville, by Geddes Brecher Qualls Cunningham; the Dallas Museum of Fine Arts by Barnes; the addition to the Portland (Maine) Museum of Art by Henry Cobb of I. M. Pei & Partners, the Dartmouth College Hood Museum of Art by Charles W. Moore, Moore Grover Harper, P.C.; the Sackler Museum at Harvard University by James Stirling; and the new wing for the Virginia Museum of Fine Arts by Hardy Holzman Peiffer. She also includes museums then in design or construction: Venturi's Laguna Gloria Museum in Austin, Cobb's museum for Oklahoma City, and Barnes's for Fort Lauderdale. "Showcase" 31. See also Patricia Loud, "The Critical Fortune," *Design Book Review* 11 (Winter 1987): 52–54.

177. Michael J. Crosbie, "Evaluation: Monument Before Its Time," *Architecture* 75 (January 1986): 64–67.

178. See Shur, "Museum Profile: Yale Center for British Art," 21.

179. "From a Conversation with Peter Blake," July 20, 1971, and "From a Conversation with William Jordy," in Wurman, *What Will Be Has Always Been*, 127–33 and 236–42.

180. Mrs. Kahn and her daughter have both said the Kimbell was the building Kahn found most satisfying. The French architect Christian Devillers commented to the author on Kahn's description of the Kimbell as his "favorite child" during a visit to the museum in 1988.

181. Kahn, "The Visible City — International Design Conference at Aspen, Colorado, June 1972," in Wurman, *What Will Be Has Always Been*, 158.

182. Kahn, "From a Conversation with Robert Wemischner," April 17, 1971, in Wurman, *What Will Be Has Always Been*, 116.

# Louis I. Kahn as Museum Designer     CHAPTER 5

Louis I. Kahn had a particular affinity with buildings that were to contain art. Only shortly before his death he responded with interest to two inquiries about commissions, of the many he received, concerning museums.[1] One of his last projects was for a museum in Houston, a gallery with open storage, a concept more reminiscent of the open stacks of a library than a traditional museum. This was to house the distinguished collection belonging to John and Dominique de Menil consisting of antiquities (primarily Mediterranean Neolithic), Byzantine, modern twentieth century, and tribal arts. Although it is not possible to trace the building's history completely, existing drawings provide insights into the evolution of his ideas about museums, or at least this particular museum, in the year before his death.

Fifty-three of Kahn's own drawings related to the de Menil project are in the Louis I. Kahn Archives at the University of Pennsylvania. Of these, twenty-five are site plans or studies associated with the museum, while the others are for housing or a related hotel;[2] there are also a number of office drawings for the museum in the collection. The Menil Collection itself preserves nineteen sheets, mostly duplicates (in sepia prints) of Kahn's drawings in Philadelphia. Three handsome exceptions are prints of site plans that Kahn colored in pastel for a presentation to the clients. It is on the basis of these preliminary works, tentative as they are, that we can see that Kahn had initiated a new concept, a new approach. The client's program gave him an innovative idea of what a museum could be, and his de Menil, had it materialized, would have been a contribution to the museum as a building type. He himself said, in a letter to a possible client who had contacted him about designing a museum, that this recent commission had "stimulated the sense of the great variety of possible spaces."[3]

Kahn first met the de Menils, who left France and settled in Houston in 1941, when he came to Houston in April 1967 to deliver a lecture in the President's Lecture Series at Rice University. He was asked then by Mrs. de Menil to write a foreword to the catalogue of architectural drawings and prints by Boullée, Ledoux, and Lequeu, *Visionary Architects*, an exhibition she was instrumental in bringing from France to the United States.[4] Kahn also spoke at the University of St. Thomas, Houston, in the fall of 1967, when the exhibit was on view there. These works bore special significance to him, since they included drawings he found meaningful at the time he was working on the design for the Kimbell Art Museum. (Subsequently, in the 1969 Boston lecture when he described his vision of the interior of this museum, he referred to the inspirational projects of these architects, focusing on the famous drawing of a huge barrel vault with skylight that Boullée had proposed as an expansion of the Bibliothèque Nationale.)[5] Kahn made other trips to Houston, and in 1969 a book was published based on his April lecture and talks with architectural students at Rice University.[6] Later that same year a commission to design an art center for the University resulted in several more visits, including contacts with the de Menils.[7] Mrs. de Menil was director of the Institute of the Arts at Rice University, which would have been part of the art center. She actively worked in the arts at Rice, St. Thomas, and other Houston art institutions.

For various reasons the Rice project was not continued beyond July 1970, but in 1972 John and Dominique de Menil chose Kahn to be the architect for their personal museum. The site was adjacent to the University of St. Thomas on land originally

Project for the de Menil Museum, Houston. Detail of site plan. Catalogue 113.

acquired for the latter's expansion, not far from Rice, in the residential Montrose section of Houston. As their representative, Simone Swan, executive vice-president of the de Menil Foundation, came to Kahn's Philadelphia office in November 1972 to retain him as designer for their gallery.[8] The program she describes was distinguished by the openness with which works of art were to be treated and by the Foundation's desire to involve the public as fully as possible in experiencing the collections and sponsored activities. Objects from the Foundation were then on loan to museums, institutions, and offices throughout the world, including Paris and New York, but predominantly in Houston.

The building itself was to embody this openness and generosity of spirit. Mrs. Swan reports that Kahn responded with joy to this intention, almost as though it exceeded hopes he had long been cherishing. Indeed, it was the type of philosophical characterization he sought to define his Platonic ideal of "form." The design was to accommodate collections that had become so sizable that much would have to be stored, only some of the objects being on display at any one time.[9] But the necessary storage was to be integrated in such a way that works would be readily available to those who wanted to view them. It was the sort of challenge Kahn welcomed. He labeled sketches showing what he conceived for this purpose "The Storage" (see figs. 5.8 and 5.11). He must have spoken at length about this special aspect of the program to William Marlin when describing his current work, for Marlin referred to the design as "a storage for the art collection of the de Menil Foundation in Houston which 'was wanting to be' a 'treasury space.'"[10] Although exhibition space in a more traditional format was to be provided, the whole collection was to be available to any visitor with relatively little effort. Even drawings that had to be protected from light were to be centrally located in cabinets with drawers clearly marked and easily accessible. Everything was to be open to anyone who made an appointment to see it. Nothing was to be hidden away. It was a concept with enormous appeal to Kahn.

The Foundation foresaw that the Montrose area adjacent to the immediate site, much of it also owned by the de Menils, would over time become one with a demographic mixture: students and faculty from the several Houston area universities, families with children, young professionals, people of different generations and occupations and economic levels, all drawn by the calm and beauty that would be found there. In this sense it was to be to the de Menils an ideal community. The Rothko Chapel already distinguished the neighborhood. This chapel, a nondenominational sacred place commissioned of the painter Mark Rothko (1903–70) in 1964 by the de Menils, was to have been a collaboration between him and Philip Johnson, who designed the floor plan. (The de Menils had earlier commissioned Johnson to design buildings for the University of St. Thomas in the block east of the site.) However, the two men disagreed over the skylight Rothko wanted, and Johnson withdrew from further participation. The chapel was completed by Houston architect Howard Barnstone and his partner Eugene Aubry.[11] A reflecting pool and a twenty-six-foot high sculpture, *Broken Obelisk*, by Barnett Newman (1905–70) are placed on axis. The Rothko Chapel, dedicated in early 1971, the year before Kahn's commission, soon became a spiritual center.

Kahn liked the possibility of "redeveloping" an area, just as he was doing in the urban environment of the Yale Center for British Art in New Haven. Here, however, was a suburban site with the openness of a park, closer in feeling to the spacious park site of the Kimbell than to urban New Haven. Thus he could contemplate the whole Montrose neighborhood surrounding the museum's immediate site, including the chapel, as part of an overall scheme.

The de Menil Foundation's plans for the new undertaking included special educational and cultural programs — colloquia, conferences, meetings, symposia — which it was felt would make the area a gathering place for visitors from beyond the immediate scene. The concept recalls that envisioned for the Yale Center for British Art and British Studies but with more ecumenical interests and without its academic goals. Small and large conference and meeting rooms would be needed. Permanent

residents were also to be drawn into the activities. According to Mrs. Swan, a community bulletin board or marquee was one means under consideration to inform neighbors and invite them to attend either scheduled or impromptu events and exhibitions.[12] Existing housing would be expanded and improved, and in fact Kahn devoted a number of sketches to housing units, a hotel, and several conference amenities.[13] Yet the intimacy of the suburban neighborhood of existing 1920s bungalows and small-scale 1950s mansard-roofed apartments was to be respected.

Kahn's first sketches for a project typically encompass a wide point of view, and the interest in possible site development only encouraged this tendency. A sketchy site plan (fig. 5.1), which may well be among the earliest, takes in a large area but centers on the block that is bounded by Branard Street on the south, Sul Ross on the north, Yupon on the east, and Mulberry on the west. This block holds the cruciform Rothko Chapel (the interior is an octagon shape, but the addition of apse, narthex, and vestries shape the exterior), located off-center to the east with the reflecting pool and Newman sculpture on axis with it. In this sketch Kahn placed a complex of several structures on either side of Branard Street, leaving most of the block open as a park. The block to the west shows only a vague indication of buildings. Kahn wrote the name of Max Ernst on the drawing, and it was for the purpose of talking with the collectors about the prospective museum and of attending, with Dominique de Menil, an exhibition of the work of this artist on display at Rice University that he came on a trip to Houston in early 1973.[14] Mrs. Swan considers this visit to the exhibition to be a time of significant exchange between Mrs. de Menil and Kahn concerning the museum. He was still absorbing information that would help him with his design.

This sketch mentioned above was only a tentative possibility. Another one of a site plan, dated March 10, 1973 (fig. 5.2), concentrates on the same block, locating to the northwest a much larger, rectangular building with an east-west orientation. Here too is a sketch of five palm trees in profile; palms are to be found along several streets in the area. We can sense Kahn responded to the flat Gulf coastal plain and the warm, humid climate of Houston with its lushness, greenness, and subtropical plants even in this early phase. In his drawings for the museum he included outdoor courtyards, porches, and palms. (Mrs. Swan uses the term "royal palm scheme" on the basis of projected plantings east of the chapel to describe his design.)[15]

As the scheme developed, galleries and storage were placed on an axis characteristically north-south in orientation (fig. 5.3), paralleling the axis of the chapel,

**5.1**
*De Menil Museum. Schematic site plan.* **Catalogue 100.** Louis I. Kahn. Louis I. Kahn Collection, University of Pennsylvania and Pennsylvania Historical and Museum Commission.

**5.2**
*De Menil Museum. Sche-*
*matic site plan, various*
*sketches.* **Catalogue 101.**
Louis I. Kahn. March 10,
1973. Louis I. Kahn Collec-
tion, University of Pennsylvania
and Pennsylvania Historical
and Museum Commission.

sculpture and reflecting pool. Another sketch-plan for the site (fig. 5.4) shows this,
along with some indication of attention given to a complex of other structures such as
a hotel, meeting rooms, and housing units. The simplicity of the museum as sketched
here (numbered "2" with the chapel numbered "1") suggests that it may have been at
this point simply a long, loft-like space with ten columns ranged along the center, a
plan seen in one of the sepia prints now in the Menil Collection. But small sections on
the right in this sketch indicate that vaults with skylights are already part of the design
at this stage, although possibly for another building.

An oversize drawing of a site section captures the mood and scale of the pro-
jected museum (fig. 5.5). The palms figure here, along with other trees (with his typi-
cally rendered flat, oval-shaped foliage), in conveying a sense of the character of the
site through its lush vegetation. A system of bays and vaults is suggested by the large,
double-vaulted room in the center that is surmounted by a roof garden. The latter motif,

**5.3**
*De Menil Museum. Schematic site plan, partial section.* **Catalogue 102.** Louis I. Kahn. Louis I. Kahn Collection, University of Pennsylvania and Pennsylvania Historical and Museum Commission.

**5.4**
*De Menil Museum. Schematic site plan, various section studies.* **Catalogue 103.** Louis I. Kahn. Louis I. Kahn Collection, University of Pennsylvania and Pennsylvania Historical and Museum Commission.

one that Kahn had wished to employ outside the galleries at the Yale Center in New Haven but finally had had to abandon, would probably have been more successful in the Houston climate. On the section only the roof garden and foliage are shown as higher than two stories; the structure basically conforms to the low, primarily two-story neighborhood. Kahn would make the building horizontal and spreading rather than

**5.5**
*De Menil Museum. Schematic site and building sections.* **Catalogue 104.** Louis I. Kahn. Louis I. Kahn Collection, University of Pennsylvania and Pennsylvania Historical and Museum Commission.

**5.6**
*De Menil Museum. Schematic site plan.* **Catalogue 105.** Louis I. Kahn. Louis I. Kahn Collection, University of Pennsylvania and Pennsylvania Historical and Museum Commission.

tall, as he did with the Kimbell Art Museum in its park setting (a decision reinforced in that case by the forty-foot height restriction). Such characteristics are true even for the hotel, which sketches indicate might have been as much as four stories in height. They also depict setbacks, and the top floor is shown almost as a pavilion.

The whole project, including housing and facilities for meetings and conferences, is more fully explained in two extensive site plans (figs. 5.6 and 5.7) which offer different possible arrangements. (The area shown includes the St. Thomas University buildings designed by Philip Johnson east of the Rothko Chapel.) In both of these plans the museum gallery appears as a series of vaults, recalling (though this may not be the intended effect) those of the Kimbell, separated by a long courtyard and with an east-west unit connecting them on the south. In both plans the museum is centered within the whole area. Kahn offered two different geometric configurations for the other buildings, either of which appear to require closing Mulberry Street and possibly Branard Street, entirely or in part, to achieve the desired patterns. (Handwritten notes on an

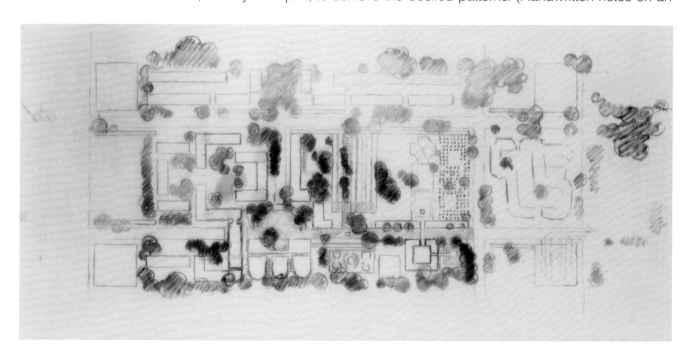

office drawing for the project in the Kahn Collection in Philadelphia record a set of figures for the density of an anticipated development of housing — 12.6 acres for 150 dwellings, or 8.2 acres, also for 150 dwellings — and furnish a count of existing houses.) Kahn positively liked the neighborhood aspect of the setting for this institution and talked of pots of geraniums on roof gardens and blue-lighted doorbell buttons.[16]

To provide the storage space that was so essential in the program for this museum, he envisioned special bays adjacent to the main north-south axis of galleries, with meeting rooms and auditorium in the unit to the south or in a connector between the long axes. His schematic "The Storage" (fig. 5.8) shows these, each gabled and creating the effect of a row of small houses when taken together. The construction material was projected to be brick, according to Mrs. Swan, and that would have reinforced the domestic effect. Other drawings for the bay system, however, indicate that Kahn might have combined concrete with brick, as he did in India. One draw-

**5.7**
*De Menil Museum. Schematic site plan.* **Catalogue 106.** Louis I. Kahn. Louis I. Kahn Collection, University of Pennsylvania and Pennsylvania Historical and Museum Commission.

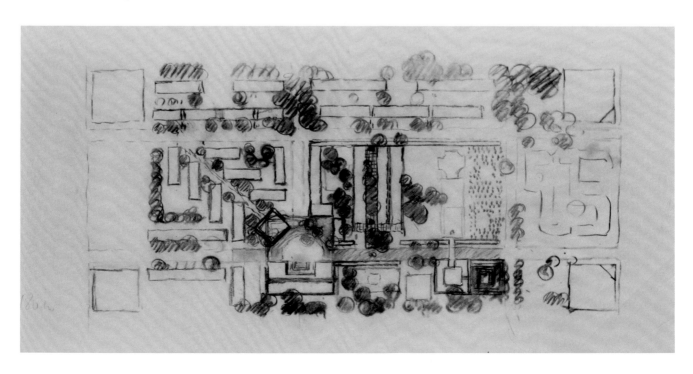

**5.8**
*De Menil Museum. Schematic east elevation, "The Storage."* **Catalogue 107.**
Louis I. Kahn. Louis I. Kahn Collection, University of Pennsylvania and Pennsylvania Historical and Museum Commission.

**5.9**
*De Menil Museum. Schematic cross section, "Sculpture Gallery."* **Catalogue 108.** Louis I. Kahn. Louis I. Kahn Collection, University of Pennsylvania and Pennsylvania Historical and Museum Commission.

ing (fig. 5.9), with partial section, depicts the "Sculpture gallery to porches off green court and to Meeting R[oom]" (at one end is a door to locked storage), and a third sketch, a cross-section (fig. 5.10), shows an "auditorium or large exhibit [gallery], lowered to give proportionate height." The room has natural light sources, skylights, at the "peak" (as Kahn noted) of two triangular spaces suggestive of the shape of the gables of the bays, possibly a folded plate as projected in the first Kimbell design. A "scheme

**5.10**
*De Menil Museum. Schematic cross section.*
**Catalogue 109.** Louis I. Kahn. Louis I. Kahn Collection, University of Pennsylvania and Pennsylvania Historical and Museum Commission.

**5.11**
*De Menil Museum. Schematic west elevation, scheme 2.* Louis I. Kahn. Louis I. Kahn Collection, University of Pennsylvania and Pennsylvania Historical and Museum Commission.

2" of "The Storage" offers an alternative west facade that also has bays with intervals between, inscribed by Kahn on the sketch as "exhibition rooms with alcoves and porches" (fig. 5.11). The porches particularly would connect the building to the park setting. The scheme with "The Storage" on both long facades relates to the plan sketch (fig. 5.12) wherein one can see the more extensive assignment to storage through the duplication of bays.

**5.12**
*De Menil Museum. Schematic site plan, elevation, section.* **Catalogue 110.**
Louis I. Kahn. Louis I. Kahn Collection, University of Pennsylvania and Pennsylvania Historical and Museum Commission.

**5.13**
*De Menil Museum. Detail of schematic site section.*
Louis I. Kahn. Louis I. Kahn Collection, University of Pennsylvania and Pennsylvania Historical and Museum Commission.

Kahn's idea was that these bays contain two levels. Where the units connect to the main exhibition space there would be a balcony across the end, making it possible to look into that interior space from the storage areas. A detail of another sketch (fig. 5.13) suggests this effect, displaying figures looking down from a balcony, this one probably exterior. This detail of his drawing also includes the Newman obelisk and a large room with a Pantheon-like space and an oculus. It is placed where the Rothko Chapel actually stands. A sepia print of the sketch in the Menil Collection has a penciled notation on the verso captioning it as "Projection (chapel, obelisk and meeting hall)." When shown in an exhibition in Houston at Rice University in 1979, this was interpreted by one viewer as a "round-topped building with a giant fireplace" and as "an addition to the chapel."[17] But the structure may be a version of the chapel's octagon-shaped main room, possibly even a suggestion for an alteration. At the other end of the axis of chapel, sculpture, and pool is a meeting room that can be read on the site plans as a separate building across Branard Street (for example, figs. 5.6 and 5.8).

The design for the Menil museum must be considered only tentative and unsettled. Kahn was busy with other projects and had his own rhythm of working on one and then another as he balanced in his own way his complicated architectural career. In 1973 he was in the midst of construction on the Yale Center for British Art and working on designs for the Graduate Theological Union Library for the University of California, Berkeley (also shown with palm trees in perspective views); the Roosevelt Memorial, New York; and the Pocono Arts Center in Pennsylvania. He was continuing work in India and Bangladesh, ending a project in Jerusalem, and engaged in other projects in Nepal, Iran, and Morocco. The death of patron John de Menil in 1973, so soon after the commission engaged Kahn's attention, also delayed progress. Work continued, however, since the museum was part of de Menil's legacy, and Kahn again came to Houston.

It was either at this time, or possibly later that year, that he brought the presentation drawings that are included among his works in the Menil Collection. Made from original charcoal drawings now in Philadelphia, certain of the de Menil sepia prints that Kahn colored in pastel for the client deal generally with the building and its landscape in a larger context. These demonstrate Kahn's sensitivity to placement and siting and to his interest in the qualities of the environment as they interact with the building. One of the site plans (fig. 5.14) has the main body of the museum consisting of the long, U-shaped building enclosing a large court and storage bays on the east, facing the chapel. A second long shape enlarges the structure on the east, and a sizable con-

**5.14**
*De Menil Museum. Schematic site plan.* Louis I. Kahn. Louis I. Kahn Collection, University of Pennsylvania and Pennsylvania Historical and Museum Commission.

**5.15**
*De Menil Museum. Schematic site plan.* **Catalogue 111.** Louis I. Kahn. The Menil Collection.

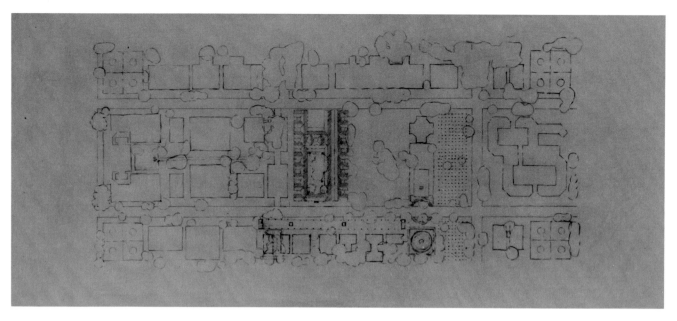

**5.16**
*De Menil Museum. Schematic site plan.* **Catalogue 112.** Louis I. Kahn. Louis I. Kahn Collection, University of Pennsylvania and Pennsylvania Historical and Museum Commission.

**5.17**
*De Menil Museum. Schematic site plan.* **Catalogue 113.** Louis I. Kahn. The Menil Collection.

necting element between the two long axes is double their width and has twin roof elements like those seen in the cross section (fig. 5.10), further increasing its size. To the west on the site is a large rectangle with what appears to be a bridge over Branard Street. Kahn's colored version of the site plan (fig. 5.15), marked as version "1" and signed in pastel, is enhanced by the gray-greens and blues of foliage and water that convey a civilized, park-like suburban environment. Mulberry Street has been closed between Sul Ross on the north and Branard on the south so that the blocks are united. The plan conveys a total unity of concept.

The site plan identified as version "2" by Kahn in pastel (fig. 5.16, the Philadelphia drawing, and fig. 5.17, the Menil version) has the larger scheme for the museum: storage bays on both the outer east and west facades, nine on each side. Other than that, the general layout is much the same, although there is variation in the park setting. In the center of the area west of the museum is a ribbon of blue. The thin stream it marks recalls the channel of water through the center of the plaza between laboratory buildings at the Salk Institute. It would enliven the relatively narrow strip of landscape

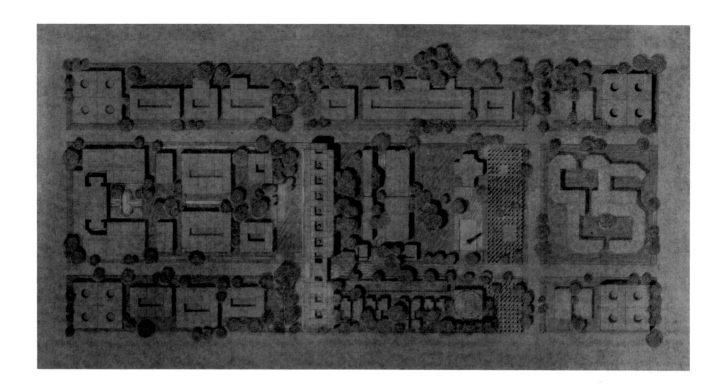

between the symmetrically placed structures to either side. The blue pastel relates the pools and fountains in the overall site design. This element—water—would have contributed further to the unity of the scheme.

The long museum in this version stretches from Sul Ross to Branard Streets, appearing slightly longer than that in version "1." Another plan in the Menil Collection, one showing only the roof of the museum of this design, is inscribed with dimensions: 260 feet long by 160 feet wide. Floor area was calculated to be 32,400 square feet "with western porches," and there is a notation that it would be 27,400 square feet without these. This design would have created an open museum with the requested integrated storage. The spatial effect of these storage areas themselves is a matter of speculation; the open-ended relationship to the main space would have been crucial to the experience of openness. In a sense the design would have combined spatial concepts of the Kimbell Art Museum and the Yale Center for British Art: long halls for exhibition with bays for storage.

Kahn had already confronted the issue of incorporating an open storage for the "study collection" at the Yale Center, his answer there being the southwest gallery of the top floor. In the de Menil museum another and broader solution would have been offered. The Foundation wished to have extensive storage and wanted it readily available. Kahn considered this an expression of generosity on the part of the donors and wanted that quality to be visually expressed. His design would have institutionalized the concept of study-storage to a greater extent than had been done in New Haven. This de Menil design might therefore have materialized as a new kind of museum expanding the building type.

A later site plan (fig. 5.18) in the Menil Collection, also worked with pastel, is dated October 1973 and is among the last dated works for the commission. While it continues the established design in its horizontality, extensiveness and the axial arrangement with bays, there is a narrowing or indentation in the center on both sides of the long axes. The explanation for this change is not clear. It may have reflected a change to the plan in response to some new idea about how the museum was to show its works of art to visitors. Possibly Kahn wanted to break the 260-foot long expanse into more room-like spaces. He may have considered additional access to the outdoors or even some means of integrating the services of the building. At any rate, the courtyards are retained, one completely enclosed and one open on the north end, the important connecting section apparently remaining as before. The variation in itself, even if not major, serves to remind us of the design's continuing evolution. It cannot be considered finished.

One can only speculate about Kahn's final vision of the de Menil museum, since the project ended with his sudden death in March 1974. If only because of the archi-

**5.18**
*De Menil Museum. Schematic site plan.* **Catalogue 114.** Louis I. Kahn. The Menil Collection.

tect's method of work, it must be accepted that there undoubtedly would have been significant changes. He relied upon his own experience and expanding knowledge, absorbing all possible aspects of the site to determine what it had to offer. Yet each work became even more specific, sometimes almost idiosyncratic, as it developed and as he responded to the client and to circumstances. We have seen that decisions made on one matter often affected others as Kahn applied his logic to problematic features in design and construction. For the de Menil design, natural light, an essential consideration in both the Kimbell and the Yale Center, would have been of utmost importance. Its incorporation and eventual control had to be a paramount consideration in planning. There is no indication, though, that a particular scheme had yet led him to consult lighting specialist Richard Kelly, with whom he conferred during the design of his other museums. (Kelly at this time was deeply involved in research into the diffusers for the skylights at the Yale Center.) Kahn often referred to the Kimbell Art Museum in speaking about the quality of light he wanted in the Menil spaces.[18] For Kahn, natural light's introduction was inseparable from the constructive system. Visual evidence in the sketches suggests that the lighting from overhead in both larger spaces and storage bays would be through narrow openings, but the system seems not to have been explicitly explored at the time of his death.

What direction would the architect have taken in working out the "treasury space" of the de Menil museum so that it was consistent with all that he considered essential in architecture? A decision on the structural system does seem to have been made. Bays in fact represent both structure and functional space. Kahn's employment of the separate units for storage can be interpreted as planning for a service aspect if they are considered subordinate to galleries, as is normally the case. Yet the requirement that all works in the collection be available for viewing was understood by him as identifying the nature of this museum and seems to have interested him so deeply that storage space as such should be viewed as basic to his concept. It apparently dominated his ideas for this building and might have led to a museum significantly different from his others — in fact, from modern museums in general.

Planning for the services — ducts and conduits — so characteristically addressed at an early stage in most of Kahn's projects is not explained on the basis of the available materials. We cannot be sure of the direction Kahn would have taken. There exists the cross section (fig. 5.10) depicting an underground "tunnel for existing utilities." This single sketch should remind us that Kahn had probably formed his ideas concerning the manner in which these were to be handled. The air-floor construction of the Yale Center, which he found so appropriate for the horizontal channeling of return air and for containing conduits without disturbing the main space, may have been envisioned for the de Menil as well. He may have thought to employ spaces under the roofs in some way. It is our misfortune and loss that we do not fully know what this building of Kahn's "wanted to be" and might have been had he lived.

It was after a three-year search following his death that Renzo Piano, recommended to Mrs. de Menil by Pontus Hulten who had worked with him on the Pompidou Center, and his partner Richard Fitzgerald were commissioned to bring into being the museum for the Menil Collection. The building they designed, a consciously independent statement, in no way derives from Kahn's earlier work on the project. Nevertheless, certain characteristics that reflect common requirements are present, although there were some changes in the client's program. The storage so central to Kahn's concept for this particular museum, for instance, now has greatly reduced importance. Arrangements by visitors can be made to see works not displayed, but the openness, or, at least, the invitation to look at these works that is characteristic of Kahn's plan is abandoned. Traditional exhibition has more significance in the program followed by Piano, and the building is much larger. As for site development, it has been omitted. There is no new housing, conference buildings, or hotel. (Bookstore, auditorium, and administrative offices, however, have their places in small houses apart from the museum proper.) Yet the accord between the institution and its domestic suburban

neighborhood clearly was retained and has been admirably realized by Piano. Finally, we recognize the importance of the museum's park setting.

Siting is different from Kahn's proposals, for the building is placed in the second of the two blocks, between Mulberry and Mandell and Sul Ross and Branard Streets, and oriented with a main east-west axis instead of Kahn's north-south. (Two existing entrances are centered in a short cross-axis.) But the concept of an organizing axiality is similar. The Rothko Chapel block is left open, primarily parkland, and the lawns surrounding the museum further contribute to our feeling of spaciousness. Piano, too, responded to the local scene, placing porches (or "piazzas") around the building and using open spaces, pockets, for planted courtyards and gardens. Neighborhood intimacy is retained in part through materials: gray cypress wood siding combined with a white-painted Miesian steel frame. (The surrounding wood-frame bungalows use the same colors.) Despite the size (larger than Kahn's design, as it is 500 feet long and several floors higher than the houses on the Branard Street side), the building's overall reticence, simplicity in detailing, coloration, and scale (twenty by forty feet as the modular unit) as well as the open space all create an effect that sensitively blends building with surroundings.

But it is the client-requested natural light in the galleries (we recall Kahn spoke of this, mentioning the Kimbell) that most recalls Kahn's museums and the earlier plan for this one. Stimulation for Piano's concept of lighting has been directly attributed to the inspiration of a small, flat-roofed gallery with reflectors in the Israeli kibbutz of Ein Harod.[19] Piano and engineer Peter Rice worked out a system with reinforced concrete reflectors carried on ductile cast-iron trusses to reflect light with minimum shadows, an innovative solution for dealing with extensive skylights, actually a glass roof, over most of the galleries. While not based on the transparent and translucent Kimbell reflectors, the heavy, opaque reflectors of the Menil are related by having a curved shape and lighting fixtures integrated with them, and it seems probable the Kimbell's lighting and reflectors had some impact on these aspects. In the Menil Collection the reflectors have become multiple louvers or baffles (their designers have liked to call them "leaves"), visually sculpting the ceilings of the interior spaces and allowing them to be bathed with a living and natural light responsive to the conditions outside. The light is similar to that in Kahn's Kimbell Art Museum. Though his work on a museum for the de Menils was not directly utilized in the Menil Collection, nonetheless his insight, philosophy, and accomplishment as a museum designer do seem to have influenced Piano.

The evolution of Kahn's three museums from concept to design to realization is consistent with his theories expressed in articles in *Perspecta* and in his landmark talk for the Voice of America on "Structure and Form," as well as in statements made throughout his career. Theoretical concerns had occupied him especially during the 1950s, after the completion of the Yale University Art Gallery, a decade when at last more commissions were received and his architectural ideas matured. Much of his writing of this time — or more usually "speaking," for most publications were originally public talks, discussions, or interviews later edited for print — was devoted to clarifying and explaining his beliefs: the Platonic idea of a work, its actual design and then construction, during which design continued as decisions responded to changing conditions, available funds, or, alternatively, to his idea of order. Nothing could be taken as settled; nothing could be assumed, ever. A new or different approach and continuous testing were always cordially embraced by Kahn, if not by his associates. Principle itself was the only constant: directness and clarity, both in structure and in expression.

The Yale Art Gallery helped Kahn formulate his evolving architectural theory. By the time he returned from his tenure as Resident Architect at the American Academy in Rome to begin work on the Yale Art Gallery, the program for the addition was essentially formed. Dean Charles Sawyer, who acted as client on behalf of Yale, Architecture Department Chairman George Howe, and the Building Committee had specified flexible loft spaces that would be economical to construct and would offer multiple possibilities for use until such time as the gallery would have the whole building. This was

a quite straightforward, functional concept, not at all resembling the ambitious earlier program of Philip Goodwin, which had included more typical museum and academic elements. Kahn, who had embraced the open spatial plan as well as the structural systems and aesthetics of modern architecture, could readily accept this newer program determined largely by George Howe. But to consider only aspects such as these would have been unfulfilling for Louis Kahn. Indeed, he was selected by his colleagues at Yale to become architect of the new addition to the gallery in the belief that he would be able to turn a bland concept into a work of art.

Kahn succeeded admirably. His approach to planning, derived from the International Style and his own practical experience in public housing, logically led to grouping the service elements and separating them from the exhibition areas or studios and classrooms. He believed the spaces themselves should reflect the nature of their use. Writing in the same issue of *Perspecta* that reported on the completed building, he first enunciated the dictum that came to be identified with the name of Kahn: "the nature of space reflects what it wants to be." The architect had to ask:

> Is the auditorium a Stradavarius
>              or is it an ear
> Is the auditorium a creative instrument
>              keyed to Bach or Bartok
>              played by the conductor
>          or is it a convention hall
> In the nature of space is the spirit and the will to exist in a certain way[20]

He went on to identify nature as "why," order (also called form) as "what," and design as "how."[21] For the Yale Art Gallery "order" was the creation of flexible space appropriate to the showing of works of art. He wanted north light, traditionally preferred by artists, and the programmed loft spaces that had been sanctioned by the Museum of Modern Art. (Partitions, just as they had in the Museum of Modern Art, mandated artificial light.) Those expansive areas led him to consider using a tetrahedron space-frame construction because it would require few columns. (Code requirements, we recall, led to its modification before construction.) The utilization of the triangular openings in the fabric of the ceiling structure to integrate horizontal distribution for air ducts and vents, conduits and lighting fixtures was an inspired extension of the idea of the concentrated central core for mechanical services. Kahn was later to state that with the ceiling of the Gallery he first began to realize the distinction of served and service spaces; that the essentials for the arrangement were there, although he was not then conscious of it. At the time he was concerned to make a place that was not concealed. "It was the revolt against the hung ceiling which caused all this to be made. It was the first ceiling of that type."[22]

Kahn's early interest in monumentality, as witness his 1944 statement that buildings possessing this elusive quality "indicate a striving for structural perfection,"[23] led him to assert the structural members solidly, even sculpturally, in reinforced concrete so that they are read directly. This is seen most clearly in the unified tetrahedron ceiling-floor, the few, widely spaced columns, the stairwell, and the service core. On the exterior he followed the example of early Le Corbusier whose "Dom-ino" construction freed both exterior and interior walls from structural responsibility. A frame was not expressed on the exterior, since the columns and the tetrahedron slab were the significant structural members. Gray brick and glass were simply screen walls, the former with drip moldings marking floor levels and the latter with standard steel sash creating harmoniously scaled units and panes. Structure, function, and visual statement are unified, consistent.

The universal Miesian space created in the gallery for anticipated temporary multi-use, that was exactly as called for in the program, made it possible to accommodate the art and architecture departments as well as the showing of art. It was only later, in 1957–58, as the classrooms and offices on the second floor began to be con-

verted into galleries in renovations over which he had no control, that Kahn regretted the universality of those spaces that could be so easily changed into fixed rooms. It was not flexibility in itself that he rejected. As he was to remark to Richard F. Brown while working on the Kimbell Art Museum, "I don't like to see space nailed down. If you could move it and change it every day, fine."[24] And in his 1959 address to the Otterlo Congress of modern architects, while finding "certain aspects which are very good still" to be praiseworthy, he criticized his Yale Gallery as follows:

> If I were to build a gallery now, I would really be more concerned about build-ing spaces which are not used freely by the director as he wants. Rather I would give him spaces that were there and had certain inherent character-istics. Then the visitor, because of the nature of the space, would perceive a certain object in quite a different way. The director would be fitted out with such a variety of ways of getting light, from above, from below, from little slits, or from whatever he wanted, so that he felt that here was really a realm of spaces where one could show things in various aspects.[25]

To understand this change in Kahn's concept for a museum is to understand his comment in a later interview (1972) that he liked to have projects for the same type of institution:

> It is also true that in the work completed is the mass of qualities unexpressed in this work which waits for the opportunity of release. I would never feel bored to be given a commission similar to the one I just did . . . for that rea-son, without any sense whatsoever that I would become a specialist in that field of expression — it tells you how meager it must be to be a specialist.[26]

Far from resenting similar commissions, Kahn seemed to welcome those that gave him an opportunity to explore other potentials and to reconsider previous deci-sions. It is consistent with his embracing change in the given, evolved design. The point was not to create variations on a theme or, to use his own word, to become a "specialist." The point was to reflect on accumulated knowledge and experience in the creation of something different, responsive to a particular situation. This is a philo-sophical approach to architecture and is demonstrated by Kahn's museums. They also illustrate his own changing conceptions regarding a museum as he responded now to a client, now to a collection, now to an institution or a site. Each museum, while it represented in his mind the universal "nature of a place where you see paintings,"[27] was unique and individual in his work. A Kahn museum is generic, standing as an example of the type "museum" for the late twentieth century. But each also is specific, called into being in a certain place by a certain patron under certain conditions.

In 1959 at the Netherlands conference cited above, when he spoke of his chang-ing ideas on an art gallery since designing the one at Yale, Kahn was at work on the Richards Laboratories at the University of Pennsylvania, the *Tribune Review Press* (1958–61) and the Rochester First Unitarian Church (1958–63; and later the school, 1965–69). None are associated with art, but these are important buildings in his career. They mark a certain maturation in further unifying structure with function, both programmatic and service, and in integrating the introduction of light into a building with its structural system and program. The Rochester church with corner hoods bring-ing light into the central space was notable in defining architectural space through the interrelationship of structure, light and program. It was used by Kahn in *Perspecta* to explain his thoughts on the relationship of form and design. In the same article he dis-cussed other important buildings begun in 1959: the project for an American Consu-late in Luanda, Angola (1959–61), a key building for his architectural handling of strong natural light, and the Goldenberg House, designed for Rydal, Montgomery

County, Pennsylvania (1959), which he used as an example of response to "internal need" or, in his famous phrase, of being "what it wants to be."[28] While there was no museum commission on the horizon at the time of his talk, it would seem from his reference that the design of a museum was nevertheless an interesting possibility in his mind.

Although Kahn did not receive such a commission until the Kimbell in 1966, there were several art-related projects in the early 1960s. A small art museum, not developed beyond a schematic stage, was included in the project for a Fort Wayne Fine Arts Center, School, and Performing Arts Center (1961–73); the unrealized project for the Philadelphia College of Art (1964–66) included studios, libraries, and a theater as well as dormitories. Educational facilities for the Maryland College of Art of the Maryland Institute were the subject of drawings during 1965–69.[29] The Kimbell, however, was to be Kahn's first complete museum. Even before its completion, Kahn's reputation as a museum architect was recognized.[30] When Jules Prown decided upon recommending him to Yale as architect for the Mellon Center for British Art and British Studies, among the considerations were Kahn's own gallery across the street from the site, his special relationship to Yale and his reputation as a master among architects. Early publications on the Kimbell were yet another, and influential, consideration, for it was seen as a worthy modern example of the genre.

When Kahn began the Kimbell museum design, all his "unexpressed qualities" derived from observations, thoughts, and experience with art museums were primed for release. One of the most characteristic features of the Kimbell Art Museum, the vaults in series with skylights, may serve as an example. Describing these as the "basic structural and space-creating idea," Brown said that no discussion between the two had led to their use, that the idea was "already in Lou Kahn's mind and had been for a long time, I think."[31] Vaults and skylights were linked; the skylights were an integral part of the whole structure. Despite the fact that Brown wanted natural light, he resisted skylights as too troublesome and dismissed them even as a possibility in his program. Kahn must have won him over through his power of persuasion and by evoking the quality of light they would make possible.

Light in Kahn's buildings was always taken into consideration deliberately, even — from his point of view — programmatically. At the Yale gallery he brought in north light, although it is true that installations of works of art depended on electric fixtures. By the end of that decade, again in the Netherlands in 1959, he articulated the essential role of light in architecture. To him, it meant part of the basic structure in "the thoughtful making of spaces":

> we can very easily state that a space in architecture is one in which it is evident how it is made, and that the introduction of a column or any device for making a roof is already thought of from the standpoint of light, and no space is really an architectural space unless it has natural light. Artificial light does not light a space in architecture, because it must have the feeling in it of the time of day and season of the year — the nuances of this is [sic] incomparable with the single moment of the electric bulb.[32]

In Philadelphia, Kahn's own top-floor office was lit by large, bare windows, described by Brown after his first visit there as introducing light that was "matchless" and "superb."[33] Since Brown knew he wanted natural light (though not skylights) in the Kimbell museum, his response to this architect for whom "light is the creator of all things" was immediately positive. Brown also knew how effectively and architecturally Kahn controlled natural light at the Salk Institute in La Jolla, California. Likewise he would have seen the 1965 exhibition of Kahn's work in the La Jolla museum, for he was at that time director of the Los Angeles County Museum and a member of the board of trustees of the La Jolla Museum of Art.[34] He would also have seen the important 1966 retrospective at the Museum of Modern Art, New York. In the beginning, Kahn

had not been placed at the top of Brown's list of possible candidates for the Kimbell commission (although he may have simply been cautious in proposing to the business-like trustees an architect thought to be an eccentric genius), but his visit to the studio-office, where he saw the light, absorbed the atmosphere, talked with Kahn, and watched him at work, evidently convinced him that he wanted this artist-architect above all others.

Kahn seemed almost immediately to have an intuitive "form" for the Kimbell Art Museum: a serene, almost classic, vaulted room bathed in natural light descending from above. The building that resulted seems to stand in illustration for his essay "Architecture: Silence and Light," which itself is a kind of summary of his architectural—even his life—philosophy while he was at work on the Kimbell. The interweaving of these two different sensory domains, the visual and the auditory, is characteristically "Kahnian."

> I sense Light as the giver of all presences, and material as spent Light. What is made by Light casts a shadow, and the shadow belongs to Light. I sense a Threshold: Light to Silence, Silence to Light—an ambiance of inspiration, in which the desire to be, to express, crosses with the possible.[35]

His drawing to illustrate the essay's reference to architecture (fig. 5.19), "Architecture is the making of a room; an assembly of rooms. The Light is the light of that room," shows the sun outside low-vaulted space and recalls the shapes of the Kimbell's vaults. At the very time he was executing this drawing, the vaults for a building that was to make so much of natural light were in the process of being cast.

Yet one must remember that to Kahn the form or concept (to him, virtual synonyms) was a "sense of inseparable parts," not a specific shape or plan. Beaux-Arts "parti" may be related to his conception, but for him the form demonstrated an intuitive grasp of the projected building.

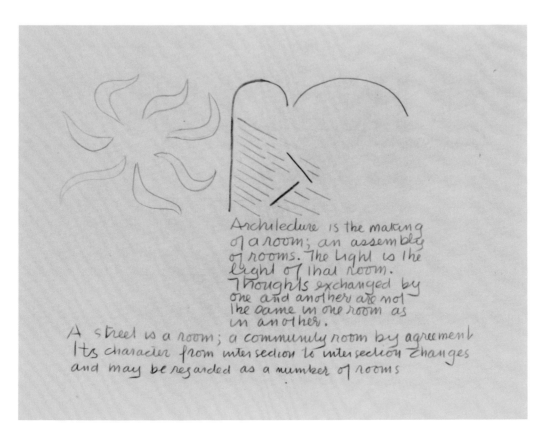

**5.19**
*"Architecture is the making of a room." Preparatory drawing in notebook for illustration for essay "Architecture: Silence and Light."* Louis I. Kahn. Louis I. Kahn Collection, University of Pennsylvania and Pennsylvania Historical and Museum Commission.

> I maintain that form has nothing to do with outward appearance; in "design" we are concerned with appearance, we choose an aspect and anyone can do as much. Form is the area in which the architect can give the best of himself because of his knowledge of the inseparable elements.[36]

Thus, concept is abstract, elastic. This may well be why many of Kahn's buildings, the museums particularly, have proven so adaptable to changing demands over the course of time. He intended them to be able to cope with change. In speaking of a "form-school," for example, he advised that architects not be bound by a building program specifying identical classrooms. "What you should do is discover new kinds of spaces: here a little room with an open fire, there a room where three or four students meet and chat quietly. Don't call these classrooms, call them rooms, rooms without labels."[37] He might have said, rooms of varied potential.

Richard Brown's program for the Kimbell museum, while it went into detailed requirements and estimated costs, was ideal for Kahn. It did not physically fix the rooms wanted so much as describe qualities: the "experience of a visit to the museum should be one of warmth, mellowness and even elegance . . . The spaces, forms and textures should maintain a harmonious simplicity and human proportion between the visitor and the building and the art objects observed."[38] Kahn, as we have seen, had come to think of architecture in terms of rooms. We recall Cret's "single room used for the display of works of art" in his 1934 talk on museum architecture. Kahn's earliest published reference to the Kimbell museum, the talk in Boston in November 1967, referred to rooms structured by vaults in concrete with "the luminosity of silver" achieved by natural light that would enter from skylights and be directed by reflectors to spread on the underside of the vaults. To this silvery light he would add other kinds of light by cutting "across the vaults, at a right angle, a counterpoint of courts, open to the sky, of calculated dimensions and character."[39] Essential form, then, consists of the room, or space, conceived in terms of vaulted structure, the introduction of light from above into this space, and functional services.[40]

Essential form endured through the three major design phases for the Kimbell museum, despite radical changes in plan. When interviewed in early 1969, after the design was first published, Kahn told a Fort Worth art editor that the projected museum would not be "formidable but like a friendly house," with "friendly-sized rooms" and a "beautiful environment of natural gardens."[41] Fifteen months later, with the last design phase well under way and the construction contract signed, Kahn said to the same writer that his "paramount decision in making a space [for the Kimbell collection] was to honor natural light and not place the art in a mausoleum atmosphere." "When the art was made, the mood of the day was obvious. In the galleries you should always know if it's morning, afternoon or night." He continued to use the analogy of "a friendly home," adding that "to emphasize important paintings, there'll be houses within the house."[42] By this he must have meant the vaults with the low spaces between and the possibility of partitions. No interior divider, however, was intended to reach vault height and thus affect the internal continuity of space.

After the building was completed, Kahn continued to describe it as "based on the room-like quality. And the natural light as being the only acceptable light."[43] Brown thought of the museum as a contemporary version of a traditional palace of art. "I like to think this is the palace of a great noble and that he has invited you into his home to enjoy his collection."[44] But Kahn never seems to have used the analogy so explicitly. To him the house concept grew out of a wish to scale the building to intimate human experience. In another context, speaking of the Rochester Unitarian Church, he said, "So you should never lose sight of the home, because a person coming from his home to a place away from his home must feel he is in a place where home is not *away* from him."[45] The siting of the museum, its landscaped paths recalling sacred ways, its groves recalling those planted in sacred sanctuaries — all suggest that the classical temple of art might have been in his mind. But he himself spoke only of light, of its role in seeing art, and of the institutions of man.

By this he meant the original inspiration for a work. Kahn's recurrent example of human institution was a school, which he said began with a group under a tree, one teaching and others learning before anyone was aware of what was taking place. He wanted to consider fundamental meaning so that he could create answers to "desires" rather than merely "needs." Desire was not in the program. It is the architect's intuitive sense of potentials, sense of "the yet not made." That is to say, he wished to go beyond the requirements in order to provide "availabilities" to people. Such a building would "serve architecture."[46] He approached the literal program a client might present only to transcend it, to tap the "beginnings" or source of the work so that he found a meaning beyond immediate demands. No arrogance was intended either toward the client or his program. On the contrary, Kahn explicitly meant to provide for requested specific needs above or beyond such "availabilities."

After seeing the Kimbell Art Museum, the explicitness of space in the Yale Center for British Art comes as something of a surprise. Clearly, Kahn sensed a different order or form in a building intended for varied and established collections (paintings, books, prints, and drawings) and in a museum that was both part of an academic setting and belonged to an inner city. He responded with a multifloor plan, as he had for the Yale Art Gallery. The Center's program was complex, including provision for spaces to develop a study center as well as galleries, and the environment seemed to demand that a sense of the city and of the University be preserved.

The University had acquired a generous building site, the block on Chapel Street across from Swartwout's old Art Gallery and Kahn's own 1951–53 addition. From the beginning, according to Prown, Kahn used a simple, regular, geometric shape that echoed the city block: "a very rigid rectangular pattern, which surprised me. The first things that came back were in the shape of a domino, that is, like a two-part building," said Prown.[47] The areas within, however, were special rooms around two courts. In this case Kahn described his inspiration as "the idea of intimacy between book, painting, drawing — this is in the room-like quality of the collections. The construction is that of twenty-foot bays. The rooms are made with concrete columns and slabs."[48] The twenty-foot dimension, used by Alfred Barr in the Museum of Modern Art, was one he considered the best for viewing art, even in his own home. Anything smaller he thought not acceptable.[49]

Rather than the ideal and classic space for a Kimbell museum collection that was growing and evolving, Kahn here designed rooms for an existing collection, one he had already experienced in the Mellons' own house. The intimate scale of most of these works and their rich diversity in media called for a variety of rooms — libraries, print and drawing storage, special exhibition areas, and galleries. Further, the University required other types of rooms in which scholars, specialists, and students were to study, research, conserve, lecture, and discuss. Kahn's innate sense of scale determined proportions and dimensions, even with the preordained square footage assignments in the program, just as his feeling for universal human qualities in architecture guided him in determining the special character he deemed appropriate for the whole and for individual sections, such as the libraries and exhibition rooms. Keeping in mind complex aims and functions, he created for the institution an almost domestic scale and character that was based on human measure. Latent in the background of both the collections and the libraries are recollections of great houses, be they English or Italian. Indeed, the libraries have been described as "English" by more than one critic.

Although the type of partitions and their placement indicate that Kahn intended the galleries to have the flexible space that has been deemed desirable since modernist architecture redefined museum arrangements, the sense of rooms is nevertheless confirmed by the bays, based on the twenty-foot module of pier placement. Interior partitions for the Mellon are movable, just as they are in the Kimbell, and were patterned after the "pogo panels" originally devised for the Yale Art Gallery, following the suggestion of George Howe. In spite of Kahn's intentions, however, they have not been moved often in the Center, so strongly do the bays assert themselves. Just as the vaults on columns in the Kimbell museum create a sense of rooms, notwithstanding

any divisions made by temporary panels, the bays of the Mellon Center also act to establish discrete room-like spaces.

As at the Kimbell, natural light was an essential part of the program for the Yale Center. It enters the building through windows and from skylights, although only the galleries on the top floor can take full advantage of the latter. Kahn wanted to relate this characteristic gallery light to other areas, and so he employed two courtyards, one at the entrance extending the full height of the building, the other, associated with the libraries, one level lower. (The auditorium occupies its equivalent space on the ground floor.) By bringing sunlight into its shaft of space, each court offers natural light to all floors through court windows as well. (The third level, because it was planned to have low light levels for objects that must be shielded from excessive light, has only narrow openings.)

The drama of space and light may differ, but the Yale Center's toplighted courts cause it to resemble other Kahn buildings where a great central space is lit by natural light from overhead and is surrounded by other, smaller spaces. In the Rochester Unitarian Church, the National Assembly at Dacca, Erdman Hall Dormitory at Bryn Mawr, and the Phillips Exeter Library, lighted cores of space are of central importance to each building's character. Yet each introduces light from above differently: hooded clerestories, high windows, skylights above massive structural beams. Each building also varies in the amount and quality of natural lighting penetrating below. In the British Center courts, light seems more pervasive than in the large spaces of the other buildings. The skylights here are those of a museum dedicated to employing natural light.

The skylights of the galleries are used throughout the uppermost floor, but the light is at its strongest in the entrance court where skylights are without the light-diffusing cassettes used elsewhere and have only exterior louvers to control sunlight. Here alone do they let in undiffused light. A parallel can be drawn with the Kimbell entrance lobby and bookstore, where reflectors are without the solid metal shields employed beneath the skylights in the galleries, and the light is consequently more intense. The adjustment to the Kimbell reflectors was made for negative reasons; that is, to avoid having any direct light enter the galleries. The combination of two types of reflectors in the building, however, with the resulting effect on the light in interior spaces, bore fruit. Having found diversity in light at the Kimbell an architectural asset, Kahn consciously sought such variations in New Haven.

The Yale Center for British Art is located within a tradition of museums organized around courtyards. When considered as a type and on the basis of a single floor, Prown's "domino" plan is related to early Neoclassical museums with their courtyards and gallery rooms, such as the Glypothek and the Altes Museum, as well as to the Beaux-Arts museums of the early twentieth century that so readily came to Prown's mind as a comparison. The multiple floors around a courtyard also suggest an Italian palazzo. Modern in materials, in conveniences, and in planning for newly conceived programs, this fundamentally classic plan of the Yale Center makes it even more evocative of museums of the past than the Kimbell, despite the latter's classic vaults and porticos. If the Kimbell's open courtyards offer variation and respite from galleries and admit both light and a sense of the outdoors into the museum, the British Center veritably depends upon the two enclosed courtyards to organize the plan in a geometric sense, both two- and three-dimensionally. It could even be said that these courts channel a visitor's experience of the museum's holdings by intimating the proper path to be followed through the building. It should be noted that in combining a study center with libraries and works of art brings the Yale Center closer than any other contemporary museum to the classical, programmatic ideal of a museum in the ancient world.

On the exterior, as in the interior, Kahn consistently expressed the structural unit. Inside, room-like spaces are defined by the bays and by the grid of floors whose pattern is created by carpets bordered by travertine strips connecting the columns; on the fourth floor these spaces are punctuated by the skylights as well. Outside, the concrete frame reads with Miesian clarity, contrasting with the glass windows and steel infill panels that abstractly describe the rooms within. A subtle suppression of part of

the frame announces just where the two-story library spaces occur, for example, while the shops are separated by wider spans. The emphasis on structure made by distinctive materials is an assertion by Kahn of his strong feeling for the absolute essential in architecture. He felt such a visible expression of a building's inherent form to be in itself beautiful. This idea clearly emerges in his admiration for the expressed frame, evident in his 1944 essay on "Monumentality" and in various subsequent statements, some quoted below, which proclaim the validity of openness and honesty in architecture and carry on the tradition of the structuralists.

> The column or wall defines its length and breadth; the beam or vault its height. Nothing must intrude to blur the statement of how a space is made (1957).[50]

> I think an architectural space is one in which it is evident how it is made; you will see the columns, you must see the beams, or you must see the walls, the doors, or the domes in the very space which is called a space (1959).[51]

> A great span should have nothing in it but that which is captured by the span. And the decision of the structure of the span is also a decision in light. A column next to a column is an expression of opening and light. A vault is a choice in character of light. You shouldn't open one room to the other to find out how the space is made (1964).[52]

> A square building is constructed like a square and its light must give evidence to the square. An oblong must be constructed like an oblong. Same with the circular, same with the building which is more fluid and still must find its instruction internally in its making which is actually geometric (1967).[53]

> The structure of a room must be evident in the room itself. Structure I believe is the giver of light. A square room asks for its own light to read the square. It would expect the light either from above or from its four sides as windows or entrances (1971).[54]

> For example if you are dealing with concrete what you have to do is to keep in mind that it is not brick or stone or anything else. You are dealing with a material which is marvelous in itself. It is a cross between steel and melted stone, and you can make it do things which no other material can do (1973).[55]

Kahn's concern for fitting functional elements into the building without interfering with the "served" areas is part of this honesty in dealing with structure and with materials. In the Yale Art Gallery, as he sought to avoid hung ceilings, he happened upon the pioneering means of incorporating the distribution systems into the spaces of the tetrahedrons. Horizontal services could be linked to the core without intrusion into the galleries. Similarly, in the Kimbell Art Museum he used the U-shaped concrete channels between vaults for horizontal distribution. Its vertical systems are located in pockets adjacent to structural columns and do not actually read either on the interior or exterior. Finally, in the Yale Center for British Art the airfloor made it possible to incorporate horizontal systems within the slabs, which Kahn must have thought analogous to the earlier Yale design. Vertical systems were first planned to be on the exterior, but as constructed they are grouped at the center of the north and south sides and rise through all floors. Kahn referred to these as "air risers . . . a sort of Franklin Stove, sitting in a space."[56] Again, they are not visually obvious to visitors. They are the logical outcome of a reduced budget that required design revisions. In one instance, however, he placed the main stair tower in the library court as an assertion of a separate service feature. Kahn explained:

> If we were able in our structures of the future to isolate the equipment of the mechanical as though it had its own aesthetic existence, just as the spaces

have their own, then we would free the building of all the subterfuges we use to conceal the services of the building.

In the Mellon Center for British Art and Studies, I tried to express more dramatically this very point. In the original studies I made for Mellon, there were instruments outside which looked or will look like something independent. Instruments of different natures are for the supply of air, the exhaust of air, the machinery that goes into making the air the way you want it on the interior of the building. I had to abandon these because of the excessive costs, although I think I am abandoning something which has a meaning in the expressive possibilities of building. Now on the interior of the building, I am making points that have equal expressive power, which will be the source of distribution of air. These will be made, hopefully, of material independent of the material of building.[57]

Kahn's prophetic ideas on the expression of the service elements have been developed by architects, some in the direction of the "high-tech" manipulations in the Pompidou museum by Rogers and Piano, others experimenting in various architectural projects, not necessarily museums. But Kahn's projected structures were architectural containers, not the ducts and machines themselves, and this distinguished them.

With the last of his three constructed museums, Kahn seems more than ever to have expressed his own philosophy of museums in terms of the individual looking at art objects in natural light within a defined, room-like space. The principles underlying his ideals in architecture were applied to the creation of an institutional type he found meaningful. After devising constructive units he deemed appropriate to his Platonic idea of type and with due allowances for the particular program, he then devised ways to incorporate functional services into a building's fabric or, alternatively, to assert them separately. He also mastered the use of modern materials so that they not only served his concepts but came to represent a new degree of contemporary craftsmanship in an age of machine construction. Kahn's materials, together with their detailing, in themselves became ornament. It should not be thought that the final results were easily or automatically accomplished or were the result of some applied decoration; on the contrary, design solutions had to be discovered, to be arrived at with effort, and were an integral part of the building's essence. A building remained, as Kahn said, a "struggle."

Kahn's remarkable creativity speaks to us today in his buildings, his sketches, and his drawings. His art museums represent not only contemporary versions of a particular historical type dating back to the late eighteenth century, they are institutions deserving of special attention in themselves. When he was given his first major commission, the Yale University Art Gallery, Yale was striving to move from its traditional Beaux-Arts academic orientation into the world of contemporary design. The most advanced theories of modern architecture and museum exhibition in the mid-twentieth century prompted the program Kahn followed: a repudiation of pretentious institutional establishments ("the abandoned palace," in the words of George Howe) in order to embrace a direct, functional, unadorned structure whose interior was open and unobstructed to maximize flexibility in the presentation of works of art.

Yet while Kahn had accepted the tenets of modern architecture and made them part of his own vocabulary and philosophy, he did not forget the fundamentals of his Beaux-Arts training. It was his respect for the architectural character, the presence, of the monuments of the past, if not the palace as a museum, that led him to invent a means of introducing architectural strength into the modernist museum. He achieved it by a consistent functional planning that included provisions for services and by "striving for structural perfection" in material and construction. The tetrahedrons and the stair silo in the Yale Gallery assert meaningful sculptural shapes related to specific functional roles into the thin-walled, volumetric ideal of the International Style. Kahn did indeed accomplish something new. But he did not reject the modernist aesthetic; it is clearly embodied by the Yale Art Gallery.

By the time of his museum commissions for the Kimbell Art Museum in 1966, the Yale Center for British Art in 1969, and the museum for the de Menils in 1972, Kahn was far more experienced and increasingly confident. He turned away, in his new designs, from the universal space of the modernists so explicit in his first gallery, while still holding to the theoretical principle of flexibility in arrangements within the interior. A museum was a room, and, like any room, it had to demonstrate its structure and to possess its own means of obtaining natural light. Modernist, maze-like arrangements of partitions that ignore these definitions as they guide a visitor through an exhibition did not succeed architecturally in making a museum.[58]

Thus for the Kimbell Art Museum the basic exhibition space was his classic vaulted gallery, a room then dramatized in scale and by means of natural light from the skylight controlled by the reflector. Both its elongated shape and the opening at the apex of the vault were made possible through advanced engineering and construction techniques. In plan, the museum is related to traditional villas and Beaux-Arts museums with a formal forecourt, its service areas assigned to the podium, the latter much as Cret had done at the Detroit Institute of Arts. Rooms in the Yale Center for British Art, discreet spaces of particular character, are somewhat more varied in size and shape than those in the Kimbell. But they too depend on the constructive system — in this case bays based on the grid rather than vaults on columns — and have their own light. On the lower floors, windows, either to the exterior or onto one of the interior courts, introduce all-important natural light and offer the visitor views either of the University and the city or inward into the building itself. On the fourth floor, skylights with diffusing cassettes both admit light and repeat the dimensions of the structural bay. Even closer than the Kimbell to the plan of a traditional Neoclassical or a Beaux-Arts museum with its organization around the double courts, the Yale Center is also more urban with the multiple floors mandated by its complex program and city site.

Kahn as museum designer increasingly drew upon what he found usable from historical museums without attempting to repeat the past. Historical motifs as such were not at issue. His understanding of how and why a venerable idea or a building scheme succeeded aesthetically or organizationally allowed him to consider similar directions rather than to employ any specific building as a source. His use of the word "inspiration" in speaking of the drawings of Boullée comes to mind, for to him the buildings and designs of the past evinced a shaping imagination — they were not models. The creativity with which he utilized his references transcends them. He realized three distinctive, different museums, each of which satisfies its own program, functions as a work of art and in practice as a museum, to an unusually high degree of satisfaction for visitors and staff members. And we have seen in the de Menil project the beginnings of what might have been an even more innovative design.

Kahn's logic was original and inventive. Each museum was a unique case for him, in accordance with his modernist belief in reinvention, inspired by specific individuals, conditions, and collections. Yet each also can be said to be within the museum tradition. It is as if he had so thoroughly absorbed the salient characteristics of those museums he had known as a youth and a man that his intuition could respond with deeply sensed forms. To these he brought his insights, his experience, and a taste formed by living through the changes that architecture underwent in the first half of the century. His museum designs reflect his individual genius and are, in themselves, a grand synthesis of his architectural ideals. Yet they create appropriate settings for works of art rather than existing as monolithic examples of architecture that could overwhelm such works in spatial dynamics or mannerist detail. His sober, thoughtful method of considering thoroughly every aspect of design and construction and his sense of a hierarchy in architectural decisions saw to that. He transformed past and present and offered a new approach to museum design. Architects after him have had greater freedom, a freedom that has made it possible to look afresh at the Classical and Renaissance themes that once dominated museum buildings while upholding the values and contributions of modernism. For some of them, this has led to an elegant historicism, for others to a renewed, decorous modernism. Kahn's museums opened up the possibilities.

**Notes**    1. In March 1974 two letters went out from Kahn's office over his signature to the chairman of the Planning Committee, Board of Trustees, Hudson River Museum, and to the chairman of the Art Museum Development Committee, Miami University in Ohio. In both he mentioned his recent museums: the Kimbell, the Mellon, and the de Menil. Letter, March 2, 1974, Kahn to Frederick J. Stock. For the Ohio committee he recommended a visit to the Kimbell Art Museum to see the recently completed building and to talk with Dr. Brown, "who offered the excellent program and who could speak about his relation with the Architect." Letter, March 2, 1974, Kahn to Donald W. Fritz. Earlier he had written to the city manager and assistant city manager of Long Beach, California, arranging a meeting in his office, "I assume you will have visited the recently completed Kimbell Art Museum in Fort Worth which I designed." Letter, August 15, 1973, Kahn to J. R. Marisell and Robert C. Creighton. Kahn Collection, Master Files, File Box LIK 10. The Kahn Collection is owned by the Pennsylvania Historical and Museum Commission and is on deposit in the Architectural Archives, University of Pennsylvania, Philadelphia.

2. See *Louis I. Kahn Archives*, vol. 7, 2–29. Ronner and Jhaveri, 2nd ed., *Complete Works*, 424–35.

3. Letter, March 2, 1974, Kahn to Frederick J. Stock. Kahn Collection, Master Files, File Box LIK 10.

4. A letter confirmed his willingness. Letter, May 22, 1967, Dominique de Menil to Kahn. Kahn Collection, St. Thomas University, Box LIK 15. See J.-C. Lemagny, *Visionary Architects: Boullée, Ledoux, Lequeu* (Houston: University of St. Thomas, 1968). Kahn came to Houston to lecture at St. Thomas University on November 2, 1967, in connection with the exhibition. Letter, October 11, 1967, D. de Menil to Kahn. Kahn Collection, St. Thomas University, File Box LIK 15.

5. Kahn, "Space and the Inspirations," 14. See Loud, "History of the Kimbell Art Museum," in *In Pursuit of Quality*, 34–35 and fig. 29.

6. *Louis I. Kahn: Talks with Students* (Houston: Rice University, 1969) [Architecture at Rice 26]. The book was edited by Ann Mohler and Peter C. Papademetriou of Rice University.

7. Anderson Todd of Rice wrote Kahn that the board of governors was enthusiastic about having him work at Rice. Letter, October 4, 1969, Todd to Kahn. Kahn mentioned his pleasure in seeing the de Menils again in a note to Todd. Letter, undated (but probably between October 4 and 24, 1969), Kahn to Todd. In early November the acting president wrote Kahn to state formally the board's wish to have him design the Rice art center. Letter, November 4, 1969, Frank Vandiver to Kahn. Kahn accepted; letter, November 18, 1969, Kahn to Vandiver. All, Kahn Collection, Rice University, File Box LIK 32. Kahn's drawings for the Rice project are published in *The Louis I. Kahn Archive: Personal Drawings*, vol. 6, 338–41; Ronner and Jhaveri, *Complete Works*, 2nd ed., 376–77. See also Stephen Fox, *The General Plan of the William M. Rice Institute and Its Architectural Development* (Houston: Rice University, 1980): 81–82 [Architecture at Rice 29].

8. Conversation with Simone Swan, March 18, 1989. Mrs. Swan, who worked with the de Menils on the project, has been most generous in providing information. Only drawings are in the Kahn Collection at the University of Pennsylvania; files have not been located. Therefore, Mrs. Swan's recollections and files are of inestimable value. We look forward to an article on this unfinished project and possibly more information on Kahn's initial design for her house on Long Island, begun only months before his death. The latter (and the Menil gallery) is mentioned by William Marlin in his essay "Louis Kahn: Humble Titan of World Architecture," *Christian Science Monitor*, May 8, 1974.

9. Paul Winkler, Acting Director of the Menil Collection, said in a talk on "The Evolution of the Menil Project," October 21, 1988, at the ARLIS/Texas Conference, that the collection, begun in 1941, numbered some 13,000 items after forty years. Kahn was engaged on the project some ten years earlier, but in 1972 the collection was already sizable and expected to grow.

10. Marlin, "Louis Kahn: Humble Titan."

11. See Dominique de Menil, "The Rothko Chapel," *Art Journal* 30, no. 3 (Spring 1971): 249–51. Howard Barnstone was also to be Kahn's local associate architect for the de Menil gallery.

12. Conversation with Simone Swan, March 18, 1989.

13. See *The Louis I. Kahn Archive: Personal Drawings*, vol. 7, 18–29.

14. "Notebook," *Houston Chronicle*, January 23, 1973, in the Menil Collection files. Although it was stated in the article that the Menil Foundation denied reports that Kahn was to design a museum for the de Menils, it was confirmed that he had visited them several months before, when he came to see the Rothko Chapel. The Max Ernst exhibition at Rice University opened on February 9, 1973.

15. Conversation with Simone Swan, March 18, 1989.

16. Ibid.

17. Ann Holmes, "The Early Visionary Plans for Houston's Land Use and Buildings" (a review of the exhibition "Civic Architecture in Houston since 1900" at Rice University School of Architecture), *Houston Chronicle*, November 11, 1979, in the Menil Collection files.

18. This was close to the time that the Kimbell Art Museum had been completed, and Kahn was pleased with the lighting there. Mrs. Swan has said he often mentioned the importance of light and referred to the Kimbell in discussing the effects he sought for the Menil museum. Conversation with Simone Swan, March 18, 1989.

19. Reyner Banham, "In the Neighborhood of Art," *Art in America* 75 (June 1987): 128. Paul Winkler describes the visit to the small kibbutz museum as seminal. He says that Piano began sketches for louvers to bounce light downward while on the plane coming back from that visit to Israel. After months of work the reflectors were changed into a curved shape. Winkler, "Evolution of the Menil Project," October 21, 1988. While under construction, the project was described by Jonathan Glancey, "Piano Pieces," *Architectural Review* 177 (May 1985): 58–63.

20. Kahn, "Order Is," *Perspecta 3* (1955): 59. This is the same issue in which Kahn's Yale Art Gallery is discussed by Boris Pushkavrev, "Order and Form," 47–56.

21. In "Structure and Form" (1960–61), Kahn changed from "order" to "form" to define "what." His idea did not essentially change, but he chose another word to describe it.

22. John W. Cook and Heinrich Klotz, *Conversations with Architects* (New York: Frederick A. Praeger, 1973): 212.

23. Kahn, "Monumentality," 578.

24. Kahn, in Nell E. Johnson, comp., *Light Is the Theme* (Fort Worth: Kimbell Art Foundation, 1975, 1987): 47. In talking with Cook and Klotz, Kahn said something similar concerning "a casual arrangement." "I don't like it nailed down. If you could move it and change it every day without making a *nature* out of it, fine." *Conversations with Architects*, 203.

25. Kahn, in Jurgen Joedicke and Oscar Newman, eds., *New Frontiers in Architecture, CIAM at Otterlo* (New York: Universe Books, 1961): 213. Kahn had speculated on a specialized, non-art museum for Philadelphia in 1953, near the time of the completion of the Yale Art Gallery. This was in connection with an extensive program by the city's board of trade and conventions for renovation, repair, and "modernization" of existing facilities. The north building, identified as the Commercial Museum, for exhibitions, hospitality, education and the promotion of trade was on the agenda. Kahn speculated in two somewhat sketchily written drafts on the site and proposed alterations to incorporate control of natural light and provision for artificial lighting and air-conditioning. His suggestions mark his concern for incorporating natural light and for ordering mechanical and electrical features that would be needed — an awareness of providing serving spaces as he had accomplished at Yale. I wish to thank architect John Knowles for calling this file to my attention when we were both engaged in research in the Kahn Collection at the University of Pennsylvania. Commercial Museum, Philadelphia. Kahn Collection, LIK Box 59.

26. McLaughlin, "How'm I Doing, Corbusier?" 26.

27. Kahn was speaking of the Kimbell Art Museum. McLaughlin, "How'm I Doing, Corbusier?" 23.

28. "Kahn," *Perspecta* 7 (1961): 9–28. See also Alison and Peter Smithson, "Louis Kahn," *Architects Yearbook* (1960): 115. On the Rochester Unitarian Church, see Ronner and Jhaveri, *Complete Works*, 2nd ed., 116–23; *The Louis I. Kahn Archive*, vol. 2, 16–28. On the Angola project, see Ronner and Jhaveri, *Complete Works*, 2nd ed., 59–61; *The Louis I. Kahn Archive*, vol. 2, 144–59. On the Goldberg house, see Ronner and Jhaveri, *Complete Works*, 2nd ed., 146–49; *The Louis I. Kahn Archive*, vol. 1, 464–67.

29. For the schematic plan for the Fort Wayne art museum, see *The Louis I. Kahn Archive*, vol. 2, 316 (drawing 605.155). Richard F. Brown especially requested that information on the Fort Wayne Fine Arts Buildings and the Philadelphia College of Art be included with materials to be sent for presentation to the board of trustees of the Kimbell Art Foundation in his first letter to Kahn. Letter, March 2, 1966, Brown to Kahn. Kahn Collection, Correspondence with Richard F. Brown, File Box LIK 59. For these projects, see Ronner, Vasella, and Jhaveri, *Complete Works*, 2nd ed., 198–207, 276–81, 282–85.

30. Before the design was completed, it was widely published. See Plagens, "Louis Kahn's New Museum in Fort Worth," *Art Forum* 6 (February 1968): 18–23; "Home in a Barrel Vault," *Time* 91 (February 23, 1968): 67; "Recent work of Louis I. Kahn," *Kenchiku Bunka* 24 (January 1969): 145–70; "Louis I. Kahn," *L'Architecture d'Aujourd'hui* 40, no. 142 (February–March 1969); C. Ray Smith, "The Great Museum Debate," *Progressive Architecture* 50 (December 1969): 84–85. Six drawings for the Kimbell were included in the exhibition of museums curated by Ludwig Glaeser for the Museum of Modern Art (September 24–November 11, 1968); *Architecture of Museums* (New York: Museum of Modern Art, 1968).

31. Brown, in "Kahn's Museum, An Interview with Richard F. Brown," *Art in America* 50 (September–October 1972): 48. "And when he was commissioned to do this particular job, he reached for that structural idea as ideal for it. And he knew exactly where he could get the engineering done."

32. Kahn, in *New Frontiers in Architecture*, ed. Joedicke and Newman, 210.

33. Brown, "Statement: Louis I. Kahn," in *In Pursuit of Quality*, 328.

34. The La Jolla museum mounted an exhibition of Kahn's work in January 1965 with a catalogue, *The Work of Louis I. Kahn*, with an introduction by Vincent Scully, Jr. (La Jolla: Museum of Art, 1965). Brown's copy, inscribed "Return to Ric Brown," is now in the Kimbell Art Museum library.

35. Kahn, "Architecture: Silence and Light," in *On the Future of Art*, sponsored by The Solomon R. Guggenheim Museum (New York: Viking Press, 1970): 21–35. As with buildings, Kahn sought freshness in the meaning of a word. Three years later Kahn called material not "spent light" but "utilized light." "L'Accord de l'homme et de l'architecture: Une conference de Louis Kahn," *La Construction moderne* (July–August 1973): 17. The English version of Kahn's talk (as he delivered it) is "Harmony Between Man and Architecture," *Design* (Bombay) 18 (March 1974): 26.

36. Kahn, "L'Accord de l'homme et de l'architecture," 16; "Harmony Between Man and Architecture," 25.

37. Kahn, "L'Accord de l'homme et de l'architecture," 16; "Harmony Between Man and Architecture," 25.

Project for the de Menil
Museum, Houston. Blueprint
of plan view of roof with floor
area. The Menil Collection,
Houston.

38. Brown, "Pre-Architectural Program" (1, C), in *In Pursuit of Quality*, 319.

39. Kahn, "Space and the Inspirations," in *L'Architecture d'aujourd'hui*, 142 (February–March 1969): 15–16. Kahn spoke of the "Green Court, Yellow Court, Blue Court, named for the kind of light that I anticipate their proportions, their foliation, or their sky reflections on surfaces or on water will give."

40. Jacques Lucan discusses Kahn's consideration of the room in relation to Guadet's elements of composition (rooms, passageways, stairs, etc.). "Da Guadet a Kahn: il tema della stanza," *Domus* 50 (January–February 1986): 72–75. Guadet's *Eleménts et théorie de l'architecture, Cours professé à l'Ecole nationale et spéciale des Beaux-Arts* (Paris, 1899) was in Kahn's personal library. See also Kenneth Frampton, "Louis Kahn and the French Connection," *Oppositions* 22 (Fall 1980): 21–53.

41. Latryl Layton, "Kimbell Art Museum to be 'Friendly House,'" *Fort Worth Press*, February 5, 1968.

42. Latryl L. Ohendalski, "Kimbell Museum to Be Friendly Home, Says Kahn," *Fort Worth Press*, May 4, 1969.

43. Interview with William Marlin, Philadelphia, 24 June 1972, Kimbell Art Museum files. Marlin used selections from the interview for the Kimbell Art Museum and the Yale Center for British Art sections of *Architectural Forum* 137 (July–August 1972): 56–61.

44. Brown in Barbara Rose, "New Texas Boom, from Fort Worth to Corpus Christi, to Bring Together Great Art and Great Architecture," *Vogue* 160 (15 October 1972): 130.

45. Kahn, in Cook and Klotz, *Conversations with Architects*, 190.

46. Ibid., 188–90. "Even when serving the dictates of individuals, you still have no client in my sense of the word. The client is human nature. . . . That means that when you are designing a house you are designing it for the *person* but you are designing it also for the person who will take it *after* this person," 190.

47. Prown, in *Processes in Architecture* 33.

48. Kahn quoted in "The Mind of Louis Kahn," 83. Marlin also used this quotation in his essay "Louis Kahn: Humble Titan."

49. According to Mrs. Esther I. Kahn, he did not want paintings hanging in his Philadelphia living room on Clinton Street because the span was less than twenty feet wide and thus insufficient for showing art.

50. Kahn, "Spaces, Order and Architecture," *Royal Architecture Institute of Canada Journal* 34 (October 1957): 377. An edited and shortened version is "Architecture Is the Thoughtful Making of Spaces," *Perspecta 4* (1957): 2.

51. Kahn, closing remarks, in *New Frontiers in Architecture*, ed. Joedicke and Newman, 210.

52. Kahn, "A Statement," *Art and Architecture* 81 (May 1964): 33.

53. Kahn, "Statements on Architecture," *Zodiac* 17 (January 1967): 57.

54. Kahn, "The Room, the Street and Human Agreement" (edited version of American Institute of Architects Gold Medal address), Architecture and Urbanism, special edition (1971): 7.

55. Kahn, "Harmony Between Man and Architecture," 27; "L'Accord de l'homme et de l'architecture," 18.

56. Kahn, in "The Mind of Louis Kahn," 83.

57. "Conversation with Peter Blake," July 20, 1971, in Richard Saul Wurman, *What Will Be Has Always Been: The Words of Louis I. Kahn* (New York: Access Press and Rizzoli, 1986): 127.

58. Kahn compared his concept of space with Miesian space and illustrated both with diagrams for Cook and Klotz. His emphasis was on the "evidence of how it was made" which, when present, made a space a room. Kahn said he would never divide a space because "there's no entity when it is divided." Cook and Klotz, *Conversations with Architects*, 212.

—

FLOOR AREA

a) PLAN WITH WESTERN PORCHES = 32,400 □'
b) PLAN WITHOUT WESTERN PORCHES = 27,400 □'

WALL STORAGE = ~ 13,000 □' @ 10' WALL HEIGHT

# CATALOGUE

Yale University Art Gallery

Some significant drawings for Kahn's museums were unavailable for this exhibition (several are illustrated, however). Italicized references are to previous publication with illustration; see bibliography.

1. ***Interior perspective***
charcoal on white tracing paper, 23 x 29.7 cm
Louis I. Kahn Collection 370.3
University of Pennsylvania and Pennsylvania Historical
    and Museum Commission
        *Louis I. Kahn Archive, v.1:266*

**fig. 2.14**

2. ***Interior perspective***
graphite, charcoal on white tracing paper, 23 x 29.7 cm
Louis I. Kahn Collection 370.2
University of Pennsylvania and Pennsylvania Historical and
    Museum Commission
        *Louis I. Kahn Archive, v.1:267*

**fig. 2.15**

3. ***Exterior perspective, view from northeast***
black and colored crayon, 34.3 x 36.2 cm
1951
Yale University Art Gallery 1975.13.1

**fig. 2.16**

4. ***Exterior perspective, view from northeast***
black and colored crayon, 45.2 x 54.6 cm
1951
Yale University Art Gallery 1975.13.2
        *Complete Works (1987):67*
        *In Pursuit of Quality:30*

**fig. 2.18**

5. ***Exterior perspective, view from southeast***
charcoal on white tracing paper, 23 x 29.7 cm
Louis I. Kahn Collection 370.4
University of Pennsylvania and Pennsylvania Historical and
    Museum Commission
        *Louis I. Kahn Archive, v.1:268*
        *In Pursuit of Quality:28*

**fig. 2.20**

6. ***Section and plans, reevaluation of structural system***
ink on vellum and white tracing paper, glued to
    gold paper, 33.5 x 48.2 cm
Louis I. Kahn Collection 370.7
University of Pennsylvania and Pennsylvania Historical and
    Museum Commission
        *A & U (1973):105; (1975):272*
        *Louis I. Kahn Archive, v.1:270*

**fig. 2.24**

7. ***Section, reevaluation of structural system***
ink on white tracing paper glued to board, 38 x 50.7 cm
Louis I. Kahn Collection 370.8
University of Pennsylvania and Pennsylvania Historical and
    Museum Commission
        *Louis I. Kahn Archive, v.1:270*

**fig. 2.25**

8. ***Perspective view of Chapel Street entrance***                    **fig. 2.32**
   black crayon, 37.5 x 67.3 cm
   1952
   Yale University Art Gallery 1975.13.3

9. ***Schematic floor plan and interior perspective***                 **fig. 2.41**
   graphite on white tracing paper, 30.5 x 78.5 cm
   Louis I. Kahn Collection 370.1
   University of Pennsylvania and Pennsylvania Historical and
      Museum Commission
         *Louis I. Kahn Archive, v.1:267*

10. ***Plan, elevation, section, detail of terrace and sculpture court***   **fig. 2.42**
    ink on white tracing paper, 30.5 x 69.2 cm
    22 August 1954
    Louis I. Kahn Collection 370.6
    University of Pennsylvania and Pennsylvania Historical and
       Museum Commission
          *Wurman & Feldman (1962): no.27*     *Giurgola & Mehta:62*
          *Complete Works (1987):69*           *A & U (1975):206-207*
          *Louis I. Kahn Archive, v.1:269*

# Kimbell Art Museum

11. ***General site model of first design [for Kimbell Art Museum]***   **fig. 3.2**
    clay, 27 x 22 in, scale 1″:100′
    January/February 1967
    Kimbell Art Museum
       *In Pursuit of Quality:23*

12. ***Schematic site plans, partial sections***                       **fig. 3.3**
    graphite, negro lead on yellow tracing paper, 30.5 x 80 cm
    March 1967
    Louis I. Kahn Collection 730.4
    University of Pennsylvania and Pennsylvania Historical and
       Museum Commission
          *Louis I. Kahn Archive, v.5:195*

13. ***Schematic plans, elevation, sections***                         **fig. 3.4**
    graphite, negro lead on yellow tracing paper, 43.2 x 54.9 cm
    March 1967
    Louis I. Kahn Collection 730.37
    University of Pennsylvania and Pennsylvania Historical and
       Museum Commission
          *Louis I. Kahn Archive, v.5:212*

14. ***Schematic sections***                                           **fig. 3.5**
    graphite, negro lead, green pencil on yellow tracing
       paper, 30.5 x 33 cm
    Louis I. Kahn Collection 730.148
    University of Pennsylvania and Pennsylvania Historical and
       Museum Commission
          *Louis I. Kahn Archive, v.5:262*
          *In Pursuit of Quality:22*

15. *Schematic elevation, section, axonometric view*                    fig. 3.6
    graphite, negro lead on yellow tracing paper, 30.5 x 59 cm
    Louis I. Kahn Collection 730.147
    University of Pennsylvania and Pennsylvania Historical and
        Museum Commission
            *Louis I. Kahn Archive, v.5:262*
            *In Pursuit of Quality:21*

16. *Schematic vault sections, reflectors*                    fig. 3.7
    graphite, negro lead, blue pencil on yellow tracing
        paper, 45.7 x 43.2 cm
    March 1967
    Louis I. Kahn Collection 730.137
    University of Pennsylvania and Pennsylvania Historical and
        Museum Commission
            *In Pursuit of Quality:22*          *Louis I. Kahn Archive, v.5:256*
            *AIA Journal (1979):61*             *Complete Works (1987):340*
            *Sketches for the KAM:no.1 cat.1*   *Tyng (1984):55*

17. *Perspective of gallery interior*                    fig. 3.8
    charcoal on tan wove paper, 47 x 31.8 cm
    March 1967
    Louis I. Kahn Collection 730.194
    University of Pennsylvania and Pennsylvania Historical and
        Museum Commission
            *Louis I. Kahn Archive, v.5:285*
            *In Pursuit of Quality:27*

18. *Vault and reflector studies*                    fig. 3.9
    charcoal on yellow tracing paper, 72.4 x 102.2 cm
    Louis I. Kahn Collection 730.142
    University of Pennsylvania and Pennsylvania Historical and
        Museum Commission
            *In Pursuit of Quality:27*          *Louis I. Kahn Archive, v.5:259*
            *AIA Journal (1979):61*             *Complete Works (1987):340*
            *Sketches for the KAM:no.2 cat.5*   *Tyng (1984):55*

19. *Site model with Amon Carter Square*                    fig. 3.10
    chipboard, 48 x 34 inches, scale 1":32'
    Kimbell Art Museum
            *Complete Works (1987):340*
            *In Pursuit of Quality:23,24*
            *Sketches for the KAM:no.3 cat.7*

20. *Schematic plan, elevation, axonometric view*                    fig. 3.11
    graphite, negro lead on yellow tracing paper, 61 x 70 cm
    Louis I. Kahn Collection 730.127
    University of Pennsylvania and Pennsylvania Historical and
        Museum Commission
            *Louis I. Kahn Archive, v.5:251*
            *In Pursuit of Quality:26*

21. *Schematic elevations and sections*                    fig. 3.14
    graphite, negro lead on yellow tracing paper 49.5 x 44.7 cm
    July 1967
    Louis I. Kahn Collection 730.39
    University of Pennsylvania and Pennsylvania Historical and
        Museum Commission
            *Louis I. Kahn Archive, v.5:213*

22. *Perspective view from southwest*                              **fig. 3.15**
    charcoal on yellow tracing paper, 60 x 104.2 cm
    22 September 1967
    Louis I. Kahn Collection 730.195
    University of Pennsylvania and Pennsylvania Historical and
        Museum Commission
            *Louis I. Kahn Archive, v.5:286          A & U (1975):208-209*
            *Complete Works (1987):344               Giurgola & Mehta:96*
            *Sketches for the KAM:no.6 cat.12*

23. *Schematic site elevation*                                     **fig. 3.17**
    graphite, negro lead on yellow tracing paper, 30.5 x 96 cm
    27 September 1967
    Louis I. Kahn Collection 730.122
    University of Pennsylvania and Pennsylvania Historical and
        Museum Commission
            *Louis I. Kahn Archive, v.5:248*

24. *Schematic gallery level plan, section studies of sections*    **fig. 3.19**
    charcoal on yellow tracing paper, 61 x 76 cm
    Louis I. Kahn Collection 730.83
    University of Pennsylvania and Pennsylvania Historical and
        Museum Commission
            *Louis I. Kahn Archive, v.5:231          Complete Works (1987):344*
            *Architectural Review (1974):332         A & U (1973):112*
            *L'Architecture d'aujourd'hui (1969):23   Latour:290*
            *Sketches for the KAM:no.4 cat.16*
            *Art Forum (1968):21*

25. *Schematic elevations, studies of vaults*                      **fig. 3.22**
    graphite, negro lead on yellow tracing paper, 34 x 104 cm
    Louis I. Kahn Collection 730.130
    University of Pennsylvania and Pennsylvania Historical and
        Museum Commission
            *Louis I. Kahn Archive, v.5:253*

26. *Site model*                                                   **fig. 3.26**
    basswood on chipboard base, 34 x 24 in., scale 1":30'
    November 1967
    Kimbell Art Museum
            *In Pursuit of Quality:48        Complete Works (1987):344*
            *Art Forum (1968) :18,22*
            *Sketches for the KAM:no.7 cat.18*

27. *Schematic site plan and building plan*                        **fig. 3.27**
    pastel over blue-line print, 63.5 x 81.4 cm
    Louis I. Kahn Collection 730.OD
    University of Pennsylvania and Pennsylvania Historical and
        Museum Commission

28. *Schematic plan, sketches of service level*                    **fig. 3.29**
    charcoal on yellow tracing paper, 74.9 x 82.5 cm
    3 June 1968
    Louis I. Kahn Collection 730.41
    University of Pennsylvania and Pennsylvania Historical and
        Museum Commission
            *Louis I. Kahn Archive, v.5:214*
            *Sketches for the KAM: no.8 cat.26*

29. *Schematic auditorium section, sketches*                    **fig. 3.30**
   charcoal on yellow tracing paper, 46 x 66.3 cm
   July 1968
   Louis I. Kahn Collection 730.139
   University of Pennsylvania and Pennsylvania Historical and
       Museum Commission
           *Louis I. Kahn Archive, v.5:257*
           *Sketches for the KAM:no.9 cat.32*

30. *Schematic plans for auditorium, bookstore, entrance, portico*    **fig. 3.31**
   charcoal on yellow tracing paper, 47 x 43.3 cm
   Louis I. Kahn Collection 730.106
   University of Pennsylvania and Pennsylvania Historical and
       Museum Commission
           *Louis I. Kahn Archive, v.5:241*

31. *Schematic service level plans, studies*                    **fig. 3.32**
   charcoal, red pencil on yellow tracing paper, 61 x 90 cm
   20 August 1968
   Louis I. Kahn Collection 730.44
   University of Pennsylvania and Pennsylvania Historical and
       Museum Commission
           *Louis I. Kahn Archive, v.5:215*

32. *Schematic plan for lounge, bookstore and*
   *loan gallery and connector*                              **fig. 3.35**
   charcoal on yellow tracing paper, 30.5 x 52.5 cm
   20 August 1968
   Louis I. Kahn Collection 730.46
   University of Pennsylvania and Pennsylvania Historical and
       Museum Commission
           *Louis I. Kahn Archive, v.5:216*

33. *Schematic site and building plans, elevation studies, section*    **fig. 3.37**
   charcoal on yellow tracing paper, 45.5 x 66.5 cm
   24 August 1968
   Louis I. Kahn Collection 730.7
   University of Pennsylvania and Pennsylvania Historical and
       Museum Commission
           *Louis I. Kahn Archive, v.5:197*
           *In Pursuit of Quality: 51*

34. *Schematic auditorium plan, sketches*                       **fig. 3.41**
   colored pencil on yellow tracing paper, 30.5 x 40.5 cm
   September 1968
   Louis I. Kahn Collection 730.51
   University of Pennsylvania and Pennsylvania Historical and
       Museum Commission
           *Louis I. Kahn Archive, v.5:217*

35. *Schematic and drafted site plans*                          **fig. 3.42**
   graphite, green, blue and tan pencil on blackline print,
       75 x 92 cm
   29 October 1968
   Louis I. Kahn Collection 730.10
   University of Pennsylvania and Pennsylvania Historical and
       Museum Commission
           *Louis I. Kahn Archive, v.5:199*

36. **Site model**                                                       **fig. 3.46**
    basswood on maple wood base, 58 x 47 in., scale 1″:16′
    September 1968
    Kimbell Art Museum
        *In Pursuit of Quality:52*
        *Complete Works (1987):346*
        *Sketches for the KAM:no. 11 cat.39*

37. **Schematic service level plan, sketches**                            **fig. 3.50**
    charcoal on yellow tracing paper, 63.8 x 94 cm
    16 March 1969
    Louis I. Kahn Collection 730.58
    University of Pennsylvania and Pennsylvania Historical and
        Museum Commission
        *Louis I. Kahn Archive, v.5:220*

38. **Schematic east elevation**                                          **fig. 3.51**
    graphite, negro lead on yellow tracing paper, 30.5 x 175 cm
    Louis I. Kahn Collection 730.129
    University of Pennsylvania and Pennsylvania Historical and
        Museum Commission
        *Louis I. Kahn Archive, v.5:252*

39. **Schematic gallery level plans**                                     **fig. 3.52**
    charcoal on yellow tracing paper, 61 x 96.5 cm
    16 March 1969
    Louis I. Kahn Collection 730.61
    University of Pennsylvania and Pennsylvania Historical and
        Museum Commission
        *Louis I. Kahn Archive, v.5:222*

40. **Sketch of site plan with letter to Mrs. Kay Kimbell**              **fig. 3.54**
    ink on white paper, 8 x 11 in.
    25 June 1969
    Kimbell Art Museum
        *Light Is the Theme:63*
        *Complete Works (1987):347*
        *In Pursuit of Quality:62-63*

41. **Schematic elevations of vault ends, detail**                        **fig. 3.55**
    charcoal, red pencil on yellow tracing paper, 41 x 71.1 cm
    August 1969
    Louis I. Kahn Collection 730.124
    University of Pennsylvania and Pennsylvania Historical and
        Museum Commission
        *Louis I. Kahn Archive, v.5:249*
        *Sketches for the KAM:no.13 cat.46*

42. **Schematic plans, sections and studies for court with fountain**     **fig. 3.56**
    graphite on yellow tracing paper, 30.5 x 40 cm
    December 1969
    Louis I. Kahn Collection 730.67
    University of Pennsylvania and Pennsylvania Historical and
        Museum Commission
        *Louis I. Kahn Archive, v.5:224*

43. **Schematic courtyard plan with trellis elevation**                   **fig. 3.57**
    charcoal on yellow tracing paper, 30.5 x 79 cm
    Louis I. Kahn Collection 730.111
    University of Pennsylvania and Pennsylvania Historical and
        Museum Commission
        *Louis I. Kahn Archive, v.5:244*

44. ***Schematic kitchen elevation***                                    **fig. 3.58**
charcoal on white tracing paper, 30.5 x 51.5 cm
1 December 1969
Louis I. Kahn Collection 730.125
University of Pennsylvania and Pennsylvania Historical and
    Museum Commission
    *Louis I. Kahn Archive, v.5:250*

45. ***Schematic library plan with two mezzanines***                     **fig. 3.59**
charcoal on yellow tracing paper, 45.7 x 66.7 cm
Louis I. Kahn Collection 730.95
University of Pennsylvania and Pennsylvania Historical and
    Museum Commission
    *Louis I. Kahn Archive, v.5:235*

46. ***Schematic library plans with single mezzanine***                  **fig. 3.60**
graphite, negro lead on yellow tracing paper, 45.7 x 60.7 cm
31 December 1969
Louis I. Kahn Collection 730.75
University of Pennsylvania and Pennsylvania Historical and
    Museum Commission
    *Louis I. Kahn Archive, v.5:228*

47. ***Schematic plans, elevation, interior perspective for library***   **fig. 3.61**
graphite, red pencil on yellow tracing paper, 47 x 63.5 cm
15 March 1970
Louis I. Kahn Collection 730.79
University of Pennsylvania and Pennsylvania Historical and
    Museum Commission
    *Louis I. Kahn Archive, v.5:229*

48. ***Schematic section with detail of light track power source***      **fig. 3.64**
graphite, red pencil on yellow tracing paper, 30.5 x 48 cm
Louis I. Kahn Collection 730.186
University of Pennsylvania and Pennsylvania Historical and
    Museum Commission
    *Louis I. Kahn Archive, v.5:282*

49. ***Schematic and drafted elevations of west entrance wall***         **fig. 3.65**
graphite on yellow tracing paper, 45.7 x 76.5 cm
Louis I. Kahn Collection 730.114
University of Pennsylvania and Pennsylvania Historical and
    Museum Commission
    *Louis I. Kahn Archive, v.5:245*

50. ***Door elevation sketches***                                        **fig. 3.66**
graphite on yellow tracing paper, 27 x 61 cm
May 1970
Louis I. Kahn Collection 730.177
University of Pennsylvania and Pennsylvania Historical and
    Museum Commission
    *Louis I. Kahn Archive, v.5:275*

51. ***Schematic vault section with material specification***            **fig. 3.68**
graphite, negro lead, blue and red pencil on yellow tracing
    paper, 46 x 56 cm
Louis I. Kahn Collection 730.150
University of Pennsylvania and Pennsylvania Historical and
    Museum Commission
    *Louis I. Kahn Archive, v.5:264*
    *Sketches for the KAM:no. 14 cat. 48*

52. **Schematic section, plan and detail for drinking fountain**     **fig. 3.71**
charcoal on yellow tracing paper, 75 x 104.2 cm
Louis I. Kahn Collection 730.182
University of Pennsylvania and Pennsylvania Historical and
    Museum Commission
        *Louis I. Kahn Archive, v.5:279*

# Yale Center for British Art

53. **Schematic section**     **fig. 4.1**
graphite, negro lead on yellow tracing paper, 46 x 107.5 cm
4 February 1970
Louis I. Kahn Collection 805.240
University of Pennsylvania and Pennsylvania Historical and
    Museum Commission
        *Louis I. Kahn Archive, v.6:446*
        *Complete Works (1987):378*

54. **Schematic second floor plan**     **fig. 4.2**
graphite, negro lead on yellow tracing paper, 31.5 x 79 cm
22 February 1970
Louis I. Kahn Collection 805.8
University of Pennsylvania and Pennsylvania Historical and
    Museum Commission
        *Louis I. Kahn Archive, v.6:345*
        *Complete Works (1987):378*

55. **Schematic first floor plan**     **fig. 4.3**
graphite on yellow tracing paper, 45.5 x 82.5 cm
March 1970
Louis I. Kahn Collection 805.18
University of Pennsylvania and Pennsylvania Historical and
    Museum Commission
        *Louis I. Kahn Archive, v.6:348*

56. **Schematic first floor plan**     **fig. 4.4**
charcoal on yellow tracing paper, 31 x 78.5 cm
9 April 1970
Louis I. Kahn Collection 805.32
University of Pennsylvania and Pennsylvania Historical and
    Museum Commission
        *Louis I. Kahn Archive, v.6:353*
        *Complete Works (1987):379*

57. **Model**     **fig. 4.5**
chipboard, 7-½ x 46 x 31 inches
May/June 1970
Louis I. Kahn Collection 805M2
University of Pennsylvania and Pennsylvania Historical and
    Museum Commission
        *Complete Works (1987):383*

58. **Schematic first floor plan, elevation, sections, sketches**     **fig. 4.6**
charcoal on yellow tracing paper, 45.5 x 67 cm
April 1970
Louis I. Kahn Collection 805.40
University of Pennsylvania and Pennsylvania Historical and
    Museum Commission
        *Louis I. Kahn Archive, v.6:358*
        *Complete Works (1987):380*

59. *Schematic plan*                                                                fig. 4.7
graphite, negro lead on yellow tracing paper, 30.5 x 62 cm
10 May 1970
Louis I. Kahn Collection 805.66
University of Pennsylvania and Pennsylvania Historical and
    Museum Commission
        *Louis I. Kahn Archive, v.6:366*

60. *Schematic partial first floor plan, section*                                   fig. 4.8
graphite, negro lead on yellow tracing paper, 30.5 x 63.5 cm
Louis I. Kahn Collection 805.156
University of Pennsylvania and Pennsylvania Historical and
    Museum Commission
        *Louis I. Kahn Archive, v.6:404*

61. *Schematic partial plans, sections*                                             fig. 4.9
charcoal on yellow tracing paper, 45.5 x 70.5 cm
Louis I. Kahn Collection 805.157
University of Pennsylvania and Pennsylvania Historical and
    Museum Commission
        *Louis I. Kahn Archive, v.6:405*

62. *Interior perspective of entrance court*                                        fig. 4.10
graphite, negro lead on yellow tracing paper, 56 x 76 cm
Louis I. Kahn Collection 805.335
University of Pennsylvania and Pennsylvania Historical and
    Museum Commission
        *Louis I. Kahn Archive, v.6:490*

63. *Schematic plan, second floor and mezzanine*                                    fig. 4.11
charcoal on yellow tracing paper, 46 x 77 cm
9 April 1970
Louis I. Kahn Collection 805.34
University of Pennsylvania and Pennsylvania Historical and
    Museum Commission
        *Louis I. Kahn Archive, v.6:354*
        *Complete Works (1987):379*

64. *Drafted, rendered west elevation*                                              fig. 4.17
graphite on vellum, 39 x 106.5 cm
10 June 1970
Louis I. Kahn Collection 805.188
University of Pennsylvania and Pennsylvania Historical and
    Museum Commission
        *Louis I. Kahn Archive, v.6:418*

65. *Schematic north elevation*                                                     fig. 4.18
charcoal, blue and red pencil on yellow tracing
    paper, 30.5 x 81 cm
June 1970
Louis I. Kahn Collection 805.200
University of Pennsylvania and Pennsylvania Historical and
    Museum Commission
        *Louis I. Kahn Archive, v.6:425*

66. *Schematic section of fourth floor gallery*                                     fig. 4.19
charcoal on yellow tracing paper, 30.5 x 136 cm
June 1970
Louis I. Kahn Collection 805.257
University of Pennsylvania and Pennsylvania Historical and
    Museum Commission
        *Louis I. Kahn Archive, v.6:455*
        *Prown (1982):29*

67. ***Interior perspective of fourth floor gallery***                     **fig. 4.20**
    charcoal on yellow tracing paper, 30.5 x 30 cm
    Louis I. Kahn Collection 805.328
    University of Pennsylvania and Pennsylvania Historical and
        Museum Commission
        *Louis I. Kahn Archive, v.6:483*

68. ***Schematic section, elevation of fourth floor gallery, and garden***   **fig. 4.21**
    graphite, negro lead on yellow tracing paper, 30.5 x 58.5 cm
    Louis I. Kahn Collection 805.225
    University of Pennsylvania and Pennsylvania Historical and
        Museum Commission
        *Louis I. Kahn Archive, v.6:439*
        *Complete Works (1987):381*

69. ***Schematic north elevation and section***                            **fig. 4.22**
    graphite, negro lead on yellow tracing paper, 46 x 86 cm
    September 1970
    Louis I. Kahn Collection 805.202
    University of Pennsylvania and Pennsylvania Historical and
        Museum Commission
        *Louis I. Kahn Archive, v.6:427*
        *Complete Works (1987):381*

70. ***Schematic north elevation***                                        **fig. 4.23**
    charcoal on yellow tracing paper, 46 x 98.5 cm
    22 September 1970
    Louis I. Kahn Collection 805.205
    University of Pennsylvania and Pennsylvania Historical and
        Museum Commission
        *Louis I. Kahn Archive, v.6:428*

71. ***Schematic plan, elevations of bridge***                             **fig. 4.24**
    graphite, negro lead on yellow tracing paper, 30.5 x 38 cm
    7 November 1970
    Louis I. Kahn Collection 805.296
    University of Pennsylvania and Pennsylvania Historical and
        Museum Commission
        *Louis I. Kahn Archive, v.6:469*
        *Complete Works (1987):380*

72. ***Schematic interior library perspective***                           **fig. 4.31**
    graphite, negro lead on yellow tracing paper, 56.5 x 90 cm
    Louis I. Kahn Collection 805.339
    University of Pennsylvania and Pennsylvania Historical and
        Museum Commission
        *Louis I. Kahn Archive, v.6:493*
        *Complete Works (1987):386*

73. ***Model***                                                            **fig. 4.76**
    basswood, 13-½ x 37-½ x 39 inches
    October 1971
    Louis I. Kahn Collection 805M1
    University of Pennsylvania and Pennsylvania Historical and
        Museum Commission
        *Architectural Forum (1972):83*
        *Complete Works (1987):387*
        *Prown (1982):37*
        *Giurgola & Mehta:101*

74. *Schematic interior perspective of third floor galleries*    **fig. 4.33**
charcoal on yellow tracing paper, 60.5 x 75 cm
October 1970
Louis I. Kahn Collection 805.322
University of Pennsylvania and Pennsylvania Historical and
    Museum Commission
        *Louis I. Kahn Archive, v.6:479*
        *Complete Works (1987):382*
        *Prown (1982):27*

75. **Schematic fourth floor gallery section**    **fig. 4.34**
charcoal on yellow tracing paper, 30 x 71 cm
September 1970
Louis I. Kahn Collection 805.286
University of Pennsylvania and Pennsylvania Historical and
    Museum Commission
        *Louis I. Kahn Archive, v.6:465*
        *Complete Works (1987):384*

76. *Schematic fourth floor gallery sections*    **fig. 4.35**
graphite, negro lead, charcoal on yellow tracing
    paper, 30 x 68.5 cm
10 December 1970
Louis I. Kahn Collection 805.287
University of Pennsylvania and Pennsylvania Historical and
    Museum Commission
        *Louis I. Kahn Archive, v.6:466*

77. *Drafted, rendered north elevation*    **fig. 4.41**
graphite, colored pencil on vellum, 81.5 x 137.25 cm matted
14 January 1971
Louis I. Kahn Collection 805.212.1
University of Pennsylvania and Pennsylvania Historical and
    Museum Commission
        *Prown (1982):18*
        *Drawing Toward Building, 1732–1986:241 cat.133*

78. *Drafted, rendered east elevation*    **fig. 4.42**
graphite, colored pencil on vellum, 81.5 x 137.25 cm matted
14 January 1971
Louis I. Kahn Collection 805.212.2
University of Pennsylvania and Pennsylvania Historical and
    Museum Commission
        *Complete Works (1987):387*
        *Prown (1982):25*

79. **Schematic first floor plan**    **fig. 4.43**
blue pencil, brown pastel on yellow tracing paper,
    46 x 61 cm
Louis I. Kahn Collection 805.377
University of Pennsylvania and Pennsylvania Historical and
    Museum Commission
        *Louis I. Kahn Archive, v.6:510*

80. **Schematic first floor plan, section**    **fig. 4.44**
charcoal on yellow tracing paper, 46 x 83 cm
19 July 1971
Louis I. Kahn Collection 805.354
University of Pennsylvania and Pennsylvania Historical and
    Museum Commission
        *Louis I. Kahn Archive, v.6:500*

81. ***Drafted and schematic plan***                                     **fig. 4.45**
    graphite, colored pencil, charcoal on yellow tracing
        paper, 46 x 84.5 cm
    3 July 1971
    Louis I. Kahn Collection 805.346
    University of Pennsylvania and Pennsylvania Historical and
        Museum Commission
            *Louis I. Kahn Archive, v.6:497*

82. ***Schematic plan***                                                 **fig. 4.46**
    colored pencil, charcoal on yellow tracing paper, 46 x 86 cm
    3 July 1971
    Louis I. Kahn Collection 805.347
    University of Pennsylvania and Pennsylvania Historical and
        Museum Commission
            *Louis I. Kahn Archive, v.6:497*

83. ***Schematic section***                                              **fig. 4.47**
    graphite, negro lead on yellow tracing paper, 30.5 x 57.5 cm
    25 July 1971
    Louis I. Kahn Collection 805.398
    University of Pennsylvania and Pennsylvania Historical and
        Museum Commission
            *Louis I. Kahn Archive, v.6:519*

84. ***Schematic interior perspective of fourth floor galleries***       **fig. 4.49**
    graphite, negro lead on yellow tracing paper, 60.5 x 78.5 cm
    October 1971
    Louis I. Kahn Collection 805.473
    University of Pennsylvania and Pennsylvania Historical and
        Museum Commission
            *Louis I. Kahn Archive, v.6:561*
            *Giurgola & Mehta:102*

85. ***Schematic fourth floor plan***                                    **fig. 4.50**
    charcoal, purple pastel on yellow tracing paper, 46 x 82 cm
    Louis I. Kahn Collection 805.375
    University of Pennsylvania and Pennsylvania Historical and
        Museum Commission
            *Louis I. Kahn Archive, v.6:509*

86. ***Schematic section of fourth floor galleries***                    **fig. 4.51**
    charcoal on yellow tracing paper, 30.5 x 90 cm
    Louis I. Kahn Collection 805.455
    University of Pennsylvania and Pennsylvania Historical and
        Museum Commission
            *Louis I. Kahn Archive, v.6:598*

87. ***Interior perspective of library court, looking west***            **fig. 4.55**
    graphite, negro lead on yellow tracing paper, 60.5 x 54 cm
    1971
    Louis I. Kahn Collection 805.470
    University of Pennsylvania and Pennsylvania Historical and
        Museum Commission
            *Louis I. Kahn Archive, v.6:558*
            *Giurgola & Mehta:102*

88. *Interior perspective of library court, looking east to stairwell*    **fig. 4.56**
graphite, negro lead on yellow tracing paper, 60.5 x 80 cm
Louis I. Kahn Collection 805.471
University of Pennsylvania and Pennsylvania Historical and
    Museum Commission
      *Louis I. Kahn Archive, v.6:559*      *Architecture (1986):65*
      *Complete Works (1987):389*      *A & U (1973):117*
      *Architectural Review (1977):41*
      *Cook and Klotz:205*
      *Architectural Forum (1972):82*

89. *Schematic partial elevation*    **fig. 4.59**
graphite, negro lead, red pencil on yellow
    tracing paper, 30.5 x 42 cm
Louis I. Kahn Collection 805.414
University of Pennsylvania and Pennsylvania Historical and
    Museum Commission
      *Louis I. Kahn Archive, v.6:530*

90. *Schematic partial elevation*    **fig. 4.60**
graphite, negro lead, red pencil on yellow
    tracing paper, 30.5 x 35.5 cm
Louis I. Kahn Collection 805.415
University of Pennsylvania and Pennsylvania Historical and
    Museum Commission
      *Louis I. Kahn Archive, v.6:530*

91. *Schematic north elevation*    **fig. 4.61**
charcoal on yellow tracing paper, 30 x 48.5 cm
Louis I. Kahn Collection 805.419
University of Pennsylvania and Pennsylvania Historical and
    Museum Commission
      *Louis I. Kahn Archive, v.6:533*

92. *Schematic perspective of entrance*    **fig. 4.68**
graphite, negro lead on yellow tracing paper, 30 x 38 cm
1971
Louis I. Kahn Collection 805.466
University of Pennsylvania and Pennsylvania Historical and
    Museum Commission
      *Louis I. Kahn Archive, v.6:554*
      *Prown (1982):33*

93. *Schematic interior perspective of entrance court
without skylights*    **fig. 4.69**
graphite, negro lead on yellow tracing paper, 44 x 30 cm
Louis I. Kahn Collection 805.468
University of Pennsylvania and Pennsylvania Historical and
    Museum Commission
      *Louis I. Kahn Archive, v.6:556*
      *Space Design (1977):27*
      *Prown (1982):35*

94. *Schematic interior perspective of entrance court with skylights*    **fig. 4.70**
graphite, negro lead on yellow tracing paper, 40.5 x 30 cm
Louis I. Kahn Collection 805.469
University of Pennsylvania and Pennsylvania Historical and
    Museum Commission
      *Louis I. Kahn Archive, v.6:557*
      *Space Design (1977):7*
      *Prown (1982):34*

95. **Schematic study of lighting detail**                    fig. 4.71
charcoal on yellow tracing paper, 30.5 x 35.5 cm
7 July
Louis I. Kahn Collection 805.425
University of Pennsylvania and Pennsylvania Historical and
    Museum Commission
        *Louis I. Kahn Archive, v.6:536*

96. **Schematic study of skylight, partial plan**             fig. 4.72
charcoal on yellow tracing paper, 30.5 x 43 cm
7 July
Louis I. Kahn Collection 805.427
University of Pennsylvania and Pennsylvania Historical and
    Museum Commission
        *Louis I. Kahn Archive, v.6:536*

97. **Interior perspective of second floor exhibition space
for prints, drawings, and rare books**                       fig. 4.73
graphite, negro lead on yellow tracing paper, 30.5 x 38 cm
1971
Louis I. Kahn Collection 805.475
University of Pennsylvania and Pennsylvania Historical and
    Museum Commission
        *Louis I. Kahn Archive, v.6:562*

98. **Perspective view from northeast**                       fig. 4.74
graphite, negro lead on yellow tracing paper, 59 x 81 cm
1971
Louis I. Kahn Collection, 805.464
University of Pennsylvania and Pennsylvania Historical and
    Museum Commission
        *Louis I. Kahn Archive, v.6:552*      *Tyng (1984):57*
        *Space Design (1977):6*               *Prown (1982):38*
        *Yale Alumni Magazine (1972):30*
        *Cook and Klotz:205*

99. **Perspective view from west**                            fig. 4.75
graphite, negro lead on yellow tracing paper, 60.5 x 80 cm
October 1971
Louis I. Kahn Collection 805.465
University of Pennsylvania and Pennsylvania Historical and
    Museum Commission
        *Louis I. Kahn Archive, v.6:553*      *Giurgola & Mehta:99*
        *Space Design (1977):6*               *Architecture (1986):65*
        *Yale Alumni Magazine (1972):31*      *Complete Works (1987):391*
        *Architectural Forum (1972):82*       *Prown (1982):39*
        *A & U (1973):113, (1983):172*

# De Menil Museum

100. **Schematic site plan**                                  fig. 5.1
graphite, negro lead, green pencil on yellow
    tracing paper, 45.7 x 107.3 cm
Louis I. Kahn Collection 810.12
University of Pennsylvania and Pennsylvania Historical and
    Museum Commission
        *Louis I. Kahn Archive, v.7:8*

101. **Schematic site plan, various sketches**          fig. 5.2
graphite, negro lead on yellow tracing paper, 61 x 51.5 cm
10 March 1973
Louis I. Kahn Collection 810.1
University of Pennsylvania and Pennsylvania Historical and
    Museum Commission
    *Louis I. Kahn Archive, v.7:2*

102. **Schematic site plan, partial section**          fig. 5.3
graphite, negro lead on yellow tracing paper, 45.5 x 64 cm
Louis I. Kahn Collection 810.4
University of Pennsylvania and Pennsylvania Historical and
    Museum Commission
    *Louis I. Kahn Archive, v.7:4*

103. **Schematic site plan, various section studies**          fig. 5.4
colored pencil, charcoal on yellow
    tracing paper, 45.7 x 85 cm
Louis I. Kahn Collection 810.9
University of Pennsylvania and Pennsylvania Historical and
    Museum Commission
    *Louis I. Kahn Archive, v.7:6*

104. **Schematic site and building section**          fig. 5.5
charcoal on yellow tracing paper, 45 x 239.5 cm
Louis I. Kahn Collection 810.19
University of Pennsylvania and Pennsylvania Historical and
    Museum Commission
    *Louis I. Kahn Archive, v.7:11*

105. **Schematic site plan**          fig. 5.6
graphite, red pencil, charcoal on yellow
    tracing paper, 45.7 x 102.2 cm
Louis I. Kahn Collection 810.7
University of Pennsylvania and Pennsylvania Historical and
    Museum Commission
    *Louis I. Kahn Archive, v.7:5*
    *Complete Works (1987):424*

106. **Schematic site plan**          fig. 5.7
charcoal on yellow tracing paper, 46 x 107 cm
Louis I. Kahn Collection 810.5
University of Pennsylvania and Pennsylvania Historical and
    Museum Commission
    *Louis I. Kahn Archive, v.7:4*
    *Complete Works (1987):424*

107. **Schematic east elevation, "The Storage"**          fig. 5.8
graphite, negro lead on yellow tracing paper, 45.7 x 99.5 cm
Louis I. Kahn Collection 810.22
University of Pennsylvania and Pennsylvania Historical and
    Museum Commission
    *Louis I. Kahn Archive, v.7:13*
    *Complete Works (1987):425*

108. **Schematic cross section, "Sculpture Gallery"**          fig. 5.9
graphite, negro lead on yellow tracing paper, 45.7 x 99.5 cm
Louis I. Kahn Collection 810.24
University of Pennsylvania and Pennsylvania Historical and
    Museum Commission
    *Louis I. Kahn Archive, v.7:15*

109. ***Schematic cross section***                                      **fig. 5.10**
    graphite, negro lead on yellow tracing paper, 45.7 x 99.5 cm
    Louis I. Kahn Collection 810.25
    University of Pennsylvania and Pennsylvania Historical and
        Museum Commission
        *Louis I. Kahn Archive, v.7:16*
        *Complete Works (1987):425*

110. ***Schematic site plan, elevation, section***                      **fig. 5.12**
    graphite, negro lead on yellow tracing paper, 30.5 x 45.7 cm
    Louis I. Kahn Collection 810.14
    University of Pennsylvania and Pennsylvania Historical and
        Museum Commission
        *Louis I. Kahn Archive, v.7:9*

111. ***Schematic site plan***                                          **fig. 5.15**
    pastel on sepia print, 45.7 x 103 cm
    The Menil Collection

112. ***Schematic site plan***                                          **fig. 5.16**
    graphite, negro lead on yellow tracing paper, 43.7 x 102.2 cm
    Louis I. Kahn Collection 810.15
    University of Pennsylvania and Pennsylvania Historical and
        Museum Commission
        *Louis I. Kahn Archive, v.7:10*
        *Complete Works (1987):425*

113. ***Schematic site plan***                                          **fig. 5.17**
    pastel on sepia print, 45.7 x 102.2 cm
    The Menil Collection

114. ***Schematic site plan***                                          **fig. 5.18**
    pastel on sepia print
    October 1973
    The Menil Collection

# Yale Art Gallery   APPENDIX A

1. Yale Art Gallery Program, January 18, 1951:

## Art Gallery Annex

Nature: loft building
Ground plan: four bays wide, five bays long, each bay 23' x 25'
Area: 23' x 25' x 20 = 11,500 sq ft
Height: Basement and three floors = 56' (height from last Goodwin design)
Cube: 11,500 x 56 = approximately 650,000 cubic sq ft
Total bay cubes: 20 x 4 = 80
Use of Bays: Art Gallery = 24 or 30%
             Remainder = 56 or 70%

| | |
|---|---|
| Cost: Art Gallery = 650,000 x .30 x $2.00 = | $390,000 |
| Remainder = 650,000 x .70 x $1.50 = | 682,500 |
| Building cost | $1,072,500 |

| | |
|---|---|
| Additional costs: Bridge, Tunnel, Garden, Paving, alterations to Weir Hall and Gallery, fees, etc. | 427,500 |
| Total cost | $1,500,000 |
| Use Areas: Gallery | 13,800 sq ft (3 floors) |
| Architecture | 13,800 sq ft (2 top floors) |
| Present architecture area | (13,000 sq ft) |
| Unassigned | 18,400 sq ft (basement and first floor) |

2. Recapitulation of Areas, March 28, 1951:

## Howe's Original Scheme

| | |
|---|---|
| five bays x four bays, 23' x 25' | 11,500 sq ft per floor |
| Museum has 8 bays x 3½ floors | |
| Architecture has 12 bays x 2 floors | |
| Therefore, Museum has 4,600 sq ft x 3½ = | 16,100 sq ft |
| Architecture has 6,900 sq ft x 2 = | 13,800 sq ft |
| Design has 6,900 sq ft x 1½ = | 10,400 sq ft |
| Total usable space | 40,300 sq ft |
| Plus ½ floor for air-conditioner | 5,750 sq ft |
| Total built space | 46,000 sq ft |

## Scheme of February 14, 1951

four bays x four bays, 23′ x 25′                                                       9,200 sq ft
                                                                                       per floor

Museum has 8 bays x 3½ floors
  (three floors & ½ basement)
Architecture has 8 bays x 3 floors
Design has 8 bays x 1½ floors
Therefore, Museum has 4,600 sq ft x 3½ floors =                                       16,100 sq ft
Architecture has 4,600 sq ft x 3 floors =                                             13,800 sq ft
Design has 4,600 sq ft x 1½ floors =                                                   6,900 sq ft
Total                                                                                 36,800 sq ft
      Plus two floors connecting wing 24′ x 70′ =                                      3,400 sq ft
Total usable space                                                                    40,200 sq ft
      Plus ½ floor for air-conditioner                                                 4,600 sq ft
Total built space                                                                     44,800 sq ft

## Scheme of March 28, 1951

Museum has bridge 40′ x 80′, three floors (3200 x 3 = )                                     9,600
      Plus basement loft 50 x 80, one floor                                                4,000
      Plus circulation 24 x 60, three floors                                               4,300
                                                                                      17,900 sq ft

Architecture has loft 50 x 80, three floors
      (150 students @ 80 sq ft pp)                                                        12,000
      Plus top floor connecting link 25 x 70                                               1,750
                                                                                      13,750 sq ft

Design has loft 50 x 80, one floor                                                         4,000
      Plus lower floor connecting link 25 x 70                                             1,750
                                                                                       5,750 sq ft

Total usable space                                                                    37,400 sq ft
      Sub-basement under bridge for
      air conditioning equipment                                                           3,200
Total built space                                                                     40,600 sq ft

# Kimbell Art Museum   APPENDIX B

1. Summary of Pre-Architectural Program, June 6, 1966, by Richard F. Brown:

    A. Allocable interior space, basic building:
        1. Operations level .............................................14,950 sq ft
               a. Administrative offices
               b. Curatorial offices
               c. Boardroom
               d. Library and research area
               e. Conservation studio
               f. Greenhouse

        2. Public level ................................................60,950
               a. Auditorium
               b. Bookstore
               c. Lounge or reception hall
               d. Restrooms
               e. Stairwells

        3. Service level...............................................21,500
               a. Loading dock with receiving area
               b. Offices
               c. Shops
               d. Photographic studio
               e. Storage
               f. Mechanical room

        4. Net interior allocable space ...............................97,400

    B. Plus underneath parking area on service level ...................35,000

    C. Building mechanical (plumbing, heating,
       wiring, air-conditioning) ......................................... 135,400

    D. Total cost for facility .......................................... $5,871,500

    E. Architectural and design fee.................................... 600,000

    F. Grand Total Cost of Museum................................ $6,471,500

2. Comparative Space Breakdown, August 15, 1968, by Richard F. Brown (square footage in round figures):

|  | Present Drawings | Program | Minus 6th Bay 20 Ft. off N&S |
|---|---|---|---|
| A. Public Exhibition Space: | | | |
| 1. Permanent Collection: | | | |
| a. Interior Galleries | 34,400 | 32,800 | 23,000 |
| b. Enclosed Gardens & Courts | 4,100 | xxx | 4,100 |
| c. Central bridge spine (upper level only) | 4,100 | xxx | 4,100 |
| | 42,600 | 32,800 | 31,200 |
| 2. Special Exhibitions: | | | |
| a. Temporary shows gallery | 8,000 | 7,200 | *6,400 |
| 3. Other Public Areas: | | | |
| a. Entrance spine (upper plus lower levels) | 3,800 | xxx | 3,800 |
| b. Central circulation spine | 4,200 | xxx | 3,800 |
| c. Auditorium-Lounge-Bookshop | 8,000 | 6,000 | *6,400 |
| d. Lower level below number 3 (above) | 8,000 | xxx | *6,400 |
| e. Central Bridge Spine (lower level only) | 4,100 | xxx | 4,100 |
| | 28,100 | 20,950 | 24,900 |
| 4. Service Areas: | | | |
| a. Below Permanent Gallery (minus gardens) | 34,400 | 21,500 (svce.) | 23,000 |
| b. Below Central Circulation Spine | 4,200 | 14,950 (operations) | 4,200 |
| | 38,600 | 36,450 | 27,200 |
| 5. Unfinished space below temporary show gallery, | 8,000 | xxx | *6,400 |
| B. Grand Totals | 125,300 | 97,400 | 96,100 |

C. It also must be kept in mind that the two north and south gardens must be used as public exhibition space as well: nearly 18,000 square feet; plus the potential installation of objects in front loggia and other surrounding entry and garden areas.

# Yale Center for British Art   APPENDIX C

1. Schedule proposed by Jules Prown, October 29, 1969:

| | |
|---|---|
| 11/69 to 1/70 | Complete academic and building programs. Site and peripheral development decisions. Preliminary study by architect. |
| 1/70 to 4/70 | Schematic design development and approval. |
| 4/70 to 9/70 | Final design development and approval. |
| 9/70 to 4/71 | Contract documents. |
| 5/71 to 6/71 | Bid, approval and construction award. |
| 7/71 to 6/73 | Construction. |
| 6/73 to 12/73 | Move in. Open 12/73 or 1/74. |

2. Area Requirements, January 1970:

| | |
|---|---|
| Gallery, approximately 600 paintings plus 200 drawings on public view | 40,000 sq ft |
| Gallery, room for changing exhibitions | 3,000 |
| Reserve view, approximately 700 paintings on view | 5,000 |
| Print Room, to house 20,000 drawings and prints (boxed), generous space for viewing prints, drawings, and large rare books from adjoining Rare Book Library. Conservator's studio for care of drawings, prints, rare books | 5,000 |
| Lecture Room, seating 400 | 4,000 |
| Conservation Laboratory for Paintings | 6,000 |
| Rare Book Library, for approximately 30,000 volumes (adjoining Print Room) | 5,000 |
| Research Library, for approximately 50,000 volumes (connecting with Rare Book Library and Print Room) | 5,000 |
| Reading Room, Research Library Liberal working space for approximately 50 readers | 3,000 |
| Ten small private studies for fellows and visiting scholars, 10' x 10' | 1,000 |

| | |
|---|---|
| Four Seminar Rooms, 20' x 25' | 2,000 |
| Photographic Archive for Study of British Art | 3,000 |
| Small Lunch Room for scholars and staff | 1,000 |
| Photography Studio | 1,000 |
| Gallery Work Shop and Registrar Work Area | 2,000 |
| Space Requirements for Staff | 2,000 |
| Total New Square Footage | 88,000 sq ft |

Allowance for elevators, stairs, toilet rooms, mechanical
    rooms, service areas, and public spaces          88,000
                                                    x 1.67
                                              146,960 sq ft

147,000 square feet of gross area represents the net area as 60% of the gross. It may be possible to reduce the gross area slightly by utilizing some public and circulation spaces for exhibition purposes.

3. Schematic Design, August 17, 1970, Tabulation of New Square Footage:

| | Program | Design |
|---|---|---|
| Public Display | 40,000 sq ft | 31,382 sq ft |
| Temporary Exhibition | 3,000 | 2,970 |
| Reserve View | 5,000 | 5,856 |
| Rare Books & Prints | 10,000 | 11,974 |
| Research Library, Photo Archive, Studies for Fellows, & Seminar Rooms | 14,000 | 18,954 |
| Lecture Hall | 4,000 | 4,583 |
| Conservation Lab, Ptgs | 6,000 | 5,185 |
| Gallery Workshop & Registrar's Areas | 2,000 | 9,933 |
| Photography Studio | 1,000 | 1,885 |
| Staff Offices | 2,000 | 2,420 |
| Food, Conversation, Rest,* Private Dining | 1,000 | 1,129 |
| Total | 88,000 sq ft | 96,271 sq ft |

*Lounge included in 'Public Display'

4. Design Development, December 21, 1970 (Alternative, January 5, 1971),
   Tabulation of Net Square Footage:

|  | **Program** | **Design** |
|---|---|---|
| Public Display | 40,000 sq ft | 32,914 sq ft |
| Temporary Exhibition | 3,000 | 3,500 |
| Reserve View | 5,000 | 6,006** |
| Rare Books & Prints Library | 10,000 | 10,608*** |
| Research Library, Photo Archive, Studies for | | |
|     Fellows, & Seminar Rooms | 14,000 | 17,169 |
| Lecture Hall | 4,000 | 5,808 |
| | | (4,950) |
| Conservation Lab, Ptgs | 6,000 | 3,933 |
| Gallery Workshop & Registrar's Areas | 2,000 | 7,630 |
| | | (6,400) |
| Photography Studio | 1,000 | 1,825 |
| Staff Offices | 2,000 | 2,698 |
| Food, Conversation, Rest,* Private Dining | 1,000 | 1,178 |
| Totals | 88,000 | 93,915 |
| | | (93,081) |
| Mounted Photographs Exhibition Area (2M) | | 1,254 |
| Bridges' Throughway (2M) | | 2,982 |

*Public lounge included in 'Public Display'
**From this figure 936 sq ft can be deducted and assigned to Seminar Rooms
  (one at each end of the Reserve View Room)
***This figure includes the Paper Conservator Areas

5. Design Development Drawings Dated March 15, 1971, Net Areas in Square Feet:

| | |
|---|---|
| Public Display | 33,191 sq ft |
| Temporary Exhibition | 3,630 |
| Reserve View | 6,117 |
| Rare Books and Prints Library | 12,358 |
| Research Library, Photo Archive, Studies for Fellows, & | |
|     Seminar Rooms | 18,868 |
| Lecture Hall | 6,612 |
| Conservation Lab Paintings | 6,612 |
| Gallery Workshop and Registrar Areas | 6,920 |
| Photography Studio | 2,056 |
| Staff Offices | 3,400 |
| Food, Conversation, Rest | 2,096 |
| Mounted Photographs Exhibition | 1,338 |
| Bridges' Throughway | 3,180 |
| Total | 103,663 |

6. Program Net Areas in Square Feet, April 29, 1971:

| | |
|---|---|
| Public Display | 22,000 sq ft |
| Temporary Exhibition | 3,000 |
| Reserve View | 6,000 |
| Rare Book, Drawing, and Print Dept. | 10,000 |
| Photographic Archive and Research Facility | 6,000* |
| *250 included for Registrar Records (if associated with Registrar then remove from Reader Viewing Area) | |
| Studies for Fellows/Visiting Scholars | 500 |
| Seminar Rooms (Two) | 1,000 |
| Lecture Hall | |
|   For 200 persons and projection booth | 2,000 |
| Conservation Studio Paintings | 2,700 |
| Gallery Workshop and Registrar Areas | 5,000 |
| Photography Studio | 1,420 |
| Staff Offices | 2,650 |
| Food, Conversation, Rest | 1,300 |
| | |
| Total | 63,570 sq ft |

7. New Areas in Square Feet, July 26, 1971:

| | |
|---|---|
| Public Display | 33,000 sq ft |
| Temporary Exhibition | 3,376 |
| Reserve View | 4,660 |
| Rare Book, Drawing, and Print Dept. | 11,516 |
| Photographic Archive and Research Facility | 5,963 |
| Studies for Fellows/Visiting Scholars (6) | 536 |
| Seminar Rooms (2) (1) in RV 390 (1) (double use) | 380 |
| Lecture Hall | |
|   For 200 persons and projection booth | 3,861 |
| Painting Conservation Studio Omitted | |
| Gallery Workshop and Registrar Areas | 4,731 |
| Photography Studio | 1,487 |
| Staff Offices | 2,660 |
| Food, Conversation, Rest | 1,368 |

8. Programmed Net Areas in Square Feet, October 29, 1971:

| | |
|---|---|
| Public Display | 23,691 sq ft |
| Temporary Exhibition (included in Public Display) | |
| Reserve View | 4,131 |
| Rare Books, Drawings, and Print Dept. | 12,695 |
| Photographic Archive and Research Facility | 5,051 |
| Studies for Fellows/Visiting Scholars | 714 |
| Seminar Rooms | 5 [?] |
| Lecture Hall | 2,491 |
| Painting Conservation Studio Omitted | |
| Gallery Workshop and Registrar Areas | 5,845 |
| Photographic Studio | 1,833 |
| Staff Offices | 2,808 |
| Food, Conversation, Rest | 1,597 |
| | |
| Total | 61,441 |

Abercrombie, Stanley. "Edison Price: His Name Is No Accident." *Architecture Plus* 1 (August 1973): 34.
——. "Louis I. Kahn, Pellecchia and Meyers, Benjamin Baldwin, Yale Center for British Art." *Interiors* 136 (July 1977): 52–59.
"After Architecture, Kahn's Kimbell Art Museum." *Design Book Review* II (Winter 1987): 35-55.
Aloi, Roberto. *Musei: Architettura — Tenical.* Milan: Ultrico Hoepli, 1962.
Andres, Glenn M. *The Villa Medici in Rome.* New York and London: Garland, 1976.
"A New Building for the Arts." *Yale Alumni Magazine* 18 (December 1953): 8–13.
Bach, Richard F. "The Detroit Institute of Arts." *Architectural Forum* (February 1929): 193–202.
Banham, Reyner. "The New Brutalism." *Architectural Review* 118 (December 1955): 355–61.
Barnett, Jonathan. "The New Collegiate Architecture at Yale." *Architectural Record* 131 (April 1962): 125–38.
Bazin, Germain. *The Museum Age.* New York: Universe Books, 1967.
Brawne, Michael. *The New Museum: Architecture and Display.* New York: Frederick A. Praeger, 1965.
——. "Museums, Mirrors of Their Time?" *Architectural Review* 175 (February 1984): 17–19.
"Break-away Forms Cast Arching Roofs." *Construction Management and Economics* (April 1972): 90–92.
Brewer, Cecil C. "American Museum Buildings." *Journal of the Royal Institute of British Architects* 20, third series (April 12, 1913): 365–403.
Brown, Carter. "Architecture Versus the Museum." *American Institute of Architects Government Affairs Review,* Issue 71–3 (March 1971): 5–6.
Brown, Jack Perry. *Louis I. Kahn: A Bibliography.* New York and London: Garland, 1987.
"Building Engineering: 1. Tetrahedral Floor System: Yale's New Design Laboratory Conceals Lighting and Ductwork with a 31–inch Deep Floor Structure." *Architectural Forum* 97 (November 1952): 148–49.
"Building Engineering: 2. Thru-Way Floor Truss." *Architectural Forum* 97 (November 1952): 149–50.
Burroughs, Clyde. "The New Detroit Museum of Arts." *Museum Work* 8 (1925): 66–74.
Coleman, Laurence Vail. *The Museum in America, A Critical Study.* Washington, D.C.: American Association of Museums, 1939.
——. *Museum Buildings: Volume 1, A Planning Study.* Washington, D.C.: American Association of Museums, 1950.
Cook, John W., and Heinrich Klotz. *Conversations with Architects.* New York: Frederick A. Praeger, 1973.
Cooper, Henry F. S. "The Architect Speaks." *Yale Daily News,* Special Supplement: The New Art Gallery and Design Center, Dedication Issue (November 6, 1953).
Cret, Paul P. "The Architect as Collaborator of the Engineer" and "Theories in Museum Planning." In *Paul Philippe Cret,* by Theophilus B. White. Philadelphia: Art Alliance Press, 1973: 16–65; 73–78.
Crosbie, Michael J. "Evaluation: Monument Before Its Time." *Architecture* 75 (January 1986): 64–67.
Dean, Andrea O. "A Legacy of Light." *American Institue of Architects Journal* 67 (May 1978): 83–88.
——. "Showcase for Architecture." *Architecture* 75 (January 1986): 28–31.
"Design/techniques: Structural Methods. Three-dimensional Floor System." *Progressive Architecture* 53 (January 1954): 82.
Drexler, Arthur, ed. *The Architecture of the Ecole des Beaux-Arts.* New York: Museum of Modern Art, 1977.
Dube, Wolf-Dieter. *The Munich Gallery, Alte Pinakothek.* London: Thames and Hudson, 1970.
Durand, Jean-Nicolas-Louis. *Précis des leçons d'architecture donnée à l'école polytechnique.* Paris, 1802–5.
"Exhibition at the Museum of Modern Art, April 1966, Devoted to the Work of Louis Kahn." *Art in America* 54 (March–April 1966): 124–25.
Filler, Martin. "Opus Posthumous. Yale Center for British Art, Yale University, New Haven." *Progressive Architecture* 59 (May 1978): 76–81.
Fox, Stephen. *The General Plan of the William M. Rice Institute and Its Architectural Development.* Houston: Rice University, 1980.
Frampton, Kenneth. *Modern Architecture: A Critical History.* New York and Toronto: Oxford University Press, 1980.
——. "Louis Kahn and the French Connection." *Oppositions* 22 (Fall 1980): 21–53.
——, and Alessandra Latour. "Notes on American Architectural Education from the End of the 19th Century Until the 1970s." *Lotus International* 27 (1980–II): 5–39.
Gilman, Benjamin I. *Museum Ideals of Purpose and Method.* Cambridge, Mass.: Riverside Press, 1918.
Giurgola, Romaldo, and Jaimini Mehta. *Louis I. Kahn: Architect.* Zürich: Verlag für Architektur, 1975.
Glaeser, Ludwig. *Architecture of Museums.* New York: Museum of Modern Art, 1969.
Goodyear, A. Conger. *The Museum of Modern Art: The First Ten Years.* New York: Museum of Modern Art, 1943.
Green, Wilder. "Louis I. Kahn, Architect: Alfred Newton Richards Medical Research Building, University of Pennsylvania, Philadelphia, 1958–1960." *Museum of Modern Art Bulletin* (1961): 1–24.
Guadet, Julien. *Eléments et Théorie de l'Architecture,* third edition. Paris: Librairie de la Construction Moderne, 1909.
Hall, Edwin T. "Art Museums and Picture Galleries." *Royal Society of British Architects Journal* 19, third series (April 1912): 393–412.
Hamburgh, Harvey. "Some Heraldic Shields in Kresge Court." *Bulletin of the Detroit Institute of Arts* 59 (Spring 1981): 38–47.
Hamlin, Talbot. "Modern Display for Works of Art." *Pencil Points* 20 (September 1939): 615–20.

Hannema, D., and A. van der Steur. "La Technique de l'eclairage dans les musée et le systeme adopte au musée Boymans." *Mouseion* 33–34 (1936): 161–83.

Harbeson, John F. *The Study of Architectural Design*, revised edition. New York: Pencil Points Press, 1927.

Hitchcock, Henry-Russell. *Early Museum Architecture, 1770–1850*. Middletown, Conn.: Wesleyan University Press, 1934.

———. *Architecture: Nineteenth and Twentieth Centuries*, revised edition. Baltimore: Penguin Books, 1967.

———, and Philip Johnson. *The International Style: Architecture Since 1922*. New York: Museum of Modern Art, 1932; W. W. Norton, 1966.

Hudnut, Joseph. "The Last of the Romans." *Magazine of Art* 34 (April 1941): 169–73.

Hudson, Kenneth. *Museums of Influence*. Cambridge: Cambridge University Press, 1987.

Huff, William. "Kahn and Yale." *Journal of Architectural Education* 35 (Spring 1982): 22–31. A revised and expanded version is in *Louis I. Kahn, l'uomo, il maestro*, by Alessandra Latour. Rome: Edizioni Kappa, 1986.

Hunter, Sam. "Introduction." In *The Museum of Modern Art: The History and the Collection* by the Museum of Modern Art. New York: Museum of Modern Art, 1984.

Huth, Hans. "Museum and Gallery." In *Essays in Honor of G. Swarzenski*. Chicago: Henry Regnery, 1951: 238–45.

"In the Philosophy of Louis Kahn, Engineering and Architecture Were Inseparable Parts of Total Form." *Architectural Record* 156 (mid-August 1974): 84–85.

*Introduction to the Philadelphia Museum of Art*. Philadelphia: Philadelphia Museum of Art, 1985.

Joedicke, Jurgen, and Oscar Newman, eds. *New Frontiers in Architecture, CIAM at Otterlo*. New York: Universe Books, 1961.

Johnson, Nell E., comp. *Light Is the Theme*. Fort Worth: Kimbell Art Foundation, 1975.

Jordy, William. "The Span of Kahn." *Architectural Review* 155 (June 1974): 318–42.

———. "Kahn at Yale, Art Center, Yale University." *Architectural Review* 162 (July 1977): 38–43.

———. Review of *Louis I. Kahn: Complete Works, 1935–1974*, by Heinz Ronner, Sharad Jhaveri, and Alessandro Vasella. *Louis I. Kahn: Architect*, by Jack Perry Brown, comp. *18 Years with Architect Louis I. Kahn*, by August Komendant. *Louis I. Kahn*, by Romaldo Giurgola and Jaimni Mehta. *Travel Sketches of Louis I. Kahn*, by Pennsylvania Academy of Fine Arts. *Light Is the Theme*, by Nell E. Johnson, comp. *Louis I. Kahn: Sketches for the Kimbell Art Museum*, by David M. Robb, Jr. *The Architecture of the Yale Center for British Art*, by Jules David Prown. *Journal of the Society of Architectural Historians* 39 (March 1980): 85–89.

Kahn, Louis I. "L'Accord de l'homme et de l'architecture: Une conference de Louis Kahn." *La Construction moderne* (July–August 1973): 10–21.

———. "Architecture: Silence and Light." In *On the Future of Art*. New York: Viking Press, 1970: 21–35.

———. "Architecture Is the Thoughtful Making of Spaces." *Perspecta* 4 (1957): 2–3.

———. *A City Tower: The Concept of Natural Growth*. University Atlas Cement Company, United States Steel Corporation Publication, 1957.

———. Closing Remarks. In *New Frontiers in Architecture, CIAM at Offerlo*, edited by Jurgen Joedicke and Oscar Newman. New York: Universe Books, 1961.

———. "Harmony Between Man and Architecture." *Design* (Bombay) 18 (March 1974): 23–28.

———. "I Love Beginnings." *Architecture and Urbanism* 2 (special edition, 1975): 279–86.

———. *Louis I. Kahn: Talks with Students*. Houston: Rice University, 1969.

———. "Louis I. Kahn on Beaux-Arts Training." In "The Span of Kahn," by William Jordy. *Architectural Review* 155 (June 1974): 332.

———. "Louis Kahn." *Perspecta* 7 (1961): 9–28.

———. "Louis Kahn: Statements on Architecture." *Zodiac* 17 (January 1967): 54–57.

———. "Monumentality." *New Architecture and City Planning*, Paul Zucker, ed. New York: Philosophical Library, 1944 577–88.

———. "Order in Architecture." *Perspecta* 4 (1957): 58–65.

———. "Order Is." *Perspecta* 3 (1955): 59.

———. "Order of Movement and Renewal of the City." *Perspecta* 4 (1957): 61–64.

———. "The Room, the Street and Human Agreement." *Architecture and Urbanism* (special edition, 1971): 33–34.

———. "Space and the Inspirations." *L'Architecture d'Aujourd'hui* 40 (February–March 1969): 15–16.

———. "Spaces, Order and Architecture." *Royal Architecture Institute of Canada Journal* 34 (October 1957): 375–77.

———. "A Statement." *Art and Architecture* 81 (May 1964): 18–19, 33.

———. "Structure and Form." *Voice of America Forum Architecture Series*, no. 6. Washington, D.C.: Government Printing Office, [1961].

———. "Toward a Plan for Midtown Philadelphia." *Perspecta* 2 (1953): 10–27.

———. "The Value and Aim in Sketching." *T-Square Club Journal* 1 (1931): 4, 18–21.

———. "The Wonder of the Natural Thing." In *Louis I. Kahn, l'uomo, il maestro*, by Alessandra Latour. Rome: Edizioni Kappa, 1986: 399–403.

Kahn, Louis I., Collection. Architectural Archives, University of Pennsylvania, and Pennsylvania Historical and Museum Commission. Philadelphia.

"Kahn's Gallery at Yale Wins 25–Year Award." *American Institute of Architects Journal* 68 (May 1979): 11.

"Kahn's Museum: Interview with Richard F. Brown." *Art in America* 50 (September–October 1972): 44–48.

Kimball, Fiske. "The Modern Museum of Art." *Architectural Record* 66 (December 1929): 559.

——. "Planning the Art Museum." *Architectural Record* 66 (December 1929): 581–90.

Kimbell Art Museum. *In Pursuit of Quality: The Kimbell Art Museum*. Fort Worth: Kimbell Art Museum, 1987.

——. Museum Files. Fort Worth.

Klenze, Leon von. *Sammlung architecktonischer Entwurfe*. Munich: Gotta, 1830.

Komendant, August. *Contemporary Concrete Structures*. New York: McGraw-Hill, 1972.

——. *18 Years with Architect Louis I. Kahn*. Englewood, N.J.: Aloray, 1975.

*Kröller-Müller Museum*. Haarlem: Joh. Enschede den Zoneon Grafische Inrichting B. V., 1978.

Latour, Alessandra. *Louis I. Kahn, l'uomo, il maestro*. Rome: Edizioni Kappa, 1986.

Lemagny, J.-C. *Visionary Architects: Boullée, Ledoux, Lequeu*. Houston: University of St. Thomas, 1968.

"Lighting Starts with Daylight." *Progressive Architecture* 54 (September 1973): 82–85.

Loud, Patricia C. "The Critical Fortune." *Design Book Review* 11 (Winter 1987): 52–55.

——. "History of the Kimbell Art Museum." In *In Pursuit of Quality: The Kimbell Art Museum*, by Kimbell Art Museum. Fort Worth: Kimbell Art Museum, 1987: 3–95.

"Louis I. Kahn." *Architecture and Urbanism* (special issue, 1975).

"Louis I. Kahn." *Architecture and Urbanism* (special issue, 1983).

"Louis I. Kahn: Oeuvres 1963–1969." *L'Architecture d'Aujourd'hui* 40 (February–March 1969): 1–100.

"Louis I. Kahn: Silence and Light." *Architecture and Urbanism* 3 (January 1973).

*The Louis I. Kahn Archives, Personal Drawings*. Vols. 1–7. New York and London: Garland, 1987.

Lucan, Jacques. "Da Guadet a Kahn: il tema della stanza." *Domus* 50 (January-February 1986): 72–75.

McCleary, Peter. "The Kimbell Art Museum: Between Building and Architecture." *Design Book Review* 11 (Winter 1987): 48–51.

McLaughlin, Patricia. "How'm I Doing, Corbusier?" *Pennsylvania Gazette* 71 (December 1972): 18–26.

McQuade, Walter. "Architect Louis Kahn and His Strong-boned Structures." *Architectural Forum* 121 (October 1957) 134–43.

——. "The Building Years of a Yale Man." *Architectural Forum* 118 (June 1963): 88–93.

Marlin, William. "Louis Kahn: Humble Titan of World Architecture." *Christian Science Monitor* (May 8, 1974).

Mellingham, G.-Tilman. "Soane's Dulwich Picture Gallery Revisited." In *John Soane*. London: Academy Editions, 1983.

Meyers, Marshall D. *Louis I. Kahn. Yale University Art Gallery, New Haven, Connecticut, 1951–1953. Kimbell Art Museum, Fort Worth, Texas, 1966–1972*. Tokyo: A.D.A. Edita, 1976.

——. "Louis Kahn and the Act of Drawing: Some Recollections." In *Louis I. Kahn, l'uomo, il maestro* by Alessandra Latour. First published in *Louis I. Kahn: Sketches for the Kimbell Art Museum*, by David M. Robb, Jr. Fort Worth: Kimbell Art Foundation, 1978.

——. "Masters of Light: Louis Kahn," *American Institute of Architects Journal* 68 (September 1979): 60–62.

——. "Marshall D. Meyers." In *Louis I. Kahn, l'uomo, il maestro*, by Alessandra Latour. Rome: Edizioni Kappa, 1986: 71–87.

"The Mind of Louis Kahn." *Architectural Forum* 137 (July–August 1972): 42–89.

O'Gorman, James. *The Architecture of Frank Furness*. Philadelphia: Philadelphia Museum of Art, 1973.

*The Organization of Museums: Practical Advice*. Paris: UNESCO, 1960.

"P/A Views." *Progressive Architecture* 35 (May 1954): 15–16, 22, 24.

"The Paul Mellon Center for British Art: A Classic Accommodation between Town and Gown." *Yale Alumni Magazine* 35 (April 1972): 30–31.

Pennsylvania Academy of Fine Arts. *The Travel Sketches of Louis I. Kahn*. Philadelphia: Pennsylvania Academy of Fine Arts, 1978.

Pevsner, Nikolaus. *Sources of Modern Architecture and Design*. London: Thames and Hudson, 1968.

——. *A History of Building Types*. London: Thames and Hudson, 1976.

Pietrangeli, Carlo. *I Musei Vaticani, cinque secoli di storia*. Rome: Edizioni Quasar, 1985.

Plagens, Peter. "Louis Kahn's New Museum in Fort Worth." *Art Forum* 6 (February 1968): 18–23.

"Post-tensioned Shells Form Museum Roof." *Engineering News Record* 187 (October 28, 1971): 24–25.

*Processes in Architecture: A Documentation of Six Examples*. Cambridge, Mass.: Massachusetts Institute of Technology, 1979.

Prown, Jules David. *The Architecture of the Yale Center for British Art*, second edition. New Haven, Conn.: Yale University Press, 1982.

——. "On Being a Client." *Journal of the Society of Architectural Historians* 42 (March 1983): 11–14.

——. "Jules D. Prown." In *Louis I. Kahn, l'uomo, il maestro*, by Alessandra Latour. Rome: Edizioni Kappa, 1986: 133–43.

Pundt, Hermann G. *Schinkel's Berlin, A Study in Environmental Planning*. Cambridge, Mass.: Harvard University Press, 1972.

Pushkarev, Boris. "Order and Form, Yale Art Gallery and Design Center Designed by Louis I. Kahn." *Perspecta* 3 (1955): 46–58.

Ricciotti, Dominic. "The 1939 Building of the Museum of Modern Art: The Goodwin-Stone Collaboration." *American Art Journal* 17 (Summer 1985): 50–76.

Rich, Daniel Catton. "Perfection at Rotterdam." *American Magazine of Art* 28 (October 1935): 580–90.

Rich, Lorimer. "A Study in Contrasts." *Pencil Points* 22 (August 1941): 497–516.

Ritchie, Andrew C. "Director's Report for the Years 1957–62." *Yale University Art Gallery Bulletin* 29 (April 1963): 5–6.

Robb, David M., Jr. *Louis I. Kahn: Sketches for the Kimbell Art Museum*. Fort Worth: Kimbell Art Foundation, 1978.

Ronner, Heinz, Alessandro Vasella, and Sharad Jhaveri. *Louis I. Kahn: Complete Works, 1935–1974*. Basel and Stuttgart: Birkhaüser, 1977.

——and Sharad Jhaveri. *Louis I. Kahn: Complete Works, 1935–1974*, second revised and enlarged edition. Basel and Boston: Birkhaüser, 1987.

Roob, Rona. "1936: The Museum Selects an Architect. Excerpts from the Barr Papers of the Museum of Modern Art." *Archives of American Art Journal* (1983): 22–30.

Rose, Barbara. "New Texas Boom." *Vogue* 160 (October 15, 1972): 118–21, 130.

Rosenau, Helen. "The Engravings of the Grand Prix of the French Academy of Architecture." *Architectural History* 3 (1960).

——. *Boullée and Visionary Architecture*. London: Academy Editions, 1976.

Sanderson, George A. "Extension: University Art Gallery and Design Center." *Progressive Architecture* 35 (May 1954): 88–101.

Scully, Vincent J. *Louis Kahn*. New York: George Braziller, 1962.

——. "Architecture and Man at Yale." *Saturday Review of Literature* (May 23, 1964): 26–29.

——. "Yale Center for British Art." *Architectural Record* 161 (June 1977): 95–104.

Searing, Helen. *New American Art Museums*. Berkeley: University of California Press, 1982.

Seling, Helmut. "The Genesis of the Museum." *Architectural Review* 141 (February 1967): 103–14.

Seymour, A. T. "Contractor Challenged by Kimbell Museum Design." In *Louis I. Kahn, l'uomo, il maestro*, by Alessandra Latour. Rome: Edizioni Kappa, 1986: 321–29. First published in *Fort Worth Star-Telegram*, "The Kimbell Art Museum," special supplement (October 2, 1972).

Shepard, Richard. "After a Six-Year Honeymoon, the Kimbell Art Museum." *Art News* 71 (October 1972): 22–31.

Shur, Susan E. "Museum Profile: Yale Center for British Art." *Technology and Conservation* 4 (Spring 1979): 20–25.

Simonson, Lee. "Skyscrapers for Art Museums." *American Mercury* 11 (May 1927): 399–403.

Smith, C. Ray. "The Great Museum Debate." *Progressive Architecture* 50 (December 1969): 84–85.

Smithson, Alison, and Peter Smithson. "Louis Kahn." *Architects' Yearbook* 9 (1960): 102–18.

Smithson, Peter. "Louis Kahn's Centre for British Art and British Studies at Yale University." *Royal Society of British Architects Journal* 83 (April 1976): 149–51.

Speck, Lawrence W. "Evaluation: The Kimbell Museum." *American Institute of Architects Journal* 71 (August 1982): 36–43.

Stein, Clarence. "The Art Museum of Tomorrow." *Architectural Record* 67 (January 1930): 5–12.

——. "Making Museums Function." *Architectural Forum* 56 (June 1932): 609–17.

——. "Glass Walls for New Art Museum." *Art News* 31 (October 29, 1932): 3.

——. "Architecture et amenagement des musée." *Mouseion* 7 (1933): 7–26.

——. "Eclairage naturel et eclairage artificiel." *Museographie* (Paris: International Museums Office, 1934).

——. "Form and Function of the Modern Museum." *Museum News* 16 (January 1939): 5–12.

——. "Study Storage: Theory and Practice." *Museum News* 22 (December 15, 1944): 9–12.

Stern, Robert A. M. "Yale 1950–65." *Oppositions* 4 (October 1974): 58.

——. *George Howe: Toward a Modern Architecture*. New Haven, Conn., and London: Yale University Press, 1975.

Sterne, Margaret. *The Passionate Eye: The Life of William R. Valentiner* (Detroit: Wayne State University Press, 1980).

Summerson, John, "John Soane: The Man and the Style." In *John Soane*. London: Academy Editions, 1983.

Tatum, George B. *Penn's Great Town: 250 Years of Philadelphia Architecture*. Philadelphia: University of Pennsylvania Press, 1961.

Tor, Abba. Review of *18 Years with Architect Louis I. Kahn*, by August Komendant. *Architectural Record* 162 (mid-August 1977): 107–08.

——. "A Memoir." In *Louis I. Kahn, l'uomo, il maestro*, by Alessandra Latour. Rome: Edizioni Kappa, 1986: 121–28.

Tyng, Alexandra. *Beginnings: Louis I. Kahn's Philosophy of Architecture*. New York: John Wiley and Sons, 1984.

Tyng, Anne Griswold. "Geometric extensions of conscience." *Zodiac* 19 (1969): 130–62.

——. "Architecture Is My Touchstone." *Radcliffe Quarterly* 70 (September 1984): 5–9.

Valentiner, William [Wilhelm]. "The Museum of Tomorrow." In *New Architecture and City Planning*, Paul Zucker, ed. New York: Philosophical Library, 1944: 656–74.

Waterfield, Giles. *Soane and After, The Architecture of Dulwich Picture Gallery*. London: Dulwich Picture Gallery, 1987.

White, Theophilus B. *Paul Philippe Cret*. Philadelphia: Art Alliance Press, 1973.

——., ed. *Philadelphia Architecture in the Nineteenth Century*. Philadelphia: Art Alliance and University of Pennsylvania Press, 1953.

*The Work of Louis I. Kahn*. La Jolla, Calif.: Museum of Art, 1965.

Wurman, Richard Saul. *What Will Be Has Always Been: The Words of Louis I. Kahn*. New York: Access Press, 1986).

——, and Eugene Feldman, eds. *The Notebooks and Drawings of Louis I. Kahn*. Philadelphia: Falcon Press, 1962; Cambridge, Mass.: Massachusetts Institute of Technology, 1973.
"Yale Center for British Art: Kahn's Last Work." *Space Design* 155 (August 1977): 5–24.

All photographs, with exceptions noted, are courtesy of the Louis I. Kahn Collection, Architectural Archives, the University of Pennsylvania, and the Pennsylvania Historical and Museum Commission, Philadelphia; Will Brown, photographer.

American Association of Museums, Washington, D.C.: 2.10.
Bibliothèque Nationale, Paris: 1.3.
Michael Bodycomb, Fort Worth: pp. 53, 99, 100, 171, 172.
The Detroit Institute of Arts: 1.16, 1.17, 1.18, 1.19, 1.20.
Lionel Freedman, New York: 2.29, 2.30, 2.40, 2.43, 2.44, 2.45.
Kimbell Art Museum, Fort Worth: 3.10, 3.16, 3.20, 3.21.
Marburg/Art Resource, New York: 1.6, 1.7, 1.8, 1.9, 1.14.
The Menil Collection, Houston; Paul Hester, photographer: cover, 5.16, 5.18, 5.19, pp. 244, 273.
Museum of Modern Art, New York: 1.30, 1.35, 1.36, 1.37, 1.38, 1.39, 2.11.
Musée du Louvre, Paris: 1.4, 1.5.
National Gallery of Art, Washington, D.C.: 2.12, 2.13.
Pennsylvania Academy of Fine Arts, Philadelphia: 1.21, 1.22, 1.23, 1.24.
Philadelphia Museum of Art: 1.28, 1.29.
Pio-Clementino Museum, the Vatican Museums, Vatican City: 1.1, 1.2.
Rijksmuseum Kröller-Müller, Otterlo: 1.31, 1.32, 1.33, 1.34.
Sir John Soane Museum, London: 1.13.
Anne Griswold Tyng, Philadelphia: 2.22, 2.23.
University of Pennsylvania Archives, Philadelphia: 1.25, 1.26, 1.27.
Victoria and Albert Museum, London: 1.11, 1.12.
Bob Wharton, Fort Worth: frontispiece, p. 6.
Yale Center for British Art, New Haven: 4.88, p. 12.
Yale University Manuscripts and Archives, New Haven: 2.1, 2.2, 2.46, 2.47, 2.48, 2.49.
Yale University Art Gallery, New Haven: 2.16, 2.18, 2.32, 2.50, 2.52.